ARTS
OF THE
INDIAN AMERICAS

Also by Jamake Highwater

The Sun, He Dies *(novel)*

Anpao: An American Indian Odyssey *(novel)*

Journey to the Sky: Rediscovering the Maya *(novel)*

Eyes of Darkness *(novel)*

The Ghost Horse Trilogy *(novels)*
 Legend Days
 I Wear the Morning Star
 Kill Hole

Moonsong Lullaby *(juvenile)*

The Primal Mind: Vision and Reality in Indian America

Many Smokes, Many Moons: A Chronology of
 American Indian History Through Indian Art

Dance: Rituals of Experience

Ritual of the Wind: North American Indian Ceremonies,
 Music and Dances

Song from the Earth: American Indian Painting

The Sweet Grass Lives On: Fifty Contemporary
 North American Indian Artists

Masterpieces of North American Indian Painting *(8 folios)*

Indian America: A Cultural and Travel Guide

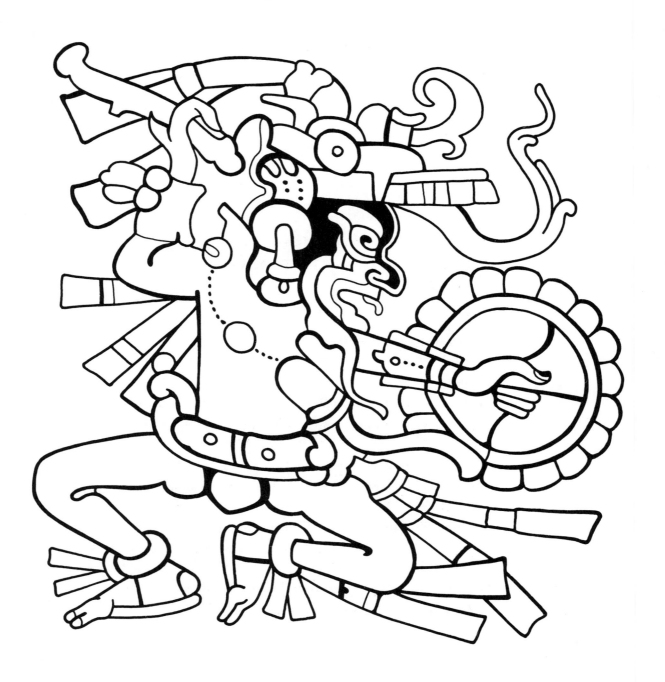

From the Dresden Codex; style of the Classic period A.D. 1100–1200.

ARTS
OF THE
INDIAN AMERICAS

Leaves from the Sacred Tree

JAMAKE HIGHWATER

ICON EDITIONS

1817

HARPER & ROW, PUBLISHERS, New York
Cambridge, Philadelphia, San Francisco, London
Mexico City, São Paulo, Sydney

The line drawings throughout the text, unless otherwise
credited, are reproduced courtesy of Dover Publica-
tions, Inc., New York City.

The illustration of the stylization process of one of the
falcon-headed, staff-bearing attendant figures on the
monolithic gateway at Tiahuanaco, from *Ancient Arts
of the Americas* by G. H. S. Bushnell, is reproduced
courtesy of Thames & Hudson, London.

The maps of tribal groups in North and South America
are reproduced with the permission of Frederick
J. Dockstader.

The illustrations concerning the iconography of North-
west Coast art are reproduced, with the permission of
Hilary Stewart, from the book *Looking at Indian Art of
the Northwest Coast,* published by the University of
Washington Press.

The extended quotation from Stephen C. Jett's "Pre-
Columbian Transoceanic Contacts" in the anthology
Ancient Native Americans edited by Jesse D. Jennings is
reproduced with the permission of W. H. Freeman and
Company, Publishers, San Francisco.

Unless otherwise credited, all photographs are from the
author's collection.

FIRST EDITION

Designer: Abigail Sturges

Library of Congress Cataloging in Publication Data

Highwater, Jamake.
 Arts of the Indian Americas.

 (Icon editions)
 Bibliography: p.
 Includes index.
 1. Indians—Arts. I. Title.
E59.A73H53 1983 700'.8997 83–47556
ISBN 0–06–033330–2 83 84 85 10 9 8 7 6 5 4 3 2 1
ISBN 0–06–430135–4 pbk 83 84 85 10 9 8 7 6 5 4 3 2 1

For
John Williamson

Contents

Color inserts follow pages 52, 244, and 308.

The entire essence of time, as of light, is to *make visible*.

Maurice Merleau-Ponty

THE SACRED TREE

An Introduction

There, where the tree of life is standing,
Will my songs and my flowers
Adorn the land of mystery . . .

Aztec song

Art is the most fundamental way of *seeing*. The art of the Native Americas is a unique and significant variation in human perception. The Indian art of North, Central, and South America makes a special kind of conception of the world visible to us, and it is a vivid depiction of what is most fundamental and real about the American Indian experience.

The possibility that Native Americans have a unique vision of the world is a basic assumption of this book. And it is in the arts of Indians that we clearly grasp something of the otherness of the inhabitants of this ancient land newly named America.

It is usually assumed that all humankind has a common heritage and a common destiny, but the evidence of recent anthropological studies points to a contrary consensus. Europeans were convinced for centuries of the absolute superiority and virtue of their own cultures and religions, certain that underneath all apparent diversities there was an ideal and perfect spiritual unity among all human beings. And so they self-righteously set out to convert all nations with which they came into contact. The immense impact on the cultures they have overrun does not mean, however, that all the people influenced by Europeans were necessarily heading toward the same cultural, sociological, and political destinies as their invaders.

These observations suggest alternatives to the European experience. Scholars and philosophers of the late twentieth century have largely overturned the certitude of the West and demonstrated that the windows through which Western thinkers and scientists have traditionally looked at the rest of the world have, by and large, been mirrors in which they have seen everything in terms of themselves and their own narrow definition of reality. The American anthropologist Carlos Castaneda has suggested in his controversial Don Juan books that there are many shapes and not just a single shape of history. Castaneda calls the Indian cosmos "a separate reality"—a wholly alien but perfectly valid way of seeing and understanding the world. The concept of a separate reality is no longer alienating; we now grasp the idea of "otherness" and thoroughly comprehend alternative lifestyles, experimental art forms, relative moral standards, and all the other attributes of a troubled but enlightened pluralism.

Art is an integral part of all cultures. It is art that makes visible to us even the most subtle differences in the ways we see and interpret the world around us. For this reason there can be no single better approach to the special mentality of Indians than through their many forms of art. Within each folktale of the Indian Americas, in the images painted upon pottery and adobe walls, among Indian rituals and dances, and among the pictographic shadows of forgotten ancestors we discover an American reality entirely unsuspected by the pioneers and conquistadores. Those artistic images—both ancient and ultramodern—those iconographic emblems of a whole race of people are the true chronicles of the Indian Americas, told through the Indians' own sense of reality; they provide a unique perspective that has the power momentarily to wrench us away from ourselves and to show us other possible worlds. They are worlds that beckon to us today more than ever, for they

suggest urgently needed alternatives to the twentieth-century Western dilemma.

These thoughts are intended to suggest that the pottery, baskets, architecture, dances, songs, and other facets of Indian life are unique and exceptional, like all great art. But they are also *works*—subject to nothing but themselves, products of the same kind of effort which goes into growing crops, cutting wood, hunting animals, or conducting the life of the tribe. They are the things that result when Indian people apply the correct efforts to the proper materials. They are as pertinent to Indian civilizations as the greatest works of Western people are to the greatest Western cultures.

It is also important to recognize something that ethnologists have continually pointed out: simply to speak of Indian "works of art" is already a qualitative kind of thinking, insofar as it attempts a separation of art from daily life, which is entirely alien to the Indian world. It therefore seems extremely important to insist from the outset that the term "art" is not used in this book in the classical Western sense. Instead, it is given a wider and less idealized connotation, in order for us to include in our discussions utilitarian objects, curative rituals, and so-called crafts, which, until very recently, were usually ignored by art historians and critics.

The art of Indians is both highly traditional and highly dynamic. When Indians have understood the aesthetics and media of Western culture they have adapted them to their own scheme of the cosmos. An Indian work of art is therefore nothing more or less than the product of Indian sensibility. The amalgamation of alien influences into Indian art has been so thorough that the result of assimilating European techniques and materials—such as the silver jewelry in the Southwestern United States, which dates from about the mid-nineteenth century—is often considered to be "typically Indian." But fundamental to all these art works, even to those which seem to cross the boundary between the worlds of Europeans and Indians, is the fact of Indian sensibility.

For many years it was, at best, difficult for non-Indians to evaluate Indian art, and, as Frederick J. Dockstader (1973) has pointed out, "surprisingly, not all Indians are able to achieve a satisfactory judgment of their own work, just as all Caucasians are not capable of judging Western art equally." Today the consensus in regard to the arts of the Indian Americas has been widely revised. Whereas only a few years ago it was unlikely for most non-Indians to accept as equal to theirs the aesthetic achievements of Native Americans, today Western critics and collectors are beginning to recognize them as important works of art whose interest and strong attraction are undeniable to the contemporary sensibility. As James W. Reid has noted, Native American art possesses "a subject matter which can be both poetically sensitive and monumentally powerful and an approach to form and content that can be appreciated by an audience accustomed to the abstract forms of twentieth century art."

Unquestionably the first element of the Native arts of the Americas which strikes us is their concern with seemingly different subject matters than those of pre-modern Western art. Traditional Western illusionist concerns such as portraiture, landscape, genre, still life, and

erotic love appear to be absent, at least in the manner to which we are most accustomed in the West. And yet, as we shall eventually see, all of these facets of Western art are, in fact, diffused in the Indian aesthetic, but in ways brilliantly unique and inventive. But such achievements are not visible to us unless we permit ourselves to see them.

James W. Reid emphasizes the remarkable flowering of abstraction in the primal arts of the Americas when he says that "while Western art until the late nineteenth century was following a relatively unilinear direction of realism, the Pre-Columbian artist was exploring concepts which we normally associate with the twentieth century." Modernism was not a Western twentieth-century invention so much as the amalgamation into Western art of vast, strong influences from primal cultures. (We are much aware of the impact of African masks on the works of Picasso; the influence of Mesoamerican sculpture on the vision of Henry Moore; of Pueblo Indian dances on the theatrical rites of Martha Graham; and of Navaho sand painting on the art of Jackson Pollock, and so on.)

The modernist approaches Indian art as familiar territory: a visual world of fantastic dream images which call to mind Surrealism; an expressionism manifested in elaborated forms and fearsome masklike faces; the use of color to depict form and volume and to function independently in the manner of contemporary color-field painting; intentional and arbitrary restructuring of what used to be considered "realistic" form and "linear" perspective in order to conform with purely formal imperatives of the surface on which images are rendered and the techniques employed to render

them; the repetition of motifs in a serial imagery which itself becomes the "subject" of the format; and a spontaneous and lyrical freedom of line and form approaching pure improvisation. All such familiar modernist qualities, and many more, are to be discovered in the arts of the Indian Americas.

Just as we must avoid the realistic mandate in viewing Indian arts, so too we must rethink the traditional Western inclination to praise so-called "high" civilizations and to discount "primitives" of the jungles as producers of nothing but chaos and savagery. Just as the recent work of the Leakeys moved the cradle of *Homo sapiens* from the "fertile crescent" (where Anglo predisposition had previously located it) to Africa (where Caucasians were disinclined to place their origins), so too scholars such as Donald W. Lathrap have abandoned the Andean highlands as the source of refined American Indian culture and relocated its origins in the Amazon Basin. We must therefore quickly jettison the prejudice of earlier scholars who stated as recently as 1965 that "little of artistic importance is known from the vast territory of Brazil; much of the area consists of lowland tropical forests which proved unsuitable for the development of high aboriginal civilizations, and those parts of the east which might be expected to be more favourable were remote and difficult of access from the main centers." Lathrap wrote in 1975 in striking disagreement: "All available evidence clearly indicates that this pottery tradition . . . was initially a lowland Tropical Forest development spreading from the west Amazon Basin up the eastern slope of the Andes." It is noteworthy that the great majority of Latin American ar-

chaeologists are in agreement with Lathrap.

These are only a few of the intellectual adjustments we are called upon to make in order to approach with insight the separate reality made visible in the arts of the Indian Americas. Simply to use the word "art" introduces a problem basic to the different ways the West and Indians view their creative activities. Only a few American Indian cultures have given any specific importance to. artists: the Maya, the Inca, the Northwest Coast Indians, and a few others developed a special professional rank for creative people. Among other tribes art was an effervescence of life, a gift shared by everyone. It therefore stands to reason that Indian art is largely an anonymous activity, a process of individuating a long tradition rather than being—as it is in contemporary Western societies—an obsession with "originality." Of course, certain talents always rise above tribalism by the sheer impact of genius: so, in modern times, we have celebrated various outstanding Indian artists, such as Julian and Maria Martinez, Nampeyo, Fred Kabotie, and Charles Loloma. One suspects that in earlier times the same process was at work: there seems little question that the unique style of Mimbres pottery, of southwestern New Mexico, was the achievement of an individual or perhaps several individuals who established something resembling a "school" of art which eventually became part of tribal tradition. The same might be said of the Temple Mound cultures of the Southeastern United States, which also evolved a unique kind of imagery too individual, at least for us today, to have reasonably been the result of group cre-

ation. Thus, even the anonymity of Indian art is not a formal rule, for wherever the human spirit is at work there are always those whose exceptional vision leaves some trace of their influence and genius.

In a prior book, entitled *The Primal Mind*, it was my intention to conceptualize the core of Indian mentality. This book is devoted to Native American objects as works of art. That is a complex and relatively novel subject. And, of course, the scope of this book—the entire Western Hemisphere—is staggeringly broad. I think I am therefore wise to quote George Kubler, who said, when introducing his excellent work *The Art and Architecture of Ancient America*, "my volume, like others before it, falls far short of the avowed aim, to explain the principal archaeological objects as works of art." And yet, even with this grave reservation in mind, there seems so great a need today for a book addressed to the general reader which focuses upon the Americas (ancient and modern) as a vital source of art works and artistic inspiration that I have undertaken this considerable task despite inevitable incompleteness and difficulties. *The Primal Mind* deals with ideas, whereas this book deals with objects which make those primal ideas visible. Yet the two books are very much interrelated and speak out of the same sensibility; they are branches of the same tree.

Everywhere in the Americas there are tales of the sacred tree. Black Elk spoke of it when he recalled "a holy tree that should have flourished in a people's heart with flowers and singing birds, and now is withered. It may be that some little root of the sacred tree still

lives. Nourish it, then, that it may leaf and bloom and fill with singing birds."

The Maya too dreamed of the sacred tree—*Yaxche*, the great ceiba found throughout Central America. It represented the fifth world direction (up and down), standing at the very center of the earth, its trunk and branches piercing the various sky-worlds, its roots penetrating into the underworlds.

That sacred tree is the core from which Native American thought and language spring, from which Native vision and feeling emerge. And those great arts of the Indian Americas are the leaves of that sacred tree.

I am exceedingly grateful to my editor, Cass Canfield, Jr., for his concern, keen insights, and generous efforts in publishing this book. I also wish to thank Frederick J. Dockstader, whose pioneering work in my field and whose encouragement have had a very great impact upon my thinking. I am also indebted to Richard Conn, Curator of Native Art at the Denver Art Museum, for his invaluable reading and critique of the original manuscript of this book.

The focus and thrust of *Arts of the Indian Americas* was much shaped and sharpened by a decade of debate and conversation with scholars and students of Native American art. I have had the good counsel of so many experts and friends that I cannot possibly thank all of them publicly, but I am deeply grateful to all of these people for their contributions to this book. Since my theme draws upon the most fundamental influences and experiences of my lifetime, I cannot give adequate credit to all the sources reflected in this book, but perhaps the Selected Bibliography at the end will help to highlight some of the major sources of ideas and opinions in my depiction of the Native arts of the Western Hemisphere.

There are, however, certain people whose assistance during the years I did research for this book must be noted. I therefore wish to thank Jennifer Newton, of the International Communications Agency, who arranged essential contacts throughout Latin America; Jerre Cox and his assistant, Phyllis Lane, of Braniff International Airlines for providing the ideal itineraries and the fine services of their airlines; Beatriz de Leon of the American Embassy in Bogotá; Leonor Hernandez of the Museo del Oro of Colombia; Cecilia Duque Duque, director of the excellent Museo Populares y Tradiciones of Bogotá; Robert Rockweiler, former press director of the American Embassy in Quito; Hernan Crespo Toral, director of the exceptional Museo del Banco Central of Quito, who provided unlimited hospitality and scholarly assistance during my visit to Ecuador; Vicente Mena of the Casa de la Cultura, Quito; Eugenia Rodriguez and the staff of the Cotocollao Archeological Excavations in Ecuador (under the auspices of the Museo del Banco Central); and Olga Fisch, whose pioneering work in textiles and whose championing of Native arts are legendary. I also wish to thank Caroline Meirs of the American Embassy in Lima, as well as Lima Tours, which provided a vivid glimpse of Peru during uneasy political times; and thanks to Rosalia Avalos de Matos, curator and director of the Museo Nacional de la Cultura Peruana, Lima; and to Edouard Versteylen, Conservador General and a major specialist in textile conservation at the Museo Na-

cional de Antropologia y Arqueologia, Lima, for his uncommon hospitality and a rare and highly educated survey of the astonishing collection of Peruvian textiles under his administration. I am also much indebted to Luis G. Lumbreras, general director of the Museo Nacional de Antropologia y Arqueologia of Peru, for his cordial welcome and aid. To Elvira Lulli of Fop Tur Agency of Peru I am more than grateful, insofar as she single-handedly saved my research trip from the problems and complexities of national strikes, political upheaval, faulty communications, and humid ninety-degree weather. I am also most happy to have worked in Lima with Betty Herrera of Lima Tours, and thank her for sharing her informed viewpoints.

Earlier, during research for prior books, which have greatly influenced the writing of *Arts of the Indian Americas,* I also had the assistance of the directors of the National Anthropological Museum of Art, Mexico; Ralph T. Coe of the Nelson/Atkins Museum of Art, with whom I was associated during the presentation of "Sacred Circles: Two Thousand Years of North American Indian Art"; the directors of the Museum of Man of the British Museum, London; Roland Force of the Museum of the American Indian of the Heye Foundation, New York City; the directors of the Museum für Völkerkunde, Berlin; the director of the Museum of the Americas, Madrid; as well as Jeffrey F. Kriendler of Pan American World Airlines; Don Miguel Gonzalez Marin, Secretario de Turismo, Yucatán; Dolores Yurrita Gignard and Federico Rodriguez of the Instituto Guatemalteco, Guatemala City; Claude O. Bertin of Villahermosa; and the directors and archivists of the Musée de l'homme, Paris.

One of the inevitable complexities of producing a book such as *Arts of the Indian Americas* is researching and securing appropriate, definitive illustrations. I have had enormous help in this arduous task, and I wish to thank the numerous sources listed in the captions, but especially Pamela Dinse of Sotheby Parke-Bernet and of Editorial Photocolor Archives, who opened a tremendously valuable and rarely seen trove of photographs from private collections. I am also deeply thankful to photographer Gabriel Cruz and to general director Hernan Crespo Toral of the Museo Arqueologico y Galerias de Arte del Banco Central del Ecuador, Quito, for providing photographic materials almost never seen outside Latin America.

I am also much indebted to my administrative assistant, Frank Burrus, who shared the pleasures and difficulties of my research trips, helped to assemble thousands of photographs for this project, and provided much enthusiasm and concern during the years that this book was being researched and written.

To all these people and many more I now offer the marvelous shelter of the wide limbs of the sacred tree!

Jamake Highwater
Piitai Sahkomaapii
Mexico City, 1982

NOTE: In view of the purposes of this book the term "primitive" has been changed to "[primal]" in all quoted materials, except when the quoted authors clearly mean to imply "savage" or "rude and wild." It is pointless to perpetuate an offensive term or to quote authors whose ideas about aboriginal peoples are quite the opposite of what is today implied by the term "primitive."

Attribution for all materials quoted in this book may be found in the Selected Bibliography, under the author's name. If there is more than one book or article listed for a given author, the date of the publication of the work from which a quotation is drawn is listed parenthetically after the name of the author each time it appears in the text: for example, "Frederick J. Dockstader (1973)."

TWO

A CULTURAL
AND
HISTORICAL OVERVIEW

Where did Indian art begin? Where did it come from, and what cultural purposes brought it into existence? These are vast and largely unanswerable questions. That fact will distress many of us, for we are inclined to be upset by inadequate answers, rather than to recognize that we may be asking the wrong questions. Nonetheless, we still need to try to summarize the available answers to these rationalistic queries before we can put chronology behind us and become involved in the actual experience of the artistic creations of the native peoples of the Western Hemisphere.

Establishing dates for Indian art objects is difficult, for it is only within the period of written records that a chronology can be established, and few aboriginal peoples of the Americas developed an interest in writing. Thus we must rely heavily upon archaeological dating, a rather recent "science" which has many promising technologies.

A. E. Douglass was one of the first to produce a dating technique, after he discovered that certain trees in the Southwestern region of the United States develop growth rings in proportion to rainfall. The tree-ring dating method, called *dendrochronology*, operates on the basis of counting rings in reverse chronology and thereby establishing the date when a particular tree was cut down. This was the first successful step in helping to establish chronological data about the ruins of the early inhabitants of North America, but unfortunately the technique failed to have universal application, since many trees do not develop growth rings in the obliging manner of the members of the Pinaceae family of the American Southwest.

A more universal dating method came out of the atomic experimentation of World War II. Willard F. Libby devised *radiocarbon dating*, which is based upon the fact that carbon 14 is present in all organic matter and deteriorates at an even rate following "death." Therefore, if we measure the amount of carbon 14 in a fragment of shell, bone, wood, or other similar material, a date can often be computed for the objects found in association with the organic fragments. This system has overcome most of the skepticism which greeted its first applications, and the method has become highly sophisticated and accurate. Yet it is still impossible to pinpoint a date with radiocarbon dating without a fairly wide margin of potential error. On the other hand, most of the chronology of contemporary archaeology is indebted to Libby's discovery.

More recent methods also offer promise of dating archaeological finds. The procedure known as *thermoluminescence* is used in dating pottery. This very complex method involves the microscopic examination of refired pottery. Another technique, known as *obsidian hydration*, may eventually prove valuable in the many regions in which obsidian was commonly used in the fabrication of implements. *Pollen analysis* is yet another method, based upon the annual deposit of pollen. And, finally, *lexicostatistics*, or *glottochronology*, is proving valuable in its capacity to establish chronologies on the basis of the time it takes human beings to change speech patterns. This technique has provided some astonishing information about American migratorial history, even in regions where the language once used has vanished.

Yet, with all this scientific effort to es-

tablish an American chronology, there is no ultimate and final "history" available to us. This situation becomes clear if we simply survey any of the dozens of books in print which deal with American archaeology and ethnography: although all of them offer elaborate and well-researched chronological tables, almost no two are in agreement.

If we add to the relatively narrow success of contemporary science to produce a Native American chronology the fact that Indians relied upon a vital and highly effective oral tradition, rather than a written tradition, of literature, we begin to grasp the difficulties of establishing a fixed history of the Western Hemisphere. Writing was devised in perhaps only two major areas of the Americas, and we do not yet possess the "Rosetta stone" necessary for its complete decipherability. Of the writings of the early American peoples, only the Maya, the Mixtec, and the Aztec left any extensive body of visual/written communication; and these cultures were the focus of wide-scale destruction by such missionaries as the notorious Bishop De Landa, who destroyed vast libraries of American records, leaving only three examples of Maya writing and perhaps another twenty-five Mixtec-Aztec books (codices) out of the thousands mentioned by early European observers. Stone glyphs have survived better than the "writings" made on bark and skin, but they have not yet been completely deciphered.

The calendrical systems of Middle America are unrivaled in ancient world history, enabling us to place events in a relative, if not absolute, chronology, as we learn more about deciphering the date glyphs of the Maya and others. Yet, despite the virtual mania of Mesoamerican Indians for inscribing dates on monuments and art objects of all kinds, there is nothing as tentative and constantly subject to revision as the chronology of the Americas. A perfect example of the upheaval in American chronology is the recent revision of a concept developed by Meggars, Evans, and Estrada (in the "Early Formative period"), who discussed similarities between the ceramics of Valdivia (presumably the first American pottery) and Middle Jōmon in Japan, and postulated that Valdivia pottery (of the western coast of Ecuador) was introduced to Guayas from Japan by the chance landing of Jōmon fishermen whose boat had been blown off course. Though this theory was widely accepted for a number of years, recent research by such people as Donald Lathrap has determined that "these ceramic similarities do not seem sufficiently close to warrant a detailed discussion of this theory here. It seems clear today, a decade after the Jōmon theory was proposed, that the immediate ancestor of the earliest Valdivia pottery (Loma Alta) is to be sought in Ecuador and that pottery in South America is many centuries older than the postulated Jōmon Odyssey" (1977).

Even the long-standing notion that the Olmec people of the Mexican Gulf Coast were the "mother culture" of the Americas has been severely questioned by recent researchers, such as Norman Hammond, who, writing in *Scientific American* ("The Earliest Maya") states: "The establishment of such an early date for the possible inception of the Maya Formative period has effectively removed the Olmec civilization from further consideration as the initial stimulus

of Maya culture and even suggests the possibility that Maya culture acted as an influence on the emergent Olmec society."

Clearly, American history is an enigma. But the temporal theories of the hemisphere are not the only subjects of controversy. Ethnography has also come under fire, because contemporary scholars are inclined to abandon the strict "Cultural Areas" into which the Americas were once divided as self-contained and autonomous cultural systems.

It was long held that Mesoamerican and North American and Andean cultures were separate from one another, developing independently and not being influenced by each other. Recent archaeological studies, however, have shown undoubtable contacts and mutual influences in such matters as pottery and figurine design, metalworking, architectural motifs and structures, the preeminence of the jaguar in religious symbolism, corn as a major staple of the diet, and numerous other elements between widely separated regions of the Americas. For the catalogue of the Metropolitan Museum of Art's exhibition "Before Cortes: Sculpture of Middle America" (1970), Elizabeth Kennedy Easby and John F. Scott wrote: "Although there were regional differences, all of Mesoamerica came to share a number of exclusive features, which gave it a basic unity. Among these were ceremonial plazas with impressive stone and stucco architecture and towering pyramids with majestic stairways; elaborate systems of picture and hieroglyphic writing; arithmetical calculations based on a vigesimal system, and at least among the Maya, the use of zero and placement numeration; a complex calendar in which a ceremonial year of 260 days was inter-meshed and ran concurrently with a solar year of 365 days in such a way that the same combination of days in the two calendars reappeared only once every 52 years, a cycle that assumed supreme ritual importance; a ceremonial ball game; screen-folded manuscripts or books of buckskin and bark paper in which the wise men made records, the contents including rituals, astronomical data, legal matters, genealogies, history, and maps; large markets with a wide variety of domestic and imported products; confession of sins and penance; and auto-sacrifice, drawing blood with thorns or stingray spines. The cross-fertilization and integration among the various cultures of Mesoamerica were achieved by a combination of proselytizing, trading, and conquest. Art undoubtedly played an important role in both trade and religion."

What has been said in regard to Mesoamerica and Andean cultures may be extended, to some degree, to the wide-ranging influences of the Valley of Mexico: upon the Cliff Dwellers of the American Southwest and—through them—the Puebloan peoples of that area; and upon the Temple Mound peoples of the Mississippi and Missouri rivers, whose Mesoamerican influences greatly shaped not only their own cultures but also reached—through their example—as far north as the Saint Lawrence River, where the early Iroquois tribes received the muted cultural influences of the Mexican civilizations. Time and geography are malleable elements of the cultural history of the Americas. Despite much regional diversity there is also an apparent spiritual unity among Indians of widely separated geographical areas.

Chronological Table

SOUTH AMERICA	MESOAMERICA		NORTH AMERICA	
	Mexico	Maya Zone	West and Southwest	East and Southeast

Date	South America	Mexico	Maya Zone	West and Southwest	East and Southeast
1500	Inca Empire — Local states elsewhere	Aztec Empire, Chichimec invasions, Toltecs, Mixtecs *in Oaxaca*	Mayapán, Toltec-Maya, Chichén Itzá, Maya collapse	Pueblos in SW	Mississippian towns and temple mounds
1000	Chimu Empire (N. Coast)	Classic civilizations (Teotihuacán, Monte Albán, and El Tajin)	Puuc sites (*Uxmal, etc.*)		
500	Tiahuanaco-Huari expansion, Mochica (N. Coast), Nazca (S. Coast)		Classic period	First pottery in SW	Earthworks, burial mounds — Hopewell, Fort Center, Adena, Poverty Point
AD / BC	Tiahuanaco (S. Andes)	Late Formative period (Cuicuilco, El Arbolillo)	Formative period		first farming
1000	Chavin, Paracas, oldest metalworking in America	Olmec civilization — La Venta, S.Lorenzo	First pottery	Agriculture in SW	
2000	pottery introduced, first ceremonial centers, permanent villages on coast	Permanent villages (Ocos, Tehuacán, Oaxaca), oldest Mexican pottery			Pottery in SE
3000	Pottery in Colombia and Ecuador			Desert Culture	Archaic cultures
4000		Semi-nomadic hunters, plant gatherers and small-scale farmers, First experiments with agriculture (Tehuacán, Oaxaca, Tamaulipas)	(No information)	Bat Cave (first maize in USA)	Shell mounds near rivers
5000	First experiments with farming on coast and in highlands, Lomas camps on Peru coast, Guanaco hunters in Andes				
6000				Old Cordilleran in Rockies	
7000	Hunting bands in Patagonia and High Andes	Mammoth-kill sites in Basin of Mexico, Ajuereado phase in Tehuacán (hunters and plant gatherers)	Fluted point near Guatemala City	Plano points	
8000				Folsom bison hunters	
9000				Mammoth-kill sites	Clovis hunters
10,000				Wilson Butte Cave 13,000 B.C.	
Before 10,000 B.C.	Flea Cave (Ayacucho) possible tools, 17,600–12,700 B.C.	Hunting camps at Tlapacoya 22,000–20,000 B.C.		Man in Alaska Trail Creek 15,000 B.C. Old Crow circa 27,000 B.C.	

persistence of hunting-gathering in Great Basin

Peru and Bolivia

American Cultural History

In every region of the Americas the people tell the story of the other worlds which came and went, which were swallowed up by misfortune and catastrophe, from which the four-legged and two-legged beings fled. These tales of beginnings are at the core of all Indian rituals—they tell of other suns and other moons and of a long and difficult migration. Western science also has rituals and stories based on its own kind of intuition and speculation. Archaeologists and anthropologists envision a different kind of ancient migration from that of Indian folk traditions, and in their version Indians traveled over the long glacial bridge of the Bering Straits—they were hunting people, in search of game, who walked from northeast Asia into the uninhabited Americas perhaps 15,000 to 65,000 years ago, and in time became the native peoples of the Western Hemisphere.

The Aztec were latecomers when they were building their empire; the ruins of Teotihuacán—just forty miles from present-day Mexico City—were so ancient that their origin and architects were lost in memory. The Aztec people, finding enormous mastodon bones buried among the ruins, imagined a race of giants had built the great pyramids and causeways of Teotihuacán, for they could not believe that *mere* human beings could have produced such gigantic structures. Centuries later, when Europeans came upon the same mysterious ruins, they could not imagine that *mere* Indians could produce buildings of such magnitude and splendor; and so they in turn conjured up lost tribes of Israel and lost worlds such as Atlantis and Mu, whose craftspeople had somehow escaped a terrible deluge and found shelter in the Americas. There, presumably, they built great cities—and then vanished utterly.

It was once believed that human habitation in the Western Hemisphere was relatively recent, consisting perhaps of only 10,000 to 12,000 years. New finds and new techniques are constantly moving back the date of initial American habitation. A conservative figure is now 25,000 to 45,000 years ago, while some young scientists (Goodman) have suggested that modern *Homo sapiens* originated in the Americas, developed a highly complex culture, and then—and only then—migrated to Asia and Europe, bringing to those continents the first, sudden appearances of refined, so-called Cro-Magnon culture as well as the famous but unprecedented art found in the caves of France and Spain. These schemes of a reverse migration are, of course, highly controversial, but their publication by several well-trained experts gives some indication of the upheaval that exists in the intriguing history of the Western Hemisphere.

It is little wonder that the first evidence of North American culture is related to hunting magic—such as the one-thousand-year-old cave painting from the Pecos River area of Texas which depicts a large figure, draped with pouches for hunting implements, holding arrows or perhaps spears in one

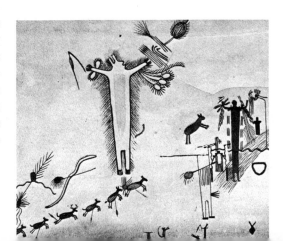

Rock painting from Panther Cave in the Pecos River Valley, Texas, c. 1000 B.C. Texas Memorial Museum, San Antonio. Reproduction by Forrest Kirkland.

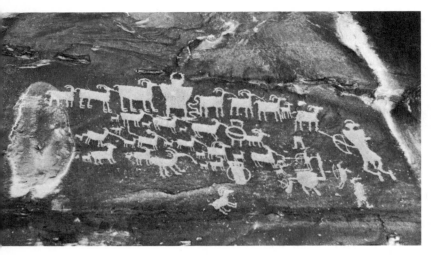

Petroglyphs by the Cliff Dwellers. Vernal, Utah, Anasazi period.

hand and, in the other, an *atlatl*, the spear-launching device whose name derives from the Aztec. In these pictographic works of early Indians is seen the marriage of hunting, farming, ritual, and art. The close relationship between hunting and farming and American Indian art has been sustained for thousands of years. So central is the fertility of the earth and the abundance of game to Native American iconography that animals and plants themselves are the basis not only of the icons of the art but also the source of the media in which Indians produced images: animal figures are incised and painted on skulls and bones, on skins and tusks; plants are reproduced on earthen surfaces, adobe walls, rock-faces, and pottery, with mineral and vegetable dyes. There is, in this way, a persistent symbiotic relationship among American Indians, animals, plants, and the techniques and media with which art and imagery are produced.

Long before the Stone Age hunters found their way into the Americas, the land was a beautiful, immense sweep of lush foliage and fruits. There were presumably no people in the vast hemisphere. The wind whirled through the sweet grass, cool and moist, for to the north a solid sheet of ice a mile thick covered most of the continent. Rain-filled clouds poured ceaseless torrents upon the immense plains.

Beyond the wall of ice in the north, a distinctive group of Asiatic-Paleolithic people were slowly making their way from Asia to what is now Alaska, wandering across the intercontinental land bridge that had been exposed as the earth's water accumulated in glaciers, drastically reducing ocean levels by as much as three hundred feet. These first Americans were lured into a world without prior human inhabitants by the promise of plentiful game.

Every autumn these primal peoples of the Arctic Circle saw the sun dip deeper into the horizon until, finally, the daylight dwindled, leaving them in the pale luminescence of the northern lights and the winter moon. With the shortening days the animals turned toward the south. Skeins of swans, geese, and ducks, curlews, plovers, and sandpipers left their Arctic breeding grounds and flew southward toward the sun. The birds were followed by the small horses, once native to America, and by the huge bison, caribou, and the shaggy mammoths. Game grew scarce and the snow heaped upon the frozen tundra where the ancient Paleo-Indians huddled. It was the trail of the migrating animals which drew the hunters through the precarious expanse of ice and into North America.

The artifacts of hunting are easier to date than art objects because they are often made of substances more durable than the media of art, such as the famous Clovis and Folsom spear points which hunters chipped from stone over

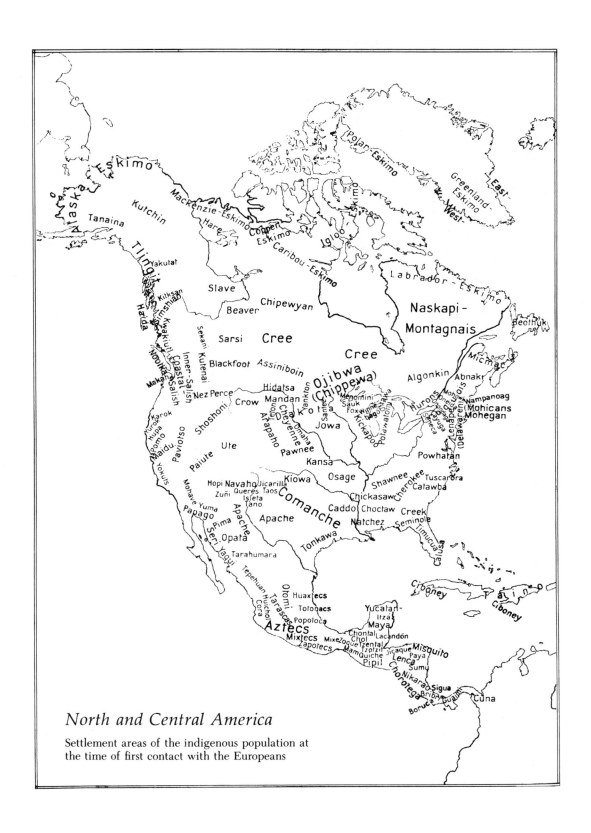

North and Central America

Settlement areas of the indigenous population at
the time of first contact with the Europeans

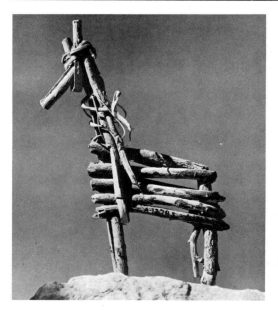

Stick deer, 3²⁄₁₆ × 2³⁄₈ inches. Grand Canyon area, Arizona, c. 2500 B.C. Arizona State Museum, Tucson.

ten thousand years ago and which are among the earliest archaeological finds of the Americas. More artistic, though hardly less utilitarian, are the decoy ducks found at sites such as Lovelock Cave, Nevada. Made by Indian hunters of 2500 B.C., these decoys were built upon ingenious frameworks of tule, to which strands of cattail leaves or yucca strips were bound to fill out the shape of the duck, which was then finished with feathers and paint, ground from minerals and roots. Another fascinating "hunting sculpture" is a small deer constructed of split twigs, which was one of many found since 1933 when the first such object was discovered in the least accessible caves of Arizona's Grand Canyon. The split-twig deer is thought to be about three thousand years old and was probably a talisman used by prehistoric Indians in hunting rituals.

What may be the most spectacular archaeological find in the Americas is a six-inch-long fragment of mastodon pelvic bone, unearthed by Mexican anthropologist Juan Armenta Camacho near Pueblo, Mexico, in 1959. Scratched into it are the likenesses of camels, tapirs, mastodons, and other now extinct prehistoric animals, and it is believed to have been carved when the bone was fresh, some thirty thousand years ago.

The shift from a lifestyle centered upon big game to a wider economy, based on the exploitation of a variety of plant and animal foods—foraging as opposed to hunting—and a parallel change in ancient art iconography gradually occurred in many of the Indian cultures of the Americas. By about 2500 B.C. foragers in present-day Mexico had succeeded in domesticating a cluster of high-yield plants native to the Americas: corn, beans, chili peppers, squash, and avocados. The cultural impact of this alternative lifestyle was enormous. In the arts there was a shift away from pictographic art celebrating hunting to abstract geometric designs woven into objects produced by the newly invented art of basketry, which provided an ideal collecting container—lightweight and flexible—for a foraging people.

The new foraging lifestyle and incipient farming forever altered the relative homogeneity of Western Hemispheric big-game hunting culture, and from the beginnings of these socioeconomic inventions the ethnographies of the Americas become regional.

North America

The Arctic

There are hundreds of so-called tribes in the massive region stretching across the Arctic Circle, eastward from Alaska to Labrador. But these peoples are not dis-

tinctive "tribes," for they are often closely related bands that share similar languages and cultures. Among them are the Innuit, or Eskimo people, who are usually subdivided into the Western (or Alaskan) branch, the Central, and the Eastern branch (including Greenland). It has often been noted that the Innuit of the West are more artistically productive than those of the Eastern Arctic area.

Another major Arctic group is the Aleut people, related to but distinct from their Innuit neighbors. Anthropologists do not usually classify Innuits and Aleuts as Indians, for they are thought to be true Mongoloids, whereas Native Americans are considered to be of a pre-Mongoloid, Asian extraction. But insofar as all Arctic peoples are clearly part of the cultural heritage of the Western Hemisphere, the arts of the Innuits and Aleuts are included in this study.

The Arctic is also inhabited by a number of small Indian groups that migrated into the territory from the south. Since their migration they have been strongly influenced both by the environment and the cultural example of Arctic peoples and, in turn, they have also influenced Innuits and Aleuts. Among these Indian tribes of the Arctic are the Ahtena, Chipewyan, Ingalik, Koyukon, Kutchin, Montagnais, Naskapi, Tanana, and a number of other Athapascan-speaking groups.

The Arctic world is inhospitable and offers little in the way of raw materials for making art. Yet out of this dour environment has come some of the most strikingly imaginative and often humorous of Indian art. It is during the long, bleak winter nights that Innuits have an abundance of time for working ivory obtained from walruses and whales. The Arctic art style tends to favor carving in the round, with incising for decoration, with black/brown charcoal sometimes employed to accent incised lines, and with a limited use of the technique of

Innuit (Eskimo) pipe made of walrus ivory.

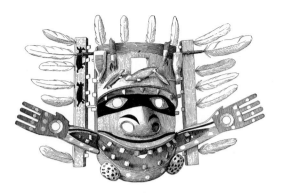

Innuit (Eskimo) mask representing a tunghak, *a being that controls the supply of game.*

inlay. Almost all available ivory is naturally of an elongated, tapered shape, and this fact largely predetermines the idiomatic forms of Innuit carvings. There is evidence of art by Innuits dating from several thousand years ago, and such fossil ivory carvings provide an almost unbroken iconographic history among Arctic carvers.

One of the most striking elements of Innuit art is its sense of humor, expressed in the form of caricature. Among such humorous art objects are the driftwood masks which are the most renowned of Innuit creations. Their humor and imaginative daring have been widely celebrated by collectors and scholars. The beginning of the mask trade-art tradition (about 1950) was the result of non-Indian agents working with crafts groups in order to devise a successful commercial outlet for Innuit artists; in this way, the masks owe their inception to commercial motives rather than to a strict execution of the sculptural heritage of Innuit culture. Even more recently a form of graphics, derived largely from the techniques of Japanese printmaking, has become the most popular art product of various Arctic cooperatives.

The Northwest Coast

The Northwest Coast region is a wide sector of the North American continent, encompassing a large and diversified group of cultures. In terms of artistic style, it includes coastal Alaska and western British Columbia, including Vancouver Island. There are numerous tribes in this part of the Americas, but the most dominant are the Tlingit, Haida, and Tsimshian in the central-northern area; and the Bella Bella, Bella Coola, Makah, Nootka, and Kwakiutl in the south.

The Northwest Coast tribes were blessed with nature's unlimited generosity; they grew rich and comfortable foraging in their rain-drenched land. The immense forests of spruce and cedar provided the materials for the development of what is generally regarded as the finest achievement of Native North American carvers and sculptors. Here, along the major shipping routes established by early European traders, we discover the perfect exemplification of the positive influence of Western tools upon Indian craftspeople, demonstrating their uncommon ability to adapt foreign technologies to their own purposes. With the introduction by traders of steel knives, Native artists quickly perfected an exceptional and flamboyant sculptural tradition rivaled by no other Indian people in North America—great totem poles, immense wooden dwellings decorated with richly carved doorposts, vivid ritualistic masks, rattles, figurines, and a great variety of other carved objects which became the first Indian achievements to be widely and eagerly appreciated as "fine art" by Europeans. These sculptural skills were greatly augmented by an ancient tradition of painting and

inlay techniques which produced marvelously vivid effects.

The conceptualization of form by the artists of the Northwest Coast is one of their major distinctions. They were able to take a given shape or a particular surface and spatially adapt designs to fit the prescribed space perfectly, excelling in a type of formal arrangement of realistic detail which may be regarded as a unique Indian invention of what, in the West, is known as abstraction.

The most renowned of Northwest Coast art forms are the great totem poles, often sixty to seventy feet high, which were not—as it is often assumed—religious icons but historical monuments celebrating the wealth, social position, and rank of various important persons who commissioned the poles. Upon entering a village, the stranger was greeted by the great poles standing in front of the dwellings, thus allowing the visitor instantly to grasp the prestige of the owners of various houses.

Clearly the purpose of the art of the Northwest Coast was largely to provide luster to the prestige and power of the individual. In this way it is similar to the political use of art by the merchant princes of the Italian Renaissance. In both societies wealth was the principal criterion of power.

The scarcity of high-quality Northwest Coast art is the result not only of missionaries' repression of that culture at the end of the nineteenth century, but also of the *potlatch* practiced by the chiefs. The potlatch was a ceremonial custom requiring important personages to give away most of their valued possessions as a show of power and political generosity. In turn, rivals had to give back as many or more gifts at subsequent potlatch ceremonies. This flaunting of material wealth—involving especially the great art commissioned by rivals—eventually assumed ridiculous proportions: with the mass burning and destruction of commodities like blankets. From all this mayhem come the surviving masterworks which we value so greatly today.

From the surviving art of the tribes of the Northwest Coast we realize that their craftspeople were capable metalworkers as well as carvers. Besides the limited amount of copper that was obtained locally, much of the metal used for artifacts was obtained as cargo brought in for trade. This copper was worked with exceptional skill, especially

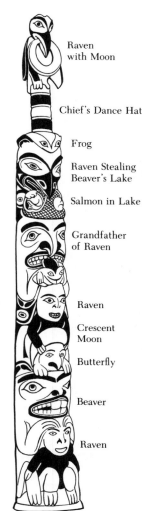

Raven with Moon

Chief's Dance Hat

Frog

Raven Stealing Beaver's Lake

Salmon in Lake

Grandfather of Raven

Raven

Crescent Moon

Butterfly

Beaver

Raven

Northwest Coast totem pole.

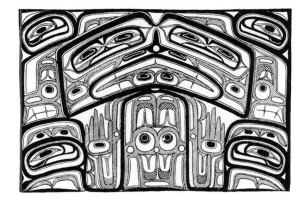

Design on a large Tsimshian box for keeping blankets, an important form of wealth among the Northwest Coast tribes.

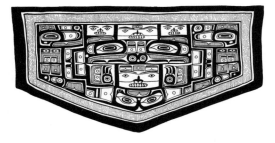

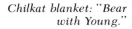
Chilkat blanket: "Bear with Young."

by the Haida and Tlingit artists, who produced masks, overlays, knives, and large shields called "coppers" which were very highly prized for their "monetary" value at potlatch ceremonies.

There was even a limited amount of weaving among the tribes of this region; the Chilkat blankets for which the Coast is the most famous were woven from the wool of mountain goats and cedar-bark fibers. Some tribes also raised small white dogs for their hair, which was spun into yarn.

In addition to these textiles, basketry also was finely developed. Weavers used cedar bark, shredded and spun into fibers, and worked into marvelous shapes of the finest structure and patterns. Containers were made in a great variety of shapes and sizes, and many of these were dyed in brilliant colors.

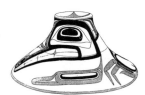
Tsimshian hat made of spruce-root basketry with a painted design.

Ivory carving, that outstanding art form of the Innuit people in the north, was also widely practiced on the Northwest Coast. Here the ivory was obtained from walrus tusks and whale teeth and then worked into a great variety of three-dimensional curvilinear forms. The carvers of the Northwest Coast tended to be more intricate and inventive in their formal working of ivory in comparison to the effective simplicity of the Innuit carvers, who evolved a quite different aesthetic attitude about objects,

which were less flamboyant and self-conscious than their Coastal neighbors' in the south.

There is among the Coastal tribes a monumentality and sense of enormous scale which is not often seen among North American Indians, with the notable exception of the Temple Mound Builders of the Mississippi and Missouri rivers, whose influences were largely Mesoamerican. The coastal tribes worked on a large scale: their dugout canoes could carry as many as forty or fifty people; their houses held a number of related families and were constructed from enormous cedar planks which were very brightly painted. The entire resources of the communities were used for the celebration of prestigious persons and families.

Of all the Northwest Coast arts surely the most renowned is mask making. The remarkable and intriguing masks are carved from wood and painted for use in many religious and social ceremonies. Of the numerous forms of masks, some were caricatures, some were portraits, others were representations of deities, still others depicted powerful spirits which seem to have overwhelmed every aspect of the Northwest Coast cosmos. Of the mask makers the Kwakiutl created a particularly interesting form of the dance mask, sometimes called "mechanical" or "transformational" masks, insofar as they were constructed of one mask enclosed within an outer mask, with movable parts which make it possible for the performer of a ritual, by pulling strings attached to these parts of the mask, to open the outer part of the carving and thus reveal, almost by magic, the inner, transformational deity within. Used in ritual dramas, in which large

puppets, elaborate costuming, and vivid pageantry were also involved, these masks provided a spectacular theatrical/ religious presentation of abstract ideas as sacred drama.

The arts of the Northwest Coast are highly diversified from tribe to tribe, and one can generalize only in a very tenuous sort of manner about the tribal distribution of artistic styles and skills. Probably the Tlingit of Alaska are the most versatile. The Tsimshian are also exceptionally artistic and have a highly distinctive sense of the abstract. But it is the Kwakiutl who produce the most strikingly theatrical and bizarre, the most colorful and austere, objects of wood. In contrast, the Haida are the people almost single-handedly responsible for the somber, black "slate carvings" (which are actually sculpted in argillite, a soft stone found only in the Queen Charlotte Islands). These diverse styles and forms are aspects of the rich cultural history of the Northwest Coast.

After a long decline, the Northwest Coast is again producing young artisans of exceptional talent. This new generation is actively reviving the traditional arts of their tribes with great authenticity and artistic merit. They are, however, so taken up with the revitalization of their nearly lost heritage that—unlike the young Indians of the rest of North America—they have not applied themselves to any great degree to the formalization of a contemporary art idiom which merges traditional Indian styles with modernist elements. Therefore the Northwest Coast arts of the late twentieth century are essentially a preoccupation with the revival of the techniques and styles of the late nineteenth century.

Basin and Plateau Region

The Basin and Plateau region consists of the present-day states of Idaho, Nevada, and Utah, as well as part of Oregon, Washington, and Montana. The largest tribes of the region are the Bannock, Nez Percé, Yakima, Kutenai, Salish, Paiute, Shoshoni, and Ute. Habitation of this area appears to have occurred relatively late in prehistory; the tribes of the area devised aesthetic skills and conceptions of a wide variety of forms. These are the Indians traditionally called "Diggers" by the first Europeans to encounter them, due to their practice of digging camas roots and their lack of spectacular costumes, which, at that time, was "something of a cultural index in the minds of Europeans" (Dockstader). This low status designated for these Indians was a long way from their actual achievements, for these tribes had evolved fine basketry, a complex cosmology, and a variety of remarkably expressive linguistic forms which were sophisticated by any index of standards.

Eventually the tribes of the Basin and Plateau region, when they went out into the buffalo country to supplement their diets of roots, nuts, and berries, came into contact with the Plains Indians. From this Plains contact came many

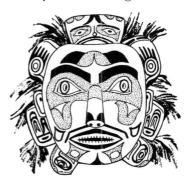

Kwakiutl mask.

cultural influences. The Nez Percé began to produce artifacts very similar to those of the Crow, as did the Shoshoni. The mobility of these tribes may account for their lack of pottery, while the absence of timber in their region was probably the determining factor in their lack of sculptural activity. On the other hand, their baskets are of a very impressive weave and design, and their paintings on animal skins, similar in format to those of the Plains tribes, achieved an uncommon artistry and sense of color and line.

These tribes were among the first Western peoples to be invaded by white men and to become assimilated. They accepted Christianity with little struggle, some tribes even sending for missionaries, and at first seemed eager to accept the lifestyle of Europeans. Those who have been the most successfully assimilated are today those who seem the most estranged and alienated in regard to their personal identities. Today, much of their culture is extinct, although Native languages, social gatherings, and even some religious beliefs survive.

California

Undoubtedly, in the California area the most remarkable aesthetic achievement is in the form of basketry. The California tribes excelled not only in comparison with the other native peoples of the Americas, but no other peoples in the world have proved as adept at basketry as these of the Pacific Central Coast.

The once numerous peoples of California were brutally decimated by the greed and exploitation accompanying the Gold Rush period in the mid-nineteenth century, when Indians were

hunted for sport or simply annihilated *en masse* in order to clear the land for settlement. To list all the tribes of the region would require a good deal of space, for the tribes were numerous and their linguistic variety was easily as great as in any sector of North America. Of the tribes most important from an aesthetic standpoint there are several in each region: in the north—the Hoopa, Karok, Klamath, Shasta, Tolowa, and Yurok; in the central region—the Maidu, Miwok, Pomo, Yokuts, and Wintun; in the south—the Chumash, Diegueño, Luiseño, Kawia, Mohave, and Yuma.

The basketry of all these tribes is one of the supreme achievements of the Americas. The craftsworkers produced the finest weaving imaginable, often embellished with bird feathers, shells, and other found ornaments. Probably it is the Pomo who surpassed all other tribes in their basketry, making miniature baskets the size of a fingertip or immense containers measuring four or five feet in diameter; each variation and size produced by working grass into remarkably refined and handsome objects.

The cultural activities of the California tribes are seen almost exclusively in their basket making, for none produced important ceramics, and little wood carving has been discovered. Apparently (with the exception of Chumash sculpture) they were neither accomplished sculptors nor, as far as is presently known, did they ever create any exceptional textiles despite their skills as basket weavers. But there is no question whatever that in their one area of expertise—basketry—they created an almost unlimited array of shapes, forms, and patterns.

Maidu

Pomo

California basketry.

The Southwest

The "ancient ones" of the American Southwest are collectively called *Anasazi*, a wide scattering of peoples of present-day Arizona and New Mexico. It is generally assumed that the so-called Mogollon people of central Arizona–New Mexico co-existed with but were eventually assimilated by the Anasazi, while the Hohokam (a people of southern Arizona) were perhaps the remote ancestors of today's Papago and Pima tribes, who live in the same dusty desert that their forebears did. Among the most intriguing of the early Southwestern peoples were the Mimbres (Mimbreño), a Mogollon people, who produced some of the most strikingly original pottery designs of the Americas. These tribes of prehistory are little known, and their relationship culturally and racially to contemporary Southwestern tribes is uncertain. Either they wholly disappeared, leaving only their remarkable dwellings and artifacts as evidence of their rich lives, or, perhaps, they were ancestral to the various contemporary tribes of Arizona and New Mexico. These tribes include the largest North American Indian population today: the twenty-one Rio Grande Pueblo groups, the vast Navaho population of Arizona, as well as several Apache bands, the Havasupai, the Hopi, Acoma and Zuñi, the Walapai, the Papago, and the Pima tribes.

There are several important media of artistic expression among the well-known, much researched, and highly praised art works of the American Southwest. The peoples of this region were particularly strong as colorists, producing figurative and geometric designs with a vivid sense of hue, and using pigments rendered from minerals. Though they produced painterly works on wood (such as the headdresses called *tablitas*, was well as kachina dolls, dance plaques, altars, "war gods," and prayer sticks), their most renowned decorative painting was executed on pottery and on the adobe walls of their ceremonial houses (*kivas*), where they produced murals over many successive generations.

Weaving was another medium in which the Southwestern tribes excelled. Originally using a native cotton which predated the Spanish importation of sheep, the Pueblo people had a long tradition of excellent textiles. The acquisition of sheep wool and colorful dyes from the Spanish overlords brought the art of weaving to a sudden and splendid climax among their Navaho neighbors—newcomers to the region, who had arrived a mere one thousand years before the Spaniards and whose Athapascan culture was thoroughly transformed by the example of the Pueblo art and rituals.

Despite a rich supply of stone in their region, the Pueblo artists were not outstanding sculptors, for reasons we cannot determine. Even the production of wood carving was limited and never reached anything like the grandeur and technical finesse of the Northwest Coast carvings.

Of all the North American regions, it is

Mimbres pottery.

Navaho blanket.

the Southwest where a highly complex social organization strongly conventionalized communal activities, including art and ritual. The strain of individualism which marks the personalities of the peoples of the Northwest Coast, the Great Plains, the Northeast, and the Woodlands had no existence among the Pueblo people in the American Southwest, and their culture is marked by the rigid and conservative forms of a highly traditional and closely unified communal structure. Even the Navaho and other Southwestern peoples, though less conservative than the Pueblos, were strongly influenced by the conventions of the ancient traditions of the forebears of the Pueblo groups.

Pottery, the greatest of all the prehistoric arts of the region in terms of quality and variety and the sheer quantity of production, remains an important activity of Southwestern craftspeople. The working of grass into various containers was also an important craft, but its production has dwindled except for the creation of ceremonial baskets and a limited number of trade objects made essentially for collectors.

Silversmithing is a very recent art in the Southwest, though for many people it represents the epitome of Indian crafts of the region. The Navaho began working in silver in 1853 and did not begin to make the complex settings for turquoise until late in the nineteenth century, when a large tourist market developed for "Indian jewelry." The Hopi began to specialize in "overlay," while the Zuñi became well known for their exquisite mosaics. But almost this entire jewelry industry was devised within the last one hundred years.

Though sand painting is generally thought to be a Navaho invention, it is probably an adaptation of ancient Pueblo ritual art. As with weaving, it appears that the Navaho assimilated the art of sand painting and developed it into a more complex expression than its Puebloan inventors.

Except for the initial enthusiasm of art collectors and curators for the monumental arts of the American Northwest Coast, probably no area in the Americas has been more carefully studied, and probably no Native arts more accurately and thoroughly examined and catalogued, and no Indian culture more analyzed and written about, than that of the Southwest.

The Plains

The Plains was not a densely populated area nor did it possess any of its widely publicized color and character until the eighteenth century, when the nomadic tribes of the region acquired the horse, which allowed them to evolve the traditions, arts, and lifestyle that are so famous today. Only with the mobility provided by horses did these tribes become great hunting and warring tribes, famous for their fanciful porcupine-quill decorations, dramatic buckskin and beadwork costumes, flamboyant feathered headdresses, and elegant painted and quilled buffalo hides. Even the holy of holies among the Plains people, the ritual known as the Sun Dance, is of relatively recent origin, for the nomadic bands were too scattered and poor to sustain an elaborate ritual life; therefore religion was—and remains—among the Plains Indians a largely individual practice.

Despite the renown of the Plains Indians—which amounts to a veritable stereotype of *all* Native Americans—the

Acoma

Zuñi

Puebloan pottery.

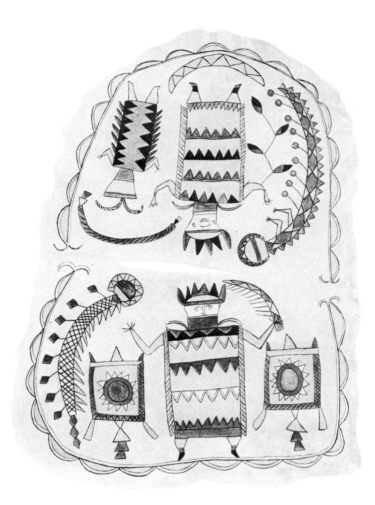

An Apache medicine shirt of deerskin, with a slit in the center for the head.

Plains people represent a wide variety of cultural forms, languages, and arts. There was a great number of tribes who were native to the Plains or, with the acquisition of the horse, came down into the unbroken grasslands to hunt. In the northern Plains there are the Arapaho, Arikara, Blackfeet, Cheyenne, Crow, Mandan, and the several Lakota (Sioux) bands. In the central Plains there are the Kansa, Omaha, Oto, Pawnee, and Ponca. The southern Plains are dominated by the Comanche, Kiowa, Missouri, Osage, and Wichita tribes.

Historically, two arts were of special importance among these Plains peoples. The first, porcupine quillwork, is a very old tradition making use of small quills which are boiled, flattened, dyed, and then applied to animal hides in the form of geometric appliqué. With the introduction of glass beads from Europe, quillwork underwent a fundamental transition; it almost disappeared as a medium insofar as the same designs could be created with sewn beads, and beadwork permitted not only the geometric designs traditional to Plains Indians but

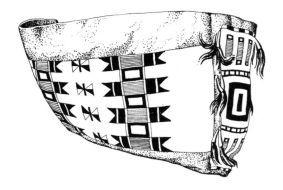

Arapaho beadwork on hide.

Arapaho medicine case, made of painted raw hide.

also allowed the development of curvilinear patterns largely borrowed from European floral figures. The beads from Venice and Prague, which were introduced in the eighteenth century, virtually replaced all forms of Plains decorative media.

The art forms of the Plains Indians greatly resemble the adoration of nature found among most pantheistic peoples: a tendency to celebrate the beauty of the world by adorning the body as well as the home and its utilitarian objects with elements taken from nature. Not only did Plains tribes take infinite aesthetic interest in their costumes and homes, but they also devised elaborate painted patterns for their bodies and faces; they produced a wide variety of imaginative hairstyles, and they used every means possible to aggrandize the person. The same concern for decorative symbolism and painterly skill that was devoted to regalia and artifacts was also given to horses, which were handsomely bedecked with lavishly decorated gear. Unfortunately, we know most of this splendor and finery from the displays of dusty nineteenth-century materials on department-store dummies. Such exhibits of the material culture of the Plains fail utterly to capture the dynamism of

Plains Indian regalia, for every article of clothing and equestrian paraphernalia was devised to accentuate motion and vitality and grace. Except for the most authentic powwow displays we rarely have the opportunity today to experience the dazzling flair and brilliance which underscored the whole culture of Plains Indians at the peak of their power.

In proportion to other art forms, little woodworking exists on the Plains. There are some finely carved bowls, fetishes, and attractive figurines and effigies—especially celebrating horses—but by and large, carving was not the favored technique of the Plains. Nor was pottery of any great importance, serving mainly utilitarian purposes and never achieving any magnitude of form or finish. What has been said of carving and pottery may also be said of basketry. It was not a major achievement of the Indians of the Plains.

Characteristic of their symbiotic relationship with their environment, the most emphatic artistic interest was in objects made from animal skins, which were highly decorated for social, personal, and religious purposes. It was in the manipulation of hides into robes, containers, and shields that the Plains craftsworkers achieved real rank as artists, inventing quillwork and adapting beadwork to a wide variety of symbolic and decorative purposes. In the use of fringes and feathers and hairlocks and animal teeth and claws, they produced a theatricality in their arts which was unique. It is essential to emphasize that every element of "decorative" style which we know as Plains art was never really decorative so much as it was a tribute to the powers of the animals whose skins and furs and feathers were incorporated into every mode of Plains Indian art. Not only were the spir-

its of such creatures honored, but Plains art also paid respect to the grace, agility, and strength of the animals whose bodies were given to craftspeople as the spectacular medium of an art devoted to the celebration of the fertility and wonder of the earth and all its offspring.

The Midwest

It is in the Midwest that we discover the descendants of the mysterious Mound Builders whose great ceremonial centers had reached their height just prior to contact with Europeans. This Mound Culture was not strictly one culture but many, extending from the Great Lakes south to Alabama, and from Oklahoma eastward as far as Tennessee and Georgia. The classical age of the Mound Culture was about A.D. 1000, though its influences and social organizations lasted until the arrival of the Spaniards and the French along the mouth of the Mississippi.

Like the later culture of the Northwest Coast, the Midwest tribes were devoted to monumentality in everything they did. The symbol of a bird was the talisman of their cult, which was apparently devoted to a conception of death as a great crescendo of life, and everything the Mound Builders made was in some way connected with their celebration of death.

Their largest settlement, Cahokia—outside present-day St. Louis, Illinois, was the biggest earthwork known to have been constructed. Similar mounds, often in zoomorphic form (such as the famous Serpent Mound in Ohio), were built widely along the Mississippi and Missouri river valleys. Their purpose is not entirely understood, but it is gener-

ally assumed, from early records of French explorers in Louisiana, that the mounds were crowned by wooden temples—a form of religious structure bearing such close resemblance to the pyramids of Mesoamerica that it is generally agreed that the Mound Builders were either satellites of the Valley of Mexico or were far-flung posts of highly developed Mexican trading routes. In any event, it seems very likely that much of the Mound Builders' cosmology and material culture was strongly influenced by Mesoamerican examples.

The two prehistoric cultures of this region which are best documented are the Hopewell and the Adena, presumably forebears of the later, historic, tribes we know today. At a much later time the Dakota (Sioux) migrated into the Lakes Area from the south and then, with the invasion of Europeans, which pressed eastern tribes westward, they were forced out into the Plains, where they warred endlessly with the Chippewa and the Blackfeet.

Little in the way of early textiles or basketry has survived in the Mound Builders' area, due to climatic conditions, but from the graphic evidence of stone, shell, and bone objects, we have some notion of the excellent achievements in these media. Despite some work with copper, there was limited merit in the metalwork of the Midwest.

In prehistory the Mound Builders were highly accomplished carvers and sculptors, producing some of the most austere and wondrous icons of the Americas: seated stone figures, effigy pipes of inordinate aesthetic quality, ceremonial vessels made from whelks and conchs engraved with elaborate designs and motifs. Their shell gorgets

Engraved shell, Tennessee

Stone pipe, Ohio

Engraved stone, Mississippi

Engraved shell, Illinois

Mound Builder objects.

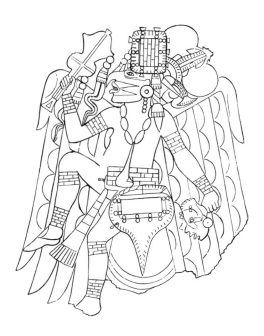

Mound Builder winged human figure engraved on copper plate, from Etowah Mound, Georgia. The figure is carrying a human trophy head.

ans' use of quills and probably predated it. Quilled birch-bark containers are among the most handsome of Midwestern artifacts. An impressive technique surrounds the use of bark as a medium for building containers and for producing scrolls with incised images, which, despite some controversy, are agreed to have served as mnemonic devices, recording ceremonial activities, songs, tales, and so on.

The Southeast

The Southeast is an extension of the Mound Builders' prehistoric domain, and the mounds and great monuments found in the Midwest are also found here. Again, there is much evidence to support the notion that there was considerable exchange between the Southeast and ancient Mexico. The Spanish and French explorers were eyewitnesses to the lavish ceremonial life of the Natchez, Creek, and Timucua people, whose ritual life seems close in symbolism and focus to the religious rites of Mesoamerica. Other tribes of the region include the Alabama, Catawba, Cherokee, Chitimacha, Choctaw, Human, Koasati, Mobile, and many other small groups. The Tuscarora originated here and then traveled northward, where they joined the Iroquois Confederacy. The Sioux apparently also originated here, traveling first to the Great Lakes and then out onto the Plains. And, finally, the Seminoles separated themselves from their Creek forebears and established themselves as an independent tribe in Florida.

were also highly refined and brilliantly executed, with stylized and engraved pictographs. Their production in wood of animal masks and figures in the round was unique in manner, and astonishing in expression and power. And though the quality of the pottery was not extraordinary, the incising and, especially, the elegantly simple configurations of abstract curvilinear forms painted on the pots were so sophisticated that it is only toward the end of the twentieth century that we completely grasp their perfection. The Mound Builders and their descendants also made ceremonial plaques and silhouettes of copper, mica, and silver which were probably used for personal adornment.

In historic times the most lavish accomplishments were the production of complex beadwork and the unequaled use of porcupine quillwork—a form which was distinct from the Plains Indi-

The description of the Temple Mound people of the Midwest may be extended to describe the artistic skills of the prehistoric peoples of the Southeast. It was,

however, particularly in this region that a highly refined ceramic tradition flourished, of polished water bottles, bowls, huge burial urns, and a variety of other containers—all exquisitely decorated with geometric incised lines, appliqué, and muted pigments.

Today the most active media of the Southeast, where the culture was very nearly decimated by the encroachment of settlers, are basketry of a very fine caliber and the production of cloth patchwork textiles by the Seminole Indians.

Iroquois False Face mask.

The Northeast

Two major Indian groups live in the Northeast region: the Iroquoian and the Algonquian peoples. The Iroquois are famous for their great federation, which included the Cayuga, Oneida, Mohawk, Onondaga, and Seneca. Early in the eighteenth century the Tuscarora tribe migrated from its Southeastern homeland to form the last of the Six Nations Confederacy, which occupied the present-day states of New York and Pennsylvania and southern Ontario. Today the Iroquois are still a confederacy of numerous tribes in New York State.

The most important of the Algonquian-speaking tribes were the Passamaquoddy, Abnaki, and Penobscot of Maine, and the Malecite, Micmac, Montgnais, and Naskapi of Labrador. There are numerous smaller bands, which occupied Connecticut, Rhode Island, Massachusetts, and Long Island. The populations of Algonquian peoples were greatly decreased by the coming of the European settlers, and much of their culture, languages, rites, and arts was lost during the late nineteenth century.

There is among the tribes of the Northeast, as there is among many assimilated Indians, a strong cultural renaissance. Gradually artists are becoming more numerous in this region. Among the Iroquois there are several fine painters, and among the Tuscarora there is a reflowering of the stone carving which was a major activity of the Tuscarora when they were still living among the peoples of their Southeastern homeland. The most notable and persistent Iroquois art is the carving of False Face Society masks, which have a central importance in the Longhouse religion, though their use clearly predates the founding of the Longhouse by the Iroquois prophet Handsome Lake in 1799.

Other important Iroquois artifacts are shell wampum ceremonial belts and fan-

Iroquois silverwork.

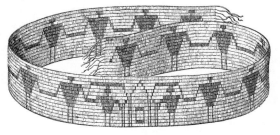

One of the finest wampum belts, an Onondaga example containing almost 10,000 beads.

ciful cornhusk masks and dolls. But one of the most intriguing arts of the region was lost two centuries ago: the elaborate painted and tattooed designs which were applied to the body by early Woodlands people. This body art was clearly a brilliant and impressive aspect of the art of the Northeast.

Mexico

It is somewhat arbitrary to separate Mexico from North America, insofar as the influences of Mesoamerica were impressive both in the Southwest and the Southeast of the United States. But, in the long view, the heritage and arts of Mexico and Central America constitute traditions sufficiently distinct from those of North America to justify discussion of the region below the Rio Grande River as a self-contained area. Quite apart from the cultural distinctions, there is the additional and very substantial fact that post-Columbian Indians of Hispanic America were deeply influenced by Spanish traditions. For all these reasons we will consider Mexico and Central America as a region with a more or less unified tradition.

As already mentioned, there is a good deal of scholarly dispute about the origins of the culture of Mesoamerica. (The area is also called Middle America, consisting of Mexico and parts of Central America; marked on the north by the Sinaloa, Lerma, and Pánuco rivers which separate the nomadic tribes of the northern desert from the agricultural peoples of Mesoamerica; and including central and southern Mexico, the Yucatán Peninsula, Guatemala, El Salvador, parts of Honduras, Belize, and Nicaragua, and

northern Costa Rica.) Traditionally it is accepted that the earliest art forms of Mexico were those produced by the mysterious "rubber people"—the Olmec—whose traditions flowered as early as 1000 B.C. throughout a wide region, from Guerrero to Veracruz and as far south as Honduras. There is currently a good deal of dispute about the long-held notion that Olmec civilization was the "mother culture" of the region. More and more sites have been discovered in Central America (particularly in Belize) which apparently predate the earliest Olmec finds. According to archaeologist Norman Hammond, writing in *Scientific American:* "Work over the past two seasons on the eastern margin of the Maya area in Belize (formerly British Honduras), often regarded as a backwater, has pushed the beginnings of the Maya Formative (or Preclassic) period back by more than 1,500 years, from about 900 B.C. to perhaps as long ago as 2600 B.C. The new findings place the Early Formative Maya culture among the oldest settled societies in Mesoamerica or, for that matter, in the entire [Western Hemisphere]. The existence of architectural traditions typical of Classical Maya dwellings, such as plastered floors and platforms with timber-framed superstructures, in the lowlands that long ago is indicative of a developmental period for Maya culture of far greater duration than has been supposed."

Whatever the chronological relationship of the Olmec people to the origins of Mesoamerican culture, it still appears that the Olmec were the producers of the first widely influential center of power and technology in the Americas. They reigned supreme in the present-day Mexican states of Tabasco and Vera-

cruz on the Gulf Coast. This region is hot and humid, with rainfall that can reach one hundred and twenty inches annually. Throughout the steaming lowlands sluggish rivers make their way through the jungle. It is an inhospitable region, where few people live today. But archaeologists have discovered abundant evidence that in this very unlikely environment the cultural forms that prevail in Middle America were forged at least one thousand years ago.

The Olmec, who produced this culture, are of unknown origin. Sagas of the Aztec people tell of a land on the sea that was settled so long ago that "no one can remember" the time of its beginnings. The place is called Tamoanchan—a word which is not Nahuatl (the Aztec language) but Maya and means "Land of the Rains." So it is possible, as Hammond has asserted, that the Olmec may have been related to the Maya, at least linguistically if not racially.

The craftsworkers of the Olmec were undaunted by monumentality. These were the artists who carved the colossal heads found at La Venta. Tests on charcoal found at La Venta have established the date of the site at about 800 B.C. Insofar as La Venta was at the peak of its cultural activities at this date, the inception of the Olmec Formative period has been placed at about 1200 B.C.—a time when the Golden Age of Greece was still seven hundred years into the future.

All through the Olmec culture the theme of the jaguar is a visible and dominant image. Some carvings depict this tropical American cat realistically, while other renderings combine jaguar and human features. Many sculptures represent some sort of holy infant—often with the turned-down lips of the jaguar.

Some experts consider that these Olmec baby-face figures are "were-jaguars," or human beings with sacred feline blood. It is speculated that the jaguar cult, glyph writing, calendrical science, and many of the other distinctive Mesoamerican achievements originated with the Olmec. Again, however, there is a good deal of debate on these issues. But whatever the relative importance and age of the Olmec world, there is little question that its cult of the jaguar, Mesoamerica's first "formal religion," was of enormous influence for the entire region. The seeds of that vastly important Olmec mentality may have been self-perpetuated, without significant impact from any other cultural sources, but it may be more than coincidental that the Maya finds in Belize long predate the Classical Olmec sites and, furthermore, that the Chavin culture of northern and central Peru originated at about the same time and was also much preoccupied with icons of jaguars and were-jaguars.

The Olmec origins are likely to remain a mystery for many years to come, but there can be no doubt that Olmec religious iconography was widespread. Olmec sculptural motifs, figurines, and rock carvings have been discovered as far north as Mexico City and as far south as Honduras.

La Venta, the principal site of the Olmec, was not a city. It was clearly a ceremonial center, a sacred mecca located on an island little more than two miles square, an area hardly capable of supporting more than thirty families by the slash-and-burn method of farming used by the Olmec. Clearly La Venta was a shrine resided over by holy people, visited by countless pilgrims bearing gifts and providing their labor for the build-

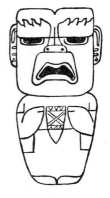

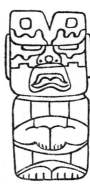

Olmec jade and greenstone carvings: were-jaguar figures.

ing and upkeep of the ceremonial structures.

Another people, closely associated with the Olmec, were the Zapotec of Oaxaca. One of the first major satellite centers, presumably set up by Olmec missionaries, was Monte Albán, near the present Mexican city of Oaxaca and about two hundred miles southwest of La Venta. The structures at Monte Albán which are currently standing (and restored) were built long after the demise of the Olmec culture, but archaeologists, tunneling into the structures, have found evidence of much earlier buildings, some of which contain large stones with Olmec-like images carved in bas-relief. It is assumed that these stones were torn from the original, underlying Olmec-type structures and used as construction materials for new pyramids, which, typically of the Mesoamerican architectural methods, were enlarged and rebuilt over previous sites. The carved stones found within the superstructures of late Monte Albán buildings were bas-reliefs depicting naked men in curious limp postures. They are traditionally called *Danzantes,* or "dancers." The carving is coarse, but the thick lips and flat noses indicate the likelihood that they were influenced by Olmec artistic style.

Other Olmec traces found at Monte Albán are ceramic incense burners with were-jaguar faces. These objects, like most early Mesoamerican art, were religious in nature, supporting the theory that Monte Albán was a ceremonial center and not a "city." Its region was arid and barren and could never have supported an appreciable population. Apparently it was visited by pilgrims who climbed the slopes bearing offerings.

Danzantes. *Monte Albán, Oaxaca, Mexico.*

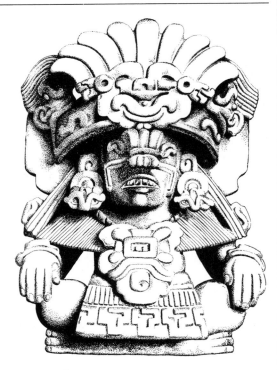

Zapotec funerary urn.

These processions of worshipers continued for about 1,400 years. The first known shrine of Monte Albán was built about 500 B.C., and the final evidence of ceremonial use of the site is dated about A.D. 900. Monte Albán was one of many Olmec satellites. The jaguar cult is also found in Guatemala and El Salvador. Another of the major cultural achievements of the Olmec may have been the invention (or at least the perpetuation) of a form of writing—the oldest in the Americas. No examples of glyphs have been found thus far at La Venta itself, but many of the *Danzantes* at Monte Albán have undeciphered glyphs carved near the mouths of the figures, in the typical Mesoamerican method used to indicate speech. These early glyphs may have been conceived by the Olmec or perhaps by their Zapotec converts in

Monte Albán, but they were obviously a most successful invention, for all forms of writing used in Mesoamerica seem to descend from these archaic glyphs.

During the decline of the Olmec influence, the mountain-walled Valley of Mexico, where the Aztec would eventually hold dominion and where contemporary Mexico City stands, was exceedingly remote and isolated from the mainstream of Mesoamerican culture. Yet even into this virtual backwater the Olmec influences managed to penetrate. In clay pits in the village of Tlatilco near Mexico City typical Olmec figures have been found. These Olmec influences reached the valley sometime before 500 B.C. and were established as central aspects of religious life. According to the fine summary of these events by J. N. Leonard (1967), the first major flowering of this "missionary" contact of Olmec ideas with the Valley of Mexico was the construction in Cuicuilco (on the outskirts of Mexico City) of a crude, oval earthen mound about 390 feet long, faced with rough stones and rising by four stages to a total height of 75 feet. This pyramid of Cuicuilco is clearly modeled on Olmec influences. For a time Cuicuilco was an important center and then it was abandoned. And as it was declining, another important center was being constructed at Ostoyahualco across the many lakes of the Valley of Mexico. From the simple foundations begun at Ostoyahualco, about the time of the beginning of the Christian Era, eventually grew the great and immensely important civilization of Teotihuacán.

This new center, like the Olmec ceremonial sites, had great pyramids for ritual and ceremony, but unlike the Olmec models, Teotihuacán was not devoid of a civil population. All around the platforms and ritual structures were residences. We do not know the nature of the population of the city: it could have consisted entirely of holy people, artisans, and merchant/traders, but collectively these people constituted the first true city in Mesoamerica; it is called by archaeologists "Teotihuacán I" to denote its formative nature, for eventually another, much larger city rose next to and over the original structures. Between A.D. 300 and 700 this new city, Teotihuacán, spread gradually over an area of about eight square miles. Located thirty miles northeast of present-day Mexico City, it was a center of immense pyramids and causeways—the model of all future Mesoamerican architecture.

The layout of great Teotihuacán is so elaborate that it suggests brilliant city planning and great sophistication of architectural imagination. The names of the structures—"Pyramid of the Sun," "Pyramid of the Moon," "Avenue of the Dead," and "Temple of Quetzalcoatl"—are traditional, but they come from much later Aztec legends—though the Aztec knew very little about the great city, which was in ruins by the time they migrated into the Valley of Mexico in the tenth century. The name Teotihuacán means "Place of the Gods" in Nahuatl. Folk history of the Aztec tells of the time when all the gods gathered there after the last of a succession of suns had died. One by one they volunteered to throw themselves into the divine fire so that the sun would rise again.

Evidence indicates that Teotihuacán was a relatively peaceful place. There are no walls for defense, and soldiers and weapons are not prominent in the

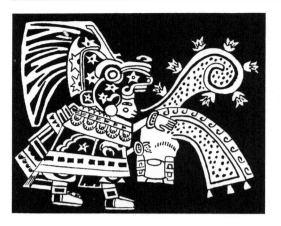

Teotihuacán mural.

art imagery. The beneficent deities Tlaloc and Quetzalcoatl were the principal power figures, indicating that the chief rituals were concerned with fertility and culture, rather than warfare and human sacrifice. In fact, the bloodthirsty gods that became dominant in later times were notably absent from the world of Teotihuacán.

The Teotihuacán culture was as influential in its time as was the prior Olmec world. It spread its mentality and iconography throughout Mesoamerica. Architectural elements in the city of Kaminaljuyu, in far-distant Guatemala, are very similar to those of Teotihuacán. Its eloquent carved stone masks became the idiomatic style of Mesoamerican "portraiture," while its sense of city planning and civic monumentality is seen everywhere in subsequent Mesoamerican history.

Then, about A.D. 700, the great city suddenly declined. It was looted and burned, its people were driven off or massacred, and its immense influence ceased. There is much support for the theory, based on archaeological evidence, that the sacking of Teotihuacán was the result of an invasion of "barbarians"—hordes of Chichimecs who swept down from the northern desert and plundered and destroyed the great city. Whatever the cause, the Valley of Mexico fell into a long silence from which it did not rise again for over three hundred years. By the time of the Aztec people—those latecomers to the Valley of Mexico who held dominion at the time of the invasion of Cortes—Teotihuacán was already a ruined and lost world whose people, language, and origins were entirely lost in time and memory.

Another people closely associated with the Olmec were the inhabitants of Tlatilco, Chupicuaro, and similar early sites that are renowned for their clay figurines of females with exceptionally elaborate, probably ceremonial coiffures. At approximately the same period, another group evolved in Western Mexico: in Colima, Jalisco, and Nayarit. Only recently has archaeological work in these areas uncovered much information about the local tribes that produced outstanding terracotta figures in great numbers. Despite terrific looting by *huaqueros*, tomb finds of recent years, under controlled conditions, have provided far earlier dating for this region than previously known (from about the second century B.C.)—though, once again, a definitive chronology has not been established. Another discovery in this area has caused a great deal of speculation: the distinctive shaft-and-chamber tombs of Colima, Jalisco, and Nayarit occur nowhere else in Mesoamerica but are characteristic of the Andean civilizations of South America, as are such objects as the stone "maps" with their circular depressions. "Many other elements also suggest possible connection

with inhabitants of the northern Pacific coast of South America, who could have sailed north on balsa rafts. In view of the strong differences between the culture of Western Mexico and that of the rest of Mesoamerica, and the several points of similarity to South America, some form of direct contact between northern Peru or Ecuador and the West of Mexico seems likely during the Protoclassic Period" (Easby and Scott, *Before Cortes*).

After the collapse of Mexico's greatest city, Teotihuacán, about A.D. 700, a dark age shadowed Mesoamerica for several centuries. The centralized elements of Olmec and Teotihuacán cultures faltered and then dissipated into confusion and regional strife. The unfortified centers of the old religion and the ancient learning were replaced by new, crudely constructed cities of warriors whose leaders made conquest a new lifestyle in Mexico. Deities of inordinately vicious

features and bloodthirsty ceremonies arose in place of the cult of Quetzalcoatl—the prince of peace of the Americas. City-states were highly fortified, and the grace and subtle mysteries reflected in Olmec and Teotihuacán religious art were replaced by rigidity and formality.

All these abrupt changes were apparently brought about by the Chichimecs, who stormed into the Valley of Mexico from the north in successive waves with fierce warriors for a period of about five hundred years. Yet these "Sons of the Dog," as they called themselves, these Chichimecs, also carried with them the culture and racial strain that would eventually become the forebears of ancient Mexico's most noted and imperialistic people, the militaristic Aztec.

These so-called barbarian Chichimecs were not merely a nomadic, hunting-foraging people. They were quite similar in culture to the Germanic tribes that overwhelmed the Roman Empire in the fifth century. They had a strong material culture and sufficient agricultural know-how to support a large population. And it was their numbers, finally, which made them so successful in replacing the culture of the Valley of Mexico. (A foraging people would necessarily have been far too few in number to have any widespread impact and would have been quickly destroyed in the confusion of Mesoamerica's Dark Ages.) It was long speculated that the Chichimecs were simple nomads with a particular predilection for strife and exploitation, but archaeologists have recently found farming settlements in the mountains and deserts of Northern Mexico from which these ancient "barbarians" came. Clearly, they were an immense and

Shaft-and-chamber burial. The Andes.

fierce population, supported by an active agricultural lifestyle, long before they left their arid homeland and descended upon Teotihuacán.

Gradually a new form of order overtook Mexico and its great central valley. Many of the restless Chichimecs settled down and were assimilated into the ancient population, much as the European barbarians were absorbed into the remnants of Roman colonies and provided the loyal manpower needed to repel new waves of invaders from the north. So too the Chichimecs helped defend their new cities against successive waves of Chichimec invaders. By about A.D. 970 one of these Chichimec cities had enough power and a large enough population to dominate the Valley of Mexico as well as many distant city-states of Mesoamerica. These were the Toltec people of the city of Tula, whose ruins are found fifty miles north of Mexico City. Part of their prestige and power clearly came from the fact that they had successfully adapted much of the ancient culture of the Teotihuacán and Olmec peoples to their own purposes, assimilating their folk history as their own and attempting to combine their warlike tribal deities, which they had brought with them from the north, with the priestly philosophy of Quetzalcoatl, whose creed they learned from the holy people they overran in the Valley of Mexico. This uncomfortable dualism—of a war god and a god of art and love—would remain a central focus of Mesoamerican mentality until the invasion of Cortes—an event that would be greatly aided by internal friction of civil wars and a philosophical dualism.

It is with the ascension of the Toltecs to dominancy in Mesoamerica that the recorded history of Mexico commences. The Aztec inherited the folk history and pictographic "books" of the Toltec and also of the Mixtec peoples, and from these sagas we are able to reconstruct with some certainty the subsequent chronicles of Mexico, much as Homeric poems allow us to reconstruct early Hellenic history.

Toltec folk history begins with the tale of a Chichimec band migrating from the northern desert region early in the tenth century, led by a powerful priest-king named Mixcoatl. These wanderers eventually settled at Culhuacán, a place south of modern Mexico City, where Mixcoatl's son, Topiltzin, was drawn into the residue of the Quetzalcoatl cult he found among the ancient inhabitants of the Valley of Mexico. When Topiltzin eventually ascended to his father's Toltec throne, he changed his name to Quetzalcoatl in honor of the god he worshiped. Then, about A.D. 950, Topiltzin-Quetzalcoatl moved the Toltec capital to a new city, called Tula, built, according to legend, with the aid of *Nonoalca* (Deaf and Dumb People), who were probably the remaining great artisans of Teotihuacán and were "deaf and dumb" insofar as they could not speak the Toltec language. These artists were far more capable than the Toltec craftspeople of the time, who were only a few generations removed from their Chichimec barbarism, and so Topiltzin commissioned them to carve statues, produce pottery, and design and build temples. Thus Tula was made into a great city, with both a culmination and reshaping of the ancient arts of Mesoamerica as an expression of Toltec ideals.

The achievements of Topiltzin-Quetzalcoatl, however, also culminated in a

frantic dualism: a conflict between the Chichimec tribal god of war and the deity devoted to culture, Quetzalcoatl. The warrior god, Tezcatlipoca, demanded blood for his survival, but the heritage of Quetzalcoatl found blood sacrifices repugnant and urged followers to offer butterflies instead of human hearts.

There are several different conclusions to the saga of Topiltzin, but the version which possesses the elements of religious history recounts that the god Tezcatlipoca eventually dethroned the gentle priest-king, Topiltzin-Quetzalcoatl, by persuading him to drink the potent *pulque*, which made him become so drunk that he slept with his sister. Disgraced, he left his Toltec throne and with a group of deformed retainers he sailed into the east on a raft of entwined serpents, promising to return to his people and his throne.

Clearly, Tula was torn by great internal religious strife, between those devoted to the old gods of Teotihuacán and those who preferred the fierce deities brought by the Toltecs from the north. The followers of the war gods were victorious, and thus Topiltzin and his deity Quetzalcoatl were sent into exile.

Today Tula has been partially restored and makes a strong impression with its rigid linear architecture and sculpture. Standing in a row on the main pyramid platform are four columns in the form of warriors, fifteen feet tall. These columns originally supported the temple's timber roof. Such pillars and the rigid warriors they depict are highly characteristic of the Toltec iconography.

Hardly a generation after the founding of Tula, Toltec armies were swarming over most of Mexico, dominating the coasts and reaching into Guatemala as well as into their own northern Chichimec homeland. By about A.D. 1000 they had achieved their greatest expansion: advancing into northern Yucatán and there overwhelming the ceremonial centers where the Maya still flourished. It is probable that the Toltec invaders destroyed some Maya centers, but they apparently were also very active in the construction of new structures, which were built by Maya artisans with the abundant influence of Toltec style. A large part of the immense center called Chichén Itzá is such a joint Maya/Toltec achievement. The architectural concept of Chichén Itzá is clearly Maya, but there are strong Toltec elements as well: for instance, the death heads typical of the Toltec religion.

The strong influence of the Toltec people had wide-ranging impact, affecting not only the Maya of Yucatán but also reaching far north into what is now the United States. It is speculated by

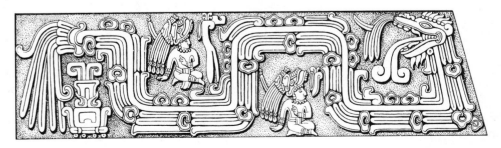

Toltec carved and painted stonework.

scholars that the Mound Builders of the Mississippi Valley—whose simple burial sites date from about 1000 B.C.—eventually transformed their basic funeral structures into lavish mounds with temples on the truncated summits, structures very reminiscent of Toltec pyramids.

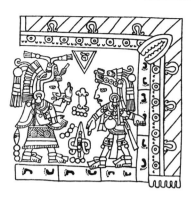

Mixtec codex emblem.

The great cultural emanation from Tula came to an end about A.D. 1160 when Tula was destroyed, probably by yet another wave of Chichimec tribes from the north. Tula was deserted, but the heritage of the Toltec people survived through numerous warrior groups who claimed Toltec ancestry. Curiously, the decline of Tula did not cause the total collapse into a dark age which the fall of Teotihuacán had caused nearly five hundred years earlier. The Toltec empire did not entirely crumble, for new groups of Chichimecs wandered the entire region, attacking various city-states, which managed to hold out against the assaults and thus sustain the Toltec tradition.

One of these tenacious peoples was the Mixtec, who had staunchly maintained their great center at Mitla, in the rugged mountains southeast of the Valley of Mexico, for many years. Their civilization was not only undisturbed by the Chichimecs, but it actually expanded throughout much of the territory lost to the Toltecs due to the fall of Tula. They ventured into the Oaxaca region, reoccupying the long-abandoned Zapotec ceremonial center at Monte Albán, and used some of the ancient Zapotec tombs for the burial of their own rulers.

The Mixtec were a completely separate people from the Toltec. Their homeland, in the vicinity of Mitla and Monte Albán, was apparently little influ-

enced by the dominancy of the Toltec in the Valley of Mexico; and, as already noted, they survived the Chichimec invasions that destroyed Tula and the Toltec empire.

It was the Toltec folk history as well as the pictographic "books" of the Mixtec which eventually gave historical status to the emerging Aztec people. By about A.D. 1000 the Mixtec confederation of city-states had initiated a highly developed and militaristic civilization, strongly influencing the later Aztecs. Mixtec dynastic history is documented in A.D. 692, including the saga of the famous ruler Eight-Deer Tiger-Claw. The history of Eight-Deer is preserved in seven books (*codices*) of pictographic writing.

Another group of Mesoamerican people should be mentioned briefly, though their centers and cultures are only now being fully excavated and appraised. These people lived along the east coast of Mexico—in the area of Veracruz, Tamaulipas, and San Luis Potosí. They shared many art forms with the then-dominant metropolis of Teotihuacán, as well as with such southern centers of culture as those of the Zapotecs and the Maya. In this way, their culture predates the Toltec and Mixtec peoples.

Of the tribes of this region, the Huastec always retained a regional identity distinct from the Maya, Totonac, or Nahua influences, which transformed many other tribes. These tenacious people appear to have remained isolated both in terms of the impact of other cultures on them and in the lack of influence they themselves had on the rest of Veracruz art of the Classic period, c. 250 B.C. The ruins of El Tajin in Veracruz are still largely unrestored, but its famous pyramid is known for its great beauty—consisting of 365 niches, one for each day of the year, it is designed in a unique "airy" manner. The most distinctive feature of the Tajin style is its elaborate scrollwork, forming complex interlacing, which lends a delicacy and openness to the architectural structures of the region.

The Tarascan tribes of this region were renowned for the many "smiling-face" effigies which they made—a rare representation of human emotion in the faces of Mesoamerican figurines.

It is also in the vicinity of Veracruz that a triad of distinctive stone objects has been unearthed. These objects have been named the *palma* (so called because of their similarity to human hands), the *hacha* (so named because of their resemblance to axes), and the *yugo* (yoke). There are numerous theories about these three types of objects, which will be discussed later, in the section concerned with sculpture. Let it suffice here simply to say that these peculiar objects are generally associated with the renowned and still mysterious sacred ball game which was central to much Mesoamerican ceremonial life.

After the collapse of Tula and the Toltec empire, the Valley of Mexico experienced continual warfare for more than two hundred years. City-states survived the constant assaults of enemies, but none of them gained control over the valley. That militaristic achievement was finally reached by the Aztec, who made their first appearance in the valley about A.D. 1200. Descendants of one of the last waves of Chichimecs to press southward into Central Mexico, the Aztecs were destined, in a few centuries, to grow, from a band of impoverished and nomadic tribesmen, into the lords of the Valley of Mexico. Thus the Aztec people

Totonac stonework: yoke and slab.

were the culmination of Mesoamerican history—the classical militarists of the Chichimec barbarians, raised, like their European counterparts who ascended from Germanic tribes, to the pinnacle of political domination. Then, curiously and ironically, the barbarian inheritors of Europe confronted the barbarian inheritors of Mexico, in the climactic battle which left the Spaniards victorious and which marked the end of Mesoamerican civilization.

Central America

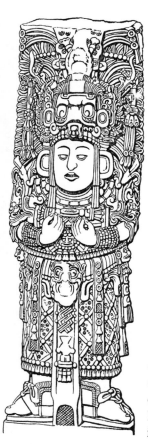

Maya stela. Copán, Honduras.

While the great lords of the Valley of Mexico were straining toward their first period of dominance, the Maya world was taking shape in the south. The most celebrated culture rediscovered in Central America is that of the Maya people—a complex and highly refined society centered in present-day Guatemala and Honduras, where the ceremonial centers of Quiriguá, Tikal, and Copán are the most notable of the restored Maya sites.

It was once conjectured that the Maya had their origins in the cool Guatemalan highlands, but the discoveries of recent years have shifted the homeland of the Maya to the low, hot rainy forests of the Guatemalan province of Petén, the lowlands of Mexico's state of Chiapas, as well as parts of Honduras and Belize.

The Maya rose to unparalleled heights of sophistication, culminating in a golden era about A.D. 600, and then mysteriously collapsed by A.D. 900, long before Europeans invaded the Americas. Their intellectual and aesthetic achievements are probably the most complex of the Western Hemisphere, prompting many historians to regard the Maya as "the Greeks of the Americas." Their influences spread into El Salvador, Belize, and throughout the southern half of Mexico, where numerous Maya sites have been unearthed. Of these Maya-oriented centers perhaps the most awesome are Chichén Itzá, Uxmal, Palenque, Uaxactún, and Bonampak.

The various Maya ceremonial centers did not form an empire, though there are numerous references in history to a "Maya empire." There is no evidence of a dominant capital ever existing. Instead, the centers seem to have constituted a loose federation bound together less by political power than by cultural and religious interests.

The murals discovered at Bonampak in 1946, by a young American photographer named Giles Healey, dispelled the long-standing notion of the Maya as peaceful intellectuals, for the paintings depict raids for sacrificial victims; yet there still remains ample reason to maintain that the land of the Maya suffered little from warfare and aggression. There was strife, of course, but there were not the overwhelming and continual confrontations we find elsewhere in Mesoamerica after the fall of Teotihuacán. Some Maya stelae have been found deliberately defaced and broken and thrown carelessly into heaps, suggesting periods when the Maya revolted against the rulers depicted in the stelae. But, in general, the Classic Maya period was remarkably stable and culturally conservative.

The artistry of the Maya is legendary. They produced craftspeople in many media: clay, shells, bone, stone, and stucco. They were unequaled painters, and their featherwork and textiles appear to

have been exceptionally refined and elaborate. Curiously, there are exceedingly few examples of metalwork in gold, silver, or copper among the Maya, even though the materials were readily available in their region. On the other hand, they were masterful carvers of jade, the most highly prized material of their culture; they shaped this precious green stone into lovely pendants, producing exquisite inlays and ornaments, as well as delicately carved figurines.

The painting of polychrome vases and the exceptional murals of Bonampak attest to the masterful painting techniques of the Maya. Writing, developed to its most complex form by these ancient people, will be treated as a component of art: the glyphs themselves are marvelous visual icons, and the Maya sculptors seem to have covered every available space with a calligraphy which is as notably aesthetic as that of the Orient.

Beginning in Guatemala about A.D. 250, and in Belize about 2500 B.C. (according to Norman Hammond), the Maya may have represented the *mother culture* of Mesoamerica (and not the Olmec, as previously assumed by scholars for decades). About A.D. 550 there came a fifty-year period when ceremonial building ceased abruptly. In some unknown way the culture of Teotihuacán may have had a direct or indirect relationship to the Maya people, perhaps marking the beginning of the long confrontation between the Valley of Mexico and the invading Chichimec tribes. Then all elements of Teotihuacán influence vanished from the Maya centers.

The Maya culture revived and continued to prosper for another three hundred years. Then, about A.D. 800, their civilization in the southern lowlands be-

gan to decline. By A.D. 900 it had completely collapsed, All construction stopped. The ceremonial centers were abandoned. The Maya heritage persisted for centuries in northern Yucatán, but the Maya homeland in Guatemala was desolate and uninhabited.

Scholarly explanations for the decline of the Classic Maya civilization are numerous, but none of the suggested causes—disease, soil exhaustion, radical change in climatic conditions—satisfy experts entirely. Currently it is thought that drastic changes in the social and political control of the centers were the basis for a peasant uprising in defiance of the long-standing dominancy of a priestly-aristocratic elite.

Whatever the reason for its decline, the collapse of the lowland Maya culture brought to a close the last Classic culture of Mesoamerica.

South of the Maya realm, in Nicaragua, Costa Rica, and Panama, the terrain becomes more rugged, the vegetation thickens, and the land narrows into the Isthmus. On this complex land bridge between the Americas there is little formal history.

Undoubtedly there was a vast store of folk history, but the invading Spaniards destroyed the custodians of the past, and we are left today relying for the ancient saga of Central America totally upon the research of archaeologists rather than historians.

The result is, as C. A. Burland (1976) has said, "shockingly incomplete." The Indians of the region spoke a multiplicity of languages. "Nowhere," Burland tells us, "is there any continuous linkage between groups speaking similar tongues. The whole area seems to have

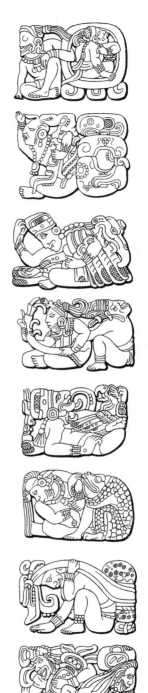

Maya glyphs.

been the scene of periodic two-way migrations, probably not peaceful ones. The peaks of civilizations were reached in plateaux in the north and on isolated stretches of coast in Panama, while in the far south fortified villages along the river valleys and the high plateau were the centers of culture. But nowhere were the conditions such that a tribe could develop a high culture in isolation, and nowhere was there a chieftainship, except among the Colombian Chibcha, strong enough to dominate the neighboring tribes. But everywhere there were areas of high art where handmade ceramics were beautiful, and gold ornaments plentiful. This region was a golden land of incredible wealth."

It is uncertain how the Central American aesthetic tradition began, but it is generally assumed that various influences came up from South America and diffused throughout the Isthmus region, intermingling with what may have been the remains of the declined Maya population and its sphere of culturation. Though prosperous and rich in materials and though sophisticated in the arts, the Central American and Caribbean peoples do not appear to have been great builders, and they left no major ruins or ceremonial centers to compare with other areas which were the focus of religious and civil power in Mesoamerica and elsewhere. The archaeological record is still extremely fragmentary for this region, but it tends to give us a glimpse of a long-enduring pattern of localized tribes controlled by petty chiefs. Unquestionably there were trade contacts with Aztec Mexico and with Inca Ecuador.

The impact of the style of the Maya craftspeople is important in the Forma-tive period of El Salvador and Honduras. The main route of these influences was along the highlands, although there are many exceptions to this line of cultural exchange. For instance, in the Ulúa Valley (western Honduras) Mayoid (Maya-style) pottery has been discovered, as well as a series of white marble vases in the shapes of Maya vessels but having no glyphs. This Maya influence declines toward the Atlantic coast of Honduras, where the Mosquito Indians long made hand-coiled, good but unrefined pottery. They also carved stone bowls of massive size, strong in design but lacking delicacy of execution.

The mountainous and forested region of Nicaragua, once controlled by the Nicarao Indians, has been so slightly researched that we have virtually no history for the area. Early explorers found large stone figures—nearly lifesize, some of them depicting men with alligator heads or, in some cases, carrying alligators on their backs. There are traces in Nicaragua of a grand architectural impetus: groups of low mounds which probably supported wooden palaces, as well as numerous enigmatic giant spheres carved from stone—many standing on plinths (stone foundations). These stone balls were very carefully and accurately wrought, but we have utterly no knowledge for what reason and by whom they were made.

The Guetar Indians were in control of a long coastal area on the Atlantic, leading down through Costa Rica. They were exceptional craftsworkers in stone and carved fine figures of were-jaguars in a very dynamic and lifelike style. The iconography is clearly Olmec but the style is clearly regional. The Guetar lived in forests where jaguar and alliga-

tors were plentiful.

The stone tables (*metates*) used for grinding corn and other seeds were very elaborate in this region, assuming marvelous forms reminiscent of the curvilinear wooden *duhos* of the West Indies, but these Central American metates are often decorated with symbolic crocodile heads. They are apparently much earlier in manufacture and far stronger in design than stools made in various animal forms, such as jaguars and monkeys. In the highlands of Costa Rica these metates become very complex in design, with numerous intertwining animal forms which produce an openwork substructure to the actual grinding surface. These metates are clearly of a highly ceremonial design, the production of which, both in quality and quantity, far exceeded the daily function of the metate as a practical grinding stone, and suggests that its function was both aesthetic and ritualistic. Elegantly shaped and highly refined in execution, the metates are found in a great variety of sizes, forms, and regional styles.

Lower Central America devised at least three distinctive styles of monumental sculpture. The columnar stone figures of Nicaragua depicted, as already noted, lifesize standing or seated figures. The contrasting figures of Costa Rica are much freer in plan and shape, with many openings and projections executed by carvers with a great deal of skill. Finally, the towering stone figures of Barriles, near the Costa Rican border of Panama, have columnar proportions but carving with an extremely open technique, which results in a far less rigid style than that of the large figures of Nicaragua.

There is much similarity between the

work created in Costa Rica and Panama, though local styles can be recognized. This similarity is strictly a matter of influences (we do not know the direction the influence flowed), insofar as the peoples of these two areas are very distinctive, speaking local languages and having dissimilar ritual lives. It appears that a great deal of trading and fighting went on between these tribes.

Clothing was in the form of short skirts and loincloths, ideal for the terrain, but jewelry and featherwork were both plentiful and elaborate. Body painting was also important to these (and most other) tribes, who lived in climates which encouraged nudism.

We have so little information about this area that it is difficult to speculate, but most scholars agree that on the whole "the coastal regions were the sites of the higher civilizations and the forested mountain regions were the refuge of less advanced tribes who had been driven to take shelter among the rocks and trees" (Burland, 1976).

The major icons of the region were various power figures, such as earth and sky, as well as alligators and jaguars, monkeys, and wide-winged birds not unlike the talismans found among the Mississippi Mound Builders. "All these characteristics are of a southern aspect," according to Burland (1976), "and may well be linked with the deities of the coastal peoples of Peru." The whole character of the region is closely linked to the powers of the natural world, and its animality is different in quality and expression from the ferocious religious art of the ancient Mexicans or the placid and delicate scheme of Maya ritual art. "We are still in Central America," Burland concludes, "but the arts have be-

Central American ceremonial metates.

Stone statue. Chontales, Nicaragua.

come thoroughly South American in aspect."

One of the important centers of art production of the region was the Nicoya Peninsula on the Pacific coast of Costa Rica. Here a group of villages sustained a small population from fishing and agriculture of the slash-and-burn method. The area was sufficiently supported by natural resources to allow a high degree of art production for nearly two centuries. During this period there were many changes in the culture, differences in pottery styles, and an increasing use of gold until the thirteenth century, when the culture quickly declined and vanished. An important product of the Nicoya Peninsula was a series of club heads made from hard green stones. They are not simple, utilitarian objects, but carved to represent animal and human heads. Clay figurines are also found in several early sites, and the tradition was strongly perpetuated in Nicoya after the apparent Maya introduction (about the sixth century A.D.) of polychrome techniques, resulting in the creation of large and brilliantly colored effigies.

The Chorotega, Nicarao, and Guetar Indians developed superb polychrome pottery, but their most evolved and notable art was magnificent work in gold casting—producing a higher quality of goldwork than that of any other Central American people. The development of gold as a form of ornament extends the entire potential range of the medium: from cut plates to finely modeled wax castings, often in the shape of bells decorated with figures of monkeys. This metalwork is consistent with the Mesoamerican techniques: the object is modeled in a plastic substance such as wax or crude

Club heads, or "ax gods," made of jade and jadeite. Costa Rica.

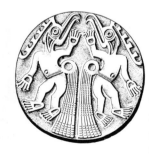

Characteristic imagery from Panama: alligator deities.

rubber and then replaced by metal in lost-wax (*cire perdue*) casting.

Panama, a narrow ridge of mountains once entirely covered by thick forests, was the center of a highly sophisticated culture in ancient times. The greatest achievements were on the Pacific coast, where Indian traders in dugouts sailed easily up and down the coastal villages and exchanged objects and materials with the fishermen and craftspeople. The grandest artistic creations were produced in the region from the Veraguas coast to the peninsula of Chiriquí. Developing for two thousand years, the pottery was brilliant in finish and design. The plentiful supply of gold, washed out from river sand, provided the basis for a great deal of activity in goldwork: pendants were often six by four inches, suspended on loops and guilloche frames. Iconography includes figures of dancing men, alligators, and jaguars. The figures are nude except for a characteristic belt, and each male displays a bare penis with (in many cases) the glans uncovered. Female figures are uncommon from this region.

The most accomplished pottery from the Veraguas coastal region was made in the period about A.D. 1000. The vessels are simple parabolic forms, even and thin-walled and perfectly fired. The surfaces are matt, and the color a muted khaki tone. Some vases have hollow legs containing clay pellets to make a rattle. This type of vessel has been traditionally called "armadillo ware."

Farther south, in the Chiriquí Peninsula, color and imaginative designs dominate the iconography. Jaguar-men dance; musicians play flutes and ocarinas. These images are found on countless

golden plaques designed to be worn as ear and nose ornaments. Thousands of golden bells have been found in graves. Pearls were worn as necklaces and bracelets. Pottery is covered with dancing figures—jaguar-men and alligator-men, drawn on a unique background of intersecting stripes in several different colors. The decoration is perfectly suited to the spatial surface of the plates, which were a favored shape of the potter's art, although the geometric nature of the designs suggests that the style originated with weavers and was then transposed to pottery. (Unfortunately, the climate of the region has destroyed all traces of early textiles.)

The entire region of Chiriquí in Panama was the center of an extensive village life with magnificent artistic achievements. This area, fortunately, has been thoroughly investigated by archaeologists, who have unearthed several layers of deposits representing temporal sequences. The richest period, according to Burland (1976), occurred about A.D. 1200. "Changes in style probably indicate the passage of tribes from the north toward the Colombian area, and from Colombia outward into the north." It was in this region that the Spaniards first heard of "a marvelous golden land to the south" which proved to be unlucky Peru.

"From the south of Panama the prospects of the American Indians opened out into the wide continent of South America. The early hunters penetrated the highland zones rather than the swampy coastal regions of the Pacific and spread along the Atlantic coasts, though there are few remains to mark their passage" (Burland, 1976).

The Caribbean Islands

The primary tribes of this area are the Arawak, Carib, and Ciboney, who settled in present-day Puerto Rico, Española, Cuba, and Jamaica. It seems that the Taino, a band of the Arawak, were the most aesthetically skilled.

It is generally agreed that the native populations of the Antilles (West Indies) were the result of early migrations from South America, there being unmistakable linguistic relations between the Arawaks and the tribes scattered throughout Venezuela and the Amazon Basin. Also the style of their pottery attests to South American origins.

The rulers of the Arawaks were chiefs, known in the Arawak language as *caciques*—a term subsequently applied by the Spaniards to all Indian leaders throughout Indian America. The ruling class possessed marvelous decorative objects that were apparently symbols of their rank. It seems that the Arawaks did not devise an organized priesthood, and therefore local shamans were responsible for communicating with the world powers through idols, known as zemis. The "temples" of the region reported by early explorers were doubtlessly the houses where the chief's zemis were kept. The zemi was usually tri-pointed, often in human or zoomorphic form, and constructed of a variety of materials. Some theorists suggest that the zemis were lashed to wooden staffs.

The most common art motif is the human head—often a death's head. Another frequent find is the so-called comma stone, whose significance has been lost, though these stones have been discovered throughout the Antilles.

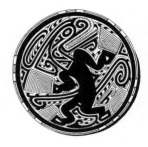

Pottery from Panama: geometric and figurative designs.

Three-pointed stones. West Indies.

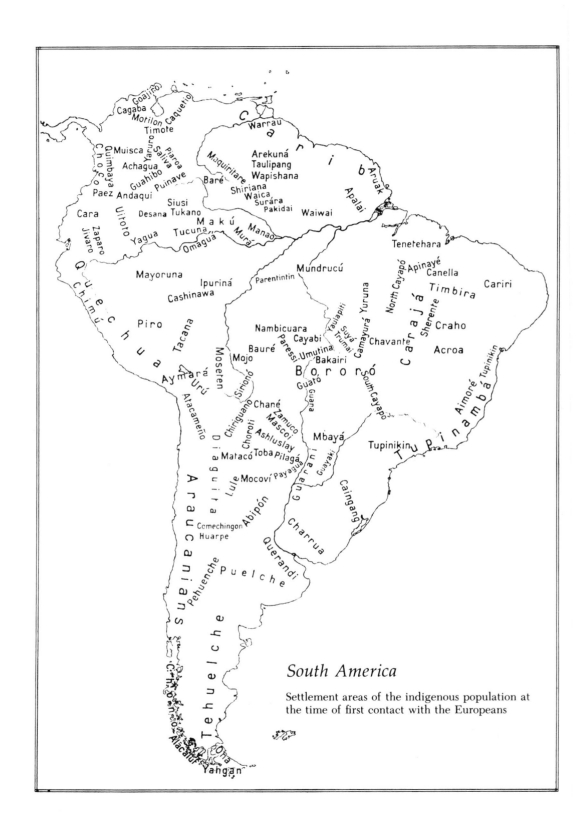

South America

Settlement areas of the indigenous population at
the time of first contact with the Europeans

It is speculated that the Arawaks settled most of the islands by A.D. 1000, following their migration out of South America over the course of about two centuries. After their settlement, they were apparently forced from the Lesser Antilles by the highly aggressive and cannibalistic Caribs. In the confrontation, it seems that Arawak women were spared, and they perpetuated their arts and language until all the Caribs spoke Arawak. The warlike nature of the Caribs is well known. They were still attacking the Greater Antilles when Columbus arrived, and they managed to retain their independence even from the technically superior Spaniards for two hundred years, while the submissive and peaceful Arawaks were entirely exterminated by disease, slavery, and mistreatment. In fact, the Caribbean is the setting of the most tragic moments of the European invasion and destruction of the native cultures in the Western Hemisphere.

South America

In the archaeology of South America two concepts have emerged which are of enormous significance in providing an overview of the cultural history of the Americas. Both theories are the result of work by Donald W. Lathrap, as well as by a number of Latin American scholars.

First, Lathrap has made it clear that early civilizations in western South America had their origins somewhere in the Amazon Basin, rather than in the Andes or on the Pacific coastal desert; there is very considerable evidence to support the Amazon origin thesis postulated by Lathrap (1970/1975).

Second, the Lathrap research basically reshapes the previous view that the cultures of the Americas were highly insular, self-contained, and self-perpetuating civilizations. "In summary," he writes (1975), "the spectacular pottery of the Ecuadorian Formative seems to have served as a source of inspiration for the developing ceramic traditions of Mesoamerica and Peru. This influence started in the second millennium B.C. and continued well into the first millennium B.C. Specific spectacular techniques of ceramics, such as iridescent painting, were borrowed from Ecuador. Complex vessel shapes, such as whistling bottles, stirrup bottles and multi-tiered vessels, appeared first in Ecuador and then slightly later in Mesoamerica or Peru."

These viewpoints will be more elaborately discussed when we deal with Native American iconography and with the history of the ceramic arts. In terms of this cultural overview, it suffices to realize that the Andean and Mesoamerican centers of power were *not* isolated and aesthetically self-contained. We must also revise the view that the Andean societies were "highly evolved" while the cultures of the Amazon Basin existed in an eternal cultural backwater. Contemporary research not only alters the chronology of South America, it also makes considerable shifts in the demography of cultural history.

The archaeology of South America is not only younger but also far less thorough and extensive than research in the United States and Mexico. Peru has been the subject of several decades of scattered and intensive excavation, but only now is a firm chronology finally emerg-

ing—based largely on the pioneering efforts of the Peruvian Indian archaeologist Julio C. Tello. In the 1960s and 1970s several teams conducted much-needed excavations and research in Venezuela, Colombia, and Ecuador—those nations whose lands connect with the Isthmus and therefore represent the bridge by which populations and cultures flowed between the Americas.

The most remarkable sculpture of this wide region comes from the southern central highlands of Colombia. In the archaeological zone known as San Agustín are remarkable dolmen-like tombs and temples, with large carvings of men and animals. It is currently agreed that these structures are quite early in date, from about 500 B.C. to perhaps A.D. 250. Some of these monuments depict tusked warriors with shields and animal-shaped helmets. These stone figures vary greatly in style and figuration, yet collectively they have a characteristic boldness and solidity of line and mass. The grimacing, fanged (tusked) megalithic stone figures have often been compared in style to the early Chavin sculpture of Peru, though a specific correlation between the sprawling San Agustín site and developments in Mesoamerica and Andean South America has not yet been established.

Little is known about the people of San Agustín, their origins, language, religion, or social customs. But significant investigation tends to indicate a "sequence of cultures which have been farming communities for a long period commencing around 3000 B.C. Areas expand or contract; changes of style mark the coming and passing of peoples without names for us. Many of the investigations made have been due to haphazard discoveries and the depredations of

Stone carving. San Agustín, Colombia.

tomb-robbers. Hence there is no clear archaeological continuity. But it is plain that in this terrain of the mountainous rain forests there has never been a unified imperial culture such as those of Peru and Mexico" (Burland, 1976).

The closest this region came to forming a dominion seems to have been the achievement of the Chibcha Indians of the grassy highlands of Colombia, in the area of Bogotá and Tunja. These people kept a "history," a verbal record of the exploits of four generations of high chiefs. That epic has survived and explains that the Chibcha originated on the high plateau around the sacred Lake Guatavita, where the waters of a great flood had driven their ancestors to higher and higher ground. The hero Bochica appeared and opened the walls of the crater lake so that the waters flowed away and the endangered Chibcha were saved. And so, ever after, each new chief was taken to the sacred lake to make an offering of gold to the spirits below First he was rolled in wet clay and then he was covered with gold dust. He leaped into the icy lake and the glistening dust turned into a cloud as it filtered into the depths. This is, of course, the source of the saga *El Dorado—the Man of Gold*, which enticed and perplexed the greedy Spanish conquistadores and subsequent treasure hunters.

The Chibcha are famous for the matt surfaces in their art, including the finish of their goldwork and pottery. The vessels of clay are among the finest anthropomorphic pottery. They include the depiction of chiefs and their wives in highly formalized shapes painted in white and black. The Chibcha were also skilled metallurgists and produced many flat figures of gold and copper alloy,

with rough surfaces and a gradation of color from coppery green to the pale yellow of gold. The Chibcha did not neglect textiles, though examples are extremely rare. There is, however, a sheet in the collection of the British Museum that is painted with typical Chibcha icons and a repeated pattern of images of the seated sun god, Bochica. The colors are muted: pale green, brown, and cream on white cloth.

To the west of the region dominated by the Chibcha peoples, there are two vast river valleys—the Cauca and the Magdalena, which join in the lowlands to form the Sinú River, which flows out into the Caribbean at the port of Barranquilla. These rivers of the wooded Andes were the homeland of several small tribes that were collectively responsible for producing the richest goldwork of the Americas. The cultures of the river valleys of Colombia, from north to south, include these major tribes: the Tairona, at the mouths of the rivers; the Quimbaya, in the midst of the region; the Calima in the southwestern district; and the Sinú in the southeast. There was apparently much trade and continual fighting among these river people. "The whole of the great river valleys," Burland writes (1976), "seems to have been always divided among many tribes, all at war with one another and all cannibals." Yet the beauty of their work is astonishing for its delicacy, imagination, and finish.

Most of the current information about Colombian pottery comes from the Colombian scholar Jesus Arango Cano (1976/1979). Two major ceramic styles have been identified: that produced by the Quimbaya and that created by the Calima peoples. There were also important ceramics associated with several other tribes: the Pijao (or Tolima), the already mentioned Chibcha (or Muisca), the Tairona, Sinú, Tamalameque, Racheria, Tumaco, Quillacinga, and Cauca. These ceramic traditions show striking dissimilarities from region to region. For instance, the Quimbaya were consummate naturalists, known for their anthropomorphic offering jars and their double-spouted stirrup bottles. The Calima, on the other hand, were the makers of remarkable "basket-carriers," as well as double-spout stirrup jars which were incised and painted with surrealist motifs of exceptional imagination and which show great finesse of execution. The Taironas were outstanding for their mythical iconography, worked in beautiful abstract motifs of stylized serpents and dragon-like creatures. The Tumaco excelled in the production of strange figures with deformed heads, similar in manner to Egyptian pieces of the earliest epochs. It is in the Tairona country that the settlement of Puerto Hormiga was discovered, with pottery antedating 3000 B.C. No continuity has been established, however, from that time to later endeavors.

It appears that the most refined period of Cauca and Quimbaya cultures occurred in the eleventh or twelfth centuries A.D. Both tribes had masterful goldworkers. "The great skills of the metal workers suggest that they were a separate social caste who had leisure to specialize in their technologies. Certainly the Quimbaya were artists of great ability who produced a kind of beauty which the Western mind can easily appreciate" (Burland, 1976). Though the goldwork of the Quimbaya and Sinu was particularly accomplished, all the craftspeople

Gold ornaments. Colombia.

of northwestern South America were master metallurgists, using numerous techniques: the lost-wax process, repoussé, welding, and others. Furthermore, platinum had been discovered in this region, a metal whose melting point is so tremendously high that modern Western technology mastered the art of using it only a century ago.

Along the Ecuadorian coast rainfall is seasonal, and the forest is less dense than in the north. Coastal Ecuador has long been the location of farming communities, which began producing ceramics in the beginning of the third century B.C. The first known center of these farming peoples is a small district in the middle of the Ecuadorian coastline, called Valdivia. The discovery of this ancient Valdivia ceramic complex (2500–1500 B.C.) originally created much excitement among scholars, due to reasonable claims that the "oldest ceramics in the Western Hemisphere" were somehow the result of Japanese influences (Jōmon ceramics from northern Japan of the same period appeared to be identical to researchers). The theory seemed valid insofar as there were no traces of a formative period leading up to the highly finished and refined Valdivia ceramics. But subsequently, far earlier indigenous pottery was located in the northern Andes.

The Valdivian complex was quite narrow geographically. The subsequent Machalilla phase (1500–1000 B.C.) was more expansive. It was noted for its stirrup-spout vessels, which probably appeared in Ecuador earlier than those that have been dated as relics of the first great Peruvian civilization, the Chavin—which was previously regarded as the "mother culture" of the Andes, much as the Olmec complex was long regarded as the

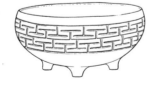

Valdivia red incised bowl with tetrapod supports.

"original" cultural source of most of the elements of Mesoamerican tradition.

The so-called Chorrera phase of Ecuadorian cultural history (1000–300 B.C.) was contemporary with Peruvian Chavin (as well as with Tlatilco culture in Mexico), and it produced exceptional effigy pottery in two and three colors, which may have eventually influenced Mesoamerican ceramic styles—especially in the introduction of whistling bottles, specifically, and double-spout stirrup vessels in general.* During the Chorrera, about 800 B.C., new waves of cultures began to appear. It was at this stage that goldwork made its first appearance in this region, at first in flat sheets and then in three-dimensional forms. Resist-dyed pottery was apparently also introduced by outside influences. By about 500 B.C. clusters of Ecuadorian cultures populated the Pacific coastal strip.

The Ecuadorian Bahía phase (c. 300 B.C.–A.D. 500) made its appearance along the central coast of Manabí Province, from La Plata Island to the Bay of Caráquez. Sites are remarkably large. A number of large platform mounds have been found at Manta, but most of these have been destroyed in the expansion of modern cities. Some are said to have been terraced pyramid platforms, faced with rough stones or clay and measuring as much as 175 by 50 meters at the base. There are both Chorrera and Machalilla elements in Bahía ceramics. One characteristic of Bahía decorative detail is an everted, cutout vessel rim. Bahía is also known for its roller stamps (a decorative stamp that is "walked" back and forth

*See Marcelo Villalba O., "La Botella de Asa de Estribo en el Contexto del Sitio Formativo de Cotocollac," 1979 (Museo del Banco Central, Quito, Ecuador).

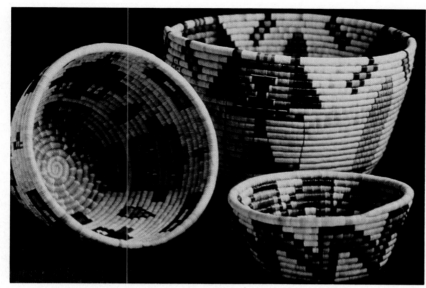

Hopi baskets, Arizona,
c. 1930.

Figure with trophy head,
embroidery, Paracas,
Necropolis, Peru, c. 1st
century B.C.

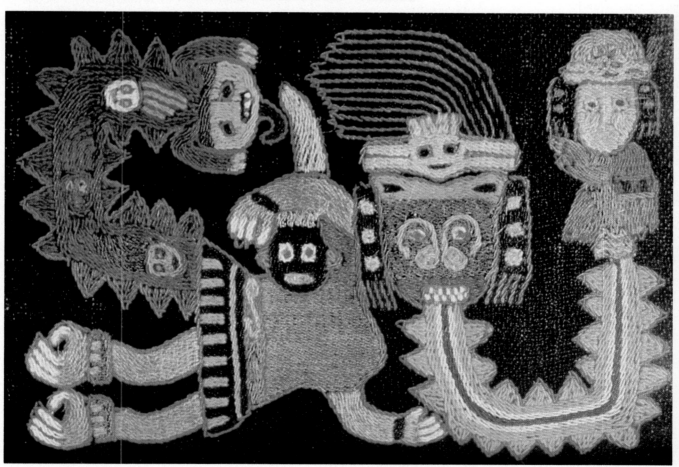

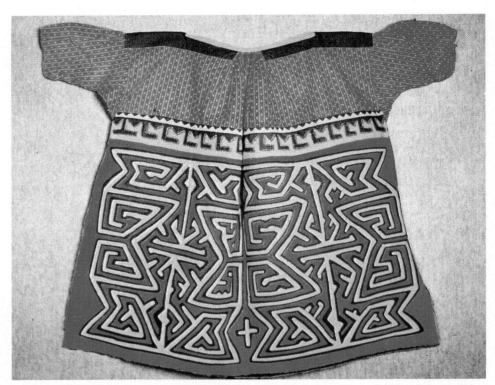

Cuna woman's appliqué
blouse, Panama, c. 1920.

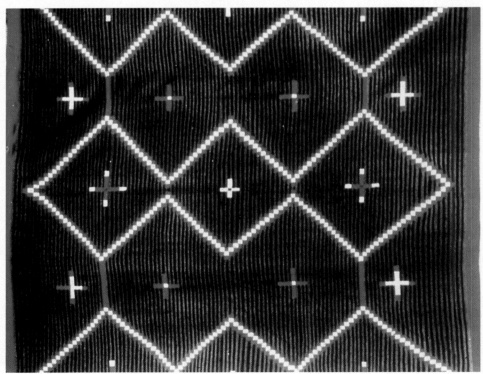

Navaho chief's blanket,
Arizona, c. 1900.

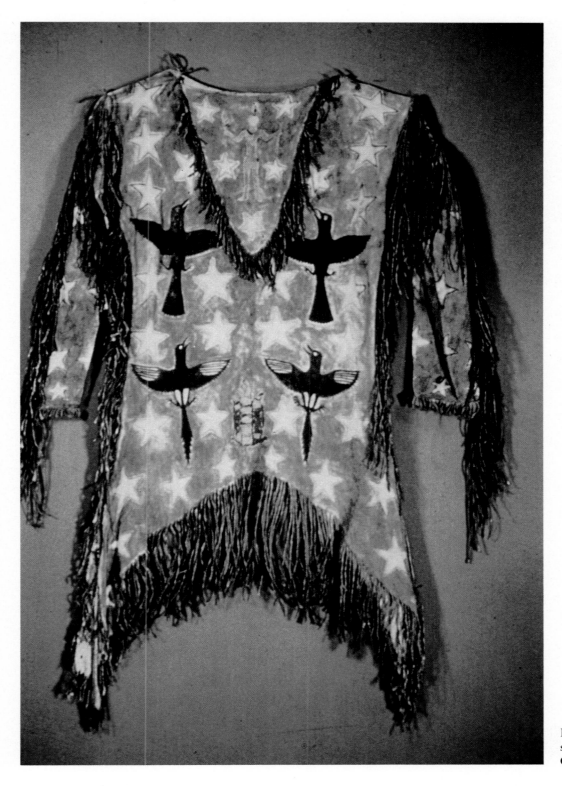

Pawnee Ghost Dance
shirt, buckskin,
Oklahoma, c. 1890.

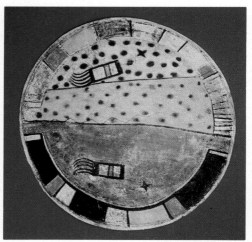

Arapaho shield, paint on
skin, Southern Plains,
c. 1880.

Seminole (?) beaded
shoulder pouch, Florida,
c. 1900.

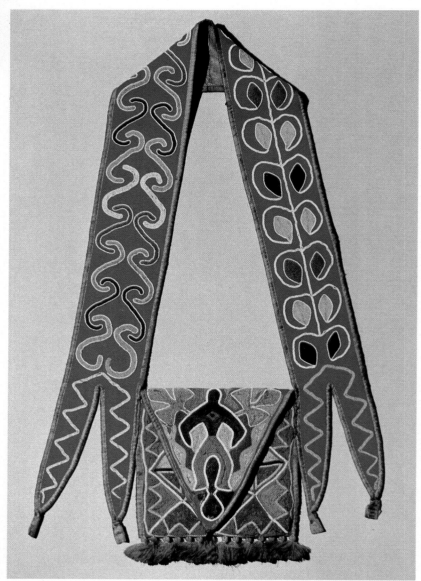

on unfired pottery, creating curved zig-zag incised lines). It is also known for its ceramic figurines and house models—a depiction of daily life and customs unprecedented in ceramic art, and a style which may have eventually provided the impetus for a similar form in Mesoamerica.

One of the most curious and artistically significant cultures related to the Bahía phase was that at the famous settlement at La Tolita—for years a site where looters found fabulous gold objects and figurines. Located on an island at the mouth of the Santiago River, it consisted (before its partial destruction) of forty mounds of earth and refuse. Many of its ceramic figurines seem related to Mexican styles, but it is now clear that the Ecuadorian examples predate (500 B.C.–A.D. 500) those produced in Mexico. "In this millennium after 500 B.C., there were some seven or eight differing cultures active in western Ecuador, all producing fine pottery, all using gold, all casting copper and various types of bronze. Basically they were all farming communities, but of their villages there are only a few earthen mounds to mark sites" (Burland, 1976).

Just as there was an abrupt change in cultural focus about 500 B.C., so too there was another change about A.D. 500. What caused these changes is not known; it was probably a matter of intertribal battles. But suddenly the variety of tribal styles gave way to great simplicity, and all but three cultural forms vanished in the west coastal region. The site of La Tolita declined, and in its place eventually arose the Mantano culture.

At this point the Scyri people of the Quito region became very strong and merged many tribes under their control. Though the Scyri were far inland and remote from the coastal tribes of Tolita, it is possible that their domination of the area around Quito may have brought down the coastal cultures. But we have no information to support such a theory. What we do know is that a new people of the south, dreaming of a World of the Four Quarters, believed that it was their destiny to unify the world. These people were the Inca. To subdue Quito and the rest of Ecuador was an explicit part of their plan. After the usual formalities, Huayna Capac, the great Incaic leader, came with his enormous armies. Ecuador lost its independence, and the people became vassals of the Inca Empire until the arrival of Pizarro.

The Cultures of the Southern Andes

Peruvian geography is unique. The coast is a rainless desert; the barren hills rise steeply from the arid shoreline, culminating in snow-capped summits of more than 20,000 feet. East of the Andes the land slants abruptly downward into the great humid Amazon Basin, where rain is almost constant. It was in Peru that a series of brilliant civilizations arose one after another, giving rise, eventually, to those famous imperialists—the Romans of the Americas—the people of the Inca Empire.

The first hunter-gatherers to reach the Andes appear to have come by way of the Isthmus of Panama at least 12,000 years ago, and probably, according to recent finds and datings, a great deal earlier. Their fragile traces indicate that they possessed only the crudest technology: they seem not to have brought very much cultural baggage with them—no

Pottery house model of the Jama-Coaque phase, about 8″ in height.

agriculture, and nothing but the rudest weapons and tools. They were clearly Paleo-Indians who migrated into South America long before agriculture and sophisticated tools were invented in Mesoamerica.

Along the arid coast are low, circular mounds dating from about 3750 B.C. The people of these mounds lived in permanent houses of stone or adobe, with roofs of poles and cane. They did not have pottery or textiles of cotton, but they did make cloth from coarse wild fibers. They also appear to have worn leather caps ornamented with pieces of shell. For nearly a century they subsisted simply on fish and whatever seeds and fruits they could gather. Then about 2800 B.C. a series of inventions or influences from other regions changed their lives. They had found out how to cultivate lima beans and other native plants of their region. Finally, about 1500 B.C., domesticated corn was either introduced from Mesoamerica or, perhaps, was cultivated independently in the Peruvian highlands. The lifestyle of these early coastal Peruvians became sedentary and secure, with a good subsistence coming from fishing and agriculture. It was the bare beginnings of a remarkable succession of highly refined civilizations which flourished in Peru.

The short-lived Inca Empire, which by A.D. 1500 had expanded to include the entire Northern, Central, and Southern Andean regions, was the climax of this long series of early civilizations, commencing about 1200 B.C. with the innovative Chavin culture.

These Peruvian cultures flourished in a land of abundance, where corn, quinoa, potatoes, manioc, beans, squash, chili peppers, peanuts, bottle gourds, cotton, tobacco, and the narcotic leaf known as *coca* were fundamental to the evolving Andean lifestyles. All of these plants were apparently domesticated or refined during the Chavin period. This vigorous culture had spread over a vast area, including northern and central Peru. The civilization is now called Chavin (though we do not know by what name it was known), after its most important center, at Chavin de Huantar on the high eastern slopes of the Andes. There, in a valley 10,200 feet above the sea, stands an immense stone building called the *Castillo*, which is constructed as a complex three-story-high network of small rooms and corridors, connected by stairways and ramps. In one of the galleries a stone figure still stands: a man-jaguar with fangs and downturned lips. Its image is curiously familiar, for a similar countenance is found among the deities of the Olmec people, of the Gulf of Mexico coast, who flourished as early as 1000 B.C. Many theories have attempted to deal with the connections between the Mesoamerican Olmec people and the Peruvian Chavin culture. There is clearly some sort of important connection between the two regions, but no one has been able to define that relationship. The most accepted theory is that many of the villages of Peru had thrived economically but had failed to produce a religious cosmology or a philosophical sense of their relationship to the world. Then the jaguar cult was introduced into the whole region and a religious unity apparently changed the lives of the isolated village people. The original source of this unifying religion is unknown. The resemblances to the Olmec iconography are obvious, and both the Olmec and Chavin religions appeared at about

the same time, roughly 1200 B.C.; both centered upon jaguar deities, and for both ceremonial centers were built, but there the similarities end. Except for a certain preoccupation with were-jaguars, the art forms and styles are vastly different. Older archaeologists tend to favor the notion that the Olmec people were the inventors of most of the elements which were fundamental to the masonry civilizations of the Americas, but there are young experts who are convinced that Peru was the cradle of American civilizations, claiming that the potent feline religious cult originated (along with architecture and ceramics and textiles) on the eastern slopes of the Andes, where the Amazon Basin has a thriving population of jaguars. Lathrap (1975) deserves repeating: "In summary, the spectacular pottery of the Ecuadorian Formative seems to have served as a source of inspiration for the developing ceramic traditions of Mesoamerica and Peru. This influence started in the second millennium B.C. and continued well into the first millennium B.C. . . . There was no comparable long tradition of ceramic experimentation in either Mexico or Peru."

Whatever the source of many of the cultural elements of the South American civilizations, certain essential Mesoamerican technological inventions did not find their way into the Andes, such as an elaborate calendar for keeping time, or a complex system of writing; these were intellectual achievements never realized in the central Andes, except for the knotted-string bookkeeping device called a *quipu*, and the remote possibility of some sort of ideographic use of designs on beans as a form of "writing," a theory that is highly controversial (see

Federico Kauffman Doig, *Manual de Arqueologia Peruana*, 1980).

Though the Chavin culture is no longer considered to have been singular or insular, it is still regarded as a seminal and unifying force in South American cultural history. Carved stone and shell objects, pottery of excellent skill, masonry architecture, and highly refined goldwork attest to a center of magnificent achievement during the heights of the Chavin period. The influence of these artistic technologies was extremely widespread, though we lack knowledge of the basis of the influence: whether it was political (which is doubtful), missionary in the religious sense (which is likely), or simply a matter of the diffusion of excellent skills by way of complex trade routes. In any event, Peru's period of unity, dominated by the Chavin example, ended about 500 B.C. This decline did not signal the beginning of a Dark Age; on the contrary, there were numerous separate cultures that emerged and flourished after the fall of the Chavin centers.

For example, burial grounds dating from 2,000 years ago have been found on the arid Paracas Peninsula in southern Peru. Producing textiles of brilliant skill and an excellent thin-walled pottery covered with incised designs and resin-base color, the Paracas population was among South America's most aesthetically refined peoples.

Over the centuries the Paracas culture merged with—or was superseded by—the Nazca culture, centered in the Ica and Nazca valleys about one hundred miles south of the Paracas Peninsula.

An outstanding feature of the Nazca culture is the "Lines," which are so massive that they are visible only from the

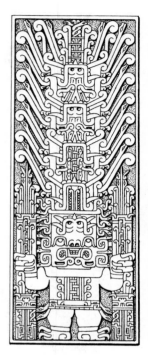

Raimondi monolith. Chavin culture, Peru.

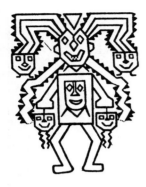

Paracas textile motif. Peru.

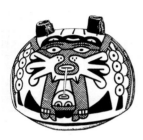

Nazca pottery. Peru.

air. These Lines are situated on the desert plain between the cities of Palpa and Nazca. The designs are astonishingly varied: there are at least eighteen kinds of birds alone, and about twelve other animal forms—monkey, spider, whale, dog, and others. There are, however, no human or humanoid forms on the plain itself; the only human figures appear on the slopes of the hills. In addition, there are more than one hundred complex geometric designs, consisting of straight lines, parallels, triangles, trapezoids—all executed with the utmost precision. The dimensions of these designs are varied—the straight lines, for instance, measure from about a mile to as much as three miles in length. The monkey figure is about 25 feet long, while the spider is about 10 feet long. There is one bird with extended wings measuring about 40 feet across! The desert plain of Nazca is not sandy, for the surface is composed of iron oxide of a light brown color. If this topsoil is removed, one finds a yellowish subsoil. It is this contrast between the color of the surface and that of the subsoil that enables the designs to be seen. The survival of the Lines some thousand years after they were made has been made possible not only by the solidity of the terrain but also by the fact that rain is very rare in the vicinity. The designs were apparently made by the Paracas/Nazca peoples who inhabited the valley between 300 B.C. and A.D. 900. The Lines appear to be based on astronomical calculations, but their exact purpose is not known. They were, however, clearly intended to be "invisible" art—not made to be seen—since there are no local heights which afford a view of the Lines.

The Nazca perpetuated the uncommon textile tradition of the Paracas, adding many inventions of their own but never quite equaling the marvelous embroideries of the Paracas mummies, discovered amazingly intact among the desert cemeteries. Where the Nazca did rise above the Paracas example was in the field of ceramics. They produced exquisite, polished pottery with as many as ten or eleven colors decorating a single vessel. A common motif is a cat face, often depicted with flared whiskers. And though the iconographic style is quite free and flamboyant, there is nonetheless a certain reminiscence in the Nazca "cats" of the Chavin jaguar deity.

Thus a central thrust in both the Paracas and Nazca cultures was an influence from the Chavin style. That same impact may also be noted in the material culture of yet another important Peruvian people, the Moche—commonly called Mochica. Living about five hundred miles north of the Nazca centers and contemporaneous with them, the Moche (whose name is derived from the Moche River near the present-day city of Trujillo) were an aggressive and pragmatic people—not unlike the stereotype of the citizens of the United States. They produced a grand but also highly realistic and earthly form of genre art unparalleled in the Americas. Between 250 B.C. and A.D. 750, they elaborated on a naturalistic pottery style that produced some of the best sculpture in the history of world ceramics. Admired, perhaps excessively, for its naturalism and humanism (as if these were universally admirable and singular characteristics), the Moche pottery is our major source of ethnographic data about the daily lives of pre-Columbian Peruvian people, detailed and frank in its depiction of hu-

man relations, houses, animals, vegetables, and even pathological deformities.

There were two basic forms of Moche pottery: effigy vessels portraying persons, objects, and animals with realistic detail; and painted vessels with less naturalistic and more stylized iconography—delicately drawn figures of commoners and chiefs, warriors and hunting parties, musicians and children, racing across the smooth surfaces of the pots.

The Moche people were also accomplished architects. Near the Moche River are two vast ceremonial pyramids, now called, for no apparent reason, the Temple of the Sun and the Temple of the Moon; constructed of adobe bricks, they tower sixty feet high.

These two peoples—the Nazca and the Moche—flourished on their arid coastline until about A.D. 600, when developments in the high Andes heralded a drastic change in the ethnography of Peru. At Tiahuanaco, twelve miles south of Lake Titicaca on the borders of Peru and Bolivia, a vast ceremonial center was taking shape, and its dominancy and power were awesome. Its importance is presumably based upon the rise of a new deity. The impact of this new religious cult was the first reoccurrence of a unifying sect since the demise of the jaguar god of Chavin times. The name of this new deity will never be known, but his image is familiar—carved upon a monolithic temple gateway at Tiahuanaco. His prevalent attributes—a puma head and tears—and the rigid Tiahuanaco style are elements of a new religious imperialism, found as far north as Ecuador and deep within Bolivia and Chile. The main centers of Tiahuanaco were built as early as A.D. 300, and by A.D. 600 the culture had expanded wide-

ly to the north, where a colony was established at the site of Wari (Huari)—giving rise, for several decades, to the inclination to treat Wari and Tiahuanaco cultures as a single entity, a viewpoint much revised in recent times. It is probable that the Tiahuanacans were not a single people, but a group of Aymara Indians who enlarged upon a vital new cosmology, and then built the structures near Lake Titicaca, which are now enormous ruins, long abandoned and plundered for building materials by successive inhabitants of the region. At Wari, near present-day Ayacucho in Peru, a larger and more self-sufficient population grew into a vast city-center which extended its domination northward. Between A.D. 600 and 1000 the convergence of Wari and Tiahuanaco styles became so widespread as to assume a pan-Peruvian character, temporarily eclipsing the impressive influences of such people as the Nazca and Moche. There is in this Wari-Tiahuanaco style a strong geometric, rigid influence from the Chavin prototype: the low-relief stone carving, tapestry textiles, and painted pottery all reflect the linear, hard-edge manner of an iconography

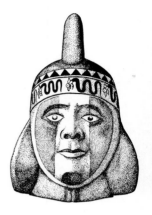

Moche pottery. Peru.

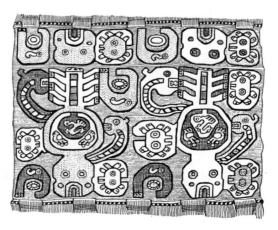

Wari textile. Peru.

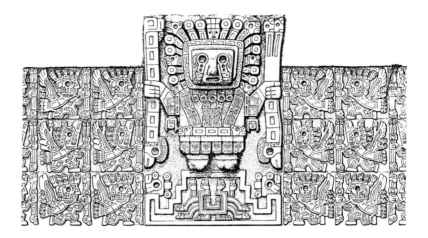

Central figure in the Gateway of the Sun. Tiahuanaco, Bolivia.

derived from the mechanical necessities of textile making.

Eventually the Nazca culture was obliterated by the influences of the Wari-Tiahuanaco dominancy. The war-like Moche in the north sank under the impact of the new Tiahuanacoan "weeping god," and reemerged as the Chimu Kingdom. These restyled and resurrected Moche/Chimu people established one of the vast urban centers of ancient Peru at their splendid capital, Chan Chan, from A.D. 1000 to 1500. According to Chimu folk history, the lands of the Moche were invaded by strangers who came from the sea on large balsa rafts, sailing from the north. These were the followers of Taycanamo, the hero of the Chimu people. With the help of Taycanamo, the Chimu survived. They tended to make use of the old adobe pyramids of the Moche as temples, building few additions. On the other hand, they did create an enormous terraced fortress in the Fortaleza valley, and the capital city of Chan Chan is a remarkable group of structures, built of adobe brick or cast in great slabs of adobe molded with patterns of birds and

creatures, deities and rainbows—very much in the manner of the iconography of local textiles. The walls were plastered and painted with bright friezes in relief. These cities must have been exceptionally handsome in their time.

Eventually the Chimu Kingdom was overwhelmed by the militaristic expansion of the Inca Empire. The Chimu king—called Chimu Capac by the Inca—was taken to Cuzco, where he retained full honors in exchange for the capitulation of his kingdom.

The Ica civilization, A.D. 1000–1500, appears to have been an extension of Nazca influences. In textile arts the Icas were equal to the Nazca tradition, and their pottery was also very fine, if not quite as brilliant in color and design as the Nazca examples. The Ica were probably a smaller group than the Nazca, and they did not have the population nor the material culture to support a wide-ranging socioeconomic domain such as that produced and exploited by the Nazca. Although the Ica Valley was an important source of cultural influences, especially in ceramics, most of the population was distributed in small vil-

lages scattered throughout the valley. The best-known site, Ica Vieja, in the Tacaraca region and about three miles south of the modern city of Ica, consists of a complex of structures built on mounds. This site was occupied until the Incaic conquest, when it probably served as the regional administrative center of the Incaic overlords.

If the Ica lived to witness the invasion by the warriors of the Inca Empire, the people of Tiahuanaco did not survive to see that event. No one knows for certain when Tiahuanaco declined or why, but it is estimated that the culture vanished about A.D. 1000, though the religious cult at the center of Tiahuanaco religion may have survived in isolated communities until a far later date.

The empire of the Tiahuanacans, however, was the first to include nearly all of geographical Peru. The dominancy of this vast religious domain was not equaled until the Inca Empire extended its power far beyond the borders of the Tiahuanaco sphere of influence.

Commencing about the time of the fall of Tiahuanaco (A.D. 1000) and thriving until the arrival of the Spaniards in the sixteenth century were the Chancay people of central Peru, whose culture has only recently been the topic of extensive research and excavation. The sites of Mango Marca, Lurigancho, Huaycan, Armatambo, and Caraponga belong to this period, although the majority of these centers managed to persist without significant interruption even during Incaic times.

The culminating highland civilization of South America was, of course, that of the Inca. Its power, however, was far more extensive in geographical terms than it was in temporal terms, for it en-

dured for even a shorter period than the Aztec domain of Mexico.

One of the most effective unifying elements employed by the most brilliant of the Incaic rulers—Pachacuti—was the official extension of Quechua—the language of Cuzco and eventually the lingua franca of the Inca Empire. Another diplomatic policy of tribal integration was brought about by a stern practice called *mitima*—the exchange of populations between various regions; discontented groups were moved to places where they would be assimilated by different tribes, while they were replaced in their original locality by loyal subjects.

The Incaic achievements are remarkable for their daring and political power—less for their artistic and intellectual merits. Developing out of the region of Cuzco, where they started building their great empire in 1438, their imperialism was perfectly sustained by a highly centralized bureaucracy and by a socioeconomic system aptly praised for its social services, prompting historians to call it "pure communism." But by 1532, when Pizarro prepared for his brutal invasion, the empire was in a state of civil war—two Incaic brothers were struggling for the throne that their dead father had left vacant. The horrendous defiling of the Incaic world is a well-known and much-documented legend of greed and cruelty. The living Quechua-speaking Indians of highland Peru are the sole heirs of the lost Incaic civilization. But little remains of their ancient heritage.

Incaic gold figure, made by the lost-wax technique. Peru.

The Southern Regions

There is evidence of people living in caves in Tierra del Fuego, off the south-

Brazil

Chile

Argentina

Pottery from South America.

ern tip of South America, by about 8000 B.C. These hunters of giant ground sloths were among the first peoples of the far south of the Indian Americas. In the thousands of years that followed, several distinctive civilizations arose among the Diaguita, Calchaquí, and Atacameño Indians of what is present-day Chile and Argentina. Out of this complex of peoples came several unique forms of pottery and stone and textile arts. Gold was never a major product of this region, though copper became one of the most important metals to be worked in the south. Through elaborate casting methods, gongs, embossed shields, plaques, and other copper objects were made with great skill and considerable aesthetic imagination. Little is known today about the Indians of Chile and Argentina, where the Native populations have been exterminated. The emergence of Indian societies began about 500 B.C., and the civilizations endured until the conquest by expansionist, Incaic warriors in the middle of the fifteenth century (about one hundred years before the arrival of the Spaniards).

Indians Today

Only in the last three or four decades have there been any valiant efforts to save Indian tradition in the Americas or to recognize Indian art as a valuable treasure of the American heritage. The most important efforts to preserve Indian art and to recognize its importance have taken place in Europe and in the United States, where Indians have retained a great deal of racial pride and non-Indian collectors and scholars have been very active in creating a wide pub-

lic awareness of the great value and cultural significance of pre-Columbian history and art.

In Latin America there has been a very slow and belated effort in that direction, and most of the focus has been on political rather than cultural issues. The fact that Indians represent a majority in many Hispanic nations tends to produce a great deal of caution among non-Indians, who fear revolution or the upsetting of the balance of power which has given political and economic power to the white minority. "For this reason," as Frederick Dockstader has pointed out, "Indianism and Indian art are sensitive issues in most of the Latin American countries." Peru, Bolivia, and Ecuador have put the greatest cultural emphasis upon Indian sensibility, as does Guatemala in Central America, while the balance of the Hispanic and Portuguese nations have varying degrees of Indian cultural concern. Mexico has probably been more successful than any other Hispanic nation in integrating Indian arts into the main currents of its society.

The triumph of contemporary North American Indians in perpetuating their culture has a great deal of historical basis: though the northern tribes lost many wars, they never lost their sense of racial identity and dignity. On the other hand, through several centuries of crushing defeats and servitude to the Spaniards, the Hispanic Indians, as Edmund S. Urbanski has pointed out, "have adopted an attitude of humility and resignation. Although the condition of the North American Indians leaves much to be desired, it seems less tragic than that of the Indians of Hispanic America, who live on the edge of the economy."

According to anthropologists, the esti-

mated number of Indians on the two American continents is about twenty-five to thirty million. There are only about one million now living in the United States and Canada, while approximately three million live in the Central American nations, and about nine to ten million Indians live in the mountains and jungles of the Andean countries of Bolivia and Peru. The rest of South America contains about another million Indians, including the Indians of Brazil, Paraguay, Chile, Argentina, and Uruguay. About ten million Indians live in Mexico.

The point to be made here is that a large majority of Indians live in Central and South America, and yet the Native peoples living in North America "have a real impact on their destinies and a strong sense of racial purpose [often] entirely lacking in contemporary Hispanic Indians" (Urbanski).

The traveler in South America soon realizes that despite all the touristical pride in Indian heritage which bombards visitors, the Indians themselves are curiously, perhaps tragically, silent. The excellent and urbane museums devoted to Indian arts and cultures essentially treat Indians as "fossils" of the past and not as extant people with a continuing culture. Furthermore, the ethnological organizations and museums are run almost entirely by non-Indians (despite the ground-breaking achievements of the Indian anthropologist Julio Tello), and even those Hispanic scholars with genuine admiration for Indian culture admit that Indians have little or no input into the ever-increasing projects aimed at sustaining Indian culture in South America.

The Indians who live in the major cit-

ies, such as Lima and Bogotá, are wretched and entirely demoralized. The only places in the northwest coastal nations of Latin America where the traveler might gain a significant glimpse of Indian lifestyles are those like Pisac, Cuzco, Otavalo, Lake Titicaca, and the wide, rugged countryside around these strongholds of a silent Native culture.

What is most strikingly tragic about Hispanic America is the number of tribes which have vanished. Some of these peoples simply disappeared in the endless cycles of history, long before the coming of Europeans, while others have been methodically exterminated by missionaries, by militarists, and, of course, by disease. Yet, despite this American holocaust, there is still a viable Indian culture in South America.

Indians of Colombia: The Guambino and Páez peoples, located in the Department of Cauca, are the major surviving Andean Indian tribes of Colombia. A number of groups, such as the Pijao, fought the invading Spaniards in 1538 until extinction, while many other Indian groups were entirely assimilated through intermarriage. The Páez and Guambino have probably managed to survive as distinctive Native peoples simply because they retreated into a remote region of the most rugged mountains, where the Spaniards could not easily pursue them. Even today these tribes are hopelessly trying to defend their few remaining lands against the encroachment of whites and mestizos.

It is possible to encounter members of the Guambino and Páez tribes at the markets held in Inzá, Silvia, San Andrés, and Belalcázar. They speak dialects of the ancient Chibcha language as well as

Spanish, and they dress traditionally: for men, a cotton shirt, woolen trousers, a white poncho worn under a second, dark-colored poncho; for women, a woolen skirt, cotton blouse, and manta—a shawl woven of wool—and a felt hat.

The Cuna (or Kuna) Indians also live in Colombia, in the far northern region, near the Panama border. They are famous for their *molas*—the reverse-appliqué panels produced for their blouses which depict mythic beings or even contemporary phenomena in brilliant colors and unique semi-abstract designs. These Indians live both in Panama and Colombia, but their stronghold is on the San Blas Islands.

Indians of Ecuador: If indigenous culture is relatively limited in contemporary Colombia, Native activity in Ecuador is both widespread and impressive. The famous Otavalo Indians have been especially tenacious about their customs and are renowned as expert weavers. Their resistance to invaders has a long history. In 1455 the Inca army moved north from Peru and conquered all of the Ecuadorian tribes, one by one, yet it took seventeen years of ruthless military activity to subdue the Otavalo Indians. There is a lake in their region called Yaguar Cocha—"Bloody Lake"—named in honor of the hundreds of mutilated Otavalo warriors thrown into the water by the Incaic victors during their long siege.

Another defeat of the Otavalo people occurred when the Spaniards invaded their lands. It is an almost inconceivable fact of South American economics that until 1964 serfdom was legal in Ecuador, when, finally, an agrarian-reform law did away with the practice of *huasi-pungo*—serfs living and working on large haciendas, receiving small plots of land in return for unpaid labor on the landowner's massive properties. The Otavalo Indians have survived centuries of abuse, and have emerged as a people of marvelous traditions and enduring personal beauty.

The Salasaca Indians originally lived in Bolivia, but in the fifteenth century the Inca had them transported to Ecuador as *mitimaes*—"laborers/colonists." Today about two thousand Salasaca Indians, speaking the once-official Incaic language, Quechua, as well as Spanish, still live in Ecuador. For generations they fought the steady encroachment of the white man. In fact, they were known as *los bravos*—"the hostile ones"—for many years, so determined was their fight for freedom. Finally, in 1947, missionaries succeeded in establishing schools and churches among the Salasacas. But the tenacity of these proud people has not faded. Even today, should anyone marry into the tribe, he or she must learn the Quechua language and adopt traditional Salasaca dress.

Several diffused groups of Indians living in Ecuador are now called by the collective name "Chimborazo." They attend the markets of towns such as Ambato and Riobamba, and they live in the surrounding villages. Today the Riobamba region is a major Indian crafts center, and the Riobamba and Ambato market days are by far the largest and most elaborate in Ecuador.

While none of the Indian tribes we have discussed have an easy life, the Otavalo people are in many ways the most happy, the most economically secure, and therefore the most pleasant to visit. They are "businesspeople," to the

extent that they welcome travelers, proudly display their crafts, and insistently retain their traditional dress, language, and customs—knowing full well that it is their elegance and beauty as Indians that attract tourists and give momentum to their ancient heritage. The Otavalo terrain itself is impressive: the great mountain Taita Imbabura is located just east of the town of Otavalo, and the snow-capped volcano Cotacachi is seen in the west. The highly enterprising Otavalanos have prospered and managed to buy back much of their lovely lands in the river valley. The craftspeople actively sell their excellent weavings in virtually every marketplace of Ecuador. Some of them also travel to New York City and Europe, with vast shipments of textiles which they sell wholesale to elegant shops.

The Otavalo market day is famous. It was renowned long before the arrival of the Spaniards, let alone twentieth-century tourists. For that matter, it was a meeting place long before the conquest of the region by the Inca's mighty warriors. The Amazonian Indians came to market for generations with cotton, monkeys, parrots, and precious dyes, which they bartered for dogs, salt, and woven cotton blankets. Today the world-famous Otavalo market is a bit touristy, but it provides an impressive and rare opportunity to see the ancient world of Otavalo Indians and their stupendously fine crafts, without intruding upon their villages and homes.

The market starts at dawn, and it is an extremely colorful and busy place of selling, eating, talking, and music making. The dress is authentic, the crafts are excellent and relatively inexpensive, the people are exceptionally friendly, and

there is in the atmosphere a happy air of pride and dignity and welcome to strangers.

The nearby Otavalo Anthropological Institute offers a good collection of local folk materials and is housed in an elegant colonial building. Unquestionably, Ecuador has much to show of its contemporary Indian traditions.

Indians of Peru: The present-day Peruvian Quechua Indians, as they are collectively called, are a conglomeration of many different peoples, including descendants of Incaic tribes who were presumably the original Quechua-speaking group. The most fascinating of the Peruvian tribes, in terms of a visible tradition retaining significant ties to the past, are the Aymara, who live in the vicinity of Lake Titicaca in the Department of Puno (on the Bolivian border). Their ancestors were called the Colla Indians— the original inhabitants of this land. Long before the coming of the Inca, they plied the icy waters of the lake in their totora-reed boats, in the most rarefied atmosphere of the high Andes.

The Rediscovery of Indian America

The tribal ancestors of the Americas haunt the Western psyche—in an intricate and probably inexplicable tradition of guilt and fascination, based upon the horrendous sacrifice of innocents to the cause of Western dominancy and the equally terrible sacrifice of a forgotten Eden which lurks behind every penitence in Western philosophy and religion.

The history and culture of the Ameri-

cas has been regarded as both a fascinating and a mundane subject, and the quest for America's shadowy origins has been the source of great moments of research and enthusiasm alternating with equally great indifference and disinterest.

In Mexico some of the most important information about the final, desperate moment of native civilizations came from the Europeans who played a large role in the destruction of Indian cultures. Hernando Cortes and his captain, Bernal Díaz del Castillo, left vivid, if ethnocentric, eyewitness accounts of the Aztec capital city Tenochtitlán before they defiled and destroyed it in 1521. The Franciscan friar Diego de Landa produced a major manuscript about sixteenth-century Maya life in Yucatán, and then burned hundreds of irreplaceable hieroglyph "books" which were the histories of the grandest of American civilizations. Another Franciscan, Bernardino de Sahagún, went to great lengths to learn the Aztec language, Nahuatl, so he could converse directly with eyewitnesses of the destruction of Mexico. Sahagun's record of history and customs, known as the *Florentine Codex*, is one of the earliest and most remarkable achievements in American ethnography.

As we know, the Spaniards were not concerned with the ancient history of the Americas, nor with their brilliant cultures. Most of the art was destroyed as heretical, and all of the exquisite gold objects were melted down into ingots and sent to Charles I of Spain, who was always in great need of funds.

It was not until 1799 that a scholarly interest in Native American culture seriously took hold—namely, in the person of Alexander von Humboldt, who in that year commenced his five-year expedition through the Americas, which resulted in thirty volumes on the Western Hemisphere. Humboldt was one of the first Europeans to take a scholarly interest in Indian architecture; he tried to distinguish between the architectual styles of various periods and various regions, making drawings of monuments and collecting an enormous amount of data. He also collected folk history.

Another early traveler and explorer was Captain Guillaume Dupaix, a retired officer of the Mexican dragoons, commissioned by Charles IV to survey the antiquities of the region. Between 1805 and 1807, Dupaix and his expedition made drawings of various highlands sites, such as Oxchicalco and the Zapotec centers in Oaxaca, before moving on to the still-unnamed Maya region, where studies of the ruins of Palenque were briefly undertaken.

The writings and reports of Humboldt and Dupaix were of very limited interest. The popularization of American archaeology was largely left to the whims of wealthy gentleman travelers, like Sir Edward Tylor and Henry Christy. These two men journeyed throughout Mexico in the 1850s, and Christy purchased numerous archaeological and ethnographical specimens. When he died in 1865, his collection was given to the British Museum—a total of 1,085 pieces, including three turquoise mosaic objects from Mexico which are now among the museum's most valuable holdings.

One of the first scholarly explorers was Eduard Seler of the Berlin Ethnographical Museum, who, in 1887, undertook a series of travels throughout Mexico. His pioneering studies of Native religion, rituals, and arts were the most influential and important of their day.

Very little was known about the Central American region until 1787, when Captain Antonio del Rio was sent by the home government to explore the ruins of Palenque. His report appeared in London in 1822, with seventeen highly inaccurate engravings by Frederic Waldeck. These documents finally aroused strong public interest in the "lost civilizations" of the Americas.

The great Maya ceremonial center of Copán had lain forgotten for centuries until the arrival of Juan Galindo in 1834, with a commission to survey the ruins on behalf of the Guatemalan government (Copán is now located in Honduras, just over the Guatemalan border). Galindo's reports awakened in an American lawyer and traveler named John Lloyd Stephens a profoundly romantic desire to explore the mysterious lost worlds of Central America. With British architect Frederick Catherwood, young Stephens made two remarkable trips in 1839 and 1842, traveling throughout the heart of the Maya realm.* Unquestionably, Stephens's fame rests upon his popularization of American archaeology. His writings, along with Catherwood's exceptionally accurate engravings, became international bestsellers. But the most important aspect of Stephens's influence upon successive generations of Americanists was his unprecedented insistence that Central American monuments and architecture were indigenous art forms and not ethnographic curiosities or the unexplainable creations of Phoenicians or Egyptians who had colonized America and then vanished.

It should be remembered that virtual-

Uxmal. Lithograph by Frederick Catherwood, 1840.

ly all the prior explorers and chroniclers of the Americas had only the slightest aesthetic insight into what they discovered. Cortes and Bernal Díaz, Pizarro and all the other conquistadores couldn't have had an inkling of the stupendous artistic value of the unexpected worlds they stumbled upon in the Western Hemisphere. And as for the padres and friars, the very existence of a red race, totally outside the repertory of the Bible, was sufficient cause for their studious and often inartistic examination of the social organizations and religious convictions of cultures they were commissioned to destroy. Alexander von Humboldt was a geographer, a botanist, a zoologist, a meteorologist, a geologist, and even an ethnographer—but he was not an art historian or a philosopher of history.

*See Jamake Highwater's nonfiction novel, *Journey to the Sky*, 1978, a recounting of the explorations of Stephens and Catherwood of the Maya region.

Dupaix and Antonio del Rio and Juan Galindo were military men whose responsibility was to clear the massive jungle and make a survey of the rubble and ruins that lay hidden beneath it. The very most they contributed to the history of the Americas was the perpetuation of a great many semi-educated notions about mariners from Egypt and Greece who had created remarkable structures which they then, unexplainably, abandoned to the jungle. And the self-styled "Count" de Waldeck added to these wrong-minded tales of pre-Columbian America his own fanciful and Egyptianesque engravings of the ruins. In this way, until about 1845, both the public and scholarly view of ancient Central America was fanciful or exploitative, with no concept whatever of the aesthetic merit or of the cultural complexities and refinement of the civilizations—past and present—of the region. Nor was there any grasp of the elaborate history of successive societies which preceded and, in many ways, exceeded in achievement the empires that the Spaniards found and destroyed when they landed in the Western Hemisphere.

Of course, there were exceptions in this long history of pragmatic explorers and surveyors. Entrepreneurs such as William Bullock constructed massive exhibitions in the heart of fashionable London, where he displayed in 1812 "a panoramic view of Specimens of the Natural History of New Spain, Maps and Pictures, Models of the Colossal and Enormous Idols, the Great Calendar and Sacrificial Stones, Pyramids, and other Existing Remains—the whole forming a Rationally Instructive and Interesting Exhibition which is now open for Public Inspection" (from the catalogue for the gallery, 1812).

Of far more significant character are the famous observations of the great artist Albrecht Dürer, who saw the exhibition of the cargo of the first treasure ship from Mexico, which arrived in Seville on December 9, 1519. Charles I of Spain was so intrigued by the trove that he put it on exhibit in Ghent, his birthplace, as well as in Brussels, where Dürer was among the spectators. "I have seen the things which were brought to the King from the new *golden land* . . . a sun entirely of gold, a whole fathom broad; likewise a moon entirely of silver, equally large . . . also two chambers full of all sorts of weapons, armor and other wondrous arms, all of which is fairer to see than marvels. . . . I saw among them amazing artistic objects. . . . I have been astonished at the subtle *ingenia* of these people in these distant lands. Indeed, I cannot say enough about the things which were before me. . . ."

John Lloyd Stephens not only marveled at the mystifying ruins he rediscovered in the jungles, but he also brought with him the experience of a world traveler who had visited Egypt, Arabia, Italy, and Greece. He insisted that the monuments were a true Indian art, produced by the ancestors of the Native people he found living in the villages surrounding the ruins. Catherwood's painstaking and artistic engravings were forceful graphic proof of Stephens's convictions about Native art and architecture.

Successors to the explorations of Stephens and Catherwood were the Frenchman Désiré Charnay and the Englishman Alfred Percival Maudslay.

Charnay traveled with a huge, primitive camera in the era when photography was just emerging as a research tool, and he produced some of the first photographs of the region. He also pioneered in the use of papier-mâché for producing molds of relief sculpture. Maudslay became one of the first researchers to produce extensive castings of the great Maya sculptures, plans of ceremonial centers, and photographs. The inscriptions he carefully collected during his explorations were the basis for the first serious attempts to decipher Maya glyphs.

These stumbling efforts to grasp the significance of the American ruins were the achievements of a generation of amateur archaeologists. As modern communications made the remote sites of ancient America accessible to many Europeans and North Americans, the days of the Stephenses and the Maudslays were ending, and the era of the big scholarly expeditions and large-scale academic excavations was beginning.

In South America the rediscovery of Native American art and culture showed the same trend as it did in Mesoamerica. The initial research was provoked largely by the attraction of "oddities of the New World." As a result of travels in the 1540s, Cieza de León contributed several manuscripts describing sites and legends, and, finally, the first Anglo history of the Inca Empire. His work is still a valuable historical resource, but his insights were strictly nonaesthetic.

Meanwhile, in ancient Peru looters were destroying pyramids, tombs, and cemeteries at a terrible rate. The massive pyramid near Chan Chan, Huaca del Sol, was the target of looters in the 1570s, who diverted the Moche River into the mound in order to expose the "treasure" at its center, thus destroying about two thirds of the main structure.

The first systematic archaeological records were made by Father Louis de Femille, a French priest, and the Peruvian scholar Baltasar Jaime Martinez Companon, who was Bishop of Trujillo in northern Peru from 1779 to 1791. But, again, the focus of research was scientific and not artistic. There was not the slightest general awareness at this point in time of the purely cultural magnificence of the Indian Americas.

The first half of the nineteenth century saw a strong surge of interest in the ancient civilizations of the Andes. The first indigenous research was undertaken by a Peruvian, Francisco Barreda, who wrote extensively on graves and temples in 1827. But foreign writers still dominated Indianist literature. The American historian William H. Prescott and the British sailor Sir Clements Markham produced bestsellers with their accounts of the Incas and Aztecs; Markham applied himself to the publication of accurate translations of the documentary records of early Spanish accounts of the invasion of Peru.

Another breakthrough came with the exacting research of Ephraim George Squier, who had made archaeological surveys in the United States and Mexico before he commenced work in Peru in 1864. As a result of his wide-ranging research and fieldwork in the Andes, Squier became the first scholar to attempt to arrange the various Andean cultures into a historical sequence. Two other exceptional observers, Adolph Bandelier and Max Uhle, made equally

important contributions to American archaeology. Bandelier went to Peru in 1892 for the American Museum of Natural History and did work in the Titicaca basin (near the Bolivian border), while the German, Max Uhle, worked mainly along the arid Peruvian coastal strip and in such highland valleys as Tiahuanaco. It was Uhle who formulated the first Andean chronology, which still has application today.

Finally, in 1909, an American explorer, Hiram Bingham, made the difficult journey down the Urubamba river and rediscovered the spectacular ruins of Machu Picchu, an Incaic sanctuary perched on a ridge high above the Urubamba gorge.

Of all these explorers and scholars, unquestionably the most important from our cultural viewpoint is Julio Tello. A Peruvian mestizo with a deep regard for his Indian heritage, Tello was greatly influenced by both Bandelier and Uhle. He studied archaeology at Harvard University and then returned to Peru to undertake the most wide-ranging cultural research attempted until that time. During the 1920s he formulated the currently accepted chronology of Andean history; moreover, his insight into the material culture of Indians was unique in its sense of artistic value and the appreciation of aesthetic techniques and media. It is with very good reason that Julio Tello is highly revered as the pioneer of an Indianist aesthetic.

In North America there had been, from the beginning of European settlement, a strong interest in the social and cultural forms of Indian tribes. One of the earliest Americans to give serious attention to the Indian past was Thomas Jefferson, the third president of the United States. His observations and fieldwork, his excavations and research made it clear that the Indian world was capable of the most elaborate and significant social forms and artistic achievements.

Squier, whom we have already mentioned in regard to his work in Peru, along with Edwin H. Davis, carried out the primary reconnaissance in the eastern sector of the United States in the nineteenth century. Their methods, however, were systematic and scientific and not concerned with interdisciplinary thinking. On the other hand, Squier strongly reaffirmed, through his careful research, what John Lloyd Stephens had already intuited. Squier argued that any similarities between Indian and Near Eastern cultures were probably the product of similar thought processes and the response to the necessities of life, rather than any actual contact between Indians and the cultures of Europe or the Near East. Likewise, Frederic Putnam, who worked in 1885 at Serpent Mound in Ohio, argued effectively that the great Mound had been built as a single human event and not in a series of long-range episodes. He also proved that earthworks were built by Indians rather than by some mysterious "lost race."

In North America there were numerous, important researchers of Indian archaeology and ethnology. Few, however, possessed the background in art history or the necessary aesthetic sensibility to approach their material with the creative genius already referred to in the observations of Albrecht Dürer in the sixteenth century. The art historian who regarded art products as objects filled

with symbolic and aesthetic value, rather than information, was very rare. The ethnologist with more concern for the intrinsic being of an art object than for its use was also rare. Franz Kugler, about 1840, wrote the first known account of the history of ancient American art (for the Prussian king, published in 1842). Kugler—writing before the appearance of Stephens's landmark views on the origins of Maya civilization—insisted upon the independence of the art forms of the Americas from European influences. He was a singular scholar. And "hence it was not until about 1910 that critics appeared who were able to penetrate the expressive devices of the figural art of ancient America, and to comprehend the spatial purpose of the architecture" (Kubler, 1975).

If there was a single early-twentieth-century influence in Indian North America that propelled the reawakening of Indians themselves to their own cultural legacy, it was probably that of Edgar L. Hewett. In the American Southwest the renaissance of Indian arts was slowly taking place at the turn of the century, and it was there that Hewett's exceptional influence was strongly felt. A man of power and of considerable artistic expertise, he was at that time (about 1915–1917) director of the School of American Research at the Museum of New Mexico, a professor at the University of Southern California, and head of the Department of Anthropology of the University of New Mexico. He was unquestionably inspired by the work of such pioneers as Squier and Bandelier and by his contemporary, J. Walter Fewkes (who had commissioned several Hopi men to make drawings of kachinas

for a landmark study of Hopi religious icons in 1900). Unlike Fewkes, however, Hewett was less interested in anthropological research than in Indian arts as an aesthetic expression. He was fully sensitive to the Rio Grande Pueblo Indian mentality, and aware that he was dealing not with aboriginal graphic curiosities and artifacts but with true *art*. Through his sponsorship of hitherto unknown and unappreciated Indian artists, such as Crescencio Martinez, Hewett not only fostered the career of the "father of the school of Southwestern Indian watercolorists" but, with his prestige, guaranteed that his protégés would win the attention of the growing community of art-conscious Anglos in Santa Fe. It is safe to attribute the emergence of an informed and ever-increasing concern for the arts of Indian America to Edgar L. Hewett in the early 1920s.

It was Hewett's exceptional aesthetic mentality which opened the focus of ethnology to include the purely artistic aspects of Native American achievements, viewed not as research materials or "primitive art," but as one of the vivid and unique aspects of the international history of human artistic expression. To a very great measure, it is Hewett's example which permits us now to put anthropology, ethnology, and history aside and—in the words of Mikel Dufrenne—to turn to "the imagination which is least human in humanity, for it wrenches us away from ourselves and plunges us into ecstasy and puts us into secret communion with the powers of nature!"

It is in art, finally, that the unknown becomes visible. "Who speaks to me with my own voice?" From ourselves comes a marvelous stranger called Art.

THREE

AN AESTHETIC VIEW
OF
INDIAN AMERICA

Is prehistory really prehistory,
or simply a *different* history?

Jacques Le Goff

1.
Native American Art Forms

Art is a way of *seeing*, and what we see in art helps to define what we understand by the word "reality." We do not all see the same things. Though the dominant societies usually presume that their vision represents the sole truth about the world, each society (and often individuals within the same society) understands reality uniquely.* The complex process by which an artist transforms the act of seeing into a vision of the world is one of the consummate mysteries of the arts—one of the reasons that art for most tribal peoples is inseparable from religion and philosophy. The act of envisioning and then engendering a work of art is an important and powerful process of ritualization. Making images is one of the central ways by which humankind conceptualizes experience and gains personal and tribal access to the ineffable—the unspeakable and ultimate substance of reality.

This act of ritualization is a metaphoric process—whether we are speaking in terms of visual art and architecture or epic poetry and the performing arts. But since I have written about these matters at length in *The Primal Mind* (1981), we will confine our discussion here to 1) the concept of form as a reservoir of pri-

* For the full content of this discussion, see Jamake Highwater, *The Primal Mind*, 1981, pp. 55–88.

mal aesthetic/religious expression, 2) the iconographic transliteration of experience in primal art, and, finally, 3) the Native American manipulation of various technologies and media—both aboriginal and European.

Art historian Herbert Read (1965) makes an important observation about the primal way of making animal images, which reflects this ritual-making mentality. "In such representations there is no attempt to conform with the exact but casual appearances of animals; and no desire to evolve an ideal type of animal. Rather from an intense awareness of the nature of the animal, its movements and its habits, the artist is able to select just those features which best denote its vitality, and by exaggerating these and distorting them until they cohere in some significant rhythms and shape, he produces a representation which conveys to us the very *essence* of the animal."

Since the time of the Gothic sensibility of the twelfth century, this grasp of essences rather than casual appearances has largely ceased to be a dominant vision in Western art. As already noted, until about 1910 critics had not penetrated the "expressive devices of the figural art of ancient America," or comprehended "the spatial purpose of the architecture" (Kubler, 1975). Karl Woermann, writing of American archaeology in 1900, was still unable to transcend his ethnocentric judgment. In *Geschicte der Kunst aller Zeiten und Völker* (Leipzig, 1900), he wrote that American Indian sculptors, in spite of their wide technical command, lacked "full understanding of the forms of representation" and suffered from "incompletion and a barbarian overloading, al-

though they were able to make their forms occupy space with unmatched monumentality." As George Kubler has pointed out, "the nineteenth-century critic could not bring himself to credit the expressive strength of American Indian art, nor again could he rank it high by Occidental standards of verisimilitude. Faithful representation was for these critics the touchstone of value, and the representation to which they were accustomed is uncommon in ancient American art."

Primal art, like contemporary nonillusionist art of the West, is distinctly and definitely not a result of "flawed realism," and the quicker we grasp this fact the faster we can come to accept the possibility of alternatives to the Western illusionist idiom of realism.

To assume that geometric or abstract art (whether primal or avant-garde) is strictly a matter of "stylization" is a means of excusing rather than grasping the fundamental nature of arts born of something other than the "Occidental standards of verisimilitude." As Herbert Read (1965) has pointed out, "'stylized' is not satisfactory as a descriptive word for this type of prehistoric art; it is not a satisfactory word in itself, for there are many styles in art, and 'stylization' is used to indicate merely one of them, a particular kind of mannerism." Read prefers the term "haptic" to describe the vitality and dynamism of primal art. "Better still," he writes, "would be the word 'haptic,' which was invented by the Austrian art historian Alois Riegl, to describe types of art in which the forms are dictated by inward sensations rather than by outward observation. The running limbs are lengthened because in the act of running they *feel* long. In fact,

the two main prehistoric styles are determined on the one hand by the outwardly realized *image*, on the other hand by the inwardly felt *sensation*, and 'imagist' and 'sensational' would do very well as descriptive labels."

Andreas Lommel (1966), the former director of the Museum of Ethnology in Munich, makes the observation that American Indian hunter art "is an extension of the hunter art of Northern Eurasia which gradually spread into North America. Animal-centeredness is a characteristic of the hunter's mental makeup. The X-ray style [showing the internal anatomical structure of animals] is one of the central motifs of hunter art." Read (1965) sees this animal-centeredness as the source of the vital form of primal art. In this context he quotes Abbé Breuil's remarks about Paleolithic cave art: "There had to exist a hidden spring of intense visual emotion." Read believes that stress was an element of the hunter's lifestyle, oriented to danger and hunger The emotionalization of the style or form of much primal art—especially of hunting-foraging societies—was therefore a ritualization of the life process.

"Our axiom in art history should be: *always expect a constant aesthetic factor; look for the external forces that transform it.* If we are concerned with aesthetic sensibility, and not with irrelevant demands for pictorial realism, then we must be prepared to find as much aesthetic appeal in a Neolithic axhead or a predynastic Egyptian vase as in a cave painting from Altamira or Lascaux. Professor Hawkes, in his *Prehistoric Foundations of Europe*, has warned us against the fallacy of assuming that the historical development from naturalism to symbolism is mere degeneration. On

the contrary—'to feel need for a true portrayal in art-magic is elementary compared to belief in the efficacy of a symbol: a portrait is individual, a symbol collective or abstract'" (Read, 1965).

What has been said about the vitalism of hunter art can be extended to describe the arts of all peoples whose mentality is strongly nature-centered. Vitality, not beauty, is the distinctive quality of such art. Whenever nature emerges and takes possession of the artist's hand, whether in Mesopotamia, China, Africa, America, or Europe, the result is haptic expression. "But," reminds Read (1965), "vitalism is not merely animalism: it is rather the Life Force itself, and as such can be manifested in the human form as well as in the animal form, and even in the abstract ornaments. It is the general characteristic of many types of tribal art, and wherever magical rites are associated with human or animal life, vitality rather than beauty is the dominant aesthetic quality. Vitality as an aesthetic factor has reappeared in all its uncompromising power in modern art."

The possibility of an inward, or haptic, art clearly betrays an individual mentality at work—something we do not normally connect with tribal arts. And yet, as we have already seen, there is a clear distinction between the Western notion of "originality" and the primal concept of "individuality." As Adrian Gerbrands (*Tradition and Creativity in Tribal Art*, edited by Daniel Biebuyck, 1969) says, "We are slowly coming to realize that the alleged anonymity of the so-called primitive arts is a fiction." The tribal artist *individuates* a tradition, though he is not expected to *originate* anything. It was not until 1927 that Franz Boas presented a modern view of the role of the primal artist in shaping a given art style. "Until then the different styles of the [primal] arts were mainly conceived of as technological *trouvailles*, engendered by the skills of weaving, plaiting, chipping, chopping, and such. It was believed that, in the course of time, these *trouvailles* were fused together in a rigid framework of stylistic convention and tradition. Inspired by Boas, Olbrechts was the first to formulate in detail the principles of modern ethno-aesthetic research" (Gerbrands, 1969).

According to Boas, "The highest type of artistic production is involved, and its creator does not know whence it comes. It would be an error to assume that this attitude is absent among tribes whose artistic productions seem to us so much bound by a hard and fast style that there is little room for the expression of individual feeling and for the freedom of the creative genius" (Boas, 1955, p. 155).

The Indian's close relationship with nature and his belief that dream and intuition, vision and hallucination are implicit aspects of reality (and not separate from it), provide him with a metaphoric sense of reality. As Martin Friedman (in the Walker Art Center's catalogue *American Indian Art: Form and Tradition*, 1972) has stated, "What appears to our eyes as fantastic hybridizations of human, animal and demonic forms carved on a pole, or painted on a hide or dance wand, are objectifications of an all-inclusive reality."

But the Indian artist could be highly descriptive, as well as poetic and spiritual, in his approach to subject matter. No better example exists than the buffalo skin and muslin paintings which celebrate the exploits of warriors. The hero

is often depicted in sequences of intense dramatic impact. "Groups of horsemen are indicated by layering generalized side views behind and slightly above one another, much in the manner of traditional Persian painting" (Friedman). Usually no top or bottom exists in these glorified visual biographies—which can therefore be "read" from any position. There is often a certain temporal, almost cinematic sequence depicted in some of these hide paintings, with one event succeeding another in the manner of a storyboard or comic book. "For all the inescapable differences between modern American art and traditional American Indian art, the two manifestations are related; their intuitive aspects and inventive forms, while proceeding from radically different premises, have something in common. Modern art has prepared us in some measure for the experience of Indian art because it has taught us to expand our definitions of reality" (Friedman).

The startling revision of attitudes tov.ard "precivilized man" has truly brought alternative worlds into focus, yet this new interpretation of neglected realms of human experience may make them far more visible than comprehensible. The revised Western vantage point can be just as ethnocentric as the obsolescent assumption that extant "primitives" are windows upon the Neanderthal world. In other words, we are still presuming that the values of one culture are apt tools with which to measure the values of another culture. The error of this kind of thinking can be seen in the way Western scholars have evaluated the motivation of primal thinking. Sigmund Freud achieved a major new insight when he formalized a conception of the "unconscious mind," but he described it as an unruly and irrational domain and the source of a force so violent and primitive that "civilization" could be achieved only through the systematic suppression of the animalistic nature of human beings that was assumed to "live" in this unconscious mind, this so-called "reptilian brain."

It stands to reason that this very negative evaluation of the "primitive" aspects of the human mind would result in a misconception of those alien worlds brought into focus by the recent revision of attitudes toward "precivilized man." Vision, dream, inspiration, ritual, and even art—by Freudian appraisal—are mere rumbles of a subterranean psychic volcano that must be kept capped lest it destroy civilization. Matters of kinship and dominancy are based upon a Freudian battle of the sexes as well as the everlasting stresses of something called "penis envy"—which would seem to have far more significance to Central European (Judaic) patriarchal mentality than it does to the social realities of most primal peoples. Art, myth, and even the essential perspective of "precivilized man" are seen through Freudian stereotypes as symptoms of an epidemical human disease—the rampant, consuming, and primitive pox of instinct out of our animal legacy.

It is very fortunate that the highly linear perspective of Freud has been revised by a number of subsequent scholars.

Form in art is clearly a matter of place and time, of tradition and locality, but it is also a result of artistic individuation. In discussing certain arts of long-extinct peoples we .cannot rely upon their pedigree or on ethnographic data.

We can rely only upon what remains and what stands before us. The Mexican scholar Ignacio Bernal (Biebuyck, 1969) provides the ideal epigram for such a situation, and I repeat it here, for myself as well: "I have been persuaded to discuss something about which I know very little. There is, of course, a very good point in my favor: no one else knows very much about the subject either."

There is no question that Paul S. Wingert (1962) speaks out of a significant, if very formal, discipline when he states, "The meaning of an art object is interrelated with its motivation and its function, and this interaction makes the significance of the art form, within its cultural context, more understandable." But "*more* understandable" does not mean *aesthetically significant*; particularly when we are looking at objects which do not have a known allegorical relationship to an extinct society. There we are clearly on our own. That every art object has an objective or morphological aspect (shape, line, surface, and color), as well as a subjective or cultural aspect (function, motivation, and societal significance), is incontestable. And to the extent that we can deal with both aspects of an art object, we shall do so; but we must also keep in mind the purely aesthetic potential of interpretation: providing the viewer with the capacity to *respond* (rather than intellectually *react*) to a "haptic" form. At the same time, because for primal peoples there is a very close correlation between art and culture, it is important to examine art forms as closely as possible within their cultural context. But in so doing, we must never give up our prerogative as art historians or art lovers to value an object in and for its self-contained aesthetic values. What Native American art lacks in terms of pedigree and cultural identity is made up for by an eternal and experiential immediacy. It is in the everlasting "now" that the vitality of art resides.

2.
Native American Iconography

In all art there are several basic iconographic concerns: one is the way space is used; another is the forms made in space; and a third is related to the way time is suggested in nontemporal art, such as painting or sculpture. These distinctions can be illustrated with a few examples: 1) geometric divisions of a surface with hard-edge lineation and solid, unshaded distribution of color is an example of the way space is used; 2) a jaguar-like linear motif repeated successively is an example of forms produced in space; and 3) depicting a progressive burst of little rifle shots in the air exemplifies the manner by which time can be suggested in nontemporal art.

The solutions for these three basic concerns are the major element in art that gives rise to a sense of "style"—a recognizable visual character. This is the basis for our recognizing the difference between a Northwest Coast mask and a Hopi kachina mask. A survey of some of these variations in the use of space, form, and time in the visual arts will bring us closer to an insightful response to Indian arts.

There are iconographic variations among all cultures, as well as within a given culture, so eventually these iconographic variants will be discussed in terms of specific cultures and specific media. For now we will concern ourselves with a few widely different iconographic styles, so we can grasp the range of differentiation and so we can learn to recognize the basic elements which make the American Indian arts iconographically unique.

There are similar iconographic styles in widely separated parts of the world. Certain visual motifs (and verbal, musical, and ritualistic motifs) are simultaneously invented by various peoples for reasons basic to human nature. These similarities have often prompted the question asked by Jan B. Deregowski in an essay in *Scientific American* (November 1972): " 'Do drawings offer us a universal lingua franca?' The answer is no. There are significant differences in the way pictures can be interpreted. The task of mapping out these differences in various cultures is only beginning."

And yet some ways of dealing with visual space seem to dominate the thinking of many different peoples. For instance, the Northwest Coast Indians solved the "problem of how to present the characteristic side view and the frontal symmetry of an animal at the same time by splitting up the body into two side views, which were combined in a symmetrical whole and kept in precarious contact with each other by sharing either the middle line or the back or the head or by cohering at the tip of the nose or the tail. Morin-Jean has shown that very similar forms occur in Oriental decorative art, on Greek vases and coins, and again on Romanesque capitals" (Rudolf Arnheim, 1969). Deregowski gives a great deal of emphasis to the so-called split image. "Although preference for drawings of the split type has only re-

cently been studied systematically, indications of such a preference have long been apparent in the artistic styles of certain cultures, for example the Indians of the northwestern coast of North America. Other instances of split style in art are rock paintings in the caves of the Sahara and the [primal] art found in Siberia and New Zealand. What art historians often fail to note is that the style is universal. It can be found in the drawings of children in all cultures, even in those cultures where the style is considered manifestly wrong by adults . . . [yet it is found that in] all societies children have an aesthetic preference for drawings of the split type. In most societies this preference is suppressed because the drawings do not convey information about the depicted objects as accurately as perspective drawings do. Therefore, aesthetic preference is sacrificed on the altar of efficiency in communication."

Recent developments in the field of the psychology of perception make it possible to describe the artistic process more adequately. As Arnheim (1969) indicates, in the past "an over-simplified concept of this process was based on a double application of what is known in philosophy as 'naive realism.' According to this view, there is no difference between the physical object and its image perceived by the mind. The mind sees the object itself. Similarly, the work of the painter or the sculptor is considered simply a replica of the precept. Just as the table seen by the eye is supposed to be identical with the table as a physical object, so the picture of the table on the canvas is simply a repetition of the table the artist saw. At best the artist is able to 'improve' reality or to enrich it with creatures of fantasy by leaving out or

adding details, selecting suitable examples, rearranging the given order of things. This theory encountered puzzling contradictions in the field of the arts. If spontaneous perception corresponded to the projective image, it was reasonable to expect that naive pictorial representation at early stages of development would tend toward completeness and perspective distortion." It could be expected, in other words, that naive realism would be the preferred and singular preoccupation of artists. "The opposite, however, was found to be true," Arnheim continues. "Representation started genetically with highly simplified geometric patterns, and realism was the late and laboriously accomplished product of such sophisticated cultures as Hellenism and the Renaissance."

A major theory, for instance, for the origin and subsequent preference of the split style was formulated by the anthropologist Franz Boas. His hypothesis postulates the following sequence of events: solid sculpture was gradually adapted to the ornamentation of objects such as boxes and bracelets. In order to decorate a box or a bracelet the artist had to reduce the sculpture to the surface pattern and include an opening in the solid form, so when the sculptured object was flattened out, it became a picture of the split type. "There is, however," Deregowski (1972) reminds us, "no historical evidence that this evolution actually took place, and it does seem that the hypothesis is unnecessarily complicated."

Whatever the basis of the split image, it is a principal feature of the iconography of Northwest Coast Indian art, and it also appears in the motifs of the Chavin figurative tradition (Paracas, Nazca, Tiahuanaco) and in the manipulation of

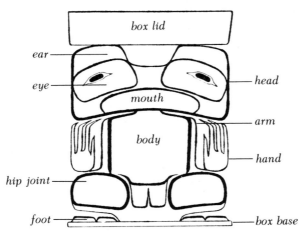

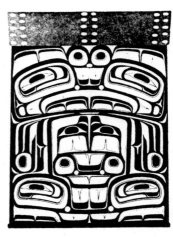

A Tlingit box design, c. 1850, shows the split image and the ornamental rearrangement of anatomical parts to conform to the spatial requirements of a given object—in this case, a wooden storage box.

space by the artists of Teotihuacán and its many successors in Mesoamerica.

Another type of image results from the atomizing, or dismembering, of figurative elements. According to Hilary Stewart (1979), "Northwest Coast art owes its structure to a general system of design principles. Depending on how these are used, the crest or motif being portrayed can vary from realistic and easily recognizable to involved and somewhat difficult to figure out—or the identity of the figure can become totally abstracted through the rearrangement of its anatomical parts."

When an image is applied to an item having a specific shape—a box, rattle, spoon, or drum—the outline of the image is manipulated to fit the intended object. The bilateralism usually associated with this kind of iconography is apparently a fundamental element of formal balance used by the artist to give abstract cohesion to the figurative realism that has been sacrificed in the process of anatomically manipulating a figure so it fits a given surface.

Another important element of the iconography of the Northwest Coast artists,

as well as of many other primal craftspeople, is the inclination to portray the essential but unseen: the artist portrays all that he or she knows about the subject, whether these qualities are visible or not. The resulting image may include the internal structure (X-ray image) of an animal or being, at the same time that the external form of the animal or being is carefully portrayed. The knowledge of the thing being painted or carved may be the basis for an emphasis (apparent "overemphasis," from a naive-realistic viewpoint) on certain features of a particular subject, depending on their importance or dramatic potential. The knowledge of a thing may inspire the artist to show it from many more viewpoints (angles) than could ever be seen at one time. All that is known about an object is more important than what can simply be "seen" at any given moment and from any given point in space. Knowledge of an object can result in condensation through selectivity as readily as it can inspire elaboration. Such parsimony—such economy of imagery—results in various degrees of abstraction—as, for example, in the way in

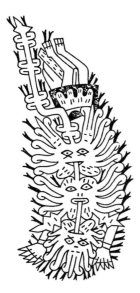

Figure from a Nazca ceramic. Peru.

which the two killer whales in a Chilkat blanket ("Bear with Two Killer Whales") are depicted.

There is also among most primal peoples an inclination to segment an object (like segmenting an orange) and to outline its two-dimensional, separate elements with a heavy contour. It is a technique found in the art of the twentieth-century painter Rouault, but its inventors appear to have been primal artists.

And, finally, there is among many primal artists, such as the Northwest Coast tribes, the classical *horror vacui*—the almost compulsory necessity to fill blank spaces. For such craftspeople a vacant surface in a composition is undesirable and unaesthetic. All space must be filled through an intricacy of design which produces an "all-over" result. Doodling is a half-conscious effort to fill space with a complex maze of details, all interconnected or related in an elaborate spatial orientation. A Chilkat blanket is a perfect example of the subjective need to fill space entirely.

"In the study of art, the relation between form and content is not often enough considered; the tendency is to place undue emphasis on one or the other. Most works of [primal] art show a highly satisfactory combination of form and content. However, it is true that contemporary observers are more likely to derive enjoyment from the form, since the content is lost in the symbolization of the culture in which the work was created" (Robert Bruce Inverarity, 1971).

What this observation suggests is that iconography can be allegorical, with its meaning not apparent unless the viewer is part of the culture in which the iconography and symbolism are a fundamental part of training and education.

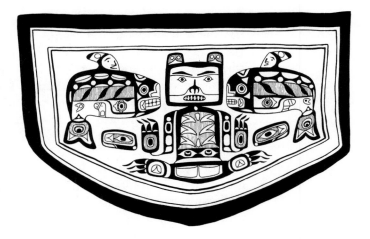

Tlingit textile: "Bear with Two Killer Whales"

For instance, the Iroquois of the American Northeast create False Faces—masks carved from a living tree. As Paul Wingert (1962) has pointed out, "The Iroquois face mask, with the crooked nose, distorted mouth, and deep folds of flesh above the brows and around the mouth, represents the Great One, who, in mythical times, entered into competition with the Creator for mastery of the world. In the course of this struggle his nose was broken, but as a consequence, he was given the privilege of instructing mankind in the making and weaving of

Iroquois False Face mask.

a mask in his likeness, together with certain ritual procedures to help man combat the evil of disease. The meaning of the mask is a dramatic expression of these circumstances, interpreted by the sculptor's rendering of the facial features to convey pain as he understands it. As a result, there are variations in the treatment of this aspect of the subject matter."

The False Face of the Iroquois is allegorical iconography—a deliberate visual expression of their mythology. Among the Kwakiutl artists of the Northwest Coast there are allegorical tales that are a highly important part of the people's worldview. The Nulmal, or "fool dancers," are much concerned, for ritualistic reasons, with the nose and its mucus, and so they carve Nulmal masks with a great emphasis upon the nose and the splayed and decorated upper lip. The famous transformational masks of the Kwakiutl dramatize mythic history by having an outer mask (for example, of an eagle) which can be moved by strings to reveal an inner mask (for example, of a human face)—thus recounting a specific event in the tribal oral tradition. There are numerous other examples of this sort of allegorical iconography.

The Winter Count of the Kiowa Indians is a radial pictographic history, painted on animal skin by tribal historians. The pictographic books (codices) of Mesoamerica are histories in the form of allegorical iconography. In the Nuttall Codex, warriors are seen crossing a lake inhabited by aquatic animals. In numerous codices, speech is represented by a volute emerging from the mouth, which is the basis of ideographic writing. In the Ledger Art created by Plains Indians during the late nineteenth century (a tradition, as we shall later see, which was highly elaborated by Indian prisoners of war at Fort Marion, Florida, c. 1875–1878) tribal and personal histories are recounted through the medium of an elaborate iconographic convention, the allegorical intentions of which are clear to us insofar as the events depicted the Indians' version of the history written about the same events by white men. The Sioux artist Kills Two produced many such historical paintings, filled

Left: An Aztec codex: speech glyphs.

Right: The Nuttall Codex: a record of a historical event.

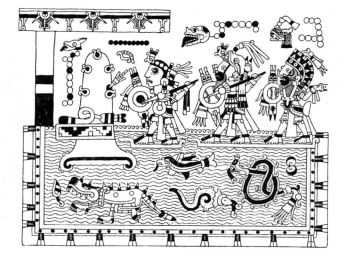

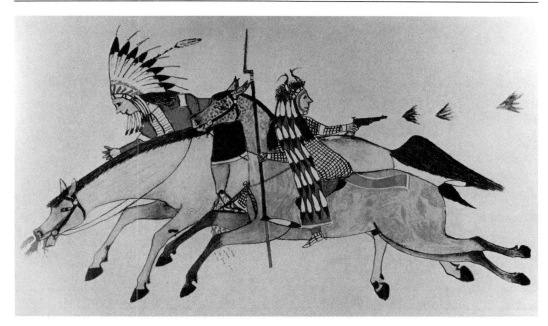

Painting, on canvas, by Kills Two (Sioux). Red Walker and his companion are shown fleeing their Crow enemies. Red Walker has a broken leg, and his horse has been wounded; his companion fires three shots as they escape.

Below: North American iconographic images.

with allegorical iconography. One such painting (on fabric) depicts the warrior Red Walker and his companion fleeing from Crow Indian enemies. The iconographic interpretation offered by Kills Two is that Red Walker has a broken leg and that his horse is also wounded—as we can see from the blood issuing from the horse's nostrils and from the wound in Red Walker's left leg. Meanwhile, his unharmed companion turns toward the pursuing enemy and fires three shots, a temporal image which would not normally be seen in a painting in the naive realistic tradition—but which is made possible in this example of Ledger Art, by showing successive temporal events in one static image.

It becomes apparent from these remarks and examples that much of the culturally based iconography of the extinct societies of the Americas is unintelligible to us on an allegorical level, and that therefore the meaning of such iconography is purely speculative.

Lightning

Sun

Clouds and Rain

Clouds

Mountains

Rocks

Person

Corn

Plumed Serpent

Bird Hanging from Sky Band

Rain Serpent

Deer

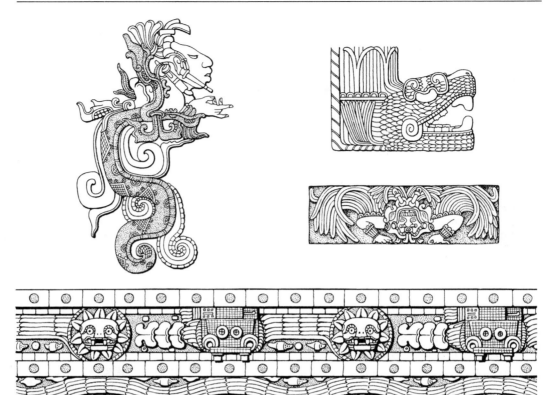

Examples of the Feathered Serpent, Quetzalcoatl, the ancient Mexican serpent deity.

Fish

Bird

Puma

Andean iconographic images.

The iconographic potential in art is unlimited. From a sampling of imagery from various regions of the Americas, we can see that the imagery is diverse and imaginative, sometimes totally abstract and at other times verging on ideograms. And yet one must not presume that the emblems of birds, deer, and deities or the geometric images are some kind of elaborate symbolical *language*. The inclination to conceive of Indian imagery as "a hidden language" is a mistake, for the iconography we find in the Native American tribes for which we possess an ethnographic profile rarely shows the intention of making symbols as an equivalent of language. The iconography of primal peoples, with the rare exception of intentional ideograms, was devoted to animating, to bringing life to objects, and not promulgating thoughts and values through a medium remotely approaching a "written language." Not only was the intent different, but also the results were radically unlike the prosaic, illusionist notion of images as substitutes for words.

Of all the motifs in the primal art of the Americas, that of the bird is probably the most widespread. Much of the imagery related to birds has a strong geometric design, suggesting that many of the motifs were probably invented by weavers and subsequently taken from textile or basketry and applied to pottery or stone, retaining their original angular and geometric character, which was a result of the technical requirements of the medium of weaving.

Drawing from the Tiahuanaco culture,

G.H.S. Bushnell has provided a vivid example of Native American iconographic style. The process of stylization—from one of the falcon-headed, staff-bearing attendant figures on the monolithic gateway at Tiahuanaco (page 58) to an extensive set of variations found in textile designs—gives us a glimpse into the process of repetition, contraction, and expansion that results in several varieties of iconographic expression. This process, as Bushnell points out, can best be understood if the figure at the left is seen in relation to the rest of the images as a series of vertical zones which can be extended, contracted, or even transposed at will. The most contracted form can be seen on the far right. Archaeological data give us some insight into the religious nature of this iconography, but the most valid contemporary approach—since the Tiahuanaco cultural meaning

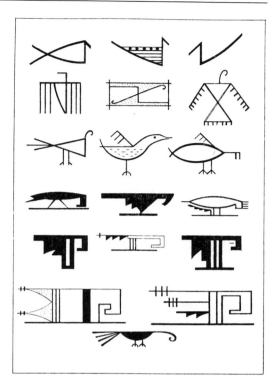

Left: United States Southwest bird iconography.

Below: "Detail of a tapestry from the expansionist Tiahuanaco period. With some imagination one can make out the principal features of the condor deity. The design contains almost every detail in an abstract or reduced form. I am obliged to Dr. G. Kutscher for drawing my attention to this phenomenon." Tiahuanaco style from the coastal area. After a photograph by Ferdinand Anton. From Bushnell (1965); reprinted with permission.

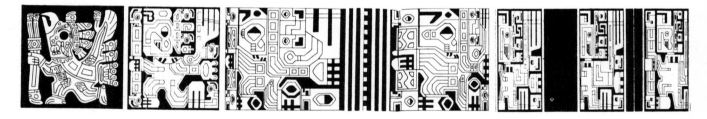

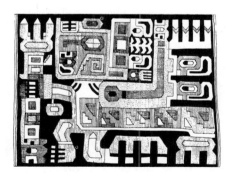

Tiahuanaco textile iconography: 3 variations on the condor deity.

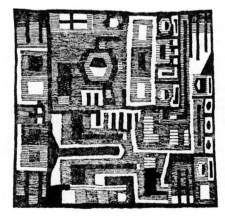

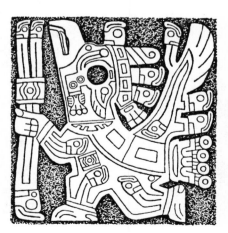

of the image is lost to us—is an appreciation of the purely aesthetic achievements, which only recently found a significant reception in the mentality of Western people. As James W. Reid has pointed out, "While Western art until the late nineteenth century was following a relatively unilinear direction of realism, the Pre-Columbian artist was exploring concepts which we normally associate with the twentieth century. Endless interpretations are possible. Although much empirical data is lacking, it is evident that such symbols originally had clear ties to defined and recognizable elements of daily life." It is best to avoid excessive interpretation where ethnographic information is lacking, and, instead, to find meaning and visual impact in aesthetic terms, since we are now capable of accepting the parallels between Indian art and modern Western art.

> Our greatest difficulties arise with conventional meanings, especially when we are dealing with preliterate societies. The key to conventional meanings can come only from literary sources; pictorical conventions can rarely be deciphered by examination of the pictorial materials alone. Literary sources for the understanding of ancient American civilizations are lacking for all societies other than those recorded by Spanish observers and by Indian survivors at the time of discovery and conquest. Hence we have intelligible and circumstantial literary sources only for Aztec civilization, for late Maya culture under Mexican influence, and for Andean society in its terminal phases. (We also have very elaborate eyewitness accounts by Indians and non-Indians of the tribes of Canada and the United States, commencing with the sixteenth century.) We have no auxiliary sources whatever to decipher Mochica art, or Classic Zapotec, or Nazca or Tiahuanaco styles of conventional meaning. . . . In actual practice we constantly make assessments of intrinsic meanings [of ancient arts] without knowing either the natural or the conventional meanings of the form under inspection . . . thus, we are obliged, like all previous students, to concentrate upon natural and intrinsic meanings. The galaxies of conventional meaning for the most part still lie beyond the range of our instruments of knowledge (George Kubler, 1975).

As Kubler makes perfectly clear, there is more to the history of art than merely solving puzzles of date and authorship, and explaining the relevance of works of art to the culture that produced them. If art history were no larger and, essentially, no different from such practical pursuits, it would be only another "antiquarian pursuit among innumerable varieties of gourmandizing over the past, along with philately and genealogy" (Kubler). The aesthetic mentality can be creative not only in its own time and culture but also in its approach to other times and cultures. The history of art is a historical and a *creative* endeavor because the seriation of works of art permits one to transcend the knowledge of even the artists themselves about their own work. Despite the many gaps and inadequacies in available data, the modern researcher of art history knows many things about the work of Phidias that neither Phidias nor his Greek contemporaries could have known. The awareness of art and artistic expression on a world basis, the realization that an individual artist has a connection to a succession of artists is what finally gives art history its impetus and its signifi-

cance. Surely this kind of discipline allows extravagant speculations, as we shall soon discover in the theories about the sources of American iconography and art forms, but it also allows the kind of profoundly creative thinking that is the touchstone of modern criticism.

It is clearly the task of the historian and critic to be as creative as the works he or she interprets.*

Form and Iconography as Alien Influences

One of the most precarious of "creative" interpretations of Native American arts derives from the inclination of a dominant society to envision itself as the only realistic and viable source of achievement. Western ethnocentricity has been unrestrained in prior centuries, though it has been strongly curbed during the last fifty years. Yet there remains the effort to justify and to fortify the motives of missionary activity by devising elaborate schemes which affirm that almost every "advance" toward "high civilization" which has been achieved by so-called primitive peoples is the direct or indirect result of the influences from Western contacts.

The inclination of most modern art historians is to treat primal societies as self-contained and self-sufficient, ignoring certain possible influences from alien cultures either because there is no definitive proof for such ancient contacts or because such contacts seem peculiarly incomplete: certain techniques and elements were presumably bequeathed by Africans or Orientals or Vikings to pre-Columbian American cultures, while numerous other possible elements were mysteriously missing from the inventory of bequeathal.

For the sake of thoroughness, and despite the immense controversy surrounding the subject of pre-Columbian transoceanic contacts, we will briefly survey the various theories about this subject. The recent summary concerned with transoceanic contacts by Stephen C. Jett is a valuable resource (*Ancient Native Americans*, edited by Jesse D. Jennings, 1978).

The conflict between the *diffusionists*, who believe that "important, even fundamental outside influences" shaped many cultural features of the Americas, and the *independent inventionists*, who emphasize local evolution of American cultures, is the largest controversy in contemporary archaeology and anthropology. In his landmark essay, "Pre-Columbian Transoceanic Contacts," Dr. Jett offers a compendium of diffusionist hypotheses, strictly from the diffusionist viewpoint and without an effort to raise the objections which surround them. The result is an important assemblage of possibilities and some tantalizing, inexplicable, but undeniable evidence in support of the diffusionists' position. Dr. Jett's fifty-page essay is too elaborate for summary here, and therefore readers are referred to the original text; I will simply quote here the conclusion of Jett's essay.

*A word of caution about the interpretation of iconography may be drawn from Erwin Panofsky, who helped to formulate the "principle of disjunction": continuous forms of iconography do not predicate continuity of meaning, nor does continuity of form or meaning necessarily imply a continuity of culture. Thus we may not use descriptions of Aztec rituals of c. 1550 to explain murals painted at Teotihuacán a thousand years earlier.

If one were to present a contemporary, capsule, "diffusionist's-eye view" of the role of foreign contacts in the development of nuclear America, it might look something like the following:

1. Significant contacts may have occurred in pre-ceramic times and may have resulted in the introduction of a few cultivated plants and even the idea of cultivation, but this, as yet, can be considered little more than speculation.

2. The appearance and spread of Colonial Formative pottery, beginning before 3600 B.C., justifies a tentative presumption of introduction from the Old World. Although possible Mediterranean sources have been cited, at present eastern Asia seems to exhibit better evidence of having been a source area. By the end of the Colonial Formative (ca. 1450 B.C.), village farming life, well-developed ceramics, bark-cloth making, color-directional symbolism, religious emphasis on felines and serpents, nagualism[*] and a number of other trait complexes had been introduced to southern Mesoamerica, probably largely from the Yangtse River area of Neolithic coastal China, via the North Pacific current. Return voyages were made, introducing the peanut to China.

3. In the meantime, Malaysians, probably from the shores of the Celebes Sea, had reached the Gulf of Panama, aided perhaps by the Equatorial Countercurrent. . . . Vegetative-reproduction-shifting cultivation, long houses, houses on piles, head-hunting, the blowgun complex, signal gongs, and other traits were introduced over a long period of time, and American food plants were carried back to Asia.

4. Beginning about 1450 B.C., quantum changes, including hierarchical social organization, construction of large-scale religious monuments and ceremonial centers, extraordinary lapidary work (Middle America) and metal working (Peru), and water control, appeared suddenly at San Lorenzo, Veracruz, and at Chavin de Huantar, Peru. A theocratic system involving a pantheon, a priesthood, craft specialists devoted to creating religious art in so-called great styles, rigid social stratification, corvée labor, and perhaps *calendars* and writing all seem to have been introduced and grafted on to the well-established Colonial Formative base. . . . Possible outside sources for the theocratic stimuli include Shang China (with the search for jade and gold providing a motive), Egypt (via religiously inspired explorations), and (somewhat later) Phoenicia (for purposes of raw-material acquisition, perhaps including *pupura* dye). Despite the religious and organizational emphases of these impacts, important technological additions to nuclear America also occurred, including advanced techniques of weaving, metal working, stoneworking, and, probably, more intensive agricultural methods.

5. The great Olmec emphasis on jade seems first to have manifested itself at La Venta, perhaps about 1100 B.C. For several centuries thereafter, there is little or no evidence of East Asian influences in Middle America. Yet it is for about this time period that Northwest Coastal stylistic similarities to Middle Chou art seem to suggest contacts.

6. Apparently no earlier than 500 B.C., and perhaps a century or two later, Chinese influences on Mesoamerica seem to have resumed. This may be related to Taoist voyages seeking the "drugs of longevity," perhaps vaguely remembered from earlier contacts; but the Guerrero jade mines were never reopened, possibly because the Burmese jadeites had been discovered by this time. The introduction

*"Nagualism": from the Native term *nagual*, referring to various beliefs formulated as rituals by Central American tribes in pre-Columbian times (J.H.).

of Late Chou-Ch'in art styles, mainly in woodcarving, occurred during this period. These, in modified form, were later translated into stone carving in Veracruz (Tajin) and elsewhere.

7. Dong-son people of northern Vietnam, falling increasingly under Chinese influence, also established relations with the Americas, focusing, apparently, on the Bahia area of Ecuador, and introducing certain metal-working techniques and object types. . . . The Chinese presence, though probably not demographically large, may have contributed to the planning and layout of a growing Teotihuacán, and may have introduced certain pottery forms and lacquering techniques. The Chinese may also have been active in coastal Peru about the same time.

8. Classical Mediterranean influences are strongly suggested in nuclear America, especially Peru. Exact source areas remain to be pinpointed, but some indications exist that a trading colony on the Persian Gulf or the Arabian Sea may have been involved.

9. Important transatlantic contacts all but ceased during the European Dark Ages, not to be resumed until the Renaissance. Chinese Pacific voyaging seems also to have dwindled away after Han times. Simultaneously, however, there occurred a waxing of voyaging from South India and its Southeast Asian colonies, particularly Cambodia. Resulting influences, from about A.D. 400 to 1000, were manifested largely in religion and religious art and architecture and were concentrated almost exclusively in the Maya Lowlands and at Tula in Central Mexico. Ultimately, introduced diseases led to the Maya collapse and, shortly thereafter, to the end of significant pre-Columbian transpacific voyaging.

Transoceanic influences must be seriously reckoned with in any consideration of fundamental cultural developments. In addition, myriad minor cultural phenomena may be "trace elements" indicating contacts that provided *opportunity* for more "decisive"—but less demonstrable—impacts. None of this is intended to suggest that any New World culture "is" Egyptian, Chinese, Cambodian, or what have you. The intent has been to show how Old World cultures may have contributed important threads to the fabric of the distinctive civilizations that we call nuclear American and perhaps have provided significant stimuli for the evolution of those civilizations.

3.
Native American Media and Technology

"European and Western society in general, while promoting and rewarding change in its own arts and sciences, bemoans the same in others. They project onto 'folk' and 'primitive' peoples a scheme of eternal stability, as though they were a kind of natural phenomenon out of which myths are constructed. Much as Lévi-Strauss (1963) has shown that these peoples use 'nature' as a grid against which to demarcate their experience, so the rulers of the world have used the powerless and the exotic as the 'nature' by which to demarcate their own 'culture.'"

This important observation by Nelson H. H. Graburn (*Ethnic and Tourist Arts*, 1976) provides an ideal backdrop for the discussion of Native American media and technology.

Our cursory overview of Native American cultural history has made it perfectly clear that change has been a constant and vital source of survival and evolution in the Western Hemisphere. It is true, of course, that this formative process does not mirror the values or the historical forms of the kind of "progress" with which the West is very much preoccupied—for contrary to the European dogma, all societies do not necessarily move with the same rhythm nor in the same direction. But the unique-

ness of Indian cultural dynamics must not be mistaken for stultification and immobility simply because change operates according to a different set of principles.

Examples of superb inventiveness among Native Americans are visible throughout the history of the Western Hemisphere. Take, for example, the remarkable developments in metallurgy, such as the discovery of platinum in Ecuador, a metal whose melting point is so tremendously high that modern Western technology mastered the art only a century ago, whereas the Indians of Ecuador were using a form of platinum at least eight hundred years ago (according to Dudley T. Easby, Jr., *Scientific American*, April 1966).

The Indian had a very clear and firm attitude toward the importance of technology. In fact, until about 1850, "the Indian world regarded the Western world as desirable largely because of its ability to supply trade goods. The superiority of whites was acknowledged only in a limited number of ways; whites were considered socially inferior, and in most technical operations, such as those related to subsistence, construction, and art, the Indians regarded their own knowledge and techniques as superior" (Carole N. Kaufmann, in Graburn's *Ethnic and Tourist Arts*).

It is therefore a highly romantic misconception of the West to envision the Indian as a nontechnological denizen of the forest with a static and Stone Age culture. This fabrication about the Indians may support the Western search for alternatives to its own terrifying technological dilemmas, but in no way does it reflect the real achievement of Indians and other primal peoples—which was

one of producing a dynamic society in which a symbiotic relationship between technology and nature served the community without the irreversible deprecation of nature.

The assumption, therefore, that European influences defiled and destroyed Native American culture is a vast over-simplification of a process which, in many ways, was not negative but exceptionally productive and significant for the Indian's own evolution. Alien influences cannot be categorically regarded as negative. Surely that point is clear if we simply consider the possible (if highly debatable) borrowings from various continents which the transoceanic theorists envision as the pre-Columbian sources of numerous Indian cultural characteristics. Whatever might have been borrowed was thoroughly Indianized and assimilated into the main current of Indian culture—just as numerous post-Columbian elements were amalgamated into the Native American cosmos. Furthermore, there is no denying that the cultural influence of alien cultures was, at heart, the basis of contemporary Europe itself—which grew out of the fusion of Oriental and Greek technology and philosophy. So there is simply no reason to discuss alien influences in Indian culture as a source of degeneration.

Long before the appearance of Columbus, the Americas experienced major technological revolutions of their own which totally altered the lifestyle of massive populations. We could speculate about the invention of new hunting weapons which changed the lives of Paleo-Indians in the Ice Age. We could discuss the history and evolution of the various projectile points invented in the

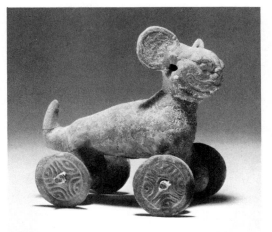

Americas—the *atlatl*, or spear-thrower, and other such devices. But we would have to indulge in a good deal of speculation to do so. In the case of the invention and impact of agriculture on the Americas, there has been little need for speculation since 1960, when the exploration of caves in the Tehuacán Valley, south of Mexico City, unearthed twenty-eight levels of human occupancy, a complete record of human history from about 12,000 years ago until about 1521, when Cortes invaded and subjugated Mexico. According to Peter Farb (1968), "no other archaeological reason in the world has ever afforded so clear a picture of the rise of a civilization step by step."

American agriculture was not only different from that practiced in Europe, but it was also far more extensive. "At the time of the Europeans' discovery of North America, the American Indians already cultivated a wider variety of plants than did the Europeans" (Farb). The grains cultivated by the European farmer, such as wheat and rye, survive and thrive as weeds, but corn is never found in a "wild" undomesticated state.

One of the most curious and debated issues in regard to Indian mentality and technology has developed from the fact that the wheel was invented in the Americas but was apparently used only for miniatures, as, for example, in this whistling jaguar toy of Veracruz, c. A.D. 250–750. There are numerous explanations for the Indian's neglect to use the wheel, but the most plausible one seems to be his indifference to the Western concept of "progress." Photograph: Sotheby Parke-Bernet.

"Every maize plant that grows anywhere today is of a domesticated variety. Its domestication has been so complete that maize would promptly become extinct were humans to stop growing it, since it does not possess any way for its seeds, the kernels, to be dispersed" (Farb).

The archaeological story recounted by the twenty-eight levels of human occupancy in the caves of the Tehuacán Valley demonstrates the gradual evolution over 12,000 years of small, nomadic bands of hunters and gatherers into a complex and massive domain based on agriculture. This food-production evolution was a slow process. Although there are indications that plants were being domesticated at Tehuacán as early as 8,700 years ago, there are no signs of settled village life until perhaps 5,000 years later, and there was not a large development in population until 5,500 years after the initial domestication of plants. Yet the so-called high civilization which Cortes found in the Valley of Mexico when he arrived in 1519 was the result of a major technological evolution in plant domestication by bands of nomadic hunters and gatherers commencing 12,000 years ago. Change was not only a fundamental part of this formative process, but *technology* (plant domestication of the most complex and extensive kind) was a persistently pursued and developed activity.

The difference between pre-Columbian and post-Columbian technological change in Indian societies was essentially a difference in *external* influences and the rapidity with which such influences were assimilated. What remained constant in this formative, technological process is the unique and complete manner by which the Indian adapted and assimilated changes into a stable, nature-oriented tradition. This process of adaptation was so strong and so thorough that, as I have already said, some of the most alien elements to enter Indian culture are now considered those which are the most characteristic: for instance, the horse culture of the Plains Indians.

In the early sixteenth century relatively few Indians lived in the Plains. It was not a preferred region. For one thing, the land made farming difficult, and for another, hunting on foot in the open country was exceedingly difficult. The cantankerous and ever-wild buffalo ruled the High Plains. But these great, burly beasts were not alone. Gradually there also appeared an animal which had not been seen in the Americas since the Ice Ages, when it became extinct. It was the *horse*. It had originated in the Americas, from which it migrated thousands of years ago to Asia and Europe, and then became extinct in its native land. The reintroduction of the horse to America started, presumably, with the ten stallions and five mares which Hernando Cortes brought with him to Mexico in 1519. The descendants of those Spanish horses ran utterly wild upon the Plains and gradually spread eastward. Only seventy-five years after the landing of Cortes, the Indians of the Southern Plains had already captured and learned to breed horses. They had become horsemen of such excellence that their entire destiny was fundamentally altered by their possession of the horse. It was perhaps the second greatest technological revolution in the Americas, after the invention of agriculture thousands of years earlier.*

* John Ewers, in "The Horse in Blackfeet Culture,"

The once desolate Plains were now teeming with Indians on horseback. By 1800, the Sioux, who had been devoted to the canoe and their own feet for transportation, had completely abandoned the water and taken to horses. The Cheyenne and Blackfeet, who had depended for centuries on the dog as their only beast of burden, were also mounted on horseback. The Comanches came down out of their homelands west of the Rockies and turned to an entirely new life, centered upon buffalo hunting. This new horse culture changed the most fundamental elements of life for countless small bands of nomadic hunters and foragers. Today we have few associations with Plains Indians apart from their roles as extraordinary horsemen and hunters. Their bows and their shields, which once had been long, were unsuited to mounted battle and hunting, and so they were greatly shortened. The regalia and traditions of Plains Indians quickly changed to suit the requirements of horsemanship. They trained their horses to follow dangerously close to the ferocious, woolly buffalo, enabling the hunter to make his kills in heroically close quarters. Never before had these once humble foragers and nomads been so rich and so powerful. The horse changed their lives and soon became the major symbol of their iconography.

In the material culture of the Indians the process of assimilating new techniques was an ancient practice. As a rule, Indians used whatever materials were most available to them: wood, buffalo hides, and clay. But availability was not a central aspect of Indian invention

and technology. To the contrary—in total contrast to the romantic view of Indian mentality as complacent, Indian craftspeople expressed a great deal of interest in rare materials, which they eagerly sought. Intertribal trade had existed in the Americas for thousands of years—it was not invented and brought to Indians by European traders. To the contrary, finished products as well as raw materials were carried vast distances and exchanged for various desirable local products. As Norman Feder has pointed out (1965), seashells from the Pacific were traded as far east as the upper Missouri River region, and were common in the American Southwest. Parrot feathers, metal bells, and various ornamental materials were brought into the Southeast from Central Mexico. Catlinite for pipe bowls was traded from a center at Pipestone, Minnesota, throughout all the Plains area, as far as the state of Washington.

In this way, the Indian craftspeople were well prepared for the arrival of the white trader and his inventory of remarkable new materials and products. "The wide variety of materials introduced by Europeans in some instances had a radical effect, being readily accepted by the Indians as more colorful than native equivalents, or better suited to their purposes" (Feder). Originally these European trade items were provided as gifts to win Indian loyalty. This was especially the case in the early days of colonization, when Europeans were a minority in the Americas. The range of cross-fertilization of Indian arts through European examples and raw materials is an immense subject, but a few important examples of both the positive and negative results of the impact of West-

suggests that Indians first learned to ride horses from the Spaniards and then began to capture wild horses.

ern technology and materials on Indian arts and traditions will provide a glimpse into the long-standing and on-going process of remarkable Indian inventiveness and cultural dynamics.

These examples will clarify Norman Feder's statement: "The romantic purist today bemoans the fact that traders stock brightly colored—often garish—materials, but neglects the fact that these items please Indian taste. The older, softer, pastel shades produced with native dyes were eagerly replaced with aniline dyes. Improved methods of coloring glass also had a profound effect on Indian arts, usually one which was less pleasing to non-Indian taste. A very few traders, in the interest of modern commercial production, have persuaded Indians to use again the older native dyes (as in the case of some Navajo rugs), or have specially ordered glass beads in the older, subdued colors. However, in general, Indians will not employ either for their own use" (Feder).

It should be added that since Feder's writing these words in 1965, there has been a vital revival of traditional viewpoints and tastes among young Indians. Though the garish feathers of the Fancy Dancers of the Plains are not likely to become subdued, there are numerous groups of Indian dancers in the United States who have steadfastly and eagerly revived the older, more restrained colors and regalia of their tribal traditions. This process was already apparent to Feder in the mid-sixties: "A few minor changes resulted from the introduction of new, better, more colorful materials," he wrote. "However, while a newer paint pigment might be substituted for an older, native one, the painted area and design usually remained the same."

Maria Martinez and her husband, Julian, might have innovated black pottery in the 1920s at San Ildefonso Pueblo, but the designs and forms of their work were absolutely consistent with Puebloan traditions. The Haida may have only recently commenced carving in argillite, but their iconography and even the style of their carving are century-old conventions of the Pacific Northwest Coast tribes.

Some of the most obvious "European influences" have proved, in the long view, to be controversial. For instance, among students of Indian arts there is still considerable debate about the origin of the floral designs used in Woodland Indian beadwork. No one knows for certain if these designs were copies of embroideries taught in French mission schools or the Indian response to floral designs seen on European garments.* In almost every case of the Indians' use of European styles and materials there is some element of controversy. There are even questions of whether certain techniques are wholly pre-Columbian or borrowed from European examples. But in every instance, the Native arts of the Americas demonstrate an inscrutable originality even when clearly based upon typical European influences. Even when the imitation of Western motifs or the use of Western materials has been apparently countercultural from an Anglo viewpoint, nonetheless the products themselves, for better or for worse, are always totally Indianized. It is that technological process of *Indianization* of alien motifs and materials that demon-

* Traditional Canadian Cree explain that floral designs are the result of the visionary quest of the dead, who live in a place filled with such flowers.

strates the manner in which Indian technological mentality functions.

There are numerous classic examples of this process of Indianization in various post-Columbian arts of the Indian Americas. The immense forests of the Pacific Northwest Coast tribes provided natural materials for the development of what are often regarded as the finest achievements of Native North American carvers and sculptors. Here, along the major shipping routes established by early European traders, we discover the perfect exemplification of the positive influence of Western technology upon Indian craftspeople, demonstrating their uncommon ability to adapt foreign materials and tools to their own purposes. With the introduction of steel knives by traders, Native artists quickly produced an exceptional and flamboyant sculptural tradition rivaled by no other Indian people in North America—great totem poles, immense wooden dwellings decorated with richly carved doorposts, vivid ritualistic masks, rattles, figurines, and a great variety of other carved objects which became the first Indian artistic achievements to be widely and eagerly appreciated as "fine art" by European tourists and explorers. The technology and tools of Europeans did not inspire or determine the form or iconography of Northwest Coast carving; it was a long-standing if somewhat modest tradition, which received an immense impetus from the introduction of tools which provided a more complex and perhaps also a more expressive technology for working in an ancient medium.

The gradual replacement of porcupine quillwork by European beadwork is another classic example of a major technological transformation of Indian art,

which, nonetheless, resulted in a thoroughly *Indian* medium. Porcupine quillwork was unique to American Indians. The porcupine has smooth, shiny quills, often as long as five inches. When these quills are soaked in water they become flexible and can be dyed, bent, twisted, and applied to surfaces as design motifs. In the Northwestern United States the quills were usually wrapped or folded around a single gut thread, which was then sewn to skin or cloth in linear designs. Dyed quills were used in a different manner among the tribes of the Great Lakes: they were pushed through holes in bark boxes and bent on the inside, forming rich geometric motifs, especially on those items produced by the Micmac Indians. Plains quillwork—though derived from Eastern tribes—represents yet another method: one-quill wrapping produces a pattern of parallel rectangles, and was used on breastplates and moccasins. The so-called one-quill folding technique results in a pattern of interlocked triangles. And to cover broad areas, quills are folded between two lines of stitches. This arduous and complicated quill technology was used for a great variety of exquisite designs, on buffalo robes, pipe bags, pipe-stem coverings. And yet this precious and elegant form of decoration and design was almost completely abandoned and replaced by beadwork, which was not only used to produce the same effects and designs as quillwork, but could also provide a curvilinear pattern which allowed radical new designs, many of them borrowed from European sources. Therefore, it makes sense that the best beadwork was developed in the areas renowned for their quillwork. The transition from quills to beads began about

1675, when Europeans introduced trade beads made in Venice and Prague. By the middle of the nineteenth century beads had almost entirely supplanted quills and other forms of Native decoration. New techniques were both learned from Europeans and invented independently by Indians: woven beadwork, diagonal plaiting, spot-stitch sewing, netted beadwork, and so-called lazy-stitch sewing provided a wide variety of styles and manners which were gradually evolved and refined by various regional tribes.

Innuit artistic goals and values are also a blend of traditional and European-introduced elements, especially in the creation of modern soapstone sculptures and balsa masks—which grew out of the Innuit heritage but were essentially the result of alien inspiration and technologies. As Graburn has pointed out, "The bolder sculptures, even when made entirely for sale, are important to the Eskimos and have become integrated into their modern culture. Although I agree that carving is an introduced art form, the Eskimos do make their own selections of stones, tools, and subject matter, often in contradiction to market demands." Clearly, the Innuit craftspeople have used European ideas and tools to their own advantage and have thoroughly amalgamated alien influences into their culture through a strongly centered Innuit aesthetic.

Beyond the technological impact of Europeans on American Indians, there is a subtler and perhaps equally important type of influence on Native arts, exemplified by the revival of lost or nearly lost elements of Indian tradition through the inspiration and assistance of non-Indian enthusiasts and experts. This pro-cess has been at work throughout the Americas, and much of what we call contemporary Indian crafts—particularly in Latin America—is the product of the guidance and inspiration of scholars and collectors, as well as the most earnest of Peace Corps workers. This revival of Indian arts through the instigation of non-Indians is perhaps best exemplified in the work of anthropologist J. Walter Fewkes, in connection with the Hano potter Rachel Nampeyo.

By about 1885, railroads had made inexpensive industrial materials and other goods widely available to Indians, and metalware and glazed china quickly began to replace the handsome pottery of the Southwestern Pueblo tribes. Except for certain religious items and specialized cooking wares, by 1900 Pueblo pottery was almost entirely dedicated to the tourist market. Then a new consciousness of pottery as "fine art" arose among the Hopi people. Just before the turn of the century, in the First Mesa Hopi village of Hano, a woman named Nampeyo taught herself first to imitate and then to elaborate on the forms and designs of a local prehistoric ware called Sikyatki Polychrome. According to J. J. Brody (in Graburn, 1976), the archaeologist J. W. Fewkes encouraged Nampeyo, as did her husband, who worked as a laborer for Fewkes and brought to his wife's attention examples of ancient pottery shards from Fewkes's digs. The nearby trading post at Keams Canyon was anxious to market Nampeyo's exceptional work to tourists who visited the post. "Within a decade Nampeyo's success, as measured by increased income, inspired potters in all of the Hopi towns to participate in a craft revival that continues to the present" (Brody).

This impulse to produce fine pottery along ancient lines spread throughout the Southwestern region. At San Ildefonso, Santa Clara, San Juan, Acoma, and among many of the other pueblos, pottery production became both abundant and highly refined. At San Ildefonso Pueblo, for instance, by 1920 the potter Maria Martinez and her decorator husband, Julian, were recognized by collectors and art patrons as prestigious "name" potters. "The most visible sign of acceptance by potters of their new role as artist/craftsmen first occurred in the 1920s, when Maria and Julian began to sign their products" (Brody).

Navaho weaving has a somewhat similar history to that of Puebloan pottery, except for the fact that the Navaho borrowed a weaving tradition from the Pueblo people, who had refined it over many centuries for their personal and religious use. Based on the use of cotton and the true loom, the art of weaving had probably reached the American Southwest by about the time of Christ,* having originated—perhaps in northern Peru—two or three thousand years before it made its appearance in what is now called the Four Corners Area of the Southwest.

In about 1540 the Pueblo art of weaving was much influenced by the Spanish settlers of Mexico, who brought the European spinning wheel and the treadle loom. Most important among the Spanish imports was the introduction of sheep, which provided a new fiber, never before available to Indians. Indigo blue and possibly other dyes were also imported from Mexico. A radically new

aesthetic became possible in Indian weaving. By 1850 wool had replaced native cotton in most textiles; many prehistorical techniques had faded away; indigo, cochineal, and bayeta (red baize which was raveled and then retwisted into weaving yarn) had become popular among Indian weavers. Simultaneously there was a strong trend toward the use of European cloth for everyday textile needs. The Navaho did not begin to weave until about 1700, when they probably learned the skill from the Puebloan people of the Rio Grande region. Pueblo textiles remained essentially traditional and noncommercial, while Navaho weaving, which has no profound historical roots, became synonymous with Indian textiles, though it is an assimilated and highly commercial activity for the Navaho.

Similar processes in relation to technological and aesthetic influences from Europeans may be discovered throughout Latin America. New art forms have been specifically invented for commercial purposes. According to Nelson Graburn, in Mexico "many of these, such as amate painting, Huichol yarn painting, Ocumicho pottery, and Seri ironwood carving have recently come under the benign influence of the Banco de Fomento Cooperativo, competing with local and Yaqui dealers." In South America, the Shipibo-Conibo Indians, who live in the Amazon Basin east of the Andes of Peru, have recently adapted their traditional ceramics to commercial motives, even inventing entirely new forms for urban buyers. The gourd carvers of Cochas Chico and Cochas Grande of the central Andes now produce painted and incised gourds for the international market, though their art dates back to an-

* This date is controversial, and a number of specialists place it at a much later time.

cient, pre-Inca times. Textiles, pottery, and utensils are often a synthesis of Indian and colonial Spanish elements. These new ethnic arts have been so thoroughly integrated into Peruvian, Bolivian, and Ecuadorian cultures that they have become, to all intents and purposes, traditional arts.

The Cuna Indians of South America use imported colored textiles, needles, scissors, and thread to make their distinctive *molas*—which they produce for their own use and which they also sell for export. Navaho silverwork incorporates both the Spanish pomegranate blossom—into a motif now known in "squash blossom" necklaces—and the Moorish *naja*—a horse amulet for warding off the evil eye. This technological process can be disdained only by the purist who has no historical perspective, for every nation has taken the arts of its subjugated, aboriginal peoples and "erected them as symbols of 'national ethnicity.'" As Nelson Graburn has insightfully pointed out, "Canada and the United States displayed Northwest Coast totem poles at Expo '70 in Osaka; Mexico and Peru institutionalized the monuments of conquered peoples and encourage the nostalgic commercial productions of their poverty-stricken descendants. In South America, the Spanish immigrants were quick to take up the drinking of mate, a Guarani Indian custom, and developed a ritual and set of paraphernalia for its use. This gave

them a distinctive 'South American' ethnicity, setting them off from the Spanish, much as the partly Korean 'tea ceremony' has become important to Japanese ethnicity and coffee sipping has become institutionalized for the Arabs. The United States, perhaps more than any other nation, has taken over symbols from its Fourth World minorities—from Pontiacs to Eskimo pie—and used them for such modern 'totems' as the Cleveland Indians, Alaskan totem poles, and Boy Scouts' tipis."

The point to be made here is that tradition and culture are, in every society and in every time of history, structures which survive due to growth, change, and alien influences. Ethnicity is often a legendary quality, suggesting profound aboriginal sources which do not really exist. Take, for example, the notion of "Jewish food," which is in no way related either to the Holy Land or to the Judaic diet of ancient Palestine. Tradition is a created and often borrowed phenomenon which provides the distinctive flavor of a particular people through a thoroughness of assimilation and acculturation. The American Indian, like all peoples, is the product of a constantly changing technology—internally invented and also borrowed from external sources. What finally makes Indian art "Indian" is the mentality which transforms new and imported materials and techniques into an expression of a distinctive cultural worldview.

LEAVES FROM
THE SACRED TREE

As I have already mentioned, an enormous part of the surviving arts of Mesoamerica and the Andean region exists without ethnographic documentation. In many cases we do not currently know, and may never know, how and by whom these precious objects were used. What I will offer, when such documentation is missing (and even when it is available but not central to the aesthetic focus of this book), is an effort to use words to describe these objects' visual impact as works of art. And finally, as Read has said of the works of the Classical Greek sculptors, and as Kubler has said of ancient Native American artisans, "we have to extract from the historical series of works of art those 'deviational' meanings that were not apparent to the people themselves who made and used the objects, and which appear only to the historian after the series is completed" (Kubler, 1975).

Drawings and photographs will be used whenever possible to provide a vivid impression of the objects under discussion. The sources of the illustrations are intentionally diverse: some illustrations were provided by private collections, thus making available art objects usually unseen by the public; some were provided by major museums, where interested readers may personally see major Indian collections and the works firsthand; and, finally, some images are taken from locations so remote that photography is one of the few means by which we are able to encounter important architecture, objects, and ceremonial activities. In all cases I have attempted to provide photographs of the most typical and aesthetically valuable examples of objects, the least known as well as the best known examples, and those which possess a uniqueness of character and expression which makes them—in any cultural context—*great* works of artistic achievement.

The organization of this major section of the book is a bit unusual, for it does not follow the chronological or regional plan of most books about Indian art. To a certain extent the classifications are traditional: architecture, sculpture, painting, and so on, but since these standard classifications of art tend to ignore or amalgamate a great variety of media into one class, I have added certain classifications used in North American Indian art histories, even though they do not normally appear in books about Mesoamerican art: skinwork, beadwork, and so on. Admittedly some of these classifications are arbitrary: figurines are discussed as part of pottery rather than carving and sculpture, but at every opportunity I have opted for an aesthetic rationale. And yet history and ethnology have not been neglected. To the extent that it is possible, without being diverted from the aesthetic focus, each chapter is concerned with an art medium in its chronological and regional evolution throughout the Western Hemisphere. In this way, an essentially aesthetic context includes a chronological and a regional substructure for our discussion of each art medium.

Finally, I have included—if only in a cursory manner—cultural elements often missing from histories of Indian art: oral and written literature, as well as music, dance, and ritual—those primal forms of expression which are at the very core of the Indian aesthetic sensibility and often shape and focus the visual art forms, which are merely "paraphernalia" in the holistic realm of tribal rites and storytelling.

4.
Basketry

Basketry is the mother of the arts. It is presumably the precursor of loomwork, quillwork, and beadwork, and it is very probably the source (at least in North America, and probably in the world) from which pottery forms evolved—a hypothesis suggested in the late nineteenth century by F. H. Cushing of the Bureau of Ethnology (see James, 1909/1972). In northeastern Mesoamerica (an area adjacent to present-day Texas), fiber is by far the most abundant material found in the archaic Desert culture, dating from about 10,000 years ago. Among the finds in this region are plaited and braided fiber (mats, sandals, and bags), knotted fiber (netting—which probably evolved into the techniques of weaving), twined fiber (mats and containers), and simple coiled baskets. Irmgard Weitlander Johnson reports in "Basketry and Textiles" (see Wauchope, 1966) that "archaeological finds in the Valley of Mexico indicate that there may have been a certain amount of basketry and matwork specialization in this Middle Preclassic period" (c. 5000–3000 B.C.), and that this basket industry was the undertaking of males—unusual for North American Indian tribes, which normally assigned the creation of baskets to women. According to European documents dating from the early sixteenth century, ropes, string, and hammocks were made of hennequen and cabuya in Panama, Pacific Nicaragua, and Costa Rica. Baskets for clothes and salt containers were fashioned by women from bijagua stalks, woven double or interwoven with leaves. Yet most discussions of the art of basketry are generally limited to modern Indian crafts and to the antiquity of the tribes of North America, where several extensive and magnificent traditions of basket making flourished. The rationale for the absence of an elaborate literature on the basketry of Mesoamerica and of lower Central and South America is based on the fact that "relatively small amounts of perishable materials have survived . . . because the climate is humid and because some tribes cremated their high personages and placed with them most of their belongings" (Johnson, in Wauchope).

Thus little remains of whatever ancient basket tradition might have existed among the Indians of Mesoamerica and southward to Tierra del Fuego. We have a glimmer of the elaborate basketwork of the Maya through their carvings, but we must conclude with Le Roy H. Appleton (1950) that "elsewhere in the Americas, basketry was usually lacking in design other than that provided naturally by the weaving process. The techniques were good enough. Baskets were made in a great variety of shapes and sizes, ranging from storage baskets large enough to hold a person down to small catch-alls for trinkets."

Therefore, it is the Indians of the American (United States) Southwest, California, and Pacific Northwest Coast who were and, in some cases, still are among the world's truly great basket weavers. Whatever basketry might have existed in elaborate aesthetic form in

other parts of the ancient Americas has been utterly lost. And so it is upon the basketry of North America that we will concentrate.

The basket maker expresses his or her aesthetic skill and taste in two important ways: in form and in decorative design. Unlike sculpture and painting, basketry imposes rather strict limitations and conventions upon the artist. A good deal of ingenuity is required to transform these limitations into forms and iconography with imagination, improvisation, and artistic merit, though the restrictions of the medium are such that they can never be entirely overcome. Designs in basketry are worked out by using rushes, reeds, grasses, bark, cane, wood splints, and vines of various colors, either natural or dyed. Other materials may be added in the weaving process, such as beads, shells, and feathers. But the technique itself is limited in terms of design and form—for the basket must be built up in square or rectangular units, which produce an inevitable geometric configuration. In contrast to textile weaving, which is based on fine materials, the units of basketry are usually large and therefore automatically produce a "stepped" effect. The fact that basketry is formed of interwoven materials results in its angularity of designs. The finer the materials of the basket maker the more this angularity can be overcome and the more curvilinear can be the designs. In some of the finest coiled baskets of California, for instance, there are as many as seventy stitches to the inch, and the effect is startlingly free and handsome in comparison to the extremely coarse baskets, made for purely utilitarian purposes, in other areas of the world.

North American Indians rank very high as basket makers, equaling and often excelling the aboriginal peoples of other continents in their variety and mastery of techniques. The coiled trays produced by the Hopi are exceptional, for this form is duplicated only in North and South Africa, South India, and regions of China. The Indians of British Columbia produce a unique form of coiled basket, using a process known as "imbrication," in which an overlay decoration is applied as the sewing of the basket proceeds, so that the form is built up with coils of cedar roots, while grasses and thin pieces of bark (dyed red or black) are used to form an overlaid design. This technique is found nowhere else in the world.

There is evidence that there was once abundant basket making among the tribes of the Atlantic and the Gulf of Mexico coasts, but, as E. W. Gifford points out (*Introduction to American Indian Art, 1931*), "there seems not to have been so high a development of the art as in western North America, where aesthetic motives seem to have played a more important role." It is only in recent years that the basketry of the Southeast (particularly among the Eastern Band Cherokee) has reemerged as a brilliant tradition, which we shall discuss at the close of this chapter, along with other basket makers of today.

Indians made baskets at least 10,000 years ago—a long time before pottery was developed and used. Basketry may well be the most important of the arts insofar as it is apparently the oldest of all human crafts, with the exception of the manufacture of basic stone tools and projectile points. Certainly, in every part of the world, basketry seems to have

Coiled Baskets

One-rod coiling

Three-rod coiling

Five-rod coiling

Fiber bundle type

Plaited Baskets

Starting

Plain plaiting

Twill

Wicker plaiting

Twined Baskets

Plain twine

Wrap twine

Twill twine

Open twine

Drawings by Asa Battles.

provided the impetus for all other forms of artistic expression, both in terms of form and iconographic design. Archaeologists (such as Jennings) have suggested that the foraging culture of the ancient desert peoples of the Southwest of the United States necessitated and motivated the creation of baskets for gathering as early as 7000 B.C., meaning that basketry in the Western Hemisphere, according to archaeological evidence, is older than that of Europe (Tanner, 1976).

Basketry is a perfect example of human adaptation of the environment and its raw materials. Baskets are objects made entirely by hand, without the aid of even the simplest mechanism, by intertwining or weaving long slender pieces of various vegetable materials. There are three basic techniques. The oldest method, apparently, is twining (which appears very early and improves markedly through time, though it diminishes in quantity in later epochs and is largely replaced by other techniques). Coiling appeared next, and finally plaiting (Tanner, 1976). Like cloth, baskets are made of two basic elements in relation to one another: the warp, which is the foundation, and the weft or woof, which is the filling that connects and mats together the warps. The selection of materials to be woven is important and has a great influence on the end product. Branches of shrubs such as willow and hazel are used as coils or are split to make strands for twining. Bundles of grass and rush stems are used to produce coil. Fine baskets are made from materials obtained from the inner bark of spruce and root fern and fibers such as Indian hemp. In the American Northeast, corn husks are braided into masks and dolls, and branches are

pounded until the wood fiber separates; the layers are split for making plaited baskets. Cane and honeysuckle are the most common materials used in the Southeast.

Plaited baskets are made by the simplest technique. Two sets of elements cross each other, alternately passing over and under those of the other set to produce a checkerboard effect. This method was characteristic of the early Atlantic and Gulf Coast basketry. Plaiting generally requires flat, wide weaving materials, which prevent the delicacy possible with other, finer materials. There is plain plaiting, twill plaiting, and wicker plaiting—all variations on a single method.

Twined baskets are far more complex in structure and are made up of a set of vertical warps with two or three horizontal wefts which twine around each other as they weave in and out between the warps. Some of the best and most intricate basketry ever made is the product of this technique. There are numerous variations of this technique—soft twine, plain twine, twill twine, warp twine, open twine, and cross-warp twine.

Coiled baskets are perhaps the best known, and are made in the same way as coiled pottery. Strips of fibers such as grasses or reeds are gathered and wrapped into bundles, which are then coiled around and around in a continuous spiral, one layer on top of the prior one. The bundle is wrapped with lengths of fiber by various methods. The coils are lashed together and sewn to the previous loop of coil. One-rod coiling, three-rod coiling, three-rod tacked coiling, five-rod coiling, and fiber-bundle coiling are all variations on the basic

method used to bind the materials into the coil.

It is possible to detect certain North American regional styles in basket techniques, though to do so is an oversimplification. Coiling and twining are essentially Western techniques, while plaiting generally comes from the East. The greatest variation in the baskets comes not from the technique employed to make them, however, but from the materials used in their construction—reflecting the environment and the availability of fibers. Though basket research and collecting has centered in California, on the Pacific Northwest Coast, and in the Southwest (Arizona and New Mexico), there are eleven basic basketry regions in North America: the Plains and the upper Missouri; the Southeast; the Northeast; the Northwest Coast; the Cascades in and around Puget Sound; just below, the Coast–Columbia River region; northern California; central California; the southern California desert; the Southwest; and finally the Basin region and the Plateau.

To the novice, all baskets look very similar. Gradually, however, one begins to notice the basic techniques and variations upon these methods, which are brilliantly employed in the making of a fine basket. And eventually one is overwhelmed by the sheer variety of forms, materials, iconographic detail, and color in baskets from various regions.

The shapes of basketry are related to the most basic geometric forms: cubes, cones, cylinders, and spheres are found in infinite variety and degrees of complexity. When made of the softest materials, basketwork becomes flexible matting or dense netting, pliable and capable of being flattened and rolled,

Cross sections of varieties of coiled basketry.

though the techniques of production are the same as those which result in rigid baskets. Among the Eastern tribes of the United States, the Algonquin and Iroquois peoples produce baskets that are either cylindrical or rectangular. The same is true of the tribes of the Southern United States, although the greater flexibility of local reed cane there invites the basket weaver to experiment in a wider variety of shapes. Where wild flax and other such fibrous plants are plentiful, as in the Basin region, the sack woven of fiber prevails, while in Canada, just east of the Rocky Mountains, where birch bark is prevalent, containers are made with solid forms. Obviously, a great deal of the form and shape of basketry results from available materials. The Innuit of Alaska tend to employ cylindrical shapes, while the peoples of the Aleutian Islands, having flexible wild grass with which to work, tend to make highly pliable bags or satchels. The cylinder and the rectangle prevail among the Haida and Tlingit. Farther south one discovers great diversity of form among the peoples of the Pacific Coast of the United States; here there is an abundance of the conical basket, an ideal burden basket to be carried by tribes who are essentially foragers. From these basic geometric forms developed a variety of shapes and vessels: dishes, jars, bottles, packing cases—which have aspects of the cylinder, the cone, and the rectangle.

A deciding factor in the creation of a basket is its use, but the basket maker is also influenced by an aesthetic sensibility, which is at the core of the basketry of primal peoples such as Indians, who believe in the power of objects made from the natural materials of the earth. "It is considered a reproach to violate the rules of bilateral symmetry or proportion in form," writes Otis Tufton Mason in his landmark 1902 survey entitled *Aboriginal Indian Basketry.* "A superficial view of a large collection of baskets from any portion of North America would strike the most careless observer as the fruits of thoughtful and painstaking labor on aesthetic lines." Mason was one of the first experts to insist that naturalistic imitation was "an entire misconception of the underlying plan" of the basket maker. He insists that the skillful weaver of baskets was not "a slave to natural patterns." To the contrary, the basket maker rarely "looks to any source other than her own imagination for the model of her basket," for, "strictly speaking, she never makes two alike."

The character of basketry is determined not only by the form but also by the ornamentation from the woven fiber itself or the surface of the fiber through the use of color. Ornamentation can be achieved in a number of ways: by employing materials which are of different colors naturally; by using dyed materials; by covering the weft and warp with thin strips of attractive materials before weaving; by embroidering on the textured base material during the process of producing a basket—a technique called "false embroidery"; by covering the textural base structure with a folded overlay of plaiting, called "imbrication"; or by adding feathers, shells, beads, and other sacred and/or decorative objects. If it were not for these techniques, which give the basket maker an immense advantage in the number of colors as well as the richness of shades and harmonies, the aesthetic power of basketry would be greatly diminished.

As Mason (1902) points out repeatedly, the "symbolism" of Indian art is not an imitation of nature but a transliteration of the Indian's sense of the power and sacredness of natural objects, of the earth and all of its animals and plants. "The Salish tribes of Washington and Oregon, and those of California, Arizona and New Mexico, all place some kind of designs on their basketry," Mason writes. There is a distinction between the iconography of various tribes, and yet there are about seven or eight motifs which constantly appear from region to region: natural phenomena, such as lightning, sunrise, clouds, and rain emblems; geographic features such as mountains, lakes, rivers, and valleys; a great variety of plant images; animals and parts of animals, such as wings, fins, eyes, teeth; human and humanoid forms; mythical figures, cultural heroes, deities, and powers; and emblematic forms that represent celestial constellations, the four cardinal directions, comets, stars, the moon, and the sun.

In Western European culture, symbolism generally means that something is "hidden" behind an emblem, whereas in the Indian world, the power of imagery is found in the emblem (the natural world) itself. Therefore it is a mistake to apply the allegorical and symbolical mentality of Western art to Indian art. The symbolic process among Indians seems to be more related to the metaphoric practices of Western poets than to the symbolism of Western mystics and philosophers, who tend to use symbolism as a means of breaking away from the discursiveness of Western thinking—a prosaic rigidity which the Indian does not experience in the first place. The iconography which I have described as recurrent in Indian design is therefore to be taken as a *power unto itself* rather than a *sign or symbol of an ineffable idea.*

Today and in the past baskets are and were made for a wide variety of purposes, but their form and iconography were and still are largely determined by utility. At the same time, the aesthetic refinement of a basket is a basic Indian impulse, apparent in the production of any object.

A brief survey of the styles of basket making in the American Southwest, the Pacific Northwest Coast, and the California coastal region will provide some indication of the variety of aesthetic excellence achieved by various North American Indian basket makers.

In the Southwest of the United States, the art of basketry flourishes today the least among the highly cultured Pueblo Indians, though it was apparently abundant and excellent at an earlier date. The single exception among the Pueblo people is the Hopi basket maker, who produces exceptional ceremonial trays, as well as other fine baskets. Whereas the baskets of the California region are coiled toward the right, Arizona baskets are usually worked toward the left. Generally speaking, the greatest production of baskets seems to have occurred during the eighteenth and nineteenth centuries, among the less sedentary tribes of Arizona and New Mexico, such as the Apache. Just the opposite is true in the case of pottery. The settled, agricultural Pueblo groups are renowned for their excellent pottery, while the gatherers, such as the Circum-Pueblo groups (tribes in the Southwest region surrounding the Pueblo villages), are famous for

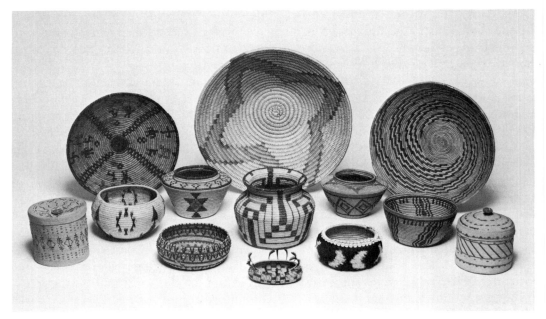

Assortment of Southwest baskets: from left to right, top to bottom: Attu twined basket, Apache coiled basket, Washo coiled basket, Paiute coiled bottleneck basket, Pomo coiled basket, Jicarilla Apache coiled basket, small Pima coiled storage jar, Pomo coiled basket, Yokut coiled bottleneck basket, Pomo coiled basket, California Mission coiled basket, Yokut coiled basket, Attu twined basket. Photograph: Sotheby Parke-Bernet.

their basketry This "rule" holds equally true in the case of the foraging tribes of California, which have produced some of the most delicate and complex baskets in the entire world. But like all rules, there are several exceptions to this one: the Hopi, as already mentioned, make flat trays and deep baskets marvelously decorated with geometric designs, plants, and kachina figures, and the sedentary Pima and Papago tribes of southern Arizona create some of the finest baskets of their region. Thus there are three distinct Southwestern groups of basket makers: the Pima and Papago of Arizona; the Pueblo tribes (including the Hopi) of New Mexico and Arizona; and the Circum-Pueblo groups, such as the Apache, Havasupai, Walapai, Navaho, Chemehuevi, and Yavapai.

A few notes about pre-Columbian basketry of the area are in order before we discuss the baskets dating from post-Columbian (historical) times. All three basic techniques of basketry—coiling, twining, and plaiting—were established and highly evolved in prehistoric times. The rare remnants of ancient baskets indicate that designs in all three techniques were highly refined artistically. The most abundant early baskets that have been found are those made by the so-called Anasazi ("ancient ones"), the culture that began with the Basket Makers, c. A.D. 100–700. The earlier baskets of the Mogollon culture (c. 100 B.C.–A.D. 1400) and the Hohokam culture (c. 100 B.C.–A.D. 1400) are very rare, because, according to Tanner (1976), their known sites were submitted to long exposure, in contrast to the cave-sheltered digs related to Anasazi culture.

In all prehistoric wicker work, the designs were very simple and coarse in construction. Designs in the most ancient plaited basketry were bulky and bold, extremely angular, and, though balanced and symmetrical, usually

worked over the entire surface. Basket decoration was carried out with dyed splints used against a natural-colored background. Occasionally bird quills and even turquoise mosaic are found worked into prehistoric basketry. Among the three basket techniques, baskets produced by coiling exhibited more variation and complexity than the other two types of weaving. For reasons unknown to us, plain plaiting was rare in the prehistoric Southwest. More often encountered among archaeological finds are examples of twilled plaiting: a weaving method using an over-two-under-two technique. Little remains of this ancient basketry, though the heritage of the Basket Makers culture apparently survived in the work of Indians encountered by Europeans after the fifteenth century. Exactly to what extent the prehistoric traditions in basketry were carried forward is unknown to ethnologists. "With the exception of the Hopis, the trend has been in the direction of the gradual elimination of basket making among the puebloans as well as some of the other tribes" (Tanner, 1976).

The Papago basket was formerly sewn with willow fiber, while bear grass and yucca were generally used in making the coils. The walls of the baskets were often pounded in order to make them smooth and even in texture. In general, the Papago basket is darker than the baskets made by the Pima. A novel form of waterproof basket made by the Papagos was used for brewing *tiswin* wine, made from cactus fruit. The Papago basket of today is usually made of bear grass or yucca. Figuration, especially human and animal figures, is common in modern designs. Probably the Papago now make more baskets than any other North American tribe.

The Pima produce undyed flat or beehive coiled yucca baskets, as well as simple forms, patterned with subtle brown and soft green fibers in geometric whorls and zigzags, and irregular broken stripes. Pima baskets, like those of the Papago, were traditionally made of willow fiber, though today the baskets are usually made of bear grass and yucca. Tough devil's-claw fiber is generally employed for making the designs as well as constructing the bottom and the rim of the basket. The rim is usually finished, not with the technique used to produce the body of the basket, but with a so-called herringbone stitch. Deep baskets are made with narrow coils of split cattail stems and produce very thin, even walls, which are remarkably refined and elegant. Figurative designs include corn patterns and icons representing coyote tracks, as well as other animal forms. The most curious of Pima baskets are those that are highly miniaturized and made for the tourist market. Some basket makers specialize in tiny baskets made of horsehair. There do not appear to be any ancient antecedents for these commercial miniatures.

As already indicated, Pueblo baskets were once numerous and diverse but are rare among most of the villages, with the exception of the Hopi, who continue to produce excellent work. Though coiled, deep baskets are still made on Second Mesa in Hopiland (Arizona), the major production of basketry is in the form of flat ceremonial trays. The coils are thick and rather soft and flexible, made of bundles of yucca or grass sewn with strands of yucca leaves dyed in

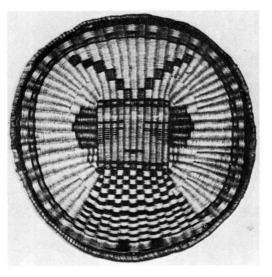

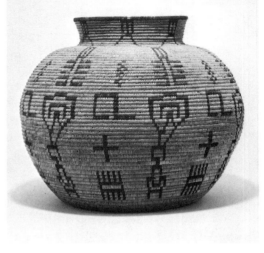

bright colors. The designs of the trays are especially fanciful and handsome, including geometric figurations as well as angular representations of plants and kachinas. According to Andrew Hunter Whiteford (1970), "Wicker baskets from the Hopi village of Oraibi on Third Mesa are the finest in North America, with brilliant colored kachinas, abstract birds, whirlwinds, and checks." In contrast, at Zuñi and San Juan villages, openwork bowls are made with simple, pleasant designs.

Among the Circum-Pueblo tribes, whose settlements surround but do not include the Pueblo villages, excellent coiled baskets with rod-bundle construction are made with distinctive skill and imagination. The coils of the bowl shapes are normally worked in a counterclockwise direction. The Western Apache usually make coiled baskets with willow stitching around the coils of three small rods. Designs are usually whirling, linear patterns or geometrically delineated figures of people and dogs. Most common are bowl shapes and extremely

large storage jars. Burden or pack baskets (made by twining) are now used as gifts and are often decorated with buckskin fringes and tin "jingles" secured to the tips of the fringes. Another famous Apache basket—especially among the Western Apache—is the bottle-basket, which is sealed with piñon gum to make it waterproof. These bottle-baskets are not very attractive, and are generally made for utilitarian purposes without much regard for design. The Mescalero Apache produce flat, loose baskets with the three-rod coiling technique. The leaf of the yucca plant is often used for stitching, providing simple geometric designs. Jicarilla Apache baskets normally have thick, five-rod coils sewn with shiny gold sumac stitching.

To continue with a brief survey of the basketry of the Circum-Pueblo peoples, the Havasupai make coiled baskets with black linear designs on a three-rod construction. They also produce pack baskets with hoop rims and leather points. The Yavapai and Walapai basketry follows along much the same lines as that

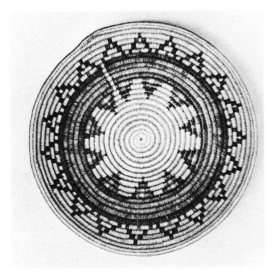

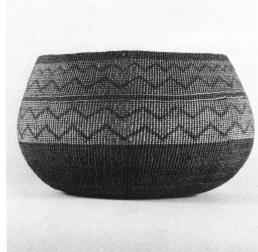

Left: Navaho ceremonial basket: the so-called Wedding Basket. Arizona, c. 1910.

Right: Hoopa twined utility bowl. Woven with two pale yellow panels of zigzag decorations. Photograph: Sotheby Parke-Bernet.

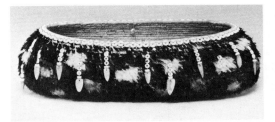

Pomo coiled boat-shaped basket. The tightly woven body is decorated with yellow, lavender, and greenish black feathers in a pattern of triangles. Photograph: Sotheby Parke-Bernet.

of the Apache, while Navaho baskets are quite rare today. The "wedding basket," though famous as a Navaho creation, is usually made today by various Paiute groups of southern Utah.

The basketry of California is probably the most extravagantly wrought, the finest in detail, and the most technically perfected of any baskets produced in the world. Northern California was a region famous for overlay twined baskets, in which the weft of conifer roots was covered with strands of glossy yellow bear grass or shiny black fern stems. There were two forms of overlay: half-twist (used primarily by the Yurok, Karok, and Hoopa peoples), and full-twist (prominent among the Shasta, Achomawi, and Maidu tribes). Full-twist is visible on both the exterior and interior surfaces of the basket, while half-twist shows only on the exterior.

Central California tribes made both twined and coiled baskets. The most acclaimed basket makers of this region were the Pomo Indians, whose great variety of shapes, excellence of techniques, and superb decorative designs surpassed all other basketry. Though the basket making of California Indians came to a standstill in the mid- and late eighteenth century, there is no doubt that among the Pomo the art was of an order unmatched anywhere else on earth.

The Pomo are famous for their coiled baskets, the most impressive of which are ceremonial pieces spotted with the feathers of the quail and woodpecker. Feather mosaic was also highly refined as a decorative device in basket making by the Pomo. The basic form is generally spherical, and the clockwise coils are one-rod or three-rod stitched with sedge root. Utilitarian Pomo twined baskets are also exceptionally handsome and highly decorative.

Like the Pomo baskets, the most impressive baskets of the neighboring Maidu, Miwok, and Wintun tribes were made by the coiling technique. The most distinctive shape of baskets in this area was that of bowls with flared walls. The Washo of this region usually produced spherical baskets of one-rod and three-rod construction. The Washo craftspeople made some of the very best specimens of central California, and like their Pomo neighbors, they frequently interlaced the basket surface with a network of glass trade beads.

In southern California the best-known baskets are coiled constructions, with the coils running toward the right. The so-called Mission tribes (those tribal units shattered by missionaries and then attached as laborers to various missions) at one time produced marvelous and brilliantly colored coiled baskets. Today that tradition is entirely lost. The coils, which were loose and large, were sewn with stitches of juncus rush, which gave a fine, glossy surface to the mottled yellow-brown baskets. These baskets were typically in the form of shallow bowls. There was a tendency to devise asymmetrical geometric motifs—a ten-

dency which is unusual in Indian basketry. The favorite colors were black and deep red.

Though the basketry of California is an achievement of inordinate skill and aesthetic refinement (a fact which is easily and overwhelmingly determined by a visit to the definitive basket collection of the Southwest Museum in Highland Park, Los Angeles), it is the basketwork of the Northwest Coast which has made the deepest and widest impact upon tourists and casual collectors. This wide region, from Alaska to Puget Sound, is famous for its sheer, flexible baskets made of delicately fine split spruce roots as well as a variety of other materials. The most impressive baskets were the result of twining, although plaiting was also an important local technique. The styles change as we move along the Cascade Range in British Columbia and Washington. Stiff coiled baskets were produced with cedar or spruce root bundles. Three interesting forms of decoration were typical of this region, while one technique—imbrication—was found nowhere else in the world.

Decoration was often applied with paint or false-embroidery and relief techniques. Imaginative animal forms were depicted with pigments on flared, conical hats and on Tlingit ceremonial headdresses. The painting is executed without regard to the weaving and often crosses the stitches; it appears only on the exterior of the object. False embroidery was a more complex device than decorative painting. It was achieved with a strand of colored grass coiled around each weft stitch as it was twisted toward the outside of the basket. The strand was interworked during the construction of the basket in such a manner

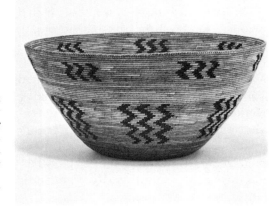

Southern California coiled basket, with flat base and high flaring sides. Woven in blackish brown with long and short panels of zigzag lines. Photograph: Sotheby Parke-Bernet.

that its color shows on only one surface. The effect was highly elaborate and delicate.

As indicated earlier, imbrication was unique to the Cascades region.* A surface of rectangular forms was created by covering the coils of the basket with a strip of colored grass or cherry bark, which was folded under each stitch as the coils were sewn.

This, then, is the classical basketry of North America. Unfortunately, most of its early history and heritage is lost to us, yet through the influence of European trade items and the creative powers of the Indians of California, the Southwest, and the Pacific Northwest Coast, several outstanding traditions of basket making have flourished and provided us with remarkable and beautiful objects. The production of most Californian basketry ended about one hundred years ago. The basket making of the Pacific Northwest Coast has been generally obsolescent since the turn of the century, while the production of baskets has proliferated considerably among some of the Southwestern tribes of the United States. Another important region where basketry is a highly developed craft is the Great Smokies of Appalachia, where the East Band Cherokees persist in their woodland lifestyle. Contemporary usage has strongly affected the shapes and uses of the baskets, but the techniques are wonderfully refined and the styles are handsome and strong. Lucy George was a well-known basket maker who perfected a weave composed of honeysuckle vines on a white oak base, colored with

*Some authorities believe that imbrication was probably invented in the Plateau.

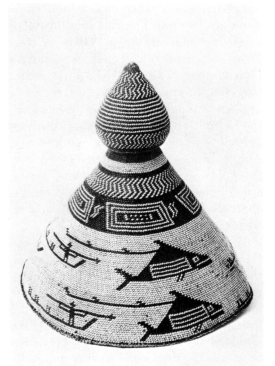

Nootka basketry hat, made of cedar bark and squaw grass. Northwest Coast, eighteenth century. British Museum, Museum of Mankind, London.

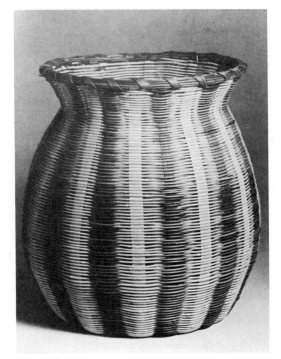

Cherokee basket, made of white oak and honeysuckle, by Lucy George (Cherokee, North Carolina), c. 1955. Collection of the author.

natural dyes—a technique which came down to her from her ancestors. Another Cherokee woman, Agnes Lossie Welch, is one of several basket makers who have revived the traditional white-oak splint basketry, producing both the traditional cuplike "underarm" basket (square on the bottom and bowl-shaped on the top) as well as other shapes for modern use. The technique of these weavers involves the splitting of white oak slats, which are then woven into a variety of forms and dyed with blood root, yellow root, and walnut root.

Forms of contemporary basketry exist throughout Mexico and South America, though in none of these areas has basketry ascended in style and technique to the level of refinement found among the Indians of North America. In fact, the standard texts on the crafts of Peru, Ecuador, and Hispanic America generally provide only a few sentences on the subject of basketry. An exception to this lack of attention given the modern Latin American basketry of Indians is in Lilly de Jongh Osborne's work, *Indian Crafts of Guatemala and El Salvador* (1965). As she states, "the basket craft is of such importance in Guatemala that in Chajul one of the early dances celebrates this craft." The dancers wear baskets as ceremonial headdresses. And yet these excellent utilitarian baskets possess none of the delicacy or exquisite technique of the basket traditions of North America. "None of the baskets in Guatemala or El Salvador are woven in a complicated technique. The majority are built up by crossing from six to ten splints of the material at the center of the basket and weaving a pair of weft reeds in and out of the main splints—different from European and North American Indian techniques" (Osborne, 1965). We may apply these remarks to all baskets now made by Hispanic Indians. They are attractive but lack complexity and refinement.

The oldest of the arts—basketry—has been preserved and renewed by many contemporary Indian craftspeople, but it is something of a miracle that basket making has managed to survive in the modern world. The number of hours of labor required to make even a simple basket, let alone the technique and artistry demanded in the making of an elegant, highly decorated, and beautifully constructed piece, is so great that traditional basketry is unimaginable in terms of today's manufacturing mentality. The introduction of inexpensive, mass-produced containers made by Anglo-Americans and Europeans is a striking tribute to the undying art of basketry, which persists—if not for its utility then surely for its great and enduring beauty of materials, form, and design.

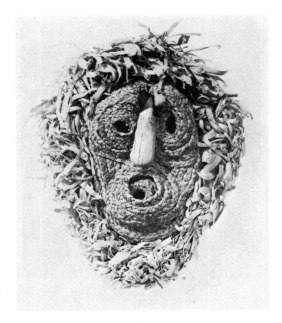

Iroquois corn-husk False Face mask. National Museums of Canada, Ottawa.

5.
Textiles

One of the most elaborate of the ancient arts of the Americas is the making of textiles. The oldest extant specimens of fabrics were found in the Andean region. Many other examples of weaving have been lost. In the areas occupied by the Mexican and Maya peoples, there are practically no remaining examples of textiles, due to climatic conditions, which are unfavorable to the preservation of fiber. Yet a rich residue of the magnificent apparel of the Indians who greeted the conquistadores exists in the descriptions of many European chroniclers of the sixteenth century. For the Maya, whose cultural centers were abandoned in the ninth century, before the coming of white people, the excellence of their weaving can be surmised only from images painted on pottery and in murals, such as the splendid images discovered on the walls of the jungle sanctuary known as Bonampak. Textile manufacturing can also be appreciated from the depiction of complex regalia on stelae and other ceremonial carvings.

Such indirect evidence is highly impressive. There is, however, more concrete proof of the achievements of textile making in pre-Columbian Peru, where schools of weavers of unmatched skill evolved forms of weaving almost unlimited in their diversity, excellence,

and complexity. As Le Roy Appleton has pointed out, "no people in the history of fabric-making have ever achieved such technical skill or excelled these people in their design or color. Theirs is the most perfect weaving record left by any peoples in the world."

Textile weaving was one of humankind's most significant inventions. Though the making of baskets surely laid the foundations upon which weaving was built, it is the unlimited versatility of weaving (in contrast to the limitations of basketry, which prevent development beyond specific limits) that has allowed textile weavers to achieve such remarkable results, both in technology and artistry.

The making of cloth implies a knowledge of the placement and fixing of threads, which usually requires special apparatus, such as a loom—on which the fixed threads (known as warp) are stretched so they may be interwoven by movable threads (known as weft); together, the warp and weft form the cloth.

The weaving material (whether cotton or wool) is usually obtained in tightly wound skeins, which have to be untangled (or combed), degreased, and softened by various techniques before they can be made into threads by twisting or spinning the fibers. Threads are then wound into balls according to color, thickness, and texture. Due to the limits of natural colors, much of the weaving material is often dyed with vegetable, animal, and mineral pigments.

The cloth produced from this material is loose or taut, depending upon the tension of the warp. Firmness of the fabric depends upon the thickness of the

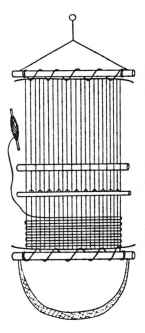

The back-strap loom.

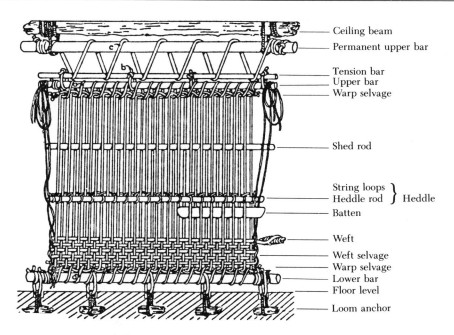

Ceiling beam
Permanent upper bar

Tension bar
Upper bar
Warp selvage

Shed rod

String loops }
Heddle rod } Heddle
Batten

Weft

Weft selvage
Warp selvage
Lower bar
Floor level
Loom anchor

The true loom.

threads and the manner by which they have been interwoven. The refinement of textile technology requires finesse, though not a very great artistic ability, but in the aesthetic elaboration of weaving great skill is indispensable.

Master weavers, called *Kumbi-camayoq* in the Inca Empire, achieved remarkable results, which continue to impress us in our own era. It is the textile work of pre-Columbian Peru that truly stirs the imagination and, as Pal Kelemen has stated, "places reality before our eyes." For the ancient peoples of Peru cloth had a calculable value. Neither gold nor other laboriously worked metals had the value of textiles. For the Peruvians, textiles became the outward symbol of power and wealth. And so it is with their production of superb weavings that this survey begins.*

Because of the arid conditions of the coastal desert of Peru, even the oldest

and crudest woven remains have been marvelously preserved there, providing archaeologists with detailed evidence of the evolution of textile making. The development of weaving apparently commenced there almost 10,000 years ago, with the production of rope. The making of rudimentary fiber ropes culminated about 3,000 years ago, in textiles of marvelous technical quality, design, and colors. The production of actual woven "cloths" commenced in Peru about 8,000 years ago, when Peruvians began to make a fabric composed of loops (like primitive netting), the manufacture of which did not require any ap-

* There is not a clear line between the technology of basketry and that of textiles. There is also a thin line between the techniques of skinwork, featherwork, and beadwork. For instance, skins, though not made of fibers, are nonetheless worn in a manner similar to cloth and are therefore often considered part of textile manufacture. In this book, however, skinwork, featherwork, and beadwork will be discussed separately from fiber weaving.

paratus, since it was made by the process of interlacing (joining fibers with knots). These first utilitarian textiles were made of vegetable fibers. True cloth did not replace vegetable materials until several thousand years later, when cotton was domesticated and wool was collected from the camel-like llama and alpaca. These essential materials for the production of textiles appeared about 2500 B.C., but their use was not firmly established for another one thousand years, when the technique of spinning was invented.

It was the Chavin civilization which was apparently responsible for the rise of textile art to a place of eminence. In fact, the Chavin culture represents the climax of an elaborate process, with multiregional influences, in which vast and exceptional discoveries took place. It was during the Chavin period that imaginative use was made of a wide range of natural resources and various raw materials. Cotton and wool made their first appearances during this period. The use of dyes was established. And, finally, there was the full employment of the loom and the appearance of nearly all the textile techniques known to the early Peruvians, which formed part of a technological revolution that was apparently connected to widespread social reform. Though little specifically is known of these events of the second millennium B.C., it is clear that social and artistic evolution were aspects of a complicated interplay of political and technical expansion. It is safe to say that the Chavin civilization can be credited with this remarkable process.

The appearance of cloths known as "llanas" or "smooth" (made by interlacing thin threads to form a delicate, flat surface) soon gave rise to designers using fiber surfaces like "canvases," on which to portray colorful and patterned successions of deities and geometric motifs. While limited experiments in figurative design had occurred earlier, it was not until the smooth cloths appeared that weavers were able to evolve a unique pictorial tradition—a process which gave rise to "textile painting" in the Andes, where true painting has not been found.

The initial textile techniques did not include tapestries, and therefore certain conventions and limitations characterize early fabrics. "Because the woven support for the design is flexible," George Kubler points out, "and is meant to be worn as clothing in unforeseen folds and overlappings, textile designers are always reluctant to cover the surface with large pictorial compositions which are visible only when stretched out, as could be done in tapestries. Far more appropriate for clothing are small-figure designs of geometric character, spaced in repeating patterns so that one visible

Paracas embroidered burial cloth (detail), showing figure with human trophy head. Peru, 100 B.C. National Museum, Lima.

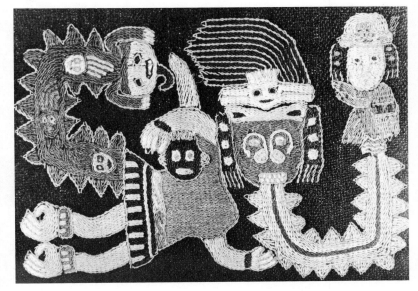

portion suggests and recalls all the portions concealed by the folds of the cloth." Of course the technical characteristics of the loom itself further limit the designer; large curvilinear shapes are usually restricted to techniques such as embroidery. "The weaver must resolve all curves into the rectangular co-ordinates of warp and weft. An escape from the requirements of the loom is given only by additive techniques imposed upon the finished cloth, such as embroidery and certain brocades" (Kubler).

In later Chavin times, weavers began to make tapestries, a form which gave great scope and daring to the use of many-colored threads. Harmoniously blending the warp with threads, the weft was completely hidden, and images and designs were thus formed without the addition of anything that was not an intrinsic component of the cloth. Yet even this liberating tapestry technique could not change the limitations of the

loom: the imagery was rectangular. So important was this geometric precept in the manufacture of pictorial textiles that the images portrayed on pottery and stone steadfastly imitated the rectilinear forms of weaving—providing a unique style in Andean art in all media.

The achievement of the Chavin people in textile manufacture flowed into the cultures of various related but later civilizations of Peru. As the populations of settlements increased, it became possible to support a special class of artisans who dedicated themselves entirely to the making of remarkable textiles. Excellent specimens of this illustrious textile production were rediscovered on the southern coastal desert of Peru, where a prodigious hoard of mortuary fabrics was found at the so-called Necropolis of Paracas, dating from before the Christian Era. The famous mestizo scholar, Julio C. Tello, found in Paracas a huge cemetery, containing in just one of its numer-

a

Excellent specimens of Paracas textile production are the burial materials that have been discovered in the southern coastal desert of Peru. (a) Mummy bundle. (b) Grave site.

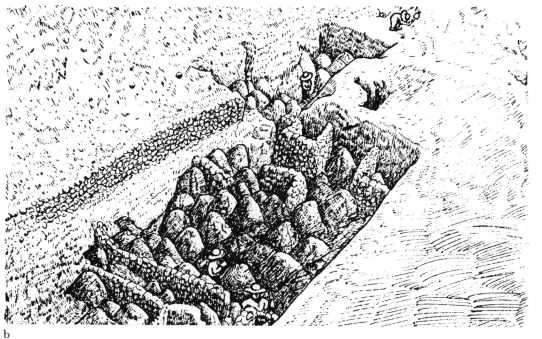

b

ous enclosures 429 mummified bodies completely wrapped in textiles of the most varied and glorious quality, forms, and sizes. These Paracas tapestries and textiles display elaborate workmanship, as well as evidence of considerable specialization among weavers. It is now assumed that various stages of the process passed from hand to hand: from spinners to weavers to dyers, embroiderers, and various other specialists. Thus, as early as the second century A.D., textile experts existed and were perhaps similar in rank to the weavers called *Kumbicamayoq* in Incaic times.

The textiles at the climax of the Paracas period were exceptionally rich and varied. Although the majority of the cloths were embroidered, there were also numerous examples of bands or strips of killim textiles, which, because of their elasticity, were often used as belts, turbans, and headbands. Another important Paracas invention closely resembles knitting but is actually a type of needlework similar to embroidery. This form of weaving was used to make unique three-dimensional images, which appear in relief against a smooth fabric base.

The Paracas weavers apparently recognized important variables in raw materials. For instance, they knew that cameloid wool (llama and alpaca) absorbs and retains an extensive range of colors, without the need for complex use of chemicals to set the dyes, whereas quite the opposite is true in the case of cotton. Therefore large Paracas textiles tend to be made of cotton, while wool was used for colorful detail.

The dyes were mainly obtained from vegetable sources, providing blues, yellows, greens, and reds. (It is possible that

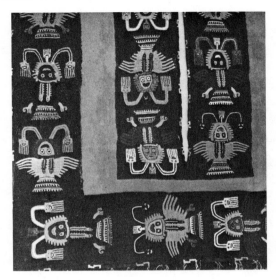

Paracas textile (border detail). Peru. National Museum, Lima.

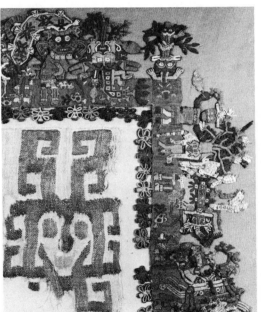

Paracas mantle. Peru, 65 B.C.–A.D. 20. Photograph: Brooklyn Museum.

a parasitic insect, the cochineal, was also used, to produce vivid red hues.) These colors made the Paracas textiles a brilliant polychromatic display never surpassed anywhere else in the world. Combined with this rich palette was an iconography of vast imagination and pictorial brilliance—a persistent inven-

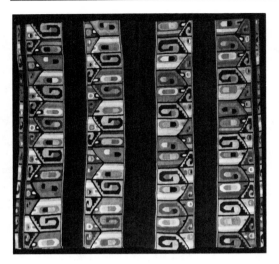

Poncho-shirt. Interlocked tapestry with cotton warps and alpaca wefts. The geometric motifs consist of stepped frets or spirals paired with stylized profile heads, a classical example of idealized figurative-geometric design. Classic Tiahuanaco style. Textile Museum, Washington, D.C.

tion of rectilinear forms of staggering variety and complexity, subtlety, and elegance.

While this evolution of textiles was under way, the scattered urban centers of Peru were changing from small ceremonial settlements into sprawling townships, populated by a variety of peoples: Nazca, Moche, Tiahuanaco, and many other tribes. In the period covering at least the first five centuries of the Christian Era, textile art began to develop into distinctive regional styles. The central Peruvian textiles were essentially made of cotton and wool, and employed a gorgeous array of colors. The northern weavers of Peru, especially those of the Moche people, worked in somber colors but employed extremely rich iconography. Their contentment with just two or three drab tones made it possible for them to work almost exclusively in cotton (which is more difficult to dye than wool). In the south, the region of the Tiahuanaco people, wool was the most common fiber used by weavers, but—perhaps due to the lack of dyes—the colors are dull and tend toward sepia,

which is the natural color of cameloid wool. In the central region of Peru, consisting of the Lima, Ica, Ayacucho, and Huancavelica peoples, the climate and soil were suitable for many dye-producing plants, such as molle, chilca, kishka-kishka, lambras, achiote, and the nopal cactus on which the red-dye–producing cochineal feeds. This abundance of sources of dyes was an important impetus for the further evolution of regionalized textiles. This period also saw various social changes which greatly affected the production of textiles. During the fifth and sixth centuries the land was divided into a number of "states," which struggled for the domination of Peru. One of these domains was in Ayacucho, in the central sierra region, and was a prime producer of high-quality textiles. The people and their culture are now called Wari (Huari).

It appears that toward the end of the sixth century alien tribes invaded Ayacucho. These conquests were the basis for a vast new empire, which was finally established during the sixth and seventh centuries and which apparently dominated Peru until at least the tenth century. The elaborate culture that resulted from this expansion has been persistently called "Tiahuanaco," in spite of the fact that many artifacts of the region are readily recognized as Wari. One reason for this confusion, according to L. G. Lumbreras, "is the fact that from the time of Max Uhle the entire Wari culture was identified as Tiahuanaco and it is only since the 1950s that the two cultures have been separated." Another aspect of this confusion is clearly the fact that in the Wari textiles there frequently appears an anthropomorphic figure which is closely associated with the reli-

gion of the Tiahuanaco people. Thus it would seem that Wari iconography was derived from Tiahuanaco sources, though it gradually changed and acquired characteristics unique to Wari culture. There is, nonetheless, an important distinction between the cultures of the Tiahuanaco and the Wari peoples.

The rise and expansion of the Wari domain produced a wide-ranging and major reaction throughout Peru. With regard to textiles, this expansionist period resulted in very substantial changes. Perhaps a good indicator of Wari influence may be seen in the so-called Phase V (eighth century) of the Moche culture. Because of contact with the Wari civilization, Moche people began to abandon their use of typically somber colors and, instead, to employ brilliant hues in their weavings—in which strong blue tones alternate with the bright shades of red

and yellow. Wari influences may also be the source of a less naturalistic emphasis in Moche art. Lumbreras suggests that Wari culture did away with "the dislike of abstract and reticular weaves and permitted the portrayal of new personages and outlines which did not require naturalistic models."

The influences of the Wari style were enormous, touching the Chimu people—tribes who developed a civilization on the north coast, which eventually replaced that of the Moche after the eleventh century. In every direction the Wari impact may be discovered in the iconography and styles of the textile arts. It is notable for its formality, clearly modeled upon an official or religious dictate. Little was arbitrary in Wari weaving; every element of production seems to have been institutionalized. The tapestry technique predominated,

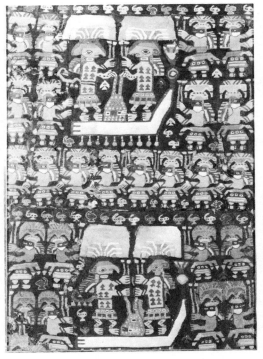

Left: Wari-style tunic (fragment), with shell collar design, felines, musicians, and feline-headed staff-bearing figures. Dumbarton Oaks Museum, Washington, D.C.

Right: Moche textile, c. A.D. 200–700, in deep purplish-red, green, ocher, tan, blue, white, and pink on a dark brown ground. Figures of victorious warriors are holding a prisoner upside down between them; they are surrounded by rows of warriors. each holding a staff, and with llama heads, fish, and other animals in the field. Photograph: Sotheby Parke-Bernet.

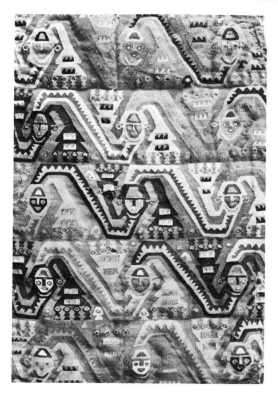

Chimu textile. Peru, north coast. National Museum, Lima.

a

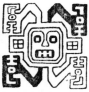

b

(a) Wari bilateral symmetry: the "triangular head" motif. (b) Wari radial symmetry.

as did the use of cotton in the warp and alpaca or vicuña wool in the weft. "The rigid discipline of these ceremonial cloths demanded standards ranging from the width of the looms to the use of color and design" (Lumbreras). These elements provided the basis for the unified influence of Wari textiles, specifically, and of their arts in general.

What is most characteristic of Wari influence is the tendency to frame rectangular patterns in accordance with bilateral and radial symmetry. The easily recognized "triangular head" of a deity conforms exactly to this bilateral symmetry; the head consists of opposing triangular pairs, which in turn form a triangle consisting of two triangular forms joined by their hypotenuse where the head is the motif of one of the triangles and the graded steps occupy the other.

This is a typical motif of Wari style, and it is probably the most commonly discovered figure of textiles wrongly attributed to the Tiahuanaco culture. In contrast, radial symmetry consists of designs with four similar elements, facing each other around a central point, and forming complex figures which introduce elements such as spirals, graded steps, or by the repetition in four opposing directions of the same feline or bird motif.

Another dominant characteristic of Wari textiles was the tendency to produce parallel bands depicting a single figure which is repeated over a large area of the cloth. These iconographic elements persisted in Peru long after the fall of the Wari empire toward the end of the tenth century.

According to L. G. Lumbreras, these Wari weaving elements make it easy to uncover an underlying unity in the textiles of coastal Peru. "Not only in the use of the same techniques, dyes, and materials, but also in the ornamental designs and even in the personages represented," there is a continuity of manufacture, quality, and character strongly marked by Wari influence. "Never, except in the period corresponding to Paracas," Lumbreras affirms, "did the Peruvian textiles reach such a high degree of development." And then, from the fall of the Wari empire until the upheaval in the Andes caused by the formation of the Incaic empire, there was a steady decline in the quality of textiles.

When the Incaic domain was founded in Cuzco in the fifteenth century, there was a resurgence of textile production. And yet Incaic weaving was distinctly inferior to that of its predecessors. Like the Aztec people in the Valley of Mexi-

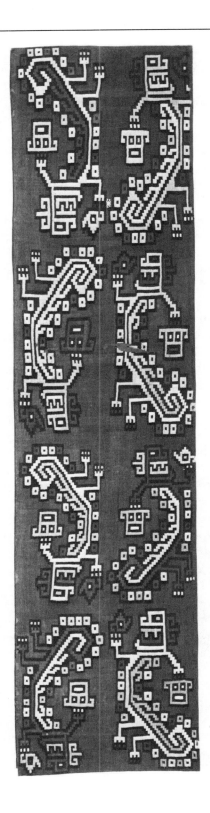

co, the Andean empire under the rule of a succession of powerful Inca "kings" was far more noted for its militarism, expansionism, and Romanistic pursuit of dominancy than for its culture and refinement. Yet the Inca did impose numerous elements of custom, technique, and style on art and clothing. These ideas naturally affected the wide-ranging settlements of the domain and had reached a lavish flowering by 1532, when Francisco Pizarro waged his brutal war of conquest upon the Inca Atahualpa, whom he executed for his refusal to accept Christianity.

An outstanding characteristic of the Incaic textile is the use of the *tocapu*— the combination of square units of different weaving techniques. According to Lumbreras, this unique design was used only in the manufacture of robes for the nobility. Some experts believe that the *tocapu* represents some generalized form of hieroglyphs, which, when arranged in a series, served to indicate

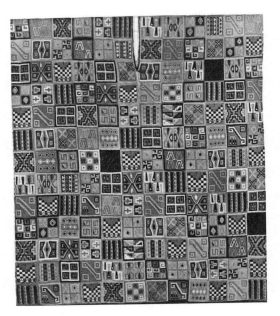

Left: Nazca-Wari hanging with alpaca warp-and-weft interlocking pattern and large anthropomorphic animals (probably pumas) holding trophy heads. Peru. Textile Museum, Washington, D.C.

Right: Poncho-shirt with cotton warp and alpaca wefts. Inca period, Peru. Dumbarton Oaks Museum, Washington, D.C.

designations of rank and, possibly, notable deeds. "Each *tocapu* is a square in which there are several different geometric symbols grouped in such an arbitrary manner that they can only obey a certain logical 'grammatic' order" (Lumbreras).*

Apart from the controversial *tocapu,* there are also purely ornamental, geometric designs which are intriguing *llamita*—formed by transversely crossing lines and producing an exceptionally rich effect. Whatever the significance of this complex iconography, the textiles themselves are excellent but lack the class or finesse found in the earlier Paracas and Wari textiles.

Finally, it should be emphasized that the production of textiles and the Incaic style did not vanish with the arrival of the Spaniards in the sixteenth century. On the contrary, the ancient traditions lingered and evolved into what is now called the Neo-Inca, or Transitional, style—a phase of Peruvian culture which reflects the long heritage of Andean textile making. Later, when we will discuss contemporary Indian textiles, we will return to this subject in order to convey something of the brilliance remaining in the work of present-day craftspeople in Peru.

Before we leave the subject of Andean textiles, perhaps a technical overview of Peruvian accomplishments in this medium will help to summarize the magnitude of the weaver's art in this region.

The numerous spindle whorls of clay

and stone found in all the settlements of the Andes indicate that thread was probably spun by the same methods in all locations, the strands twisted by hand and kept even by a revolving weight at the end of the thread. According to Pal Kelemen, much of the weaving was done on the back-strap or girdle-back loom. This device consists of a loom bar, a stick holding the warp, which is attached to a tree or a house post. A belt encircles the waist of the weaver, so that the warp can be slackened or tightened with a simple forward or backward motion of the body. The width of the woven material cannot be much greater than the weaver's convenient reach—about thirty inches. Looms of this kind are still in use today in Central and South America. The Peruvians also employed a large rectilinear loom, which allowed several persons to work together. It was made in a horizontal configuration, with the warp pegged out close to the ground.

Most Peruvian textiles have four selvages—an achievement almost beyond the conception of modern weavers, as is the amazingly complex technique of warp interlocking used at the height of Andean textile making. Practically every conceivable textile technique type was known in ancient Peru, including every known form of tapestry, numerous types of brocade and weft-pattern techniques, as well as warp patterning and several sorts of gauze. Double cloth and even triple cloth were woven with the use of two and three separate warps of contrasting colors, the sets of wefts alternating so that the design appears as a complete fabric on both faces, in reverse coloring. Several techniques were un-

* Federico Kauffmann Doig makes affirmative references to this controversial subject in his *Manual de Arqueologia Peruana,* 1980.

known to the rest of the world, notably the previously mentioned three-dimensional cross-knitting, by which tiny elaborate figures were fashioned in relief, and, sometimes, almost in the round. Textiles were embellished with embroidery of many different kinds, as well as by resist-dyeing ("tie-dyeing"), and by the application of fringes and tassels, shells and spangles, cutout disks and squares of hammered metal. The feathers of rare tropical birds were also used as ornamentation, either through interweaving or tasselling. The weaving technique of the Andes had more finesse than that of any other part of the world. While Gobelin tapestries seldom have more than twenty warps to the inch, in one famous Peruvian piece some fifty-two warps have been counted (Kelemen).

Clearly, Peruvian textiles constituted one of the most brilliant and technically accomplished arts of the Indian Americas.

There is considerable controversy about the dependency or autonomy of textile development by Indians in the United States. As Clara Lee Tanner (1968) has pointed out, "Whether the true vertical loom developed in the Southwest or whether it was introduced from Mexico is still a question." In any event, this complex form of the loom had appeared among North American Indians during what is called the Pueblo II period (c. 1200), and it made possible "the outstanding fabrics produced by pre-Columbian weavers" (Tanner). This "true loom" was constructed quite simply, despite the complexity of its conception: two upright poles supported by

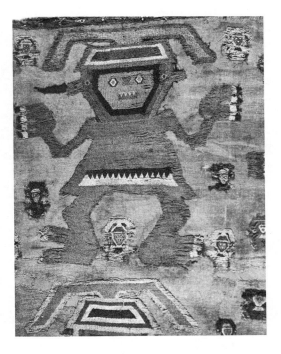

Chancay large embroidered mantle (detail), made of cotton gauze, with a polychrome wool embroidery. Peru, A.D. 100–1400. St. Louis Art Museum.

two horizontal poles. To the upper and lower bars were tied the warp selvages. These were formed as a continuous figure-eight network of thread, secured with cordage at each end. Usually a heddle (a long slender stick) was attached to the warps to facilitate the insertion of large numbers of weft elements at one time. In southern Arizona, a comparable but horizontal loom was also known in pre-Columbian times. Also the backstrap or waist loom was employed in North America. The same general form of whorls (for spinning fiber) discovered in the Andes has been found in various prehistoric Southwestern sites. It appears, however, that no wool was used for pre-Columbian North American Indian textiles, although there is evidence of the use of animal hair combined with other materials.

The exact origins of North American

Indian textiles are unknown. There are, however, numerous tales among the tribes which attribute the invention of weaving to such varied sources as the observation of birds building their nests and spiders making their webs.

Equally unknown are very early examples of North American fabrics. Pottery shards from the tribes of the Mississippi Basin and Eastern Woodland are imprinted with the texture of textiles. Most of these examples are simple basket weaves, dating from perhaps two thousand years ago. Later, about the third century A.D., the peoples of the American Southwest were already making splendid flat-braided sashes with a finger-weave technique still employed today. Some of these belts of spun white dog hair and brown animal hair, unfaded and pliable, are now exhibited in museums. And, as we have already seen, in the Southwest, where textiles reached a marvelous perfection, the loom had been devised by the Pueblo II period. End bars from back-strap looms have been unearthed at Pueblo Bonito. And in Arizona's Canyon del Muerto, burial remains have revealed well-spun cotton fabric.

In other regions of North America there are but few remains of textiles, due to climatic conditions which make preservation impossible. It is evident that the Haida and Chilkat, as well as other Northwest Coast tribes, produced blankets, leggings, and other fabric goods from their earliest history. But almost nothing remains of the prehistoric textiles in these areas.

In the American Southeast the people wove pliable mats of soft fibers. The Algonquin tribes of the Northeast employed threads made of buffalo hair and Indian hemp to construct twined bags and sashes. But the only wide-ranging evidence of a truly continuous evolution of textile making is found in the arid lands of the American Southwest.

One of the most important developments in the Southwest was the invention of tapestry: a medium most commonly executed in an over-one–under-one alternation of warps and wefts. Twilled tapestry technique was also developed, with different rhythms, such as over-two–under-two, and other variations. Tanner has pointed out that uniformity and symmetry are always the results of good textile weaving. "The Southwestern aborigine," she explains, "never reached the point of curvilinear design in woven pattern. Even in embroidery and painting on finished fabrics he was more influenced by traditions of the decorative arts than by the potential of creating new (and curving) designs in freer techniques of decoration. The only approach to curvilinear design was in tie-dye, and this was more the result of technique than of creativity."

According to Tanner the inheritance from the prehistoric past in textiles was exceedingly rich and varied in the American Southwest. In techniques and equipment, materials, forms, design units, and concept the Pueblo people followed closely in the footsteps of their forebears. "Perhaps the two most important changes through historic years [in the Southwest] have been the virtual disappearance of textile production from all puebloan groups with the exception of the Hopis, and the gradual development of the craft by the Navajos in the years since 1700" (Tanner). Other important changes also occurred, of course,

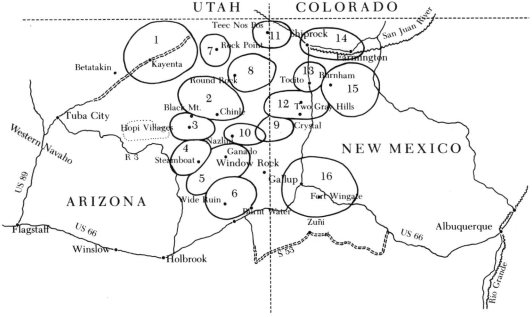

such as the substitution of wool for cotton and the shift from weaving blankets for use to the production of rugs for sale.

After the Spanish contact in the Southwest and the introduction of sheep, wool quickly rivaled the use of native cotton and animal hairs. The Pueblo peoples, who were apparently the originators of weaving among extant Southwestern Indians, were using wool as early as the 1600s, while the Navahos, who did not learn to weave until about 1700, used wool from the very beginnings of their efforts as weavers.

Whereas the coastal deserts of Peru have yielded an elaborate visual history of Andean textile making from days long before the coming of Europeans to the Americas, it is only with the arrival of settlers that a significant history of weaving becomes available in North America—due, again, largely to the lack of substantial prehistoric examples of textiles rather than to the lack of their production. Some early Indian styles dis-

appeared entirely, but others not only survived but became very highly refined. Plain weave, tapestry, embroidery, and brocading have been highly developed since the coming of the Europeans—due more to the introduction of materials and clothing styles than to any technical influences from Europe. Indians adopted the white man's vest and made it entirely their own. Native people also took the English hunting jacket and transformed it into the familiar fringed buckskin coat that is famous as Indian attire. Eventually European frontiersmen borrowed back the buckskin outfits from the Indians. In this way, there was a rich and significant exchange of styles, materials, and designs during the first years of contact between Indians and settlers. Ultimately these many transcultural exchanges reached a grand climax in the excellent trade items which Navahos began producing in the early years of this century. But their textiles, for all their merit, are relatively re-

cent and simple in comparison to the distinctive textiles produced for centuries by the tribes of the Pacific Northwest Coast—perhaps the most exciting and aesthetically pleasing of all North American Indian fabrics.

There is no continuous history of these Northwest Coast textiles, due to the rapid rate of decay of textiles in the region. The most impressive among extant woven products are the twined ceremonial fabrics of the Tlingit group known as the Chilkat. With impressive skill the weavers of this tribe twined goat's wool threads to make long shirts, aprons, and blanket-shaped capes. These pieces were made with white and dark brown wool, and also with wool dyed yellow and blue. The iconography of these fabrics depicts the totem figures of various clans. The images are ancient and were perpetuated by the men of the tribe, who drew the designs, whereas it was the women who did the actual weaving. Eventually, with the coming of white men, the textiles declined and were replaced by Hudson Bay blankets and other trade items.

Another tribe of the Northwest Coast area with an intricate and excellent sense of the weaver's art is the Salish. A current revival of their textiles provides an impressive glimpse of the work of the women of this tribe, whose reservation is in British Columbia, just above Washington state. Unfortunately, the ten- to twelve-foot mantles of woven goat and dog hair which were once the pride of the Salish weavers may never again be produced by them. At one time the Salish people kept little white dogs which they regularly sheared for their wool. This dog hair was often combined with bird down or even milkweed fluff to produce exquisite ceremonial blankets. Today, however, the weavers almost exclusively use wool and confine their production to such trade objects as saddle blankets, wall hangings, and tapestries.

The fabrics of the Innuit and Aleut peoples were made from nettle fibers, bird quills, grasses, and other plant fibers, as well as from the furs and skins of animals. Because such fabrics are not textiles in the sense the term is used in this book, we will reserve the discussion

Tlingit (Chilkat) blanket. Woven from mountain goat wool and braided cedar bark fiber dyed yellow, blue, white, and black, with a bear (?) mask in the center against a field of totemic motifs and a cut fringe along the bottom edge. Photograph: Sotheby Parke-Bernet.

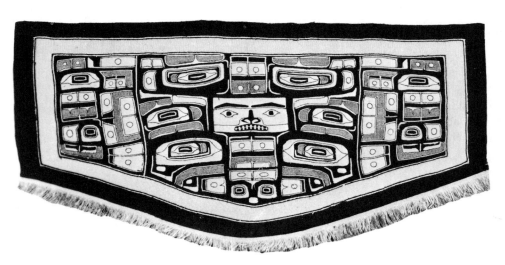

of weavings and clothing from this—and several other regions of the Americas—until the chapter on skinwork, beadwork, and featherwork.

The Woodlands tribes of North America also depended largely upon plant fibers—slippery elm, red elm, and basswood bark—for the manufacture of weaving threads. In the seventeenth century traders introduced broadcloth, muslin, and calico as well as blankets, which quickly replaced Native textiles. Only among the Ojibwa did the art of weaving evolve into a real triumph of textile manufacture. The twined bag, made on a simple square frame, was handsomely patterned and delicately constructed.

In the Southeast, the Cherokee worked with spun fibers of Indian hemp on six-foot true looms, making excellent carpets which were observed and admired by settlers as early as 1700, though no examples of these fabrics now exist. Cedar bark, hemp, and nettle were soon replaced as materials for weaving among the Cherokee, Creek, and Choctaw peoples when white traders introduced European textiles.

Thus the history of textiles in North America is a broken record of achievements. Only in the Southwest is the chronology somewhat clear.

The true loom was used by North American Indians only in the Southwest and in the prehistoric Southeast. In other areas textiles were finger-woven, except for belts made with the European "reed" heddle (introduced about 1675). The American Southwest is now and has long been the most impressive weaving region north of the Rio Grande. Weaving here, as we have already seen, is not only ancient but also persists as an essential part of the modern Indian's econo-

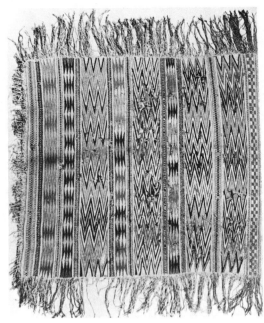

Coast Salish (lower Fraser River) blanket. Made from commercial yarn for local nobility, c. 1833. Perth Museum, Scotland.

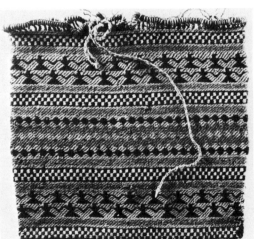

Ojibwa blanket bag of cotton. Minnesota, c. 1900. Smithsonian Institution, Washington, D.C.

my. In dealing with today's textiles of the Southwestern United States it becomes clear that, despite immense outside influences, textiles are still produced much as they were a century ago. The Hopi and particularly the Navaho are now the best weavers. Other Pueblo tribes do very little work in textiles today, while the Apache of this region

were never weavers. Until about 1900 the Pima Indians wove simple cotton blankets on a horizontal frame, and the Mohave and Yuma peoples of the Southwest made sashes and small bags, but none of these products compare with the refinement and complexity of Navaho and Hopi textiles.

The belt loom, which is a true loom, is the main type of Indian loom found south of the Rio Grande. Apparently the simple belt loom is much older than the more complex blanket loom, though both forms are quite similar in construction, character, and use. Belt looms are much employed by Navaho women and Hopi men. The blanket loom of the Southwest is an example of the vertical loom, a structure much favored by Navaho weavers, who can work more rapidly with this loom than with the process of finger weaving. The fabric is woven by passing weft threads over and under

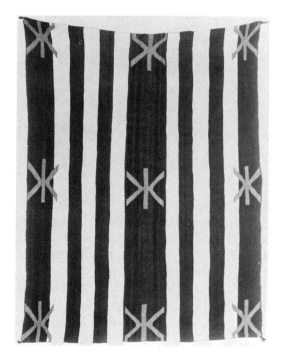

Navaho chief's blanket. Bayetta and wool, nineteenth century. Nelson Gallery of Art/ Atkins Museum, Kansas City.

the strands that make up the vertically stretched warp on the upright frame. Whole groups of alternating warps are moved by means of a heddle. As these warps are passed back and forth, the weft is moved between and bound in an over-and-under weave similar to the technique of plaiting. The large vertical blanket loom may have been independently invented in the American Southwest, for it is not found in other parts of the Western Hemisphere.

As we have seen, Navaho weaving was not begun until about 1700, though the Spaniards had introduced sheep to the area about 1600, making wool readily available. It was the alliance of the Pueblo and Navaho peoples, for joint protection against the European invaders, that enabled the Navahos to have close contact with the reclusive Pueblo tribes—a contact from which, among many customs, they learned to make wool blankets. Traditionally the weavers among the Pueblos were men, while among the Navahos women specialized in this craft.

The classical period of Navaho weaving came in the middle of the nineteenth century. The Navahos became enamored of a bright red cloth called baize which was imported from England. (The same material was known in Spain as *bayeta*.) Unable to obtain the rich red hue with their natural dyes, the Navahos unraveled and respun strands of baize into thin, hard blankets, which became the emblem of Southwestern weaving. The strong red was mixed in patterns with indigo dye from Mexico and the creamy natural white of undyed native wool. New colors invited the creation of new designs, such as terraced motifs and zigzags and narrow strips—

reassertions of ancient Southwestern pottery iconography. By 1875 baize disappeared from Navaho weaving, but the enthusiasm for the bright red hue remained. Aniline dyes, ready-colored four-ply Germantown yarns, and cotton warp (rather than the much stronger wool warp) quickly replaced baize and hand-spun sheep wool. By the time the Navahos were assigned by the United States government to their current lands, commercialization of textile manufacturing had already begun among Indian weavers. Following the American Civil War, the Navahos responded to the wishes of non-Indians by producing pictorial rugs which depicted modern figures and animals. Diamond designs in bright Germantown yarns took over almost entirely about 1875. The thin, hard blankets of earlier days gave way to thicker rugs, for Anglo-American homes. Then the golden era of the Navaho weaver ended, and textiles became undistinguished and garish. Navaho weaving did not revive until the 1920s, when traders with imagination began to encourage the weavers to return to traditional techniques and natural dyes. By 1940 the quality of the craft had been restored to a very high level of artistic and technical achievement. Curiously, the price of old rugs is often higher than the amount charged for new ones, even though some of these old rugs represent the decline rather than the artistic triumph of the art of weaving. In many ways, the rugs available today in the Southwest are finer than those created from about 1870 through 1920.

The eight most popular types of Navaho rugs today are these: *Wide Ruins* from west of Gallup—banded patterns with geometric figures in subtle colors from vegetable dye; *Ganado rugs* from Ganado—characterized by bold, simple designs on a deep red background; *ceremonial, or Yei, tapestries* from the Shiprock area—based roughly on the figurations of sand painting but having no sacred significance and never exactly duplicating sacred entities or power symbols; the *two-face weave*—displaying a different design on each surface, achieved by laying two different wefts back to back; *twill weaving*—used for saddle blankets; *storm-pattern rugs* from Tuba City—zigzag and rectangular designs suggesting lightning; *Klagetoh rugs*—very typically Navaho to most people because of their rich color combinations and strong geometric patterns; *Two Gray Hills*, named after a region between Gallup and Shiprock—geometric designs of a distinctive appearance in soft natural colors.

Astonishingly, the whole pattern of any Navaho rug, with all its thousands of interwoven strands, is carried entirely in the mind of the weaver. She does not make sketches or plans, and no design is ever repeated exactly. Each gesture across the loom horizontally represents hardly a millimeter of progress in the creation of the rug. From start to finish it is a long, difficult process demanding great artistry and technical expertise.

As Clara Lee Tanner has said, weaving in the Indian Southwest of the United States today presents an intriguing picture. The Puebloan peoples who invented the art have ceased to weave (except for the Hopis), while the latecomers to the area—the Navahos—have borrowed the craft and are currently its major proponents. "With few exceptions, the development of weaving represents a continuum, at least from early

Christian Era days to the present. The loom, techniques, and forms developed in those prehistoric years prevail to this day. Spanish introduction of wool supplemented the native cotton; Anglo-Americans later substituted commercial cotton, wool, and aniline dyes. Other than this, there has been little change in materials. Navajos use wool almost exclusively, while the Hopis produce the majority of their woven fabrics in cotton. Design has undergone considerable change, although here again tribal tradition has prevailed" (Tanner).

In Hispanic America, contemporary textiles are a synthesis of Indian and early Spanish techniques and forms. Textiles are found in abundance in many local and regional markets, where they remain an essential and visible aspect of ethnicity. These ethnic textiles are an important part of the cultures of modern Peru, Bolivia, and Ecuador in particular, and have been so thoroughly integrated into twentieth-century life in these countries that they are, for all intents and purposes, traditional (Graburn). The popular arts of Brazil—in comparison to Andean nations—are less Indian than Euro-African in background, while in Argentina and Chile there is very little contemporary folk emphasis in textiles, specifically, or the arts generally. "Few aboriginal peoples of this area have maintained any degree of autonomy, except for those on the fringe of contact in the vast Amazon and Orinoco basins, and now, even these are fast being overrun. Farther north, the peoples of Colombia and Panama (until recently a part of Colombia) are more fortunate" (Graburn).

And yet the ancient textile art did not simply pass out of existence with the coming of European invaders. Many European medieval customs were infused into the life of Latin America. For instance, the Christian tradition of veiling all altars before Easter resulted in many commissions for Indian weavers. Many handsome Lenten veils were produced, using Native techniques and European iconography. "The pictorial representation of biblical and allegorical scenes in tapestry started in the Netherlands, where the technique of the Gobelins was invented. Since the Netherlands and Spain were politically connected for a time, such work soon came to the [Western Hemisphere], and the weaving talent of the pre-Columbian Indians was transorchestrated for the use of the Spanish overlord. Raw materials were at hand; to wool from the llama family was added that from sheep; silk and the use of metal thread were introduced. The possibilities multiplied. In the large and often unheatable halls in which the descendants of the conquistadores established themselves, there was need for woven materials to cover the floors and walls, even the doors. They helped keep out the cold, and at the same time made living more cheerful" (Kelemen).

That transitional period has resulted in the continuity of at least some major aspects of Hispanic Indian textile art. The Indian artisans of El Salvador and Panama, as well as those of coastal Colombia are noted today largely for their clothing arts. For instance, the Cuna Indian women of the San Blas islands (on the Atlantic coast of Panama) make remarkable *molas*. Molas are the appliquéd front or back panels of blouses that are the traditional dress worn by Cuna women. The art of mola making, as

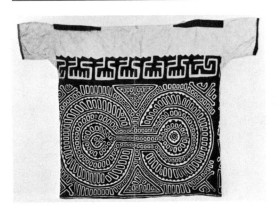

Mari Lyn Salvador (see Graburn) points out, developed during the last hundred years, combining the "creative utilization of new materials and processes (cloth, scissors, needles) with the traditional art form of body painting." Though the Cuna may sell their mola blouses as trade items, they make them primarily for their own use, following their individual and tribal fashions and technical standards. Molas are, therefore, as Graburn mentions, "a reintegrated modern, but culturally embedded, art form."

Farther north, in Guatemala, there are about two hundred separate villages where parts of traditional dress are still worn. These costumes are colorful and elaborate, mainly hand woven, with each village having a characteristic style and combination of colors (Osborne). Many of the designs which appear on the textiles of Guatemala are ancient, similar in form to those used centuries earlier by the ancestors of today's weavers, who may no longer understand the original meaning or implications of the designs, though they still know how to make them.

One important item of the weaver's art in Guatemala is the *tzute*—cloths that are woven on a back-strap loom and are decorated in ways that indicate their specific place of origin. Many of these *tzutes* are ceremonial in function, while others have frankly utilitarian purposes that seem far less important than the aesthetic effort put into their creation. Their sizes and uses are diversified and intricately linked to the artistic attitudes of Native people. They can be used to cover the head and shoulders, to carry children, or simply to make a bundle of various items, which are then carried on the head (Anderson). As mundane as these functions may seem to outsiders, they are activities which are sufficiently important to the Indians to require the very finest textiles. For this reason, the *tzutes* often represent some of the best weaving found in Guatemala today.

The Guatemalan craftspeople also

Cuna mola, *woman's blouse with appliqué. San Blas Island, Panama, c. 1910.*

Tzute (shawl) of cotton and silk. Guatemala, c. 1930.

produce excellent blankets, tapestries, belts, head bands, and a variety of so-called *huipil*—a word derived from the Aztec term *huipili*, meaning "covering." Today the *huipil* is the highly decorative blouse of the Native women's costume. Like the *tzutes*, these handsome blouses epitomize the Guatemalan reverence for beauty and the sustained excellence of their textile arts.

In Peru, where the textile arts reached unparalleled heights, the production of textiles did not falter even in the years immediately following the subjugation of the Inca world. From the earliest days of Spanish domination the artistry and wondrous technical gifts of the textile makers were enlisted to create tapestries with European iconography and biblical themes (Cavallo). Today that tradition continues; there is a remarkable amalgamation of folk weaving techniques combined with post-Columbian materials and tools.

An important center of weaving in the Andean region is the suburb of Santa Ana in the city of Ayacucho, where weavers work in extended family groups, using the horizontal pedal loom—a model of European origin which was adapted by and has been used by Indians since the sixteenth century. In this famous textile area, the wool of lambs is spun very thickly and then dyed shades of brown for the manufacture of items such as carpets, rugs, blankets, and cushions. Many of the Ayacucho weavers have unique and recognizable styles. For instance, the Sulca family is particularly noted for its expertise in dying techniques and the weaving of tapestries which depict traditional Andean scenes with high quality and imagination.

Hualhuas (Junín) is another village of great importance as a weaving center. The style is a combination of bands of natural and vegetable-colored fibers, and the predominant products are blankets, which are valued in the whole Mantaro valley.

The ancient back-strap loom is still very much in use in the department of Cajamarca, where saddlebags and ponchos of lamb's wool and cotton are made for sale to tourists. The saddlebags characteristically have a geometric design against a background of red, blue, dark red, or brown stripes, and are especially handsome in style and technique.

Renowned among the woven products of Peru are the waist bands made in Viques (Junin). Woven only by women, the bands are made for personal use as well as for sale. Both men and women traditionally wear the waist bands, winding them several times around the torso. The unique technique for producing the bands is known as *estambre* (worsted)—and results in the finest examples of textile making in the Mantaro valley. The belts are decorated with a variety of figures, each having a specific name. The traditional iconography, however, has recently given way to tourist influences, and now designs with such objects as airplanes, peacocks, and ships are favored.

In the northeastern jungle which flanks the Andes, the best-known textiles are produced by the Shipibo and Conibo Indians. Barely affected by the Spanish invaders or, for that matter, by the Quechua influences spread in pre-Columbian time by the Inca Empire, these Amazonian tribes have preserved many elements of their ancient arts and iconography. The women of the region use

Women of an Andean (Ecuadorean) weaving cooperative using back-strap looms and displaying a variety of textiles for sale.

back-strap looms and cotton fiber to produce panels for skirts, as well as blankets and the Amazonian tunic known as "cushmans." These textiles are decorated with beige or blackish-brown images against a background the color of terracotta. Some of the most traditional Shipibo and Conibo pieces are also embroidered with colored threads or decorated with cloth appliqué. Most characteristic of this region is a geometric motif which is repeated successively over the entire surface of the fabric—a style which apparently evolved from pottery decoration.

From its ancient origins and its exquisite evolution of styles and forms, which rival the greatest of world textiles, the weaving of the Indian Americas persists today as a visible continuum of Native heritage. The influence of European technology and the impact of production for tourists has tended to extend rather than to deplete the caliber and range of Native textile imagination and technology. It is perhaps one of the great miracles of humankind that, after four hundred years of constant cultural assault, the Indians of the Americas are still doing exceptional weaving. And although the number of regions where textiles are a strong part of the cultural life has diminished drastically, there remains in the art of the Hopi, Navaho, and Peruvian weavers an aesthetic continuity which makes us wonder all over again how the human spirit endures and how the arts prevail against the greatest odds.

6.
Skinwork, Featherwork, and Beadwork

Skinwork, featherwork, and beadwork are closely associated with weaving. Because the development of these media parallels but is distinctive from the production of textiles, we shall discuss the various art forms composed of feathers, quills, and beads separately from weaving. And, because these forms of art are tangential to textiles and because only a few examples have survived from pre-Columbian times, our discussion will necessarily be both brief and selective—focusing on only the major achievements in these decorative arts.

Skinwork is found among all the tribes of the Americas in which hunting played even a slight part. And it can therefore be said that almost all Indians made some use of animal skins. It is unquestionable, however, that the most renowned and lingering use of skins is to be found among the tribes of North America, and our discussion will therefore focus on their specialized achievements in this medium.

Skins were widely used to make clothing, tipi covers, shields, and boats, as well as a great variety of containers for the storage of food, guns, medicines, and household goods. The furs of animals were used for robes and blankets and for making decorative hides, pictographic chronicles such as "Winter Counts," and ceremonial costumes. Pelts were also items of trade both in pre-Columbian times and during the years when European traders were introducing new products to the tribes in exchange for the much-sought skins of beavers and other prized pelts.

The curing of skins is exceedingly hard work. Animal skins must be treated before they can be put to any lasting use, otherwise they rapidly become hard and stiff or begin to rot and deteriorate. Indians had several techniques for preserving skins—some simply to keep them from spoiling and others to soften them for use as buckskin clothing. Traditionally it was the men who performed this work in the Southwest and Northeastern parts of North America, while women were assigned this arduous labor in most other regions of the United States and Canada. The most difficult preparation of skins—that of the large and bulky buffalo hides—was entirely the duty of women, as well as one of their major technological achievements.

Skins were stretched and pegged on the ground or tied to drying racks, and then fleshed out* with chisel-like tools. After they had dried in the sun, the skins were scraped, with a tool with a flint or iron blade to plane the surface and thus trim the thickness of the hides. If the skins were to be used as rawhide, the hair was scraped off; if they were to be used as winter robes, the hair was preserved. Often skins were smoked, to give them color and to keep them pliable.

Rawhide, which is untanned skin from which the hair has been removed,

*"Fleshed out" refers to removal by scraping of all tissue from the surface of an animal skin.

is the material from which a great variety of important Indian artifacts was constructed. Rawhide is usually cream-colored, often translucent (thicker than parchment but similar in texture and color), hard but flexible, highly durable, lightweight, waterproof, and almost unbreakable. When fresh and wet it can be easily bent into shapes and folded and molded into forms. When dried it is quite hard and tough. These qualities made rawhide ideally suited for practical use, at the same time providing an ideal surface for decoration. Applied design was a favorite form of decoration, and the materials used included quills, beads, ribbons, moose hair, and shells. Quillwork was native to the Americas, whereas beadwork and ribbon appliqué were executed largely with materials supplied by white traders.

Porcupine quillwork (as noted earlier in greater detail) is found only among the Indians of North America, and was the major medium for applied design until the introduction from Europe of glass beads, which quickly supplanted and eventually replaced quills. The porcupine has smooth, shiny quills up to five inches long. When soaked in water they become flexible and can be dyed, bent, sewn, and twisted. Northwest quillwork was done by wrapping quills around a single thread, which was then sewn to cloth or skin. Elaborate quillwork on birch bark spread from the Northeast to the Great Lakes area, and became a celebrated decorative art form. Dyed quills were pushed through holes in bark boxes and bent on the inside; a lining concealed the ragged ends and also held them securely in place. Woven quillwork is found mainly among the Cree and Chipewyan of Cen-

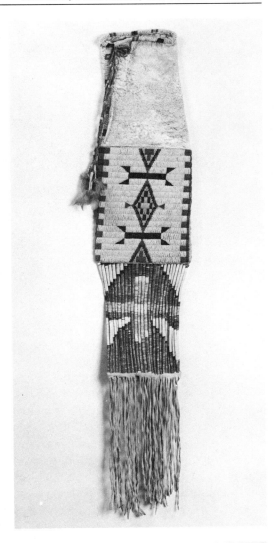

Plains Indian pipe bag with quilled lower margin and beaded upper margin. Photograph: Sotheby Parke-Bernet.

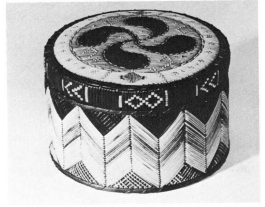

Micmac birch bark box with wooden base and porcupine quillwork. McCord Museum of McGill University, Montreal.

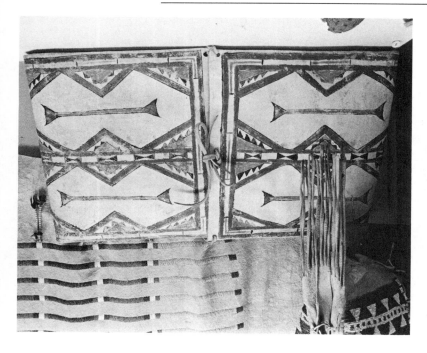

Cheyenne hide container (parfleche). Powdered pigment on dried raw hide, nineteenth century. Southern Plains Indian Museum, Anadarko, Oklahoma.

Comanche war shield. Powdered pigment on buffalo hide, nineteenth century. Southern Plains Indian Museum, Anadarko, Oklahoma.

tral Canada and Athapascas of the Western Subarctic; it is the finest quillwork in North America (Whiteford). As a simple band is plaited on stretched fiber warps, soft, flattened quills are woven in and out of the wefts. The quills, pushed tightly together, give the appearance of small, cylindrical beads.

Another use of quills was in a form of embroidery done with a combination of moose hair and porcupine quills—a technique probably introduced by the French, and popularized by the Huron and Iroquois. But the most famous quillwork was achieved by the Plains Indians, who developed a distinctive style from the technique derived from Eastern tribes.

No people in the world have made wider or better use of rawhide than the Indians of the Plains of North America. So essential was it as a material that it usually took the place of wood, bark,

and clay in the construction of utilitarian and of decorative, ceremonial, and religious artifacts.

Rawhide was used as binding for tools. Applied wet, the skin dried and shrank tight and hard, making a solid bond between, for example, the wooden handle and the stone head of a war club. Parfleches (a French term for rawhide) are envelopes of rawhide that were used in the Plains to hold dried foods and numerous other household objects. Called "Indian luggage" by early settlers, the parfleches were folded from a single sheet of hide and then painted with geometric designs—a task undertaken exclusively by women. Boxes and various other containers were also made of rawhide. One of the most celebrated uses of rawhide was the making of shields. Most Plains shields were made from the strong, thick skin of bull buffaloes (often sewn with two layers for additional protection). Shields were painted by men, and depicted the visionary beings and animals who provided them with mystic protection and guidance. The design and use of small, round shields apparently arose with the adaptation of horses in hunting and warfare, for the pre-

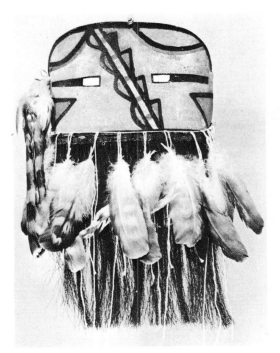

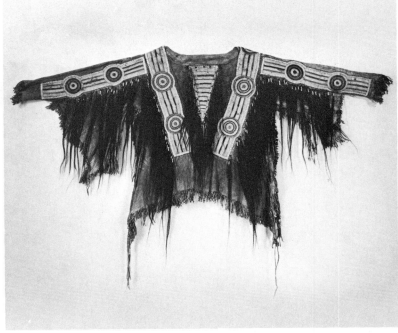

Columbian full-body shields were impractical to use on horseback. The shield and its visionary iconography are found among all the Plains and Prairie tribes, as well as the peoples of the Southwest, where many Plains customs were imitated during the eighteenth and early nineteenth centuries.

Drums, like shields, were often covered with rawhide and painted with visionary images. As we shall eventually discuss in the section on Native American music and dance, rattles also were molded from rawhide. Boats structured from animal ribs or pliable branches were rawhide-covered. Saddles were covered with hide. And various figures were cut from hide and used by Plains Indians as sacred implements in their Sun Dance ceremony.

A unique and important use of rawhide appears in the American Southwest, where masks are constructed by the Pueblo Indians to represent the various power figures (kachinas) of their annual cycle of ceremonial dances. Helmet masks were fitted over the heads of the kachina impersonators and decorated with crowns (*tabletas*) of wood, paint, and horse-hair fringes. With the exception of the ritual masks of the American Northwest Coast region, these Puebloan masks are the most dramatic and impressive religious costumes of North America.

Tanning was an important technique among Indians, done by rubbing hides with an oily paste of brains and liver, and then soaking them in water for several days. Then the hides were stretched, wrung out, and dried. The result of this process was, of course, leather (skin which has been tanned so it remains soft and pliable). Such leather was essentially used by Indian women to make articles of clothing and other items: pouches,

Left: Zuñi kachina mask, representing Itetsipona, the Double-Face Being. Buckskin, rimmed with horsehair and feathers, c. 1905. Collection of the author.

Right: Brulé Sioux (South Dakota) quilled and beaded buckskin shirt with hair locks. Collected in 1855 from Spotted Tail at Fort Laramie, Wyoming. Museum of the American Indian, Heye Foundation, New York City.

Plains tipi, c. 1900. Glasgow Historical Society, Montana.

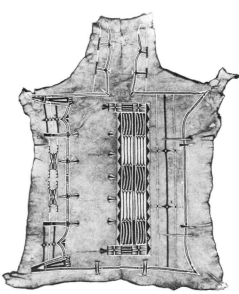

Sioux (Dakotas) beaded robe. Buffalo hide and beads, c. 1860. Denver Art Museum.

sheaths, moccasins, shirts, leggings, dresses, tipi linings, and even toys such as dolls and childhood talismans. The popular term for the material from which Indian clothing was made is "buckskin"—which usually means smoked deer hide but can also refer to other skins tanned by Indians, such as buffalo, antelope, and elk.

Buckskin was decorated with beads, quills, and paint. Painted tipis were the classic dwellings of the tribes of the Great Plains. The skins making up a tipi could be as much as thirty feet across, supported by poles as long as forty feet. An average tipi required some twenty buffalo hides, which were sewn together

with sinew and then ceremonially painted. A finished tipi cover could weigh as much as one hundred pounds.

Furs were also widely used by Indians, primarily for robes and blankets, and as the raw material for weaving. In a number of regions strips of rabbit fur were twined into soft, fluffy cloaks. The buffalo robe of the Plains was not only an article of apparel but was also an elaborate record of the exploits and deeds of the man who wore it. Conventionalized pictographic designs were painted on the skins to depict adventures in hunting and warring.

Fur costumes were also used in ceremonies. The California Hupa costume for the White Deer Dance has a wolf fur head band, deer fur kilt, and the complete hide of a white deer, which is used as a ritualistic flag (see page 146). In the Plains and on the Northwest Coast, people wore ermine-skin decorations on shirts and in headdresses. And in the frosty north, Ojibwa women wore mittens, fur-lined moccasins, and fur capes.

Some of the most intricate use of furs was that by Innuit women, who carefully pieced together small strips and squares of variously colored furs into a patchwork to make panels or bibs or other trim for parkas (Neale). Tiny stitches joined half-inch widths of fur into lovely mosaic patterns. The Central Innuit, living along the western border of Hudson Bay, wore two parkas in inclement weather, with the fur of one turned inside and of the other turned outside to provide maximum insulation. Another excellent and remarkable weatherproof garment was made by the Aleut. A hooded parka was constructed of flattened seal intestines, the ribbons of gut sewn in horizontal strips and then constructed into a translucent, entirely water-resistant garment.

Skins have long been made pliable, and they are often worn in the same way as cloth. Indians have used hides and furs in a remarkable variety of ways. The list is very long, including items made from deer skin, elk skin, bear hides, buffalo hides, dog skin, fish skin, seal gut. Skins were used almost everywhere in North America. Pueblo women wore white buckskin puttees; Apaches had a deerskin poncho fringed at the ends, and deerskin loincloths and leggings. Mountain tribes had the full-sleeved deerskin shirt with fringes. The Plains tribes made great use of buffalo robes. Other hides, such as otter, fox, beaver, panther, and lynx hides, snakeskin and white dogskin, and bear, mountain lion, and mountain goat hides, were worn for ceremonial and decorative purposes as cloaks, arm and leg bands, ponchos, and hats. Skins—decorated with beads, quills, paint, and stitching—were a staple of North American Indians.

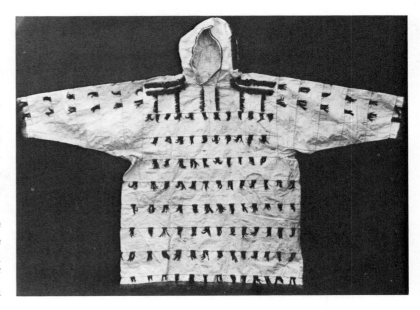

Innuit waterproof parka, made of walrus intestine and sealskin. St. Lawrence Island, Alaska, c. 1925.

Featherwork, a very ancient method of laying feathers on a woven base of fiber threads and tying the stems of the feathers into the fabric during the weaving process, had its greatest evolution in pre-Columbian Mexico and Peru. Unfortunately, however, only a few specimens of this elegant art have survived. Early Spanish accounts and Indian iconographic histories on skin and adobe surfaces from the time of the invasion provide some idea of the importance of featherwork in the ceremonial lives of the Peruvians and Aztecs, and the sculptures and paintings of such ancient peoples as the Maya and Toltec attest to the voluptuous use they made of feathers on the cloaks of people of rank, in headdresses, on shields, and on the standards of warriors.

More accessible to us, though perhaps less grand in concept and design, are the turkey-feather mantles made in the North American Southwest, on the Gulf of Mexico coast, and on the Eastern Seaboard, as well as the elaborate feather headdresses of the Plains Indians, which are so renowned that they have become stereotypes of North America's Native peoples. Also very visible, in the living tradition of South American Indians, are the handsome objects made of the plumes of tropical birds. And, finally, we must mention the exquisite feather baskets which we have already praised in our discussion of the basketry of the California tribes.

Feather mosaic, a remarkable pre-Columbian art form unknown in Europe, was expertly practiced in the Mexican, Maya, and Andean areas (Kelemen). Colorful plumage from native birds was interwoven into the fabric of mantles, arranged in marvelous headdresses, and applied to ceremonial shields, standards, and fans. Weaving was not the only means of using feathers, for often they were simply glued into elaborate patterns, though the most attractive artifacts are the result of each feather being attached to a thread and then stitched into a woven fabric, row by row. When in place, the plumage was trimmed in the appropriate patterns.

Feathers of macaws and parrots are commonly found in such feather mosaics. Other, more dazzling colors were obtained with the use of feathers of birds from the deepest tropical rain forest—such as hummingbirds. Some plumage, such as that of the quetzal of Central

American Horse, an Oglala Sioux, photographed in 1877 in his full regalia. Denver Art Museum.

America, was strictly reserved for the ornamentation of garments worn by people of high rank. In Mexico, the great Lord Montezuma II reportedly kept an elaborate aviary of exotic birds for both his pleasure and decorative use. The famous quetzal headdress and feathered shield now in the collection of the Vienna Museum of Folk Art were apparently given to Cortes by Montezuma during his first meeting with the Spanish invader.

In the Aztec domain, feather weavers (*amanteca*) were highly regarded as artisans of the first rank. They formed a guild of their own and were considered to be part of the professional classes. "Let no one doubt the magnificence of this art," Victor von Hagen has written (1959). "One piece has been preserved, the headdress sent by Montezuma to Hernando Cortes when he first landed at Vera Cruz and was believed to be Quetzalcoatl returning to reclaim his empire. This was sent in turn to Charles V, who passed it on to his fellow Habsburg, Archduke Ferdinand of Tyrol; it was long preserved in the castle of Ambras. When discovered and its history made known, it was sent to Vienna, and there today it rests in a burst of golden-green iridescence in the Museum für Völkerkunde—a double assurance, if that be needed, of the Aztecs' sense of beauty."

Another precious gift sent to Cortes by Montezuma was a round shield of feather mosaic which depicts a blue coyote outlined with gold on a red background, said to be the "name glyph" of the Aztec king Ahuizotl. The shield is made of a jaguar pelt stretched on a wooden frame about two feet in diameter. The feathers were glued, rather than

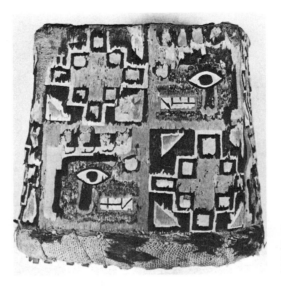

Tiahuanaco-Wari style featherwork cap, A.D. *600–1200. Brooklyn Museum.*

Incaic feathered mosaic panel. Blue macaw and yellow canary feathers on cotton. South coast, Peru, A.D. *1400–1532. St. Louis Museum of Art.*

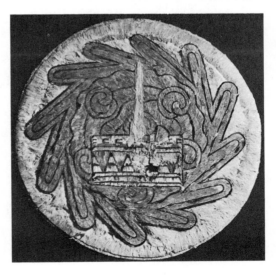

Aztec featherwork: the figure represents Chalchihuitlicue, Lady Precious Green; c. 1500. National Museum, Mexico City.

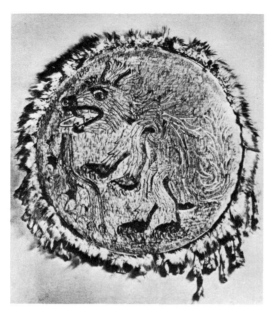

Aztec standard made of feathers. Museum für Völkerkunde, Vienna.

woven, onto the lively figure of a rampant coyote, with fiery plumage forming a radiating fringe.

The Aztec feather art survived the invasion, as we can see from a bishop's miter, made by Indians, which is constructed in a manner similar to the shield. "The jewel-like beauty and glowing tones of such a piece can scarcely be imagined. The sky in the background is an iridescent blue-purple with stars shading from pale to dark yellow. The closed eyes of the Christ are indicated by tiny crescents of gold feathers," writes Pal Kelemen. This miter is believed to have been made at the order of Bishop Vasco de Quiroga, who spent seven years in the state of Michoacán, Mexico. Many such feather-mosaic pieces were commissioned for various regalia connected with the Roman Catholic Church. The methods used to produce these Christian objects were the same as those used by Aztec artisans since ancient times: the feathers, not

wider than one eighth of an inch, were glued on strips of *amate* paper, so placed as to overlap smoothly, and then were fastened to cloth (Kelemen). The glue was made from the juice of an orchid plant. The technical finesse of these objects is no less perfect and aesthetically remarkable than that of the few precious specimens of feather mosaic which remain from the golden years before the coming of the Spaniards.

The evidence of Incaic featherwork is even more fragmentary than that of Aztec feather mosaics. "Featherwork was made by knotting the ends of the feathers into half-hitch looped fabrics, and this must have provided highly colored garments, but nothing is known of any pattern" (Bushnell). The Chosen Women of the Inca were responsible for fashioning feather tunics, a mosaic of jungle-bird plumage, interwoven into fabric by the insertion of the quills into the warp of the weaving. "The luster, splendor and sheen of the fabrics of featherwork," wrote Jesuit Bernabe Cobo, "were of such beauty that it is impossible to make them understood, unless by showing them." Little survives of this highly praised art form of Peru.

The featherwork of North American Indians is a central element of the Native mystique. The flowing bonnets of the Plains have become an international symbol. But, in reality, featherwork of great variety was found among many of the tribes of North America. In the Southwest featherwork continues to be highly ceremonial in intent and use. Plumes and down are employed to decorate both kachina dolls and kachina masks. For instance, the famous Hopi Sun kachina mask has a halo of eagle feathers, and the Zuñi Warrior kachina

has a ruff of feathers. Feather prayer sticks (*pahos*) are used as offerings at the altars. Eagles, sacred birds throughout North America, were ritualistically kept for their plumage, and macaw feathers were often imported via elaborate trade routes from Mexico.

There is little question today (Whiteford) that the tribes of the Eastern United States invented the feather headdress which gradually developed into the lavish bonnet of the Plains. In the Southeast downy egret plumes and stuffed eagle heads were worn by high-ranking men. A head band of stiff tail and wing feathers was used by many tribes from Virginia to the St. Lawrence River. Though not possessing the remarkable technology of the feather mosaics of Mexico and Peru, the featherwork of North America was nonetheless highly colorful, elaborate, and diverse in style, spreading from the Eastern United States throughout North America.

Undoubtedly the featherwork of the Plains is the most lavish. Plumes of eagles, hawks, and owls were widely used to decorate weapons and clothing. The classic feather headdress of this region consists of matched eagle plumes fastened loosely to a cap with a decorated band in front and, often, ermine or ribbon streamers on the side. Some bonnets had single or double pendants, which extended as much as eight to ten feet in length. Except at ceremonials, most men wore only one or two feathers, in positions indicating their rank and achievements. Whereas the Sioux headdress swept back in classic style, the Blackfeet bonnet was an upright crown similar in style to that worn in the Eastern United States. The use of feathers extended beyond the construction of headdresses;

feathers were also used to decorate spears and dance wands. The buckskin covers for rawhide shields were often decorated with feather pendants; ritual pipes (called calumets) and wands were often ornamented with feather fans, woodpecker scalps, and the heads of mallard ducks. The famous dance bustles of the Plains were commonly decorated with plumes and a feather rosette. The Indians of the Plains made endless and marvelously colorful use of feathers—an expression both of their love of flamboyance and of their desire to gain the power of sacred birds through the imitation of their plumage.

In California the featherwork is a good deal subtler than among the tribes of the Plains. Flamboyance is largely replaced by great brilliance and sophistication of design, probably the result of a long Californian tradition of exquisite basketry. Dance regalia was often deco-

Incaic featherwork, probably a headdress. Linden Museum, Stuttgart.

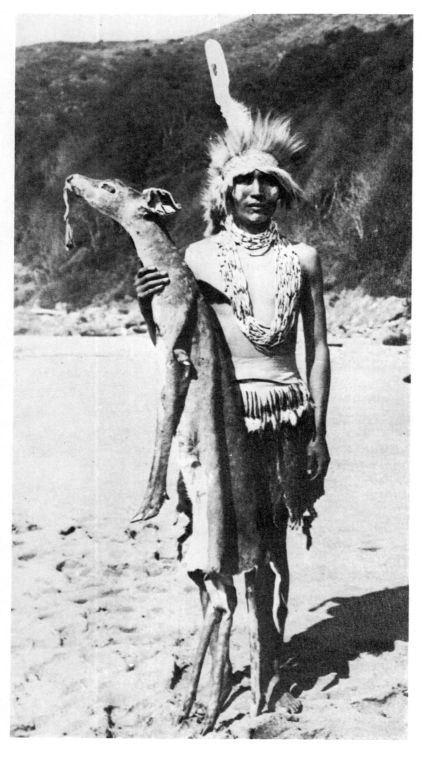

rated with numerous small feathers, with a mosaic-like effect. Headdresses made of golden quills of flicker feathers mounted on deerskin bands were among the most handsome elements of Hupa and Pomo costumes. The Hupa and Yurok Indians also made glistening red crowns by sewing as many as fifty woodpecker scalps to a deerskin head band, which was part of the costume worn in the Jumping Dance. Probably the most striking headdress was made for the World Renewal Rites of the tribes of central California: this consisted of many slender rods tipped with down or poppies, which produced an effect almost as theatrical as that of the crowns worn by showgirls in Las Vegas. California Indians also created feathered belts, made by sewing complex patterns of feathers to buckskin. Darts, or so-called tremblers, were made in many different, bright colors and were worn in the hair or carried by dancers. Skirts and mantles of turkey feathers were worn by the Pomo Indians and the various Mission tribes. Among the most remarkable featherwork of California, as previously noted, were the ceremonial baskets spotted with feathers of quail and woodpecker or decorated with feather mosaic.

Today a great deal of controversy surrounds the continued use of feathers—particularly those of endangered species—in the arts of Indians. Yet, despite this rather ironic and late concern of the dominant society for the besmudged American environment, Indians of North America have continued to produce a small amount of fine featherwork for personal and ceremonial use.

The most impressive featherwork still

being produced today is found not in North America but in the deep jungles of the Amazon Basin. Though little aesthetic skill is normally expected from tribes living in tropical conditions, the forest people of central Brazil have a richness of artistry that derives from a strong use of their environment (Dockstader, 1967). To be appreciated most effectively, this art should be seen against the backdrop of the jungle, but even in photographs and in museum cases a certain splendor survives. The masterful combinations of plumes result in marvelous decorative collars, headdresses, fetishes, and other ritual regalia and paraphernalia. One of the more astonishing creations to come from the forest is the extraordinary *cara grande* mask of the Tapirapé people: the huge feather-decorated shield "mask" worn on the shoulders during purificatory rites and representing the spirits of dead enemies. Few other objects in South American art have the dramatic color and vivid impact of these strange, feathered faces. Effigies are made of black wax and embellished with feathered crowns, white downy fluff glued to the body, and shells inlaid as eyes. Magnificent headdresses are made with brilliant feathers of local birds, mounted on split reeds and worn by the men during ceremonies. Similar plumage is fastened to turbans which fit over and around the head. Chin labrets, collars, and instruments—such as bone flutes—are also highly decorated with feathers, produc-

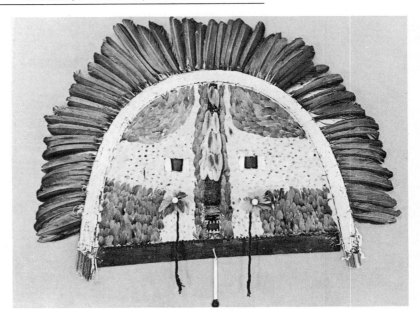

Wooden mask used by Banana Festival "Cara Grande" male dancers of Tapirapé, Brazil, c. 1960. Wood covered with feathers and shell inlays.

ing true artistic triumphs in personal decoration.*

Beads, as personal adornments, have been used throughout the world by primal peoples since the very earliest times. Seeds, shells, pearls, bone, clay, metal, semiprecious stones, and, after contact with white traders, glass have been the sources of the beads which Indians of the Americas have woven, strung, and sewn into remarkable patterns.

Stringing, as found in necklaces, bracelets, and other such ornaments, was the most widespread use of beads. Weaving, sewing, and embroidery became prevalent in beadwork only after the introduction of glass beads from Venice and from Prague, about 1675. The techniques for making beads prior to the arrival of European glass beads were carving, engraving, inlaying, and the casting of gold, silver, and copper. In Central and South America, as we shall discover when discussing metalwork, a brilliant production of jewelry was

Facing page: White Deer Dance attire with feather headdress. Photograph by Emma Freeman, c. 1900, northern California.

* A definitive study of the featherwork of Brazil is found in *Arte Plumaria del Brasil*, the catalogue for the exhibition of the same name, published in Spanish and Portuguese by the Ministry of Education and Culture, Brazil.

achieved in pre-Columbian times. For now, however, we will restrict our survey of beadwork to North America, where a vast variety and great abundance of exceptional and unique beadwork has existed among almost every tribe.

The simplest approach to the production of beadwork among North American Indians is through a brief discussion of the several techniques adapted or invented by them. *Woven beadwork* is done with warp strands stretched in a manner similar to that for a belt loom—or on a frame or bow. *Diagonal plaiting* is much used in the sashes of the Great Lakes region; it is a technique also used for beaded hair streamers by tribes such as the Menominee, Potawatomi, and

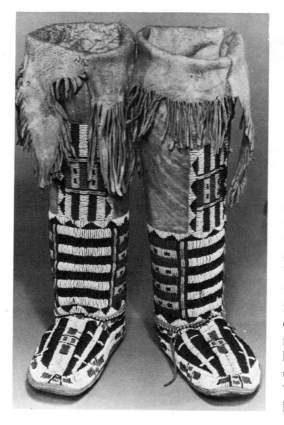

Cheyenne woman's boots, made of hide and beads. Wyoming, c. 1870. Denver Art Museum.

Winnebago. *Spot-stitch sewing* is done by laying threaded beads in a design and sewing them in place. This technique was used for complex linear patterns in the Northeast. Floral patterns, introduced from Europe, were produced in the Great Lakes region and the northern Plains with this technique. Among the Chippewa spot-stitched leggings, floral shoulder bags and aprons, moccasins, and head bands were popular. Plains *lazy-stitch sewing* is characteristic of the beadwork of the Sioux, Cheyenne, and Arapaho of the central Plains, and of the Utes of the Basin area. This technique is effective for decorating large areas and for the production of strong, geometric designs. An appearance of parallel ridges results from sewing the beads in short rows fastened only at the ends. The usual Plains beads are "seed" beads, which came into the region by 1800, but did not become very popular until some fifty years later, almost completely replacing quillwork. The later "pony" beads were used in simple patterns from about 1860 (Whiteford). Iroquois *embossed beading* is a type of lazy-stitch in which the arching of the stitch is emphasized by crowding the beads and raising the design with padding. It was sometimes combined with spot stitching on moccasins, but was used especially for decorating velvet pouches with floral designs and for men's caps. Pony beads—often translucent—were widely used between 1860 and 1890 on articles for the tourist trade. *Netted beadwork* is executed in a variety of ways to produce netting in which beads take the place of knots or loops. It is a method widely used to cover rounded surfaces, as in Washo Indian baskets. The handles of Peyote fans and rattles used today in re-

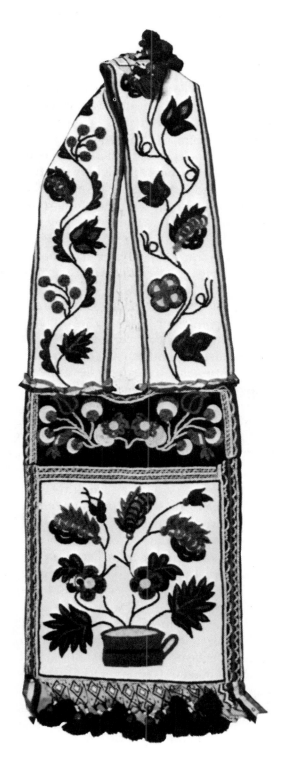

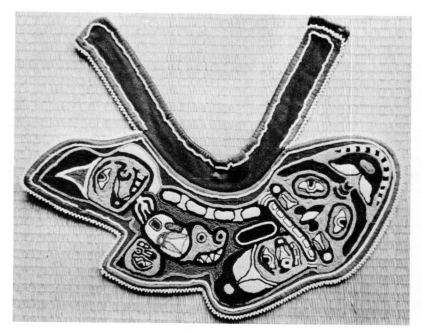

ligious ceremonies are beaded in the "gourd stitch" technique—which is similar to netted beadwork. Apache women's collars are also made in this manner, producing a very solid beaded surface. Northwestern *spot-stitch sewing* spread from the Great Lakes across the northern Plains into the Plateau area and then north to the coast. It was much used by the Blackfeet and Crow for geometric beadwork designs until about 1880, when floral motifs from Europe became the vogue. It is generally agreed that floral designs were inspired by European embroidery.

Unfortunately, the impact of Indian beadwork is almost entirely lost when it is seen in the inanimate environment of the museum. This brilliant decorative art was invented for its ability to enhance motion. Only in the dance arena, at ceremonials and rituals, can we still glimpse the splendid vividness which Indians brought to the lavish and intricate designs of their work with beads.

Northwest Coast Tlingit beaded collar. Portland Art Museum, Oregon.

Ojibwa bandolier bag, made of velvet, cloth, beads, and ribbon. Wisconsin, c. 1890. Collection of the author.

7.
Pottery

The past makes itself vividly known to us through the evidence of millions of pottery fragments which have survived all the assaults of time and nature. Pottery shards have traditionally been the major traces through which archaeologists glimpse prehistory. And yet, there is no other medium of human expression which so continually arouses debate in regard to its evolution, chronology, distribution, and diffusion.

Discussions of the origins of pottery in the Western Hemisphere, as we shall see, are bristling with discord among experts, with theories raised and abandoned three and four times within a single decade. The ever-growing abundance of pottery materials is a strong impetus behind the need for constant revision of our views. Therefore in this chapter on pottery we must particularly avoid current dogma· and look toward the near future, when many of the unanswered questions about the evolution of ceramics in the Americas may be resolved.

As early as 1961, Donald W. Lathrap pointed out numerous problems in the old idea that two areas of so-called high civilization in the Western Hemisphere arose from an essentially uniform cultural base. This "Spinden Hypothesis," as it has been called, was based on four premises: 1) the earliest ceramic traditions of South America represent a north-to-south spread, from a place of origin in Mesoamerica; 2) the earliest centers of Mesoamerican ceramics coincide with the early centers of seed-crop agriculture (maize, beans, squash); 3) the spread of such basic agricultural patterns connects fairly closely with the spread of pottery; and 4) many of the basic and significant cultural similarities shared by Nuclear America are the result of this expansion of a single, fairly uniform culture (see Robert Wanchope, ed., *Handbook of Middle American Indians*, vol. 4, pp. 265–276).

"Recent archaeological excavations," Lathrap points out in this article, "have tended not to support certain aspects of the Spinden Hypothesis." It seems that agriculture long predated the appearance of pottery in numerous Mesoamerican sites, and that pottery was not truly an invention of Mesoamerica. "It is generally agreed," Lathrap later wrote in 1975, "that civilization . . . arose in two areas of the New World—one called Mesoamerica, including roughly the southeastern half of Mexico, Guatemala, and the western strip of Honduras, and the other the Central Andes of South America, including most of Peru and the northwestern part of Bolivia. The degree to which these two developments leading ultimately to civilization were independent of one another is a question still hotly debated by scholars." Lathrap himself believes that pottery originated in the Amazon Basin, on the eastern slopes of the Andes in present-day Ecuador, and gradually spread to the highlands and coastal region. What evidence we have at hand, Lathrap (1975) asserts, suggests that "the Formative cultures of

coastal Ecuador did, in fact, exercise a decisive influence on both of the New World areas where civilization was ultimately achieved." Evidence in support of this diffusion of pottery from coastal Ecuador is impressive.

Iridescent painting was an inevitable result of the long period of ceramic experimentation in the Ecuadorian Formative. In contrast, there is no evidence of such a tradition of experimentation in southern Mesoamerica that could account for the iridescent pottery of Ocos. "We must conclude that this technique was transmitted in fully developed form to coastal Guatemala from Ecuador" (Lathrap, 1975). The so-called napkin-ring ear spools are found in Guatemala as well as in the Tlatilco culture of the Valley of Mexico, yet the same sort of ceramic spool is found in an earlier stage of Ecuadorian prehistory (Terminal Valdivia, c. 1600 B.C.)—"so this form of ear ornament is clearly older in Ecuador than in Mesoamerica" (Lathrap, 1975). Hollow figurines appeared in West Mexico and from there penetrated the Central Mexican highlands. Most lines of evidence suggest that this group of figures appeared in Mesoamerica between 1200 and 100 B.C. In just about the same time range very similar hollow figurines appeared on the central coast of Peru without any known local developmental antecedents. Yet another example of these hollow figurines has been found in the Rio Chico area of Manabi (Ecuador). If, indeed, all of these examples relate to the same artistic tradition, which way did the influences flow? The Mexican examples occur in the context of the very earliest Formative cultures in that particular area in Mesoamerica. There are no known prototypes or antecedents

in Mesoamerica. The Peruvian examples also lack local experimental antecedents. The large hollow figurines of the Chorrera tombs on the Rio Chico are the end products of a gradual stylistic evolution in coastal Ecuador that started as early as the San Pablo style of Valdivia figurine; this suggests that the figurine tradition of the three areas has a historical unity and that the immediate point of origin was coastal Ecuador. The long distances and the lack of comparable examples in the intermediate area again suggest transmission through coastwise voyages.

The stirrup bottle, which is basic to the Chavin ceramics of the north coast of Peru, has its probable origin, according to Lathrap, in the Machalilla epoch (1500–1100 B.C.) of Ecuador's prehistory. There were also many Ecuadorian influences upon Chavin iconography. "Although coastal Ecuador did not accept Chavin religion and iconography to any notable degree, Ecuador was the physical source of two elements that were basic to Chavin religion. Two marine shells, *Malea* and *Spondylus,* are frequent and important elements of Chavin religious art" (Lathrap, 1975). The people of Chavin had to obtain these shells by long-distance trade routes from coastal Ecuador.

Today it is generally agreed that the ceramic art of the Americas had its origins in Ecuador. There is still some speculation among archaeologists that pottery may have also developed independently in the Southwest of the United States, which is based on very early finds of baskets daubed with clay to make them watertight. But in general the consensus appears to be that pottery arose in Ecuador and diffused throughout the

Americas from that starting point: it reached the Peruvian societies as they achieved great refinement; it extended into Mesoamerica, where Olmec groups were apparently "founding" the multifarious succession of Mexican cultures; and, finally, it spread from the Valley of Mexico into what is today the Southwest (Arizona and New Mexico) of the United States. This chronology will, at least for the present, provide the most acceptable basis for our discussion of Native American pottery. But before we undertake the complex history of Indian ceramics, we must examine some of the features of American pottery which are found throughout the Western Hemisphere.

The various tribes of the ancient Americas did not know the potter's wheel. Their production of ceramics was the result of building objects from coils or strips of clay, smoothed with the hand or with some type of small implement like a river stone, a fragment of wood, or a shard. Objects were also sometimes formed by pressing clay into molds or by a method using a paddle and anvil—that is, by supporting the inner surface of the clay vessel with a stone (anvil) while shaping its exterior with a small wooden paddle.

All the five classical pottery areas which we shall discuss in this chapter offer distinctive forms of ceramic art and show a marvelous diversity of styles, from imitations of basket-weave patterns incised into naked clay to complex sculptural pots, depicting ceremonial traditions as well as daily life in great detail, and the inimitable fresco vases with their spectacular iconography. Every shape and type of ceramic have

been found: bowls, jars, pitchers, and platters, as well as figurines and vessels unique to the Americas, such as stirrup-spout whistling bottles. These fine pots are painted, carved, stamped by a mold, or sculpted into human, animal, and plant shapes. Geometric designs, assimilated presumably from the example of textile patterns, are prevalent among the painted and incised ware, while pottery perforated before firing—the ceremonial and mortuary vessels of Mexico and Central America—was produced with such great refinement that it is usually attributed to a class of professional full-time potters.

The process of making pottery varies according to locality, but the coil method is by far the most common one. Coils or ropes of clay are rolled out by hand and used to build up spirally the sides of a vessel, working upward from the base. With wet hands, the potter shapes the coils into a form by adding more and more coils of clay, one above the other, slightly overlapping. Each coiled layer is pinched to the layer beneath to make it adhere. A paddle is often used to shape the exterior of the vessel. This paddling is employed primarily to model the pot after it has been built up to the desired size. Shaping the pot is a slow and arduous process; the walls must be allowed to dry as they are gradually curved into a shape, and this curving is achieved by using prized pieces of shell or shard— exactly the appropriate size and shape for each job—with which the inside and outside of the pot are smoothed and gently curved into the shape desired by the potter.

After the pot has been dried in the sun, the surface is dampened and scraped smooth with a sharp-edged in-

strument. Cracks and holes are carefully filled with wet clay, and the entire surface is rubbed with a dry corncob or a similar burnishing tool.

For pots which are to be decorated, a process called slipping is frequently used. The slip is a very rich mixture of water and colored clay. Several coats are applied to the surface of a pot with a tool such as a rabbit's tail or a brush made from plant fiber. The pot is dried after each coat of slip. After the slipping, the pot is polished for many hours or even for several days. A smooth "polish stone" is usually used for this purpose; such stones were handed down from mother to daughter for generations. Vessels which are not to be painted are often given a high-gloss finish by rubbing them with fat. True glazing was rare in the Americas. In some regions, however, a durable polish of wax, fat, or resin was sometimes applied.

The method of pottery firing is unique. Large jars are usually fired separately, but the smaller vessels are generally fired in groups. Pots are inverted and placed on rocks (or on metal grills or even tin cans, by today's Indians), with a fire built beneath them. Among the tribes of the post-Columbian Southwest, and perhaps among several other pre-Columbian cultures, it has been traditional to stack dried sheep or cow dung over the pots, covering them completely. This makes the fire burn evenly and slowly. Contact with the fire can stain the finish of pots, so they are usually protected from the flames. A black, shiny finish is obtained by smudging— which requires the potter to smother the fire with damp manure and surround the pots with sheets of metal to reduce oxygen in the fire. A dense smoke results

from this procedure, impregnating the pottery with carbon and rendering the desired black finish. An open fire, however, without smudging, gives the clay the familiar reddish tone of most pottery.

Pottery is decorated by a variety of techniques throughout the Americas. Painting is the most widely used method for decorating pots. It is generally agreed that now and in the past potters made no sketches, but made their designs free-hand—improvising out of a long tradition. The medium used for painting was usually ground minerals and boiled plant juices.

Negative designs are produced by a reverse process: instead of painting the design, the potter paints the background black, leaving the desired design in the color of the original base slip that covers the naked pot.

Resist painting is a prehistoric technique somewhat similar to stencil printing. First, designs are painted on a pot with a material such as wax. Then the entire surface of the pottery is painted— but the area prepainted with the resistant material (such as wax) does not take the paint, and thus the wax shields the original color from the effects of the pigment. When the wax is removed the undercolor of the pot becomes an imprint of the design painted on the surface in wax.

Corrugation results when a potter smooths a pot on the inside, but leaves the ridges of the clay coils on the outside of a vessel. This is one of the most common of early ceramic techniques. Sometimes the potter creates a scalloped effect on the outer walls of a pot by pinching the coils as they are applied.

Impressing designs with shells, tex-

tiles, or fingernails in the soft clay of a pot is another important early technique. Sometimes patterns are made by poking designs into the soft clay surface; this method is called punctuation.

Incising or scratching designs into the soft clay surface of an unfired pot is done with a tool of wood or bone.

Engraving is like incising but usually involves finer lines, scratched into the dried, hard surfaces of pots which have already been fired.

Stamping was developed from the various impressing techniques. Designs are pressed into the clay while it is soft. The tools used for stamping are paddles or stamps, which transfer their relief patterns onto the surface on which they are pressed.

Effigy modeling and molding are two important techniques which produce both simple and extremely complex figurative and sculptural effects. A pot is built up into various three-dimensional forms: human, animal, plant, and so on. A similar result is attained by pressing wet clay into molds.

A more specific discussion of the re-

Ceramic fragments with incised motifs. Valdivia culture, Ecuador, 4000–2000 B.C. Museo del Banco Central del Ecuador, Quito.

gional forms of pottery and decoration will be undertaken in the context of the following ceramics areas: Ecuador, Colombia, Peru, the Isthmian region (Panama), the Maya area, the Mexican area, and finally the Southwest and Southeast of the United States.

Among the archaeologists of Ecuador there is general agreement about a series of dates, which, for the sake of simplicity, may be broken down into three major epochs: Valdivia (dating from about 3100 to 1600 B.C.), Machalilla (dating from 1500 to 1100 B.C.), and Chorrera, or Engoroy (dating from 1000 to 300 B.C.). If we accept the carbon-14 assays for this chronology, we must note, according to Lathrap (1975), "the appearance of Formative sites in Ecuador 1000 to 1500 years earlier than in either Mexico or Peru."

The initial discovery of Valdivia culture was in locations on or near the seashore. Intensive archaeological surveys, however, have indicated that not all Valdivia sites were oriented entirely or even primarily toward the sea. For instance, the Loma Alta site, which has provided the earliest securely dated Valdivia ceramics, is nine miles up the Valdivia River. Valdivia communities have large, deep deposits of cultural refuse as well as large quantities of well-made pottery. Although the Loma Alta shards appear to be the ancestors of the other phases of Valdivia ceramics, they are not necessarily the oldest pottery in Ecuador. Archaeologists have recovered at the Valdivia site a few fragments of pottery in a different style from a level underlying that containing Loma Alta materials. This pottery, which has been named San Pedro, is apparently outside the known

range of Valdivia stylistic forms. Though these San Pedro materials are older than those of Valdivia, they do not appear to be ancestral to them. These facts suggest the existence of not just one but a minimum of two distinct pottery traditions at a time period prior to 3000 B.C.: namely, San Pedro and a yet undiscovered form ancestral to the earliest Valdivia pottery of Loma Alta.

The earliest known Valdivia pottery of Loma Alta is technically developed, and the lack of any clear antecedents to this highly evolved Ecuadorian ceramic tradition has roused speculation among specialists. Meggers, Evans, and Estrada have discussed similarities between the pottery of Valdivia and Middle Jōmon ceramics of Japan, and have postulated that Valdivia vessels were introduced to coastal Guayas from Japan by the chance landing of Jōmon fishermen whose boats had been blown off course. "It seems clear today," Lathrap wrote in 1975, "a decade after the Jōmon theory was proposed, that the immediate ancestor of the earliest Valdivia pottery (Loma Alta) is to be sought in Ecuador and that pottery in South America is many centuries older than the postulated Jōmon Odyssey."

For the moment the origins of Native American pottery remain unknown, though examples of ceramics date back farther than 3000 B.C. The exact interaction among various South American Formative cultures is also shadowy. For instance, during the various phases of Valdivia there is a consistent developmental activity in pottery making, and then, quite abruptly, "the elaborate use of zoned textured decoration in combination with multi-colored, resin-based paints put on the vessel after it was fired

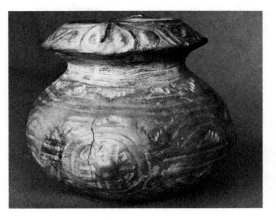

Ceramic jar with incised motif. Valdivia culture, Ecuador, 4000–2000 B.C. Museo del Banco Central del Ecuador, Quito.

appears suddenly in the Valdivia tradition and has no local developmental antecedents. . . . All available evidence clearly indicates that this pottery tradition known from the lowland forest site of Tutishcainyo and the Huánuco Basin sites of Kotosh and Shillacoto was initially a lowland Tropical Forest development spreading from the west Amazon Basin up the eastern slope of the Andes. This aesthetically spectacular style, which is a manifestation of developed Tropical Forest culture, greatly modified and enriched the ceramic inventory in the final phase of Valdivia" (Lathrap, 1975).

Thus, the tropical region of South America appears to have been a major contributor to pottery development in the Western Hemisphere despite the conventional notion that great cultural innovation is not possible in tropical zones. Lathrap (1975) notes that "another characteristic of the Tropical Forest tradition shared by the eastern Peruvian lowlands and the Huánuco Basin was the use of a particular form of closed bottle with two spouts and a connecting bridge." It may yet prove possible, as Lathrap is inclined to suggest, that the origin of numerous Native American

cultural traditions, including pottery, may yet be found in the Upper Amazon.

The ceramics of the Machalilla culture of Ecuador continue many features already noted in late Valdivia, and, as such, Machalilla pottery can be looked upon as an outgrowth and continuation of Valdivia, though a completely convincing transitional phase has not been described in published literature. An important innovation in Machalilla ceramics is a tall pedestal base—a tradition which appears to be yet another borrowing from the Amazon and Orinoco drainages. "Bottles with a rather short, markedly flaring neck and red-on-tan linear decoration occur in Machalilla. These are of the greatest interest, since they are essentially identical with the very early bottle forms of West Mexico and Tlatilco. Ecuador would appear to be the source of the West Mexican bottle tradition" (Lathrap, 1975).

Another important Machalilla invention seems to be the stirrup-spout bottle—a vessel which eventually became essential to the ceramic art of northern Peru (from about 800 B.C.). The stirrup spout also appears in the Capacha culture of Colima in West Mexico in 1450 B.C. and continue as a West Mexican

Effigy jar with incised representation of a coiled snake. Ceramic with red slip and smudged black; the eyes are inlaid with obsidian. Chorrera culture, Bahía de Caráquez, Ecuador, 500 B.C.–A.D. 500. Museo del Banco Central del Ecuador Quito.

specialty even up to the time of Tarascan ceramics, c. A.D. 1400. From Mexico the stirrup spout spread to the United States, both into the Southwest and the Southeast, where it occurs only rarely. Available dating suggests that the Machalilla development is the source of both the Peruvian North Coast tradition and similar vessels in West Mexico. It now seems clear that the stirrup spout developed in Machalilla is a modification of the kind of double-spout-and-bridge bottle found in the earliest known ceramic tradition of the Upper Amazon.

Chorrera culture represents the artistic climax of Ecuadorian prehistory, though many of the aesthetic achievements which reach their most masterful elaborations in Chorrera have their origins in Machalilla and Valdivia times. A distinction of Chorrera ceramics is a creamish white slip which appears as a rarity in the late Machalilla epoch, c. 1100 B.C. Also typical of Chorrera ceramics are numerous and elaborate anthropomorphic and zoomorphic vessels, which represent the most accomplished realistic modeling in the Native arts of the Americas, having their antecedents in the somewhat rare anthropomorphic pots of the Machalilla culture. Though we must not overevaluate the naturalistic ceramic tradition simply because it appeals to the conservative, illusionist premise of art, we still must recognize the importance of this realist trend as an influence upon Andean effigy pottery, such as that of the Moche.

Another element of Chorrera ceramics is the use of resist decoration. The so-called iridescent painting of Chorrera pottery is a slight refinement of the red-and-black color scheme common in Ma-

chalilla ceramics. Thus massive influences from the Amazon and from previous Ecuadorian cultures gave form and style to Chorrera ceramics. The major innovation in Chorrera pottery was the conversion of the double-spout-and-bridge bottle into a bottle with a spout, bridge, and whistle. A lavish research program concerning the gradual evolution of this ceramic form has been undertaken by Marcello Villalba O. of the Museo del Banco Central de Quito ("La Botella de Asa de Estribo en el Contexto del Sitio Formativo de Cotocollac," 1979). According to Lathrap (1975) "Chorrera vessels seem to be the prototype for the early Paracas bottles on the South Coast of Peru, which frequently carry elaborate Chavin designs. The pitch of the whistle in the Chorrera bottles was carefully regulated and, in some instances, there are two whistles at an interval of a third. The musical implications of the whistle were often emphasized by the addition to the whistling bottle of an effigy of a performer on the panpipes." The significance of the Native panpipes is unknown, but the iconography is clearly associated with the bottle, which produces a whistling sound as water is poured from it. This effigy–whistling bottle may also be the origin of the hunchback flute player, which is

a dominant and recurring icon in Mesoamerican cultures.

The sculptural forms of Chorrera vessels are diversified and marvelously finished. One form deserves special attention. There are numerous elegant bowls, frequently on high pedestal bases, in which the whole interior area of the pot is conceived as the body of an animal, with the head, limbs, and tail executed as a miniature modification of the rim, and with the head looking inward, toward the interior of the vessel. Most of the Chorrera examples of this remarkably abstract tradition represent bats. The whole concept of transforming an open bowl into a zoomorphic effigy through modification and modeling of the rim is typically Amazonian. These pedestal bat bowls seem to be a further example of influences coming to Chorrera from the Amazon.

The Chorrera ceramic pillow, or neckrest, also requires comment. "This form is strikingly similar to east Asian pillows and it has been suggested that they represent the influences of transpacific contact during the first millennium B.C." (Lathrap, 1975).

We cannot leave the discussion of Ecuadorian ceramic art without a refer-

Ceramic zoomorphic bowl with bat motif. Chorrera culture, Ecuador, 1800–800 B.C. Museo del Banco Central del Ecuador, Quito.

Ceramic neck rest. Chorrera culture, Bahía de Caráquez, Ecuador, 500 B.C.–A.D. 500. Museo del Banco Central del Ecuador, Quito.

Left: Hollow figurine of a standing woman with ear spools and with painted and engraved motifs representing body paint or a textile costume. Ceramic red slip and smudged black; the engraved lines are filled with white pigment. Chorrera culture, Ecuador, 1800-800 B.C. Museo del Banco Central del Ecuador, Quito.

Right: Manabi seated mother and child. The mother holds the sleeping infant in both hands, straight legs extended forward, with pierced mouth and bulging eyes, and a shirt with geometric ornamentation. Los Esteros, Bahía, c. 500 B.C.–A.D. 300. Photograph: Sotheby Parke-Bernet.

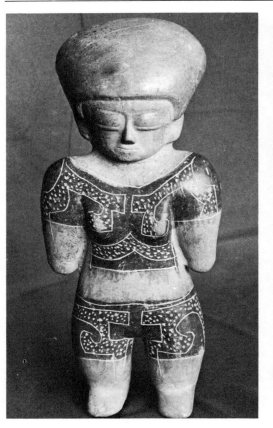
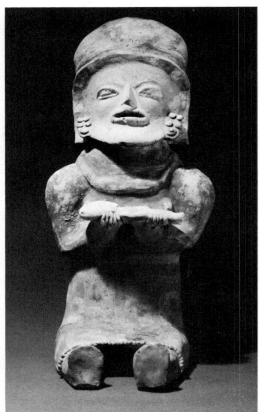

ence to the figurine tradition. Lathrap (1975) has indicated that "the figurine tradition so typical of the Ecuadorian Formative cultures represents the earliest known appearance of this form of artistic expression in the [Western Hemisphere]." The earliest Ecuador figurines of human beings are carved stone. Most typical of early Valdivia culture are carved female figures with tiny faces almost hidden by a mass of hair. The top of the head shows a short incised line running from front to back. The arms are barely indicated, and the legs are separated by a narrow slot-like cut. A clear definition of the breast shows that a woman is intended, but "the whole figurine has the overall form of a penis with the massed hair explicitly in the form of the glans" (Lathrap, 1975). There are a few instances of male figurines, but females are much more numerous. The final development of carved figurines in late Valdivia culture clearly anticipates the facial features of Chorrera hollow figurines. A peculiarity of the figurines of the Machalilla period (which on the whole are rather abstract and stylized) is a row of perforations or punctuations along the edge of the head or along the edges of the ears. "One suspects that hair or feathers were inserted as a form of adornment" (Lathrap, 1975).

The hollow Chorrera figurines are seen by many experts, including Lathrap, as "a high point in the ceramic art" of the Indian Americas. Lathrap con-

cludes that "the figurine tradition of Mesoamerica was directly derived from that of the Ecuadorian Formative." As such, we may view the ceramic arts of early Ecuador as the crowning climax of a long tradition of pottery making, whose probable origin was in the depths of the Amazon Basin and whose refinement was achieved both along the coast and high in the Andes of present-day Ecuador.

In a general survey it is not possible to discuss every aspect of the Native arts of each region and each period of the Americas, and yet it would be aesthetically remiss not to mention the exquisite pottery produced in the Carchi, or Tuncahuan, style at El Angel in the Province of Carchi in the north highlands of Ecuador—on the border of Colombia. There is little known and little written about this remarkably handsome ceramic style. Geometrical forms and animal silhouettes in black negative paint over red and cream slips is the dominant style, influenced, apparently, by Colombian negative painting methods. The Ecuadorian resist-decorated ceramic tradi-

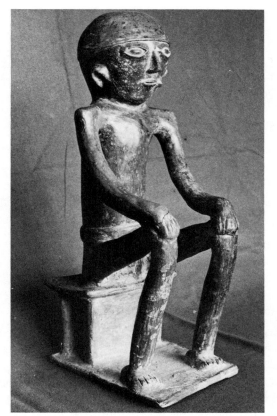

Coquero—a person chewing coca. Ceramic with negative (resist) painting. Carchi culture, Ecuador highlands, 500 B.C.–A.D. 1400. Museo del Banco Central del Ecuador, Quito.

tion of the Carchi culture consists primarily of dishes, footed plates, and amphoras about three feet high. Since the beginning of this century, when Verneau and Rivet published numerous photographs of Carchi material, little else has been written on the subject. Dating is generally designated at A.D. 1000–1500. Some figurines of Carchi origin are known: modeled figures of men seated on benches chewing wads of coca. The figurines are finished with the same resist decoration (black on red ceramic is common) as the exceptional dishes produced by this remote highland culture.

Before leaving Ecuadorian pottery and turning to the pottery of Colombia, there are a few essential implications of

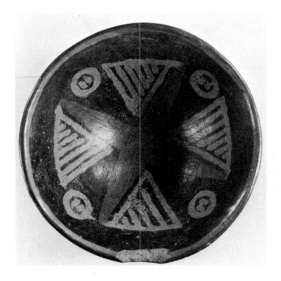

Ceramic bowl. Negative (resist) painting on clay. Carchi culture, Ecuador highlands, c. A.D. 600. Collection of the author.

ethnography, aesthetics, and iconography which can be surmised from the ceramics of Ecuador. For instance, a number of the large, hollow figurines suggest that body painting with complex designs was widely used in the Chorrera culture. Various flat stamps and roller stamps found in Chorrera refuse also suggest that body painting was much favored as a form of personal adornment. In the Tropical Forest similar roller stamps are still used exclusively for the purposes of laying painted designs on the face and body.

The wide use of hallucinogenic drugs also appears to have played a major part in the lives of early Ecuadorian Indians. "The chewing of dried coca leaf with lime is one of the most widespread characteristics of Andean peoples . . . and there is strong reason to believe that the full complex of chewing cultivated coca with lime was present in Valdivia culture from the beginnings of the Loma Alta occupation (c. 3000 B.C.). Since there are numerous relationships between the ethnography of the Tropical Forest cultures and Andean cultures, it is possible to assume that hallucinogenic drugs may have played a substantial part in the cosmology and ritualism of early Ecuadorian peoples. . . . Tropical Forest cultures of South America are remarkable in that they use far more hallucinogenic drugs and integrate the use of such drugs into their religion in a more complex way than any other peoples on earth" (Lathrap, 1975). The importance of the custom of coca chewing can be illustrated by a dynamic and carefully modeled figurine in Charcras style from the Valdivia site. In this figure the characteristic quid of coca in the cheek is clearly depicted. This is the earliest known example of a long tradition of figurines depicting coca chewers manufactured mainly in the northern highlands of Ecuador (late Valdivia, c. 1600 B.C.).

A curious Chorrera whistling bottle may explain aspects of the drug use and the belief systems. The head of the creature depicted is a toad rearing back and presenting threatening claw-like limbs. On closer examination these limbs seem to be the heads of raptorial birds. This

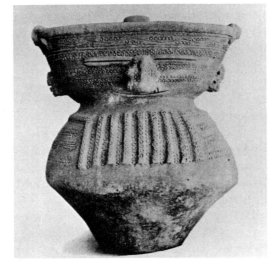

Left: Quimbaya anthropomorphic jar, with two human faces and the zoomorphic motif of four frogs; decorated with incised circles. Colombia. Collection of the author.

Right: Calima anthropomorphic vessel. Colombia.

threatening toad may relate to the mythology of a number of Central American and South American groups. The toad (according to Peter T. Furst, "Hallucinogens in Precolumbian Art"*) is an all-powerful female deity who is both a source of life and the destroyer of life. Furst has argued that the importance of the toad deity is tied to the use of the poisonous skin secretion of certain species of toad as an hallucinogenic drug.

Bushnell has pointed out that little is known about the chronology of Colombian pottery. "Great strides have been made recently in building up a cultural succession," he wrote in 1965, but even in 1979, when Jesus Arango Cano published his definitive *Precolumbian Ceramics* in Bogotá, Cano did not venture to provide a single date for the various finds of the several distinctive ceramic styles of Colombia. The situation has not changed: chronology is as much an unknown for the highly praised and documented metalwork of Colombia as it is for the pottery. The inclination, therefore, in the discussion of Colombian ceramics is to deal with regions irrespective of cultural succession. "The isolation in which the various groups and their cultures lived, determined," according to Arango Cano, "that each region had a distinct kind or kinds of ceramics." For instance, the famous Quimbayas were consummate naturalists, renowned for their anthropomorphic offering jars, their double-spouted stirrup vessels, spindle whorls, and stamps for body painting or ceramic incision. On the oth-

Humanoid figure as whistle, with zoomorphic mask. Tairona, Colombia, c. A.D. 800. Collection of the author.

er hand, the Calimas (a people distinct from the Colima culture of Mexico) excelled in making the so-called basket carriers, their own double-spouted stirrup jars, and a unique style of surrealist iconography with which they painted their pottery. The Chibchas had the finest anthropomorphic pitchers (Arango Cano). The Taironas were outstanding in their mythical conceptions, which they worked into marvelous, abstract motifs: twisting serpents and dragons. Of all the Taironas' ceramics, perhaps the best known are their zoomorphic and anthropomorphic whistles. The Quillacingas distinguished themselves with their ocarinas (a unique Latin American wind instrument), producing them in the form of seashells. Their bowls, richly decorated with negative painting in several colors, are also renowned. The Tumacos excelled in figurines with strange,

*In Mary E. King and Idris R. Traylor, Jr., eds., *Art and Environment in North America*, Special Publication No. 7, Texas Tech University Museum, 1974, pp. 11–101.

Tumaco warrior with feline facial features. Colombia. Banco Popular of Armenia collection, Colombia.

Quimbaya seated chief. Negative (resist) decoration in polychrome. Colombia. Collection of the author.

deformed heads—similar in style to pieces from early Egyptian dynasties. They also produced fine jaguar and were-jaguar figures.

Each Colombian region, each geographical and tribal area, had a strong localized style; their typology was highly defined and in many cases, according to Jesus Arango Cano, is the sole means by which we may now identify various Colombian cultures.

The most exceptional and also the most praised of the ceramics of Colombia were produced in the Quimbaya region—which currently comprises the departments of Caldas, Risaralda, and Quindío and part of the north of the Valle del Cauca. The Quimbaya negative painting in black over red or red and white is probably related to styles in southern Colombia and Ecuador and, further, to Recuay styles in Peru (Bushnell). This painting is used not only on vessels but also on some examples of a rather flatly constructed, hollow figurine with a large, somewhat square head and slender limbs usually portrayed in a squatting or seated position. Another distinctive Quimbaya ceramic technique is generally called *champlevé:* a manner of differentiating between surface areas by deeply excised rows of small triangles or quadrilaterals. The most striking and perhaps the most typical of Quimbaya ceramics is a series of pieces representing seated chiefs. Traditionally these figurines have square, flat heads of very shallow depth. They have negative pictorial decorations in several colors. On the wrists and legs are often incised images that depict bindings, which are common among these Indians; the forehead is usually encircled by a braid, which symbolizes power (Arango C.).

Ceramic art in Venezuela is virtually confined to the west and the center of the country (Bushnell). Among the various pottery styles several features tend to recur. There are tripod vessels with the legs swollen toward the top and prolonged upward beyond the rim of the bowl. There are also tripods with the feet united by a ring. And, finally, there are effigy jars with applied details as well as black-on-white curvilinear painting. According to Bushnell, "characteristic of Venezuela are vigorously modelled figurines." The most frequent subject of these figurines is a woman with a head of enormously exaggerated width, with curved or squared top, the latter representing a headdress. These figures usually have applied coffee-bean eyes; breasts are rarely indicated by more than applied buttons; and the buttocks and lower limbs are voluptuous. Some male figurines are also found, as well as figures without sexual differentiation which have wide heads surmounted by a top-knot, with the features and limbs ingeniously indicated by abstract grooves and cuts. These have marvelous, smooth convex surfaces which show a remarkable similarity to the modern twentieth-century sculpture of such artists as Arp and Brancusi.

There are several areas in northeastern Brazil that have pottery of interest, but the most important pottery of the region is the so-called Marajóara style of Marajó Island, at the mouth of the Amazon, where finds date from the last few centuries before the European invasion. According to scholars such as Bushnell, this ceramic style was brought to the island, probably from eastern Colombia or Ecuador, already fully developed. Once

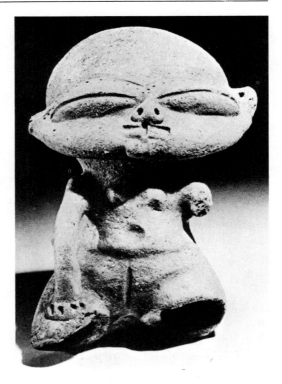

Buffware effigy. Lake Valencia, Venezuela, A.D. 1000–1500.

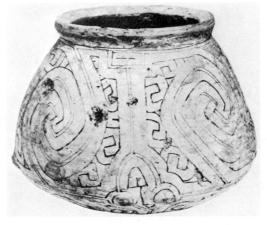

Carved redware bowl. Marajó Island, Brazil, A.D. 1000-1500. Collection of the author.

adapted by the islanders, however, the pottery appears to have declined in quality. The most characteristic ceramics are large burial urns, often in the shape of stylized human figures, and cylindrical stools. The decorative techniques are striking, with entire surfaces covered with complex scroll patterns.

There is also a site on the Tapajós River, a tributary of the Amazon some three hundred miles from the mouth, where significant ceramics are produced. From this area comes the ceramics style generally known as Santarém (Bushnell), which was produced between A.D. 1000 and 1500. "It is distinguished by its exuberant modelling and has little painting apart from the occasional use of red" (Bushnell).

The chronology of Brazilian pottery is unknown. In fact, scholars such as Bushnell believe that "little of artistic importance is known from the vast territory of Brazil," and only in the work of Donald Lathrap (1970) can one discover the spectacular outlines of a still unknown history of the brilliant pottery production and cultural invention which characterized the upper Amazon.

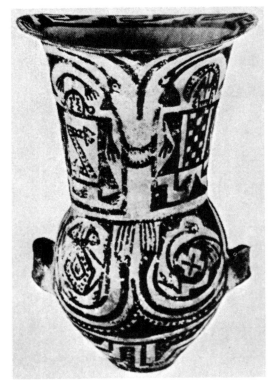

Ceramic urn. Santamaria culture, Argentina. Museum für Völkerkunde, Berlin.

"So far as we know at present, pottery arrived in Peru around 4000 years ago, spreading rapidly throughout the country, so that between 1800 and 1300 B.C., when the Early Farmers arrived, it was already known on the coast, on the sierra, and in the jungle" (Luis Guillermo Lumbreras, 1980). The earliest pottery of this region is technically deficient, but—as Lumbreras has suggested—the technical faults do not signify a pottery that was newly born; the defects are those of the learner, not of the discoverer. "The shapes and the workmanship indicate a long established maturity which clearly did not begin in Peru" (Lumbreras, 1980). Thus it appears that Peru borrowed its ceramic tradition from cultures in Ecuador and Colombia, where pottery long predates the earliest Peruvian finds.

After several centuries of regional experimentation, numerous advances were made until about 1300 B.C., when a unique style emerged which archaeologists normally designate as Chavin—a name given to a civilization of exceptional social and economic advancement. The center of this culture was located in Ancash, in the northern Peruvian Sierra. Here flourished a marvelous and refined production of pottery.

Chavin culture appears to have had two phases. The first lasted for about five centuries (1300 to 800 B.C.) and was characterized by a remarkable creative energy, with a pervasive and constant exploration of new ceramic shapes and decorative forms. All this excellence was achieved with the simplest pottery techniques: the vessels were constructed by hand, without the use of molds or ceramic tools; the decoration was made by

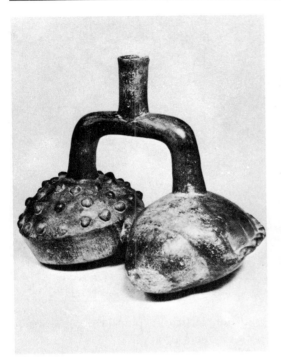

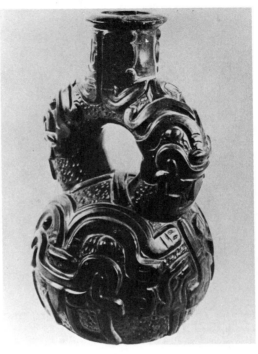

Left: Chavin double shell effigy with stirrup spout. Cupisnique culture, Peru, 500–200 B.C. Museum of the American Indian, Heye Foundation, New York City.

Right: Chavin stirrup spout vessel with feline motifs. Cupisnique culture, Peru, c. 800 B.C. National Museum, Lima.

incisions, applied strips of clay, or simple modeling. Some of the pieces were painted, but most of them were unpainted and tended to be black, gray, or dark brown, showing signs of basic defects in firing techniques.

The second phase developed more or less concurrently with the first, and it is generally accepted as an extension of Chavin culture, though some scholars regard it as a quite distinctive and geographically separate evolution.

"Although," writes Lumbreras (1980), "archaeological literature has generalized this period with the name of Chavin, it must also be pointed out that at the same time in Peru other related cultures were developing though they were individual and different. Such is the case of Cupisnique on the north coast which is frequently confused with that of Chavin. Probably one of the most striking differences is that the Cupisnique bottles

are distinguished by a strange spout known as the 'stirrup spout,' which is not found in the old Chavin period where the jars are tubular in form, resembling a trumpet and with a bell-like neck." This distinction between Cupisnique and Chavin pottery suggests a significant diversification in Peruvian ceramic style: in the north, the Cupisnique artists apparently had learned to use clay to form sculptural pieces, whereas in Chavin culture the artists were not primarily concerned with shape but with iconographic designs, in the form of incisions on smooth, relatively simple pottery forms. This tendency, which began in such early times, has been maintained in Peru throughout all history, and without any exaggeration one can point out two definite artistic horizons, one based on sculpture and the other on design, the former from the north and the latter from the center and the south, the first

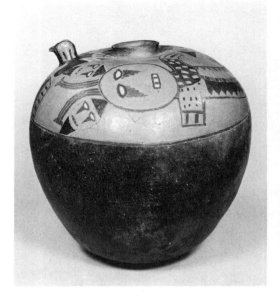

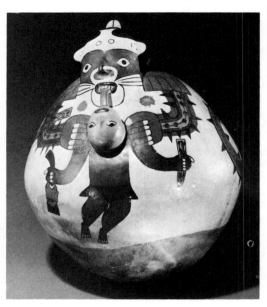

Left: Ceramic Paracas storage jar. Peru, 300–100 B.C. The Michael C. Rockefeller Wing, The Metropolitan Museum of Art (Gift of Nathan Cummings, 1974), New York City.

Right: Nazca monumental painted effigy jar. Peru, c. A.D. 100–500. Photograph: Sotheby Parke-Bernet.

arising out of Cupisnique culture and the second from Chavin.

The cultural evolution of pottery in Peru seems to follow these two distinctive phases which Lumbreras describes: this is especially apparent when we examine a culture that was forming around the site of Ica during Chavin times—a culture known as Paracas. The earliest examples of Paracas pottery are contemporary with the Chavin development of highly decorated vessels and reveal the close contacts between Paracas and Chavin potters.

At the same time that one must recognize the Chavin influences upon the ceramics of the Paracas culture, it must also be noted that new emphases were given to the production of vessels in Paracas: a strong interest in color, for instance, which was entirely lacking in the Chavin culture. The colorist emphasis among Paracas potters later became a classical feature of the south coast of Peru, where Nazca and, later, Ica pottery represented the climax of a long

tradition of bright, painted iconographic pottery decoration.

Then, about 500 to 400 B.C., began a progressive disintegration of the classical Chavin styles. The result, however, was not a decline in the ceramic arts but a move toward more elaborated and expressive pottery. It must be recalled that the Chavin style was marked throughout its long history by poor firing, which resulted in black or dark brown vessels. The disintegration of Chavin pottery styles evidently brought about an experimental period, during which potters discovered more refined firing methods and better criteria for selecting raw materials—all of which quickly led to strong regional differences in ceramic styles.

"Initially the regionalization went through an experimental stage consisting of the search for new shapes and techniques," Lumbreras (1980) has stated. For example, the Paracas influence on Nazca pottery resulted in the decline of the meek polychrome painting of Para-

cas vessels (caused by painting with vegetable dyes after firing) and the rise of the vibrant polychromatic decoration of Nazca pots (painted with mineral pigments which could be fixed by firing). This achievement, according to Lumbreras, resulted from the technical mastery of the south coastal desert of Peru, where excellent clay and a variety of minerals were readily available to potters.

Thus, with the beginnings of Nazca pottery, we have visible evidence of a brilliant technological advancement in the selection of clays and in the firing of vessels. At about the same time potters also began to use molds to produce models on a large and imposing scale.

The economic resources and stability which seem to have brought about the advancement of Peruvian pottery also made possible a remarkable achievement in textile production. The gradual domination of weaving, as an art closely connected with rank, economy, and religious custom, eventually became a serious threat to the future of the plastic arts of ancient Peru—so much so, that all the authority was in the control of the textile artists, starting with a special "textile design" which in many cases was standard. This orthodoxy, which gained enormous power in the field of textiles, eventually changed the impulse of the ceramic arts: iconography and forms were modified to simulate the rectangular designs produced on a loom.

When standardized textile iconography is applied to pottery, it limits the possibilities of self-expression which are peculiar to sculpture, and pottery is changed into a canvas for drawing and painting.

By following the history of Peruvian

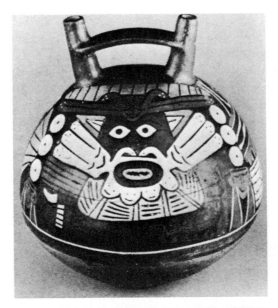

Nazca vessel. Peru, c. A.D. 100–500. Museum für Völkerkunde, Berlin.

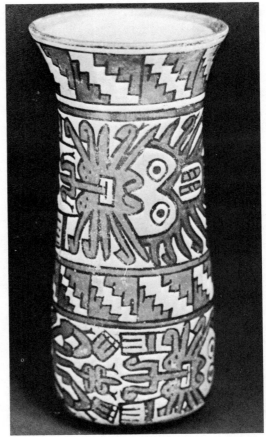

Nazca polychrome vase. Peru, c. A.D. 550–650. Collection of the author.

weaving, it is possible to follow the history of pottery. A good example is the ceramics of Nazca: "The Nazca pottery faithfully follows the creative impulse of the master weavers" (Lumbreras, 1980).

Tracing the development of pottery through orthodox textile production, however, does not provide us with the whole picture of Peruvian ceramics. The interaction of pottery and textiles was apparently limited to the south. In contrast, in the north the development of pottery followed an impulse in which textile patterns did not have the same influence as they did in the south. In the north a pervasive sense of plasticity determined the forms and realistic designs of objects made of clay. But one must not assume from this contrast between northern and southern Peru that the inclination toward naturalism in the north is somehow more significant or more refined than the emphasis upon rectilinear abstraction in the south. We must simply note the contrasts between the pottery traditions of the Peruvian north and south. Lumbreras (1980) explores and attempts to explain the relative lack of impact on pottery in the north by the techniques of textile production by pointing out that the north of Peru was not a suitable location for the growing of cotton or the raising of the wool-bearing, Andean Camelidae family of animals (such as the llama). Therefore "weaving, both the industry and the art, was scanty rather than plentiful."

The northern triumph of pottery is found in the culture known as Moche (Mochica). By far the most celebrated and famous vessels are the so-called "portrait *huacos*"—consisting of carvings of human faces which were apparently portraits of individuals, as well as

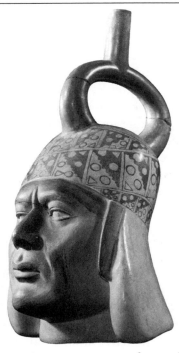

Moche stirrup spout vessel in the form of a portrait. Peru. Art Institute of Chicago.

an amazing assortment of vessels in the form of persons, deities, animals, and vegetables, all produced with remarkable skill and extraordinary attention to realistic detail. There is little question that Moche pottery was renowned in its region, for its influences are clearly seen throughout the valleys of the north coast, from Piura to Nepena and even as far south as Huarmey.

It was in Piura that the Moche tradition was transformed into a local culture with distinctions of its own. Called Vicus, this regional culture produced some of the most exquisite ceramic shapes in all Peru. Exceptionally little is known of the people or their history, but their arts are a brilliant reminder of their brief dominance (A.D. 100–800).

Nearby, in the Callejon de Juaylas of the Ancash mountains, the Recuay culture was developing at about the same time (c. A.D. 100). The Recuay pottery is distinctive: it consists mainly of bowls,

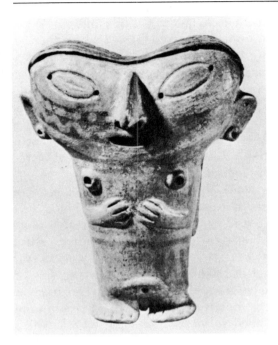

spoons of various sizes, annular-based cups, tripod jars (ollas), oblong jars with narrow necks and broad everted rims, bottles with modeled heads joined by a bridge handle to a spout, double vessels, short-necked jars with modeled figures on the upper portion, stirrup-spout jars, effigy vessels, and bugles. The decorative techniques can be grouped into three dominant modes: negative painting, positive painting, and modeling. All three techniques are often discovered on the same vessel. The so-called black-negative technique involved a clever use of the firing oven: the workers apparently covered certain areas of a vessel with waterproof materials and then smoked the pottery in the oven. The water-proofed portion of the pot took on only a pale color, while the rest of the vessel became quite dark.

Recuay pottery seems to have evolved out of Moche influences, but it should be stressed that in Recuay designs there was a notable influence of textile patterns, in contrast to the free realistic plasticity of Moche ceramics.

At the end of the sixth century A.D. something took place in Peru which had a violent cultural effect upon the whole region. It seems that a powerful urban center developed in Ayacucho. The culture which sprang up in this center is called Wari (Huari), and it was the seminal force of an expansionism which grew, like a mighty empire, spreading from Piura and Chachapoyas to Arequipa and Cuzco. With the Wari people came a remarkable ceramic art which spread with an energy and suddenness as great as their political domination. This diffusion of pottery was certainly not brought about by pacific means, nor was it the result of artistic or technological competition; it was the result, instead, of a purely political-militaristic enforcement—with pottery somehow forming part of a complex of objects and ideas exported from the Wari culture to its various satellites (Lumbreras, 1980). This cultural imperialism introduced various artistic and technical forms and

Ceramic anthropomorphic figurine. Vicus, Peru. National Museum, Lima.

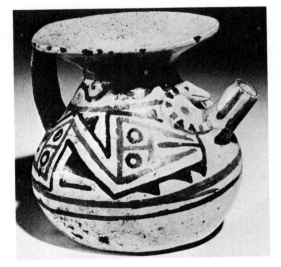

Painted pitcher, with bird-mask motif on the side. Recuay, Peru, c. A.D. 300–800. Museum of the American Indian, Heye Foundation, New York City.

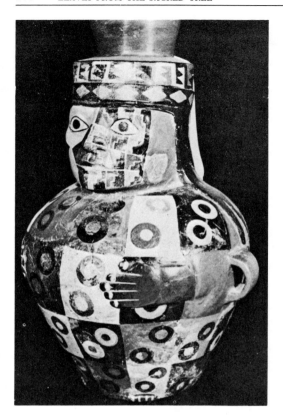

Wari clay effigy of a turbaned male. Peru, fifth century B.C. *National Museum, Lima.*

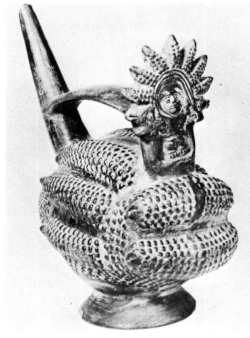

Maize god: stack of corn cobs with figure at top. Modeled blackware. Chimu culture, Peru, c. A.D. *1490. Museum of the American Indian, Heye Foundation, New York City.*

methods which were peculiar to Wari. In some regions the new Wari influences were entirely assimilated, while it appears that in other regions there was considerable resistance to Wari aesthetic ideals. In Nazca and Lima, for instance, the new Wari ceramics were rapidly and easily accepted, while in the north there was apparently a great deal of resistance to Wari influences.

Wari pottery is excellent polychrome ceramic art of a very high technical level and with an iconography and morphology of great richness and diversity. Wari wares were produced by several refined techniques, such as the use of molds, which had already been used in the north, as well as by a technique called *falsotorno*, or hand-wheel, which permitted the potters to produce their artifacts in quantity. The result was a mass production of pottery never equaled in Peru; today in the city of Wari we can still discover vestiges of the great pottery workshops which produced such quantities of vessels in ancient times.

A distinguishing characteristic of Wari pottery is the emphasis upon "textile designs," with rectilinear patterns like those produced on a loom. It was, according to Lumbreras (1980), the role of the Wari potters "to spread this art concept throughout all Peru."

Wari culture was very successful in its artistic imperialism, unifying certain technical and aesthetic criteria in Peru during the centuries of its influence (A.D. 700–1100). When Wari culture began to decline, a reaction set in among the nations that had been under its control; there was a return to the old gods, the old customs, and regional ways. Of course, the old traditions had never com-

pletely vanished and had been maintained surreptitiously in domestic pottery.

A vigorous renaissance became evident in the eleventh and twelfth centuries A.D., when the various kingdoms of Chimu, Chancay, and Ica began to emerge on the Peruvian coast, and other centers, such as that of Cuzco, were founded in the Sierra. The Chimu reintroduced the traditional patterns of the Moche; while the Chancay, Lima, and Ica people reverted to the designs of the Nazca culture. During the same period, along the coast and also in the Sierra, many small villages were returning to their own unique and local customs, though they also continued to develop new lifestyles under the new conditions left by the dissipation of Wari domination. Undoubtedly one of the major effects of the years of Wari influence was the inclination toward mass production. Thus, the ceramics made in molds became the most prevalent type produced in the post-Wari period—so much so, that among the Chancay potters even plates and other household pottery were made with the use of molds. In contrast, on the north coast people returned to their ancient sculptural style, using monochromes and duplicating certain models from pre-Wari times. Gradually pottery changed from a classical craft into a simple folk art.

The last vestige of Peruvian pottery is, of course, that produced by Incaic potters. The Incaic, or Cuzco, style began to emerge and spread throughout Peru (and also to other areas to the north and south) from the time of the founding of the remarkably powerful Tawantinsuyo empire at the beginning of the fifteenth century. The process of cultural expan-

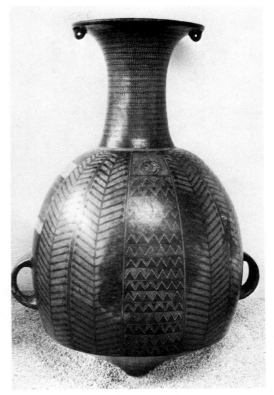

Aribalo—a clay storage jar. Inca culture, Ecuador, c. A.D. 1500. Museo del Banco Central del Ecuador, Quito.

sion was very similar in manner and impact to that of the Wari empire. But whereas the Wari pottery was distinguished and inventive, Incaic ceramic art was functional and rather unimaginative: it was geometrical in design and limited to two or three colors in its decoration. The Incas, however, exported their pottery to the entire empire, imposing its use in urban centers and in the homes of the people of rank. When the Spaniards arrived in the sixteenth century, the Incaic aesthetic was in full bloom. The people of Cuzco had greatly enriched their iconography with well-made naturalistic pieces and with modes of expression which, despite Spanish repression, continued into the seventeenth century. Even today, as Lumbreras has pointed out, the people in the distant Si-

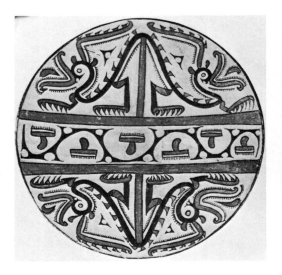

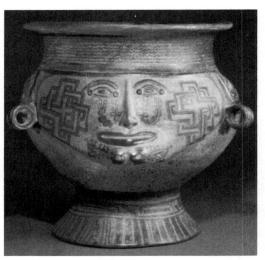

Left: Large painted plate, with birds above and below in radial design, and with a central band showing six weaving combs. Cocle culture, Panama, A.D. 500–800.

Right: Large Nicoya head vase, with pedestal foot and the rounded body molded with a human head, c. A.D. 500–800. Photograph: Sotheby Parke-Bernet.

erra villages still continue to create a pottery whose tradition reaches back several centuries.

The tribes of the Isthmian regions of Panama were exceptional potters. Examples of their ceramic art have been found in the graves of people of high rank. The style appears to have lasted at least from the fourteenth century to the arrival of the Spaniards. Among the superb finds are bowls, plates, and various types of jars decorated in white, red, and black. The characteristic patterns consist of scrolls, chevrons, birds, crocodiles, serpents, turtles, and other animal forms, frequently confined within panels and drawn "with a remarkable combination of sweeping boldness and delicacy of detail" (Bushnell).

There were numerous regional styles of pottery in Central America, but the most impressive ones to the modern eye are the types collectively called Nicoya Polychrome, from the Pacific coast of Costa Rica. Typical of this ceramic form are egg-shaped vessels with bulbous tripod feet or a ring base—decorated in

red, black, orange, and, rarely (and exceptionally for the Americas), in blue or purple. Some pots have modeled heads emerging from the side, often representing a turkey, macaw, or armadillo; other anatomical details may be indicated on the surface of the vessel in low relief or, more often, in paint. Other frequently encountered painted patterns are varieties of jaguar or plumed-serpent images, "clearly derived," according to Bushnell, "from Mesoamerica." A variation of these types of polychrome pottery is found in the interior highlands of Central America, though this highland pottery represents, by comparison, a small proportion of the ceramic products unearthed on the Pacific coast.

There is no standard chronology for the pottery of the Isthmian region. There is of course a certain uniformity in the iconography, as might be expected in an area where cultural diffusion was a constant factor, with peoples moving to and from Mesoamerica and South America.

In Chiriquí (Panama), two notable types of wares have been discovered,

known to be of late pre-Columbian times. These are generally called Lost Color Ware and Alligator Ware. The first of these is decorated with negative dots and lines in black over a white or red slip or a combination of the two. Alligator Ware is painted in black, white, and red, and gets its name from the predominance of alligator motifs.

Many authorities still believe that the West Indies were populated from Venezuela, "though there are features which point to other directions," according to Bushnell. "The first pottery-making, manioc-growing people spread out from the Orinoco through Trinidad and the Lesser Antilles to Puerto Rico about A.D. 200, carrying with them thin, well-made pottery of a pre-Barrancoid style (from Chiapas) decorated with simple white-on-red painting and incised cross-hatching, but not of great artistic interest. The Los Barrancos style followed in Trinidad and Tobago in the second half of the first millennium. Apart from this there is little to say about the Lesser Antilles. The pottery styles of the Greater Antilles are artistically unimportant, but of greater significance are objects of stone, shell and hardwood connected with the Arawak worship of *zemis*, deities which were shown on carvings in human or animal form."

The initial Olmec culture (1200–500 B.C.)—from which we are able to date the earliest known Mesoamerican pottery—had its geographical centers in San Lorenzo, La Venta, and Tres Zapotes in the swampy rain forests of southern Veracruz and Tabasco (Mexico). The Olmec art style appears to have spread its influences to most parts of Mesoamerica, and as far southward as Costa Rica—according to Lee A. Par-

sons, "following established routes of procurement for the coveted jade." The Olmec impact upon subsequent cultures in Mexico, Guatemala, and Honduras is immensely important, but it was not a single influence. There is evidence of an intermediate culture, centered in the Pacific coastal lowlands, called Izapan (200 B.C. to A.D. 200), where two important artistic innovations occurred. An offshoot of the Izapan style is found at Kaminaljuyu, in the highlands of Guatemala. All these stylistic features seem to derive from the Olmec legacy, and later contributed directly to Classic Maya civilization (Parsons).

The next seminal region of pan-Mesoamerican expansion is generally considered to be that of the Teotihuacán culture, in the central highland Valley of Mexico. The climax of Teotihuacán culture occurred about A.D. 400–700, during which time the Teotihuacán rul-

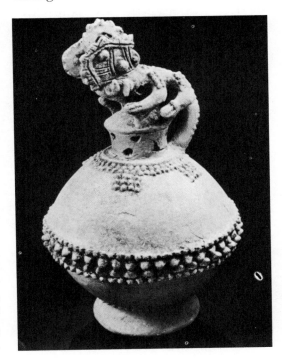

Nicoya two-part effigy incense burner (incensario). *Unslipped red clay. Costa Rica, c.* A.D. *300–800. St. Louis Art Museum.*

ers colonized a wide region, extending as far south as the Maya area of Guatemala. "Wherever Teotihuacán presence was felt, we find the cylindrical tripod vase, 'thin orange' ware, and the composite incense burner" (Parsons). The Teotihuacán people also provided the cultural impetus in the Mexican highlands that was inherited by the Toltecs and Aztecs in Postclassic times.

During the intervening period (c. A.D. 700–900), the Maya in eastern Mesoamerica, evolving in regional isolation, greatly overtook and outshone all other Mesoamerican cultures, reaching a peak of refinement unprecedented in the Americas. Then, mysteriously, at the outset of the Toltec civilization (c. A.D. 900), the Maya ceremonial centers were abandoned one by one, and their exceptional world disappeared.

By the tenth century A.D. the Toltecs had gained complete control of Central Mexico. Toltec influence is usually marked by the use of glazed "plumbate ware." Their cultural hero, Quetzalcoatl

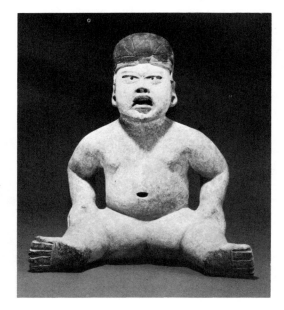

Olmec seated "baby" figurine, with open mouth, incised teeth, recessed pupils, and domed head with geometric incisions (possibly a helmet); the body is painted white and the hair is red and black. Mexico, Middle Preclassic period, 1150–550 B.C. Photograph: Sotheby Parke-Bernet.

(Feathered Serpent), left a pervasive mythology and iconography for many generations after the fall of the Toltec capital, Tula.

The final ceramicists of Mesoamerican pre-Columbian history were the Aztecs, from the Valley of Mexico. Their establishment of a city—Tenochtitlán (present-day Mexico City)—occurred during the Late Postclassic period (A.D. 1400–1521).

The most characteristic Olmec figurines are distinguished by features made by punching, by slitting, and by modeling (Kubler). All figurines possess a "stem," to which the face is joined. The hair (or turban) was constructed as a separate piece, added to cover the joint between the stem and the face. A common feature of all Tres Zapotes and La Venta figurines is a certain convention for the eyes, which have deep central punctuations at the iris, flanked by triangular punches, resulting in a vivacious effect. Each eye is an inverted "V," suggesting an upward gaze. Kubler suggests that the relationship between the producers of clay figurines and the sculptors of stone and jade must have been one of "reciprocal exchanges." The clay figurines apparently evolved first. "Certain parallels have been drawn between Olmec and Chavin art in the Andes. Both represent anthropomorphized feline monsters by incisions and flat low reliefs of ideographic character" (Kubler).

Miguel Covarrubias, the late Mexican painter and scholar, believed that the figures of jaguars, dwarfs, and babies which occur prominently in Olmec clay figurines and sculptures were stylized representations of an "Olmec ethnic style" of Asiatic origin and of great an-

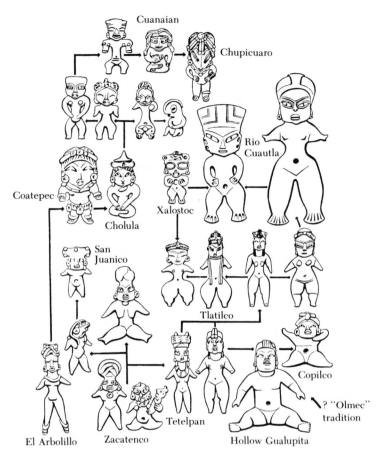

Preclassic clay figurines: chart of interrelationships. From M. Covarrubias, *Indian Art of Mexico and Central America,* p. 29; reprinted with permission.

tiquity. According to Covarrubias—who was the first researcher to venture an interpretation of the conventions of Olmec art—the iconography may represent jungle powers ("spirits"), called *chaneques* by present-day Indians of the Veracruz coast. These *chaneques* are mischievous old dwarfs with baby faces, who play tricks on people and who provide rain if propitiated. The tiger, Covarrubias believed, was a totem related to Mexican cults of an earth deity and a symbol of the night. On these assumptions Covarrubias constructed an elaborate iconographic genealogy, charting a progression from the Olmec archetypal baby face to the Maya serpent-masked

god, and, finally, to the Aztec rain god (see Covarrubias, 1966).

The earliest pottery unearthed in the Valley of Mexico consists of brown, black, red, and white vessels with limited painted decoration in red and white or yellow. There are numerous forms of bowls and jars, but the major examples are pots modeled to represent fish, birds, animals, and gourds in a very accomplished manner, the best of which have a polished black finish. As already noted, a form peculiar to this region is a bottle with a spout in the shape of a stirrup, with two branches rising from the top of the closed vessel and joining to

form a single tubular opening. Bushnell argues that this type of pottery became "most common in Peru at a later date," though Lathrap reverses the chronology and believes, as we have indicated, that the stirrup bottle originated in Ecuador.

The most frequent method for decorating the pottery was by roughening or otherwise differentiating certain zones, which were outlined by broad incised lines. The zones were sometimes left unpolished; they were also recessed by scraping or were covered with stabbed

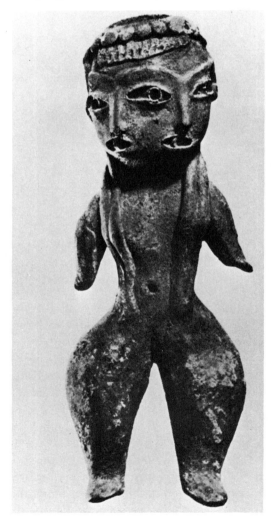

Terracotta female figure with two faces. Tlatilco culture, Preclassic Mexico. National Museum, Mexico City.

dots or with rocker stamping, a series of zigzag lines produced by rocking a curved object over the clay surface. Recessed areas were sometimes tinted red by rubbing them with hematite powder after firing. These decorative techniques were often used to depict hands, jaguar claws, and snakes, or elaborate geometric patterns.

Another early ceramic tradition of the Valley of Mexico is that of the remarkable figurines which usually depict women, young and old, naked or wearing short skirts. There is a wide variety of forms in these figurines: two-headed females, men with masks, hunchbacks, dwarfs, acrobats, musicians with drums, and even the first known player of the sacred ball game. These ceramic figures are closely connected with the Tlatilco culture, which first appeared about 800 B.C. After its decline, there were no major artistic developments in the Valley of Mexico before the beginning of the Classic period. The last century B.C. saw the rise of Teotihuacán culture, resulting in the first major settlement of Mesoamerica and the beginning of the Classic period.

The chronological stages of Teotihuacán culture are normally marked by the different styles of figurine modeling. The earliest, which preceded the construction of the great Teotihuacán pyramids, have prognathous faces, with the mouths and eyes formed by applied strips of clay. In both the first and second periods there is broad headgear. In the second period, when the pyramids were under construction, the figurines were more delicately modeled—with less prognathism, the nose pinched out to a fine point, and the eyes and mouth formed by simple cuts. In the third stage

modeling is more accomplished and the faces tend to resemble the typical stone masks of Teotihuacán culture. Some of the figurines of the third stage were made with molds. Stage four is marked by a sudden emphasis on decorative detail and a great variety of figural types. Most of these figurines are lavishly dressed, with such accessories as great feathered headdresses. This stage is thought to date from after the invasion and destruction of Teotihuacán (c. 600 A.D.).

The Teotihuacán pottery shapes were highly traditionalized; particularly characteristic is a flat-based tripod with straight or slightly concave sides. These tripods are often incised with designs; sometimes part of the clay surface is scraped away and has been rubbed with red hematite, resulting in what is called champlevé decoration. The most finely wrought tripods are covered with stucco, forming mythological designs. This kind of decoration, which is called paint cloisonné, is exceptionally fragile and only a few examples have survived intact (Bushnell). Other ceramic forms include jars with flat bases and globular or high-shouldered bodies surmounted by a flaring neck. A great variety of this form, called a *florero* (flower vase), has been found; it has a small body and a trumpet-shaped neck of exaggerated height, flaring out to a diameter greater than that of the body. The *florero* usually has a gray finish.

About A.D. 600, as we have already noted, Teotihuacán was destroyed, but the culture left a wide-reaching impact. This Postclassic period is marked by long ages of which we know very little, with various local cultures apparently emerging and then disappearing. One

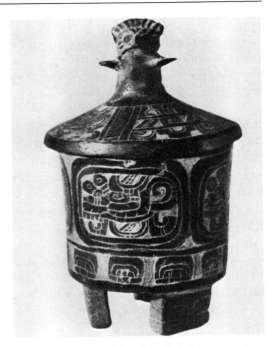

Teotihuacán clay tripod vessel with cover and incised decorations. Statens Etnografiska Museum, Stockholm.

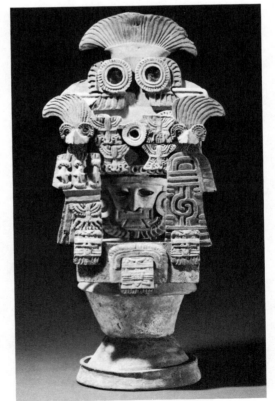

Teotihuacán lidded incense burner (incensario), with waisted cylindrical base surmounted by a conical lid supporting the rectangular framework of a shrine or temple facade (?); in the doorway is a mask with lozenge-shaped mica-inlaid eyes, flanged nose ornament, earrings, and massive crested headdress with applied birds' heads, medallions, and bow-shaped ornaments. Classic period, c. A.D. 250–650. Photograph: Sotheby Parke-Bernet.

such short-lived culture was located at Xochicalco in Central Mexico. "Its civilization is thought to have been one of the strands from which the subsequent Toltec one was spun" (Bushnell).

Apart from the militaristic style of carving at the Toltec center of Tula, little remains of Toltec art except examples of pottery. The most important ceramics were the so-called Mayapán ware, orange to buff in color, usually in the form of bowls which were decorated inside with groups of parallel, wavy lines. Pottery used essentially as a trade item was widespread at this period and is called Plumbate, named for its appearance. Numerous shards of Plumbate ware have been found in the Toltec remains at Tula.

The end of Tula and the Toltec domain was brought about by the arrival of successive waves of nomadic peoples from the northwest of Mexico, collectively called the Chichimecs—"barbarians," as far as the Toltecs were concerned, but "who do not appear to have differed materially from the nomadic component of the Toltecs," according to Bushnell. The Chichimecs of Tenayuca (a site a short distance from Mexico City, where they settled in 1224) were followed by other tribes: Acolhuas, Tepanecs, and Otomis—all possessing a common language, Nahuatl, and all settling in the Valley of Mexico and assimilating various aspects of the Toltec culture.

The Aztecs were one of the last of the wandering tribes to settle in the Valley of Mexico, where, on the western shore of the great lake, they founded Tenochtitlán about 1350. The art of the Aztecs is much indebted to what is generally called Mixteca-Puebla art, the art of the Mixtec people who lived mainly in Oaxaca. As both Bushnell and Covarrubias have pointed out, there is little that distinguishes Mixtec from Aztec art, for most of the characteristics—including an inspired if awesome grotesqueness—derive entirely from the Mixtec sensibility.

The prior Aztec pottery is a thin, delicately made orange ware, decorated with cursive designs in fine gray tones, but it is speculated (Bushnell) that even this "Aztec" pottery had originated in Puebla at an earlier date, and was doubtlessly adopted by the Chichimecs of Tenayuca, who eventually passed it along to the Aztec latecomers in the Valley. Two stages of pottery have been firmly identified as Aztec in origin: the first is abstract (generally but not always), while the second stage is marked by naturalistic drawings of birds, butterflies, fish, and insects. To this second stage of pottery, which continued after the Spanish invasion, belongs a fine glossy red ware bearing somewhat heavier but nonetheless delicate designs in black, typically forming scrolls or the pattern of conch shells—which were possibly a symbol related to Quetzalcoatl.

Aztec clay vessel. Mexico, c. A.D. 1500. Museum für Völkerkunde, Berlin.

Another form of Aztec pottery was mold-produced figurines of dull monochrome ware, representing gods, temples on pyramids, and human beings of rank. These ceramics were produced in great abundance, but they have little artistic merit. They contrast remarkably with the finer wares, and were probably made for use in humble households.

The Classic and Postclassic art of the Gulf of Mexico coast had a distinctive character, though with influences from the highlands, especially from Teotihuacán. Covarrubias has pointed out that the keynote of highland art is a combination of angularity, order, and rigidity, while the Gulf Coast art is softer in its modeling and shows an emphasis on curvilinear scrolls.

There are two traditions of ceramic sculpture in the area of central Veracruz: the Remojadas tradition (150 B.C.–A.D. 700), and the Nopiloa tradition (c. A.D. 600–900). Remojadas pieces were usually modeled by hand, while Nopiloa figures were probably mold-made. Shiny black paint, called *chapopote*, was used in the Nopiloa tradition. The Las Animas (found north of Veracruz Port) and the so-called Laughing Figurine style of the Nopiloa area seem to be related in expression (Kubler). The bodies of the Las Animas figures are handmade but have molded heads, while the entire figure of the Nopiloa district is produced in molds. The Las Animas and Nopiloa figurines closely resemble one another in details, in their lively configuration and movement, in their filed front teeth, in their conventionalized smiles, and in the broad sculptural simplification to represent elaborate costuming. Currently there is no adequate explanation for the

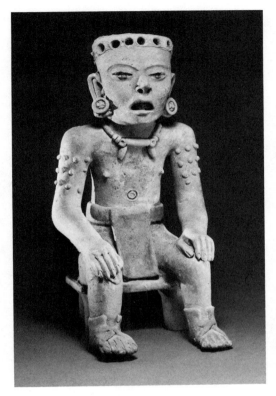

Veracruz seated ruler. Early classic period, c. A.D. 250–550. Photograph: Sotheby Parke-Bernet.

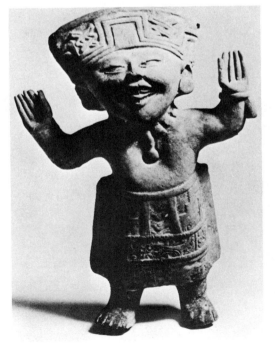

Veracruz standing clay figure of the "Smiling Face" style. Mexico, Las Remojadas culture, c. A.D. 1300–1521. Museum of the American Indian, Heye Foundation, New York City.

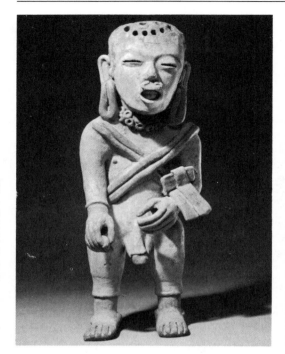

Veracruz standing figure of Xipe Totec. The figure once carried a trophy head in the right hand, and wears the flayed skin of a victim over his head and body in the traditional manner. Early classic period, c. A.D. 250–550. Photograph: Sotheby Parke-Bernet.

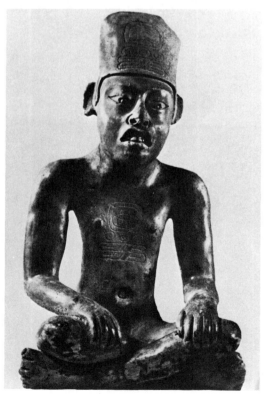

Zapotec terracotta scribe from Cuilapán, showing Olmecoid influences. National Museum, Mexico City.

typically smiling visage of these figurines, though the tradition suggests, according to Kubler, "a long development from an archaic base."

Monte Albán, the great ceremonial center of the southern highlands of Mexico, was built by the Zapotecs in what is generally called "Olmecoid" style (Parsons). Funerary ceramics from the earliest phase of Monte Albán culture (500–200 B.C.) demonstrate strong Olmecoid features, such as vessels in forms derived from the Olmec were-jaguar image. But the ceramics of the Zapotecs also reveal a powerful individuality. Anthropomorphic vessels of fired clay, which were part of the tomb furnishings in both Monte Albán and the various valley towns of Oaxaca, were created in a strong, sculptural manner which was a unique regional creation. "Probably each region of the Classic Zapotec civilization supported distinctive local styles in the manufacture of funerary pottery. The fundamental types are numerous, and their development from simple to complex forms must span about a thousand years, embracing both the Formative and Classic Zapotec eras (500 B.C.–A.D. 1000). . . . All local styles display from beginning to end the same succulent treatment of the clay. The Zapotec potters translated all forms into sheets, rolls, drops, and lattices of wet-carved details. No other American potters ever explored so completely the plastic conditions of wet clay, or retained its forms so completely after firing. The Zapotec never forced the clay or plaster to resemble stone or wood or metal; he used its wet and ductile nature for fundamental geometric modelling, and he cut the material, when half-dry, into smooth

planes with sharp edges of an un-matched brilliance and suggestiveness of form" (Kubler).

Zapotec pottery shows considerable influence from Maya and Teotihuacán sources, though there remains in its ex-pressiveness a unique tradition derived from the so-called *Danzante* stage of the local culture. Monte Albán was aban-doned about A.D. 900, and the Mixtec people (perhaps at a later date and pos-sibly as invaders of the declining Zapo-tec world) entered the region and estab-lished their capital, Mitla. There is little analysis of Mixtec pottery currently available (Kubler), but one style has been identified as *Nuine* (the Mixtec word meaning "Hot Land"). It is char-acterized by thin orange ceramic vessels, figurine heads lacking bodies, and clay urns portraying wrinkled old men. The pottery shapes include effigy jars, tripod censers, pitchers, and bowls. Polychrome vessels are painted with scenes and mo-tifs almost identical with those of the Mixtec deerhide ritual manuscripts.

It has already been mentioned that the Mixtec people were an important source of an art tradition called Mixteca-Puebla, and that this tradition was the central influence in a wide area which eventually included Tenochtitlán, the capital of the Aztec domain. The Mix-tecs showed great skill in the minor dec-orative arts and developed an iconogra-phy with strong and often grotesque symbols. The artistic heritage they be-queathed to Mexico is very considerable, though they lingered rather briefly in Oaxaca, where they occupied the once-great site of Monte Albán. The Mixtec stage of Oaxaca is usually called Monte Albán V, although the Mixtecs made lit-tle use of that ruin except for burials.

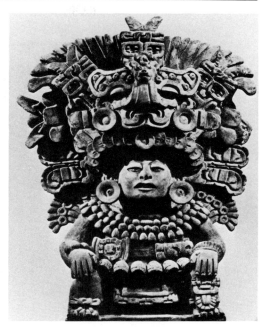

Zapotec terracotta funerary urn in human form. National Museum, Mexico City.

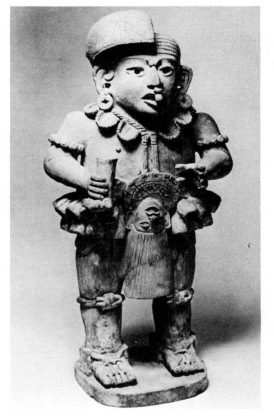

Zapotec standing clay figure, with half-shaven hair and trophy head. Mitla, Mexico, c. A.D. 1000. Museum of the American Indian, Heye Foundation, New York City.

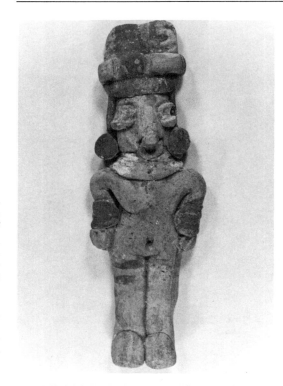

On the northern threshold of the western region of Mexico, at Chupicuaro, Guanajuato, a cemetery of Late Formative date (c. 100 B.C.) has yielded well-modeled solid figurines (so-called Pretty Ladies), with large heads and applied details. Collection of the author.

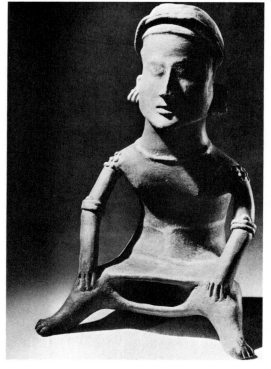

Michoacán seated woman. Mexico, A.D. 200–950. Museum of the American Indian, Heye Foundation, New York City.

"Western Mexico," according to Bushnell, "is a large area with many facets; it lacks great ceremonial centers and stone monuments, and the chronology is little known in detail, but it is doubtful if the framework of Formative, Classic, and Postclassic has much meaning there, since work of Formative aspect may well have persisted through Classic times elsewhere. The chief artistic expressions in this area were in pottery and small stone carvings. The potters were concerned more with daily life than with the religions of other parts of Mexico, and we look in vain for the feathered serpent, Tlaloc, Xipe, and Huitzilopochtli"—who were central to the iconography of other Mexican cultures.

Farther west is Michoacán, which in late Postclassic times became the home of the Tarascan Indians. Indigenous pottery figurines with some Olmecoid features have been found in this area, but they are not of very much artistic value. The major art of Michoacán appears to have been stone carving, as well as pyramids constructed in a unique T-shaped plan, with a central stairway on the crossbar and a round platform at the foot of the upright, on which there was a circular shrine.

The chief pottery producers of the west were located in the states of Nayarit, Jalisco, and Colima (distinct from the Calima culture of Colombia). These three traditions of ceramics may be described as a whole, although they each had special features. All are noted for their large hollow pottery figurines, which were modeled by hand and were in style and form rather lively and spontaneous. Those of Nayarit have been described as having the manner of caricature, with massive features and thin

arms. Another typical characteristic of Nayarit pottery is an emphasis on the depiction of daily life, with both single and multiple figures in various scenes (for example, a ball game being watched by a formal audience). In this class of scenic pottery is a form found in several variants: a man apparently bound to bed or bench, rendered in a very stylized manner and with unknown iconographic significance. More comprehensible to us today are numerous genre figurines, representing such mundane and charming activities as a woman handing a man a drink. The small figures and scenes are usually produced in solid forms, while the large figurines, as already noted, are hollow. From the Nayarit area also come ceramic vessels modeled in the shapes of vegetables.

The Colima figures are also related to daily life, but are usually constructed with softer and rounder contours than in the robust and rugged style of the Nayarit culture. The Colima figures are smoothly finished and often have a red slip. The most renowned subject from this area is the fat, hairless Colima dog, which is shown in various naturalistic poses but is also rendered wearing a mask, which is of unknown significance. Similar to Nayarit ceramics are single solid figurines and groups.

Jalisco is intermediate both in geographical location and character in relation to Colima and Nayarit pottery. The fully modeled warriors and crouching figures from Ameca in Jalisco are superior in technique and aesthetic concept to those of the other two regions (Kubler).

Each of the three regions produced variations upon the same ceramic style, in a developmental sequence which Kubler assesses to be perhaps five centu-

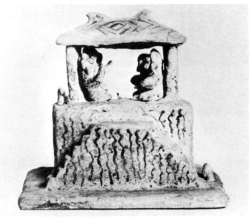

Nayarit clay house model. Western Mexico, c. A.D. *100–250. Museum of the American Indian, Heye Foundation, New York City.*

Colima terracotta dog. Western Mexico, c. A.D. *100–250. National Museum, Mexico City.*

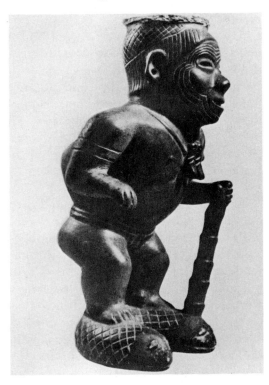

Jalisco clay hunchback figure standing on two fish. Western Mexico, c. A.D. *200. National Museum, Mexico City.*

ries—running parallel to the events of the Valley of Mexico and the Panuco culture of the Gulf of Mexico coast. "It has often been thought [for example, by Bushnell] that west Mexican art, in its protective aboriginal isolation, escaped much of the tyranny by ritual that characterizes other Mesoamerican regions, and that its manufacturers merely 'report' daily village life. Recently, however, P. Furst has sought to connect living Cora and Huichol ethnography with west Mexican archaeology, on the score of shamanism and the ritual use of hallucinogenic plants. The hypothesis is attractively simple, but it presupposes that ancient peoples were less changeable and more alike than the archaeological finds warrant. It also avoids the possibility that modern shamanism is a recent rustic development among peoples of Catholic tradition in isolated environments" (Kubler).

It is safe, therefore, to accept Bushnell's assertion that West Mexican ceramic art was essentially concerned with the depiction of daily life and was not linked to the dominant religious iconography of the rest of Mesoamerica. "All in all," Bushnell concludes, "the modeled work of these three states can justly be described as folk art."

The Maya centers are distributed over a wide area of Mesoamerica, from northwest Honduras, through the lowland forests of Campeche and the Guatemalan Petén area, to the open arid plains of Yucatán. Though the Maya world has many similar cultural features, there are also vast regional differences. The most pervasive adjectives in the writings of Mayanologists are the words "excellence" and "brilliance," for

Maya covered blackware dish with hollow panther-head ornament. El Petén, Guatemala. Peabody Museum, Harvard University. Cambridge, Massachusetts.

the Classic Maya art truly requires superlatives to describe its unsurpassed aesthetic and intellectual achievements.

There are three dominant forms of Maya pottery: polychrome painted ware, carved vessels, and solid figurines. The carved ceramics belong, according to Kubler, to the end of the Maya period, during which the Maya created large figural sculptures, which are thus ascribed to the Late Classic, or Puuc, period; they were constructed both in the Guatemalan highlands and in the Puuc territory of northwestern Yucatán. These figural carvings usually adorn ornate ceramic shapes, such as globular and pyriform vessels. The invention of carved pottery is apparently of Early Classic date; the technique is called gouged-and-incised—scroll patterns were engraved in the clay and reinforced by slices, or gouges, repeating the main contours. A somewhat later development, called plano-relief carving, is typical of the end of the Early Classic era, both in the area of the Maya as well as Teotihuacán in the Valley of Mexico. In plano-relief carving the background was carved to produce a design in two planes, front and rear, without modeled passages between the ground and the

figure. Modeled carving is the final refinement of the Maya Late Classic period, and was apparently greatly valued among the Maya aristocrats.

The production of figurines was probably introduced to the Maya peoples from the Mexican mainland, according to Kubler. Few figurines have survived, not only because they are highly perishable but also because the centers which produced them were limited in number. One such center was the island of Jaina. The Jaina types are the most numerous, and their workmanship is superlative. There are two main groups: handmade whistle figurines, dating from the opening generations of the mid-Classic phase, and later mold-made rattle figurines, of the Puuc period, Late Classic times.

The typical Maya handmade figurine is ten to twenty-five inches high, and is made of a fine orange clay, whitewashed, and painted in distinctive blues and ochers. Though not as highly regarded as the polychrome painted pottery, these figurines are among the most eloquent of Maya ceramics.

Maya polychrome vessels are executed predominantly in reds, browns, and yellows, with the addition of black and sometimes blue—the exact source of which, according to Bushnell, "baffles investigators." There is painted decoration on ware of many different shapes, mostly some form of plate or bowl. The bowls are highly diversified, including the open bowl (which may have a flange low down on the outside), vertical-sided tripod bowls with slab feet like those of Teotihuacán culture, shallow open tripods, deep cylinders, and pear-shaped jars which may have ringed bases. The decoration painted on these ceramics includes scenes of offerings

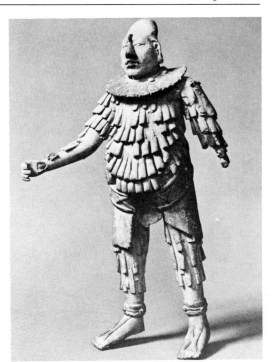

Maya male figure in Jaina style. National Museum, Mexico City.

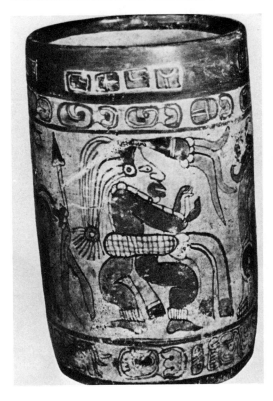

Polychrome clay Maya vessel, Guatemala. Classic period, c. A.D. 700. Musée de l'Homme, Paris.

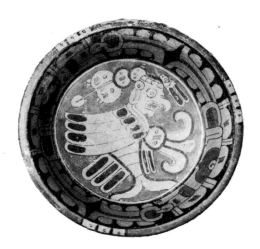

Classic Maya plate with polychrome figurative motif and glyphs around the margin. Guatemala, c. A.D. 800. Collection of the author.

and other ceremonies, processions, persons of rank, and various glyphs, which "in many cases appear to be merely decorative and without meaning" (Bushnell). Most of the iconography is typical of Maya decoration, but some examples found at Tikal show strong Teotihuacán influences.

There is much to admire in Maya pottery, but it seems that the most remarkable achievement in their ceramic art was contributed by painters rather than potters. The most celebrated Maya ware has an evenly rounded cylindrical shape, which was covered with a slip of fine stucco and then turned over to painters. "Such 'fresco' vases of very high quality also exist in the Teotihuacán culture," according to Kubler, "but the Maya developed them to a still higher expression."

In the United States, the most noteworthy pottery has been produced in the Southwest and the Southeast, where, it is generally assumed, ceramic art was adapted from Mesoamerican examples and influences. The pottery of the Southeast flourished from perhaps A.D. 500 onward, and then quickly vanished after the invasion of Europeans and the decimation of the Mississippian civilizations, whereas the ceramics of the American Southwest have continued to develop into modern times and have, in fact, received unusual and widespread attention among non-Indians.

Long before the arrival of Europeans, a succession of Indian civilizations evolved in the Southeastern United States, achieving remarkable cultural triumphs, although today we know comparatively little about their history and their social customs. Southeastern tribes began to make pottery in the early centuries of the Christian Era (the period of Burial Mound II, A.D. 500, according to Covarrubias). Sometimes these earliest vessels were painted, but more often they were decorated by modifying the surface—by scratching (incising) a design into the moist clay or by applying small pieces of clay to the ceramic walls. The most abundant examples of pottery in the Southeast are little jars with incised patterns of lines and dots, an early iconographic style which apparently lasted into the sixteenth century. The most famous of the Southeastern ceramics were produced by the people of the Hopewell culture, named for a site in central Ohio, a point from which this great culture spread into New York, Michigan, Tennessee, Indiana, Illinois, Wisconsin, Iowa, and Kansas. The people of Hopewell made unpainted ceremonial ware of special shapes decorated with curvilinear incised designs, stylized and naturalistic birds—notably the roseate spoonbill (Covarrubias), with areas differentiated by punctate patterns or stamped zigzags made with a rocker stamp. Fine clay figurines, of a "Mayoid"

style, have been discovered in the Turner Mounds in Ohio. These were modeled freehand, and the "fact that the Indians used no molds such as were prevalent in Mexico at the time is a sign that Hopewell received no further influence from the south or is considerably older than archaeologists surmise" (Covarrubias, 1966).

The Southeastern scroll, a specific design closely associated with this region, consists in its most common form of two interlocking curved lines. This characteristic motif was used over the entire area on pottery and on seashells and stone disks. "It even appears on one of the few surviving fragments of native cotton cloth" (Conn).

"Among the arts of the Mississippi period (A.D. 900–1700) stands the prolific development of pottery in many new styles, forms, and decorations. The most spectacular pieces come from the middle southern and lower Mississippi Valley areas, where beautiful bottles, jars, and bowls have been found. Some are painted in red, white, and black or sepia on yellow clay, incised or stamped on gray, red, or black clay, with simple geometric motifs or with dynamic swirling, interlocking spirals or curvilinear swastikas; others are decorated with naturalistic designs of the death cult—eagles, skulls, bones, hands with eyes on the palm, solar discs, and so forth—while still others are modelled in the shape of human figures, squatting hunchbacks, human heads [trophy heads, presumably], birds, frogs, and fish" (Covarrubias, 1966).

While most Southeastern ceramics were decorated by incising or building up the clay surface, those produced in very late pre-European times, along the

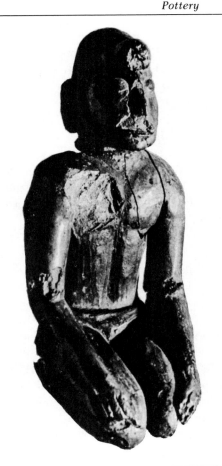

Hopewell clay figure. Mound Builder culture, Ohio, c. 300 B.C.–A.D. *500. Peabody Museum of Archaeology and Ethnology, Harvard University, Cambridge, Massachusetts.*

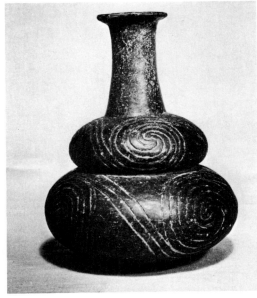

Mound Builder (Alabama) incised vessel with classic scroll motif. Alabama Museum of Natural History, Birmingham.

lower Arkansas River, were commonly painted. Typical was a globular bottle, with a conical or cylindrical neck. The painted motif was almost always a variation on the Southeastern scroll (interlocking swirling spirals). The Southeastern tribes produced, in addition to simple effigy pots, vessels which incorporated various elements of effigy pottery into bowls—for example, a round ceramic container with faces quartering its girth.

The ceramic art of the Southeast and Woodlands reached its maturity at the most robust period of the culture: with local achievements such as effigy earthmounds, elaborate ornaments of hammered copper and silver, antlers as headdresses, stone effigy pipes, "banner stones," silhouettes of mica, pendants of bear teeth set with pearls, incised seashells, and the characteristic scroll motif. This "serene art faded away," according to Covarrubias (1966),* and a new "barbaric culture rolled like a wave from the south, carrying with it many Mexican el-

ements . . . such as pyramids to support ceremonial structures, stone statues, certain pottery styles, shell gorgets, and . . . elements from the southern cult, skulls, bones, eagle-warriors carrying severed heads, feathered rattlesnakes, and so forth. This culture also decayed, so that its grandiose traits were not evident to the early settlers from abroad. The Woodland cultures reflected the ups and downs of Mexican pre-Spanish cultures, and the character and spirit of their art is in such measure an extension of Middle American civilization that it has been called, perhaps wrongly, 'peripheral Mexican.'"

The art of pottery of this vast region did not effectively survive into historic times. Rather, artists turned to wood, bark, woven fiber, and leather to create their containers and utensils (Maurer).

According to Tanner (1976), "pottery was one of the most diversified of all the prehistoric Southwest craft arts." It was also among the most vital and important ones of the Native Southwestern Indian arts. "It presents a faithful record of the changes in style and fluctuations of feeling for form; it gives clues to the activities of its makers by indicating functional aspects, and it presents an unbroken record of artistry from its inception before the opening of the Christian Era to the present" (Tanner, 1976).

We do not clearly know the origins of pottery in the Southwest. It is presently believed that ceramics first appeared in the early Hohokam and Mogollon cul-

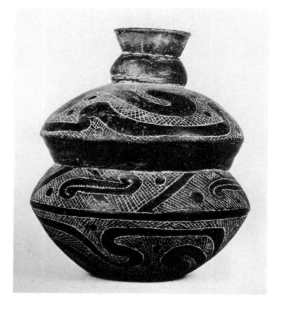

Caddoan Mound Builder incised clay compound bottle. University of Arkansas Museum, Fayetteville.

* The idea of the "serene art" period is now controversial; some authorities do not find evidence to support the notion of an art of peaceful overtones being replaced by a militant art style brought into the region by barbarous nomads.

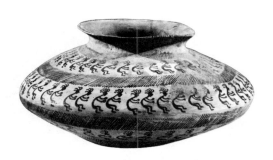

tures and that its source was probably Mexico. Hohokam people were already producing excellent pottery by approximately 200 B.C.; though unpainted, the ware demonstrates a finesse which would not exist in the first stumbling efforts to "invent" pottery. These earliest pieces therefore indicate that the ceramic art was borrowed from another culture, at a relatively sophisticated level of its evolution. "Early wares in the Mogollon, although not as refined, also show developed rather than beginning characteristics" (Tanner, 1976) And it is probable that later (c. A.D. 700) Anasazi pottery was borrowed from the example of Mogollon ceramics. Tanner (1976) believes that "all in all, a very rich heritage in ceramics was passed down from their prehistoric ancestors to the Indians of today." Vessel forms, layout styles, colors, design elements, and iconography were all richly and fully explored by the ancient tribes of the Southwest. There is a continuous line of development in the ceramics of this region.

The two basic forms that have dominated for more than two thousand years of pottery making in the Southwest are the bowl and the jar. In this region the jar is commonly called an "olla." Large bowls may have been used for storage, but far more frequently they were used for ceremonial occasions. "Seemingly,

individual serving dishes were not made by the Indian populations. Any and all of these vessels could also have special uses, particularly of a ceremonial nature. When this was the case, decoration was often of a special type" (Tanner, 1976).

Clearly, the Southwest has the most important ongoing tradition of pottery in North America. Even today, each village (pueblo) has its distinctive style and designs and shapes of pottery and its own outstanding, often illustrious, potters. The tradition, as we have already briefly noted, is ancient, descending through a long series of cultures, which belong to three major archaeological periods: the Mogollon, the Hohokam, and the Anasazi.

Hohokam pottery characteristically has a red negative design on a buff background. Scroll motifs (similar to those of the Hopewell culture of the Southeast) are typical of this ware. Modeled Hohokam effigies—tiny clay figurines—show strong Mexican influence and originally had religious significance.

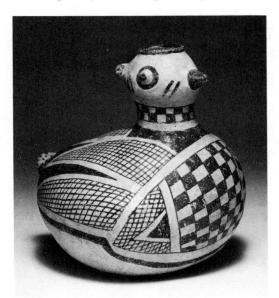

Hohokam clay vessel, decorated with bands of dancing figures in profile. Arizona, c. 200 B.C.–A.D. 1200. Arizona State Museum, Tucson.

Anasazi bird effigy vessel, c. A.D. 700–1750. Photograph: Sotheby Parke-Bernet.

These effigies were almost always found in association with burials. The Hohokam culture existed at the time of the Mogollon culture—100 B.C. to A.D. 1400.

As far as we know, the Cochise culture (5000 B.C.) was the foundation of the Mogollon culture. It is the ancient Cochise culture which is generally regarded as the source of the whole line of cultural developments which occurred in the prehistoric Southwest.

A part of the Mogollon culture was the Mimbres group. Of all the prehistoric Southwestern pottery, that of the Mimbres people, who flourished on the highlands in the tenth and eleventh centuries, remains the most remarkable in regard to design and sophistication of execution. The black-on-white bowls have zoomorphic and anthropomorphic forms in mineral paints, showing both elaborate stylization and intriguing naturalistic details of daily life. The Mimbres vessels were characteristically "killed," to allow the power of the vessels to escape by a hole knocked through the base of the pots before they were buried with a corpse. So individual is the iconography of this exceptional pottery

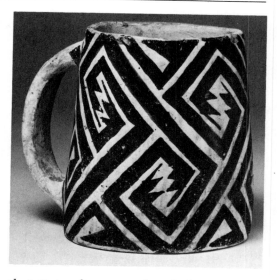

that it is often speculated that a single artist inaugurated a "school" of ceramics, which then diffused into a wide tradition.*

Anasazi—a Navaho word for "the ancient ones"—is the prehistoric culture which presumably developed into that of the modern Indians of the pueblos. About A.D. 700 the Anasazi peoples learned to make pottery. Their ceramic art is divided into several stages of development. During the Developmental Pueblo period, A.D. 700–1050, adobe and stone apartments replaced pithouses at such locations as Chaco Canyon, Mesa Verde, and Kayenta. Black-on-white slipped pottery is most typical of this early period, whereas the older, Formative ware was essentially plain white, unslipped, and coarse in finish—with some tan and brown decoration. In the Great Pueblo period, A.D. 1050–1300, the large stone or adobe towns were built. These great apartment complexes

*See J. J. Brody, *Mimbres Painted Pottery* (Albuquerque: University of New Mexico Press, 1977).

Mesa Verde mug: thick-walled vessel, painted in black over a burnished white slip. Colorado, c. A.D. 1200–1300. Photograph: Sotheby Parke-Bernet.

Mimbres bowl with a geometric band, white slip, and black decoration, and a "kill hole" in the center. New Mexico, c. A.D. 1000–1200. Collection of the author.

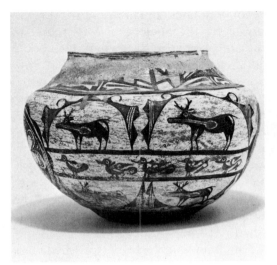

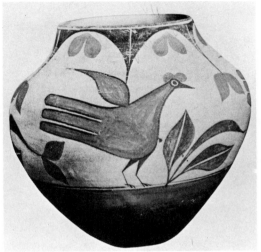

Left: Zuñi clay jar, painted in black and red on white slip, with a fragmentary neckband of stylized "dagger" motifs. Photograph: Sotheby Parke-Bernet.

Right: Zia Pueblo painted olla (jar) *with bird design. Rio Grande Valley, New Mexico, c. 1900.*

were abandoned about 1276, when a drought forced the people to move south to the sites of current Hopi, Zuñi, and Rio Grande pueblos. The Regressive Pueblo period, A.D. 1300–1700, was dominated by the Spanish occupation. Glazed painting on pots and polychrome replaced the black-on-white tradition, and the iconography was not used for a period of time.*

The modern pottery of the Southwest is made principally in the various pueblos. The pottery of Acoma Pueblo is distinguished by its thin walls and light weight. It is polychrome, usually with a white slip, reddish base, and red and black design. The geometric designs are very popular, especially in black against a background of white slip. Birds and floral designs are also common on Acoma pottery.

Zuñi produces owl figurines decorated with black and red on white slip. What little pottery is still produced at Zuñi (where silverwork is more popular among craftspeople than pottery making) is distinguished by its large designs painted in brown-black paints with touches of bright red. Principal motifs are large scrolls edged with triangles and large rosettes with scalloped edges, along with such rain symbols as frogs and dragonflies. Also prevalent are motifs of deer, with white rumps and red heart lines—the characteristic canal drawn from the mouth to the chest (the iconographic meaning of which is still being debated).†

Zia Pueblo slips are white or yellowish-buff, decorated with birds and deer and stylized floral patterns of very delicate, extended lines. Red and black are the favored colors of the designs.

Cochiti pottery is not particularly distinguished, except for an occasional cream-colored pot decorated with black plant designs. Recently the potters of Cochiti have developed a human figur-

*See Robert H. Lister and Florence C. Lister, *Anasazi Pottery* (Albuquerque: University of New Mexico Press), 1978.

†See Larry Frank and Francis H. Harlow, *Historic Pottery of the Pueblo Indians: 1660–1880* (Boston: New York Graphic Society), 1974.

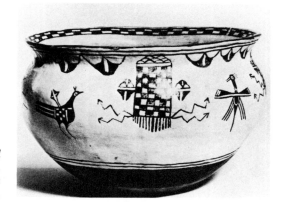

Cochiti Pueblo bread bowl. New Mexico, c. 1920. Denver Art Museum.

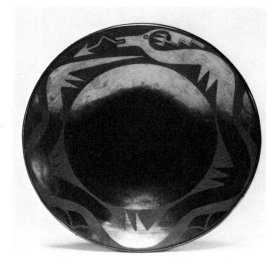

San Ildefonso Pueblo blackware dish, painted in black against the polished black ground, with the serpent Avanyu (the Plumed Serpent of Mexico) and rainclouds; inscribed "Maria" near the base, and presumably by Maria Martinez. Photograph: Sotheby Parke-Bernet.

become famous. Julian's designs were inspired by the ancient pottery found in the archaeological digs where he worked as a laborer. The black sheen is produced by a technique called smudging: the fire is smothered with fine, damp animal manure. This "closed" fire (with little draft) produces dense smoke, which impregnates the pottery with carbon and gives it a black, shiny finish. San Ildefonso also makes pottery with white, black, and beige designs on a red slip, as well as the new and popular polished red ware.

San Juan Pueblo favors polished dark red finishes for the upper section of pots, leaving the lower body of the pot an unslipped tan color. Incised designs on brown pottery are also common in this pueblo.

Picuris and Taos both make unpainted vessels for cooking. The gold-tan clay contains mica. Some of the pots have loop handles or scalloped rims and notched fillets.

Hopi potters make excellent polychrome ware. The potter's art among the Hopi was revived about 1900 by a woman named Nampeyo of Hano on First Mesa. She was influenced by the anthropologist J. Walter Fewkes to copy the fine pottery excavated from prehistoric Hopi sites. The result was a vast renaissance, in which the ancient Sikyatki designs of black, orange, and white were recovered from the Regressive Pueblo period and reused in a new pottery tradition. The heritage of Nampeyo continues. Today the villages on First Mesa in Hopiland make all forms of decorative ware. Bird motifs (particularly a parrot design presumably borrowed from Mexico) appear frequently on the tall Hopi vessels.

ine—a storyteller surrounded by many tiny children—which is an appealing form of folk art.

San Ildefonso and Santa Clara pueblos both produce very distinctive polished red and black wares with matt designs. In Santa Clara the pots are sometimes very deeply carved, and recently a polished red ware has become very popular there. It is, however, the highly polished black jars, with flared rims and impressed designs, which are the most elegant. In San Ildefonso in 1919 Maria and Julian Martinez introduced matt black paint on polished black ware, which has

Until about 1600 glaze paint for decoration was used by only some pueblo potters. The glaze paint is glossy and vitreous. Such glaze painting occurred sporadically as early as A.D. 1000; shortly after 1600 the glaze-ware technique was lost.

As opposed to glaze paint (which is glossy), matt paint is dull and flat. It has been the most prevalent decorative medium in the Southwest since the earliest times. Two basically different types of matt paint have been used: organic and mineral. Organic paint is used for black decoration only. It is made by boiling down various leaves, such as those of the Rocky Mountain bee plant—the paint from which is called *guaco*. Mineral paint is made by adding finely pulverized rock to a binder liquid, which results in various colors, such as red, brown, yellow, and black. After 1700, at many pueblos pottery was often painted with organic black paint—though mineral black has persisted at Santa Ana, Zia, Laguna, Acoma, Zuñi, and the Hopi villages (Frank/Harlow).

An iconographic motif discovered among the pottery of most of the Southwestern pueblos is the so-called ceremonial line break. Continuing an ancient tradition whose origin is unknown, many of the pueblo potters incorporate the line-break convention into the decoration of their ware. It is traditional for the motifs painted on vessels to be framed above and below with one or several encircling black lines. The line break is a short interruption of these lines.

Today's Southwest Indian ceramics are diverse both in character and quality. The late Maria Martinez and her artist descendants, Santana and Adam

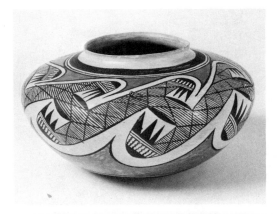

Hopi clay jar, painted in black and red on a creamy-orange slip. Signed Rachel Nampeyo. Photograph: Sotheby Parke-Bernet.

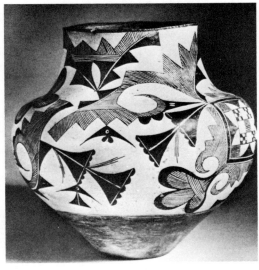

Acoma Pueblo clay jar. New Mexico, c. 1885. Denver Art Museum.

Martinez, represent an unbroken line of master potters. Lucy Lewis of Acoma Pueblo is another great craftsperson whose ware is highly prized. Priscilla Namingha Nampeyo is the great-granddaughter of Rachel Nampeyo of Hano, and is one of today's preeminent Hopi potters, while her grandmother, Fannie Polacca Nampeyo, still produces pottery in the Sityatki style, which her famous mother, Rachel Nampeyo, handed down to her.

The Southwestern potters persist as eloquent artists. And as Tanner has pointed out, the immense change from

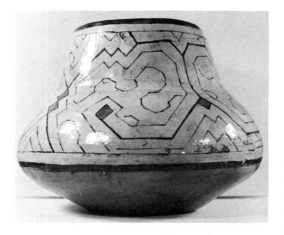

Clay vessel, painted with black on a cream slip and polished with resin. Shipibo tribe, Amazonia, Peru, 1981. Collection of the author.

group-dominated styles to individual creation is certainly the major factor in the future of the crafts of this region.

In addition to the American Southwest, there are a few other regions in which ceramics continue as a vivid Native American expressive form, and these deserve at least a brief discussion. In Peru, for instance, in the villages of Ayacucho, Cuzco, and Santiago de Pupujua, and among the Omagua and Shipibo Indians of the northeastern zone of Loreto significant pottery is still produced. In the pottery-making villages of Quinua the craftspeople make the celebrated little clay churches which were originally intended to be fixed on the roofs of houses to ward off evil spirits (Salas). These ceramic churches are delightful examples of Native art.

The Shipibo tribe, from the northeastern Peruvian Amazon Basin, produces some particularly important pottery, which comes from a cultural and artistic tradition radically different from that of the Andean tribes. Apparently the Shipibo pottery is not essentially a tourist product, but is made by the tribe for its own use. The vessels are exquisite in design and extremely light in weight. The iconography is based predominantly upon the motif of the cross and the serpent, religious emblems which are repeated in geometric forms. The pottery is baked in rudimentary ovens dug out of the earth, and polished, after firing, with resin from trees, to produce a glazelike finish.

In Peru there are a few isolated potters who, like their North American tribal counterparts of the Southwest, have managed to build reputations as individual artists. Such a potter is Edilberto Merida from Cuzco, who has created a kind of "protest" pottery—using a grotesque, naturalistic style depicting the social disorders and sufferings of the peasants and Indians. Another potter who has gained special recognition is Leoncio Tineo from Ayacucho, who has a personal style which portrays the people of the countryside in a serene and whimsical manner.

In Ecuador, a continuing Indian pottery tradition exists among the Sarayacu Quichua people of the Bobonaza region in the southeast. Among these craftspeople a distinctive tradition has endured; they produce a specific array of vessels—storage pots, cooking pots, drinking bowls, soup bowls, and so-called Fiesta pottery (Kelley and Orr). The clay used is gray and rust. Paints and slips are mineral, not vegetable. The purpose of glazing, according to the potters, is to make the ware waterproof. There are two types of glazes: resin of a gum tree and white resin of a rubber tree. The potter begins painting a drinking bowl, for instance, by applying two coats of slip: white to the interior, and either white or yellow to the exterior. No preliminary designs are drafted. The potter starts with the interior of the bowl and

paints a specific iconographic motif in a series of improvisations around traditional themes. "We paint only what we think in our hearts." (Kelley and Orr). The motifs are seemingly geometric, alternating in color between rust and black. The border designs, though abstract in appearance, have been identified by potters as various animals: boa, crab, snake, turtle, fish, and water turtle. The ceramics of the Sarayacu Quichua are rare examples of a fragile but tenacious South American pottery tradition.

In the Valley of Mexico a far more commercial pottery market exists than in Ecuador, and yet much of the pottery is intended for Native use. According to Thomas H. Charlton (see Graburn), pottery of this area originates from several ceramic traditions. The domestic ware is mainly produced in Texcoco and San Sebastián, Michoacán and Tulancingo. The more elaborate ware, though still made for domestic use, comes from Dolores Hidalgo and Oaxaca. Large amounts of pottery are brought great distances to be sold at markets. Though the emphasis of these markets is on ceramic ware for use, the San Sebastian potters have recognized the tourist market for about a century. They produce various incised and unglazed polished red, polished black, and polished buff ware both for Mexicans and for the foreign tourists visiting the great pyramids at Teotihuacán. In addition, the San Sebastian potters make reproductions of various pre-Columbian figurines for the same tourist market.

The pottery of contemporary Mexico is not aesthetically distinguished. It relies heavily upon bright pigment and rather crude shapes and finishes. There is, however, in the crudity of some of

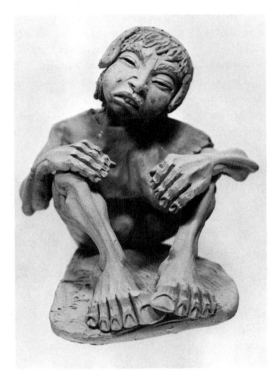

Edilberto Merida, clay figurine. Cuzco, Peru, 1981. Collection of the author.

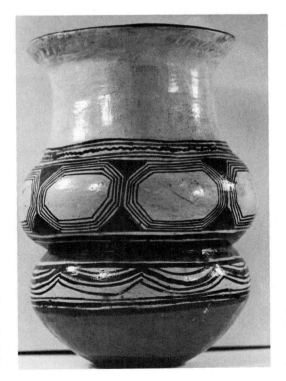

Clay jar. Sarayacu tribe, Amazonia, Ecuador, 1980. Collection of the author.

the unpainted and partially glazed ware, a robustness and naiveté which is as appealing as the rustic blown-glass objects also produced in present-day Mexico.

The lines of development of Native American pottery reach into the remotest history of the Western Hemisphere and extend into the experimental mentality of the late twentieth century. Such

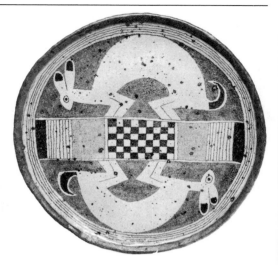

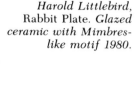

Harold Littlebird, Rabbit Plate. *Glazed ceramic with Mimbres-like motif 1980.*

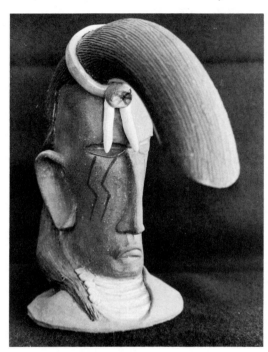

Bill Glass, Jr., Hairdo. *Modeled stoneware, 1980.* Photograph: Knokovtee Scott.

artistic application of clay is found in the works of contemporary North American Indian artists such as Harold Littlebird and Bill Glass, Jr. Littlebird descends from the Pueblo Indians of Santo Domingo and Languna in New Mexico and has recycled many motifs from the ancient traditions of his forebears. The Cherokee Indian artist Bill Glass, Jr., makes high-fired clay figurines, which represent an effort to use the traditions of pottery in a new and abstract sculptural manner. These new works in clay have displayed a vast new potential for the ceramic arts.

8.
Carving and Sculpture

To an art historian following the Western European tradition, the artist's invention of sculpture in the round may represent the highest evolution of sculpture. Three-dimensional sculpture and carving as "fine art," however, are concepts that the traditional Indian would not understand. From the pre-Columbian Native American viewpoint, creative work is never the effort of a single personality but the expression of a tribal consensus or, in an individualized form, the expression by an artisan of a collective spiritual experience.

Though exceptionally fine Indian carving and sculpture are found throughout the Western Hemisphere, there are highly contrasting regional styles. Part of this regionalism is doubtlessly the result of the materials available in different areas. Most extant examples of sculpture are carvings, but, as we have already seen in the discussion of pottery and figurines, there is also clay sculpture and there are sculptural modifications of basketry—such as effigies produced by means of textile techniques (Feest). By far the easiest medium to use for carving is wood, but since wood is not readily available in some parts of the Americas, and rarely survives from ancient times, stone and ivory sculpture represent the longest surviving continuum of Indian plastic art, "even though it

must be assumed that excellent wood carving was produced by at least some of the prehistoric groups" (Feest).

A sufficient number of examples of sculpture have survived to indicate that the people of pre-Columbian America carved and sculpted in a variety of locations, at different periods of time, and to very different effects. According to Pal Kelemen, "some very early pieces show a strong feeling for the three-dimensional, while others are done only in incised outline. In some cultures, one can observe how relief carving was developing more and more toward the round; others seem to have been content with the elaboration of design on a rather flat surface." In almost each example of Native sculpture, however, we discover a sense of form, design, and use of materials, and a splendor of technique equal to the plastic arts of the most celebrated world civilizations. The sculpture produced by Native Americans is one of the Indian arts most widely and easily comprehended and appreciated by non-Indians. Yet the abundant sculpture which has survived is somewhat obscure to Anglo and other present-day observers, for it is always difficult to judge art, especially if it functioned both ornamentally and ritualistically, once it is removed from its setting. And there is another aesthetic problem: in many cases the handsome but time-worn and now faded objects which we admire today were once lavishly colored—painted in a manner similar to the way sculpture and architecture in many early Western civilizations were. Our appreciation of the present-day "stern simplicity" of a Maya monument may, therefore, be as much a false impression of the way the sculpture originally looked as is our long-standing

admiration of Hellenic marble sculpture, whose bright pigments have also vanished over the centuries.

It is difficult, as Kelemen has pointed out, "to take full measure of pre-Columbian sculpture, since much of it functioned as ornament and most of what we see today is stripped from out of its setting." But certain aspects of the aesthetic aims of Indian sculptors remain vivid to us. They had, for instance, a strong feeling for the materials in which they worked, and the style of their designs and the mood of their iconography were apparently evolved from the interplay of imagination and media. It is also clear that the tools and techniques of the pre-Columbian sculptor were highly ingenious. Tubular and solid drills were employed, rotated on bowstrings. Deep cutting was executed with the use of hard stone and hardwood tools. The array of objects produced by such seemingly "crude" means is startling both in its diversity and its finesse.

The sculptural objects which have made the greatest impact upon art historians are those produced by the Maya, Mexicans, Mound Builders of the United States, and the tribes of the Northwest Coast region of North America. For the purposes of an overview, it is possible to generalize about the plastic arts of these four cultures. Most Maya carving was worked in low relief with incised lines, and most of it was so intrinsically connected to architecture that it can safely be called ornamental. The Mexicans, on the other hand, tended to work in the round. The eloquence of the Maya reliefs and stelae (monumental time markers) is in sharp contrast to the Mexican artisans' rather grisly iconography. And yet Maya sculptures are singular and generally independent works with a life of their own, rather than just adjuncts of architecture. Curiously, the Peruvians to the south, who did outstanding work in modeled clay and cast metals, did almost no sculpture that compares favorably with the work of the Maya and Mexicans.

The effigies and sculpted monuments of the Mound Builders of the Mississippi and Ohio rivers were of an entirely different character, though it is generally speculated that the impetus for their creation—if not their development—came from Mexico. Another kind of Native American monumental art, created by the Mound Builders, may also have its origins in the Valley of Mexico or even on the desert coast of Peru. This is land art, or earthwork; it is characteristic of both the mound people of North America and the Nazca culture of South America. The artificially amassed earthworks constructed by the prehistoric inhabitants of the Eastern United States were conical and shaped in the form of animals, while the Lines of the Nazca were produced one thousand years ago by the removal of the iron-oxide surface of the desert and the consequent exposure of the yellowish subsoil. These Lines are astonishingly varied: there are eighteen kinds of birds, about twelve animal forms, and several human figures, as well as more than one hundred geometric designs. These Lines and earthworks will be included in our discussion of Native American sculpture and carving, since they are reflected in the late-twentieth-century art of conceptualists and earth-builders.

The carving traditions of the Northwest Coast of North America are ancient but the technology is a rather recent de-

velopment. Both the monumental totem poles and the startlingly theatrical ceremonial masks of this region were largely the result of the introduction of steel tools by white traders in the nineteenth century. Though wood carving existed throughout the Americas, it is not an exaggeration to claim for the Northwest Coast tribes the most refined and remarkable achievements in this field. As Christian Feest has aptly stated, "The extraordinary quality of Northwest Coast wood carving is responsible for its comparatively early recognition as 'art' by European observers."

There is also some interesting carving among the Innuit and the Southwestern tribes of the United States. The False Faces of the Iroquois (masks carved from uncut, living trees and used ritualistically), the stone tools and metates for grinding corn in Central America and the West Indies, and the stone reliefs and carved wooden masks of the Southeastern United States are excellent in their workmanship and imagination. Also striking, if rather fierce and crude, are the sculptures of San Agustín in Colombia, as well as the massive granite figures of Costa Rica. All of these traditional forms of stone sculpture and wood carving, along with outstanding examples of today's works by master Indian sculptors, will be discussed as part of the rich heritage of the plastic arts of Indian America.

Despite the diversity in art styles at different times and in various regions, the Mexican archaeologist Ignacio Bernal has stated that one common thread runs through practically all Middle American cultures, beginning with the Olmec at San Lorenzo, Veracruz, in

1200 B.C., and extending until the Spanish invasion of 1519: this is "the feeling for order and exact proportion, the real mania for ritual" in a totally ceremonialized society. These were the elements of Indian plastic art from its outset, though we have no precise date for the origins of sculpture in the Americas. By far the earliest carved artifact rediscovered is a six-inch-long fragment of mastodon pelvic bone unearthed by Mexican anthropologist Juan Armentia Camacho near Puebla, Mexico, in 1959. It is scratched with the likenesses of camels, tapirs, mastodons, and other animals now extinct in the Americas, and it is believed to have been carved when the bone was fresh, about 28,000 B.C. The next important sculptural find in Middle America dates from ten to twelve thousand years ago, and it is the sacrum of a now-extinct ancestor of the llama and alpaca. Now fossilized, this bit of bone, thoughtfully shaped when it was fresh to bring out its natural resemblance to an animal head, was discovered nearly forty feet deep in Upper Pleistocene deposits, at Tequixquiac, in the north of the Valley of Mexico. From the evidence that we have, after the manufacture of these humble sculptures nothing else that can be called art seems to have appeared for many centuries.

By far the earliest known carved artifact of the Americas—a six-inch-long fragment of mastodon pelvic bone—unearthed by the Mexican anthropologist Juan Armentia Camacho near Puebla, Mexico, in 1959. Incised with the images of camels, tapirs, mastodons, and other animals now extinct in the Americas; c. 28,000 B.C.

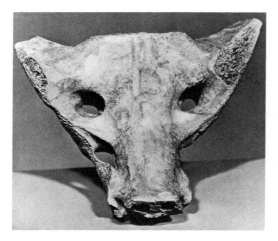

Head of a coyote. Carved bone (sacrum of an extinct species of llama). Tequixquial, Mexico, c. 12,000 B.C. National Museum, Mexico City.

The next known appearance of plastic art was in the Tehuacán culture about 1500 B.C. and was followed, within a few centuries, by the flowering of a tradition of clay figurines in Veracruz, the Valley of Mexico, Guerrero, Oaxaca, Chiapas, and the Pacific coastal region of Guatemala (Easby/Scott).

As we have already noted in the section on pottery, these figurines were the first of a long line of clay figures, as well as the beginnings of clay sculpture, an art form that reached marvelous perfection in later times. The figurine cult soon spread throughout Middle America, diverging into regional styles, which had at least one outstanding similarity: their makers symbolized the human being without imitating its realistic proportions and details. This visual tradition, which disregarded the natural in favor of the essential, continued as the basic element in the evolution of sculptural styles.

Larger effigies, capable—unlike the cult figurines—of sitting or standing unaided, were made possible by an important technical discovery about 1400 B.C.: they were constructed to be partly or entirely hollow; this innovation prevented the tendency of large, solid fig-ures to crack during manufacture due to the natural shrinkage of the dried or fired clay.

"To produce a figure taller than eight or nine inches, it is necessary either to add extra temper, such as sand, to the clay or to adapt the form itself to the natural limitations of the material by modeling a flat 'gingerbread man,' as was sometimes done in Western Mexico. Hollow construction, though far more difficult, permitted greater size while giving the artist more choice in design and proportion" (Easby/Scott).

All but the smallest hollow figures have perforations, which act as vents for escaping moisture and air during drying and firing. Though often placed inconspicuously in the figure, these perforations were sometimes used in a decorative manner, to give emphasis to eyes or the mouth. Alternatively, a large opening might be left in the top of the head; then the figure resembled an effigy jar, the form that probably gave impetus to creating hollow sculpture.

The figurine and hollow-figure makers tended to simplify and to alter naturalistic details and proportions in order to achieve a more significant composition. A contrasting style of large, seated figures was derived, apparently, from the more realistic tradition of the Olmec culture. The Olmecs were exceptionally influential, as evidenced by the enormous number of stylistic elements, iconography, and imported and borrowed objects of Olmec origin which are found among the cultures of their contemporaries. Though remarkably little is yet known about the Olmecs, there is no doubt that their monuments mark the beginning of civilization in Middle America.

The term Olmec means "the rubber people," the dwellers in Olman. To the Aztecs, whose historical frame of reference was limited to the fifteenth and sixteenth centuries, the name Olmec referred to an ethnic group scattered widely in the southern region of Mexico. Actually, the Olmec culture apparently included many tribes and underwent several major historical transformations which have still to be fully understood. There are also some scholars, as I have already indicated, who contest the long-standing notion of the Olmec as the "mother culture" of Mesoamerica.

Some authorities believe that the iconographic mentality of the Olmec people was highly rarefied and depended only superficially upon a strong naturalistic conception of form and style. Writers such as Kubler, however, emphasize the familiar consensus that "accurate anatomical relations and visually faithful modeling are the distinguishing traits of the colossal heads" for which the Olmec

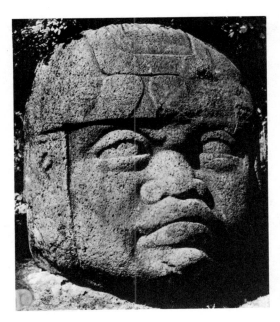

sculptors are the most renowned. Sixteen such heads were known in 1970: one at Tres Zapotes, another from Cerro Nestepe, four at La Venta, nine at San Lorenzo, and one in the Tuxtla mountains. Some of the heads at San Lorenzo appear to have been mutilated and buried long ago, for reasons presumably politico-religious, but not clearly understood by current researchers. It is agreed that these huge heads once stood, like the head at Tres Zapotes, upon foundations made of unembellished stone. Kubler believes that all the heads may once have been coated with smooth purple-red paint on a white clay base, "of which traces survive on part of the northwest head at La Venta."

Olmec sculptural style, whether executed in basalt or jade, has a deceptive simplicity. As Easby and Scott have pointed out, "though superficially alike, the monolithic [Colossal Heads of La Venta] appear to be idealized portraits, differing subtly in facial proportions, expression, and the motifs carved on their great round helmets. . . . An apparent naturalism appeals immediately to the eye but soon troubles the mind with a disquieting sense of meaning not understood." The naturalism of the Olmec, according to many scholars, rests upon a mode of symbolization: realistic human and animal elements are fused with such assurance that the unreal seems strangely believable.

Though it is frequently pointed out that the most pervasive symbol of Olmec art is the jaguar, it is important to recognize that the naturalistic image of the animal itself seldom appears without the infusion of humanoid characteristics. This were-jaguar is apparently more important to Olmec iconography than the

Classic Olmec monumental head. La Venta, Tabasco, Mexico; c. 800–200 B.C.

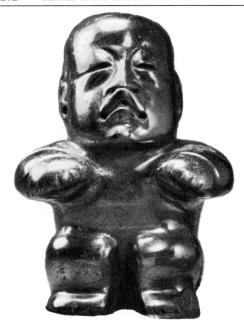

Olmec seated "baby/ jaguar" figure of hematite. Wadsworth Atheneum, Hartford.

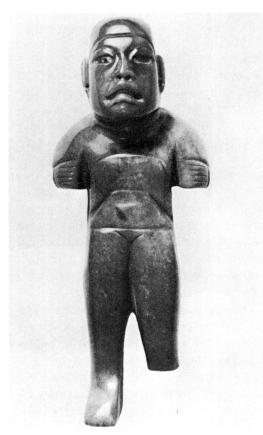

Olmec standing male nude (no genitals) of jade. Museum für Völkerkunde, Vienna.

jaguar itself; it is precisely the humanoid jaguar which permeates all aspects of Olmec art, and radiates outward in time and space to affect almost every culture of Mesoamerica until the time of the Spanish invasion in the sixteenth century.

"Belief in a deity with the form or attributes of the jaguar, symbolic of power and life force, may have existed in pre-Olmec times; such a belief is reflected in the Chavin art of Peru and the Shang [art] of China, suggesting a common origin that was more ancient than the early art styles in which it first appears in each of these widely separated parts of the world" (Easby/Scott).

Another jaguar-related figure which dominates Olmec art is that of a child in the arms of an adult. The child is depicted as a were-jaguar with a large, trapezoidal mouth, broad nose, slanting almond-shaped eyes, and fangs.

Except for headdresses, pectoral ornaments, and belt fastenings, most Olmec figures carved in the round wear the simplest of clothing. Some are depicted with loincloths or short kilts, but even when the figures are nude there is seldom any indication of sex, despite the fact that sculptors were otherwise highly naturalistic in their portrayal of human anatomy. This custom of suppressing sexual characteristics in hierarchic images has no parallel in Western European art.

The jaguar symbolism of the Olmec also appears in polished stone axes (celts), found in great abundance among La Venta ceremonial offerings. These large axes of greenstone and jade were carved to depict the jaguar, often shown with fangs. The purpose of these ritual celts is unknown, but they are so numer-

ous as to suggest a central importance in Olmec religious life.

The sculptural art of the Olmecs, which is the only substantial art of this culture which has survived, has few subjects not connected with the jaguar, the were-jaguar, and the jaguar-child. As Easby and Scott have pointed out, Olmec forms are composed of ample masses subtly shaped and balanced to give an impression of great solidity. Though often symmetrical in design and poorly finished in back, the sculpture is fully three-dimensional in conception and intent. Technical mastery was a basic element of the style, and so was the use of fine material, much of it obtained from great distances. Basalt for most of the monuments (the largest ones weighing twenty-five tons or more) came to the central Olmec sites overland and by water from the Tuxtla Mountains, some fifty miles to the northwest.

Until a chronology becomes established, no one can say whether the Olmecs of Veracruz and Tabasco independently created the politico-religious system embodied in their art, or whether, as they became more artistically successful than their contemporaries, they simply expressed widely held beliefs in the more eloquent and lasting artistic forms that we know today.

Though it is still difficult to establish the existence of a "mother culture" for Mesoamerica, it is clear that the diffusion of elements from the Olmec culture established a strong, central style and iconography for the entire region. Hollow ceramic baby figures were the dominant form in Central Mexico; greenstone effigy axes (celts) were prevalent in Guerrero; and stone relief sculpture

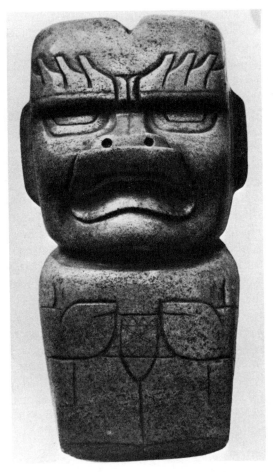

Olmec jade celt with man/jaguar head. British Museum, Museum of Mankind, London.

was the major form in the Maya highland and on the Pacific slope. Yet all of these regional variations were technically and stylistically indebted to the Olmec sculptors. Because of this influence, all of these art forms are usually called Olmecoid or, more precisely, post-Olmec.

After the sixth century B.C., when the Olmec hegemony disintegrated, the vitality of Olmec style diminished. Yet the impetus of Olmec concepts tended to survive even after the aesthetic and, probably, the religious convictions of the Olmec people were forgotten. For instance, the colossal heads found at Mon-

te Alto, on the Pacific slope of Guatemala, were surely inspired by the heads of San Lorenzo and La Venta, but the rendering of the faces had a quite different effect, and these huge pieces were apparently produced for a different purpose. The closed eyes of the Monte Alto heads suggest death, and given the variety of facial features, we can assume that these heads were commemorative portraits of deceased rulers. The technology involved in sculpting is also quite different from the work on the finest Olmec heads: the Monte Alto heads have shallow modeling to demark features, with much of the sides of the stone unworked. The echoes of Olmec themes and techniques and a few revivals of actual Olmec forms (such as the jaguar figures that appear in Oaxaca on ceramic containers at Monte Albán) suggest a once-brilliant tradition. Except for such revivals, sculpture in the round decreased markedly in the post-Olmec era (550–100 B.C.). Even later, when technical mastery of stone carving was again achieved, fully three-dimensional sculpture was rare.

Thus it becomes apparent that from the Late Preclassic period (100 B.C.) relief carving became the major form of sculptural expression. At Monte Albán we see the typical alternative to the stolid, massive Olmec style: angular and elongated forms, made to conform to the restrictions of tall, narrow, irregularly cut stones. Scrolls often curl from the mouths of the figures, indicating speech—a common motif, which appears here for the first time. On only a few of the three hundred known Preclassic relief carvings of males at Monte Albán are the genitals rendered. Instead, a circle surrounded by flowing scrolls is indicated in the groin, presumably depicting blood due to emasculation. The eyes of these figures are closed and the jaws are slack—features which justify the interpretation of these figures as slain men.

Other regional styles which show little or no Olmec influence are found in the highlands of Guatemala, where local folk traditions apparently gave rise to pedestal figures with sharp, angular features, representing animals and captives. "Mushroom stones"—an unexplained group of stone objects, often carved in the shape of figures—date mainly from the Late Preclassic period (100 B.C.). It is sometimes speculated that these mushroom stones relate to a pre-Olmec local cult involved with the eating of hallucinogenic plants to produce psychedelic effects, a practice still existing among some Indians in Mexico.

Following the transitional era of post-Olmec style, a new form of carving gradually appeared in southern Mesoamerica, emphasizing softer, curvilinear

Danzante. Monte Albán (Oaxaca), Mexico, c. 700–300 B.C. From the "Gallery of Danzantes": part of a frieze bordering the ceremonial temple.

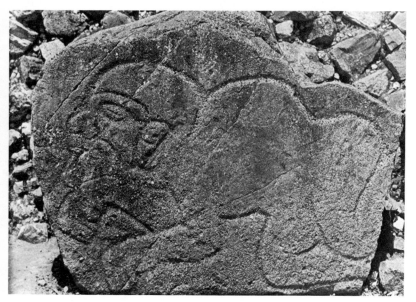

shapes and more elaborate compositions. This style has been named Izapan, and has been found at such previously Olmec sites as Tres Zapotes and Veracruz; it also appears at Kaminaljuyu, a suburb of Guatemala City. The subject matter of Izapan reliefs is far more violent and aggressive than that of Olmec carving. The composition of Izapan carvings, executed in uniformly low relief on stelae, often has a center figure engaged in combat; he is brandishing a weapon and threatening a lesser figure. We may assume that Izapan sculpture celebrates war ventures. The taking of trophy heads seems to have originated in the Late Preclassic period, since this practice is first depicted on these carvings of combat.

"Beginning late in the first century B.C. the Izapan style produced its most sophisticated monuments. The number of participants in the events depicted on a stela increases, but the artists carefully controlled their compositions by using a framing border and by having all the figures in the scene face in a common direction. The depth of the carving also varies, the very fine rendering of texture being subordinated to the deep main outlines of the figures. Glyphs appear on the Kaminaljuyu slab, with a large glyph in relief similar to those on the Monte Albán stone directly above smaller incised glyphs that seem to be the body of the text; all the glyphs remain undeciphered [1970], but they appear to be ancestral to Maya writing. In this period, glyphs render the earliest written dates discovered in the Americas, all of them clustered between 35 B.C. and A.D. 26. The southern-highlands stelae with inscribed dates all have carvings in the Izapan style" (Easby/Scott).

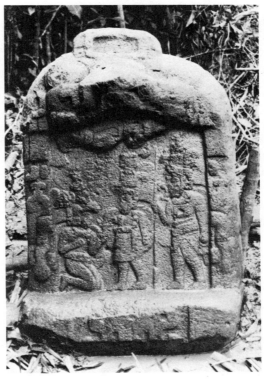

Basalt Stela D. Tres Zapotes, c. 100 B.C. National Museum, Mexico City.

The refined, sophisticated Izapan sculptures in clay and stone anticipate by several hundred years the Classical art of eastern Mesoamerica. The stelae of Izapan centers, with their refined low relief, their elaborately depicted human beings in regal profiles and elegantly costumed, and their use of hieroglyphic writing as an intrinsic element of the composition, introduce most of the motifs dominant in Classic Maya stelae.

The ancient populations of the remote western regions of Mexico were divided into two distinctive cultural styles, the Guerrero and the Colima-Jalisco-Nayarit, which, though apparently isolated from one another and untouched by each other's unique art forms, coexisted during approximately the same period (300 B.C.–A.D. 300). At the same time,

the state of Michoacán, between Guerrero and Colima-Jalisco, was occupied by yet another entirely separate ethnic group, the Tarascans. Early in the twentieth century, scholars such as Carl Lumholtz speculated that the figurine art of this region was all produced by the Tarascans, and therefore it was fashionable until recent decades to refer to the art of this western zone as Tarascan art. Today it appears that the three cultures of Western Mexico were independent of one another, but did have a strong relationship to the defunct Olmec centers on the east coast which predated their habitation of the west.

Only one Olmec characteristic entered the culture of Guerrero: the working of jade and other so-called greenstones. The Olmec impact on the Colima-Jalisco-Nayarit groups appears to have come by way of Central Mexico. Because Central Mexico excelled in the production of clay figures, both solid and hollow, Easby and Scott attribute the distinctive figurines of the Colima-Jalisco-Nayarit to the early influence of the Olmecs in Central Mexico.

With the decline of the Olmecs, a regional style evolved in Western Mexico. The Guerrero artists produced two strong local "schools"—a naturalistic Chontal style (north of the Balsas River) and the relatively abstract Mezcala style (south of the Balsas). Typical of the Mezcala style is the depiction of human figures in an elliptical shape (perhaps derived from the Olmec celts, according to Easby/Scott). It is not unusual for facial features, such as the eyes and mouth, to be left undefined or entirely unindicated, while the nose is characteristically formed by the juncture of three planes, abstractly representing the

Guerrero stone standing figure. Chontal culture, Late Preclassic period, c. 300–100 B.C. Photograph: Sotheby Parke-Bernet.

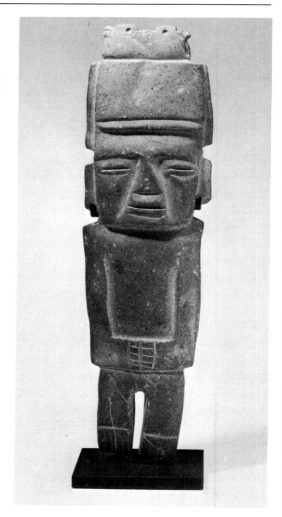

cheeks and the mouth. Horizontal cuts usually separate the figure into zones: torso, legs, heads, forehead, and so on. In the sculptures depicting temples, the same planar quality persists: a flight of steps leading to a tiered platform and to the temple proper, with grooves similar in style to those used to divide the anatomical zones of the human figures. The Mezcala style is so relevant to today's sculptural modes—with its emphasis upon planes and grooved lines—that it has attracted very favorable attention worldwide among artists and collectors.

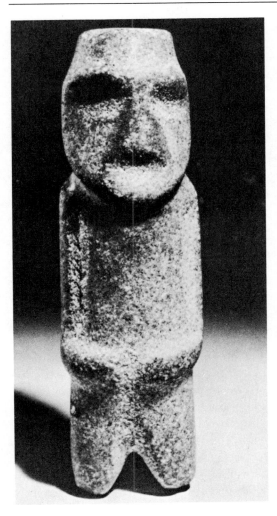

In contrast, the Chontal style is concerned with realistic detail and a greater degree of verisimilitude. Another form of Chontal carving consists of face masks, some with eye holes but many without any facial openings.

The clay tradition of the west clearly relates to the widespread figurine cult of Preclassic Mesoamerica, encompassing both solid figurines and larger, hollow figures. The Colima-Jalisco-Nayarit clay sculpture has been discussed in detail in the chapter on pottery; for our purposes here, some remarks by Easby and Scott on cross-cultural influences will serve to relate this brilliant western ceramic art of Mexico to the Americas generally: "The distinctive shaft-and-chamber tombs of Colima, Jalisco, and Nayarit occur nowhere else in Mesoamerica but are characteristic of the Andean civilizations of South America, as are the stone 'maps' with circular depressions from Colima. Many other elements also suggest a possible connection with inhabitants of the northern Pacific coast of South America, who could have sailed north on balsa rafts. Northern South America and Western Mexico are among the very few places where entire scenes, including buildings and their inhabitants, were represented [in clay sculpture]. Roofs shaped like saddles, with high peaks and low centers, such as in a Nayarit scene, occur in the art of Ecuador, the natural jumping-off point for any direct voyage to Mexico. In view of the strong differences between the cultures of Western Mexico and that of the rest of Mesoamerica, and the several points of similarity to South America, some form of direct contact between northern Peru or Ecuador and the West of Mexico seems likely during the Protoclassic period (100 B.C.–250 A.D.). The art of Western Mexico does not suggest the worship of a hierarchy of deities, each with special attributes. Instead, religion apparently revolved around shamans, who interceded in the spirit world and could defend men's souls in battles against the powers of darkness. The prevalence of shamanism would explain many representations in Western Mexican art, such as the battling tomb guardians or the plentiful Colima animals, which may have assisted the shamans in the underworld. Nevertheless, familiar

Carved greenstone effigy. Mezcala culture, Guerrero, Mexico, A.D. 100. Museum of the American Indian, Heye Foundation, New York City.

subjects and humorous vignettes, such as the village scenes from Nayarit and Colima, dominate the art of all Western Mexico. Depictions of family warmth and love emphasize the strong humanity of Western culture. Although some elements of rank surely existed—evidenced by sculptures of men in litters—the common villager was held in greater esteem than in the more rigidly class-structured societies of the rest of Mesoamerica, where priests and princes dominated the iconography."

By the third century, the city of Teotihuacán in the Central Valley of Mexico spread over an area of nearly nine square miles; it was twice the size of contemporary Rome yet far less crowded than the capital of the great empire of the West. The heart of Teotihuacán was the immense Pyramid of the Sun—as the largest and oldest of the three major pyramids was named by the Spaniards. Unlike many of the Mesoamerican structures, which were built by superimposing new surfaces upon older buildings, the great pyramid of Teotihuacán was constructed essentially as a single unit. The labor was immense: about three million tons of large adobe blocks, facing stone, mortar, and stucco were carried to the site on the backs of laborers; the resulting structure was originally over 720 feet square, with wide stairs on the west flank rising 210 feet to a temple at the summit.

Though nothing remains of the temple, the pyramidal base gives evidence of two important sculptural innovations: stone images and the slope-and-panel architectural design that eventually became the dominant style of Classic Mesoamerican architecture of Teotihuacán, as well as many other centers where this vital culture's influences were strongly felt. The manner in which sculptural details were used as ceremonial ornamentation at Teotihuacán would largely be a matter of speculation, were it not for the Temple of Quetzalcoatl, which was preserved intact when a larger and more somber edifice was superimposed on it. The Temple of Quetzalcoatl is a marvelous tribute to an almost lost art form: the panels and stairway balustrades are lavishly decorated with huge projecting heads, and much of the original blue, green, yellow, red, and white paint, as well as the obsidian eyes of the sculptured plumed serpents, have been pre-

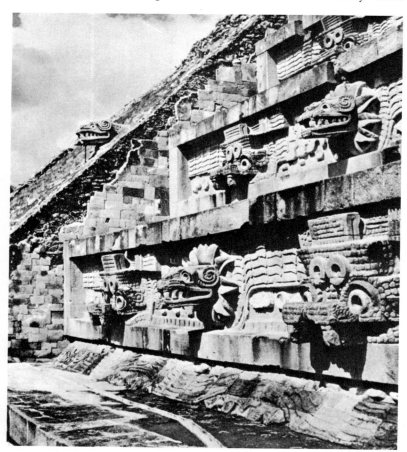

Base of the Temple of Quetzalcoatl. Teotihuacán II phase, c. A.D. 140–450. Teotihuacán, Mexico.

served. Nothing comparable has ever been discovered.

The only comparable architectural sculpture at Teotihuacán may be seen in the carved interior of the Palace of Quetzalpapalotl (which dates from the beginning of the Classical period of Teotihuacán, A.D. 250). This structure is also polychrome and set with polished obsidian. The relief is low and hard-edged and carries the theme of a composite deity, part bird and part butterly, which gives the elegant residence its name (though we have no idea what it was called by its inhabitants).

It seems that other buildings of Classic date lacked sculpture entirely. Many of them were decorated by mural painting on the facades and in the rooms and patios. These paintings seem to be religious in theme, but also are an intrinsic part of the architecture.

Architecture appears to have been the major focus of the aesthetic mentality of Teotihuacán culture, for even the free-standing sculptures have an architectonic character. Characteristic of the early sculpture at Teotihuacán is its geometric massiveness and its sense of gravitational resistance and force. And yet, the outstanding plastic expression of this vast city is not architectural but ceremonial: the serene stone masks have almost no relationship to the monumentality of Teotihuacán's public works in stone.

The masks are astonishingly uniform in style. They are rarely embellished with any form of decoration, though some have inlaid or painted designs or a mosaic covering. Almost without exception the half-open mouths and eye sockets are deeply cut and left unfinished; then they are inlaid with either pyrite or obsidian. It seems extremely unlikely

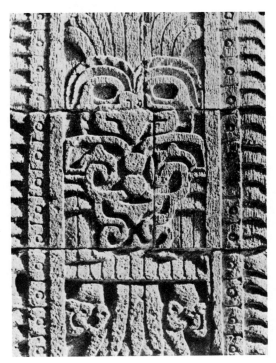

Detail from a pillar of the Court of the Palace of Quetzalpapalotl. Teotihuacán III phase, c. A.D. 400–500. Teotihuacán, Mexico.

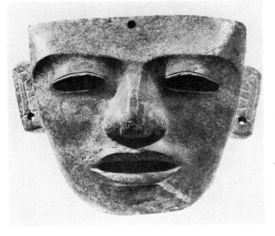

Stone Teotihuacán funeral mask. National Museum, Mexico City.

that the masks were made as part of a ceremonial costume, since they are far too heavy to be worn and since they lack eye openings. And yet the masks have perforations at each side for apparent attachment to something. Bushnell has speculated that at least some of the masks "could have been used as false

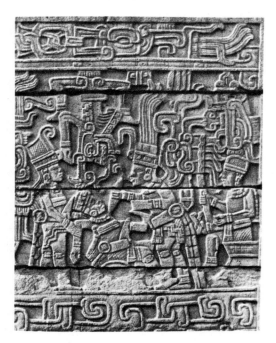

Sacrificial scene: bas-relief from the Ball Court at El Tajin (Veracruz), Mexico.

faces for mummy bundles," but there is no extant evidence to support this theory.

As indicated earlier, in the discussion of pottery, the chronological stages at Teotihuacán are usually marked by various styles of clay figurines. These small effigies represent the widest scattering of the plastic art of this great and vanquished civilization.

The Classic and Postclassic art (A.D. 250–1520) of the Mexican Gulf Coast had a distinctive character, although it was considerably influenced by the highlands (especially Teotihuacán). The Gulf Coast, however, was not strongly affected by the major style of highland art: angularity and architectonic massiveness. To the contrary, Gulf Coast art was rather curvilinear and delicate, marked by a peculiar scroll motif which is very characteristic of the region.

As we have already noted in the section on ceramic art, during the Classic

period the artisans of the Gulf Coast produced some of the greatest achievements in hollow clay sculpture. In relief sculpture the carvers were equally remarkable, excelling the brilliance of their Izapan predecessors and inventing ritualistic forms that were eventually adopted widely throughout Mesoamerica.

The area that produced this distinctive art is the central region of Veracruz, a state that curves from north to southeast in a narrow arc extending along the shore of the Gulf of Mexico and then inland to the mountains that border the central highlands. What is today referred to as the Classic Veracruz civilization can be best exemplified by the site known as El Tajin, an extensive ceremonial center which is still far from thoroughly excavated. This impressive assembly of architectural monuments—temple pyramids, platforms, and at least seven ball courts—was a major center of the still-mysterious ritual ball game, judging from the importance of the courts and paraphernalia connected with it. The reliefs of this ceremonial center clearly depict the ball game: they show the sacrifice of a ball player by other athletes, who are cutting out his heart under the gaze of the death god. These scenes are framed by the typical curvilinear scrolls of the region, which surround the otherwise rectangular arrangement of carved figures. Similar images are depicted on stone discs and stone vases. The elaborate scrollwork, with its double outline, forms complex interlacings and might be, according to Easby and Scott, more than mere decoration. "At least as early as the Izapan period, scrolls symbolized flowing water, and by extension, the rain god."

There is very little freestanding fig-

ural sculpture at El Tajin. And curiously, the styles of stone and clay sculpture, despite their coexistence, have little in common in regard to style, form, and subject matter. The scroll of the stone carvings has no parallel in the ceramic art of the region.

The stone pieces in the round which are most distinctive and remarkable at El Tajin are objects related to the sacred ball game: the yoke (or belt), the *palmas* (palmate stones), and the *hacha* (ax). The carving of these three objects is almost always hard-edged, and remarkably competent. For reasons unknown to us, the yokes often depict crouching frogs (perhaps a guise of the earth god) or serpent heads at each end and a human head in the middle, the images joined by the characteristic scrolls. The *palmas* show figures or scenes, and the *hachas* are often decorated with heads, animals, or birds. These forms are clearly related to the ball game; this is supported by their depiction in scenic reliefs of the game being played, but we do not know their exact use nor their meaning. Numerous Mesoamerican figurines from the Preclassic period show players wearing heavy belts. No one can say if these stone forms were actually worn, or were only commemorative translations of leather forms into stone, which served as trophies. It is interesting that the *palmas* are unique to Veracruz, having been devised by local sculptors some time after the invention and diffusion of the yokes and *hachas*.

Another distinctive regional sculptural style was the familiar "smiling-face" figure, the most endearing of small Late Classic forms, which exudes charm and good humor. The eyes appear to shine and the mouth is open in a lovely grin,

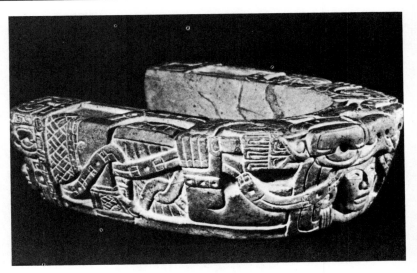

Stone yoke carved with a human form, from El Tajin (Veracruz), Mexico. Minneapolis Institute of Arts.

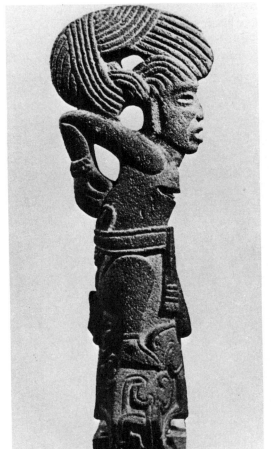

Basalt palma (slab) with wounded captive form, from El Tajin (Veracruz), Mexico. National Museum, Mexico City.

revealing teeth and sometimes a tongue. Such depiction of human feeling is rare in the sculptured faces of Mesoamerica. There is some speculation that these figures, with large foreheads, wide beaming faces, and undeveloped bodies, might represent children. In any event, they are usually discovered in burial sites and many of them appear to have been broken at the time of interment. Unfortunately, there is no clear understanding of their meaning in association with funerals, though it has been suggested that they represent companions for the deceased. On the other hand, the fact that many of the laughing figures are whistles might indicate that they were used ceremonially and then broken at the time of burial, once their ritualistic use was over.

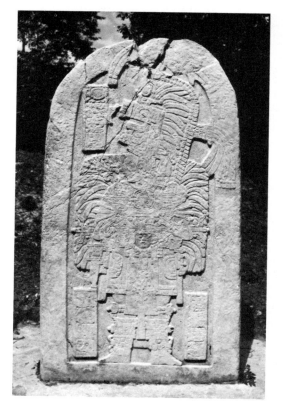

Classic Maya low-relief monument: Stela 16. Tikal, Guatemala.

Maya art reflects the mentality of the culture that produced it: it is formal, ritualistic, impersonal, and to a very large extent serene to the point of stoicism. Today's high regard for the Maya—who have been regarded as the "Greeks of the Americas"—has perhaps created the impression that the Maya centers were spheres of extraordinary influence. This impression is not correct, however; the Maya are more properly compared to the ancient Jews rather than the Greeks. They were a small population of separate tribes whose cultural views and innovations had far more impact on their successors than on their contemporaries. As Easby and Scott have perceptively pointed out, "because of the high value they set on learning and on impressive monuments, the ancient Maya now claim a vastly more prominent place among the peoples of the Americas than they seem to have held in their own time a thousand years ago and more. They surpassed all others in astronomy, mathematics, and architecture and, most significantly, developed the art of hieroglyphic writing into a far more expressive and flexible system than those used in such other regions as Central Mexico, the Gulf Coast, Oaxaca, and the Guatemalan Pacific Coast . . . [but] in spite of the intellectual accomplishments of Maya leaders throughout the central lowlands (comprising the Petén and adjoining areas in Southern Mexico, Yucatán, Guatemala and Honduras), this area was by no means the political, religious, or artistic center of Middle America." In fact, the Maya region was only one of many distinctive areas where local cultures were evolving during the Late Preclassic times (550 B.C.–100 B.C.).

The historical importance of the Maya

is largely a matter of today's overview of pre-Columbian achievements in the Americas. In its own time the Maya world was greatly overshadowed by the grand city of Teotihuacán, which rose in Central Mexico during this time as the first true urban center of the hemisphere, with its influences extending in every direction—even to the most southerly of the great Maya centers, Copán, in present-day Honduras. Though recent archaeological evidence (Hammond) seems to suggest that the Maya culture was a center of innovation during the Formative period (2500 B.C.), it is evident from Teotihuacán motifs and religious symbols carved on fifth-century Maya monuments and from imported Teotihuacán (Xolalpan phase) pottery buried in Maya tombs that Teotihuacán was a dominant and pervasive influence throughout all Mesoamerica, including the Maya region. In fact, during most of the sixth century there were extensive problems caused by the Teotihuacán presence in the Maya domain, and during this perilous time the sequence of dated stelae that were customarily erected by the Maya at intervals of about twenty years (and sometimes at the half or quarter period) was interrupted and did not recommence for sixty years. After this mysterious hiatus, and for the next two hundred years, the lowland Maya persisted—going their own way without interference from other regions or other cultures, which were largely uninspired by or ignorant of Maya ceramics, architecture, sculpture, mathematics, astronomy, and hieroglyphic writing. The Maya centers reached their climactic magnitude and magnificence in the eighth century and then, within a hundred years, for reasons yet unknown to

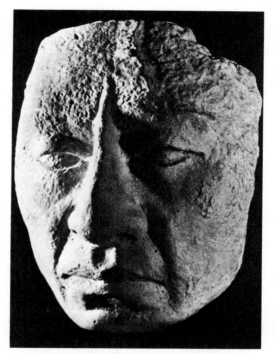

Classic Maya stucco mask found at Palenque. National Museum, Mexico City.

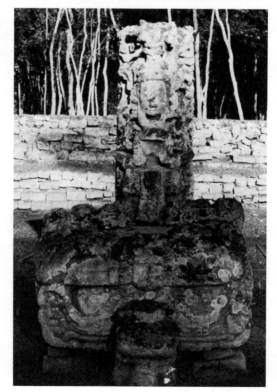

Classic Maya stone stela and altar. Copán, Honduras.

us one by one the Maya centers ceased to erect monuments, and by A.D. 900 the centers were abandoned.

Stone sculpture and architecture were the chief art forms of the Maya. The carvings were executed on the monumental stelae, on which the central (and often the sole) figure was a personage of immense dignity, surrounded and covered by elaborate ornamentation. Whether these figures were gods, rulers, or priests impersonating deities is unclear, but almost all the known examples give the impression that rank and religious power were highly interconnected. There is a formalistic manner in the composition of the stelae: action is not depicted, and there are rarely groups of persons. The iconography is constant, suggesting that aesthetic change was slow and that the culture was stable and antithetical to change (somewhat like

that of the ancient Egyptians). There are few indications of the imagination or mannerisms of individual artists. In fact, there is, despite strong regional differences in Maya motifs and styles, a pervasive sense of conformity in Maya sculpture.

Tatiana Proskouriakoff, the celebrated Mayanist, has suggested a convincing evolutionary plan for the development of Maya plastic art. She indicates that the earliest stelae were related to other styles, such as that of Izapa (an important Preclassic site in southwestern Chiapas at the Guatemalan border), having the characteristic main figure with head and feet in profile and the torso partly turned toward the viewer. Early in the Classic stage, about the fifth century A.D., the same composition continued but the costume and the ornaments of the figure became more specifically

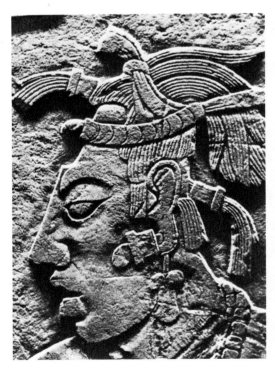

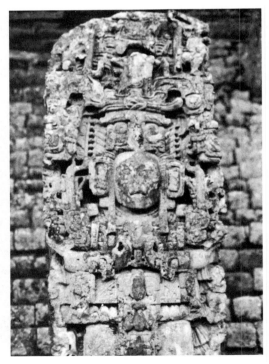

Left: Classic Maya stucco bas-relief (detail) at Palenque, Mexico.

Right: Close-up of torso and of head and headdress of a stela. Grand Plaza, Copán, Honduras.

Maya in mode, and elements such as the "serpent bar," a scepter-like object supported on both arms, made their first appearances. Then the sixty-year "silence" occurred in the dedication of stelae (from about A.D. 534 to 593), after which, when the sculptors renewed their activities, there was an acute interest in sculptural detail. At this time the figure usually stood with the body facing the viewer and with the feet splayed outward, though the face remained in profile—at least during the first stage of this new compositional period. The elaboration of ornamental and/or iconographic detail continued to increase markedly, while the figure itself remained fixed and rigid. Then, about A.D. 750, the so-called Dynamic Phase began, during which, Proskouriakoff suggests, the effect of movement was attempted on some carvings, largely by means of asymmetrical poses, accompanied by increasingly immense feather headdresses and other ceremonial paraphernalia. This was the climax of the evolutionary process described by Proskouriakoff. After A.D. 810, as we have already noted, the culture began to decline, and its decadence was marked by flamboyance and ornamental excess. This style persisted during the abandonment of many of the great ceremonial centers, until the end of the ninth century.

During the Classic period (A.D. 500–800), each of the great Maya centers excelled in a distinctive style of architectural or sculptural variation on the basic Maya forms. Copán, in present-day Honduras, produced an extraordinary series of high-relief stelae. Quiriguá, near Copán but on the Guatemala side of the Honduras-Guatemala border, erected the tallest stela of the Maya cen-

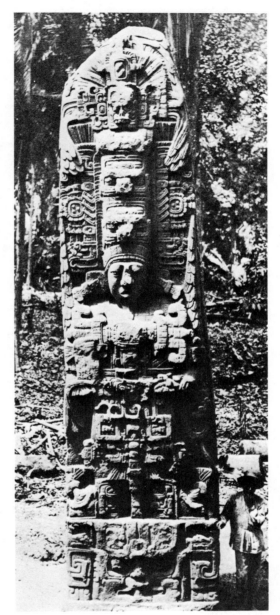

Stone Stela D: majestic figure of a god or ruler, 35 feet high. Quiriguá, Guatemala, Late Classic Maya period, c. A.D. 766. Maudslay Collection, British Museum, Museum of Mankind, London.

ters: a typically Quiriguán structure executed with the multiple figures constrained within the rectangular shape of the thirty-five-foot column. At the same location there are four immense boulders entirely covered with elaborate carvings in deep relief.

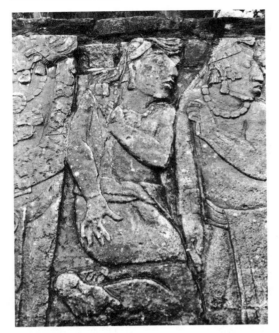

Low-relief limestone panel at Palenque: East Court of the Palace. Mexico, Classic Maya period.

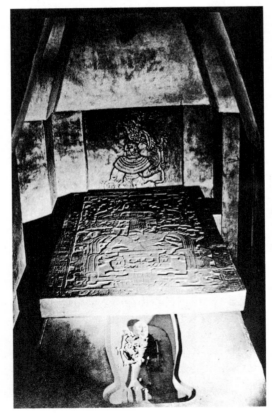

Classic Maya tomb of a priest (reproduction at the National Museum, Mexico City) within the Temple of the Inscriptions at Palenque, Mexico. Discovered in 1952. The structure is a reproduction, but the artifacts and burial objects are original.

Palenque, handsomely placed on a slope against a backdrop of verdant hills, is famous for low-relief limestone panels and stucco reliefs that are unsurpassed for their clarity of form and meticulous execution.

The Maya were extremely adept at the use of stucco. This material was widely used as a floor covering and as pavement even for vast ceremonial plazas, as well as for the sculptural decoration of buildings. At Palenque, where stucco work was highly evolved, there are exquisite panels in relief which depict figures and groups—a so-called professional style which is closely associated with Maya temple decoration. The famous tomb discovered in June 1952 by the Mexican archaeologist Alberto Ruz Lhullier in the core of the Temple of the Inscriptions contains several magnificent examples of stucco work: two stucco heads modeled in the round and decorated with red paint, as well as fine panels in relief showing a procession of elaborately dressed priests.

Uxmal, in Yucatán, is essentially an architectural site, noted for its buildings with long facades and intricate mosaic decoration in limestone. The dominant theme at Uxmal is that of masks of the long-nosed rain god, similar to those at the centers of Chichén Itzá in northern Yucatán.

Among the most significant and grandest of Maya achievements in sculpture is the great Hieroglyphic Stairway at Copán—an astonishing complex of limestone sculpture, stucco work, and architectural imagination which is surely one of the wonders of the Maya world. Over thirty feet wide and rising nearly ninety feet from the temple court, the stairway is a testament to the majesty

and brilliance of the mentality of the ancient Maya. Five larger-than-life figures originally sat at intervals on the steps, and on each rise of the stairway is a single inscription in low relief concerning, it is believed, the history of the center.

The origins of the Maya lapidary tradition are obscure, yet its very existence presupposes some connection with the Olmec, who had cherished jade and other so-called greenstones and had executed some of the first major carvings in jade in the Americas. In the Maya highlands carved jade ornaments began to appear in at least two major Early Classic styles, at Kaminaljuyu and in Quiché. Shell, like jade, was a prized material, and the Maya craftspeople worked it in the same manner as jade.

Another minor sculptural technique of the Maya was flint knapping, an essential skill of hunting societies which sometimes evolved into an art form. Maya (as well as Teotihuacán) votive offerings included so-called eccentric flints and obsidians, chipped in unusual symbolic forms. By the Late Classic this form had achieved a degree of intricacy almost unimaginable in so difficult a medium. Wooden carving has rarely survived the climate of the Maya region, and so we have little knowledge of its modes or abundance. There is, however, in the collection of the Metropolitan Museum of Art, a celebrated piece depicting a seated and moustachioed lord with folded arms, found in Tabasco, Mexico, with traces of hematite pigment. This 14-inch figure is the finest Maya wood carving known.

The arts of the West Indies (the Antilles) are relatively unimportant, with the exception of the objects made of shell,

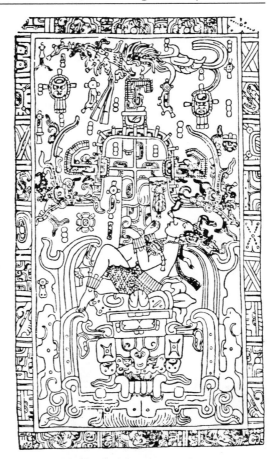

Diagram of the Maya carved cover of the sepulcher from the Temple of the Inscriptions, Palenque, Mexico.

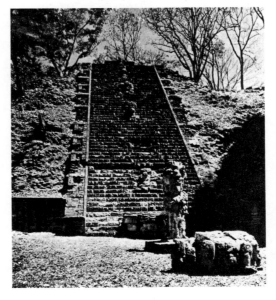

Stairway of the Inscriptions, Copán, Mexico, containing 2,500 incised glyphs as well as sculpture in the round. Classic Maya period.

stone, and hardwood connected with the Arawak worship of zemis, deities which assumed both animal and human forms and were depicted in carvings. According to Bushnell, one Arawak group, living at the time of Columbus in Puerto Rico and Hispaniola, had a ceremonial center similar in shape and purpose to the ball courts of Mesoamerica: it was a rectangular or oval area bordered with rough stone slabs bearing reliefs of zemis. There are, according to fieldwork done in 1903–04 by the anthropologist Jesse W. Fewkes, three types of zemis or, as they are also called, "three-pointed stones." In the first type the face is depicted as a projection on the front of the stone; in the second type the face is carved in the middle; the third

type have concave undersides and perhaps were trophies similar to the ball-game yokes, or belts, of Mesoamerica. The most distinguished art produced by the Arawaks dates from the last phase of their culture in Puerto Rico and Hispaniola, and particularly in the region that is now the Dominican Republic. This final phase is called Taino and dates about A.D. 1000–1493.

Central America developed at least three styles of monumental sculpture. The most southerly region—now the republics of Nicaragua, Costa Rica, and Panama—was essentially a single culture, with many artistic variations and numerous political divisions. Most of the art of this zone evolved after A.D. 500

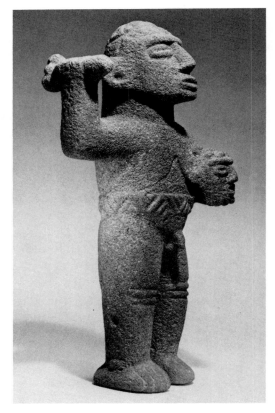

Left: Lava figure of man eating an ear of corn. Highlands, Costa Rica. From Bushnell.

Right: Costa Rican standing stone figure of a warrior with raised left arm holding a weapon; his right hand is grasping a trophy head to his chest. Guapiles (?), c. A.D. 800–1500. Photograph: Sotheby Parke-Bernet.

and is more related to South America than to Mesoamerica, though influences from the Maya region and the Valley of Mexico are visible. All three sculptural traditions of the region may have arisen from an underlying tradition of wood carving, a genre now lost, but one that might have produced wooden sculpture of heroic size, long since destroyed by the warm, humid climate. This hypothesis is strengthened by the fact that the grand columnar sculptures of stone found in western Nicaragua, depicting standing or seated figures, are carved in a form that suggests that the style originally evolved from tree trunk carvings.

The figures of eastern Costa Rica, in comparison, strongly suggest a long-standing tradition of stone carving, with numerous openings and projecting elements which are such an elaboration of openwork as to appear almost lacy. Throughout this region basalt is the stone in which the sculptors generally worked. The size of the figures is usually monumental—three to eight feet in height—and the style is strong both in its stateliness and in its volume.

Throughout Central America there are numerous carved metates (grinding slabs), standing on three or four linear legs or on a complex foundation. These metates apparently assumed an importance far beyond their daily function and became a ritual form of sculpture which is not understood by present-day ethnologists. Elaborately ornamented and handsomely shaped, these *metates* clearly served some kind of ceremonial purpose—particularly in view of the great variety of size, form, and regional styles.

Clay figurines had been produced in this region in a long Preclassic tradition,

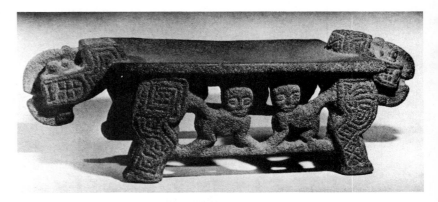

Ceremonial metate of gray basalt. Costa Rica, A.D. 800–1500. St. Louis Art Museum.

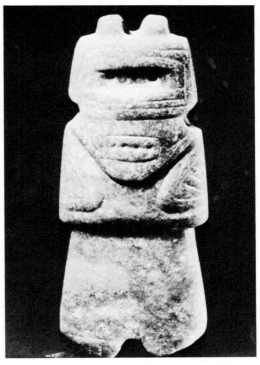

Jadeite ax god. Costa Rica, c. 300 B.C.–A.D. 500.

and were continued in Nicoya after the introduction of polychrome ceramic techniques; they gradually evolved into large and brightly colored effigies (A.D. 800).

Jade carving was probably introduced into the area by traders visiting Costa Rica from the Nicoya region. The works in jade developed into a lavish form, particularly on the Atlantic Coast, where the most distinguished jades were pro-

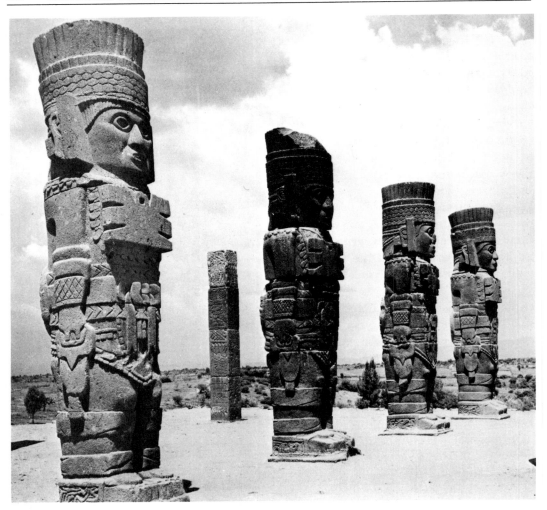

Fifty miles from Mexico City, at Tula, stand huge carved monoliths which once supported a Toltec temple. Tula, Hidalgo, Mexico.

duced before the supply of this precious stone ran low and goldwork took over as the dominant mode of art.

The rise of the Chichimec cultures— like the Toltec and later Aztec cultures—has often been compared with the invasions of "barbarians" during late Roman times (A.D. 510). There is some accuracy in the notion that the Chichimec peoples brought a ferocious tribalism into the seemingly orderly and relatively peaceful Valley of Mexico and Yucatán, but it is equally possible to draw parallels between the militaristic and expansionist mentality of the various Chichimec cultures and that of the Romans. In either case, the arrival in Mexico of waves of new populations from the north was the basis for an important transitional period in Mesoamerican history; there was still a state of upheaval at the time of the arrival of the Spanish invaders in the early sixteenth century.

The precise sequence of events which led to this transitional period is not clearly understood, nor is it known if the various stages of this apparently violent

invasion from the north were interconnected or if they represented quite separate events, involving totally different populations of migrating tribes. What is known with certainty is that in the seventh century A.D. the grand city of Teotihuacán was burned and abandoned presumably by a massive aggregation of aliens who invaded the Valley of Mexico. Subsequently the Valley of Mexico entered a "Dark Age" that lasted about two hundred years. Artistic production was limited to crude ceramics, and aesthetic development came to a halt. According to folk history, this period ended with the arrival of Nahuatl-speaking foreigners, belonging to scattered nomadic tribes in Northern Mexico and the American Southwest. These strangers, according to legend, founded a city called Tollan (Tula) on the northern extremity of Mesoamerica in A.D. 856. Despite the legendary brilliance of this city, only two large pyramids are now located there (in a region northwest of present-day Mexico City). One of the structures is the famous Temple of Quetzalcoatl, upon the platform of which stand imposing and stoical stone Atlantean figures that once presumably supported the roof. Though Tula was a small ceremonial center and its arts were modest at best, from here the Toltecs, as the rulers of Tula were known, came to reign over all of Mesoamerica through their militaristic aggression, which was strengthened by such new developments in weaponry as the bow and arrow and the *atlatl*, or spear-thrower. It is generally agreed (Soustelle, Kubler, and others) that the Toltecs brought with them, from their desert homeland, a strict religion based upon astral and war deities, rather than the gods of the earth and of

vegetation that had long dominated the Classic rites of Mesoamerica.

The impact of these aliens upon the art of Mexico cannot be denied. At Tula and wherever else the Toltec influence was felt, there is an aggressive new expression; there is a dominance of warrior motifs and an iconography devoted to the most grueling aspects of death. The style and media were equally harsh—sharp and angular. And yet, as Kubler has insisted, "the aggressive new expression was articulated in traditional Maya elements of form, and it eventually returned, in its Yucatán garb, to the Mexican highland."

Easby and Scott see the Toltec influence in a more critical framework: "Toltec images," they state, "have abruptly raised outlines, creating the impression of only two planes, that of the object and that of the background. Motifs are repeated mechanically to cover vast areas of wall surface, an example being the rows of animals on the back of the Temple of Quetzalcoatl [at Tula]. Most of the major art at Tula, such as the Atlantean columns and the rows of relief slabs, served an architectural role. These formal features remind one of the character of Teotihuacán art, whose architectural sculpture is angular, flat and repetitive. . . . Teotihuacán images are abstracted into a few basic shapes, conforming to the rectangular architecture of which they were a part; Toltec forms, while flattened, retain considerable realism in their detail. Teotihuacán surfaces are smoothly finished; Toltec forms are rough, thanks in part to the porous stone that the artists preferred."

The legendary Quetzalcoatl was represented in Chichimec folk history as a god-king and cultural hero who intro-

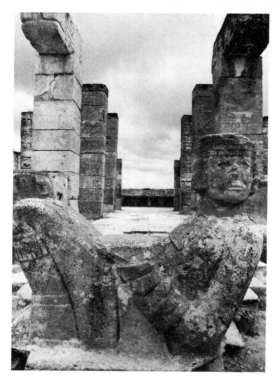

Chacmool at the summit of the Temple of the Warriors, showing the strong Toltec influence on the Maya center of Chichén Itzá, Yucatán.

Facade, Palace of the Columns at Mitla, Mexico: detail of geometric motifs. Mixtec-Puebla culture.

duced the arts to his people: metal casting, featherwork, precious-stone carving, painting, music, and the making of painted books (codices), before he was exiled for indulgences (into which he was tricked by his enemies) and fled to the "Eastern Sea"—apparently the Gulf of Mexico—in the year A.D. 987. The poetry of this Toltec tale is sublime, but its historical accuracy seems dubious. The year 987 curiously corresponds to the appearance of Toltec iconography in the Yucatán Peninsula, which can be reached by sailing eastward across the Gulf of Mexico, yet most of the arts attributed to the inventiveness of Quetzalcoatl (with the exception of metalwork) were known long before the Toltec center of Tula was founded; mosaics of feathers, however, were unknown until Toltec times, and the use of turquoise to produce lavishly inlaid surfaces became more prominent with the Toltec era.

The appearance of strong Toltec motifs in the Yucatán Peninsula was not the first nor foremost cause of major change in the Maya culture of that region. The Maya world had been severely affected earlier, by unknown causes which brought about the abandonment of the great Classic centers in northern Guatemala and the adjacent settlements of Southern Mexico. The full impact of the so-called Mexicanization of Maya art (the effect of Chichimec expansionism) can be clearly seen in northern Yucatán, particularly in the capital city of Chichén Itzá. The chronology of Toltec Chichén Itzá architecture and sculpture is uncertain (Kubler), but it is clear that when the Toltecs reached Yucatán, they found a large Maya population whose civilization depended upon the relatively independent reign of numerous small

centers containing the most beautifully proportioned stone architecture ever created in the Americas.

At Chichén Itzá the process of cultural duplexity—the amalgamation of two distinct ethnic styles—is highly visible, for the invading Mexicans did not destroy the long-standing Maya architecture, but founded their own ceremonial structures to the north of the original Maya buildings, effecting what must be regarded as a "peaceful coexistence" with the intellectually and artistically superior people of the Postclassic Maya (A.D. 950) domain. As Easby and Scott have pointed out, the details of the plan and ornamentation of the new Toltec structures at Chichén Itzá show direct parallels with Tula. For example, the small Atlantean figures from the Temple of Quetzalcoatl at Tula are recapitulated in the limestone Atlantean warriors of the Temple of the Jaguars of Chichén Itzá (both temples are early Postclassic constructions, dating from A.D. 856 to 1204). Yet there are subtle differences between the rendering of these stone carvings: the Maya sculptors, whom the Toltec lords employed to carry out their building program, gave the Mexican forms a Maya subtlety of carving and refinement. The Maya had mastered architectural sculpture during the construction of earlier Yucatán centers, and this achievement doubtless facilitated their ability to adapt the square, rigid Toltec style to their own aesthetic sensibility.

Though Chichén Itzá provides us with an example of a direct implementation of Toltec style, the rest of Mesoamerica shows only rare Toltec influences. It appears that the local chieftains and kingdoms, like those of the Mixtec in western Oaxaca, actively retained their own style, though forced to give tribute to their Toltec overlords. There was, in fact, a strong return to local art styles during the "Dark Ages" after the fall of Teotihuacán and also during the Toltec period of expansion.

Following the destruction, by unknown invaders, of the Toltec capital in 1168, the city of Puebla—Cholula—became the mightiest commercial and artistic center of Mesoamerica. At this site the grandest pyramid in the world was created. Because the iconography and techniques of Cholula and the Mixtec region were very similar, their art style is usually known as Mixteca-Puebla; this style eventually became far more ubiquitous than the Toltec example, despite the fact that it was apparently spread by traders and cultural missionaries rather than by military force.

At the same time, however, we cannot deny the wide-ranging influences of Toltec culture. It is possible, for instance, to trace Toltec techniques and iconography as far north as the Hohokam pueblos of present-day Arizona.

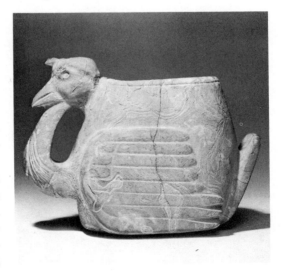

Mixtec stone bird vessel. Isla de Sacrificios, Mexico, Early Postclassic period, c. A.D. 950–1200. Photograph: Sotheby Parke-Bernet.

The Toltec image survived the longest among the Tarascan Indians in the state of Michoacán, in Mexico's Lake Patzouro region. "The militarism of the Tarascans," write Easby and Scott, "was no doubt their most lasting inheritance from the Toltecs, surviving until the [Spanish invasion], and permitting them to withstand the onslaughts of the [pre-Columbian] imperialist successors of the Toltecs in Central Mexico, the Aztecs. The Toltec tendency toward flat, hard forms was taken to its logical extreme in Tarascan images, quite the opposite of the rounded, plastic forms of the contemporary Aztec work."

The lavish abundance of sculpture produced during the relatively brief domination of Aztec culture can be explained by the imperial ambitions of the Aztecs and their Romanistic aim to overwhelm the beholder. From their legendary founding of the city of Tenochtitlán (the site of present-day Mexico City), the Aztec ascendancy from nomadic wanderers to rulers of a vast domain was truly meteoric—occurring in less than a century, between the reign of Lord Itzcoatl in 1427 to the arrival of Cortes in 1519.

It is often pointed out that the vigor of the Aztec ascendancy in the Valley of Mexico was greatly facilitated by the priests of Huitzilopochtli, the tribal deity of ferocious temperament who was apparently the only power figure in the complex Aztec pantheon who was not borrowed from other Mesoamerican tribes. Around the reputation of the austere Huitzilopochtli the priests devised the legend of the "chosen people of the Sun," whose central mission in life was to save humankind from cataclysm by nourishing the sun with human blood. That focus upon human sacrifice— which predated the Aztecs but was apparently never raised to such extravagant and lofty purposes—became the basis not only of the political and economic schemes of the warlords, but also of the grandeur and grotesqueness of Aztec sculptural art.

As already noted, the emphasis of Aztec carving was a vigorous and realistic sculpture in the round, worked in both wood and stone. The basis for this style

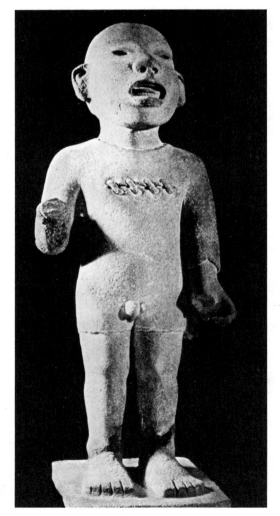

Aztec basalt figure of Xipe Totec, Our Lord, the Flayed One. Salomon Hale Collection, Mexico City.

was probably a strong tendency toward eclecticism; the style was a fusion of the angularity and flatness of Toltec forms and the styles of the many regions through which the Aztecs first wandered as homeless nomads and which they later seized as conquerors.

A minor Aztec sculptural art was the very difficult working of rock crystal, which was highly valued because it was extremely rare; it presented the artisan with endless problems due to its tendency to shatter when carved.

The Mixtec influence was clearly brought to bear on the legendary Toltec examples, which roused such enthusiasm among the Aztecs that they attributed to themselves the legacies of their grand predecessors, by adapting the tale of the "white, bearded god" Quetzalcoatl and believing in the eventual return to his lost domain in the year 1519, "One Reed" in the Aztec calendar. It is an unfathomable coincidence that the Spanish adventurer Cortes appeared on the coast of Mexico at the very location, Veracruz, and on the very date when the returning god was anticipated in ancient folk history and prophecy. Following that horrendous invasion, by 1521 the world of Mesoamerica had been broken and destroyed by the "gods" from Spain.

There has been a tendency to equate the Chavin style of the central Andes of South America (in present-day Peru) with the so-called Olmec mother culture of Mesoamerica. There is considerable reason to reject that supposition, in view of recent research by scholars such as Donald Lathrap. But for now, it will facilitate the depiction of the evolution of South American sculptural styles if we continue to employ the Chavin "hori-

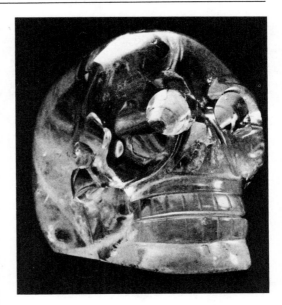

Aztec rock-crystal carved skull. Musée de l'Homme, Paris.

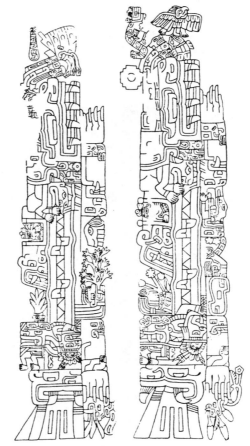

Diagrams of details from an obelisk. Chavin culture.

zon" as our point of departure. In any event, there is no doubt that Chavinoid styles had an early and wide-reaching impact on surrounding cultures.

The Chavin style, as already noted, is named after the famous site at Chavin de Huantar in Ancash, Peru. The term "Chavin" has been used in a variety of ways, but Kubler and others have suggested that it should be restricted to a stylistic definition and to an iconographic tradition related to a religious system of very early date in the central Andes. That religion centered upon the worship of feline icons and symbols of natural forces. "The style, the iconography, and the functional setting are roughly analogous to those of Olmec art in Mesoamerica" (Kubler). Presumably, Chavin art is a north Peruvian phenomenon that lasted for about thirteen centuries, from about 850 B.C. to A.D. 500.

The Chavin sculptural repertory is impressive, including in-the-round as well as relief carvings, most of them based upon ideographic ciphers drawn from feline, reptile, fish, bird, and human motifs. Often these figures are compounded into marvelous hybrids, such as birds with tiger's teeth at the base of each wing feather. A number of variations upon this style, some of which appear to predate Chavin culture (Kubler), are found at such sites as Cerro Sechin (where Kubler locates the "oldest known monumental sculpture in the central Andes"), as well as at the sites of Moxeque and Punkuri. Before 1965, nothing was known of art in the Andean highlands before the Chavin period, but now it appears that a scattering of distinctive non-Chavin styles evolved in this region. For instance, Kubler points out that "stylistic resemblances between the Sechin and Chavin styles are very faint. The Sechin sculptors show simpli-

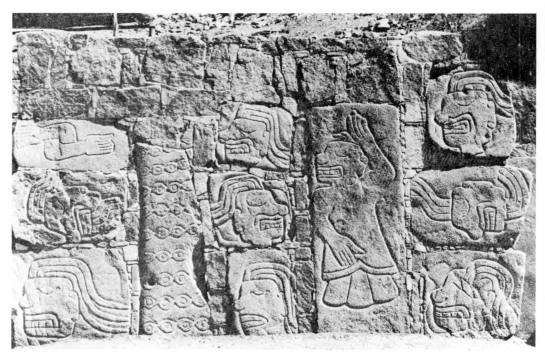

Sechin Wall of the Dead Warriors: exterior wall of the Temple Casma, Peru, tenth to eighth centuries B.C.

fied ideogrammic schemes close to visible reality. They report the facts of warfare and head-hunting directly, unlike the makers of the Chavin reliefs, whose monstrous combinations of various forms of life lead the mind into an associative labyrinth of ritual symbols, organized more like metaphorical allusions than direct expository statements." According to Kubler, the sculptural figures of the site called Moxeque (about two miles southeast of Sechin) resemble those of Cerro Sechin more closely than those of Chavin. At Punkuri (in the Pepena Valley) there are incised wall decorations in the Classic Chavin style, but there is also a typical Sechin painted jaguar, modeled in clay over a stone core. "Thus," Kubler points out, "Punkuri, alone among the coastal sites, contains both styles: the full-rounded and veristic Sechin manner as well as the schematic linear design of the Chavin wall decoration."

These insights are extremely valuable, but until far more excavation is undertaken and a more detailed chronology of the Andean highlands has been established, we must continue to emphasize that the Chavin culture constituted the most expansive (if not the earliest) of Andean art centers. Nonetheless, it is important to note that Kubler has attributed to the Sechin culture an emphatically individualistic, narrative, and naturalistic style (which Kubler always tends to favor), while attributing to the Chavin artists "a few highly stylized signs," which must serve to convey the entire content of Chavin art.

Linear designs of rarefied abstraction, compounded of body parts of different beings, are common to numerous Chavin sites. On the coast these motifs are carved in smoothed clay and pottery, while in the highland region they are incised on architectural slabs, cornices, and pottery. The origins of the Chavin culture have been variously placed in the highlands and on the coast, though recent research, as already indicated, shows the origins of Chavin culture to be in the tropical forest east of the Andes.

Most Chavin carving is executed in low relief, with details and forms shown on flat surfaces through engraving or a cutting away of the background (a type of *champlevé*). Though relief dominates the sculptural repertory, there was some carving in the round. General characteristics of the Chavin style are bilateral symmetry and motif repetition. There is also a tendency to reduce anatomical details to straight lines and curves, and fitting a figure into a grid pattern. The frequent zigzag bands appear to represent jaws with teeth. There is a profusion of fangs, carved into every imaginable form—for example, on bodies and wings. The Chavin sculptural manner tends toward a massive angularity and a monumental ritualistic cartography, as in the famous Raimondi stela now in Lima. This is a great rectangular slab over six feet high, with a standing figure with feline face and claws, holding staves in each hand; the figure is crowned with a complex "aura," which consists of a series of upward-gazing faces armed with fangs and surrounded by an aureole of snakes and scrolls.

After the Chavin culture, various cultures evolved in different regions of Peru. The major sites of this transitional period, with its emphasis upon diversification, are the north coast, the north highlands, the south coast, and the south highlands. Artistically, according to

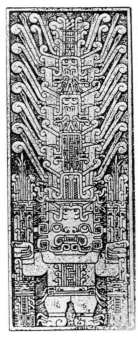

Raimondi Monolith: rubbing from the original. Chavin culture, c. 200 B.C. National Museum, Lima.

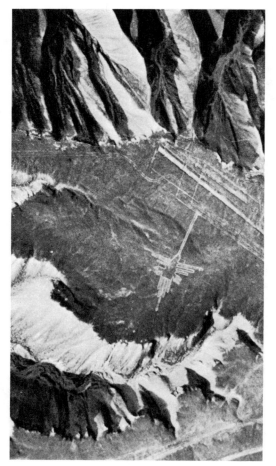

*Nazca Lines: diagram
and aerial view of
"Hummingbird."
Nazca Valley, Peru,
c. A.D. 800.*

The Paracas ceramics, developing from Chavinoid beginnings and culminating in proto-Nazca forms, were sculptural both in their decoration (deeply incised lines) and in their forms (clay mummy masks, figurative spouted bottles, and clay figurines).

The Recuay-Vicus peoples, probably a satellite of the Moche culture, typically produced large hollow vessels in a variety of figurative shapes. The Vicus culture (named after the archaeological site on a small savannah bordered on the north by the Piura River) produced a distinctive type of double vessel: the front chamber modeled in a figurative or geometric shape and bridged to a rear bottle-shaped chamber by a hollow tube and a flat strap handle. The naturalistic faces of the Moche style are replaced in Vicus figurative pottery by hawk-nosed faces with coffee-bean eyes. The same style is found in Recuay pottery. Some sculptural forms, however, are uniquely Vicus, such as the massive hollow figure with shoulders merging into an abstract torso, which includes arms and legs.

The Nazca culture, which was centered in the Peruvian Rio Grande valley, shared a ceramic orientation with its Paracas predecessors. Like the Paracas artisans, Nazca potters were more interested in ornamentating vessel surfaces with two-dimensional polychrome scenes than in the sculptural modeling preferred in northern Peru. In the late Nazca period (A.D. 300–600), however, there are rare examples of naturalistic, sculpted figures, almost exclusively in the form of human beings. All of these figures are relatively small (about five to fifteen inches in height) and are made of painted, solid ceramic.

Finally, the Chancay people produced

Bushnell, the central coast was unimportant, and the central highlands region is virtually unknown.

One of the major successors of the Chavin culture was a group of people called the Moche (Mochica). Their sculptural focus was the production of modeled pottery and small objects of bone and shell. We have already discussed in detail the ceramics of the Moche, but it is important in this survey of sculptural evolution in South America to recognize once again the immense importance of traditional, modeled pottery as it relates to the development of the plastic arts.

ceramic scenes typically consisting of village houses in which persons are represented in daily activities. They also made figurines, carved and painted wooden mummy masks, carved human figures of wood and draped them with textiles, carved mirror handles of wood, and elaborately carved and ornamented wooden structures such as litters.

A tangent of the Andean sculptural arts which needs at least brief mention is the creation on a vast scale of markings, or "Lines," on the desolate pampas surrounding the town of Nazca, located between the rivers Grande and Nazca, some 240 miles south of Lima. In this desert zone a large number of earthworks have been discovered: geometric designs as well as figurative patterns in the form of birds, spiders, and fish, formed by the removal of the dark brown pebbles which cover the yellow, sandy surface of the terrain. These huge earthworks are usually given a radiocarbon date of about A.D. 500, based upon a wooden post found with them. The purpose of the Nazca Lines is unknown, but they have been variously associated with astronomical observations and a wide range of ritual uses.

One of the most interesting aspects of the Lines is the concept of "invisible art," suggested some years ago by Hermann Kern. He pointed out that there is evidence in various parts of the world that primal peoples have long regarded invisibility as a common denominator of the sacred. This premise of "the invisible in art" has a wide-reaching potential for understanding the staggeringly difficult and complex array of massive earthworks created by various peoples throughout history. Their efforts make it possible for us to surmise their belief in the spiritual importance of their creation of vast patterns on flat land, though the makers themselves could never fully see—nor did they ever intend to be able to see—what they created. Sculptural activity of such magnitude must surely be classified as invisible art. The mystery of the Nazca Lines remains unexplained, but there are parallels found throughout the world which are worth mentioning. For example, in Blythe, California, there is an earthwork of a human figure which probably dates from pre-Columbian times; in the state of Ohio there is the Great Snake (Serpent Mound), which represents a serpent devouring an egg and dates from 1000 B.C.; in the south of England there is the White Horse of Uffington, dating probably from the early Iron Age; and in Japan there is the Tomb of Yamatotohi-

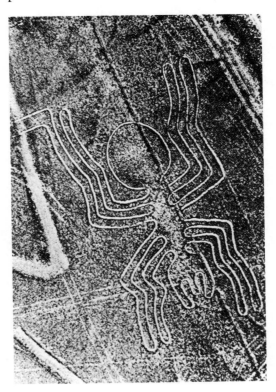

Nazca Lines: "Spider." Nazca Valley, Peru, c. A.D. 800.

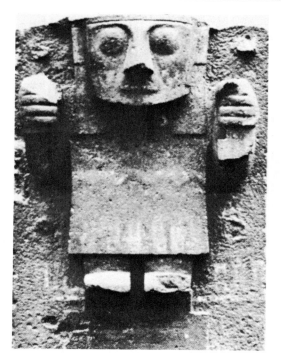

Stucco architectural decoration, Tiahuanaco, Bolivia. Museum für Völkerkunde, Berlin.

momosohime (A.D. 300–700). There is no connection between these massive earthworks except the nagging fact that they were produced by people who could never see the full result of their efforts

The major urban centers in the southern Andean highlands were strongly concerned with architecture and sculpture. The region surrounding Lake Titicaca on the boundary between Peru and Bolivia supported early cultures both at Pucará and Tiahuanaco, from about 500 B.C. until after A.D. 500. The terminal stage of pre-Columbian art history in the Andes was dominated in the fifteenth century by the territorial expansion of the Inca dynasty, from Cuzco through the central Andes and into Chile, northwestern Argentina, and Ecuador. The extent of the influence of the cultures of Tiahuanaco and Incaic Cuzco is, as Bushnell has pointed out, "one of the

most notable features of American archaeology."

Tiahuanaco is principally known for its masonry and its stone carvings. Perhaps the most impressive object of this site is the famous monolithic doorway, cut from a block of lava about twelve feet square, displaying a central figure carved in low relief and flanked by three rows of attendants, with a border at the bottom composed of complex frets ending in condor heads and enclosing heads like those of the central figure. This impressive figure stands in a frontal position, a staff in each hand. Each hand has only three fingers and the thumb. The trapezoidal head of the figure is surrounded by radiating motifs. The face has large, round, staring eyes, with descending bands of circles, which, Bushnell has observed, suggest tears.

This figure or deity has been described in considerable detail, since the weeping eyes, the standing figure itself, the condor, and the staffs recur again and again, wherever the influence of Tiahuanaco reached. Bushnell concludes, along with most scholars of the region, that this distinctive iconography (so different from the motifs of Chavin culture) "must lie at the heart of [Tiahuanaco] religion."

Besides the numerous architectural sculptures and reliefs, massive statues have been found at Tiahuanaco, some of them measuring twenty-four feet in height. These in-the-round pieces, however, are less like sculpture than pillars bearing relief designs. Bushnell feels that the extremely flat relief carving on statues and architectural surfaces may "reasonably be supposed to have been derived from textile patterns, and although no highland Tiahuanaco textiles have

been preserved, similar designs appear on coastal ones under Tiahuanaco influence."

There are also slabs with reliefs and tenoned heads. Some of these slabs (which were apparently architectural facings) and a few statues display carving in a distinctive style, heavily rounded rather than angular, which resembles the sculpture at Pucará—a site which predates the typical Tiahuanaco manner.

Pucará is located northwest of Lake Titicaca and dates about 250 B.C. to A.D. 100. The masonry of the major constructions (a horseshoe-shaped enclosure) is not as well fitted as that of Tiahuanaco, and it is surmised that the ragged chinks in the walls may once have been filled with adobe or small pieces of stone. The sculpture of Pucará consists of statues and flat, standing slabs. The most frequently encountered figure is a squat, stout male wearing a cap and a loincloth. Often these statues are carrying a trophy head.

The end of the Classic period (A.D. 950) was marked by wide-ranging unrest in the Andean region and by the spread of Tiahuanaco influences, which can be seen among the coastal cultures: the full face, the standing figure, the weeping eyes, and the attendant figures appear on coastal pottery as dominant motifs for the first time. The same iconography appears on coastal tapestries.

Wari (Huari), near Ayacucho, was a notable site in the Mantaro Valley, where the influence of Tiahuanaco culture was prominent. The Wari artistic achievement, however, was undistinguished. According to Kubler, "the architectural, sculptural, and ceramic remains at Wari all seem provincial in comparison with work from other Mantaro centers. . . . The standing statues, of squat proportions and heavy, inexpressive features, lack both the geometric clarity and the double viewing distance of Tiahuanaco sculpture."

Tiahuanaco influence on the art forms of the Peruvian south coast began to die out, and by about A.D. 1100 new cultural centers had been established on the coast, each with its own style. In the north, the Tiahuanaco example lasted somewhat longer, but even there the Tiahuanacoid presence began to fade. During that slow eclipse there developed the kingdom of Chimu (or Chimor), with its capital at Chan Chan near Trujillo.

Chan Chan originally contained ten vast compounds surrounded by walls up to fifty feet in height made of rectangular adobe bricks. The walls of the compounds were lavishly ornamented with reliefs. The motifs vary greatly, including bands of step-frets and scrolls, trel-

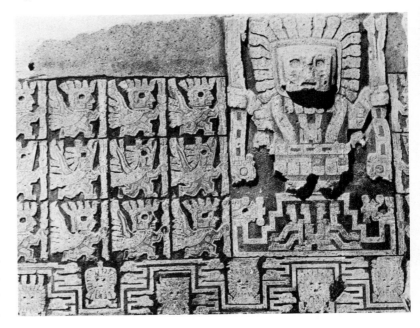

The monolithic Gateway of the Sun (detail): Tiahuanaco, Bolivia, c. A.D. 600.

lises, and realistic birds, fish, and other animals. The repetition of a few ornamental figures is a fundamental trait of Chimu sculptural art. At Chan Chan the relief composition is conceived in two planes sharply separated by vertical cuts. A few incised lines are the only modifications of the plane surface. As Kubler has pointed out, "when the artistic attainments of the late north coast peoples (i.e. Chan Chan) are placed in perspective against those of their contemporaries in the south, they appear less intense and less complex. On the other hand the political attainments of the Chimu dynasty, exemplified in the creation of enormous cities, far outstripped those of their predecessors and rivals."

The final stage of Andean sculpture was that produced by the Inca dynasty. The urban impulse to commemorate important experiences by monumental sculpture was satisfied in Inca society by intricate nonfigural carvings on the surfaces of caves and boulders. Such work was common throughout the southern highlands under the Inca regime. It consists mainly of terraced seats, stepped incisions, angular channels, and difficult modifications of the geological features of the landscape.

In this mode of sculpture there is a sense of the sacredness of place, which is a dominant concept among the Indians of the Americas. According to early chroniclers, some rocks and caves were regarded by inhabitants as *huacas*— sacred places—where powerful forces resided. Some geological forms were seen as the petrified remains of ancient races, while others were revered as the places where events of mythic history occurred. The rocky outcrops on the

heights above Cuzco were especially venerated.

The Inca regime also produced sculpture in the round, but most of the statues in the Inca style were destroyed by European missionaries. In 1930 a large stone head was excavated at a depth of twenty-five feet, below the pavement of the Jesuit church in Cuzco. This fragment is unique.

Miniature objects of stone, representing animals and human beings, are quite common; they are valued for their own aesthetic achievement, and also because they help to vivify the vanished monumental sculpture. Conspicuously absent from the iconography of the Inca works are the demons and composite beings of the other styles of Andean art. Incaic imagery is rather straightforward and realistic, or else entirely abstract and geometric. Detailed surfaces are sacrificed in favor of extreme clarity of design. Restraint and economy are the two abiding qualities of the sculptural achievements of the Inca. "The intrinsic meaning of Inca art reinforces the general impression of an oppressive state," according to Kubler. "It is as if, with the military expansion of the empire, all expressive faculties, both individual and collective, had been depressed by utilitarian aims to lower and lower levels of achievement."

In the discussion of the ceramic art of Colombia and Ecuador, considerable attention was given to the figurine tradition. Therefore, rather than repeat the survey of clay modeling in Colombia and Ecuador, we will concentrate here on the relatively few examples of stone sculpture in these regions.

Colombia has very little in the way of

architectural or stone sculpture. There is one prominent site at San Agustín, in the remote highland department of Huila, where small rectangular temples built of stone slabs and caryatid figures have attracted considerable interest, ever since their rediscovery by Fra Juan de Santa Gertruris in 1756 and their methodical exploration and excavation commencing in 1914. As a result of the work of archaeologists, subterranean galleries and tombs have been found and restored. The statues of San Agustín show various styles, which suggests that they evolved over a long period. All the figures are squat and only crudely curvilinear. Some figures are worked in the round; while most suggest the pillar-like relief forms of Tiahuanaco, though there is no evidence of influence. Most of the figures are human in shape, while showing certain animal features, such as prominent fangs protruding upward and downward from the slightly open mouths. Most of the figures have very wide nostrils. Some hold a child, a serpent, two staffs, or unidentifiable ceremonial objects. Dating of these objects is almost impossible at present, though one radiocarbon date of about 500 B.C. has been established. How this date relates to the entire site and its development is at present unclear. According to Bushnell, "there has been much speculation about relations between this and other cultures from Nicaragua to Peru."

In Ecuador the prominent center of stone sculpture is Manabi Province, where stone slabs carved in low relief depict monsters, women accompanied by monkeys, and men with birds. In the late period, the so-called Mantano Phase, occur U-shaped stone seats, carved in one piece, with a crouching man or jag-

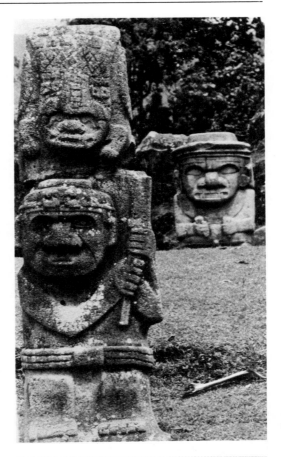

Idols in the sanctuary of San Agustín, Colombia.

Stone mortar of white stone in jaguar form. Manabí, Ecuador, A.D. 500–1500. Museum of the American Indian, Heye Foundation, New York City.

uar depicted on the base. Freestanding stone pieces belong to the same phase; they represent men wearing only a flat headdress and a loincloth or a narrow belt. These figures are highly generalized—some have very square shoulders

and short legs. According to Bushnell, these statues can be compared with those of San Agustín, "but they are very much more recent and the resemblances are too vague to inspire confidence." To the Mantano Phase also belong two carved wooden posts. One of these, now in Guayaquil, is composed of nine tiers of human figures—pairs of men and women with prominent genitals—and is crowned by the image of two alligators. The significance of these posts is unknown.

All of these pieces are characteristic of the Mantano culture of the late period (A.D. 500–1460) of Guayas and Manabi provinces, which dominated coastal Ecuador during this time.

The arts of Venezuela are largely confined to the west and central regions. The most typical sculptural products are

Polished stone figure with topknot, no sex indicated; the stone is grooved and cut. Venezuela.

lavishly modeled figurines, which, as already mentioned in the discussion of pottery, look staggeringly "modern." The most frequently encountered subject of the figurines is a female with highly exaggerated head, applied coffee-bean eyes, and bulbous thighs and buttocks. Male figures are also found, though their proportions are more naturalistic and they are usually depicted seated on stools. When these figures are slipped and painted, the effect is startling: there is a complex series of parallel lines, in black and sometimes in red on a white slip.

Venezuela also produced numerous stone figures, most of which have wide heads and ornamental top-knots, with facial features and limbs indicated in a marvelously abstract manner: by mere grooves and cuts. These figures are sexless and vary in height from one to six inches. Their bodies are smooth and convex, giving them a strong resemblance to the works of modern European sculptors (Brancusi, Moore, and others) of the 1920s and 1930s.

The area now called Venezuela developed no great cities or monuments. Excavation has revealed only simple dwellings and small villages, and no significant metalwork or textiles have been recovered in the region. Except in the Valencia Basin and certain Andean zones, even the tombs do not contain artifacts (Lapiner).

The most important art forms of Argentine antiquity evolved during the Aguada culture. The Aguada people apparently possessed a highly developed social and ritualistic structure, but few of their artifacts have been studied and still fewer have been made accessible

through publication. Stone sculpture is reported in the region, though little is known about it. Cylindrical drinking vessels, with feline and human figures carved in relief, are found in the Aguada culture (Bushnell). Information on the indigenous peoples of Argentina is as limited as it is in Chile, due, primarily, to the annihilation of the local Indian tribes and the relative lack of interest in the cultures which predated the Spanish invasion.

Wood carvings are best preserved in the arid coastal Atacameño region of Chile, adjoining the Peruvian frontier. According to Bushnell, the most impressive examples of such carving are miniature trays and tubes for taking snuff, which have handles formed by cats, birds, and human figures carved in the round.

Adena pipe. Ohio, c. 1000 B.C. Ohio Historical Society, Columbus.

The final region of South America to be briefly mentioned is pre-Columbian Brazil, of which very little is known. As we have already noted, Donald Lathrap has abandoned the notion that great cultures do not evolve in tropical zones. Because of Lathrap's research the origin of ceramics and figurines in the Amazon Basin has been pushed back from 500 B.C. to almost 2000 B.C. Excavation has only just begun in this environmentally difficult area, but the results even now suggest monumental architectural achievement, stone sculptural activity, and incredibly subtle and sophisticated ceramics at a very early date (Lathrap, 1970).

North of the Rio Grande River, in what is now Canada and the United States, sculptural activity was widespread and shows numerous regional distinctions, but the most important sculptural art was created by the Mound Builders, the tribes of the Pacific Northwest Coast and Alaska, and the people of the pueblos of the Southwest.

The oldest known stone sculpture from the Eastern United States is effigy pipes, made by the remarkable Adena culture, dating from about the last millennium B.C. The technically skilled and artistically adroit portrayals of standing male figures are unique to the Adena artists. Other iconography does, however, appear on the platform pipes of the Hopewell culture (100 B.C.–A.D. 700)—mainly in the form of animals, sculpted with the same high degree of realism found in the depiction of figures by Adena artisans. At a somewhat later period, during the so-called Mississippian culture, stylization—presumably borrowed from the Valley of Mexico—led

to partly abstract figurative representation. Many brilliant carved and sculpted objects have been discovered in the richly furnished burials of the large Hopewell mounds of Wisconsin, of Illinois, and, especially, of Ohio. These grave offerings include pottery and stone and mica artifacts. Sheets of mica were cut into silhouettes of bear or bird claws, hands, and headless human figures—for

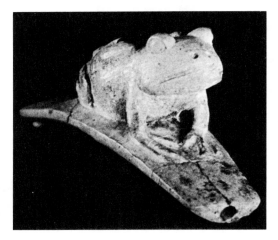

Hopewell culture effigy pipe. Ohio, c. 300 B.C. Ohio State Museum, Columbus.

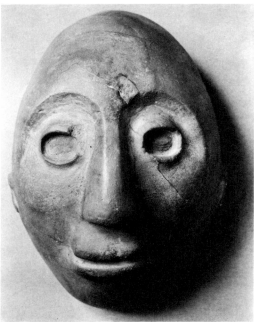

Yellow ferruginous sandstone mask. Ohio Mississippian period, c. A.D. 1200–1600. Ohio Historical Society, Cleveland.

unknown purposes. Delicately flaked obsidian knives and spear points, far too large and fragile for domestic use, were also deposited in graves (Bushnell).

The Mississippian culture of the Southeast also produced exquisitely detailed shell disks, bearing engraved designs such as faces with weeping eyes, crosses, and eagle warriors carrying trophy heads, which show strong Mexican influence. From the same period is a pair of painted marble figures (c. A.D. 1400–1500), excavated in 1962 by Lewis Larson at Etowah, Georgia, one of the most important Southeastern mound complexes. According to Ralph Coe, "unfortunately no information about the function of these impressive sculptures is contained in their method of burial. This pair represent a sculptural type which had a fairly wide distribution in the southeastern United States. About a dozen seated figures are known from later pre-Columbian times." *

The Mississippian culture also produced carved masks of ferruginous sandstone, stone ceremonial axes, and clay head pots, which have already been discussed in the chapter on pottery—figurative pots typical of the Southern Death Cult, with closed eyes and the mouth drawn open in death.

* A recent find (*Discovery Magazine*, February 1983, p. 7) in a remote Tennessee cavern has turned up the first known examples of North American Indian cave art: dozens of sketches of people, birds, turtles, and abstract figures scratched into the mud of the cave walls. The art is believed to date from the twelfth to the sixteenth centuries, and is drawn in a style unlike any seen before. The iconography, however, is familiar and clearly identifies the cave art as the product of the Mississippians, probably forebears of the Cherokee or Creek Indians of the region. Like much rock art and cave art in all parts of the world, many sketches were scratched on top of other sketches, indicating, according to archaeologists, that "the act of drawing was apparently more important than the art itself."

A limited number of wood carvings has survived from the pre-Columbian cultures of the American Southeast—namely, objects rediscovered in Key Marco, Florida (dating from about A.D. 500–1400). The earliest sculpture from this region is an eagle pole (A.D. 500–800) from the Hopewellian wood carvers, dredged in 1926 from Fish Eating Creek, west of Lake Okeechobee, Florida. The Key Marco finds include a deer mask, a wolf mask, and the head of a pelican—all carved from wood and painted. These important works, made before European contact, were found during Frank Hamilton Cushing's explorations of the Key Marco shell mounds in 1895. In Cushing's 1897 report in *Proceedings of the American Philosophical Society,* he stated, "We found two of the figureheads—those of the wolf and the deer—thus carefully wrapped in bark matting, but we could neither preserve this wrapping, nor the strips of palmetto leaves or flags that formed an inner swathing around them. . . . Near the northernmost shell beach . . . was found, carefully bundled up . . . the remarkable figurehead of a wolf with the jaws distended, separate ears, and conventional, flat, scroll-shaped shoulder or leg pieces, designed for attachment thereto with cordage. . . . In another portion of the court the rather diminutive but exquisitely carved head, breasts, and shoulders of a pelican were found, and in connection with this, a full-sized human mask of wood."

In the Southeast, the Mississippian effigy tradition was carried into historic times by the Cherokee Indians, who made stone pipes that often illustrated human sexual activities. This rather pro-

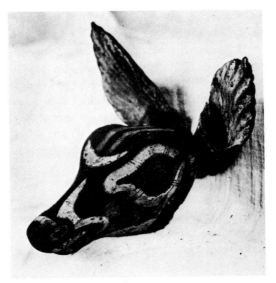

Deer mask of painted wood. Key Marco, Florida, A.D. 800–1400. University Museum, Philadelphia.

vincial pipe making among the Cherokee declined rapidly toward the end of the eighteenth century, though the technique was spreading westward and northward, and assumed a major importance among the tribes of the Northeast and the eastern Plains. Stones of various colors, particularly red catlinite, were carved by tribes from the Micmac in the Northeast and as far west as the Blackfeet in the Northwest. During the first half of the nineteenth century the finest pipes were produced in the western Great Lakes region and among the Eastern Dakota (Sioux).

In the Southwest of the United States stone sculpture was never an important activity. The Zuñi produced small ceremonial fetishes representing animals, but their carving was the most active sculptural effort of the region, with the exception of the much earlier stone figures made by the artisans of the Pueblo communities and their Anasazi precursors, and the animal effigy bowls carved from stone by the prehistoric Hohokam people. By and large, the Southwestern

tribes favored wood carving to stone sculpture.

In marked contrast to the rather unimpressive works in stone of the Southwest were the "elegantly carved soapstone (steatite) effigies of killer whales, seals, fish, and other animals, recovered from graves in the territory of the Chumash and their southern Californian neighbors. Entirely free from two-dimensional features even in their treatment of the surface, these little figurines are among the purest works of sculpture in western North America" (Feest).

Moving northward from California,

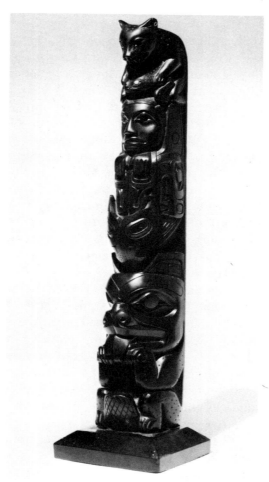

Haida argillite totem pole: a seated beaver surmounted by a vertical killer whale with tail flipped forward, a human face with incised wavy coiffure, the hands held to the front below the chin, and a bear perched at the top holding a frog to his abdomen. Height 18⅝ inches. Photograph: Sotheby Parke-Bernet.

we come to two major centers of prehistoric stone sculpture, in the valleys of the Columbia and Fraser rivers. The pieces from these areas are considerably more massive and simpler in design than the stonework from other areas of North America. The style is most frequently three-dimensional relief, although many boulders were carved in the round. The iconography is directly related to the local rock art, with patterns of circles and dots, parallel grooves, and chevrons. Along the Fraser River the sculpture is realistic and somewhat delicate in style. The most typical image is a seated human figure, holding a bowl. Dating these pieces has been difficult, but some of them were made at least 2,000 years ago. In the same general region, but slightly northward in British Columbia, a number of phallic hand hammers and pestles have been found. Carved from stone and dating about 1000–500 B.C., these objects are entirely alien to the present Salish residents, who can recall nothing of their origins or use. On the other hand, the effigy of a male holding a bowl was still used in historic times by the Salish tribes, in girls' puberty ceremonies (Feest).

The flourishing of wood carving during historic times greatly minimized the attention given stone sculpture on the Northwest Coast, but there has been at least one important exception: argillite stone carving. Argillite (or "laste," as it is usually called by the local artisans) is a black shale, quarried on the Queen Charlotte Islands, which is soft enough to be easily worked with wood-carving tools. Argillite carving has long been a virtual monopoly of the Haida tribe. The Haida carvers began producing their pieces about 1820 and continue to

supply an active tourist market with their decorative figures. Tribal prehistoric motifs have given way to subjects favored by Anglo visitors. A few major craftspeople emerged during the heyday of Haida argillite carvings (late nineteenth century): John Smith, Charles Edenshaw, George Gunya, and Isaac Chapman, who often signed their works and recognized themselves as professional artists.

In the land of the Innuit, stone carving was essentially utilitarian, involving the production of such objects as oil lamps. Then, during the late nineteenth century, when visitors became somewhat frequent in the far north, soapstone carvings of human and animal figures began to appear both in Alaska and Greenland. These tourist pieces had a certain charm and technical facility, but their production soon declined in Alaska—though it continued robustly in Greenland well into the twentieth century. The style of these pieces was only slightly related to the traditional ivory carving of the Innuit, and had a far greater debt to European realism. In the late 1940s, James Houston, the Anglo artist who later helped organize Innuit cooperatives for the production of prints, inspired the Hudson Bay Innuit to explore soapstone carving as a major tourist industry. The work that resulted from Houston's efforts was immensely successful at the marketplace. Later soapstone carving spread throughout Alaska, resulting in numerous regional motifs.

In North America wood carving is more prominent than stone sculpture. An extraordinary assortment of miniature and monumental wood pieces from the Northwest Coast is now found in major museums around the entire world, so impressive are the pieces created by carvers of this region during the golden age of their sculpture.

As Christian Feest has indicated, "much of the apparent unity of Northwest Coast art is due to the spread of a northern Northwest Coast style, which combined carving with the graphic principles of the northern Northwest Coast painting and engraving style. This process was still going on during historic times. In the nineteenth century, it strongly affected Kwakiutl and, to a lesser extent, Nootka carving. Underlying these late similarities are an older style, formerly widespread on the Coast, and distinctive local variations of sculptural expression. The older style is most obvious in prehistoric and early historic Nootka sculpture and emphasizes simple, clearly readable sculptural forms."

A major feature of Pacific Northwest Coastal sculpture is symmetry. Another common emphasis among the carvers is the treatment of planes. The complexity of sculptural form, for instance, is uniquely conceived by the Kwakiutl and Bella Coola tribespeople of the southern region of the Coast, who tend to define shapes with a great number of intersecting planes, which produce a strong angularity. The northern groups are more concerned with the classic two-dimensional style. The latter sculptural style is especially visible in realistic pieces, in which the various planes are gently rounded so that what results is an interplay between the bone structure and the flesh forms of faces and figures. This two-dimensional style is apparent in the painted designs on sculpture which tend to follow strongly outlined planes.

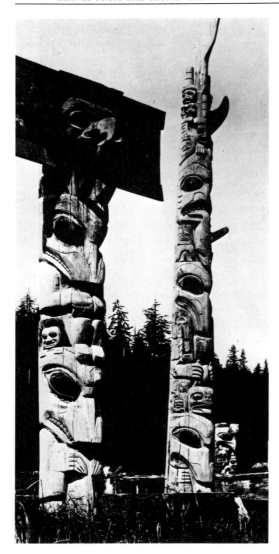

View of Skidegate Village. Haida settlement, Queen Charlotte Islands, British Columbia, Canada. Photograph: Museum of the American Indian, Heye Foundation, New York City.

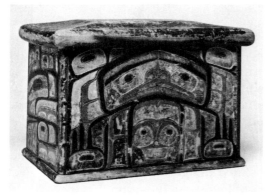

Northwest Coast lidded wood chest, probably by Bella Bella tribe. Carved in shallow relief, with bears and mosquitoes on the front and the back, and highly stylized birds' (?) profiles on the side panels. Photograph: Sotheby Parke-Bernet.

The two most prominent wood objects of the Pacific Northwest Coast are totem poles, which are the most widely known, and masks, which are very widespread in production and ceremonial use.

Ralph T. Coe has pointed out that "this art gains its ferocious mystic power—a power all the more magnificent for its sculptural restraint and superb good taste—by exploring the gap that exists between nature as we can see it and the mythological past as it can only be envisioned, and by conjuring up forces of nature that cannot be seen." This important observation helps us to understand not only the intent but also the creative mentality behind the production of totem poles and masks.

Totem poles are monumental wood carvings dedicated to the depiction of heraldic crests derived from mythic history and possessed (actually owned as material goods) by specific kinship groups. As the ethnologist and anthropologist Franz Boas realized as early as the 1890s, the peoples of the Northwest Coast are obsessed with symbolism and emblems of rank. Ralph Coe has observed that "although [Boas] classified the way each animal was represented, he did not link them with the carver's intuitive feeling for the organic ebb and flow of sculptured surfaces." A Northwest Coast mask or totem pole is an exuberant essay. Such unity of form and content has been beautifully expressed in a term formulated by a modern carver, Bill Holm. His term "formline" covers primary, secondary, and tertiary linear systems. By dwelling on what he calls the formline, the observer will be able to appreciate the unity of symbol and form, design and surface, which was such a special part of the sculptor's in-

tent—to the point where, at times, his work seems the product of some secret intervention, as if brought into being by the very forest demons it aims to represent. So important is cohesion in Northwest Coast work that the difficult question arises whether the designs or the feeling for sculpture came first.

With the introduction of metal carving tools by white traders in the nineteenth century, there was a marvelous flourishing of monumental pieces, such as poles, grave markers, and doorposts. These were erected to commemorate important tribal events, and served to identify the groups and to promote their prerogatives—thus they were not narrative but symbolic of rights validated by narratives.

Totem poles were carved from gigantic cedar trunks. The Northwest Coast obsession with fitting images to the surface to be covered determined that the poles featured one figure placed above another. Feest points out that "the vertical axis therefore tended to be divided into horizontal sections. A fairly general method of imparting a sense of monumentality, beyond the sheer size of the carving, was the alternation of figures represented in two different scales; this helped to lend rhythmic structure to the dominant vertical. The same end is attained by exaggerating the heads in an attempt to use the full width of the log."

After the first few decades of the twentieth century, the production of totem poles declined rapidly, and so neglected were whole "forests" of poles in impoverished Indian coastal villages that the poles rotted and collapsed. The art has been revived by young tribal artisans, but it has so far failed to be a true renaissance of the great works produced

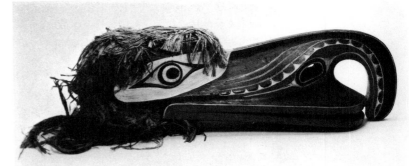

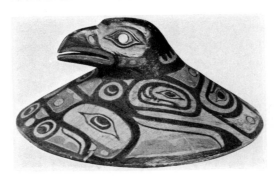

Kwakiutl wood and fiber bird mask. Photograph: Sotheby Parke-Bernet.

War helmet. Wood carving with raven on top. Tlingit tribe, Alaska, c. 1880. Museum of the American Indian, Heye Foundation, New York City.

during the golden age of the nineteenth century.

Both in pre-European times and also during the eighteenth and nineteenth centuries, wooden masks were used in curative ceremonies and in the mid-winter rites which dramatized Northwest Coast mythic history. Many distinctive masks were carved, showing a variety of humanoids, animal spirits, and identifiable portraits of persons. The styles of the masks ranged from highly realistic portraits to wildly fantastic images. To heighten theatrical impact, some masks were constructed with movable parts. The ceremonies of the Northwest Coast are emphatically flamboyant and every means was used to produce strong emotional effect. The most ingenious of the movable masks—the so-called transformational masks—were those (especially of the Kwakiutl) in which one face was

enclosed by another. By the manipulation of strings attached to the outer face, the parts flew open to reveal the inner face.

The development of Northwest Coast wood carving during the nineteenth century led to a golden era between about 1860 and 1890. The grandeur of the style has long died away, but the residue of that great age of carving is visible in the numerous examples of poles, masks, and such small works as helmets, bowls, and rattles which have survived under the protection of the world's great museums and as treasured heirlooms of Native families.

Innuit wood carving is found essentially in Greenland and on the shores of the Bering Sea, where sufficient driftwood is available to permit the use of wood, for the scarcity of timber in the region has prevented carving from becoming a major art medium. The utili-

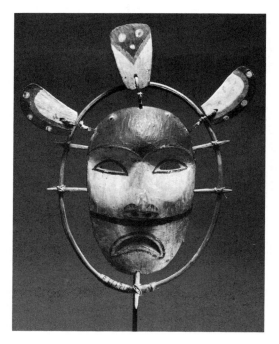

Innuit oval wood spirit mask. Goodnews Bay, Alaska. Photograph: Sotheby Parke-Bernet.

tarian products produced from wood, such as snow goggles, visors, and spear-throwers, are not particularly interesting from an aesthetic viewpoint, but some useful objects, like the marvelously carved boxes and bowls of the lower Kuskokwim and Yukon River regions, are exceptionally handsome and refined.

By far the most spectacular and abundant wood carvings, among the Innuit and Aleut peoples, are ceremonial masks. The fact that Innuits normally destroy their masks after use may explain why almost no masks have been recovered from prehistoric sites. Or, as Feest has suggested, "it may be that European contact was once more indirectly responsible for the development of a new native art form. Improved carving tools, and new forms of ceremonialism as a result of intensified contacts between villages due to improved means of transportation, have been identified as possible contributing factors in the rise of Eskimo mask making."

The most important center of Innuit mask making is also the area where the greatest variety of forms is found: the Bering Sea region. There we discover half-masks which depict only one side of the face, highly abstract masks which are only slightly recognizable as faces, transformational masks of a simpler construction than those of the Northwest Coast Kwakiutl, miniature finger masks used by women, and the most portrait-like and realistic of all Arctic masks. All of these examples are impressive, but the true hallmark of this region is the fully surrealistic masks, which employ wood, pigment, and asymmetry to produce truly exceptional effects. The use of "distortion," for a fantastic blend of effects, is amazing; these masks have

more than a casual resemblance to the most avant-garde of modern carvings.

Few examples of wood carving are found in the Eastern region of the United States and Canada. Wide-ranging assimilation and tribal relocation are doubtless part of the reason that very little carving was done in the timber-rich East since the seventeenth century. It is also possible that the climate of the area was inhospitable for the preservation of wood objects made in prehistory. Yet, early chroniclers have reported a good deal of impressive three-dimensional art in wood among the tribes of the East. Evidence of monumental carving is limited almost exclusively to literary records. Some interior house posts with humanoid faces, carved by the Delaware (Lenni Lenape) tribe in their Oklahoman exile, are some of the surviving traditional pieces of this kind.

Among the Algonquin tribes of the Great Lakes region, there is evidence of wooden figurines that were doubtlessly produced by ritual specialists to be used in magic; they show a limited number of standardized types. Some of the small wooden animal forms used by the Midewiwin are very handsome pieces, though they tend to be rather formal.

Unquestionably the major achievement in historic Eastern wood carving is that of the False Faces of the Iroquois, which were first described in 1687— though most extant examples date from the nineteenth and twentieth centuries. According to Feest, "these 'False Faces' were used in traditional Iroquois religion in curing ceremonies by members of a medical fraternity and portray first of all the Great Doctor, dwelling at the world's rim, whose broken nose and

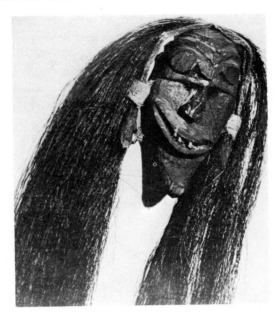

Iroquois False Face mask of carved basswood. Field Museum, Chicago.

twisted mouth derive from a mythical struggle with the Creator for control of the world; then there are the forest-dwelling 'Common-faces' seen in dreams; and finally a countless multitude of beggar masks which caricature neighbors and strangers alike. Characteristics of all these masks include distorted features, deep-set eyes with metal eye-plates, long hair made of horse tails, and generally red and/or black facial paint. Most are lifesize, but miniatures occur and are used as protective amulets." Unique to these masks is the fact that they must be carved from uncut, living trees.*

The Lenni Lenape (Delaware) tribe also produced ceremonial masks which date prior to the tribal removal from the states of Delaware and New Jersey to Indian Territory (Oklahoma). These masks

*The sculptural method involved in the creation of these masks required the carver to carve the face into the surface of a living, uncut tree, and then to cut out the carved surface and finish the working of the back.

share many stylistic traits with those of the Iroquois, but they tend to be rather simple in detail and less theatrical. In the Southeast the Cherokee also produced ceremonial masks of wood, called Booger masks, which are aimed at ridiculing strangers (Indian, white, or black) who do not behave appropriately. And finally, as we have already noted, mov-

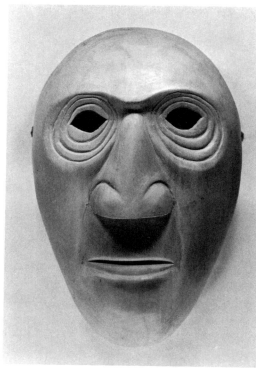

Booger mask of buckeye. Cherokee tribe, North Carolina, 1976. Collection of the author.

Dakota (Sioux) horse effigy, of painted wood, leather, and horsehair. Robinson Museum, Pierre, South Dakota.

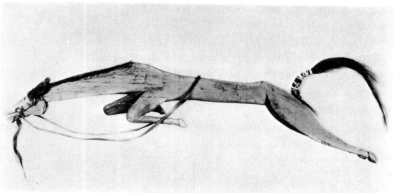

able masks for an unknown use were rediscovered buried in bundles in the Key Marco region of Florida.

There is no evidence of any three-dimensional wood carving in the Plains region, with the single and remarkable exception of a group of elegant horse effigy sticks, which range from realistic to highly abstract in their rendering of galloping horses. Made to honor courageous horses wounded in combat, this form of effigy was clearly a late and local development, though the carving style must reflect the Woodland heritage of most Plains tribes (Feest).

Wood carving is a minor art in the Southwest of the United States. It is virtually nonexistent in California and the Great Basin region. Among the Pueblo peoples, however, there has been a gradually accelerating production of unique wooden figures called kachina dolls.

The kachinas are power symbols which are impersonated, during the ceremonial year in the Pueblo villages, by carefully masked and ornamented dancers. The likenesses of these supernatural beings are carefully carved in cottonwood and pine by men, and distributed during rites to the women and children by the kachina impersonators—presumably to facilitate the identification and memorization of the attributes of a great hierarchy of power figures.

According to Feest and other scholars, the exact age of the kachina-doll tradition is not clear. None were collected before the 1850s and none are recognizably described in older Spanish reports. A single prehistoric figurine, found outside the historic Pueblo region and dating from the fourteenth century, resembles some of the simpler modern forms

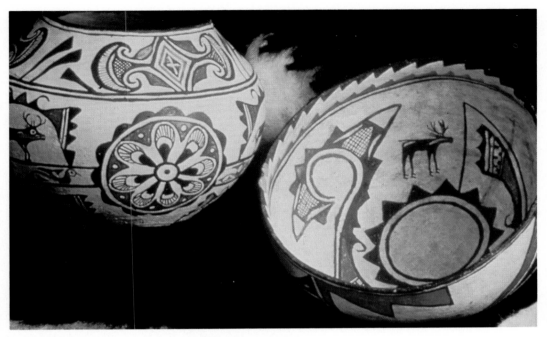

Zuñi pottery, New
Mexico, c. 1900.

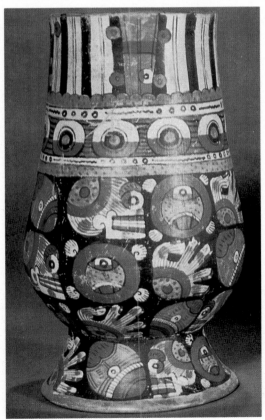

Polychrome vase,
Cholula, Puebla, Mexico,
c. 1350.

Painted male figure,
Ixtlán del Rio, Nayarit,
Mexico, c. A.D. 300.

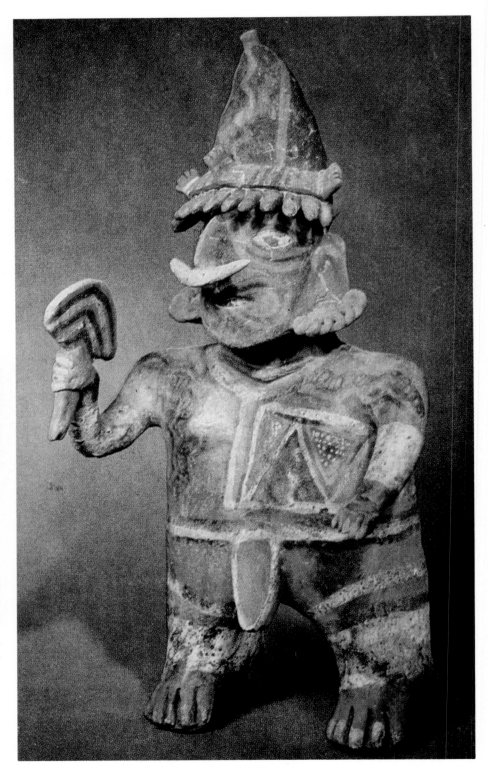

Maya vase, Guatemala,
c. A.D. 500.

Etowal figures, painted
marble, Mound Builders,
Georgia, c. 1450.

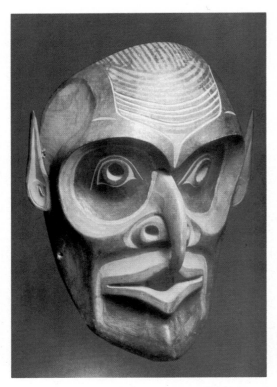

Kwakiutl mask, cedar
with paint, British
Columbia, late 19th
century.

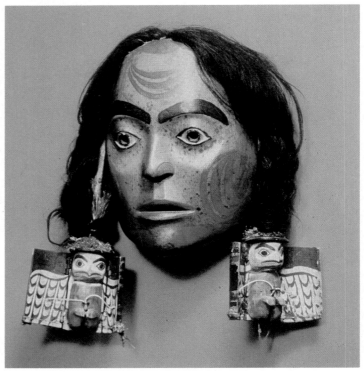

Tsimshian mask, wood
with paint, southeastern
Alaska, c. 1900.

but cannot be regarded as their precursor with certainty.

The tourist market has greatly stimulated the Hopi Indian production of brightly painted, large and small kachina dolls, outfitted with bits of fabric and feathers where such materials are appropriate to the ancient paraphernalia of particular kachinas. The Zuñi kachina dolls are less in demand commercially and therefore less common. Unlike the Hopi model, the Zuñi doll normally has movable arms and is far less elaborately painted and dressed. Despite the dissimilarity of Zuñi kachina dolls from those produced by the Hopi, there is a good deal of reason to assume that the doll tradition of the Zuñi was borrowed from the Hopi and other Puebloan groups. The carving style of the Zuñi kachina dolls has nothing in common with other traditional forms of Zuñi wooden sculpture, such as, for instance, the monumental figures of the so-called war gods.

In addition to the Zuñi kachina dolls and war gods and the Hopi kachina dolls, there are a few other Southwestern examples of wood carving: cut-out flat doll figures made to hang on cradles, dance plaques painted with kachinas and corn symbols, and "pahos," or prayer sticks, as well as the crowns, or *tablitas*, worn by Pueblo dancers and the complex carved wooden altars used in the kivas (underground ceremonial chambers).

In modern times there have been numerous craftspeople and artists who have continued and evolved the Indian traditions of stone and wood carving, but the most illustrious and the most intent upon the continuation of their heritage are to be found in North America,

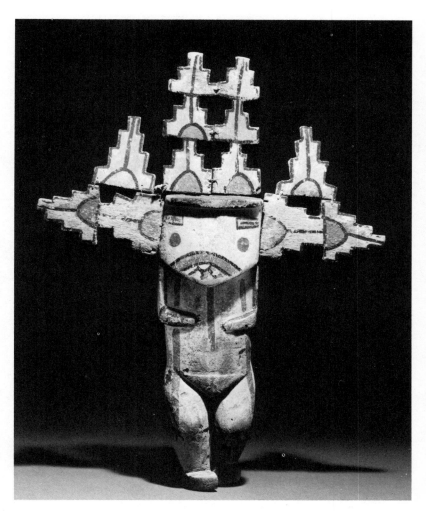

Hopi kachina doll: Shalako Mana. Photograph: Sotheby Parke-Bernet.

where European examples and influences have not been as thoroughly diverting or destructive to the Indian aesthetic legacy as in Hispanic America.

Native sculpture of the twentieth century did not gain serious consideration until very recently. It was the work of the Blackfeet artist Hart Merriam Schultz (1882–1970) that made the first widespread artistic impact in North America. Working under his Native name, Lone Wolf, he was one of the first modern Indian artists to produce sculpture. During the 1920s and 1930s he progressively turned his attention

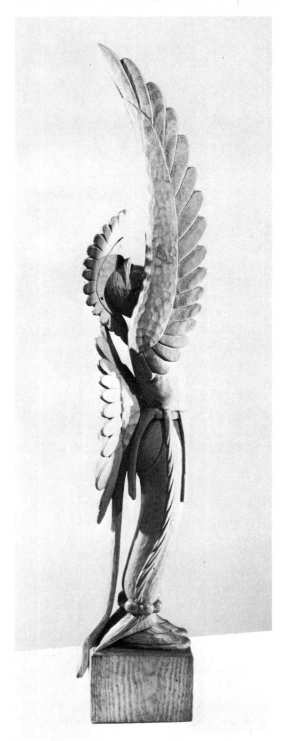

*Willard Stone, O,
Great Spirit, 1955.
Sassafras wood, height
36 inches.*

from painting to sculpting, and produced highly realistic works of intricate decorative detail and tumultuous action. His works, however, follow more the artistic traditions of white artists, such as Charles Russell, than the heritage of Indians.

Another early Indian sculptor was Roland N. Whitehorse, a Kiowa Indian born in Carnegie, Oklahoma, in 1920, who produced bronzes and stone sculptures that are closely related to the traditional style of the Kiowa painters of the 1920–1930 period. His works were regarded with respect, but it was not until the Cherokee (Oklahoma) wood carver Willard Stone began to produce his award-winning pieces in the late 1930s that Indian sculpture attracted substantial public attention. The impact of Stone's work on Oklahoma Indian artists has been considerable, but undoubtedly his most significant influence occurred many miles from Oklahoma, among the Eastern Cherokee artists of North Carolina (the original Cherokee homeland before the Removal of 1830). Amanda Crowe is the most renowned carver in the Willard Stone tradition, producing charming, naive, small-scale animal figures.

Two other important Eastern Cherokee sculptors are Going Back Chiltoskey, whose wood carvings are simple depictions of daily life among his people, and John J. Wilnoty (Wilnota), who has produced traditional carvings in wood and, more recently, a succession of startling and original stone works.

Of an entirely different artistic temperament is the Choctaw Indian sculptor Saint Clair Homer II (Homma), who was born and raised in Oklahoma, and produces some of the most lyrical and

theatrically powerful of Native American sculptures.

Of all these interesting and excellent sculptors, none has made the cumulative impact of Allan Houser (Haozous), a Chiricahua Apache from Oklahoma. Through a succession of marvelous innovative pieces that he produced in Santa Fe in the 1960s and 1970s, Houser has almost single-handedly inaugurated the modern style of Indian sculpture. He developed a spatial quality in his work which has had such a strong and pervasive impact on younger artists that it is safe to call Houser the precursor of American Indian sculpture of the twentieth century. His influence was much facilitated by the fact that for many years he was a member of the faculty of the prestigious Institute of American Indian Arts in Santa Fe, New Mexico.

Another seminal figure in modern Indian sculpture is the Tuscarora artist Duffy Wilson, who in 1969 introduced carvings in a material called steatite. Brown steatite is found in North Carolina, the region from which Wilson's tribe relocated itself in upper New York state at the beginning of the eighteenth century and where the Tuscarora people eventually became members of the Iroquois Federation. Originally a house painter, Wilson exhibited an unusual gift as a sculptor, and in 1973 he won the Heard Museum (Arizona) prize for Indian Art for his sculpture entitled *To-do-da-Ho*. This startling piece depicts a crouching, naked male with one of his legs raised and the other coiled under his body, his head wreathed with serpents. This and many of the other sculptures by Duffy Wilson have a curious and unexplainable visual relationship to the stone carvings of John J. Wilnoty of

North Carolina, and both these talented artists appear to have been motivated by an influence from the low-relief stuccos and sculptures of the Mesoamerican cultures. Considering the often-observed influences of ancient Mexican art on the effigies and mortuary sculpture of the Mound Builders of the North American Southeast, it is possible that in the works of these two Indian sculptors we see the

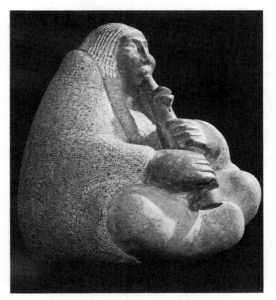

Allan Houser, The Flute Player, *1976. Pink marble, height 15 inches. The Gallery Wall, Phoenix. Photograph: Abrams Photo/Graphics, Phoenix.*

Duffy Wilson, To-Do-Da-Ho, *c. 1973. Carved steatite, height 14 inches. The Heard Museum, Phoenix. Photograph: Abrams Photo/Graphics, Phoenix.*

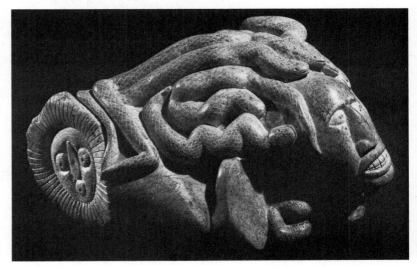

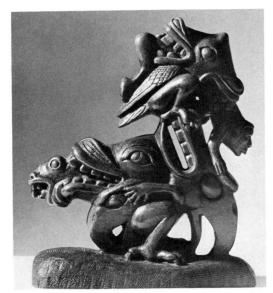

John Wilnoty, Dual-headed Totem, *1970. Red pipestone and dark stain, height 8 inches.* Courtesy of Medicine Man Crafts; Bigwitch community of the Qualla Indian Boundary; Cherokee, North Carolina.

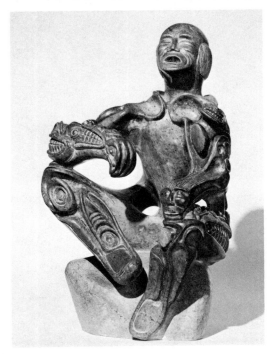

Abraham Anghik, Beckoning Spirits, *1980. Steatite, height 22 inches.* Courtesy of Bayard Gallery, New York City.

reemergence of a very ancient North Carolina style of stone carving.

A few young North American Indian sculptors deserve to be mentioned: Don Chunestudey (Cherokee); Bill Glass, Jr. (Cherokee), who works in modeled clay figures; John Hoover (Aleut), who is a fine wood carver; Doug Hyde (Nez Percé and Assiniboin), who is probably the most accomplished of the new breed of Indian sculptors; Harold Littlebird (Santo Domingo Pueblo), who has revived his people's ceramic tradition in new sculptural forms; George Morrison (Grand Portage Indian Reservation), who produces brilliant collages of wood; Lawrence J. Beck (Yupik Eskimo), who has created Innuit masks in dramatic new materials; George Longfish (Seneca/Tuscarora), the remarkable painter who has also produced an innovative series of mixed-media masks; Marvin Oliver (Quinault/Isleta Pueblo), who, among the young carvers of the Northwest Coast, has done the most to revitalize the tradition of wood carving of his people; and Abraham Anghik (an Innuit), who has transformed the diminutive carvings of his Innuit heritage into massive, monumental stone carvings of a shamanistic vision.

Thus the cycle is complete: new springs come out of old winters, and the innovative impulse of Native American art, like that of twentieth-century Anglo art, might be seen as a renewal of primal images in materials and with techniques unique to our own times.

9.
Metalwork

"Cortes and some of his captains went in first into the treasury and they saw such a number of jewels and slabs and plates of gold and chalchihuites (jade) and other riches that they were quite carried away!" Thus Bernal Díaz recalled his impressions of the Spanish invasion of ancient Tenochtitlán (Mexico City) in 1520. It took the Aztec goldsmiths, under stern command from Cortes, three days to melt down into bars this marvelous treasure of objects. Only thirteen years later, Pizarro, in looting Peru, demanded the payment of a ransom for the Inca ruler so large that it took a full month for the silversmiths and goldsmiths, working day and night, to melt down their elegant objects of art in order to save the life of their leader, who was, nonetheless, murdered by the Spaniards.

The loss of life during the invasion of the Americas was horrifying. On a different level, the wholesale destruction of priceless works of art was appalling. Moreover, the Spaniards did not grasp the value of Indian artistry. "Nothing shows Cortes' inner attitude," Laurette Sejourne has written in her study of the Aztec world, "better than his gift of glass beads to the Aztec leaders: in spite of his surprise at finding signs of great cultural refinement, he never for a mo-

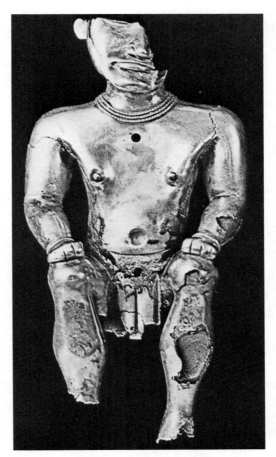

Anthropomorphic poporo of gold. Quimbaya culture, Samarraya, Colombia. Gold Museum, Bogotá.

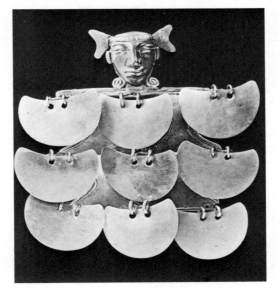

Pectoral with human head and jangles. Quimbaya culture, Valle del Cauca, Colombia. Gold Musem, Bogotá.

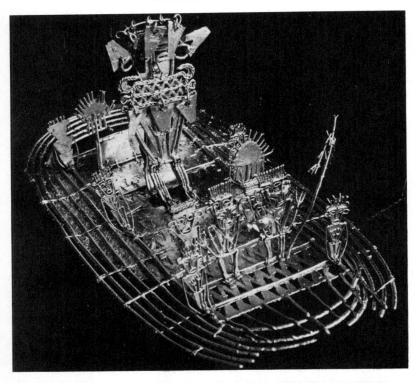

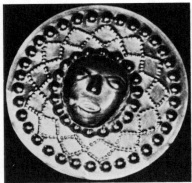

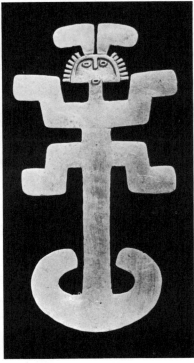

Top: Raft depicting a chief surrounded by priests and slaves en route to a ritual bath. Gold Museum, Bogotá.

Above: Ear pendant, showing head with coca in cheek. Nariño culture, town of Guachucal, Nariño, Colombia. Gold Museum, Bogotá.

Right: Stylized anthropomorphic figure of gold. Tolima culture, town of Ataco, Tolima, Colombia. Gold Museum, Bogotá.

ment doubted that he was in the presence of a barbarous people interesting only because they were fabulously wealthy."

Thus, only a pathetically small amount of the eloquent objects of precious metal arrived intact in Spain. These few pieces from Mexico won the unlimited admiration of some Europeans—for example, Albrecht Dürer, who wrote: ". . . I never have seen in all my days what so rejoiced my heart, as these things." But the vast majority of a whole people's artistic efforts was lost forever.

Metalwork in the Americas did not begin in Mexico or Peru. The earliest known metal artifacts are those of the Old Copper culture of the upper Great Lakes region of North America, beginning about 4000 B.C. Smelting did not play a part in this first American metalwork. The raw material was "native" copper—that is, copper occurring in nature as a relatively pure metal rather than copper that must be extracted from ore by smelting. Tools and weapons pounded from native copper have been found in northern Michigan, Wisconsin, and in southern Ontario and Manitoba.

Native copper, according to Dudley T. Easby, Jr. (*Scientific American*, April 1966), is sufficiently soft and malleable to be shaped by hammering, and it becomes increasingly hard the more it is hammered, until finally it is too hard to be worked further. The copper implements made by the Old Copper culture were utilitarian.

It was not until long after the Old Copper culture had vanished that the apogee of fine copperwork north of Mexico was reached, by the artisans of the Hopewell culture. About A.D. 200, in Ohio, the Hopewell copperworkers

turned a utilitarian process into an art form. They did not know how to cast or solder, "but they showed remarkable skill in hammering, in *repoussé* decoration, in cutting intricate designs out of sheet metal, in crimping, in riveting, and in hammer-welding copper and silver or copper and meteoric iron to produce bimetallic (composed of two different metals) objects" (Easby, Jr.). (In hammer-welding, two pieces of metal are placed together and joined simply by repeated blows.)

Gold, the most precious metal of Europe and the "sweat of the gods" of Mesoamerica and Peru, was apparently unused north of Mexico, except in Florida, where a few objects fashioned from sheet gold have been found.

The only other known metalwork in North America was done by the Innuit people of the Dorset and Thule cultures in the Eastern Arctic region, where they hammered and ground meteoric iron to make knives.

In South America the oldest metal finds, dating back to about 2,000 years before the Spanish invasion, were discovered in northern Peru and southern Ecuador. The oldest surviving objects of this region are ornaments cut out of sheet gold and given repoussé decoration in the Chavin style. The gold of pre-Columbian America was essentially alluvial—obtained, that is, by panning riverbeds. Silver was extracted from surface mines. The earliest methods of working the metals were without heat: hammering, repoussé, incising, and so on. Later metalworkers, in the Andes, invented the very inefficient *huairas*—cylindrical furnaces of terra-cotta that could smelt many different ores.

Smelting, however, did not replace

Embossed face in copper, with facial markings typical of Southern Cult of Mound Builders. Mississippian culture, A.D. 1000. Museum of the American Indian, Heye Foundation, New York City.

Goblet of raised sheet gold with red cinnabar. Chimu culture, Peru, A.D. 1000–1400. St. Louis Art Museum.

Above: Silver-plated beaker of raised copper sheet decorated with a repoussé motif of a human head, and then silverplated. Chimu culture, Peru, A.D. 1300–1476.

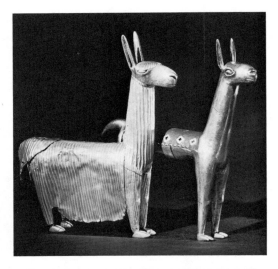

Above right: Gold figurines of an alpaca and a llama, made by the lost-wax process. Ica culture. Courtesy of the American Museum of Natural History, New York City.

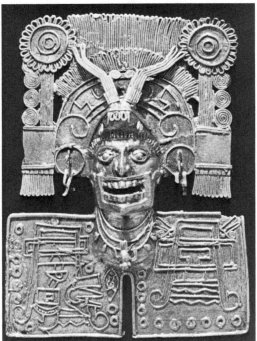

Right: Gold pectoral representing the god of death, Mictlantecuhtli. Mixtec-Puebla culture. Regional Gold Museum, Oaxaca.

prior metal techniques, but only augmented them. In Peru, for instance, the tradition of making ornaments from sheet gold persisted until the period of the Incas. "Raising" was derived from sheet goldwork: through the complex use of a series of anvils, beakers, cups, and other vessels were "raised" from flat disks of sheet metal by hammering and annealing them when necessary. Metal "molds" were also commonly used: numerous, identical beads were produced by pressing thin sheets of gold or silver over carved replicas or into carved matrices of wood or stone.

Another major advance in metal technology—casting—probably first occurred in Colombia, shortly before the beginning of the Christian Era (D. T. Easby, Jr.). This technique reached its greatest South American flowering in Peru between about A.D. 1200 and the date of the arrival of the Spaniards in the sixteenth century. The lost-wax technique—*cire perdue*—was expertly employed in this region, and eventually spread to Mesoamerica. By this method, an object is first modeled in wax (sometimes over a core of clay) and then enveloped in a clay shell, which is fired. During the firing the melting wax runs out through vents in the clay shell, leaving a negative impression (cavity) within the mold which corresponds exactly to the shape of the wax original. Then molten metal is poured into the mold. When the metal has cooled, the mold is broken and the metal piece is finished by hand.

Surely the most startlingly beautiful objects of South American metalworkers are made of gold, but it is important to note that other metals were also used. Bronze objects, for instance, have been discovered in Bolivia, Chile, and Argentina. "Indeed, the first bronze in the [Americas] was probably made about A.D. 700 in Bolivia, an area still famous for its tin deposits" (D. T. Easby, Jr.). The pre-Columbian metalworkers of Ecuador have won unlimited admiration

from modern metallurgists, for they apparently produced beads of an alloy of gold and platinum. Platinum, as we have already noted in the introduction, has a very high melting point—more than 3,000 degrees Fahrenheit—but the Ecuadorians, without ever actually melting the platinum, repeatedly heated grains of platinum and gold dust until the combination of temperature and pressure blended the two metals into a homogeneous mass.

In Colombia, Panama, and Costa Rica gold as well as a gold-copper alloy known as *tumbaga* were the principal metals. Here South American decorative use of metal probably reached its most spectacular achievement, largely due to the perfection of the lost-wax method. In these regions both solid and hollow pieces were cast. Soldering, fairly common both in Peru and in Colombia, was a method by which jingles and wire of gold could be added to the magnificent lost-wax castings, producing objects of inordinately delicate composition and beauty. It was, however, not in the Andes but in the Oaxaca region of Mexico that the highest development of the lost-wax technique was reached. During the fifteenth and sixteenth centuries, Mixtec craftspeople created objects of immense precision and delicacy. A favored Mixtec ornamental technique was the production of a fine wire filigree, resulting in a form of decorative metalwork unparalleled in the Americas.

According to D. T. Easby, Jr., "for a time it was believed that casting metal in molds might have been mastered by the Hohokam culture of Arizona in the period between A.D. 900 and 1000. This belief was based on a find of twenty-eight cast copper bells at the Snaketown

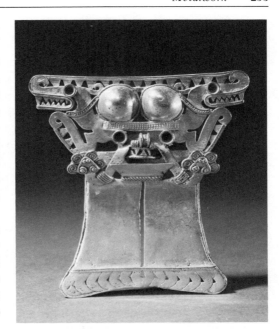

Gold alligator deity pendant. Coclé culture, Panama, c. A.D. 800–1500. Photograph: Sotheby Parke-Bernet.

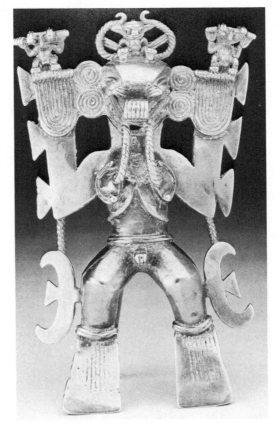

Gold alligator-man pendant. Diquís, Costa Rica, c. A.D. 900. Banco Central de Costa Rica Museum, San José.

site. Large numbers of similar bells, however, have since been found in the states of Nayarit and Michoacán in western Mexico . . . and it is now generally accepted that the Hohokam bells were imported from this area of Mexico."

There is at least one example of metalwork among North American Indian tribes which was probably pre-Columbian, besides the work of the Old Copper culture already mentioned. Northwest Coast copperwork may date back to an early period, when it was traded from the Copper River region of Alaska. Copper was known to be hammered into sheets for the construction of masks and for the embellishment of wood carvings. Unique plaques, called "coppers," were made of heavy sheets and were greatly valued in the potlatch ceremonies of the region. Each copper was given a name, and its history and value became known throughout the population of the Northwest Coast. Crest designs were engraved or painted with black lead on the coppers. With the exception of some pre-Columbian traditions of copperwork, made from native copper from Alaska, it is likely that all existing coppers of the Northwest tribes were constructed from rolled sheet copper that was brought in by Europeans.

Most metalwork in North America originated in post-Columbian times. The introduction of silver probably came to the Iroquois in the Northeast of the United States and Southeast of Canada before 1800. The technology of metalwork spread rapidly to the Great Lakes region, and then westward into the Plains and the prairie region, finally influencing the development of silverwork among the Navahos in Arizona. The ex-

ample of the Spaniards' metalwork seems to have provided designs and forms, but not the concept or the techniques of metallurgy itself.*

Working silver is uncomplicated: silver softens quite easily and can be beaten into sheets and shapes. It can also be cut without great heat and without sophisticated tools. One important technique is hammering sheet silver into an iron or wooden mold, upon which the desired design has been forged or carved in deep relief. This technique has already been described in relation to pre-Columbian metalwork in South America, but in North America this method was apparently learned from Europeans and was not a legacy from earlier Indian cultures. Stamping is another popular technique among today's Southwest silversmiths, in which a relief pattern is pressed against a softened surface. There are bracelets and rings stamped repeatedly with a single design, which is often chemically darkened in contrast to the surrounding metal. Casting silver is also a technique borrowed from the Europeans. A negative design is carved in fine-grained stone, such as pumice or sandstone, which is soft enough to be worked easily. A capstone is used to close the mold and then molten silver is poured into the orifice. When the metal has cooled the reusable mold is opened and the form is removed. With a bit of filing and polishing and, finally, bending the object into the desired shape, the cast form becomes a piece of jewelry.

The silverwork of the Navahos is the most renowned. The Navaho production of silver jewelry did not begin, however,

* It is, however, probable that the Spaniards taught the Indians the technique of casting.

until nearly 1870, which makes it a rather recent cultural adaptation of a non-Indian medium. The first known pieces were simply hammered out of American silver dollars and Mexican pesos. Casting began to be done about 1875. The early jewelry was quite simple and did not often contain turquoise and other semiprecious stones, as it does today. The "squash-blossom" necklace (which is in great danger of becoming a stereotype) is made of hollow beads and decorations largely duplicated from Mexican pomegranate iconography. The *najahe* (the crescent pendant of the squash-blossom necklace) is of Spanish-Moorish origin. Among the many objects of silver made by the Navahos, the most popular are bracelets, buckles, and *concha* (meaning "shell" in Spanish) belts—made up of stamped and hammered silver shell-like disks that are attached to a belt. These *concha* disks were probably copied from the silver hair-plates of the Plains tribes.

Zuñi jewelry is exceptionally delicate. It was a decorative art form which appears to have been learned from the Navahos about 1872. Eventually the silver base of Navaho jewelry became merely the setting for the Zuñis' complex conception of decoration—a lavish mosaic art made from the settings of various cut stones of many colors. This style of Zuñi lapidary art is so closely connected with decorative metalwork that it will be considered here rather than in the brief chapter on pre-Columbian mosaics and shellwork. There are unquestionable pre-Columbian influences in the Zuñi techniques and designs, which use a great number of small stones set in forms that depict kachinas and other emblems. The Zuñi mosaic style eventually led to the technique which is called

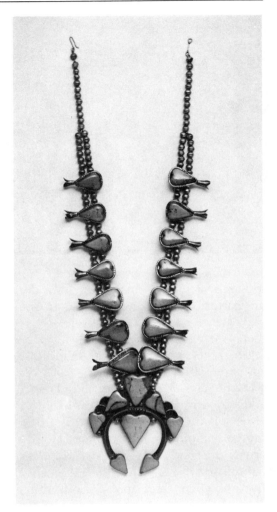

Navaho silver and turquoise necklace. Photograph: Sotheby Parke-Bernet.

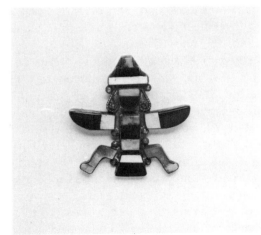

Zuñi silver pin, in the form of the Knife Wing deity; inlaid in mosaic technique. Photograph: Sotheby Parke-Bernet.

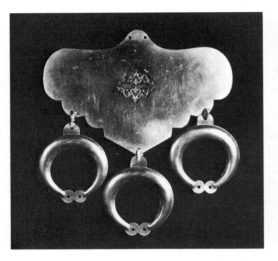

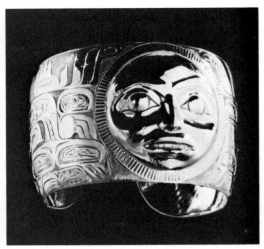

Left: Kiowa (Oklahoma) breast ornament of German silver with three circular pendants. Photograph Courtesy of the Museum of the American Indian, Heye Foundation, New York City.

Right: Haida (Northwest Coast) gold bracelet, 1971.

channel work, in which a raised silver grid separates individual stones in a mosaic pattern with an overall smooth surface. Recently the Zuñi jewelers have been setting single nuggets—a single polished stone in its natural shape in a contoured silver base.

In the last decade there has been a tendency for the various Southwestern tribes of the United States to interchange techniques, but the most characteristic method in Hopi silverwork is that of overlay—a design is cut in a sheet of silver and laid over another piece of silver of the same size. The undersheet is darkened, and perforations in the oversheet are "filled" by the dark hue of the undersheet.

German silver, a hard alloy of copper, zinc, and nickel, was introduced to the United States and Canada about 1800 and became a prominent medium of the metalwork of the Iroquois, Midwestern, and Plains tribes. Earrings made of this light sheet metal were worn by both men and women in the Plains. Brooches, copied from European examples, were popular among Iroquois women, while in Oklahoma emblems connected with

the peyote religion (the Native American Church) were used as the designs for various silver ornaments. The most familiar icon of this religious group is the scissor-tailed flycatcher, a bird closely connected to the rituals of the peyote cult.

Among Plains women "trailers" were considered possessions of great prestige and beauty. The trailer hangs off the belt on the right side and is made of a series of German-silver disks attached to a band of leather or otherwise linked together. This trailer (a hanging "sash" of metal) is worn over ceremonial buckskin dresses and is typical of today's traditional Apache and Southern Plains women's ornamentation.

Southwestern Indian jewelry has had several periods of great public interest since 1900. The German silver of the Plains, on the other hand, has had a far narrower market. The commercial enthusiasm for Southwestern silverwork has caused the prices to rise astronomically, has ushered in a great number of clever fakes, and has, finally, had a very negative impact on the quality of the jewelry being produced. However, there

are exceptional jewelers still at work; the most noted and distinguished of them is no doubt the Hopi artisan Charles Loloma, whose studio is located on Second Mesa in Arizona's Hopiland.

Northwest Coast silverwork did not begin until about 1865. It did not achieve the excellence of Southwestern work, but it did include some very elegant pieces: broad, thin bracelets with conventionalized animal designs engraved with exquisite skill. Rings and elaborate hair ornaments were also produced in small quantities.

Lead and pewter were worked in a variety of ways. For instance, in the Plains and Great Lakes regions carved stone pipes were inlaid with lead and pewter, producing a brilliant effect.

With the exception of the earliest work in native copper, the metalwork of North America is a resourceful assimilation by Indians of non-Indian media. In its total Indianization of European materials, Indian metalwork is similar to the earlier adaptations of glass beads by weavers and of metal tools by wood carvers.

10.
Architecture

In a discussion of Native American architecture, we need to consider the concepts of both architectonics and shelter, which have connotations in the Indian worldview that are different from those of the dominant cultures of the West. As George Kubler has so perceptively said,

> Our conception of architecture has been dominated for so long by the need for shelter, that we lack the sense of building as monumental form apart from shelter As monumental form, architecture commemorates a valuable experience, distinguishing one space from others in an ample and durable edifice. It is not necessary to enclose rooms: it suffices, as in ancient America, to mark out a space by solid masses, or to inscribe the space with a system of lines and shapes. The fundamental modes of monumental architecture are therefore the precinct, the cairn, the path, and the hut. The precinct marks a memorable area; the cairn makes it visible from afar to many; the path signals a direction; and the hut shelters a sacred portion. From precinct to stadium is one typological series; from hut to cathedral, path to arcaded boulevard, and cairn to pyramid are others. The combinations of cairn, precinct, path, and hut yield all the possibilities of monumental form, not in terms of the solids alone, but also in terms of the space bathing the solids. The architects of ancient America were far more attentive to the spaces engendered among the elements than their European contemporaries, and they excelled all peoples in the composition of large and rhythmically ordered open volumes.

Kubler additionally notes that at Teotihuacán (as in most of the ancient American centers) architectural planning was focused on *geomantic* position—to observe the relation of the earth to the sun, by the annual zenith setting (June 21) on axis with the largest pyramid. The distribution of hundreds of small structures was determined, therefore, by a cosmic order, and "the spatial arrangement reflects the rhythm of the universe."

The Indians' unique conception of shelter has also been described by Peter Nabokov ("Native American Architecture," *Four Winds*, Winter/Spring, 1981): "Indians *used* their homes differently. Often they employed an inventory of house types, shifting from one to another as seasonal moves, available materials, or climate dictated. Some Great Lakes groups had as many as eight different types of shelter with the use of each based on a mixture of common sense and tradition."

Nabokov goes on to state that non-Indians have found it difficult to grasp the way in which Indian homes function. "Their concepts about the deeper purpose of the houses were different. A garrison mentality pervades the white American notion of a house and the traditional thoughts of 'home.' . . . Indian housing traditions were usually the woman's right and pride since she superintended and 'owned' both house and the ceremonies associated with constructing and consecrating it. Also, Indian dwellings offered a variety of inter-

actions with the outdoors—the open air ... the people moved from bare earth through a sequence of such built environments, making themselves 'at home' in each of them."*

Though the thrust of this book is not conceptual, it is nonetheless essential in the discussion of Native American architecture to have some grounding in the fundamental differences which exist between the Indian and non-Indian idea of using space and providing shelter. Therefore Kubler's and Nabokov's observations serve as an important introduction. But before we examine specific

examples of structures, an overview of American architecture will be useful.

The only Native American structures in the United States which might be given the status of architecture are the multiple dwellings created by the Pueblo Indians and Cliff Dwellers, as well as the earthworks produced by the Ohio and Mississippi Mound Builders. In all other parts of North America (and even in Mexico and Central and South America) the common dwellings were huts of stone, wood, skin, bark, grass, earth, and snow.

Although we can dignify the building of the Pueblo Indians and Mound Builders with a term such as "architecture," it is a word more properly reserved for the spectacular achievements of the peoples of Mesoamerica and the Andean region. In Mexico alone, from Nayarit to the

* An elaboration of the concept of environment in North American Indian dwellings may be found in *Pueblo: Mountain, Village, Dance* by Vincent Scully (New York: Viking Press), 1972, and *The Primal Mind* by Jamake Highwater (New York: Harper and Row), 1981.

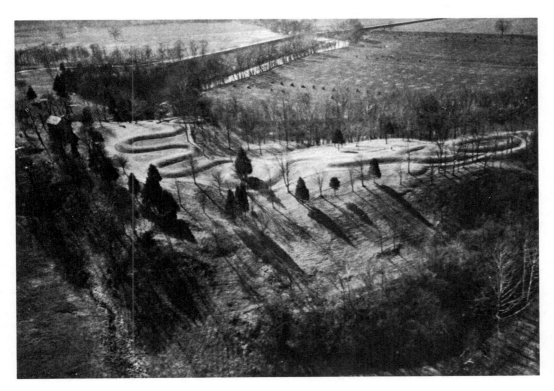

Serpent Mound, Ohio: the earthwork effigy of a snake with an egg in its mouth.

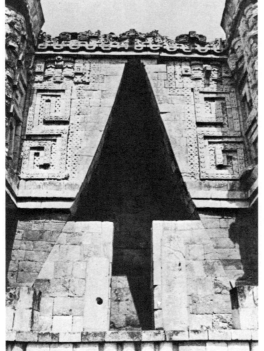

Classic Maya corbeled arch with key-pattern decoration. Palace of the Governors, Uxmal, Yucatán.

Cross sections of Maya corbeled arches: (a) the Nunnery Annex, Chichén Itzá; (b) section of ordinary arch with flat capstones and undressed sides, characteristic of the Classic period; (c) viaduct, Palenque; (d) Temple E-X, Uaxactún; (e) section of ordinary arch with flat capstones and dressed sides, characteristic of the Postclassic period; (f) section of ordinary arch with flat capstones, dressed sides, and curved soffit slopes; (g) the Palace (Structure A-V), Uaxactún; (h) arcade through the Palace of the Governors, Uxmal; (i) trefoil arch, the Palace, Palenque; (j) second story, the Nunnery, Chichén Itzá. From S. G. Morley, The Ancient Maya, p. 317.

Isthmus of Tehuantepec, the Spaniards recorded the names of some 1,600 communities. From the Isthmus of Tehuantepec to the Bay of Honduras, a region including the Maya centers, there must have been nearly as many settlements and ceremonial centers (Driver). The total might have exceeded 3,000 communities. At least one hundred of these centers of population were large enough to be called cities. "They differed from our modern cities in being less compact and congested. They were scattered over a wider area, which was more suburban than urban with its garden plots intermingled with dwellings. In the centers of these cities were courts and plazas around which public buildings such as temples, sanctuaries, palaces, pyramids, monasteries, ball courts, dance platforms, and astronomical observatories were assembled. Near these public buildings were the houses of the nobles, priests, and the wealthy, while on the outskirts of the town were located the dwellings of the lowest and poorest class. Public buildings were made of, or at least faced with, stone and, although the Spanish wrecked untold numbers of them to obtain the stones for their Christian churches, a large number still survive as ruins" (Driver).

The true, or keystone, arch is usually said to be absent in the Americas, although the domes of the Innuit snow house and the Mesoamerican sweathouse could readily be regarded as examples of the true arch. The corbeled arch, on the other hand, was widely employed by the Maya architects and has been dated as early as A.D. 317. Because of the stress limitations of the corbeled arch, the Maya structures necessarily have small rooms: the total volume of the walls of

such buildings is about equal to the space within all interior rooms. For reasons both of architectural limitations and tradition, there were no large rooms in which a multitude of people might assemble, and therefore large congregations were staged outdoors in the wide plazas and upon the steps and pyramids.

More important and more widely used than the corbeled arch was the principle of the post and beam, used in the construction of flat roofs supported by logs and covered with lime-concrete or adobe. Columns were both round and square, and were usually constructed of blocks of stone.

The Maya buildings apparently evolved from low offering platforms to high mounds surmounted by temples. Parallel to this development was the evolution of the associated structures of the Maya ceremonial centers where the priests were housed. First, a series of one-room buildings was interconnected by a common wall. Then a second and third story of recessed rooms was added by filling in the inside rooms beneath the upper floors. Finally, by enlarging the width of the openings in the outer rooms, columns—first square and later round—were constructed. Still later, these rooms evolved into porticos (Appleton).

Because the Maya did not discover the principle of the keystone and therefore used the corbel arch—built by overlapping stones bridged by a capstone—the arches were necessarily very high, providing broad surfaces of exterior walls, ideal for sculptural decoration. The Maya architects took great advantage of this opportunity, employing rich carvings and stuccowork on the several exterior surfaces available: the substructure,

or mound; the building itself; and the superstructure, called a roof comb if rising from the center line of the roof and called a flying facade if rising from the front wall.

Maya architectural detail varied from site to site, but in general the buildings were covered with intricate iconography, carved and then painted with bright colors. Sculptural pieces were often set into the walls and held by tenons, or set in recesses in the stone facade. Mosaics were used extensively. The interior walls were decorated with stone and wood carvings and paintings; the exterior plazas were plastered and brightly painted. Stelae and altars were erected periodically at the base of the great stairways of the pyramids. A final flowering of Toltec influence in Uxmal brought a new emphasis upon clean, extended horizontal line, which deeply influenced the twentieth-century architecture of America's Frank Lloyd Wright.

Most of the public structures in Mexico were built on massive substructures,

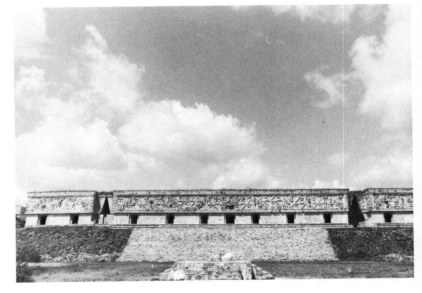

Palace of the Governors, Uxmal, Yucatán.

varying from terraces a few feet high to the grand pyramids, such as the one at Cholula, which is 1,150 feet square at the base and rises to a height of over 210 feet. (Although this pyramid is less than half as high as the largest in Egypt, its greater base gives it a volume fifteen percent greater.)

The earliest structures of Mesoamerica were serene and plain, almost entirely lacking decorative detail, but those built after about A.D. 1000 became progressively embellished with architectural sculptures. Geometric iconography was common, although various conventionalized figures of human beings and animals were also abundant. One of the most often depicted images was a representation of the feathered serpent, Quetzalcoatl, who was a prominent member of the Mexican pantheon. He first appears on the temples and pyramids at Teotihuacán, was later assimilated into Aztec architecture, and still later into that of the Maya. Architectural detail is carved in stone, modeled in baked clay, and fashioned and molded from stucco.

It is sometimes imagined that all ranks of people of Mexico and of Central and South America dwelled in lavish masonry houses. The common people lived in humble structures: from huts and pit dwellings in the north to the skin lean-tos of the Fuegians at the tip of South America. But the variation in dwellings,

it has been effectively argued (Bushnell), was not so much a matter of class as a designation of social rank (a subtle but important political and economic difference).

Fortunately for today's scholars, the Mexican custom of periodically rebuilding and enlarging temples has inadvertently preserved many of the early structures, since the old temples were filled in, the pyramidic mound raised, and a new temple built over the old one. Thus, during excavations, the relatively intact remains of prior structures are frequently encountered within the core of later structures.

The Inca architects of Peru were severe in structural purity, making little use of applied decoration for their marvelous buildings. Their emphasis was upon architectonics. Technically, Incaic buildings have been judged as superior to both Maya and Aztec structures. Part of this superiority is due to the fact that the Peruvians were master stonecutters, capable of fitting massive blocks so perfectly that they required no mortar. The Incas also knew how to bond their walls, something the Maya and Mexicans did not learn to do.

Architectural centers, planned on a large scale, were typical of the Peruvians. Stepped pyramids faced with stone, as in Mesoamerica, were the achievements of professionals, as were buildings of adobe brick, vast palaces, and great fortifications. These professionals employed clay and stone models in the designing of their buildings (Appleton). Sculptural detail, as already noted, rarely played a major role in the conceptualization of structures among the Incas, but exceptions such as the Chimu city of Chan Chan and the Gateway of the Sun

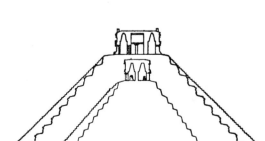

The stages of rebuilding the great pyramid of Kukulkán, known today as the Castillo, Chichén Itzá, Yucatán.

at Tiahuanaco demonstrate an uncommon capacity for brilliant decorative detail, if the architects chose to be flamboyant. Otherwise, the Incaic architectural effect is that of the majesty of an elegant technical finesse: the great beveled stones, fitted asymmetrically and interlocked, varying from large to small, and producing a pattern of light and shade provide, in all their simplicity and austerity, the most beautiful of impressions.

A few examples of the varieties of Native American dwellings and architectural styles—from region to region—will put these generalizations into focus.

Every tribe of North America constructed some form of dwelling. Caves were used temporarily for habitation, and nomads sometimes slept outdoors, but every Indian group used a constructed type of shelter at least part of the year. As already noted by Peter Nabokov, many tribes used more than one type of dwelling, depending on the season and ceremonial cycles. A detailed list of all the types of shelter used by the Indians of North America would be enormous, to say the least. Harold Driver has remarked that such a list would fill several volumes. Thus, we will follow Driver's excellent suggestion of simplifying the categories of dwellings by focusing on a single representative type for each region: the type of structure used for the greatest part of the year. Since the structures of the Southwestern United States may reasonably be called architectural, they will be described in somewhat greater detail than the less complex dwellings of the other tribes of North America.

The most famous house type of the Arctic is the domed dwelling built of snow blocks by the Central Innuit, although it is not used at all in Alaska and rarely used east of Hudson Bay.* The builder cut rectangular blocks of well-packed snow, which were placed on edge to form the base wall. Next another series of blocks was cut and set on top of the first set, and this process was continued until the circular wall reached the height of three or four rows. Working from the inside, the builder added each upward spiraling row of blocks, each one tipped a bit inward to narrow the circle which was to end in a dome. "This was the only type of true dome known to architecture which can be constructed out of blocks without first building a scaffold to support it" (Driver). When the last block was put in place at the top, the builder cut a hole for entrance and exit and let himself out. To complete the dwelling, a low passageway, or tunnel, of snow was constructed, which led into the entrance of the main structure. This tunnel was negotiated on hands and knees. There are many variations of this structure to be found: structures with multiple domes, interconnected by tunnels, and so on.

The houses of the Eastern Innuit had walls made of sod or stone, laid to a height of four or five feet. The roof was spanned by whale ribs, covered with sod. The tunnel entrance was similar to that of the snow house.

On the Northwest Coast large plank houses were supported by a massive framework of legs, to which the planks were attached. The framework usually

* Skin tents are the dominant type of shelter of this region, and the snow house is almost always a temporary residence.

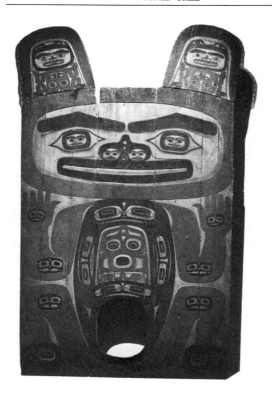

Tlingit house partition. Painted with the most important crest of the Shakes family, this famous screen was originally part of the Grizzly Bear House at Wrangell Village, southeastern Alaska. Following custom, it was installed parallel to the back wall to separate the chief's apartment from the rest of the house. It is made of cedar, paint, and human hair. Wrangle Village, Alaska, c. 1840. Denver Art Museum. Photograph: John Webb.

region was the lean-to, made of two frameworks of poles covered with bark, hides, or brush, which were leaned against one another so that they formed something like a gabled two-pitched roof. The open ends were covered with protective sidings.

The conical tipi of the Plains was a meticulously constructed portable dwelling with a tailored buffalo hide cover—it was ideally suited to the lives of nomadic hunters. The erection and dismantling of the tipi was the duty of women. A foundation of three or four major poles was made by tying the ends together and then standing them up in a tripod or tetrapod. After a covering was put in place, the tipi was staked down. An inner skin lining was often attached to the exposed poles in the interior, where a central fire was built—the smoke hole at the apex provided an excellently controlled draft and chimney.

The Prairies had a number of house types. The Dakota (Eastern Sioux) tribes lived in hide-covered tipis similar to those of the Plains. In the Missouri River region the earth lodge was prevalent, while a grass-thatched house was the rule in the extreme south. In the Great Lakes region a low domed dwelling, the "wigwam," was the most popular form of house.

The earth lodge had a cylindrical base, on which rested a conical roof. A tunnel-like entrance led into the interior. The whole structure was covered with earth and could be as large as forty feet in diameter, with a height of five to seven feet. The ground was often excavated, a foot or more, before the foundation was laid. Posts and rafters were used to support the roof, while the cylindrical base could be constructed, in log-

remained in the same spot for generations, but the planks forming the roof and walls were often transported to other sites when there was need to change residences. The dwelling could be quite spacious, occupied by several groups, which collectively made up one extended family. The houses stood with the gabled end facing the sea. In this end was the doorway, usually an oval hole in a large plank. All floors and terraces were plank-covered, and the interior usually had platforms of poles and planks fastened to the walls, on which people could sit and sleep.

The dominant house type of the Central Subarctic region was a crude conical tipi with hide or bark covering. The hides were not sewn together, as they were in the Plains tribes of the nineteenth century. Another dwelling of this

cabin fashion, of interconnecting logs. A firepit was dug in the center of the lodge, and a smoke hole was made above it in the roof.

The typical Caddo and Wichita domed thatch house was constructed of a number of long, flexible poles which formed a superstructure when set in the ground in a circle, and were bent inward to the center, where they were tied together. The structure was then covered with brush. The domed houses of the western Great Lakes are called wigwams.

The longhouse of the Iroquois Indians dominated the Northeastern region of the United States. From sixty to seventy feet in length, about eighteen feet in width, and eighteen feet in height, these famous structures were built of poles set in the ground at intervals, over which bark, most often from elm trees, was sewed into a covering with overlapping layers like shingles. The half-cylindrical roof was constructed in the same manner, with numerous smoke holes cut into it for the fires of the large extended family occupying the longhouse.

Except in Florida, parts of Alaska and the Aleutian Islands, and the Southwest of the United States, Indians no longer live in their traditional dwellings nor in anything remotely resembling them. There are, however, several heritage villages (outdoor museums), occupied by tribespeople who reenact their earlier lifestyles, and there are also museums with dioramas which reproduce with exactness traditional Indian homes, villages, and encampments. And, finally, there are ruins of ancient Indian settlements, such as Mesa Verde.

The living past is harder to discover. In the Florida Everglades some of the Seminoles have retained their nineteenth-century lifestyles and dwellings. And among the Innuits who have remained nomadic hunters, housing has not drastically changed since 1800. At Taos, Acoma, and Walpi, the traditional dwellings of the Rio Grande Pueblo Indians are still occupied by highly traditional factions of the tribes. Among the Navaho in Arizona one still sees the typical hogan—a six-sided pit house built of logs cemented with clay and dirt, and covered with soil. The doorway always faces east, and the structures are still burned when the head of the family dies.

The most architectonic of Southwestern settlements of the United States were probably the legacy of early pre-Columbian sites of Mexico. One group of people of this arid region, called the Hohokam, were apparently influenced by Mexican building styles. They settled in the desert valley in Arizona at about the time of Christ and remained there until the thirteenth century. Their dwellings were oval pit houses, sunk about a foot into the ground, with wattled walls supported by posts. A rudimentary form of ball court has been discovered in this area, strongly suggesting that the Hohokam played the ritual game which was the focus of much ceremony in Mesoamerica. It is believed that today's Pima tribe descends from the Hohokam people.

About the ninth century, yet another group of nomads appeared in the American Southwest. This group brought with them a tradition presumably from Mexico: the knowledge of building shelters of adobe and wood. They settled in New Mexico, where they cultivated cotton, domesticated the turkey, and became

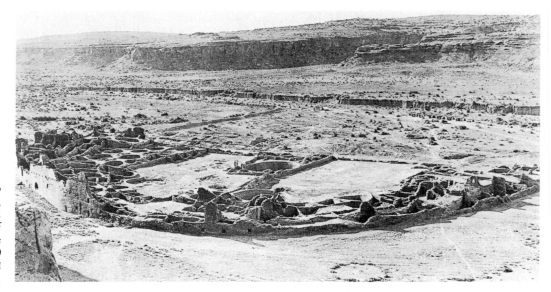

Ruins of Pueblo Bonito: Chaco Canyon, New Mexico. The town originally consisted of 800 rooms and was inhabited by 1,200 people. Anasazi culture, c. A.D. 1100.

skilled potters. "Forced to scatter by marauding tribes, some of them—those now known as Cliff Dwellers—retired to the mesas (the table-topped bluffs so-named by the early Spaniards). Others drew together on the banks of rivers, where their communities prospered. The Tyuonyi Pueblo ruin in Frijoles Canyon, New Mexico, shows the outline of such an early 'apartment house,' which tree-ring dating places between 1417 and 1505. Ranging from one to three stories in height, the structure sheltered several hundred people. It was built in the shape of a D for best security and had only one entrance, with a plaza inside the walls. Neighboring tribes of diverse origin adopted this practical solution" (Kelemen).

This diverse assortment of peoples was given the name "Pueblo" by the Spaniards, from their word for "village." Famous Pueblo sites are those at Pueblo Bonito and Aztec Ruin in New Mexico, and the Gila and the Salt River settlements in Arizona. Typical of all these sites (as well as of such cliff dwellings as

Mesa Verde) are circular subterranean chambers called kivas, which were used (and are still used by today's Pueblo Indians) as religious and administrative centers for the community. Some of the sites have as many as fifteen to twenty kivas, while most present-day villages have two or three. The kiva appears to have evolved from the early pit houses of the region.

The famous Cliff Dwellers, like those who created Mesa Verde in southwestern Colorado, used a buff sandstone for the construction of their apartment houses. For the roofs, branches were laid across timbers. Chinks were filled with grass, and then the whole structure was sealed with wet clay. Doors and windows were placed in asymmetrical patterns, with all emphasis upon function rather than appearance and design. Fireplaces were commonly built outdoors, under the shelter of the cliff overhang. Ladders for access to upper levels were constructed of timber. Towers of unknown function were often built into the complexly interconnected chambers

as part of the overall construction. There is no visible plan to the development of these sprawling cells of dwelling units; they seem, to the contrary, to have grown out of necessity.

In the thirteenth century occurred a series of severe droughts (one, according to tree-ring evidence, lasted as long as twenty years), and more and more of the Cliff Dwellers were forced to abandon their protective but waterpoor settlements and join their tribal allies on the banks of the large rivers. By the sixteenth century, when the Spaniards arrived, many of the ancient Indian settlements were already uninhabited and in a state of ruin. Some of the most spectacular sites were entirely forgotten. Mesa Verde, for instance, was not rediscovered until the end of the nineteenth century, when two cowboys in search of lost cattle came upon a hidden canyon and caught sight, for the first time in several centuries, of the buildings fitted into the vast natural cavern high in the rock wall.

The most elaborate and evolved architecture of the Americas is doubtlessly that of Mesoamerica and the Andean region. There is some growing evidence of masonry settlements in the Amazon Basin, and excavation is gradually revealing some interesting architectural elements in Chile, Argentina, and elsewhere, but the available data for such regions are so limited that these regions will not be considered in detail here. No architectural remains of high artistic merit have been discovered in the Isthmian countries, nor were any mentioned by the conquistadores. Therefore, the centers and cities of Mesoamerica and the Andean region will be our focus here.

The first site in Mesoamerica that was a substantial population center is Teotihuacán, located about thirty miles northeast of Mexico City, which was destroyed and abandoned long before the first recollections even in Indian folk history. We do not know who built this massive city, what it was or what any of its structures were called, or what the people called themselves. Even in regard to the functions of the various structures of Teotihuacán, we have only been able to make educated guesses, on the basis of much later cultures of the region. What has survived, however, is a remarkable achievement in building. This

Cliff Palace, Mesa Verde, Colorado.

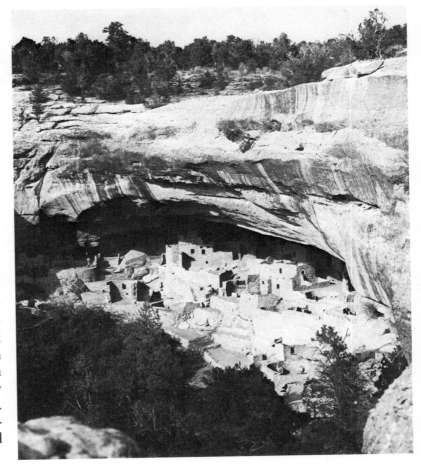

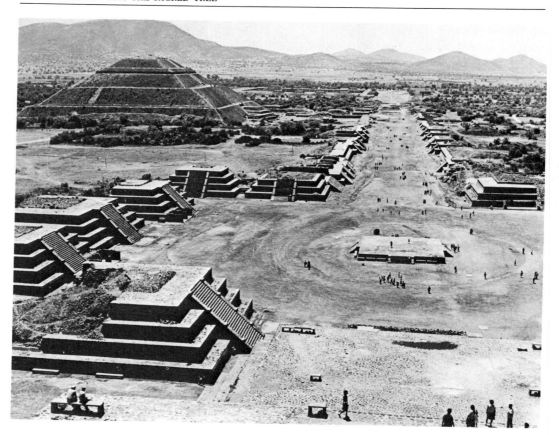

Teotihuacán: general view. The Valley of Mexico.

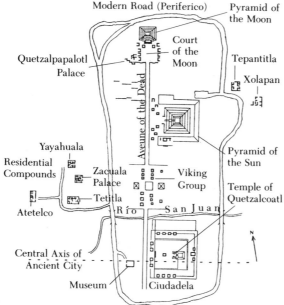

Plan of Teotihuacán.

vast center, in size and influence probably the most important of all Classic sites (Bushnell), is grouped around a great avenue which was at least two miles long. At its north end is a great stone-faced pyramid (now called the Pyramid of the Moon), and to the east of the avenue is an even greater pyramid (now called the Pyramid of the Sun). On either side of the main thoroughfare (called the Avenue of the Dead) are the ruins of smaller pyramids, platforms, courts, and palaces. According to Bushnell, the plan of these buildings is conscious and orderly but is not an evident attempt at symmetry.

Unlike most Classic centers, Teotihuacán is usually regarded as a true city—rather than a ceremonial site—from the

evidence of numerous dwellings for common people as well as those of rank. As we have already indicated, Teotihuacán was a city of suburban rather than urban character, sprawling out so widely that there was little chance of crowding and congestion.

Teotihuacán is of great importance architecturally, for many characteristics of American building apparently had their origin here. The religious structures at Teotihuacán are based on the principle of the slope and panel (*talud-tablero,* as it was known in Spanish): the widely copied facing of ceremonial buildings, in which a rectangular panel (*tablero*) was cantilevered over a sloping wall (*talud*). Repeated on stepped pyramids, it accented the grandeur of the terraced design. The panels of the final stage of pyramid building at Teotihuacán were plain—though they may have originally been plastered and painted (Bushnell). But in the court known as Ciudadela,

the chief pyramid shows an earlier stage, in which the panels were filled with monumental sculptural detail, depicting feathered rattlesnakes meandering along the facades, their heads alternating with stylized bespectacled faces of the rain god. Seashells often appear in association with the serpents' bodies. Serpents decorate the supporting slopes and the balustrades of the great stairway. This decorative architecture has survived from an early stage of Teotihuacán, for, like so many Mesoamerican monuments, this one was hidden by a later and larger structure.

The so-called palaces of Teotihuacán, believed to have been residences of the persons of high rank, are organized around rectangular courts (somewhat similar in plan to the grand homes of Pompeii). The houses of Teotihuacán have open fronts, with roofs supported on columns, which often have carved low-relief figures. The roofs are crowned

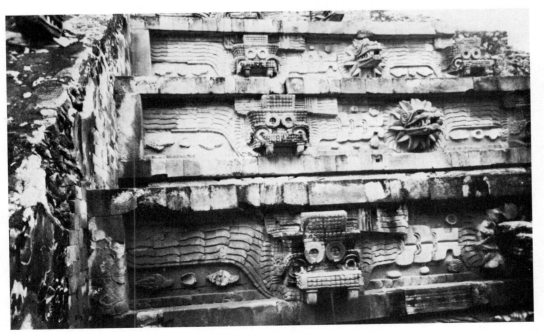

The Pyramid of Quetzalcoatl, decorated with carved sculptures of the rain deity and the Plumed Serpent, with seashells lacing together the images of the two deities. The Pyramid of Quetzalcoatl was overbuilt by subsequent structures, the last of which was the Citadel—Ciudadela— the center of Teotihuacán, the Valley of Mexico, in its final architectural flowering.

by crestings, in which the merlons have motifs such as the mouth of the rain god.

As already noted, the fall of Teotihuacán is recognized by scholars as the beginning of an epoch of obscurity and diffusion—a Dark Age in the Valley of Mexico. The Toltec culture represents the early Postclassic period in Central Mexico, and the capital city of Tula is a summation of Toltec architectural thinking. "The pyramid which has been most fully studied is faced with stone," writes Bushnell, "and over this was laid an outer facing of carved slabs secured by ten-

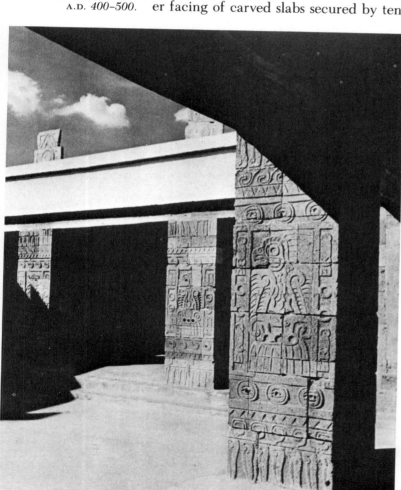

Court of the Palace of Quetzalpapalotl (Quetzal-Butterfly). Teotihuacán III phase, Teotihuacán, the Valley of Mexico, c. A.D. 400–500.

ons. It has five stages, with yet another variety of the old slope-and-panel facing, a lower plain slope and a 'panel' divided into two, the upper division being roughly equal in height to the slope and the lower slightly greater. The upper division has a row of passant jaguars and coyotes framed above and below with a plain square moulding, and the lower has pairs of eagles eating human hearts, similarly framed, with a recessed panel between each bearing a composite crouching monster crowned with feathers, which is identified as the feathered serpent god called by the Aztecs Quetzalcoatl, in the guise of the morning star. The whole was formerly plastered and painted." The pyramid was crowned by a temple, of which almost nothing remains excepting four great standing figures, fifteen feet high, and four square piers with carving in low relief, which are presumed to have supported the roof. Each figural column consists of four separate stones tenoned together (though found scattered at the time of the initial excavations of the site). The massive, columnar figures are stiff and angular, grim warriors carrying spears and spear-throwers, with each detail of their dress and insignia carefully rendered.

A new architectural feature at Tula "is a large vestibule at the foot of the pyramid stairway, which had three rows of square piers supporting the roof. . . . Gone are the lively little figures of the rain god's paradise at Teotihuacán, gone is the exaggerated floridity of the later paintings of the god himself, everywhere are signs of that obsession with war and death which was to reach such a climax in Aztec times" (Bushnell).

For all of its militarism, however, the

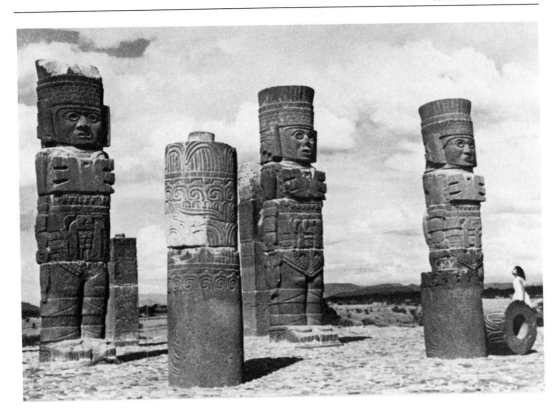

Atlantean figures from the Pyramid of Quetzalcoatl. Toltec culture, Tula, Mexico.

capital of the Toltec world was not a fortress. As Kubler has noted, "The absence of all fortification is immediately striking. Like Teotihuacán in its last phase, Tula was a ritual center surrounded and invaded by dwellings." And there can be no doubt that the Toltec lords, coming after the theocracy of Teotihuacán, perpetuated certain urban features of their more pacific predecessors, and that the fortress cities of Mesoamerica belong to a later time than that of the Toltecs.

The fall of Tula in the twelfth to thirteenth century was precipitated by invading Chichimec tribes—who do not appear to have differed materially from the nomadic component of the Toltecs. Many Chichimec structures of this period adorn the Valley of Mexico. The

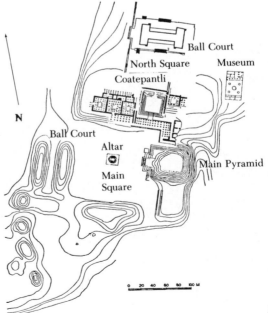

Plan of Tula.

most prominent of these is at Tenayuca, a short distance from Mexico City. Here a group which settled about 1200 rebuilt a pyramid first constructed by the Toltecs. It is distinguished by twin temples at the summit, and it was surrounded by a ring of stone snakes.

Right: Reconstruction: Main Temple (Temple Mayor) *of Tenochtitlán* (Mexico City), c. A.D. *1519. Courtesy of Secretario de Educacion Publica, Mexico.*

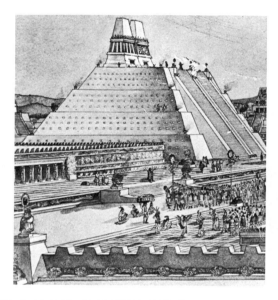

Below: Double stairway of Aztec temple at Tenayuca, Mexico, c. A.D. *1500.*

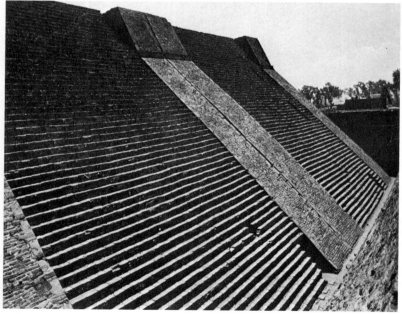

The Aztecs were the successors to the Toltec and Chichimec domains in the Valley of Mexico. "The metropolitan concentration of the Aztec state is apparent from descriptions of the capital, Teotihuacán, which underlies Mexico City, and which was destroyed in the Spanish siege during the spring and summer of 1521" (Kubler).

Tenochtitlán differed from all prior urban settlements of the Valley of Mexico in two important features: the sacred precinct was walled, and it was overshadowed by a vastly larger residential city and its suburbs. This design clearly reversed the layouts of the ritual centers at both Teotihuacán and Tula, where dwellings were subordinated to the vast ritual plans of the cities. The Chichimec architectural imagination seen at Tenayuca is recapitulated at Tenochtitlán: "A pyramidal platform, symbolic of the heavens, rises with stairways facing west. On the top terrace, twin shrines dedicated to the ancient rain god and to the Aztec tribal god symbolize the coupling of sedentary and nomadic traditions, of agricultural and military vocations, in Aztec society. The pyramidal profiles are plain, save for the stairways, where the pitch of the balustrades changes near the top to give the effect of a steep crowning cornice, and to make the top dozen steps seem more abrupt. The walls of the temple cella, of tapered profiles, continue the silhouette of the pyramidal platform" (Kubler).

Ball courts, introduced from the lowlands in Late Classic times, were common in the Aztec religious districts. According to one sixteenth-century chronicler, a ball court adorned every Aztec city. Kubler points out that none of these courts have survived.

For descriptions of Aztec palaces we must depend entirely upon the texts of eyewitnesses of the Spanish invasion. Parts of the palace at Texoco have been depicted in sixteenth-century drawings, which show rows of chambers aligned upon platforms surrounding a courtyard. Simpler homes (such as those excavated at Chiconcuautla) appear to have been laid out in the same design: small chambers with porchlike, colonnaded vestibules surround a court.

According to Kubler, "Aztec architecture is not remarkable for important structural innovations." The buildings and cities of the Aztecs, however, were the culmination and the terminus of the architectural evolution of the Indian peoples of the Valley of Mexico.

The ancient cities of the Gulf Coast of Mexico—now called the Classic Veracruz civilization—can be exemplified by the major site of El Tajin. Here, between A.D. 100 and 1100, a center evolved through twelve building periods. The Olmec forerunners of the Classic phase in Veracruz left remarkably little architectural evidence, and what does remain of Olmec structures is found at lowland Gulf Coast sites in the great river basins. At La Venta, excavations have uncovered part of a massive ritual center of Preclassic mounds and enclosures. It probably housed only the priesthood (Kubler). The structures at El Tajin are both more elaborate and far better preserved.

Yet El Tajin is far from being completely excavated. The site features temple pyramids, platforms, and at least seven ball courts, suggesting that the ball game was particularly important here (Bushnell). A notable feature of El Tajin is the Pyramid of the Niches, consisting of six terraces and a summit temple reached by only one steep stairway. Each terrace is lined with a row of stucco-covered square stone niches under an overhanging cornice; this construction and design are unparalleled in any other area of the Americas.

The Classic sites of Oaxaca were built by the Zapotecs and Mixtecs. Zapotec culture is known chiefly from the vast hilltop center of Monte Albán, near the present-day city of Oaxaca. This plan encompasses a great plaza, enclosed by pyramids and platforms. Another group of such religious structures is located in the middle of the enclosed plaza. A great stairway rises from the court at the north end leading to a platform bearing the remains of two rows of circular columns. Adjoining the northeast corner of the great court is a ball court with sloping walls. All of these structures belong to the climax of the Classic period, called Monte Albán Stage II, and date about A.D. 1 to 900. Also ascribed to

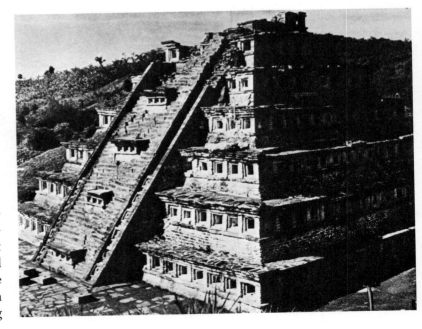

Pyramid of the Niches, El Tajin (Veracruz), Mexico.

Stage II is an older building, thought to be an observatory, dated about 300 B.C. to A.D. 1. Stage I (700–300 B.C.) is represented at Monte Albán by stone slabs with relief carving of figures called *Danzantes*, incorporated at a later date on a group of structures on the west side of the site. There was apparently a break at the end of Stage I (Bushnell), "which is ascribed to the arrival of new people bringing new features, perhaps as conquerors. The 'observatory' is faced partly with re-used *Danzante* slabs, and partly with slabs of its own date bearing incised glyphs, thought to denote places, each supported by an inverted head, perhaps to indicate its fall."

The Monte Albán pyramid and platform facades of Stage III are based on variations of the slope-and-panel design, which originated at Teotihuacán. Less derivative than the platform construction are many stone-lined tombs, found on the sides of the hill. From rather simple rectangular boxes in Stage I, these tombs gradually became chambers reached by stone stairways; the tombs were roofed with flat slabs or with two sloping rows of slabs leaning against one another to form a ridge. By Stage III the tombs are sometimes painted with murals and carved with glyphs.

According to Kubler, "Monte Albán is the most grandiose of all American temple centers, rising from the valley floor as an acropolis, studded with courts and pyramidal clusters." Two features are major devices used by the architects of Monte Albán: very wide balustrades, far more generously proportioned than those found in other Mexican or Classic Maya sites, and a series of ingenious paneled friezes consisting of two or more layers of masonry built out from the wall face. "These profile projections," Kubler writes, "give great importance to the short vertical distances between terraces, and they, more than anything else, contribute to the vertical effect. In facades of extreme length, their effect in series is to break the horizontal by a *pointille* succession of lights and shadows, like a dotted line."

Monte Albán was abandoned about A.D. 900. The decline of Zapotec culture may or may not have been the result of the invasion of Mixtec tribes. In any event, the Mixtec centers in central Oa-

Monte Albán: general view. Oaxaca, Mexico, 500 B.C.–A.D. 1500. From Ferdinand Anton.

Plan of central Monte Albán.

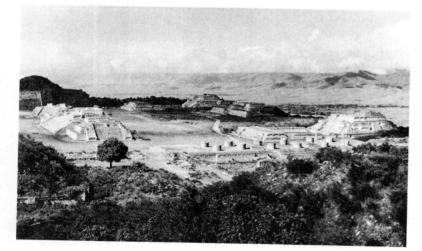

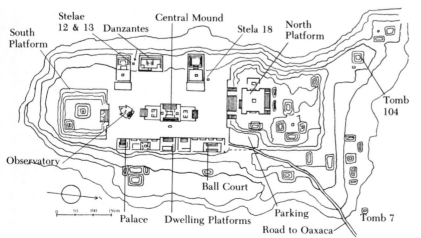

xaca became the focus of their culture. Of these centers, the site of Mitla, some twenty-five miles east of the city of Oaxaca, became the most important.

Though it is generally agreed that the Mixtec (and not the Zapotec) were the designers of Mitla, the arrangement of the surfaces at Mitla nevertheless betrays close dependence upon the decorative style of the paneled friezes at Monte Albán (Kubler). Mitla, therefore, must be looked upon as perpetuating the Zapotec ornamental architecture of Monte Albán rather than being the flowering of a unique tradition.

There are five major groups of buildings at Mitla. The complex which is southernmost consists of a court with a platform and pyramid dating from the Classic Zapotec period. The other structures are much later, and are the work either of Mixtecs or of Zapotecs under Mixtec rule. Some of these buildings were still occupied at the time of the Spanish invasion. A feature of these late structures, which differentiates them from Classic Zapotec architecture, is their length and lowness, accentuated by elongated stone panels covered with mosaic patterns; an example is the Building of the Columns. As Bushnell has indicated, the mosaics are very characteristic of the Mixtec culture—each panel has a motif in relief, in which zigzag lines, terraces, hollow squares, and frets are repeated again and again in a complex and quite elaborate and florid pattern. Kubler has commented upon the so-called marriage reliefs of Mitla: "Figural sculpture which can be assigned to the period of the building at Mitla does not come from Mitla, but from other valley towns, and the date is problematic." These relief slabs, which show seated

Facade at Mitla, Oaxaca, Mexico. Zapotec culture, c. A.D. 1200.

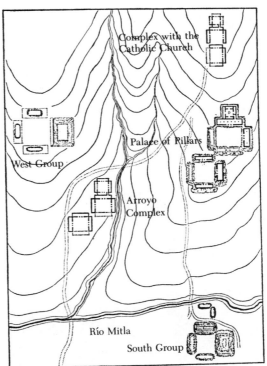

Plan of Mitla.

couples, resemble in subject matter the Mixtec genealogical manuscripts of the sixteenth century; the glyphs on the reliefs, however, are more related to Classic Zapotec styles and reflect the design of Monte Albán more than that of Mitla. The repeated scheme of the marriage

reliefs is that of two couples seated facing each other. Above the uppermost couple is a sky symbol similar in form to those painted in the tombs of Monte Albán. The glyphs are Zapotec, as are the terraced place-name signs, but the figural style and the costumes of the seated figures are those of the Mixtec genealogies. Thus, as Kubler observes, the forms are Zapotec while the content is Mixtec—a mode that perfectly parallels the mixture of themes and forms which dominates the architecture of Mitla.

Classic Maya architecture spanned the centuries from the time of Christ to about 1000, and had its homeland in central Yucatán. The term "Classic" is intended to distinguish the monuments the Maya built before 1000 from those of the so-called Toltec-Maya, built after 1000 (Kubler). As we have seen already, the most typical attributes of Classic Maya are stone architecture with cor-

beled vaults and burnt-lime cement or concrete; stelalike slabs and prisms of stone carved in low relief, commemorating the lords as well as various important events of Maya history; and calendrical inscriptions. The subject of Maya architecture is extensive and complex, and it has rightfully been the topic of numerous extensive studies.* Here we must summarize a remarkable architectural achievement in very few pages.

There are many differences among the various Classic Maya sites, though plans, motifs, iconography, and mannerism tend to be remarkably consistent and long-lived, reminding us somewhat of the Egyptian conservatism which perpetuated a relatively unchanging art style for centuries.

"Each of the greater centers excelled in some feature of architecture" (Bushnell). Tikal, in present-day Guatemala, is the largest site and is renowned for its pyramids of great height, for its intricately carved roof combs, and for the richly carved wooden lintels over the temple doors.†

At Copán, in Honduras (near the Guatemala border), the remarkable Stairway of the Inscriptions and the fine series of high-relief stelae have already been mentioned, in connection with sculpture. In this semitropical region, called the Petén, are the most ancient of Classic Maya sites. Their form is best described, according to Kubler, "as 'island cities' or 'archipelago cities,' consisting of many groups of platforms and build-

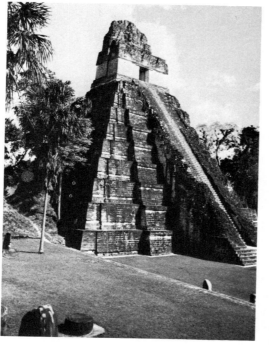

One of the two pyramids in the Central Plaza of Tikal, Guatemala. Classic Maya period.

* The reader is especially referred to George Kubler, pp. 129–219.
† "Although archaeologists once thought that Tikal was primarily a ceremonial site, many now believe it actually was an urban center" (Richard E. W. Adams, *Archaeology*, Nov/Dec. 1982).

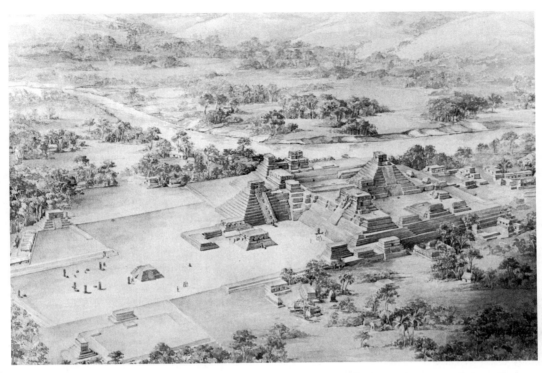

The acropolis, Copán, Honduras. Restoration by Tatiana Proskouriakoff. Courtesy of the University of Oklahoma Press, Norman.

ings on knolls and shoulders of hilly land rising above the surrounding swamps, which may have been lakes or waterholes in antiquity."

In the Petén there are consistent plans for the ceremonial centers, which were clearly not cities but religious settlements. For instance, at Uaxactún the different groups of buildings are connected by causeways. At Tikal the nine groups of courts and plazas are connected by ramps as well as causeways. And even in northeastern Yucatán, in the center called Cobán, there is a site of the Petén type, with buildings connected by raised roads.

"In Petén Maya architecture, the rooms were always much less important than the masses. The design of an edifice was secured less by the enclosure of rooms in an articulated envelope than by the ponderous combination of vast masses, solid throughout, sculpturally related, and structurally static" (Kubler). For these reasons, it is difficult to identify the function of various platforms and buildings. The so-called palaces and temples cannot be clearly defined as such; they tend to merge into one another by continuous graduations.

It is probable, according to numerous scholars of Maya architectural concepts, that a cardinal objective of the Maya architect was to achieve differentiation by height, using the levels of structures to distinguish their functions. At the same time the builders were responsive to the spaces between and among edifices, attempting, it is surmised, to achieve large and rhythmically ordered open volumes. These open volumes, with storeyed changes of level, are the most characteristic formal achievements of Maya architectural history.

The structural history of Maya architecture is concerned with four things: stones, mortar, support, and the vault. According to R. L. Roys, the general line of development is from block masonry to a concrete core veneered with ashlar slabs, from massive wall structure to slender piers or columns, and from narrow, slotlike chambers to intricate combinations of rooms which offer one another mutual support.

The famous ceremonial center of Copán in Honduras is an elegant assembly of open volumes. Its plazas are large concourses. The nucleus of Copán is an artificial hill, raised not only to mark a place of high honor, but also to focus upon the plaza located at its base. This acropolis defines the main court and provides a justification for the glorious stairway—ninety feet in width. The result of this interaction of height and expanse is highly theatrical and ritualistic And as if this brilliant assembly of open space and height were not sufficient, the Copán ball court provides yet another astonishing architectural element; it is surrounded by stepped terraces and fashioned of starkly sloping sides. Add to this the collection of stelae and altars, and you realize at once that this is one of the most refined and effective of Maya structural achievements.

Of quite a different character is Palenque, which rises in the limestone hills rising from the Tabasco lowlands, about thirty miles south of the Usumacinta River. The plan of the buildings has a persistent arrangement of double-range parallel chambers, in order that the two outer vault masses may abut a central Y-shaped vault-mass common to both chambers. On this central support rise the latticed roof combs of Palenque. The result of the use of parallel vaults keyed to a central supporting wall is an architectural effect of unprecedented lightness and permeability, permitting the construction of rather wide spans in long chambers. Thus the small temples on top of the pyramids of Palenque, like the galleries in the northern part of the famous Palace, are extremely spacious, in

The Ball Court, Copán, Honduras. Classic Maya period.

Palenque: general view. Chiapas, Mexico, Classic Maya period.

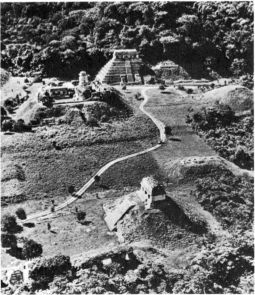

comparison to the ponderous massing of the Petén style of Copán.

"Another remarkable edifice at Palenque [besides the Palace and its fine tower] is the Temple of the Inscriptions. Its pyramidal platform contains a large vaulted crypt at ground-level, entered by a stair shaft of about sixty-five steps on two ramps, covered by ten levels of corbelled vaults in stepped ascent. The Maya architects apparently never attempted to build corbel-vaults with slanting imposts and sapstones. Their idea of stability required level vault-masses" (Kubler).

In the landscape north of Champotón, the low hills called the Puuc break the steady flatlands of the region. Here a great variety of ruins recalls the settlements which flourished around the underground cisterns typical of the peninsula. The Puuc architects of the Late Classic era transformed all prior Maya structural ideology, making distinctive alterations in the Classic style and producing startling new effects upon old themes. Earlier buildings in Yucatán and in the Petén were always built of slabs and blocks, faced with stucco. The Puuc builders, however, favored the use of rubble for the cores of their platforms and buildings, facing them in a veneer of thin squares of cut stone. The heavy piers of prior facades were replaced with columns, which improved the interior lighting and also provided a variety of rhythmical openings in the walls. The stucco exteriors so typical of the southern regions of the Maya world were here abandoned for geometric designs beautifully carved in stone, like mosaics in the upper zones of the wide facades. According to Kubler, "the Puuc style of architecture is best apprehended in the eastern sites from Chacmultun to Uxmal, as a Late Classic transformation of Maya practice which occurred in the two or three centuries before 1000. Certain forms characterize its early and its late manifestations: the storeyed or chambered pyramid; the monumental archway; the vertical facade; the monolithic core veneered with thin stone

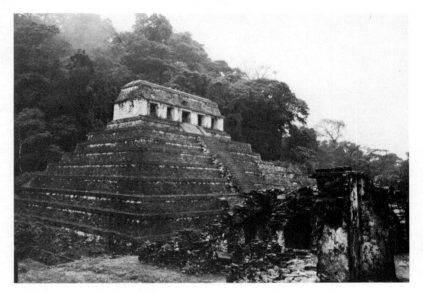

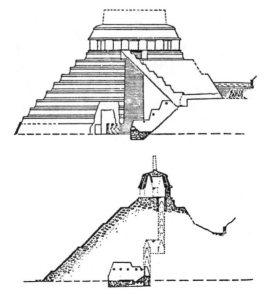

The Temple of the Inscriptions. Palenque, Mexico, Classic Maya period.

The Temple of the Inscriptions, Palenque. Elevation and section show the interior staircase leading from the rear room of the temple to the burial crypt. A light and ventilation shaft led from the stairway landing to the exterior of the pyramid. After A. Ruz, from J. Eric S. Thompson, The Rise and Fall of Maya Civilization.

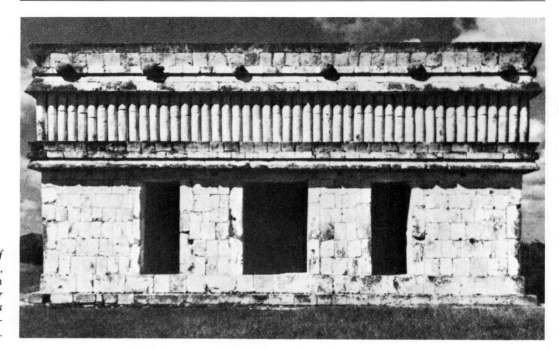

Facade of the House of the Turtles, Uxmal, Yucatán. Tortoises in relief on the upper cornice. Classic Maya period, c. A.D. 800–1000.

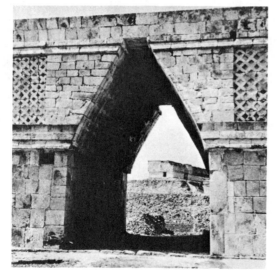

Corbeled arch of the Nunnery, Uxmal, Yucatán. Maya-Toltec period, c. A.D. 1000.

plates; the use of *atadura* (binder) mouldings; and the apertures framed by columns."

One of the most striking centers of the Puuc was Uxmal, which occupied about 250 acres. The three principal structures of Uxmal, called the Pigeon Group—so named because of the latticed and gabled facade resembling a dovecote—are the House of the Governor, the Cemetery, and the Nunnery (the terms have no relation, of course, to the original use of the buildings).

All three buildings are noted for their broad facades, in which a low plain wall, broken by a series of doorways, is crowned by a frieze on the upper zone of the wall. This effect is most prominent in the Nunnery court and in the House of the Governor, which is also renowned for its two exceptionally tall corbeled arches, which break the line of the elegant facade. In strong contrast to these buildings, with their intricately carved friezes, is the marvelously simple House of the Turtles, with a severe frieze adorned only with vertical fluting, above which is a row of small turtles sculpted almost in the round. For many, the House of the Turtles represents the perfection of Late Classic architecture.

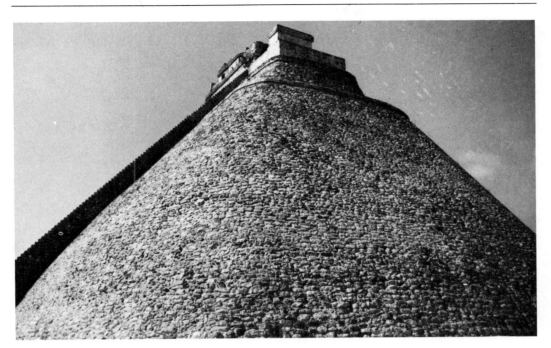

*House of the Magician,
Uxmal, Yucatán.*

"The House of the Governor is the most refined and perhaps the last achievement of the architects of Uxmal. In it many scattered solutions were brought together to make up an edifice of striking harmony and repose. Its profiles are adapted to the scale of the landscape, and its surfaces are adjusted to the hard light of Yucatán with an ease that reveals both a mature architectural tradition and the presence of an architect of great endowments. He probably had to conform to an eleven-entry plan previously set out both in the north building of the Nunnery and in the gabled House of the Pigeons . . . but the architect of the Governor's House boldly made the best of the arch. In the Nunnery, the arch is like a raw wound in the facade, incompletely thought out either as an entrance or as a break in the block. The architect of the Governor's House, however, recessed the corbel-vaulted arch behind the facade, and exaggerated

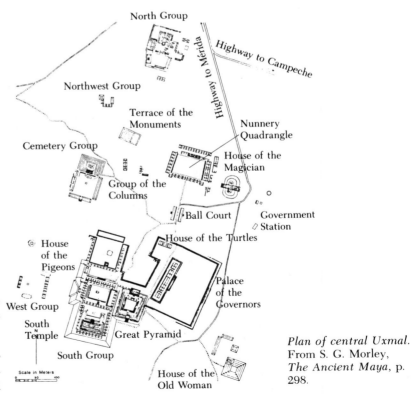

*Plan of central Uxmal.
From S. G. Morley,
The Ancient Maya, p.
298.*

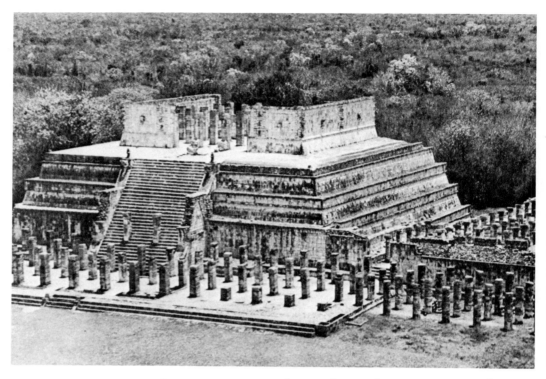

Temple of the Warriors, Chichén Itzá, Yucatán. Maya-Toltec period, A.D. 800–1200.

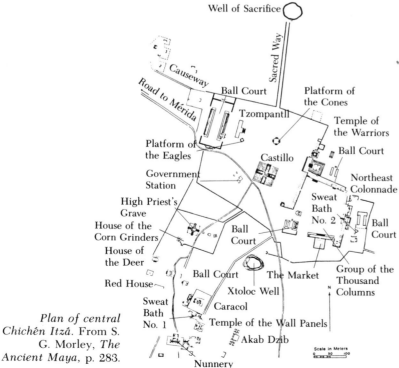

Plan of central Chichén Itzá. From S. G. Morley, The Ancient Maya, p. 283.

the vault overhangs, carrying them in convexly curved soffits like curtains down nearly to ground level, in order to accentuate the separation of the three pavilions by shadows and by striking contours" (Kubler).

The Postclassic stage of Maya architecture is best exemplified by Chichén Itzá, in Yucatán, where there was a complex interaction between the defeated Maya and their Toltec overlords. Chichén Itzá was under foreign domination until the thirteenth century. Mexican aliens probably began to rule in Yucatán as early as the ninth century. The worship of a feathered serpent god of Mexican origin, the Mexican method of human sacrifice by heart excision, with skull racks for the display of the sacrificial victims, and many other Mexican highland traits strongly suggest cultural association between the Mexican over-

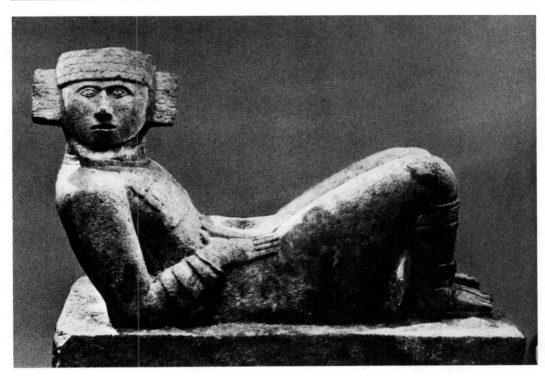

Limestone chacmool. Maya-Toltec period. National Museum, Mexico City.

lords in Yucatán and the Toltec masters of Tula.

Evidence at Chichén Itzá suggests that some Late Classic structures of recognizable Maya refinement were modified in Postclassic times, and many more were built, under the supervision of the new ruling class from Central Mexico. The close resemblance between the buildings at Chichén Itzá and those of Tula in the Mexican highland was first noted by Désiré Charnay about 1880. Most scholars now accept the thesis that the Toltecs of highland origin were the masters of Chichén Itzá in Postclassic times; although the chronology of the buildings of this site is far from complete. The conventional view, according to Kubler and others, is that an alien art was imposed upon the Maya artisans of Chichén Itzá. Clearly, the Maya craftspeople were so advanced in comparison

to their overlords that they were permitted to render Toltec style in a highly Mayanoid manner, which resulted in an intriguing amalgamation of two vastly different sensibilities and art styles. This assimilation of Toltec architectural ideals at Chichén Itzá is estimated to have commenced during the tenth century. Beneath the Temple of the Warriors is a much earlier structure, which may have been built as one of the first constructions of the Toltecs after their arrival in Yucatán. Several sculptural figures, known as Chacmools, have been been located both at Tula and at Chichén Itzá. There is an excellent example in the inner temple of the Castillo at Chichén Itzá and there is another at the top of the stairway to the Temple of the Warriors. Similar figures have been noted as far south as Costa Rica, though their exact purpose and iconographic

significance are unknown. Nevertheless, the Toltec rulers seem to have defined a specific style for the Chacmool, and they used its form in many of the buildings at Chichén Itzá.

The Toltec structures at Chichén Itzá, such as the Castillo, the Temple of the Warriors, and the immense ball court, are impressive achievements in architecture, and they surely mark this ceremonial center as the most important site of the Maya world during Postclassic times.

In Colombia only the Tierradentro region, between the upper valleys of the Magdalena and Cauca rivers, has an imposing and significant architecture. The San Agustín site, farther to the south and quite near the headwaters of the Magdalena, as we have already seen, contains important monumental sculpture. Exceedingly little is known about the chronology of this zone.

The major remains of ancient construction are the stone avenues and foundations in the province of Tairona, and the underground tombs of Tierradentro in the south. The tombs are oval, while the Tairona houses appear to have been circular. The Tierradentro tombs are usually believed to represent a long, continuing tradition, though formative dates are unavailable. These mortuary structures are cut in the soft granodiorite bedrock and constructed with slanting roof planes and radial niches. The entrances are in the form of circular or straight stair shafts. The plastered interior walls have geometric patterns and hu-

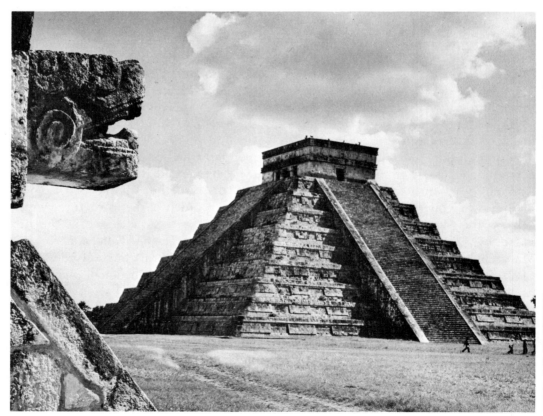

Castillo in the Central Plaza of Chichén Itzá, Yucatán. Maya-Toltec period.

man figures painted in black, red, and orange. Curiously, according to Kubler, the pottery found in these tombs is unlike that of other Colombian styles. It has been compared to the Amazonian types of Marajó Island. Much evidence tends to connect the Tierradentro tombs with the Arawak Indians of eastern South America: the shafted deep-level construction, the geometric wall paintings, and the types of pottery found on the site tend to confirm this supposition (Kubler).

There is no notable architectural achievement in Central America, though earth and stone mounds have been found in association with courts and columnar structures. Likewise, there is no evidence of a refined architecture in Ecuador. Almost nothing has been published on the architectural finds of Argentina, Chile, or Venezuela, and the emerging data (for example, Lathrap, 1970, and Turolla, 1980) on the architectural ruins in the Amazon Basin are not sufficiently developed to warrant discussion here.

In the Andean civilizations, the first indication of architectural development occurs in the ninth century B.C.—this is the so-called Chavin horizon. At Chavin de Huantar (10,000 feet up the eastern slope of the Andes) there appear to have been several stages of construction, although all the structures were faced with regular courses of stone slabs. The interiors of the buildings are traversed by a connected series of chambers on two and sometimes on three levels, very efficiently ventilated by means of ingenious stone shafts. The Chavin site was developed gradually. The oldest part is a U-shaped block, open to the east, in the

depths of which is the so-called *Lanzon,* or Great Image: a monolith of white granite representing a human figure with feline fangs and snake hair, c. ninth century B.C. Several additions were made on both sides of the central block of buildings, eventually forming a massive rectangular ceremonial center.

Other Andean highland sites of this period and probably of earlier ones have not produced sufficient data to date for a comprehensive understanding of their relationship to or independence from the cultural evolution of Chavin de Huantar. Roughly of the same period as the famous Chavin site are Cerro Sechin and Moxeque in the Casma Valley, and Punkuri and Cerro Blanco in the Nepena Valley. All of these locations tend to share some degree of the dominant Chavin architectural style; there are massive terraced pyramidal platforms of stone at Chavin de Huantar itself and similar platforms of adobe or rubble (set in mud mortar) at the settlements on the Peruvian coastal zone.

As noted in prior chapters, there was a successive flowering of local as well as

Reproduction of a tomb, San Agustín, Colombia. Courtesy of the Colombian Ministry of Culture, Bogotá.

expansionist cultures in the Andean region. Just as these civilizations had decorative arts unique to themselves or were deeply influenced by previous societies, so too their architectural achievements display a strong independence of aesthetic spirit as well as a good deal of reliance upon architectonic antecedents. As we have seen, this evolution began with the ninth-century B.C. Chavin architects and culminated in the masterful Incaic masonry builders, who had reached their finest achievement at the time of the Spanish invasion in the sixteenth century. A survey of this Peruvian architectural history will underscore the brilliance of the artisans of the Andean civilization.*

The heart of Moche (Mochica) civilization was in the valleys of Chicama and Trujillo; the original name of this society is unknown to us. "Their immense pyramidal platforms and country estates," writes Kubler, "differ sharply from the scattered villages of immediately preceding periods." Moche civilization was based upon a complex agriculture, with ingenious irrigation by a network of aqueducts, reservoirs, and canals built on a gigantic scale. The beginnings and the termination of the Moche culture are not definitely known—the dates are about 300 B.C. to about the ninth century A.D. The architectural history of the Moche region both predates the Moche horizon and extends beyond its terminus. The groups of dwellings, like those of the so-called Gallinazo period (c. 500

B.C.), were clusters of adjoining chambers built of rectangular adobe bricks, both in symmetrical and in irregular plans. Temple (or palace) platforms of rectangular form first appeared in the periods predating Moche development. Later Moche plans are attested to by the excavation of foundations of large rooms, courts, and corridors. The Castillo of Huanaco in the Virú Valley is such a late construction, built along the lower slopes which surround the Virú Valley. The steep pyramidal terraces are constructed of small mold-made adobe, built in adjacent but unbonded columns and wall sections without stone foundations. Clearly the Moche architecture was a perpetuation of much earlier styles and technologies, but was developed by the Moche on a far larger scale to achieve a more stately effect. The great buildings at Moche are exceptional because they still show the original form of the Moche pyramid cluster. Elsewhere, however, the early platforms were covered with structural additions by later builders, as at the Brujo pyramid in the Chicama Valley or at Pacatnamu in the Pacasmayo Valley.

From the evidence of pottery painting, Moche society was most likely a theocratic organization led by priestly persons. The farming class apparently lived in clusters of dwellings at the edge of the valley, while persons of rank occupied walled and terraced hillocks, the architecture of which has been depicted in great detail on many painted pottery vessels. As Kubler has pointed out, "Such a regime gave mastery of the entire society to a few persons controlling the upper valley necks," and it provided the basis for the construction of large-scale civic works, such as the aqueducts and

*The reader may wish to refer to Frederic Andre Engel's brief overview of common dwellings of the Andes in *An Ancient World Preserved* (New York: Crown, 1976), pp. 267–273, since our discussion is restricted to masonry civic architecture of the Andean cultures.

canals. Such gigantic enterprises required rigorous organization and the subordination of other concerns to public works. The utilitarian and collective bias of the Moche culture is most evident in the costly construction of enormous platforms. It also appears in a structural experiment (or accident) approximating a keystone arch construction. One Chicama Valley tomb has a curved roof of adobe bricks resembling a European tunnel vault (or the dome of an Innuit snow house). It is believed to have been built with longitudinal sticks supporting a surface layer of bricks. The sticks disintegrated, and the bricks were locked by gravity into position as an accidental vault. Intentional or accidental, the resemblance to a tunnel vault is striking.

Another architectural achievement of the northernmost Andes is from the Chimu period (c. A.D. 1400–1470). The major Chimu (or Chimor) city is called Chan Chan and is situated near Trujillo. There is little information about the origins or the decline of this city, but pottery finds strongly suggest that Chan Chan did not exist during the Moche era and that its earliest history does not antedate the twelfth or the thirteenth century. It is believed that the ruins, covering about eleven square miles, represent progressive architectural activity over three or four hundred years. The most prominent remains of the city are ten or eleven walled enclosures, surrounded by adobe brick walls rising to a height of fifty to sixty feet. Striking differences distinguish Chan Chan from other northern cities. The other cities appear to be both smaller and more provincial, and they are also of more ancient construction, whereas Chan Chan is the metropolis and the "new" city of the region. There are few pyramids at Chan Chan, and all of them are modest in size. The ruins of Chan Chan are riddled

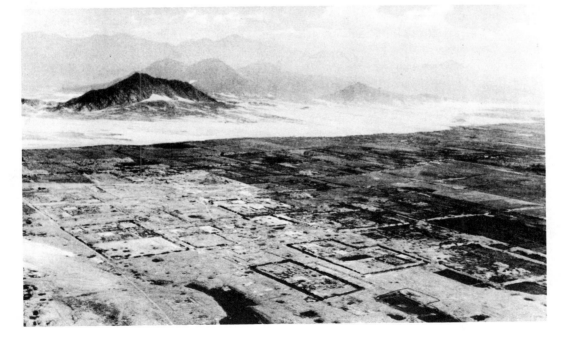

Chan Chan: general view. Peru, c. A.D. 1300–1400. From Kubler.

Andean bottle-shaped burial construction.

with deep rectangular pits, which, though they are still the subject of debate, may have been produced to supplement the irrigation system.

At Chan Chan the number and the size of the compound walls are astonishing. Scholars are undecided about the function of these walls. In what sense were these walls restrictive? Were they meant to keep the population contained or to protect the people from invaders? Thorough excavation of Chan Chan has been undertaken only recently, and thus numerous questions still remain unanswered.

The centers of the coastal valleys of southern Peru are characterized by far less ambitious urban plans than those of Chan Chan in northern Peru. The southern zone, with its characteristic polychrome ceramics and bright-hued textiles, extended from the Canete Valley, on the Pacific Coast of Peru, east and south to Bolivia, and to Argentina and Chile. As in the rest of the Andean zones, the centers of artistic development in the south were either in the coastal valleys or in the widely separated highland basins.

The two major sites of the south coast valleys were Paracas and Nazca. The Paracas Peninsula was the center of rich burials, yet there is no evidence that the peninsula was inhabited by the wealthy people who were buried there (Kubler). The existence, therefore, of an affluent, urban population in the area is problematical. The major known sites are the Cavernas tombs, consisting of bottle-shaped burial constructions, and the nearby Necropolis tombs, consisting of chambered and rectangular structures built with the remains of an earlier settlement in the same zone. This mortuary architecture dates from a time "rather later than the beginning of Chavin, and it gave rise to a different tradition, which we know largely from the very prominent cult of the dead" (Bushnell). The numerous skeletal remains that have been found are typically laid out in a crouched posture, unlike those of the north, where the bodies are usually extended. One type, discovered in groups in deep, dome-shaped, rock-cut tombs, includes numerous individuals with trepanned skulls. Another type, found in great numbers in rectangular pits, has highly deformed skulls. As we have already noted in the discussion of textiles from these sites, the "mummies" are wrapped in numerous layers of mortuary cloth.

It is curious that the same, distinctive bottle-shaped (or "shaft-and-chamber") tomb construction also occurs in the Mexican cultures of Colima, Jalisco, and Nayarit, though nowhere else in Meso-

america. "Many other elements also suggest a possible connection with inhabitants of the northern Pacific coast of South America, who could have sailed north on balsa rafts" (Easby/Scott).

Except for these tombs of the south coastal valleys of Peru, there is no current evidence of lavish settlements. The nearest architectural ruins from this desolate site are about fifty-five miles away, in the Ica Valley, or twenty-five miles distant in the Chincha and Pisco valleys.

At Nazca there appears to be little evidence of structural originality. According to Bushnell, "about architecture there is little to say." The Nazca region is similar to other areas, in that ceremonial centers were based on stepped pyramids. One of the largest sites of the Nazca phase is a group of six complexes, each containing mounds that are terraced and faced with conical adobes.

But these platforms were built over natural hills and do not approach the size and monumentality of the pyramids of the north, which were constructed over massive and artificial rubble cores.

The architectural achievement of the so-called Nazca Lines is unquestionable. I have, however, already discussed these remarkable endeavors in the chapter devoted to sculpture and earthworks, and will simply reaffirm the brilliance of the conception of the Lines by quoting from Kubler: "It is perhaps unexpected, but it is not improper, to call these lines, bands, and effigies a kind of architecture. They are clearly monumental, serving as an immovable reminder that here an important activity once occurred. They inscribe a human meaning upon the hostile wastes of nature, in a graphic record of a forgotten but once important ritual. They are an architec-

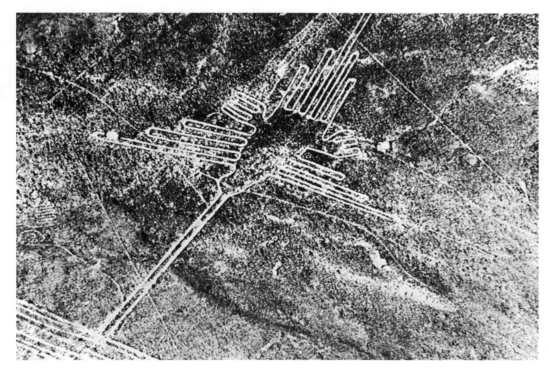

Nazca Lines: "Hummingbird." Nazca Valley, Peru, c. A.D. 800.

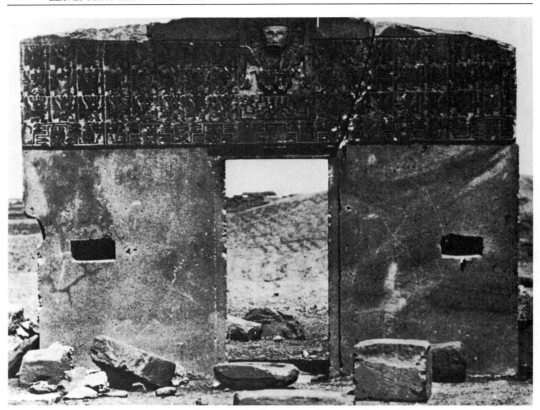

*Monolithic gateway—
Gateway of the Sun—
Tiahuanaco, Bolivia.*

ture of two-dimensional space, conse-
crated to human actions rather than to
shelter, and recording a correspondence
between the earth and the universe, like
Teotihuacán or Moche, but without their
gigantic masses. They are an architec-
ture of diagram and relation, with the
substance reduced to a minimum."

The archaeological zone called Tia-
huanaco (or Taypicala) consists of sever-
al platforms, enclosures, and buildings,
scattered over an area of about "1500 to
1300 yards" (Kubler) and constructed of
earth revetted with large fitted stones.
Isolated in the south highlands of Peru,
Tiahuanaco contains edifices similar in
function to those of the distant ceremo-
nial centers of Moche, Tikal, and Teoti-
huacán. It is far smaller than other ritual
sites, yet its orientation upon the cardi-

nal directions makes it possible to as-
sume that it was doubtlessly a station for
observations of the solar year, and as
such it was the center of the cosmos, as
suggested by its Aymara Indian name,
Taypicala, signifying "the stone at the
center."

Kubler has observed, "The site has
been sacked by every generation for five
centuries. Each year of casual plunder
has added to the disorder, so that the
disintegrated array of stones and earth-
works today allows us to form only a
ghostly idea of the original appearance,
now far beyond recall. Even with the
most generous intentions, modern at-
tempts to reconstitute Tiahuanaco yield
only a loose group of edifices falling far
short of the scale and importance of the
greater Mexican and Maya centers, as

well as of the principal coastal Andean sites.'' Tiahuanaco is comparable in magnitude and complexity to Chavin de Huantar or Cerro Sechin. Its foundation was laid probably before A.D. 400, and it may have flourished under a variety of masters until the Spanish invasion. The major flowering of the celebrated arts of Tiahuanaco probably occurred during a golden era, dated after A.D. 300. The later phases of Tiahuanaco history are unknown.

Three distinct methods of wall assembly may point the way to a possible chronology of Tiahuanaco. The first is an unbonded post-and-infill system resembling the very early one at Cerro Sechin. A second method recalls the bonding used in Greek temples: the stones are linked by shallow matching T-shaped channels in which molten copper was poured to form H-shaped cramps. This is the earliest American use of metal for structural purposes. A final stage appears to have marshaled in a radical alteration of the Tiahuanaco style, through the introduction and/or development of stone-cutting metal tools, probably of cold-hardened copper. Radical differences distinguish this phase of the Tiahuanaco style from all other ancient American architectural stone sculpture. Angular cuts, rectilinear designs, and minutely detailed ornaments are its characteristics. The architectural ornamentation, in its strict regularity and measured accuracy, recalls the textile designs of Tiahuanaco.

The most renowned of Tiahuanaco's surviving architectural features are the sculpture of such structures as the Sun Gate, already described in detail in the chapter on sculpture.

Bushnell has remarked upon the im-portance of some minor sites in the central and south highlands of Peru. At many places in the Province of Canta, east of Lima, there are interesting single-story cylindrical towers of masonry. They are probably pre-Inca, though no date has been established for their construction. The walls increase in thickness from bottom to top, and a square central column, which also expands upward, supports the slab roof. Usually these towers are empty, though mummy bundles have been excavated under the floor, according to Bushnell.

In the west of the same province, at Chipprak, there are rectangular towers of the same random masonry, with trapezoidal niches extending the whole height of the facade. These buildings are reported by Bushnell to have subterranean chambers, some of them containing mummies, and the main chambers constructed with niches in the walls, which thicken upward like those previously described.

In the Titicaca Basin are the best-known *chullpas* (burial towers). The finest examples are at Sillustani: round or

Incaic wall construction. Cuzco, Peru, fourteenth to fifteenth centuries A.D.

square structures faced with finely dressed masonry or, often, built entirely of random masonry. They were probably built by the Aymara people before and after the Incas, and they are related to crude pottery which may have developed at the end of the Decadent Tiahuanaco style.

Temple of the Sun—Coricancha—Cuzco, Peru. Classic Incaic style. In his Historia Indica *(Berlin: Pietschmann, 1906), Pedro Sarmineto de Gamboa, a chronicler of Pizarro's period, has described the thrones of* Coricancha: *"There were two seats in that wall, which the sun struck as it rose, and the stones were cleverly pierced, and many precious stones and emeralds set in the holes. In these seats the kings sat, and if anyone else did so, the punishment was death."*

Sacsahuman Fortress walls. Site north of Cuzco, Peru, c. A.D. 1500.

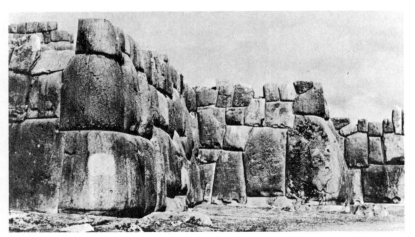

The history of Andean architecture ends in the rise in the Valley of Cuzco of the remarkable militarists of the south highlands known to us by the collective name Inca. It is in the building history of Cuzco that we can survey the full range of Inca architectural practice.

Although the Inca are believed to have settled at Cuzco at least as early as A.D. 1200, scholars such as Bushnell state that "nothing notable about their art occurred until they began to build up their empire in the middle of the fifteenth century." Throughout Cuzco, colonial and pre-Columbian walls and doorways are so intermingled that it is now impossible to determine the boundaries of the original Inca city. "The most important walls, such as those at Sacsahuaman and in the Temple of the Sun, display a (pre-Columbian) technique of shaping the individual stones which may well have continued in use until the sixteenth century. Three principal masonry types are evident: 'polygonal' walls, with large irregular stone blocks carefully fitted; rectangular blocks of stone or adobe laid in approximately regular courses; and *pirca,* or rough boulders laid in clay mortar" (Kubler). The walls of Sacsahuaman belong to the first type, while the walls of the Temple of the Sun represent the second. *Pirca* served, in the main, for the construction of plain housing. The first two methods of wall construction display remarkable precision in the fitting of stones—a hallmark of Incaic technology. All stones fit upon concavely curved depressions worked into the stones immediately below them. No block is seated upon a level surface; instead, every unit is cupped by its support, though the curve of the cup may be imperceptible. Many massive stones

retain the stubs of tenons left on the outer surfaces. "The combination of sockets or tenons with these curved seating planes immediately suggests the manner of shaping the stones for their close fit. After rough shaping with stone or bronze tools, each stone was ground against its bed in a swinging motion, suspended from a wooden gantry by rope slings catching the tenons. A few men could then abrade the swinging stone to a close fit with its neighbors by simple friction in a pendulum motion" (Kubler).

The best example of so-called megalithic masonry has been discovered at the site of the massive, triple zigzag rampart of the fortress of Sacsahuaman (a few miles outside Cuzco). This magnificent fortification is constructed of hard limestone, shaped into blocks of such overwhelming weight and size that it is difficult to imagine the labor required to move and place them. Such buildings had little in the way of architectural ornamentation, although this simplicity, which the Inca favored, did not apply to their elegant decoration of the Temple of the Sun (Coricancha), where gold plates were nailed to the stone and rich gems were set in sockets drilled around the stone niche-throne, a seat reserved for the overlord (the Inca from whose title his people have obtained their modern name). This niche, which is now stripped of all decoration, shows a characteristic of Incaic architectural detail: the use of trapezoidal alcoves, at once ornamental and utilitarian. The Coricancha rests on a remarkable foundation, probably the most frequently photographed and admired architectural structure of the Inca world: a wall set in a semi-parabolic curve. Pri-

Sacsahuman Fortress: aerial view.

The famous semiparabolic wall of the Temple of the Sun—Coricancha—in the classic Incaic style. Cuzco, Peru, c. A.D. 1500.

or to the devastating earthquake of May 1950, this marvelous parabolic structure served as the apsidal base for the Church of Santo Domingo, which had been built over the ruined Coricancha as a ruthless monument to the new religion

brought by the Spaniards. The earthquake of 1950 shook loose four fifths of all of Cuzco's buildings and destroyed much of the Dominican overlay, thus revealing the splendid original walls of the Coricancha. At present there is hope that the Santo Domingo Church will be removed, so that a restored Coricancha could appear in an approximation of its original magnificence—a sight unseen since 1533, when the Spaniards destroyed it. The restoration which is under way has proved exceptionally successful, for most of the original walls and all of the foundation, as well as the succession of trapezoidal niches and magnificent double-jamb lintels, have been recovered from under the plaster superimposition of the church walls. What has gradually emerged is the purest Incaic architectural style.

Although Cuzco is doubtlessly the crown of the Inca domain, both politically and artistically, there are architectural sites of great interest in other parts of Peru. Ollantaytambo, in the Urubamba River Valley, is a fine example of late-fifteenth-century city planning. Only thirty miles from Cuzco, Ollantaytambo is closely associated with Cuzcoan style. Ollantaytambo was probably the provincial capital of all the Urubamba Valley frontier posts, extending toward the tropical rain-forest people, whose products were essential to the highlanders' economy. The fortress of Ollantaytambo was built high on a mountain ridge above the confluence of two rivers; it commanded the passage, which was dotted for nearly forty miles downstream with the terraced towns of the Vilcabamba region, of which Machu Picchu is the most renowned.

Machu Picchu is certainly the most elaborate of the mountainside sanctuaries, composed of many terraced and gabled stone buildings. The central plaza, the only level space in the ruins, is a serene enclosure which serves as a contrast to the vertiginous slopes that surround Machu Picchu, rising fantastically into the clouds or descending dramatically to the river valley far below. There are architectural elements at Machu Picchu which deserve attention, but it must be

West facade of Santo Domingo church, showing the semiparabolic wall of the former Incaic Temple of the Sun (Coricancha) as the foundation for the Baroque apse. Cuzco, Peru.

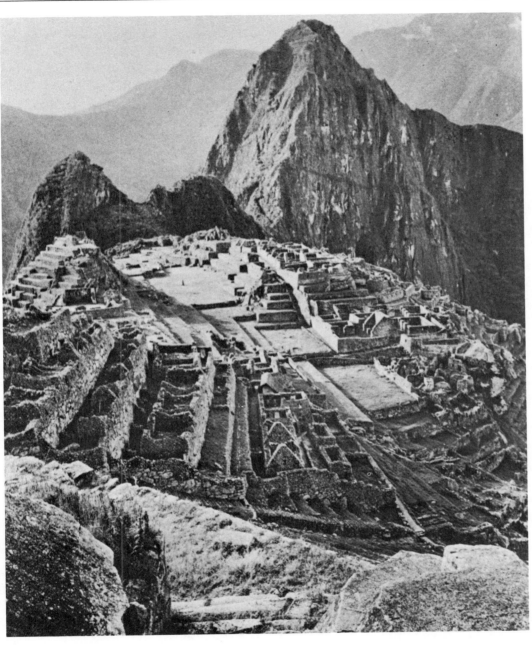

The Inca sanctuary Machu Picchu: general view. Peru.

admitted that the settlement's theatrical fogs, seclusion, magnificent sunsets, and international reputation as a "sacred place" somewhat outweigh its importance as an architectural site. For a highly picturesque touristic excursion Machu Picchu is both delightful and highly uncomfortable, but the true heart of the Incaic mentality—politically and artistically, previously and at present—is the stronghold of urban Andean Indians: the city of Cuzco.

11.
Minor Arts: Mosaics, Shellwork, and Cutouts

Mosaics

There is an unlimited number of minor art forms among the Indians of the Americas, for artisans worked in every possible medium: bone, antler, horn, seashells, and stone chips. Of these minor arts the most important is probably mosaics—a decorative technique using chips of stone, which are glued or otherwise attached to surfaces of wood or stone, to produce a handsome coloristic effect from the combination of multiple small, colored units.

This technique was used both in highland Mexico and in Yucatán. Mirrors of fitted pieces of pyrite attached to wood or stone have been found at Piedras Negras and Kaminaljuyu. Mosaic jade masks were discovered in the Temple of the Inscriptions at Palenque. Mosaic turquoise disks and masks have been found among Aztec remains. In architecture, intricate stone mosaic work distinguishes Puuc facades, such as those at Uxmal in Yucatán, and the Mixtec palace walls at Mitla in Oaxaca.

The Toltec and Mixtec techniques for shaping the tiny chips used in mosaic work differ from one another: Toltec examples (such as the plaque from the Chacmool temple at Chichén Itzá) have straight-sided polygonal chips ground to a flat plane, while the Mixtec examples resemble pebbly sharkskin (Kubler). This peculiar texture is achieved by the use of curvilinear and convex chips, surrounding figural designs in large pieces cut to the desired outlines (for example, the seventeen specimens in the form found in a Mixtec cave in the state of Puebla, Mexico).

Perhaps the most famous Native American mosaics are the nine turquoise mosaics from Mexico in the collections of the British Museum (now housed in the Museum of Mankind, London). These nine pieces are compelling enough visually to arouse enthusiasm; but their probable history as some of the first examples of Mexican art to be seen by Europeans gives them enormous ethnological importance as well.

At the time of the Spanish invasion of

Wari-Tiahuanaco mirror mosaic. Peru/Bolivia. Dumbarton Oaks Museum, Washington, D. C.

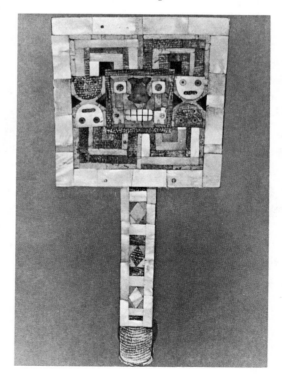

Mexico in 1519, the conquistador Hernando Cortes sent a gift of Mexican treasures to the Emperor Charles V; these remarkable objects were displayed in Brussels. The skull (a human skull covered entirely with mosaic) now in the British Museum collection is said to have come from a private Belgian collection; along with the other eight pieces now in London, it was probably part of the original treasure of Mexican art sent by Cortes. Even stripped of their feather and gold ornaments, these mosaic objects are brilliant achievements by superior craftspeople.

The mosaics of the United States have a limited distribution in the Southwest, where the technique was probably introduced from Mexico, c. A.D. 150. Produced mainly with turquoise, jet, and

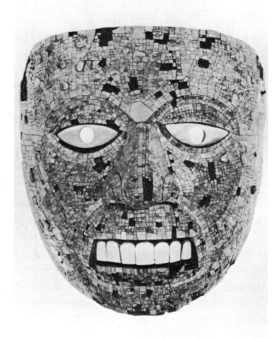

Aztec mosaic mask representing Quetzalcoatl (?). Turquoise set in resinous gum over wooden matrix; the eyes are of pearl shell, the teeth of white shell. British Museum, Museum of Mankind, London.

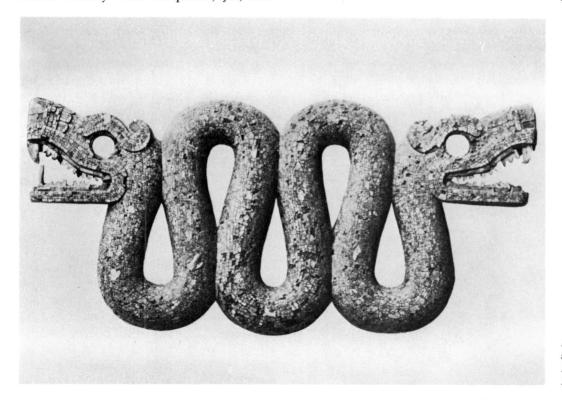

Mixtec or Aztec mosaic serpent. British Museum, Museum of Mankind, London.

shell, pre-Columbian examples of mosaic have been recovered from the Hohokam and Anasazi regions. Later, in the twelfth and thirteenth centuries, mosaic was particularly favored at the Zuñi pueblo of Hawikuh, and as noted in the chapter on metalwork and jewelry, the Zuñis remain the most accomplished workers in mosaics and lapidary art among present-day Indians. In fact, they now cut most of the stones used by all other Southwestern tribal craftspeople.

Inlay art, in which thin pieces of stone or shell are set in shallow depressions on an object's surface, is much more widespread today among the Indians of North America than mosaic, particularly on the Northwest Coast, where haliotis shell is inlaid in wood and bone (Feest). Inlay art may also have been prominent in the Northeast, but only a few early examples have survived. In post-Columbian times, inlays of European trade materials are prevalent in the Midwest and in the Great Lakes region, either as geometric lead inlays on catlinite pipes or as brass inlays on iron tomahawk blades.

A horned lizard, etched on a seashell with cactus acid. The technique was invented by the Hohokam Indians of southern Arizona c. A.D. 1000, predating acid etching in Europe by at least 300 years. Arizona State Museum, Tucson. Photograph: Helga Teiwes.

Shellwork

The Hohokam people of the Southwest invented a type of etching on seashells (brought inland via pre-Columbian trade routes). In this unique process an acid derived from cactus was used. The discovery of this technique predates acid etching in Europe by at least three hundred years. Animal and human forms were outlined and filled with pitch, and then the piece was submerged in a mild acid solution, made from the fermented juice of the saguaro cactus, which is unique to the Hohokam region; this acid corroded the surface and left a raised design when the protective pitch was removed. Characteristic iconography of this seashell etching is that of horned lizards ("horned toads") and rattlesnakes.

Seashells had many functions among the Indians of North America. For many groups they served as intertribal trade objects: conchs and whelks were frequently traded from the south Atlantic and Gulf of Mexico north to Canada and west to the Pueblos. On the Pacific Coast dentalium shells were traded for hundreds of miles, and abalone reached north as far as Alaska. In the nineteenth century traders imported shells for the purpose of trading with Indians, who obviously had a great regard for seashells.

Of the countless objects made from shells, the most important were various ornaments shaped and drilled from clam shells. One essential artifact made of shell was wampum, produced by Iroquois and Northeast Algonquin tribes, consisting of white and purple beads, ground down from the hard-shell, or Quahog, clam. Strings of wampum were used by Indians as currency. The Dutch

began to manufacture it soon after settling Manhattan. For years it was mass-produced; a small factory in New Jersey made wampum into the twentieth century. The most significant wampum, however, was not used for money but as a ceremonial object. Shell beads were woven into belts, especially by the Iroquois, and exchanged at peace treaties. Some wampum is woven with iconographic motifs representing official tribal records.

There are many other distinctive uses of seashell. Runtees are shell beads made by the Iroquois and Delaware (Lenni Lenape), engraved and perforated with two parallel holes. Inlaid pendants with motifs in turquoise and jet mosaic on pecten shells have been made for centuries by the Pueblo Indians. And on the Northwest Coast, imported abalone shell was precious as inlay material for wood carvings. Seashells were also used as ceremonial vessels. Made from univalves such as whelks and conchs, they were used by the ancient Indians of the Southeastern United States for their "black drink," which caused vomiting for ceremonial cleansing. At Spiro Mound in Oklahoma many remarkable shell vessels have been unearthed, all decorated with engraved designs. Most of the motifs, such as forked eyes and eagle dancers, are typical of the Southeastern iconography. Engraved shell gorgets are important elements in the late prehistoric cultures of the Mound Builders of the Eastern United States. Most are circular and formed from the walls of large whelks. They usually have two marginal holes and were probably hung around the neck. Fine line motifs are engraved in the pearly inner surface of the shells.

Whole shell beads and shell embroidery are found in almost all regions of the United States and Canada. The most famous surviving example of shell-embroidered clothing is the so-called Powhatan's Mantle, now in England. It is a leather mantle with small marginella

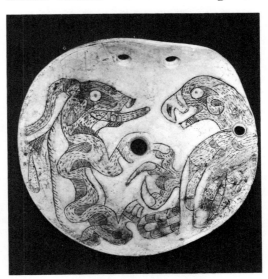

Circular shell gorget, with incised decoration representing an eagle and a puma. Mound Builders culture, Bell County, Texas, c. A.D. 1300–1700. Museum of the American Indian, Heye Foundation, New York City.

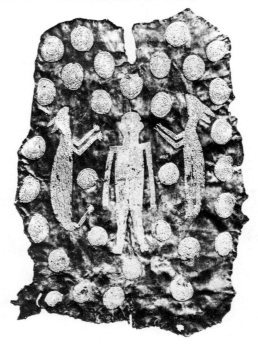

Powhatan's mantle, made of deerhide and sinew. Woodlands, Algonquin culture. Ashmolean Museum, Oxford, England.

shells meticulously sewn into designs. A similar use of shells is found among the Plains tribes, where dentalium shells were sewn over the shoulders of women's dresses in a capelike fashion. These dentalium shells were brought to the Plains by white traders about 1860 and became exceedingly popular as a decorative material.

Cutouts

A significant art form of the Indians of North America is that of positive cutouts made from flat pieces of materials such as leather, bark, shell, bone, or sheets of mica or copper. As Feest has pointed out, "even though there is a certain three-dimensional quality in these images, they clearly derive from a two-dimensional graphic tradition." Prehistoric Southwestern cutouts (such as Hohokam stone palettes), as well as later examples from the same region (such as Zuñi bird fetishes made of shell), tend toward sculptural form, in contrast to the similar cutout forms of the Eastern United States, such as the Hopewell copper and mica images or the Plains Indian amulets cut out of hide.

Native American ingenuity in the use of a wide array of materials is remarkable. Every medium—ivory, bone, horn, and so on—was exploited for utilitarian and ceremonial objects of great beauty, with infinite respect for the earth and the animals which were the constant source of the riches Indians recognized in every aspect of their world. There is not a single object produced by traditional Native Americans which is not a silent song of thanksgiving to the opulence and wonder of the cosmos.

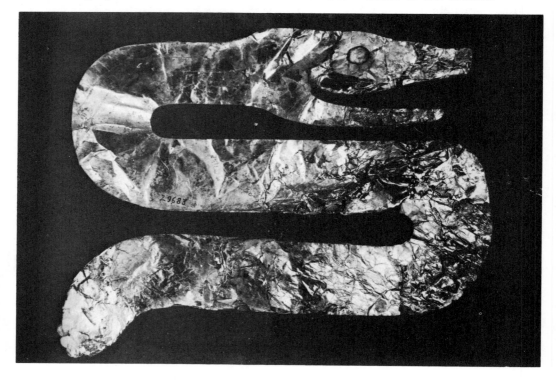

Snake: mica silhouette. Hopewell culture, Ohio, c. A.D. 200–500. Peabody Museum of Archaeology and Ethnology, Harvard University, Cambridge, Massachusetts.

12.
Painting

Painted motifs as decoration have been mentioned and praised in the chapters concerned with pottery, sculpture, and architecture, but we have thus far given little attention to painting as a medium of expression or to its history. Separating painting from the other arts is admittedly arbitrary, and does not mean that painting pottery, for instance, is not an important activity of painters. But what we wish to concentrate upon in this chapter are the several painterly aspects which eventually evolved into various "schools" of twentieth-century Indian painting.

The most effective way of approaching the subject of Indian painting and its various prehistoric antecedents seems to be through a brief survey of the hemisphere-wide tradition of rock art, followed by a profile of the most distinguished painting of pre-Columbian Mesoamerica and South America, and the ways in which this early art gave impetus and shape to several interesting Hispanic Indian and Indianist painters of the twentieth century. Finally, we will explore the various media used by North American Indians in their earliest explorations of painting, bringing us into the present century's efforts by Native Americans to perpetuate both a traditional and modernist painting heritage.

The most widely distributed form of painting in the Americas (and in the world) is so-called rock art—painted images on boulders and cliff faces, on cave walls and rock ceilings. The iconography and even the hues and styles of these earliest of all known forms of painting (pictographs) have a peculiar uniformity throughout the world. In the Americas it is exceedingly difficult to provide dates for the various "galleries" of pictographs which have been discovered. Many may be post-Columbian, but many others probably date from very early times. Luis Lumbreras (1974) has suggested that the famous Peruvian pictographs of men and animals in Toquepala may date from before the Middle Neothermal (6000 B.C., at the close of the Early

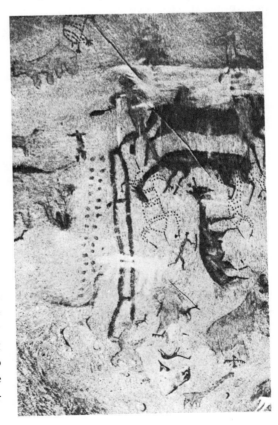

Pictograph of men and animals (?) from Toquepala, Peru. Middle Neothermal period or earlier. National Museum, Lima.

Postglacial period). It is usually assumed that millions of pictographs were made by American Indians, though weather and urban encroachment upon the land have destroyed many of them. Many more paintings are continually being discovered in caves and secluded river valleys. One of the most fascinating of recent explorations (reported by Harry Crosby in *National Geographic*, November 1980) was of the caves of the sierras of central Baja California in Mexico. The major mural of this region is almost five hundred feet long and thirty feet high, stretching across a San Pablo rock shelter long known to local people as Cueva Pintada, the "painted cave." No date has been determined for the origin of these paintings, although a wooden peg found in the cave has been carbon-dated to about the time of Columbus.

Clearly pictographs have a long and intertribal history, a tradition complicated by the fact that Indians continued to make images on rocks and cliffs until well into the twentieth century, employing mineral and vegetable pigments and iconography almost indistinct from those used hundreds of years ago by their forebears. The intent of these pictographs is as mysterious as their origins and creators, although it is generally assumed that they served both ceremonial and historical purposes. Feest and many other scholars divide the pictographic tradition into two types: "One of these is actually a form of picture writing, used for calendrical records . . . the second subtradition incorporates pictographic elements in scenic compositions which are usually biographical or historical." Clearly the use of pictographs for picture-writing and ceremony, for history and self-aggrandizement

has been a source of iconographic inspiration for modern Indian painters. Yet it is a mistake to jump to the conclusion that these emblems represent a hemisphere-wide artistic "language." As early as 1893 Garrick Mallery, the major scholar of picture-writing in North America, suggested the contrary: "To start with a theory, or even a hypothesis, that rock writings are all symbolic and may be interpreted by the imagination of the observer or by translation either from or into known symbols of similar forms found in other regions, is a limitless delusion. Doubtless many of the characters are genuine symbols or emblems, and some have been ascertained through extrinsic information to be such. With certain exceptions they were intended to be understood by all observers either as rude objective representations or as ideograms, which indeed were often so imperfect as to require elucidation, but not any hermeneutic key."*

There are four main areas of rock art in North America: California, the Columbia Plateau, the Great Basin region, and the Southwest. But, as already noted, there is hardly a geographic area in the Americas where images on rock do not exist. Except for rock art, there is no form of painting which ranges over the whole hemisphere.

In the Valley of Mexico the long use of pictographs was gradually supplemented by a more painterly art form: mural painting. As Kubler has pointed out, the exact chronological sequence of the early murals of Teotihuacán is un-

*Garrick Mallery, *Picture-Writing of the American Indians* (U.S. Bureau of American Ethnology, Annual Report No. 10, Washington, D.C.), 1893.

certain, "but the assumption is warranted that painted wall decoration began early in the Classic period (100 B.C.) with geometric designs and banded schemes." By late Classic times (A.D. 700), heraldic friezes of repeated glyph-like motifs became common. Another frequently used pattern during this period was processional files of figures in profile, apparently engaged in ritual activities. The conventions of landscape painting also became fixed. And pottery painting tended to follow the same development as mural painting, without attempting the elaborate landscape scenes of the late Classic. Similarly related to the decoration of pottery are the murals of Teopancaxco, a suburb of Teotihuacán. Here we see the development of a processional style which becomes a major form in Mesoamerican iconography: priests in profile with speech-scrolls flourishing from their mouths, advancing upon a sunlike disk. The stylization is distinctive and tends toward the angular, quasi-geometric manner of textile designs.

The earliest known landscape painting (a form which must not be confused with the naturalist orientation of post-Primitive European painting) is a highly stylized sacrificial scene from the Temple of Agriculture, near the north pyramid of Teotihuacán. "A watery foreground in two scalloped zones of waves stretches across the bottom. The picture space closes at both sides with identical pyre-like forms, surrounded by scrolls of smoke or flame (?), heaped in front of colossal pier-statues. . . . Between the statues, three uneven registers of small human figures mark the planes of land-

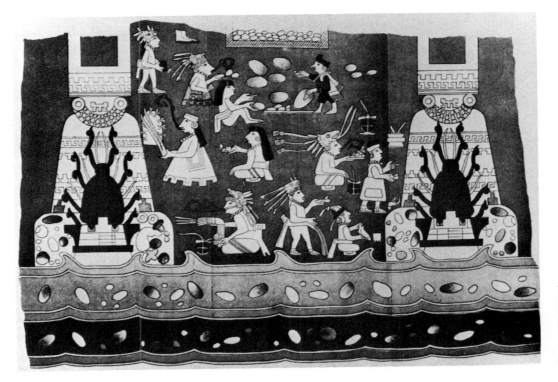

Reproduction in the National Museum, Mexico City, of a wall painting from the Temple of Agriculture. Teotihuacán II phase, c. A.D. 300.

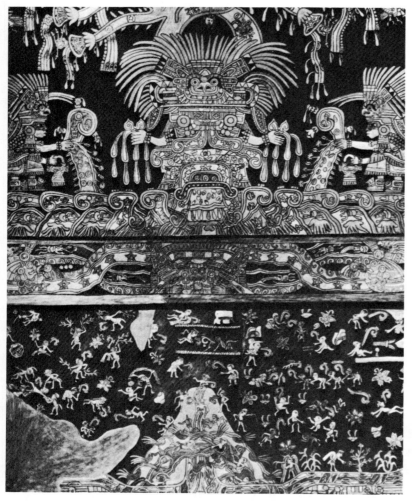

Reproduction in the National Museum, Mexico City, of a wall painting: a rain deity and his paradise in Tepantitla at Teotihuacán. Teotihuacán III phase, c. A.D. 500.

scape space in a conceptual perspective like that of Egyptian painting. The figures bear offerings. Some kneel or sit, others walk, and three priest-like figures in rich costumes and with animal headdresses have scrolls of speech or song issuing from their mouths" (Kubler).

This mural from the Temple of Agriculture exemplifies the formal, ritualistic mode of painting at Teotihuacán; a freer compositional style appears in Tepantitla, the residential compound east of the Pyramid of the Sun at Teotihuacán, noted for its wall paintings, especially the representation of Tlalocan, the para-

dise of the rain god Tlaloc. The upper wall is dominated by a painting dating from about A.D. 550, in which an image of gushing water is flanked by two priests. Below them is a frame of interweaving serpents, which acts as a margin between the upper subject and the mural beneath it: an animated landscape filled with dancing figures, butterflies, and flowering trees. The interconnected upper and lower scenes have been interpreted as representing the souls of the blessed in the land of the rain god.

Kubler has observed that the crowded symbolism of the art of Teotihuacán resembles the iconography of the Nazca people of the south Andean coast. "It also contains about fifteen signs recurring often enough," he notes, "to suggest glyph-like use. They differ, however, from Maya glyphs by their rarity and isolation. . . . Probably the entire 'writing' of Teotihuacán consists of names, time-markers, astral signs, directional symbols, and a few bar-and-dot numerals."

The iconographic system of Teotihuacán offers clues to the mentality of its creators. Representations of violence and aggression do not occur until near the end of the culture (A.D. 800). Early emblems are closely related to fertility and agriculture: flowers, water, and so on. The figures are unindividuated, tending to represent a people rather than a person. The style is impersonal and nondramatic, relying for expression upon benevolent emblems. It is, as Kubler points out, entirely lacking in direct erotic inferences; the contact between persons has no sexual or emotional connotation. Several important stylistic forms evolved at Teotihuacán which diffused widely throughout the Americas; as already

mentioned, the processional scenes with figures in profile are one of the hallmarks of iconography in the early Valley of Mexico. In regard to color, Teotihuacán used hues characteristic of its "school" of painting, as did the muralists of Pompeii. At Teotihuacán the dominant tones were red, ocher, black, and blue. There was in the distinctive red of these murals a uniqueness easily identified with the region and the period, different from "Pompeian red," though equally individual.

The late history of the Valley of Mexico (after A.D. 800) is dominated by the Aztec people. The few paintings that survive from this period consist of murals, ceramic decoration, and featherwork, but no codices have survived. "We have no certain early specimen of Tenochca manuscript painting. All the painted books known to come from the Valley of Mexico are now accepted as colonial documents, more or less remote from native tradition" (Kubler). Nonetheless, it is not impossible to define Aztec pictorial conventions, for they clearly commenced with the influences of Teotihuacán and continued that tradition by combining it with the manner of South Mexican manuscript painting. Thus, as Kubler notes, the Aztec painterly mentality "differs fundamentally from European conventions." Aztec painting, and the morphology behind it, changed very slightly from its earliest manifestations to the invasion of the Spaniards. "This scheme, like dynastic Egyptian drawing, consisted of uniformly colored areas with unvarying linear boundaries, describing only the most easily recognizable silhouettes. Sometimes a profile is selected; sometimes a frontal view; sometimes front and side are compounded to give an organically impossible but conceptually clear representation of body motions. Hollow objects and places are shown in cross-section to indicate their interiors. Thus a lake, a boat, or a pot are shown as U-shapes to indicate support, load, and interior space all at once (i.e. the images from the *Codex Nuttall*, a Mixtec painted book dated about A.D. 1350). The lower frame of the picture, or of the register, generally equals the ground line, and the upper frame is the sky. The bottom may also be read as near, and the top as far distance. Figures may overlap without marking any intended distance in depth. Distances among shapes are always signified by intervals in width or in height, and never by perspective diminution in an imaginary third dimension. Three-quarter views and foreshortening were never employed. Graduated tones to indicate roundness or shaded forms were also never used. A change in color usually

Scene from the Nuttall Codex, c. A.D. 1450. British Museum, Museum of Mankind, London.

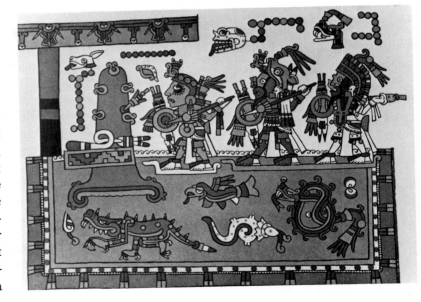

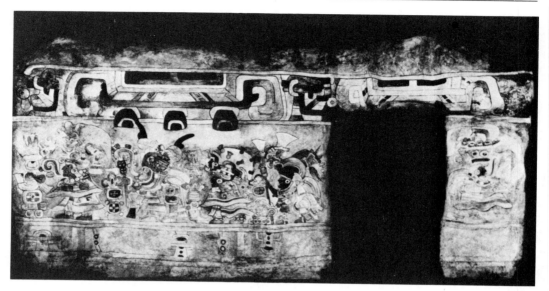

Reproduction in the National Museum, Mexico City, of a wall painting from Tomb 105 at Monte Albán, Oaxaca, Mexico, c. A.D. 600.

signifies a change of symbol. The compositional schemes always associate the general ideas of things, and they never purport to describe visual entities under instantaneous conditions. Compositional movement over the surface of many-figured scenes usually means movement in time. Radical compositions generally mean rotating sequences in time, as when the four quarters of a panel or page illustrate calendrical periods by identical figures wearing different colors and costumes.'' These perceptive remarks by George Kubler may be applied generally to the painting of Mesoamerica and may also be used as a summary of painterly mentality throughout the Americas, though, as we shall see, there are regional variations.

Though the Zapotec center of Monte Albán in Southern Mexico is the next important phase of Mesoamerican painting, it is necessary to make a brief excursion to the Gulf Coast region, where important discoveries at two highland caves in Guerrero-Justlachuaca (1966)

and Oxtotitlan (1968) have provided evidence of rich polychrome rock paintings (parietal decorations) in the Olmec style. The two caves, which are only twenty miles from one another, appear to have been sanctuaries. At Justlachuaca the paintings do not appear until one is well within the shelter—about 3,500 feet from the entrance. The dominant colors are red, yellow, ocher, and black. Depicted is a lifesize human figure (five feet, five inches high) standing above another figure, seated in the so-called jaguar pose characteristic of Olmec sculpture. At Oxtotitlan there are two shallow grottoes in the cliff face, where several paintings were executed with mineral pigments in an oil base. Scenes similar to those discovered in sculpture from the district of San Lorenzo include jaguars and baby-face figures. Nothing is known about these highland cave paintings of Guerrero—when they were executed, by whom, or why their iconography relates closely to the Olmec images of the early periods of the Gulf Coast.

The dating of the wall paintings in the tombs of Monte Albán is much clearer. These mortuary chambers were constructed during Period III of the Zapotec civilization (A.D. 200–1000), and the paintings were produced with earth colors in a dry fresco technique upon a stucco surface. The murals represent processional scenes of figures in profile, moving toward a large tableau of heraldically regular composition spread across the back wall. Except for variations in detail, the scenes depicted in the two burial chambers of Monte Albán—Tombs 104 and 105—are identical in theme and technique.

Monte Albán III, the Classic Zapotec period, ended about A.D. 900 with the infiltration of Mixtec nomads; during the transitional phase—as the Zapotec declined and the Mixtec ascended in Southern Mexico—we are confronted with an astonishing archaeological void, spanning more than five centuries (Monte Albán IV and Monte Albán V). Apparently, the Mixtec were constructing their capital city, Mitla—only thirty miles east of Monte Albán—during this "dark age." Two thirds of the centuries

richly depicted in Mixtec codices (books) are completely unverifiable in archaeological terms. What happened during this great silence? We do not know. Kubler estimates Mitla art covers the three hundred years between the eighth and eleventh centuries. The painted books—the codices of this period—are the major evidence for the art of the invading nomads in Oaxaca, as Mitla is their principal monument.

It should be clarified at this point that the term "codex" formally signifies a gathering of leaves sewn or glued together at one side, with the pictures limited to single pages. There are four variations of the codex. 1) A *tira* is a manuscript painted or drawn on a long strip. It can be folded or rolled and is read up or down, from right or from left. 2) Screen-fold refers to a *tira* folded, or pleated, like a screen, with each fold forming a page on both sides. The paintings do not cross the folds between pages. This is the characteristic format of surviving pre-Columbian codices, which are almost always composed horizontally. Maya codices were composed on bark paper, while Mexican manu-

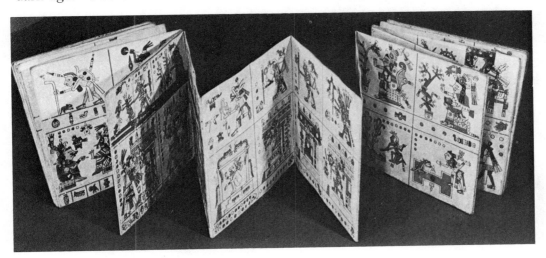

Mixtec Fejervary-Mayer Codex, with deerskin pages painted on both sides. Liverpool City Museum, England.

scripts were painted on animal skins. In both forms the surfaces were painted with white lime before the drawings were applied. 3) A roll is a *tira* that has been rolled rather than folded; it is not frequently encountered. 4) *Linezo* describes a painted cloth made from a narrow strip of cotton or maguey fiber. The term is an approximation of the English word "canvas." No pre-Columbian *linezos* are known. There is no special designation for a panel or a single-sheet painting, such as those executed on a single piece of animal hide.

The last Mexican paintings to be described here, and perhaps the most intriguing ones, are the painted books and maps of the Mixtec culture—objects appealing as art in their own right and precious as the only surviving history (genealogies) of the Mixtec nomads.

The books of Southern Mexico have a number of similarities: the deities resemble those of the Central Mexican pantheon (and are therefore identical to those of the Aztecs); the genealogical conventions resemble those of the Aztec genealogies, such as the Xolotl Codex. According to a number of scholars, the pictorial tradition of the codices was apparently learned by the Aztecs from the Tlailotlacs, a Nahua-speaking band emigrating to Oaxaca and (after being highly influenced by the Mixtec traditions of Oaxaca) returning to the Valley of Mexico about 1300. "Thus a Texcocan source supports the general indebtedness of late Mexican civilization to the Mixtec peoples of the post-Classic era, although the Aztec histories themselves give little account of the debt, which we can reconstruct only by indirect means" (Kubler).

Of the Mixtec codices the most renowned, probably, is the Nuttall manuscript. The front, which treats early genealogies in rather cursory fashion, changes on the back to a more open and spacious composition, in a brighter palette, with bigger shapes and more detailed sequences of narration—in "storyboard manner"—relating to the life of the eleventh-century conqueror known as Eight-Deer Tiger-Claw. Arthur G. Miller has indicated that "this kind of pre-Columbian picture making is directly linked to a visual mode of expression . . . which is presentational rather than representational. Another way of putting it would be to state that the Mixtec manuscripts are conceptual rather than perceptual modes of visual expression.

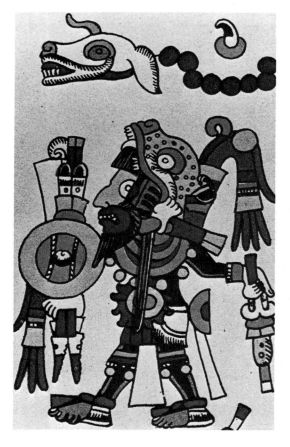

Mixtec Nuttall Codex, showing Eight-Deer in full regalia; c. A.D. 1450. British Museum, Museum of Mankind, London.

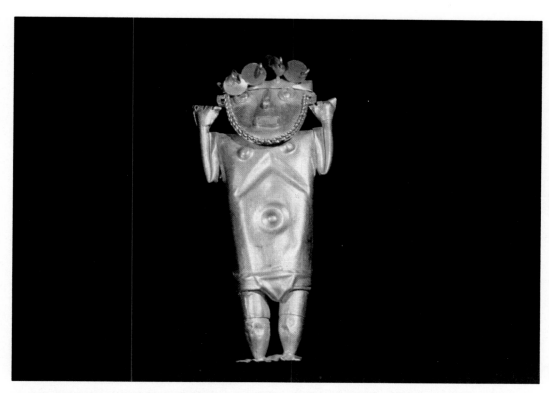

Moche idol, gold, Peru,
c. 100 B.C.

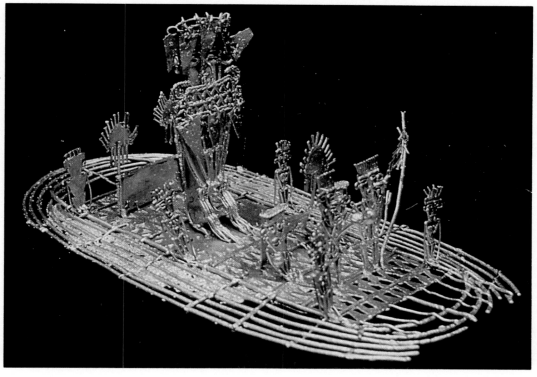

"Chief on Raft," gold,
Muisca culture,
Colombia, c. 1200.

Zuñi mosaic bracelet,
New Mexico, c. 1965.

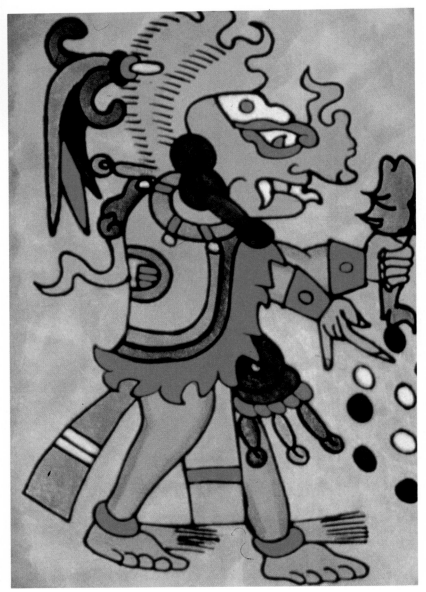

Chac, Maya rain god,
from a painted vessel,
Guatemala (?), c. A.D. 700.

Painted by Kills Two,
*Red Walker and His
Companions Fleeing the
Crows.* Ledger Art,
Northern Plains, c. 1870.

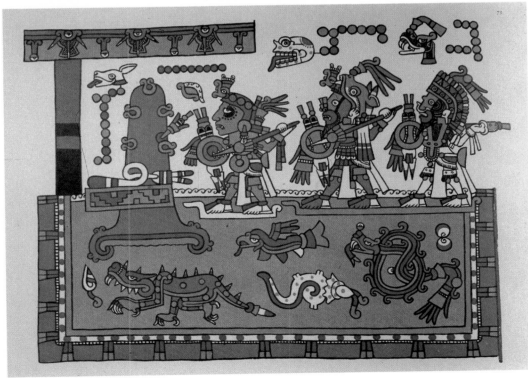

Mixtec Codex (Nuttall),
Mexico, c. A.D. 690.

Fritz Scholder, Mission Indian, *Hunter*, acrylic on canvas, 1978.

Ideas and concepts rather than the natural world are given visual form.''*

The codices constitute a priestly and scholarly memorandum, largely used for meditation. According to most students of the manuscripts, only the priests were able to interpret them. The complex conventions used to depict a sequence of ideas and concepts in a "visual language" were by no means a genealogy for the instruction or enlightenment of broad sectors of the populace.

When the Spaniards invaded Meso-america in 1519, the use of pictographs in Mexico had not attained the apparent abstraction (ideographic) caliber of "writing" among the Maya of the southern lowlands and Yucatán. Events in the codices are depicted by means of images, emblems, and rather simple hieroglyphs related mainly to names, dates, and dynasties. For instance, death is represented by a mortuary bundle (for example, in the Nuttall Codex), conquest is implied by a temple pierced with an arrow. To describe the conquest of a city located near a lake (as shown in the Nuttall Codex), the lake is painted and filled with aquatic animals, warriors are shown crossing over the water, and the glyph for the city is drawn within the water.

The iconography is complex and extensive—a serpent hanging from the sky represents rain; drought and famine are depicted by a red serpent pierced by an arrow. The eagle, the deer, the snake, and the butterfly were often symbols of the sun. In addition, the butterfly represented flame and the souls of the dead.

*Arthur G. Miller, *The Codex Nuttall*, edited by Zelia Nuttall, introduction by A. G. Miller (New York: Dover Press), 1975.

The moon was represented by a rabbit, the symbol of prolific fertility. Color was also a profound and essential symbolic "language" among the Mixtec and Aztec, as well as the Maya makers of manuscripts. White was related to twilight or a distant epoch. Red was blood and fire, the color of Tonatiuh—the sun god. It was also the color of the gold of springtime. Red and black in combination symbolized writing and learning. The human figure painted in yellow almost always portrayed a female. Clearly, color does not have a decorative purpose alone.

The codices are historical and reli-

Iconography: Death is depicted by a mortuary bundle (Nuttall Codex).

Iconography: A serpent pierced by an arrow represents drought and famine (Borgia Codex). An arrow piercing a temple symbolizes conquest (Nuttall Codex). Speech is represented by a volute emerging from the mouth of the speaker and is a form of ideographic writing (Mendoza Codex). Warriors crossing a lake inhabited by aquatic creatures symbolize a siege of a city, represented by a hill (Nuttall Codex).

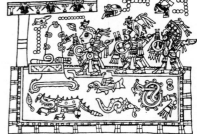

gious, pre-Columbian and post-Columbian. Only three Maya codices, thirteen Mixtec, nine Aztec, and a few other lesser manuscripts have survived. Most of the codices were burned by the Spanish missionaries in their mindless zeal to promote Christianity. The most horrendous of these zealots was Bishop Diego de Landa, who in 1562 publicly burned hundreds of manuscripts in the city of Maní, south of Mérida; in the opinion of many, this was the single greatest loss of historical documents since the burning of the Library of Alexandria. Fortunately, some of the Spanish clergy, among them the famous Fray Bernardino de Sahagún (whose merit is that he endeavored to save the cultural heritage of Indians), fully grasped that the conversion of Indians could be accomplished only if the missionaries understood pre-Columbian thought and religious conviction, and attempted to relate Indian myths to Christian ideals. Thanks to Sahagún, three of his Indian pupils—Tezozomoc, Ixtlxochitl, and Chimalpain—at the end of the sixteenth century and the beginning of the seventeenth century gathered together the traditions and customs of their people and formulated the now famous Florentine Codex under the guidance of Fray Bernardino de Sahagún.

The names given the codices—Florentine, Nuttall, and so on—are purely accidental and have no relation to their origins. Most of the names simply denote the place where the manuscripts were initially deposited or the person whose scholarship was closely connected with the discovery and/or clarification of particular codices.

There is considerable debate about the range of content, style, and form of the codices, from those produced by the Mixtec through those created by the Maya, Aztec, and other tribes. The style and the mode of construction were limited to certain recognizable conventions. The methods of "writing" have been categorized into three, still debated, forms. One consists of pictographic signs that represent events by means of images (a hill is a hill, a temple is a temple). Such conceptual painting was well known in ancient Egyptian art and in Medieval European painting. The second method uses ideographic symbols, portraying objects which intimate ideas and/or entities. (In Western iconography, for instance, a fish symbolizes Christ; in a like manner, a rabbit represented the moon to the Mixtecs.) As this method of writing evolves, it usually becomes more and more abstract, whereby the symbols have less and less affinity with the concrete objects they originally depicted. Chinese writing, for instance, is a good example of the advanced ideographic method: the idea of sorrow is represented as a woman standing beneath a door, with her image painted twice; but the objects of the woman and the door have been transformed into what appears to us to be abstract calligraphy. The third method of writing used by the ancient Nahuas people was debatably "phonetic" in form. In it the characters have entirely lost relation to the reality with which they were associated. The sign now denotes sound rather than object. For instance, *nahuac*, an abstract word that meant "near to," was painted in the form of a tongue, the symbol of speech. The image was a convention for transmitting the reference to a sound—"*nahuac*"—and not a reference to an object—"a tongue." The pho-

netic aspect of the symbol supplanted its ideogrammatic significance.

According to some experts, the Maya used ideographic writing and phonetic signs to a far greater extent than the Nahuas.

The Mixtec may or may not have combined all three methods and thus arrived at the principles of syllabic writing. In any event, the pictographic procedure of the Mixtec and Aztec books is reasonably understood by modern scholars. Unfortunately, however, the Maya glyphs have not been deciphered, except for name glyphs and date glyphs, which have been reasonably correlated to Western words and dates.

Little is known about the actual painters of the codices—whether they were a professional class, priests, or laypeople. It is also not known if they painted in the temples or in private dwellings, nor how they learned their complex craft. Early chronicles speak of great collections of manuscripts, an archive or library where codices were maintained—the largest located in Texcoco—but little else is known about the manufacture or the methods used to commission or, for that matter, to paint the manuscripts. From the evidence of the drawings themselves it seems that something similar to a painter's brush was employed, but nothing about the exact process used to execute the painting is known.

The post-Columbian codices were the record of a holocaust; the pre-Hispanic manuscripts were clearly not intended to rouse feeling but to endow religious and historical concepts with plastic expression—a process at the root of all important artistic creations of the ancient Mexican world. It is a tradition rich in the influence of the Mixtec people, and

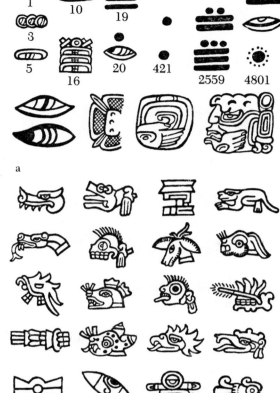

Glyphs: (a) Maya numerical symbols.

(b) The twenty Aztec glyphs for days (left to right, top to bottom): Alligator, Wind, House, Lizard, Serpent, Death, Deer, Rabbit, Water, Dog, Monkey, Grass, Reed, Jaguar, Eagle, Buzzard, Movement, Flint, Rain, and Flower.

it is also an act of painterly mentality which inevitably leads to the fullest glyphic and iconographic achievements of the Americas: those of the Maya domain.

Classic Maya pictorial traditions survive in only a few murals, vases, and manuscripts. According to Kubler, as in the ancient Mediterranean region, figural scenes in wall painting preceded vase painting, and both are older than manuscript illustration. Wall paintings date from Early Classic; the painted vases are Classic in origin; and the three surviving manuscripts are usually ascribed to Late Classic times.

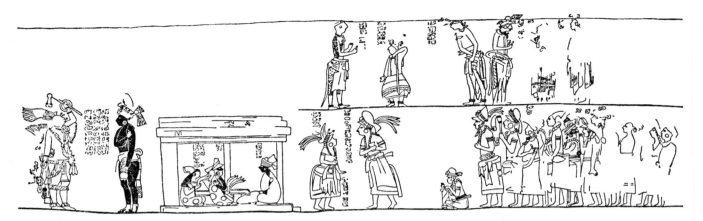

"The Early Classic development of mural technique marks an important stage in the emancipation of Maya painting from sculptural decoration, and it precedes the appearance of a polychrome figural style in pottery painting. The pictorial system in both depends upon outline drawing, colored in flat, local tones, without gradation of light and shade, and without the illusion of rounded bodies in graduated color. The oldest known Maya mural was uncovered in 1927 at Uaxactún . . . on the wall of a small unvaulted room of Early Classic date (roughly before A.D. 600)" (Kubler). This mural contains three scenes: a conference between standing figures; three seated persons inside a house; and four or possibly eight dancers on the right, moving to the music made by a seated drummer and attended by a dozen spectators. All figures are depicted wearing voluminous headdresses and billowing garments, but only the two standing figures have sandals. Some of the standing figures carry weapons typical of Central Mexico and wear non-Maya dress, perhaps, as Kubler suggests, representing representatives from Teotihuacán. The building in which three persons are seated is shown in a manner typical of Mexican manuscripts, in cross section. Nothing is known of the creators of this mural nor of its significance.

Some two hundred years later (c. A.D. 800), at Bonampak (a Classic Maya site in the jungles of eastern Chiapas, Mexico), substantially the same pictorial forms and schemes—seated personages attended by musicians and by dignitaries in conference—reappear on the walls of Structure I, greatly augmented by battle and dance scenes. The character of the painting has greatly evolved at Bonampak, particularly in terms of its arrangement: at the earlier Uaxactún site the figural friezes were composed like random strips of illustration, while at Bonampak the different registers correspond significantly to the walls, vault overhang, and capstone levels of the interior of Structure I. Fluid outlines enclosing flat planes of color remain the same as at Uaxactún, but here a new manner, of considerable expressiveness, occurs for the first time in known Maya pictorial history. The battle scene contains numerous studies of violent *action*.

This persistence of Early Classic manner and the introduction of an uncommon pictorial animation are elaborated into an epic style which fills almost every available space of Structure I. The surfaces in all these scenes are continu-

ous, with figural sequences continuing unbroken around the corners of the room. The upper register shows a sequence of preparation which represents a time earlier than the bottom register, which depicts the public appearance of the same figures; thus the scenes nearest the viewer are apparently the closest in chronological time.

The massive battle scenes suggest a punitive action by the Maya lords. As Kubler has noted, "nowhere else have we so complete a context for these themes as in the Bonampak murals, which require an entirely fresh interpretation of the cultural meaning of Classic Maya art. For many years the accepted symbol of Classic Maya civilization has been the image of a pacific priest-ruler, first represented in the stelae of the Petén during Early Classic times. The historical opposite of this theoretical god-impersonator is the Toltec Maya warrior of the post-Classic era at Chichén Itzá, where Maya and Mexican behavior and culture are clearly contrasted. The line between them was drawn at about A.D. 1000 and north of Uxmal. Now, however, it is clear from Bonampak and radiocarbon dating that these 'Mexican' modes of behavior were current in the (Maya) river cities before 800. Military leaders displaced priestly rulers in the middle Usumacinta cities some centuries earlier, and the traditional view of a pacific Maya ethos holds only for the Petén, and for pre-Classic and Early Classic periods. Classic Maya art therefore embraces and describes two quite different patterns of behavior—theocratic and militaristic."

Pottery painted before firing was common throughout the Maya period, though low temperatures tended to limit the vessel to being rather heavy, with a soft surface. During the Early Classic centuries, however, many potters successfully transcended the limits of low-temperature firing by applying a thin stucco (or clay) slip to the vessel surface. This permitted paintings of vivid colors in a wide variety of hues, although reds, browns, and yellows predominate, with the addition of black and sometimes blue (Bushnell). Painted images were applied to vessels of many shapes, but mostly to plates, bowls, and cylindrical vases.

The cylindrical surface of vases tended to prompt the painter to compose continuous designs. "The concave space of vision was inverted to fit the convex surface of the cylindrical vessels, whose field lacks a lateral frame. One solution was to align processional figures in a continuous band, which we may call re-entrant composition. Beginning, end, and center are identical, in an equiva-

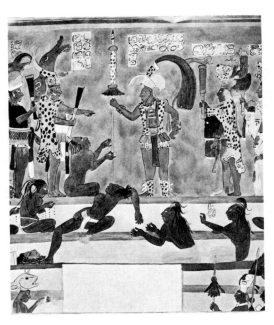

Reproduction in the National Museum, Mexico City, of a mural from Bonampak, Mexico. Classic Maya period, c. A.D. 800.

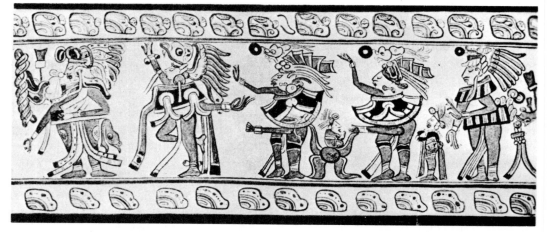

Cylinder vase painting of a religious procession. Copán, Honduras. Classic Maya period, c. A.D. 700. Peabody Museum of Archaeology and Ethnology, Harvard University, Cambridge, Massachusetts.

Toltec-Maya painting of a battle: Upper Temple of the Jaguars, South Wall. Chichén Itzá, Yucatán, c. A.D. 1150.

Salvador and Ulúa-Yojoa in Honduras) probably derive from the western types. The most celebrated style of figural scenes painted on pottery were Chama painting, dating from about the seventh and eighth centuries A.D. No other polychrome vessels approach the brilliance of those of orange, red, and black Chama style. In the Petén and in the western provinces, the tonality was duller and dimmer in hue. "Vase-painting from the Petén and [Belize] show hieratic themes; they are graphic in execution, coarser in structural technique, and more elongated and narrow than other Maya ceramic shapes of the same period" (Kubler). But Chama—at the archaeological site of Alta Verapaz (Guatemala), on the Chixoy River, polychrome pottery was outstanding—easily identified by black and white chevron bands that border the exquisite pictorial field, represents Maya pottery painting at its most accomplished and refined.

At Chichén Itzá, where Maya and Mixtec (Toltec) cultures merged, there was notable mural painting, though few details have survived. "They do not approach those of Bonampak in dignity

lence impossible on flat surfaces" (Kubler). Glyphs frequently play an intrinsic role in the overall composition. There were three chief styles of western Maya figure painting on pottery: in the Alta Verapaz, in western Yucatán, and in the Petén-British Honduras (Belize) regions. The two eastern styles (Copán/

and composition, but are full of ethnographic interest" (Bushnell). The best surviving murals at Chichén Itzá are located at the Temple of the Jaguars and the Temple of the Warriors. All are in extremely poor condition, and the painting can be studied with clarity only in reproduction.

As we know, four illustrated books of pre-Columbian Maya origin survive, and they have been amply discussed in the section on the Mixtec and Aztec codices. In all four manuscripts, extended hieroglyphic texts are illustrated by panels containing human figures, many with the attributes of gods. The writing, in this way, frames the illustrations, which apparently echo the salient points of the writing.

In the discussion of South American Indian painting, we will confine ourselves to the Andean region, since several styles of Amazonian and Panamanian body painting and fabric painting have already been discussed in the sections on textiles and pottery.

Moche (Mochica) painters tended to dismiss color and to concentrate instead upon the expert delineation of movement in almost unbroken ribbons of pattern. The line which produces these startling linear effects was either brushed or penned without the slightest variations in width, in red-brown or brown-black pigments on cream or beige slip, and in cream or beige lines on dark brown–red slip. Most figures are presented in profile, and there is little effort to suggest depth other than by the simplest overlapping of forms. Instead the Moche artist was concerned with achieving a marvelous impression of motion. "Every resource at his disposal was used to in-crease the agitation and restlessness of his work . . . the painted men run furiously; pumas attack suppliant victims; the waves curl on the waterline of a boat; the tassels of the ears in a field of corn are tossed by the wind; a flight of birds rises in all directions from a clump of cane . . . this description, however, is synthetic and non-historical, true only for the cumulative result of many centuries of development" (Kubler). In the Moche iconography there is a notable and rather obvious naturalism, which is too much admired by some art historians. On the other hand, one cannot fail

Below: Reproduction of a waterside village scene, with various activities depicted. Polychrome on plaster. Temple of the Warriors, Chichén Itzá, Yucatán, Toltec-Maya period. Peabody Museum of Archaeology and Ethnology, Harvard University, Cambridge, Massachusetts.

Bottom: Moche pottery motifs: (a) A regal person on a litter. (b) A courrier-runner. (c) A chieftain on a platform receiving prisoners of war.

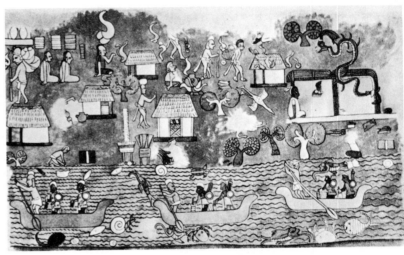

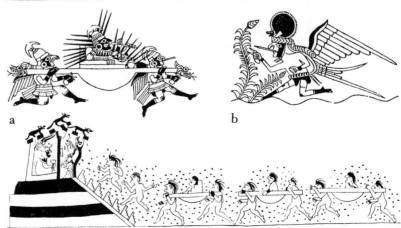

a

b

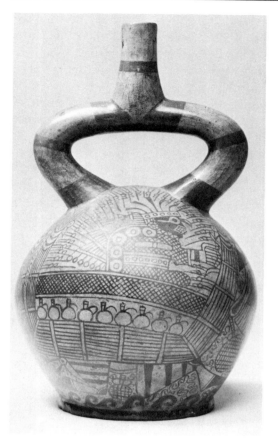

Moche painted vessel.
Peru, c. A.D. *200–500.*
Photograph: Sotheby
Parke-Bernet.

entirely upon the wondrous details of nature itself.

In modern Latin American folk and commercial painting there is a visible if somewhat diffused continuity with Indian motifs. In contrast to the present-day Indian painters of the United States and Canada, however, one cannot truly speak of a movement or a "school" of Indian painting in Hispanic America.

Mexican Indians still produce a variety of painted bark-cloth works, decorated with brightly colored animals and flowers, but the form has declined drastically, since the tourist market's demands have compromised an otherwise handsome medium. Several Andean Indians use house paint on a "canvas" made of stretched cowhide and produce delightful quasi-European renderings of village life and rituals. (Olga Fisch shows many of these charming works in her shops in Quito.)

In formal painting we can admire the Indian and Indianist works of artists such as Diego Rivera, Francisco Toledo, Miguel Covarrubias, and Rufino Tamayo, who either use European techniques to address themselves to the heart of the Indian or infuse their works, as in the case of Tamayo, with Native emblems. But this art cannot be called "Indian painting" in the same way, as we shall shortly see, that the consciously traditional works of North American Indians can be called Native American art.

As we have already observed, except for rock art there is no form of painting that ranges over the whole region of the United States and Canada. Among the Indian tribes of the Eastern zone of the United States there is little evidence that

to agree with Kubler's admiration of the uncanny Moche facility "for isolating and representing significant moments of behavior [which] also took form in portraiture and humorous characterization. Many vessels are unmistakable records of specific persons at determinable ages and in identifiable moods and attitudes." Two dominant and remarkable innovations among the Moche artists were an exquisite humor, rare in Mesoamerican and Andean art, and the inclination to create "natural" landscapes, which were apparently produced entirely for aesthetic purposes and "with an evocative vigor unparalleled in ancient America" (Kubler); they contain neither human forms nor monsters, but focus

an iconographic tradition existed during any period of history. Body painting and tattooing were widely practiced after 1492, but little prehistoric material survives to indicate wide use of painting. It is possible, of course, that painting on hide and wood might have existed during the Temple Mound times (A.D. 1000) in the Mississippian region, but no remains have been found.*

The pictorial traditions of the far western region were concentrated entirely upon basketry and pictographs. In the Northwest Coast area, art reflected the great importance of rank and wealth, and there were fine pictorial works, but they were secondary compared to the far richer sculptural achievements.

Before the turn of the century, the most important centers of North American Indian painting were in the Great Plains and in the Southwest. The fundamental differences between the mentality of these two tribal areas help to explain their creation of distinctive pictorial traditions. Among Plains Indians individuality was stressed, not only in terms of personal courage but also in the private vision on which a person built his or her metaphysical life. Plains Indians sought a personal guardian power, and most people accumulated a personal group of sacred objects that had spiritual power. These "medicines" were privately owned and illustrate the fact that power among Plains peoples has long been regarded as a personal rather than a tribal acquisition, derived from a body of community ritual.

In sharp contrast, the tribes of the Southwest (we are speaking now essentially of the ancient Pueblos) were organized around a highly ritualistic life pattern in which originality and individuality were discouraged. The Southwestern Indians of the United States were communal peoples, living a relatively sedentary agricultural life, in comparison to the small bands of Plains nomadic hunters. In the Southwest conformity was a fundamental aspect of tribal structure. In the Great Plains a far greater autonomy was possible, even to the extent that religious rites could be conducted by and for the individual.

In North America, only the Southwest is definitely known to have had a rich pictorial tradition in prehistory. Many remnants of that tradition have already been discussed in the sections on pottery, textiles, and basketry. Undoubtedly, some reasons for the survival of this heritage are the favorable climate, the low population density during prehistory, and the relative permanence of the architecturally organized Southwestern settlements.

A great deal has already been revealed about the pictorial past of the three prehistoric groups that occupied the Southwest (the Hohokam, Mogollon, and Anasazi) before the coming of the Navaho and Apache (arriving in this period: A.D. 900–1500).

The kiva murals (wall paintings on whitewashed adobe walls of pit houses), which are a foundation of Southwest imagery, date from the Mimbres period, c. A.D. 1000, although the most extensive development of such wall painting took place about A.D. 1200–1500. The kiva murals are unavailable to nonmembers of the Pueblo clans and priestly fraternities, but we know that they are dry fres-

*Of course, painting on cloth and pottery have survived, and have been discussed above.

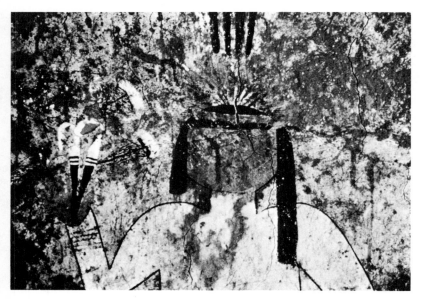

Mural: a male with a headdress holding a prayer stick (paja). *Anasazi culture, Pottery Mound, New Mexico.* Photograph: Dr. Frank Hibben.

co on plastered and whitewashed walls. The color was applied in typical Native American style (a style already described in our discussions of Mesoamerica and the Andean cultures): flat, even tones in discrete areas separated from each other by overlaid neutral or contrasting lines. Modeling, shading, perspective, scale, and textural effects are extremely limited; there is a flat, channeled surface on which three-dimensional illusion was ignored or was depicted by the use of overlapping figures. The style of the murals is largely representational, though non-naturalistic in Western terms, depicting animals, human beings, fantastic creatures, plant life, and astral forms. Landscape painting (in the Western sense of a realistic background covering an entire surface) is unknown in the murals, although the environment is sometimes suggested by clouds, rainfall, and lightning motifs. The earliest and most elaborate murals (c. A.D. 1000) are located at three sites: Awatovi and Kawaika-a near present-day Hopi First Mesa (Arizona), and Pot-

tery Mound in the Rio Grande valley between Isleta and Laguna pueblos (New Mexico). The murals show communal rather than personal imagery. In the more than five hundred recorded images, few repetitions of iconography or theme have been found, leading to the impression that the Pueblo painters did not evolve anything remotely like an iconography such as that discovered among pre-Columbian Indians of Mexico and of Central and South America. There has been great speculation about this curious fact, with the general conclusion that there was apparently no desire to formulate a symbolic hierarchy of motifs or a consistent style; the diversity of subjects seems to indicate a form of iconography that strived for unique, singular representations rather than a system of symbols, as they have come to be understood in glyphs and other forms of pictographic expression.

Despite the heterogenous figuration, these Southwestern murals have a curious similarity of appearance, and there seems to have been minimal change in either the visual effects or the techniques used over the five-hundred-year period prior to 1492.

As we have seen again and again, in relation to the traditions of basketry, textiles, and jewelry, the Navaho borrowed much of their material culture from the Pueblos, yet the history and origin of the famous Navaho dry painting—the so-called sand painting—baffle us. The sand paintings were probably taken from the Pueblo example, although there is no direct evidence that the Puebloan tribes were doing this form of ritual painting c. A.D. 800, when the Navaho migrated from central Canada to the Southwest. There are more than one

thousand different forms of sand painting, used as a central part of the Navaho curing ceremonies, by which harmony with the cosmos is maintained; all of the sand paintings are destroyed immediately after their ritualistic use. The composition of sand paintings is normally centrifugal and radial, for the painting is executed on the ground and is surrounded by the participants of the ceremonies. A framing figure usually encloses the painting. Carefully controlled lines isolate the color masses, which are made up of various ground materials. Motifs are angular, although circles occur. The subject matter is highly stylized and may include images of plants, animals, astral bodies, or supernatural beings. The figuration is conventionalized to such an extent that an overall unity of composition is achieved. These images are produced, apparently, exactingly and consistently—with only minor variations—but without resource to sketches, plans, or preliminary compositions.

The images on painted pottery, kiva murals, and sand painting constitute the dominant pictorial tradition of the Indian Southwest. A vast increase of interest, Native and Anglo, in these arts occurred with the renaissance brought about by the proprietors of trading posts in the 1880s, with the coming of the railroad and tourists. The first interest of visitors

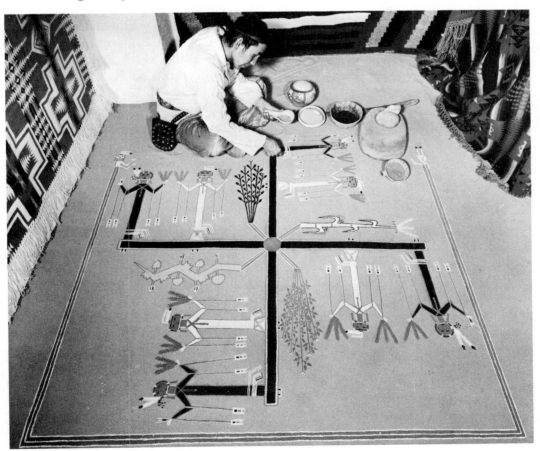

The first great sand painting of the series required for the Night Chant Ceremony of the Navaho. This sand painting is called Silneole Yikal—Picture of the Whirling Logs. Courtesy of Western Ways Features, Tucson.

Kachina. Drawn by Hopi artists commissioned by the ethnologist J. Walter Fewkes, c. 1900. Pencil and crayon on paper. The kachina is called Tawa—the Sun.

Northern Plains cylindrical rawhide container (parfleche). Photograph: Sotheby Parke-Bernet.

was Navaho blankets and rugs. Then, in 1895, the anthropologist J. Walter Fewkes unearthed some pottery, which inspired the Hano potter Nampeyo to initiate the revival of Sikyatki ware. A bit later, about 1900, Fewkes commissioned several Hopi men to make anonymous drawings of kachinas, which are among the first sponsored arts of the Indian Southwest.

In most North American tribes, specialization by an artist's sex and role in the group largely determined the kind of object to be decorated and the style to be used. Men almost exclusively produced compositions depicting life forms as well as supernatural beings. Men were the representational artists. Women, on the other hand, traditionally made abstract, geometric compositions. This specialization, for which there is no sexist value judgment, has been largely relinquished today.

In a general way, it is possible to identify the pictorial art of the agricultural Southwest with the application of rain, cloud, plant, and animal imagery on earthen surfaces. In contrast, the nomadic hunters of the Plains applied images of hunting and warring scenes on surfaces made of bone and animal skins.

It is generally assumed that on the Great Plains the geometric tradition of women was older than the figurative art of men, coming out of such antecedents of Woodland culture as weaving, quillwork, and beadwork. The geometric designs included circles and arcs, triangles, rectangles, and hyperbolas. The colors were primarily red, yellow, blue, and green, applied evenly and flat, and usually outlined with glue. The women's geometric art appears on many different objects, but principally on hide robes

and parfleches (utilitarian receptacles made of stiff hides).

The most influential Plains art form was the narrative composition, which was created to tell a story, often heroic or highly personal, celebrating a deed of courage or of spiritual awakening. Very often these representational works were drafted by a group of men, who drew on untailored hide robes and tipi liners made of skins. The paintings usually filled the entire field; often they were conceived as separate pictorial vignettes which documented specific actions. These vignettes, in their relationship to each other, suggest a narrative. As such, the images superficially resemble rock art: the figures are scattered on an un-modified surface, though on most hides and tipi linings one figure is not super-imposed on another, as in most rock art. Plains Indian composition was focused on the center of the skin, where the action was depicted and the figures were larger and more numerous. Often the composition is centrifugal, without top or bottom, suggesting that the hide was painted to be seen on the ground while surrounded by viewers.

The earliest surviving hide paintings (c. 1700), like the emblems painted on horses, shields, and other tools of war, were highly individualistic and were re-vealed to the artist through visions and dreams. The mystical images obtained from visions and dreams were painted in a flat, highly stylized manner in which perspective and volume were suggested by the overlapping of planes. This narra-tive and religious manner developed from a private iconography to some-thing new in the early nineteenth cen-tury, when encounters with Anglos brought new materials and subject mat-

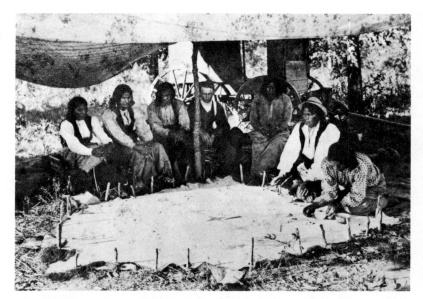

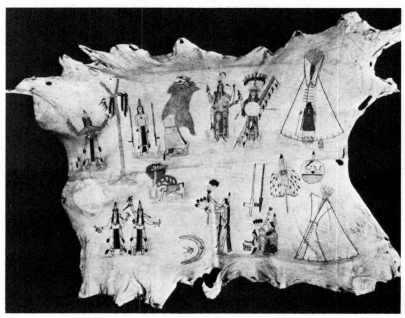

ter, as well as a fundamentally different aesthetic viewpoint. The contact with Europeans gave rise to a previously un-conscious expression of Indian group sol-idarity. Pictorial tradition became both highly conventionalized and militaristic. Cloth came into use as a substitute for animal skins, and the focus of Plains In-

Top: Comanche and Kiowa Indian elders painting history on a buffalo robe. Indian Territory (Oklahoma), 1875. Oklahoma Historical Society, Oklahoma City.

Above: Plains Indian skin painting, c. 1890.

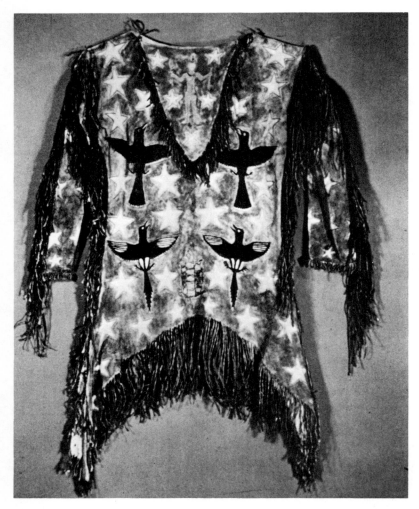

Pawnee Ghost Dance shirt, with sacred icons painted on buckskin. Oklahoma, c. 1890. Museum of the American Indian, Heye Foundation, New York City.

dian art became the tribe rather than the heroic individual.

"Winter counts"—which were calendrical records—were unique to the Teton Sioux (Dakota) and the Kiowa of the High Plains; however, they eventually had a lasting influence on the narrative style of many different Indians who were thrown together in the so-called Indian Territory, now Oklahoma, as well as in prisons, such as Fort Marion, in Florida. The "counts" consisted of a continuous series of simple images, each representing an important event in the tribal history for the year. Subjects for

the annual counts were chosen in council and were then added to the painted chronicle of the tribe. These unique counts were mnemonic symbols organized in chronological sequence that did not allow for personal imagination. They were, along with several other mnemonic methods of the Woodlands and Plains tribes, the only records remotely resembling "writing" in the United States and Canada.

Nearly all that is known of Plains painting has been uncovered since the beginning of the nineteenth century. As the ethnologist John C. Ewers (1981) has remarked, "as early as the sixteenth century European explorers saw examples of Indian art among the tribes of the American Southwest and Great Plains. During the eighteenth century later generations of explorers saw, admired, described, pictured, and collected artistic productions of the Indians on the North Pacific Coast. But it was not until the nineteenth century that the names of talented Indian graphic artists began to be associated with the works they created in the written records of white men. Surely this emergence of the individual artist from the limbo of anonymity marked a decided step forward in the history of Indian art."

Two of the first Plains Indians to emerge as named artists were the Mandans, Yellow Feather and Four Bears. "The considerable knowledge we have of these two Mandans," writes Ewers (1981), "the first graphic artists among the Western Indian tribes to be identified by name, reveals that they were both outstanding individuals in their own tribe." By the close of the 1830s both Mandan artists were dead, but by 1873 a Haida artist, named Geneskolos,

had emerged from the Pacific Northwest Coast tribes as a carver and tattooer of renown. He is the earliest known artist of the Haida. Among the Navaho Indians Ewers singles out Choh as the first Southwestern artist to be named. "I have been impressed . . . by the fact that even though the emergence of the named artist in the American West was a nineteenth century phenomenon, it occurred in Plains Indian studies a full half-century earlier than in the observations of the Indians of the Southwest. Among the tribes of the Great Plains there was a lively, secular tradition of military art that went back to prehistoric times in the painting on rock surfaces and buffalo hides. During the historic period, military art continued to find expression in the warrior-artist's recording on hides and later muslin and paper surfaces graphic records of his own achievements in warfare against both enemy tribesmen and whites. There was a very personal relationship between the artist and the brave deeds he pictured. It should not be surprising to find, then, that during the half-century after some of the paintings of Four Bears and Yellow Feather were identified by name, the works of nearly one hundred warrior-artists from at least a dozen Plains tribes were recorded . . . In the Southwest where the name of Choh did not emerge until the middle 1880s, there appears to have been no strong and continuous tradition of a secular graphic art" (Ewers, 1981).

It was in 1875 that the modern movement of Indian painting began on the Great Plains, where Indians still held their own against European invaders. These mounted hunters of buffalo became stronger and richer than they had ever been in their tribal history. Their hide-covered shields, tipi linings, buffalo robes, and pictographic historical accounts were filled with horses and heroic hunters. There was hardly a person who was not an accomplished "painter." As these great warriors of the Plains were subjugated by the United States Army and imprisoned far from their homes, they expressed their forlorn state and loneliness in an ancient graphic form. Using white men's supplies and drawing in army commissary books, traders' ledgers, and on lengths of muslin and canvas, the prisoners created emblems and images of their undying Indian heritage in their traditional pictographic styles. Of particular significance is the Ledger Art, as the genre became known, produced at Fort Marion, in Saint Augustine, Florida, in the years between 1875

Blackfeet tipi with painted cover. Montana/Alberta, c. 1930. Paint on canvas. Denver Art Museum.

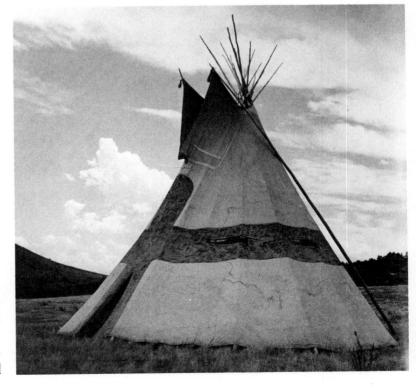

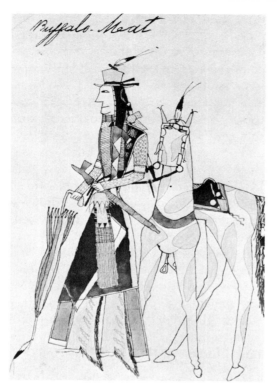

Buffalo·Meat

Right: Buffalo Meat (?), Indian with Horse, 1875. Pencil and crayon on paper. Oklahoma State Historical Museum, Oklahoma City.

Below: Otis Polelonema, Hopi Good Springtime Dancers, c. 1930. Watercolor on paper. Newark Museum, New Jersey.

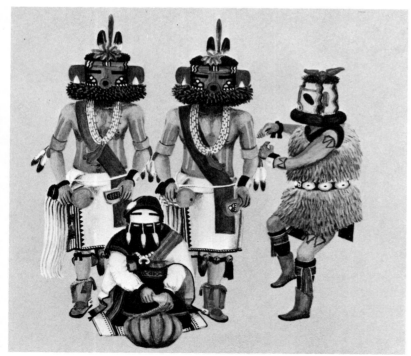

and 1878, when seventy-two young Plains Indians were imprisoned. Among these political prisoners were several ledger artists, whose fame has become legendary and whose example inaugurated a whole "school" of painters when they were released and returned to their territorial (Oklahoma) homeland. Of particular importance are the ledger drawings of the Kiowa and Cheyenne Indians Paul Zo-Tom, Howling Wolf, Buffalo Meat, and Etahdleuh Doanloe.

At about the same time, in the Southwestern United States, Pueblo and Navaho Indians began to experiment with pencils, crayons, and paper. Little is known about the earliest painters, but we know some of their work, painted on wrapping paper, ends of cardboard boxes, and other scraps. Encouraged by a few anthropologists and trading-post proprietors, individuals began to emerge as artists of reputation—a distinction that had not previously existed among the conformist Puebloan peoples.

In 1917 Crescencio Martinez of San Ildefonso Pueblo in New Mexico came to the attention of an archaeological field unit from the Museum of New Mexico, which learned that he liked to make paintings of dances at his pueblo. Less than two years later this pioneer of modern Indian watercolor painting died of influenza, but other young Indians took up his work and gradually evolved a distinctive idiom of Puebloan art. The artists had no formal, Western training (though they were hardly self-taught, since they were perpetuating a longstanding tradition, only in new materials). The most celebrated of these innovative and daring painters were Fred Kabotie, Otis Polelonema, Awa Tsireh, and Velino Herrera.

In Sante Fe in the 1920s, where an art community was coming to life among white settlers, people became interested in Indian art. But the repression of Indians did not change much until 1933, when John Collier became Commissioner of Indian Affairs. The next year the Indian Reorganization Act lifted the ban on teaching Indians anything about their own heritage. This was a great help to Dorothy Dunn, a white art historian from Chicago, who had recently founded a studio at the Santa Fe Indian School—one dedicated to an exceptional purpose: encouraging rather than obliterating the particular artistic expression of Indian peoples. The "Studio" eventually became a major center of art education for Indians.

Meanwhile, the revival of Plains Indian art began in Oklahoma about 1928, when Susie Peters, a fieldworker on the Kiowa Reservation near Anadarko, became enthusiastic about the drawings of a group of talented Native children. Their work was called to the attention of Oscar Jacobson, of the School of Art at the University of Oklahoma, where the young artists were eventually accepted as special students and became the first Indian painters to receive officially some kind of formal training. They were known variously as the Kiowa Five and the Five Kiowa Boys—though, in fact, there were more than five of them, and at one period a girl named Lois Smoky was included in their circle.

The Studio at the Santa Fe Indian School opened classes for promising artists from the tribes throughout the United States, and from 1932 to 1937, under the direction of Dorothy Dunn, the Studio helped bring into focus a style of Indian painting that, together with the works of the Kiowa Five and the drawings of the imprisoned Plains Indians, is called Traditional Indian painting.

After World War II, Traditional Indian painting became increasingly homogenized, and most of the regional and tribal characteristics began to disappear. A number of self-taught artists began to

Monroe Tsatoke, Old Hunting Horse, *1929. Museum of Art, University of Oklahoma, Norman.*

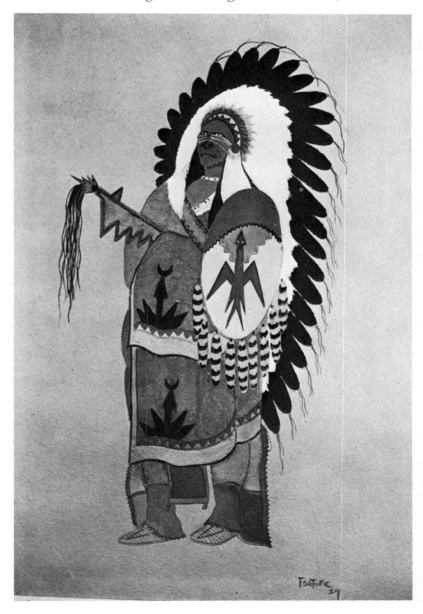

rise to prominence, and others who had briefly attended non-Indian schools also began to paint: Jerome Tiger, Blackbear Bosin, Rance Hood, Rafael Medina, and Raymond Naha. Their works were largely influenced by the Traditional idiom, except for a new emphasis upon motion and painted backgrounds, which probably arose from the impact of a painter named Quincy Tahoma, who had studied at the Studio in the 1930s.

In 1962, after a series of educational experiments utilizing contemporary art trends in the instruction of Indians, the Indian Arts and Crafts Board of the Department of the Interior and the Bureau of Indian Affairs of the United States created the Institute of American Indian Arts in the same buildings that had once housed the Studio. The intentions of the Institute were quite different from Dorothy Dunn's aim of reviving ancient Indian imagery and styles. The new art center examined Traditional Indian painting in the light of twentieth-century art modes. The result has been the emergence of a new school of painting called Contemporary Indian Art, which reflects the sophistication and worldliness of a new generation of Indians, whose education is essentially the same as that of whites, but whose cultural reference is still emphatically Indian.

Ironically and sadly, the Department of the Interior began to displace and phase out the Institute of American Indian Arts in 1980, despite massive objection from many artists and educators. During its two decades of operation, it unquestionably helped to produce, through much controversy and experimentation, some of the most influential and remarkable of twentieth-century modernist Indian artists.

As early as 1946, Studio alumnus Oscar Howe had already made major strides in the incorporation of Cubistic ideas in his otherwise Traditional paintings. R. C. Gorman had studied in Mexico and brought considerable influence from the Mexican muralists into his work. But unquestionably it is Fritz Scholder and, to a somewhat lesser degree, R. C. Cannon who were in the forefront of Contemporary Indian painting.

It is an error, however, to believe that all Indian painting of the recent past has

Rance Hood, Sioux Rainmakers, 1970. Tempera on illustration board. Tribal Arts Gallery, Oklahoma City.

Oscar Howe, Woman Seed Prayer, *1974. Casein on canvas. Gallery, University of South Dakota, Vermillion.*

been devoted to the contemporary idiom, and that all Indian painters of value were trained by the Institute of American Indian Arts in Santa Fe, for North American Indian art is highly divergent and has evolved in a great many different regions. There is, however, no question that the Institute turned out most of the important young Indian artists during the 1960s and 1970s; even among those painters who did not study at the Institute the influence of avant-garde ideas had a strong impact, through the success of people such as Scholder and Cannon, who managed to enter mainstream twentieth-century art centers. The importance of Indian art centers such as those at Santa Fe, Scottsdale, Gallup, and Tulsa cannot be underestimated. At the same time it needs to be pointed out that the exhibitions and art

Fritz Scholder, Dartmouth Portrait No. 6, *1973. Oil on canvas. Collection of the artist.* Photograph: Bob Hathorn/Al Olson.

circles of such centers have gradually become a bit elitist and self-serving. For several reasons, new trends from other regions were unduly neglected. This was not only because the status-quo–minded Southwest failed to recognize them, but also, it should be stressed, because some artists from Canada, the Southeastern

United States, the Northwest Coast, and the Iroquois region of the Northeast were not trained, as Institute alumni were, in art marketing and career management, and they were therefore rather unmotivated professionally and undisciplined personally to try to make an impact on the centers of Indian art.

In the 1960s and 1970s, Indian painters began to discover a basis for entering the modernist trends of the twentieth century at the same time that they began to discover *themselves* as individuals for the first time in tribal histories. It is therefore not surprising that in the last decade several schools of idiosyncratic art have grown out of the daring artists who have sidestepped tribal taboos and tribal expectations. Such a school is Canadian Algonquin Legend Art, which took shape in the late 1970s in northern Ontario. The art of this region is devoted to the visual realization of legends and tales of their heritage. It was the Ojibwa Indian Norval Morrisseau who brought this ancient pictorial tradition of his people's Midewiwin society into the twentieth century, when he began to recapitulate aspects of the iconography of his forebears in his contemporary paintings. Morrisseau was the first of his people to break the Algonquin taboos against the pictorial representation of these legends. Today, however, Morrisseau is one of Canada's major artists, and his influence has been very wide among other Ojibwa and Cree painters, such as the late Carl Ray, Samuel Ash, Jackson Beardy, and the Ottawa Indian Daphne Odjig.

Following this discussion of individual Indian artists, let us note that none of these artists is repudiating the validity of the Indian world or attempting to es-

Norval Morrisseau, Ojibwa Headdress, 1976. Silkscreen. Collection of John Anson Warner, Canada.

Left: Jaune Quick-to-See Smith, Porcupine Ridge Series No. 25, *1980. Mixed media on paper. Kornblee Gallery, New York City.*

Right: James Havard, Ghost Dance Shirt, Arapaho No. 349, *1977. Acrylic on canvas. Miesel Gallery, New York City.*

cape from it into some other world. To the contrary, as their art makes clear, they are highly traditional people, and their work focuses upon vital aspects of Indian culture. They often consider the inspiration for their paintings to be visions, revelations, and personal powers not distinct from the imagination that once inspired their ancestors. They represent a formative and assertive cultural aesthetic which, unlike the sadly assimilated mentality of Hispanic Indians of Mexico and of Central and South America, insists upon the right of the Indian to be both a reservoir of ancient wisdom and a member of the modern world. The difference between contemporary artists and Indian craftspeople of the past is that today's artists insist upon presenting whatever they personally envision as reality—and they do so with or without tribal consent—because the very core of their unprecedented motivation is to assert themselves as Indian individuals in highly personal and idiosyncratic images. For the first time North American Indians are producing a whole generation of intellectuals, artists, and politicians who selectively profit from and effectively cope with Western mentality. During the 1960s, 1970s, and 1980s, Indian artists of North America have helped to create new definitions of what it means to be Indian in the twentieth century and beyond. The impact of their work, especially upon Indians of Mexico and of Central and South America, has been revolutionary—suggesting how great the power of art can be in perpetuating the sensibility of a whole race of people.*

*For a more complete history of Indian art in the twentieth century, see Jamake Highwater, *Song from the Earth* (1976) and *The Sweet Grass Lives On: Fifty Contemporary North American Indian Artists* (New York Graphic Society), 1980.

13.
Oral and Written Literature

The American cultural histories, the genesis of the American continents, are Indian. As Abraham Chapman has stated, "Ultimately there can be no factually true cultural history of this continent, North and South, which does not begin with the long Indian legacy and its indelible impact on the American imagination."

As Europeans attempted to appropriate the American landscape as their own, they also imposed a history upon the hemisphere of their own making. Then, with the immense political struggles for independence in what became Latin America and the United States, this process of Europeanizing the Americas was dramatically reinforced. Today we are just beginning to rediscover and reaffirm the vast archives of Indian oral and written literature. It is a subject of great dimension and variety, and for this survey of the arts of the Indian Americas it is possible simply to scan the subject and attempt to generalize the countless ways in which Native American literary imagination has originated and vivified the iconographic, poetic, and imaginal elements central to the many media of art we have examined in this book.

When speaking of Indian *literature*, we are actually referring to several genres: texts that were originally oral compositions, which, after the arrival of Europeans, were written down in the Roman alphabet; texts existing in a number of Native recording systems used in pre-Columbian America, which have a literary legacy of their own—though many of these texts have not been successfully deciphered; and, finally, a recent tradition of writing in Spanish and English, produced by Indians themselves and by non-Indians with a profound knowledge and concern for Indian mentality.

The ancient American written and oral literature was greatly pirated and destroyed by missionaries and invaders. As we have already indicated, in the discussion of Native manuscripts, great bonfires were made of Toltec and Maya manuscripts. The books left unburned were either lost or sent to archives in the Vatican, as classified information. The literature of the Inca in *quipus* (the knotted cords which are highly disputed as "literature" by those who insist, with some reason, that they were essentially used for utilitarian purposes such as bookkeeping) was burned when the keepers of the *quipu* libraries resisted Spanish attempts at deciphering at the Council of Lima (1582–83). Thus, today we possess only a few codices. Through transcriptions and adaptations of the Roman alphabet, the Native library heritage of the Americas has miraculously survived the European invasion and cultural imperialism.

"Though sometimes inscrutable, as much by design as accident . . . American texts may be seen converging on certain fundamental topics, which may also be distinguished in the early literature of [Europe] like Hesiod's *Theogony* and his *Works and Days*, or the *Bible*, and *Gilgamesh:* the past and present

ages of the world; man's need to eat; and the authority of such professionals as the warrior, the healer, and the poet or scribe himself."*

Beginning late in the first century B.C., the Izapan style of Mesoamerica became the foundation of Native American written literature. At Kaminaljuyu, near present-day Guatemala City, undeciphered glyphs (which appear to be ancestral to Maya writing) were incised in stone slabs. "In this period, glyphs render the earliest written dates discovered in the Americas, all of them clustering between 35 B.C. and A.D. 36" (Easby/Scott). The Izapan and Olmec peoples were the first of a number of important Indian civilizations in which the process of transforming centuries of oral history into a written literature began. As we have already seen, the Izapan/Olmec writing tradition was probably the basis of glyphic literature produced by the Maya, Capotec, Teotihuacán, Mixtec, and Toltec civilizations, which preceded the literary heritage of the Aztec. A specialized study of early Mesoamerican literature is the subject of *Pre-Columbian Literatures of Mexico* (English translation, 1969) by the Mexican scholar Miguel Leon-Portilla; he outlines the existence not only of oral traditions, but recorded inscriptions, codices, written texts and documents containing mythic tales, chronicles, ritual hymns, poetry, discourses, the beginnings of a theatrical literature, and governmental and religious documents. As Abraham Chapman states, "The literature of the American Indians reflects an antique complex of

*Gordon Brotherston, *Images of the New World: The American Continent Portrayed in Native Texts* (London: Thames and Hudson), 1979.

original American civilizations and cultures, in varying stages of development, and with diverse styles and rhythms in numerous languages, the literature of civilizations and cultures very different from European culture, but civilized and cultured in its own way."

Brotherston has made a correlation between speech and script in Native American narrative tradition. "At the most fundamental level," he writes, "with the faculty of speech the artist imitates the god who speaks to create. In the properly ordered thread of his words he mimics and indeed records the divine utterance through which the world was created in oral cosmogony. Wholly dependent on memory, he composes chants and narratives with a strong and conscious emphasis on this same basic principle of coherence, which is sufficient to itself. Insofar as this verbal discourse is modified by or relies on visual symbols and signs, these are recognized as a means of creative expression which is analogous to speech. Such is certainly the case throughout the area north of the Maya, with its common fund of iconography and even principles of writing (anticlockwise reading, inversion as negation, for example). In recounting the origins of their ritual, the Mide shamans, the sandpainters of the Southwest and the Toltecs alike refer to 'culture-bringers' whose identities are similar and who are distinguished by having provided song and writing as reciprocal arts. The Great Rabbit figure said to have founded the Midewiwin invented their four-line chants as the complement to the four-symbol stanzas of the script he gave them, just as songs and sandpaintings were brought as a twin gift to the Navajo. In the Toltec tradition it is

Quetzalcoatl who has this role, the singing master and the teacher of the screenfold (codex) scribe. In the Nahua language 'to utter a flower' and 'to paint a song' are phrases which well illustrate the degree to which this reciprocity was felt between the two media. Sustained comparison between them led further to the idea of craftsmanship for its own sake, as it did among the Parnassians of nineteenth-century Europe; there are passages in Aztec poetry which catch exactly the correspondence between verse and the visual and plastic arts, and their promise of enduring fame, celebrated in Gautier's poem 'L'Art.'"

In the Maya hieroglyphic conception, the voice and the graphic image are directly related. In the Classic period of the Maya, speech and emblem have been united entirely. The rich iconography of North America was wedded to arithmetical principles of time-place, and in the south, the Chibcha and the Inca protracted this method into their *quipus*—where sign and glyph, speech, and icon have been interjoined. "The result of this combination, Maya hieroglyphic writing, is unique in the [Americas]; and in reflecting upon their literature Maya authors point to its origins in their calendar and arithmetic. They write songs which contrive to recount the beginning of time, and narratives which end but do not end. Maya authors are also distinguished by their attention to the *idea* of the book, *uooh* in Yucatec, *vuh* in Quiche. In valuing the power of the book, at its highest, to sustain and regulate, they see it less as God's actual scripture than as the work of authors who may become god-like in the exercise of their art. This in turn involves the idea of the text as literally

textile or woven, the 'mat' *(pop)* of authority on which calendrical time units are seated during their rule, and the base of wisdom which gives the *Popol vuh* its title. A similar notion is found in the Toltec tradition, where the mat of authority is equated with the matted fibres of the screenfold book (codex), and is evoked also in Inca textiles, e.g. in the figured belts of authority so carefully detailed by Guaman Poma" (Brotherston).

An excellent exemplification of classical American Indian literature is in the compilation of epics such as *Quetzalcoatl, The Ritual of Condolence, Cuceb,* and *The Night Chant* in John Bierhorst's excellent anthology *Four Masterworks of American Indian Literature* (New York: Farrar, Straus and Giroux, 1974).

American Indians, like all primal peoples, are supernaturalists, and for them time is extraordinary. Among the Australian aborigines, for example, there is the immediate and ordinary time of daily existence, as well as the experience they call "dreamtime"—which includes not only the events of our sleeping state but also those things we anticipate, envision, imagine, and conceive. The aboriginal dreamtime is the solution to the Western question asked by the late Hannah Arendt: "Where are we when we think?" For Indians, it is a question answered without ever being asked.

Dreamtime is sacred time—the realm of myth and inspiration. It is the time in which creation takes place, in which the ineffable continuum of nature flickers brightly. It is the reverberation of first things, when the cosmos makes its most ancient drummings, like the genesis de-

picted by the Quiché Maya in their saga, the *Popol vuh:*

> The surface of the earth was not yet made. There was only the quietude of water and a vast expanse of blue sky. There was nothing yet brought together, nothing which could make a sound, nor anything which might tremble or gesture or sigh. Not in the sky nor in the water was there breathing or dreaming. There was nothing standing; only the calm sea, the motionless water, alone without itself in silence. Nothing yet existed. There was only a tireless immobility and a perpetual stillness in the vast and deep darkness of the night.

The mythic antiquity of the dreamtime, however, is not truly found in the "past," as the West understands it. "The rich mythic accounts of creation," Joseph Epes Brown writes, "are not so much of chronological time-past as they usually tend to be read by us. Rather they tell of processes which are of eternal happening; the same processes are recurring now and are to recur in other cycles." Given this structure of experience, supported by primal forms of language which are utterly distinctive in their grasp and expression of the nature of reality itself, and made immediate by the experience of people's natural environment, it is impossible to conceive of *progress* in the contemporary non-Indian lineal sense in Native American thought and literature. For Indians time is sacred, symbols are sacred, and therefore literature is sacred.

In discussing Native American oral literature, Margot Astrov has indicated that to the various Pueblo peoples of North America—and to the Hopi in particular—the phenomenon of what the West calls "the objective side of the world" is intimately interlocked with that of the subjective side of experience. Not only do these two apparent polarities interlock and sustain each other holistically, but the subjective realm is apt to dominate the objective aspect of the world. This visionary mode of thought unique to many primal people, the so-called subjective aspect of consciousness, determines their reality.

The force of Native American literature arises from its unaltered emergence from dreamtime and its potent mythic metaphors. Thus the power of Native literature is not discovered in holy words and incantations alone, nor in the depiction of extraordinary events alone. The teller's or writer's story is a means of raising one's self to a higher level of achieved power (a concept demonstrated by Carlos Castaneda in his Don Juan books). It is a method of producing the *perpetual reality of the now*. It is a catalyst of time and space that brings from one dimension of experience (dreamtime) the elements that are lost to the materiality of the secular kind of temporal experience.

Primal peoples' meaningful relationship to their world is thus not history, not causality in a scientific sense, but a mythical ordering of life that has not deviated and will not in the future deviate from the traditions of a sacred immediacy of time and place.

In Latin America the Indianist novel of the early twentieth century was a reflection of the Romanticism of nineteenth-century Europe. This Hispanic genre produced almost no distinguished work. "In Spanish-American poetry, originality was to be stumbled upon almost by accident in the songs of the gaucho minstrels who inspired a gaucho-

esque tradition that was ignored by serious Spanish-American critics until the twentieth century."* No nineteenth-century Spanish writer had intimate experience of Indian culture. "Yet Indianist literature abounded: first, because the rejection of Spain made the intellectuals of America reinterpret the pre-Columbian past; second, because Romanticism had popularized the myth of the noble savage" (Franco). It was not until the twentieth century that writers with Indian blood and with a profound concern for Indian mentality emerged in Latin America. Curiously, even these important authors were seen as oddities, for the Hispanic sensibility has immense difficulty recognizing the Indian as an equal with distinctive artistic and intellectual achievement.

There have arisen in Latin America three forms of Indianism in literature since the 1920s (Franco): 1) simple documentaries dealing with the hardships of Indians; 2) politicalization of the Indian as the equivalent of the proletariat and source of revolutionary militancy; 3) poetical efforts which attempt to grasp the Indian mind through myths, poetry, and legend. "This has given rise to the best Indianist writing to date, as exemplified in novels by Rosario Castellanos (Mexico), Miguel Angel Asturias (Guatemala), and Jose Maria Arguedas (Peru), whose novels break with realism" (Franco). The works of Asturias and Arguedas attain a literary finesse and innovation which reach far beyond their impact simply as Indianist books. These authors have devised a form of Spanish which is structured so that it is analogous to Indian languages. They have rendered a unique reality which touches upon the Indian mythic mentality. And they have evolved a narrative style more akin to poetry than to traditional prose writing. Miguel Angel Asturias was awarded the 1967 Nobel Prize for Literature. He died in 1974, having achieved more than any other Hispanic writer in combining his vital concern for Indian themes and his dedication to exquisite literary technique. The Indian mentality of Latin America has influenced the works of many of the remarkable Hispanic writers of the mid-twentieth century, but none achieve the brilliant evocation of the Indian found in the works of Miguel Angel Asturias.

There are three fundamental forms of North American Indian literature of the twentieth century. There is the one largely invented by Charles Eastman and, later, by D'Arcy McNickle—an Indianized realism, which, as Oliver La Farge once said, was "simple, direct, devoid of affectations, and fast-moving."

As much as I admire *Indian Boyhood* by Eastman and *The Surrounded* by McNickle, theirs is not the kind of Indian literary mentality I wish to discuss here, but rather a very traditional Western approach to experience, which Indians adapted to their purpose of writing about Indian life—largely for political motives.

There are a number of writers whose works fall into this general kind of Western realism—with apparent influences from sociopolitical authors such as Steinbeck and Dos Passos, and with stylistic influences from Faulkner and Hemingway. The excellent stories of Simon J.

*Jean Franco, *An Introduction to Spanish-American Literature* (Cambridge: Cambridge University Press), 1969.

Ortiz (Acoma Pueblo) fit into this framework; so do the novels of the highly distinguished Blackfeet writer James Welch. There are also elements in the writing of the 1969 Pulitzer Prize–winning Kiowa Indian author, N. Scott Momaday, which borrow heavily from the realism of Western literature. But in Momaday's writings there are two other important elements. He has brilliantly dealt with a kind of "holy tradition" in his books—his style aims at conveying the core of Indian ceremony. He has also anticipated a kind of visionary writing that finds its contemporary epitome in the prose of Craig Kee Strete and Leslie Marmon Silko, as well as in most Indian poetry, but especially in the poems of Roberta Hill, Joseph Bruchac, Duane Niatum, Leslie Silko, James Welch, Wendy Rose, and Ray A. Young Bear.

Probably the most controversial Indian writer concerned with "holy tradition" is Hyemeyohsts Storm. Like N. Scott Momaday before him, Storm is essentially concerned with the kind of arduous communication that Carlos Castaneda has attempted—the transliteration from one culture to another of central metaphysical ideas. It is a literature requiring a capacity to create parables and poetic imagery, but it is not poetic as much as it is expository and didactic. It has as its primary purpose the instruction of readers in the mentality of Indian tradition, and though the viewpoint is totally immersed in the tradition being described, the writing is *about* that tradition and is not an extension of that tradition into a distinct literary form.

The fiction of Leslie Silko and Craig Kee Strete represents a force in Indian literature somewhat similar to the efforts of Indian painters in the 1960s and 1970s to break away from the Traditional style of painting and to produce an idiosyncratic idiom—an unapologetic extension of tribal mentality into a new and innovative personal form. There is no question whatever of Silko's success in writing directly *out* of her Laguna Pueblo tradition, rather than simply writing *about* it.

Craig Kee Strete works in a somewhat different manner, but the end result is very similar to the effect of Silko's best work. Committed to professional writing and therefore automatically committed to realism (whether he likes it or not), Kee Strete invokes "science fiction" as a means of describing the metaphysics of Indian mentality, which, in the realist mentality, automatically turn into fantasy—a situation painfully similar to the dilemma of Kurt Vonnegut, Jr.

It is only in this new, visionary Indian literature that we discover the rebirth of the ancient ritualism of the oral tradition. Much as Joyce produced an "Irish" literature out of the European naturalistic novel, much as García Lorca created a visionary folk style out of the formalism of the Andalusian poet of the Renaissance, Luis de Gongora, visionary Indian writers are constructing a ritualized fiction that truly stretches the connotation of the term "novel."

Among the Indians of the Americas the tellers of stories are weavers, makers of *cultural autobiographies*—a genre which faded away in Europe when the last national epics were composed. Their designs use the threads of their personal sagas as well as the history of their whole people. Though the designs are always traditional, the hands that weave them are always new. These Indian stories, like ancient designs in textiles and

pottery, have been passed from one generation to the next. Like modern Indian painters, young Indian writers have made use of new potentials of technique and imagination learned through the education available in the twentieth century—both in their Indian traditions and in the cultures of the dominant society. These visionary writers believe, as do contemporary Indian painters, in the existence of some sort of transcendent Indian sensibility, and they believe that its power and its truth can be expressed in modes typical of our day as well as in the venerated, unique styles of the older traditionalists. Just as young Indian artists with a command of modern methods and a personal style have reinterpreted Indian iconography and history in new and often startling ways, so writers have attempted to recount folk history and contemporary Indian predicaments in a prose that tries to merge the old and the new, the essential poetry of the Indian viewpoint and the fundamental realism of Western mentality.

14.
Music, Dance, and Ritual

In the effort to move closer to the centers of power in nature, the Indian often imitates and transforms himself into the things of the natural world that invest him or her with strength and vision. A person receives power through songs. Through dances the Indian touches the unknown and unseen elements which he or she senses in the world. It is perhaps an error to speak of the Indian *imitation* of animals, because performances and actions are not designed as emulation but for transformation. Dancers of modern dance have rediscovered this ancient process: they do not simply *perform* the movements of a choreographer—they *become* the movements through an intense kinaesthetic process of feeling and ideas as pure body expression (for example, in the works of Martha Graham or Lucinda Childs). It is a process difficult to describe, but for primal peoples such as Indians it is easy. "To us," an Indian explained, "the apple is very complicated and mysterious. But for the apple tree it is easy."

Almost every aspect of Indian life has its counterpart in dancing and singing and is associated with ritual. There are dances of war, of peace, of victory, of joy, and of sorrow. There are private songs and dances and there are those which are public; there are sacred performances and there are secular ones.

There are dances of courtship and dances of fertility. Some rites are devoted to bringing rain, especially among agricultural people. Other dances, such as the animal dances of hunting peoples, encourage success in the hunt, good fishing, or anything else that is crucial to Indian survival. The paraphernalia of ceremonies is extremely complex and requires great care in its preparation and maintenance, but the actual dances connected with rituals are rather direct and simple. There are traditional set patterns for the dances, but the actual steps are far less elaborate than most non-Indians realize. True, many of the sacred dances are retained by special societies within the tribes, and require careful rehearsal. It is also true that some of the steps are strenuous. But the elements of the dances that make them sacred and powerful are of a totally dif-

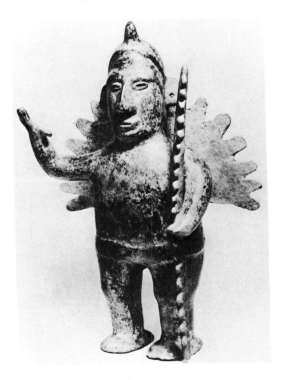

Musician in costume. Colima culture, Mexico, c. A.D. 200–1250. Museum of the American Indian, Heye Foundation, New York City.

ferent order from the pyrotechnics of ballet, flamenco, or Hindu dance. The patterns reverberate with tradition reaching beyond Indian memory. The steps of Indian dances are executed with an inner grace and simplicity. It is the deep *involvement* of the dancers in their dance that is the source of magic, not the complexity or the elaborateness of the motions. Most Indian dances are relaxed and balanced between consciousness and trance—they are perfectly controlled, dignified, and strangely remote even when the steps are extremely vigorous.

There are some common characteristics of all dances of the Indian Americas: the steps tend to favor bent knees, with the body in an erect, straight posture. Although the torso does not often move with the undulation seen in African and Oceanic dances, the Indian dancer often makes elaborate movements with his head, especially in various animal dances. There is seldom any complex use of the arms, except when the dancer is performing a subtle mimetic gesture or representing the soaring of birds.

There are certain dance steps that are especially predominant in social and ritual dances, although these are only a few of countless foot movements. The basic patterns for moving the feet are called the toe-heel step, the drag step, the stomp step, and—in North America—the canoe step. The toe-heel step is the most frequently encountered and also the simplest of Indian dance movements. It is performed to a two-beat rhythm, with the accent on the first beat, ONE-two. On the accented beat the dancer touches the ground with the left toe, bringing the left heel down on the second, unaccented beat. This action is performed alternately with the left and right foot. The direction of the step may be circular, forward, or back, and its use is found in a great variety of dances of many Indian tribes.

The drag step is another well-known Indian movement, also based on a two-beat rhythm, but with the accent on the second beat: one-TWO. The dancer steps forward on the soft first beat, touching his toe to the ground. Then the foot is dragged backward and the heel is snapped down hard on the loud, second beat. The drag step is seen most often in solo dances, and is particularly popular as a marking-time step (a vamp) in the modern Fancy Dance of the North American Plains tribes.

The stomp step is an energetic dance movement that is often found among the Pueblo and Mexican peoples. Nor-

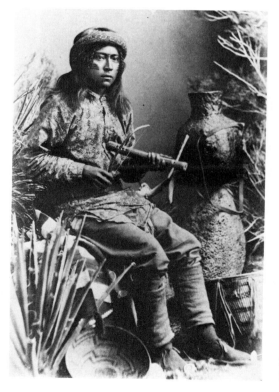

This man is playing a unique Apache fiddle. Photographed in a studio about 1882 by A. F. Randall. Smithsonian Institution, Washington, D.C.

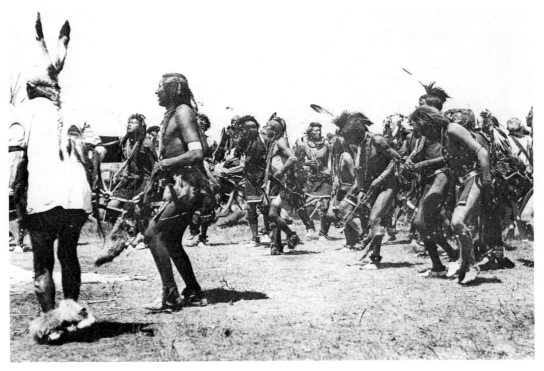

Flathead Indians of western Montana perform the Grass Dance, c. 1900. Denver Public Library photograph, Western History Department.

mally it is performed with an upright body, the hands held closely to the body at the height of the hip. The drumbeat is a three-beat rhythm, with the accent on the first beat: ONE-two-three. On the first, loud beat the dancer lifts his knee high and brings his foot down hard with a stomping force. Then on the soft beats (two-three) he comes down on his toes in two quick hopping movements that make the rattles tied just below his knees rattle with a marvelous sound.

The North American canoe step is a four-beat movement, with a light accent on the first beat: ONE-two-three-four. On the first, accented beat the dancer steps on his or her left foot and then taps the right foot softly on the two-three-four beats. The dancer then steps forward heavily with the right foot on the second accented initial beat. The first, accented step is usually executed as a short, quick leap, landing flatly with a stomp alternately on the right or left foot.

The Indian dances of the Americas are both religious rites and ceremonial games; they can be severe and solemn, or playful and humorous. Yet all of the dance forms have immense tribal significance, and none of them are performed in the Western context of "social dances"—that is, just for fun. Even at modern powwows (which today are Indian fairs), a residue of the ancient metaphorical significance of dance and ritual persists. Many dances have lost their original tribal meaning due to the constant cultural disruption of Indian peoples, and thus some dances are continued despite a failing grasp of their original purposes. It is a situation which recalls Western games, such as hide-and-seek, which apparently had strong ritual content that is now lost.

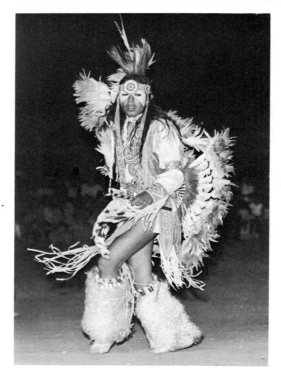

A lavishly costumed Fancy Dancer at the American Indian Exposition, Anadarko, Oklahoma, 1969. Courtesy of the Oklahoma Department of Recreation, Oklahoma City. Photograph: Fred W. Marvel.

The North American Indian Plains dance called the Fancy Dance is typical of the modifications of Indian culture produced by white influences. Based on the old Grass Dance, or Omaha Dance (mistakenly called a War Dance by whites and Indians alike), the Fancy Dance is very fast and active, involving elaborate steps and garish costumes that look as if the Follies had redesigned the beautiful, subtle garb of the Old Plains Indians. The "northern style" is especially sensual, making more emphatic use of the torso than any other Indian dance of North America. Only in the Amazon Basin is a dance of equal vigor and sensuality to be found.

Most dances are performed by men. Many, however, are performed by women, although it is rare to find a dance which men and women perform together. But whether the dances are secular

Haida wood rattle. Northwest Coast. Photograph: Sotheby Parke-Bernet.

or highly secret and sacred, they have at their foundation the universal expressive power of movement which Indians recognize as the most significant manner in which the real world is revealed to them.

The music of the Indian Americas shows a wide spectrum as well as similarities. Nearly everywhere—among the Innuit, the Indians of northern California, the scattered tribes of the Amazon Basin, the people of Tierra del Fuego—ancient forms of music exist side by side with far more modern musical styles, many of which display obvious European influences. Of course, the ethnomusicologist realizes that this is typical of most primal peoples, but in the Americas this is a very pronounced phenomenon.

The music of the Innuit is almost entirely vocal. Their sole musical instrument is a round frame drum, with which singers accompany their own songs by banging a stick against the underside of the frame. The Innuit once made use of such instruments as the clapper and the bullroarer, but for unknown reasons they abandoned them shortly after the turn of the century, possibly in order to reduce their property to a minimum to facilitate their highly nomadic existence. It is characteristic

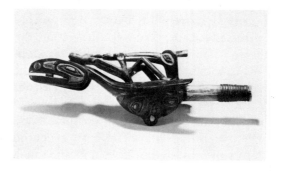

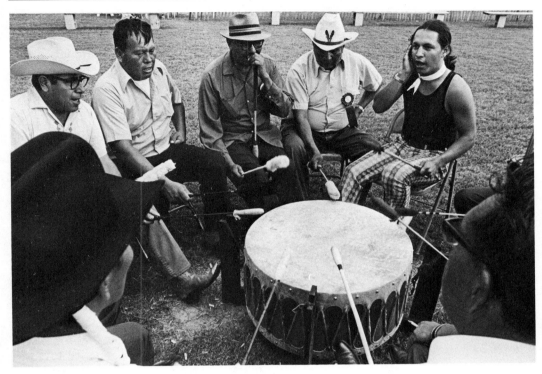

The contemporary powwow retains the tradition of ceremonies and dances which is at the core of North American Indian sensibility. A singer and several drummers perform at a powwow in El Reno, Oklahoma. Courtesy of the Oklahoma Recreation Department, Oklahoma City.

for the drum rhythm to be independent of the meter of the song. The Arctic repertory contains a great variety of songs: hunting chants, songs of thanksgiving, shamanistic incantations for health and well-being, cradle songs, narrative songs, and songs of scorn. As a rule, conflicts among the Innuit are not settled by combat but in a drumming contest, in which, through the persuasive power of songs, the opponents mock and ridicule each other. The oldest Innuit songs noted by Europeans (1902) consist of only two or three notes; such music is still found in Greenland. This simplicity, however, does not impede the involvement of the singer; the melodic structure of Innuit music is based on a "fixed center of gravity," functioning as a fixed basis for improvisation.

The music of the American Indian is a distinct musical idiom; no other peoples have produced exact duplicate sounds, even if they created similar instruments, such as drums, rattles, and whistles. The most obvious aspect of North American Indian music is the prevalence of drums and rattles and the characteristic harshness of the solo vocal rendering—a sort of flat, nonemotional sound which has certain parallels in the vocal music of the Near East. Indian music is essentially unison vocal composition, with melodic solos and percussive accompaniment. Voice production is typically strong in rhythmic accent, with tension in the vocal organs and an Asian-like pulsation on the long notes. It is music of a strong linear structure, in some ways not unlike the music of Asia. It does not excel in harmonic development. The melodic structure descends predominantly from higher to lower pitch in either terraced or downward-cascading in-

tervals. The intervals are free. Melodic polyphony—the simultaneous voicing of two or more melodic lines—is nonexistent, except for an occasional drone-type accompaniment of a voice or voices using a single, sustained pitch, or the tradition by which women often sing in unison with the men but an octave higher. Instruments are used strictly for rhythmic accompaniment; there is very little purely instrumental music, such as solo drumming or any other kind of instrumental virtuosity, as we know it in Western music. Structurally, uneven bar lengths and asymmetrical rhythmic patterns are far more common than consistent measure lengths. In Indian songs there is little sense of emotional development, or crescendi or other so-called vertical aspects of Western music. There is no clear sense of a beginning, middle, and end in Indian music; no reaching for climaxes or melodic resolutions. The Western ear tends to hear Indian music as repetitive, trancelike, subtle in its intervals and variations, long, and emotionally unsatisfying.

From these descriptions it should begin to be apparent that many modes of modernist Western music of the late twentieth century have followed a plan and form very similar to primal music, such as that of the American Indian. I am thinking, particularly, of the so-called Minimalist composers of America, such as Philip Glass, Terry Riley, and Steve Reich, as well as the earlier (1930s–40s) experiments of Henry Cowell, Lou Harrison, John Cage, and others.

The way in which the basic components of Indian music manifest themselves regionally is a vast and complex subject, but some specific examples of various tribal forms of music will help put the previous generalizations into perspective. Analysis of the various North American Indian melodies, for instance, reveals a multiplicity of scale formations, with a predominance of pentatonic structures. Tunes devised to go with words and used for singing narratives are, as a rule, confined to a scale of two or three notes, falling only within the range of a fifth. In contrast to this rather simple structure, the melodies used for the healing of diseases have intervals of fourths and thirds and cover an octave or a tenth. Other melodies tend to have an oscillating effect, to rise and then decline, giving the form of an arc. The ethnomusicologist Frances Densmore has analyzed six hundred melodies of the Ojibwa and Dakota, pointing out that about a third of them

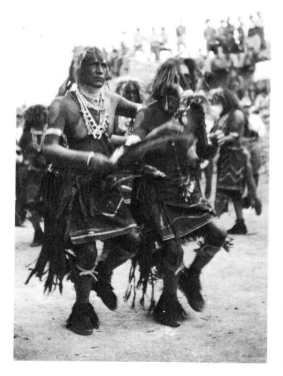

Hopi Snake Dance. Photographed in 1911 by H. F. Robinson. Museum of New Mexico, Santa Fe.

have no semi-tones and are pentatonic and that numerous melodies range over one octave. These remarks may be applied generally to many other North American tribes.

The Indian music of the Southwestern United States differs from the musical styles of the Indian tribes living farther north. In the case of Zuñi and Hopi songs, we find that the melodic flow is clearly ordered by strong points of emphasis, making the intonation clear and precise, in contrast to other North American Native music. For instance, the music for the Hopi Snake Dance has a meandering melodic line but a clear structure. The number four has a ritualistic significance among the Pueblo peoples, and this is reflected in the songs which are often repeated four times. Among the Southwestern instruments the scraping stick, a notched stick over which another stick is passed, has particular importance. The bullroarer is also used, representing the voices of the kachinas. Musicologists have often pointed to the resemblances between the music of the tribes of the Southwest and those of the ancient Mexicans: "Because of its special form of symbolism and its melodic structure, the music of the Zuñi and Hopi comes close to the music of the Indian population resident in Mexico" (Paul Collaer).

The musical heritage of Mesoamerica and the Andean region has been the topic of immense research among archaeologists. Digs in these regions have led to surprising discoveries—superb musical instruments demonstrating a sophisticated level of music and acoustics as well as instrumental finesse. The discovery of actual instruments has been augmented by many art objects portraying musi-

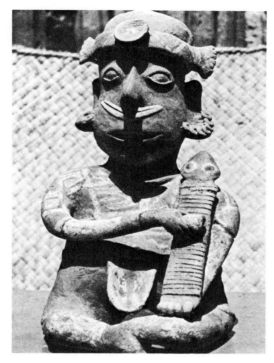

Terracotta musician figurine. Colima culture, Western Mexico. Diego Rivera Collection, Mexico City.

cians and dancers. The present-day mixture of ancient and European examples among the musicians and music of Mesoamerica provides an astonishing picture of cross-cultural influences. The "typical" music of Mexico, especially in the states of Mexico, Morelos, Tlaxcala, Puebla, and Oaxaca, consists of melodies with strong rhythmic emphasis performed on aboriginal-sounding instruments and on others of Spanish origin, as well as hybrid forms. All of these instruments are used in two major ways: in relation to religious rites of Christian and pre-Christian forms, and to accompany secular dances.

Most significant among Mexican instruments are the *huehuetl*, made from a tree trunk and covered with a membrane for use as a drum; the *teponaztli*, a horizontal slotted wooden drum; the *ayotl*, an old Mexican instrument of

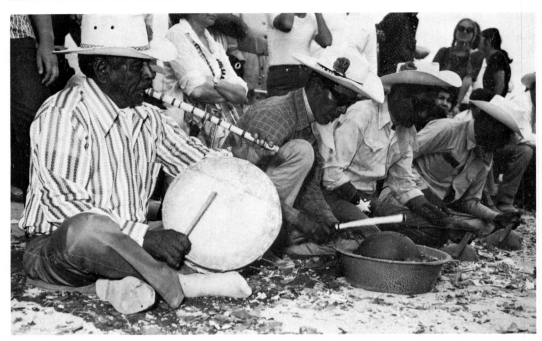

Yaqui Indian musicians playing at the famous Yaqui Easter Festival. Southern Arizona, 1955. Courtesy of Western Ways Feature. Photograph: Charles W. Herbert.

worship, composed of a turtle shell, and beaten with the branch of a deer's antler; the *chicahuaztle,* rattle sticks seen in the Pascola Dance of the Yaqui Indians; the *guiro antillano,* a scraping instrument consisting of an oblong gourd resonator with notches over which the player runs a stick; the calabash rattle known as the *ayacachtli*—a handsome example of which may be seen in the frescoes at Bonampak in Chiapas; and the successor to the Aztec *tlapitzalli,* an internal-ducted flute usually made of clay, similar to the *pitos,* which are carved of wood. European flutes are also widely used, usually played in conjunction with the small Spanish hand drum. The European metal trumpet has largely replaced the ancient shell horn *(tecciztli),* as well as the pre-Columbian Indian flute. A crude fiddle is found both among the Apaches of the United States and among the Cora Indians of Nayarit in Mexico.

In Yucatán and Central America, we find archaic forms of music that have been relatively unaffected by European influences. This music is far removed from the pentatonic system of the West and is very much closer to what can be heard in various remote regions of South America—for example, in the forests of the Amazon. Researchers have identified as many as seven hundred different types of instruments in South America. The only string instrument among them is a simple musical bow, which is common from California to Patagonia.

The Andean civilizations offer a vivid picture of musical life due to the numerous instruments discovered at excavation sites in the central and northern Andes region, the many pictures portraying music making on clay vessels, and the recognizable traditions of modern Indian music in the Andes. From these details we are able to form some sort of picture of the musical life in the region.

In Peru and Bolivia the traditional in-

struments (some of which are no longer played) include the *tinya,* a hand drum; whistling jars or vessel flutes such as ocarinas, made of shells, clay, or calabashes; the notched flute called the *quena;* and, most prominently, the panpipes. In Peru and Ecuador bamboo trumpets up to six feet in length are still in use today, and are called *clarin* or *bocina.*

In South America there are two dominant music traditions: the tendency to favor small intervals, which is found virtually in all regions; and also the very widespread inclination to avoid small intervals. Of these two contrasting traditions, the older one appears to be the form with the small intervals. "The pentatonic forms without any semi-tones may arise from a desire to produce pure and precise music, which would be typi-cal of [sophisticated] cultures" (Collaer). It should also be noted that whereas among North American tribes there are hardly any tendencies toward polyphony, this kind of music structure is found quite frequently in South America, in the form of parallel fourths and fifths; as well as pseudo-parallel imitations for three voices. We may not, however, call this South American Indian invention true polyphony, since the parallels are usually built up on irrational intervals; from a Native American standpoint, however, it cannot be denied that South American Indian musicians have formulated their own kind of forms for several voices, even with examples of "contrapuntal" patterns in the Amazon region.

Music, like all the arts, is built upon the viewpoint of a culture, and the mu-

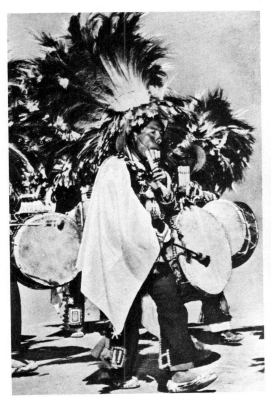

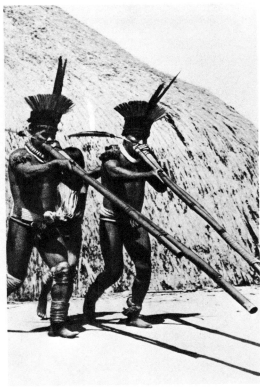

Left: Dance of the Condors of the Ayarachi tribe. Cuzco, Peru, c. 1945.

Right: Camayura dance ceremony with double clarinets. Xingú, Amazonia, Brazil, c. 1950.

sic of Indians has almost nothing in common with the attitudes that give substance and character to the music of the Western world. With these differences in mind, it is a bit easier to grasp the nature of American Indian music. For one thing, most Indians regard music as an element of much broader activity—as part of the life process—and not as a separate and discrete aesthetic entity. Music is the *breath of life,* an organic process rather than an end product. It is generally thought that Indian music is therefore functional, that it is used as part of other, nonmusical activities of daily life. But this is simply the result of an analytical, non-Indian way of looking at music. The Indian sees music as indistinct from dancing, and dancing as indistinct from worship, and worship as indistinct from living. The purpose and use of song and dance is ritualistic. Song texts often contain entirely or partly meaningless syllables. Texts may also include archaic words, loanwords, or even special phonemic alterations. These devices make song texts very different from the spoken language of a tribe and tend to obscure the "meaning" of songs. The inclination of non-Indians is to view such restricted use of lyrics as primitive, whereas Indians consider it a civilized restraint and poetic suggestiveness. Music is highly valued for its magical power, and its power to invoke special states of mind, visions, and trances. If the mu-

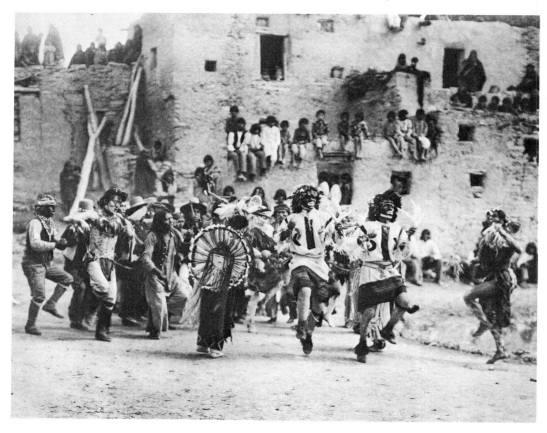

An animal dance during the winter months at the Rio Grande pueblos is a central part of the ceremonial calendar. Photographed by Edward S. Curtis, 1921. Philadelphia Museum of Art.

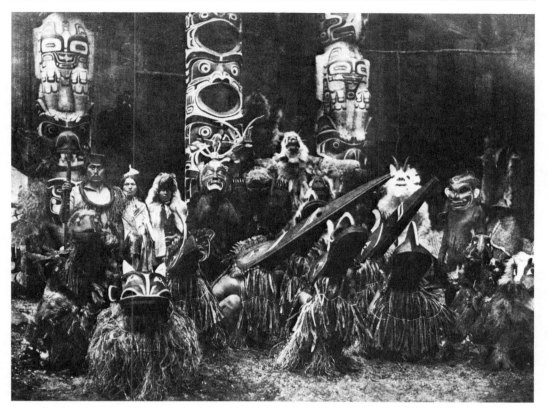

A Kwakiutl Cannibal Ceremony, in which startling masked dancers participate in the retelling of tribal folk histories. The squatting dancers with long-billed masks represent huge mythical birds of the winter dance cycle: Kotsius and Hohhuq, servitors in the house of the man-eating monster Pahpaqalanohsiwi, who is honored by this dance. The mandibles of these wooden masks are controlled by strings, and in the dimness of the house of ceremonies the masks are exceedingly dramatic. Photographed by Edward S. Curtis, 1910. Philadelphia Museum of Art.

sic is well performed, it is considered "good spirit" rather than "beautiful," a term that seems superficial and artificial from the traditional Indian point of view.

Indian music and ceremonies offer an apparatus for a type of experience which non-Indians have sought to penetrate and to understand for generations. It is part of the same mystic experience which the American composer Charles Ives sought throughout his life and which he called "the harmony of the spheres"—a metaphor which echoes back to Medieval Europe. Many non-Indian composers, from Alexander Scriabin and Olivier Messiaen to Harry Partch, have reached out for this realm, which is the natural province of the In-

dian and his ceremonial life. But it appears that the key to the portals of this extraordinary experience is so intangibly simple and ordinary that it easily slips through the complex net of classical European sensibility. Yeats, sensing the primordial fusion of many elements into ritual, called upon his own metaphoric language in order to build a bridge between the obsolescent world of Western progress and the enduring world of nature: "Who can tell the dancer from the dance?" It is the kind of question that is very familiar to Indians; its answer is, of course, in the asking. It is just the kind of paradox that climaxes the rites of initiation, by putting an end to matter-of-fact inquiry and opening the way to the experience itself.

Museums and Galleries of Indian Arts

Western Hemisphere

Argentina
Buenos Aires: Instituto de Antropología (Museo Etnográfico)

Bolivia
La Paz: Museo National Tiahuanaco

Brazil
Belém: Museu Praense (Santarém, Marajó Indians)
Recife, Pernambuco: Museu do Estado de Pernambuco (Santarém, Brazilian Indians)
Rio de Janeiro: Museu Nacional

British Guiana
Georgetown: British Guiana Museum

Canada
Montreal: Montreal Museum of Fine Arts
Ottawa: National Museum of Canada
Prince Rupert, Victoria, British Columbia: Museum of Northern British Columbia
Toronto: Royal Ontario Museum of Archaeology (Eskimos, British Columbia)
Vancouver, British Columbia: Lippsett Museum
Vancouver, British Columbia: University of British Columbia Anthropological Museum
Victoria, British Columbia: Alert Bay Public Museum
Victoria, British Columbia: Provincial Museum of Natural History
Winnipeg, Manitoba: The Hudson Bay Company Museum
Yellowknife: Manitoba Museum of Man and Nature
Yellowknife: Museum of Northern Canada

Chile
La Serena: Museo Arqueológico de La Serena
Santiago de Chile: Museo National de Historia Natural

Colombia
Bogotá: Museo de Oro
Bogotá: Instituto Colombiano de Antropología
Popayán: Museo Arqueológico de la Universidad del Cauca

Costa Rica
San José: Museo Nacional

Ecuador
Quito: Museo Arqueológico y Galerias de Arte del Banco Central del Ecuador
Quito: Folklore Olga Fisch
Quito: Museo Etnográfico de la Universidad Central del Ecuador
Quito: Museo Jacinto Jigon y Caamano

Guatemala
Chichicastenango: Museo Arqueológico de Chichicastenango
Guatemala City: Museo Nacional de Arqueológia y Etnología
Tikal: Museo Arqueológico

Haiti
Port-au-Prince: Kurt Fisher Collection

Honduras
Copán: Museo Arqueológico Nacional de las Ruinas de Copán
Tegucigalpa D.C.: Museo Nacional

Jamaica
Trinidad: Royal Victoria Institute, Port of Spain

Mexico
Chiapas: Museo Regional de Chiapas
Mexico City: Museo Nacional de Antropología
Mexico City: Stavenhagen Collection
Oaxaca: Museo Regional de Oaxaca
Teotihuacán, San Juan: Museo de Teotihuacán
Tula: Museo de Tula

Nicaragua
Managua: Museo Nacional de Nicaragua

Panama
Panama City: Museo Nacional de Panama

Peru
Nuaras: Museo Arqueológico de Ancash
Ica: Museo Historico Regional de Ica
Lima: Museo Nacional de la Cultura Peruana
Lima: Galleria Huamanqaqa
Lima: Gold Museum
Lima: Museo Amano (by appointment only)
Lima: Museo Nacional de Antropologia
Lima: Collection Xavier Prado

El Salvador
San Salvador: Museo Nacional, David J. Guzman

United States of America
Albuquerque: Indian Pueblo Cultural Center
Albuquerque: Maxwell Museum of Anthropology
Anadarko, Oklahoma: Southern Plains Indian Museum
Bacone, Oklahoma: Bacone College Museum
Berkeley, California: Museum of Anthropology
Browning, Montana: Museum of the Plains Indians
Cambridge, Massachusetts: Peabody Museum, Harvard University
Cherokee, North Carolina: Museum of the Cherokee Indian

Chicago, Illinois: Chicago Natural History Museum
Cleveland, Ohio: Cleveland Museum of Art
Columbus, Ohio: Ohio State Archaeology Society
Dallas, Texas: Museum of Fine Arts
Denver, Colorado: Denver Art Museum
Denver, Colorado: Denver Museum of Natural History
Flagstaff, Arizona: Museum of Northern Arizona
Hogansburg, New York: Akwesasne Museum
Houston, Texas: Museum of Fine Arts
Los Angeles, California: Los Angeles County Museum of History
Los Angeles, California: Southwest Museum (Highland Park)
Milwaukee, Wisconsin: Milwaukee Public Museum
Minneapolis, Minnesota: Walker Art Museum
Muskogee, Oklahoma: Five Civilized Tribes Museum
Niagara Falls, New York: Native American Center of the Living Arts
New York, New York: American Museum of Natural History
New York, New York: Brooklyn Museum
New York, New York: Museum of the American Indian, Heye Foundation
New York, New York: Metropolitan Museum of Art
Newark, New Jersey: Newark Museum
Norman, Oklahoma: University of Oklahoma Museum of Art
Omaha, Nebraska: Joslyn Art Museum
Oklahoma City, Oklahoma: Oklahoma Historical Society
Oklahoma City, Oklahoma: Gilcrease Museum
Philadelphia, Pennsylvania: University of Pennsylvania Museum
Pittsburgh, Pennsylvania: Carnegie Institute Museum
Phoenix, Arizona: Heard Museum
Rapid City, South Dakota: Sioux Indian Museum
Sacramento, California: State Indian Museum
San Antonio, Texas: Marion Koogler McKay Art Institute
Santa Fe, New Mexico: Museum of New Mexico
Santa Fe, New Mexico: San Ildefonso Pueblo Museum
Santa Fe, New Mexico: Wheelwright Museum
Tahlequah, Oklahoma: Cherokee National Museum, Tsa-La-Gi
Tulsa, Oklahoma: Philbrook Art Center
Tucson, Arizona: Arizona State Museum
Vermillion, South Dakota: Museum of the University of South Dakota
Washington, D. C.: Bureau of American Ethnology, Smithsonian Institution
Washington, D. C.: Textile Museum
Washington, D. C.: National Gallery of Art

Window Rock, Arizona: Navajo Tribal Museum

Venezuela
Caracas: Museo de Ciencias Naturales

Europe

Austria
Vienna: Museum für Völkerkunde

Belgium
Brussels: Musées Royaux d'Art et d'Histoire

Denmark
Copenhagen: Nationalmuseet

England
Cambridge: University Museum of Archaeology and Ethnology
London: British Museum, Museum of Mankind
Oxford: Pitt Rivers Museum

Finland
Helsinki: Kanallismuseo

France
Boulogne-sur-Mer: Musée d'Histoire Naturelle
Paris: Musée de l'Homme

Germany
Berlin: Museum für Völkerkunde
Cologne: Tautenstrauch-Joest-Museum für Völkerkunde
Munich: Städtisches Museum für Völkerkunde
Stuttgart: Linden Museum

Italy
Florence: Museo Nazionale di Antropologia
Milan: Biblioteca Ambrosiana
Rome: Museo Prehistorico ed Ethnografico, L. Pigorini

Netherlands
Amsterdam: Tropenmuseum
Leiden: Rijksmuseum voor Volkenkunde
Rotterdam: Museum voor Land en Volkenkunde

Norway
Oslo: Universitetets Etnografiske Museum

Scotland
Edinburgh: Royal Scottish Museum

Spain
Madrid: Museo Ethnologico
Madrid: Museo de America

Sweden
Gotenberg: Etnografiska Museet
Stockholm: Staten Etnografiska Museum

Switzerland:
Basel: Museum für Völkerkunde
Geneva: Musée d'Ethnographie

USSR
Leningrad: Museum
Moscow: Museum

Glossary

adobe Sun-dried clay brick.

anthropomorphic Derived from the human figure or its attributes.

articulate masks Masks with movable sections; the mobile sections are usually controlled by strings. Some masks have only movable eyes and lower jaw, while others open into two, three, or four inner faces. Also known as transformational masks.

artifact Any object made by human beings.

aryballus A characteristic Inca pottery form, consisting of a large jar with a conical base, tall narrow neck, and flaring lip.

Atlantean figure An architectural support in the form of a standing person; identified with the Toltec.

ball game A ritual game played by all pre-Columbian peoples from Paraguay to the southeast and southwest United States, with the greatest flowering in Mexico.

biface A chipped stone tool, with flakes removed from both faces of the object.

band An area of decoration encircling a vessel.

Basket Makers The earliest farmers in North America (above the Rio Grande River), who lived in Arizona and New Mexico about A.D. 100–900. Presumably they were the forebears of the Puebloan cultures.

bayeta The Spanish name for a cloth of English manufacture—baize—which was brought into the American Southwest via Mexico and traded to Indians, who unraveled it and used it in their weaving.

bison The American buffalo, central to Plains Indian cultures.

bitumen A pigment used in Veracruz, Mexico, commencing with Remojades I, c. A.D. 300.

bundle burial A form of secondary burial in which the bones are gathered and interred in a nonarticulated (random) pile or bundle.

cacique Native word (of West Indies origin) meaning chief or lord.

camelid (cameloid) Belonging to the Camelidae family, including the llama, alpaca, vicuña, and guanaco, the only native burden-bearing animals of the Western Hemisphere.

cardinal points (directions) Fundamental to many Indian religious concepts are the four cardinal points of the compass, as well as the central directions, up and down. Color symbolism is often connected with these directions, as are matters of power and iconographic symbols.

carina An angle, or ridge, where the profile of a vessel wall sharply changes direction.

cartouche A term applied in Mesoamerica to a closed frame in which Maya glyphs are contained. Only day-sign glyphs are rendered within such a cartouche.

caryatid A supporting columnar base fashioned as a human figure, such as the Toltec Atlantean figures.

celt Ungrooved stone axe, a common woodworking tool and also a ceremonial object.

cenote A natural well in the arid Yucatán plateau.

ceremonial break An interruption in any painted line encircling a vessel. Also called a line break or spirit path.

Chac, or Chacmool A fanciful yet standard term for the reclining stone figures of human males found in Mexico and Yucatán, thought to represent the rain deity.

chamfer Horizontal molding with intaglio effect, recessed within the walls of Maya temples or pyramidal platforms.

champlevé Decorative ceramic technique, by which the background design is cut away to accent the remaining design in relief—for example, in the cylindrical vases of Teotihuacán III.

chimesco A ceramic hollow figurine style of the Nayarit, found in shaft tombs c. A.D. 100–250.

chocolatera Tripod ceramic vessel with large feet extending outward; characteristic of Costa Rica.

chullpa Cylindrical or square burial tower made of stone or adobe; typical of the southern Andean region.

chief blanket A Navaho man's or woman's shoulder blanket of distinctive design, worn so the longer dimension runs from side to side rather than from top to bottom.

circum-Caribbean A general term for the common cultural area of the Indians of Nicaragua, Costa Rica, Panama, Colombia, northern Venezuela, and the West Indies.

Cire perdue (lost-wax technique) A technique of metal casting.

Classic period A term which has come to refer to the period of the highest achievement within various Mesoamerican and Andean civilizations. Preclassic and Postclassic refer to the periods immediately before and after the Classic period. There is no specific designation of date, but the Classic period of Mesoamerica is generally placed between A.D. 300–900.

clans, exogamous; moiety The division (into two, in moiety) of societies into groups whose members may marry people only from a different clan than their own.

cloisonné A term derived from enamel painting that is used in the Americas to denote a specific kind of ornamentation on ceramic ware.

codex As used in this book, a Native Mesoamerican manuscript (book), existing in some forms in pre-Columbian times but highly elaborated after the invasion by Europeans. The plural is codices.

comb (weaving comb) A wooden tool used to force wefts down between warps.

corbel arch An arch between two parallel walls, in which the inner faces of both walls are carried inward by means of overlapping courses of stone until the gap in the middle can be bridged; the so-called false arch because it lacks a keystone. Typical of Maya architecture.

cornice A horizontal molding running around the top of a building or the walls of a room.

counterpoint Combined melodies or, more strictly, the addition of a second melody to the first. The term and its adjective, *contrapuntal*, are similar to but technically somewhat different from the terms "polyphony" and "polyphonic." All these terms, however, apply to the interlacing of two or more melodies.

crackling or crazing A decorative feature of pottery glaze, resulting from a high firing that covers a vessel with small meandering cracks.

cultural diffusion Any of several processes resulting in the spread of cultural traits—via migration, trade routes, or merely borrowing, by one neighboring tribe from another. The opposite process is the simultaneous or independent invention of the same traits by different peoples.

danzantes Ritual dancers, often carved in relief, whose meaning is uncertain; found in Monte Albán, in the Oaxaca region of Mexico.

dendrochronology The science of comparative study of tree rings to determine the age of wood objects found in association with artifacts.

diatonic Relating to a music scale having eight tones to the octave and using a fixed pattern of intervals without chromatic deviation.

dolmen A monument of two or more upright stones supporting a horizontal stone slab; thought to be related to tomb structures.

dominant The fifth note of any modern music scale.

double The life force and the power of expression are characteristic of the "double"—a power in many Indian cultures that lives at the center of an individual; similar but distinct from the Western concept of the "astral body."

earplug, or earspool Round disk or spool-shaped ornament worn in a hole in the ear lobe.

effigy jar A jar made in the form of a figure.

embroidery Various decorative techniques used on cloth or leather.

excising A ceramic technique making deep grooves, channels, or fields where carved areas from the surface leave recessed designs, often rough-finished and painted with cinnabar.

feathers The most celebrated subjects of Indian cosmogonies were birds, and their feathers possessed great ritual as well as decorative meaning.

figurine A small clay model, usually of a human being; sometimes solid, but large figurines are necessarily hollow to prevent bursting during firing.

firing The heating process by which a vessel of clay is hardened.

floating A polishing technique in which unslipped clay is repeatedly stroked with a smooth stone in order to bring the finest-grained material to the surface, where it is polished to a high gloss without the use of glaze.

Formative (Preclassic) period Term used for the period from the introduction of pottery and the start of the Classic period, essentially in relation to the civilizations of the Andes and Mesoamerica.

fresco Painting on a layer of wet stucco (plaster).

frieze A band of painted or carved decoration on pottery or an architectural surface.

gadrooning Modeling of pottery with a series of flutings to simulate the appearance of a melon or gourd.

Germantown yarn Commercial American yarn colored by natural or chemical dyes; used in the Southwest, especially by Navaho weavers.

gingerbread A term applied to figurines of solid clay, as opposed to hollow ware, with a flat rendering of the body—especially like those found at Chupicuaro, Mexico.

glaze Material painted on the surface of a clay vessel, composed of minerals that melt during firing and resolidify to form a glassy and usually waterproof surface.

glyph Each unit of Maya writing; also used to describe the writing-like emblems found in Olmec and Monte Albán cultures.

gorgerin Shell disk engraved by the Mississippian Mound Builders.

gorget Ornamental plaque worn on the chest and suspended by a cord around the neck; a variation of the pectoral.

grave goods Offerings put with the corpse into the tomb or grave.

hacha Thin stone blade with the profile of a human head; Mesoamerican object associated with the ball game.

heartline A decorative motif, originating in the mid-nineteenth century in the American Southwest, in which animal figures on pottery (especially deer) are depicted with a line painted from mouth to chest, terminating in an arrowhead at the location of the heart. It is of unknown origin, though predominantly seen among Zuñi, Acoma, and Hopi pottery designs.

heddle Device on a loom used for raising selected warps to create a space through which the weft thread can be easily passed.

Herrera phase A period of the Parita-Cocle culture in Panama c. A.D. 1300–1500.

hocker Mesoamerican rendering of the human figure—frontal and symmetrical—with arms and legs flexed in frog-like fashion.

horizon A generalized term used to describe the frontiers of a culture which are difficult to pinpoint in a specific region and in a short frame of time. Originally applied to the civilizations of Peru, it is now used in a wide context, suggesting traits occuring for the first time in a broad and rapid spread.

horror vacui The practice of filling space entirely—a "horror of emptiness"; the term has been borrowed from pyschopathology and applied to art, especially the art of the Northwest Coast of North America.

iconography The meaning and symbolism expressed in visual motifs.

ideogram Graphic symbol conventionally used to denote an idea; employed by the Maya and the Aztec.

incensario An incense burner, often in anthropomorphic form—representing a person or a deity and becoming extremely complex in the cultures of Teotihuacán and Monte Albán (Mexico).

incised decoration Decoration in which patterns are scratched into clay or stone.

inscriptions A term applied to the use of hieroglyphic writing when carved in stone or wood, as opposed to its painted rendering in codices; an example is the Temple of the Inscriptions (Palenque).

kachina (katchina) Any supernatural being important in the religion of the Hopi Indians of the American Southwest, represented in painted figurines and in the costumes of ritual impersonators wearing masks and costumes.

kill hole A perforation in a ceramic vessel, presumably to release the "spirit."

kiva An underground ceremonial chamber particularly typical of the Pueblo Indians and their Southwestern forebears.

kiln An oven in which pottery is fired.

labret An ornament, usually cylindrical, inserted in the lower lip, through a hole made ritually—often during an initiation ceremony at the time of male puberty.

lost-wax process See *cire perdue.*

maguey One of the most useful plants (century plant) of the Americas, providing both fibers and food, as well as a fermented drink (pulque).

maize Indian corn.

mano The hand-held stone used to grind maize and other seeds.

Mesoamerica The regions of pre-Columbian Mexico and Central America occupied by urban dwellers; marked on the north along the Sinaloa, Lerma, and Pánuco rivers, and in-

cluding the central and southern portions of Mexico as well as the Yucatán peninsula, Guatemala, El Salvador, parts of Honduras, Belize, Nicaragua, and northern Costa Rica.

metate Flat-surfaced stone mortar. The handheld grinding stone is called the *mano*.

midden A refuse heap marking a former habitation area.

Middle America The area from Panama to the Rio Grande, including the Antilles (West Indies).

monolith A commemorative stone, either decorated or not decorated, erected as a single slab.

mosaic A work of art with patterns made with different-colored materials, often stones or feathers, which are fastened to a background.

mummy In the Americas the term is usually used loosely for any well-preserved corpses, especially those elaborately prepared for burial. True embalming was not practiced, so far as is known, but the internal organs were sometimes removed and the body wrapped in shroud mantles or mats before interment.

necropolis A burial place.

negative (resist) painting Before firing, a clay vessel surface partly covered with gum or wax is immersed in slip. Firing fixes the colored slip but clears the waxed or gummed portions, so the figure and its ground are reversed.

obelisk A pillar or shaft of stone.

obsidian A natural glass formed by volcanic activity.

olla Spanish word for a clay jar with a flaring neck.

Paleo-Indian Designation of the early nomadic hunters who entered the Americas in late Pleistocene times across the Bering Strait from eastern Asia. Like the people of other regions of the Paleolithic period, they made tools predominantly by chipping stones into the desired shape.

palma One of three sculptural forms associated with the Mesoamerican ball game. Fancifully named for the shape, since exact use of the objects is unknown.

Paracas necropolis Various burials in the Paracas region of Peru, especially renowned for textile finds.

patojo A shoe-shaped ceramic vessel found in cultures ranging from southern United States to Peru.

parfleche A French term, meaning rawhide, used to describe various storage bags and boxes made by Plains tribes of the United States.

pastillage Sculpture built of pellets of plaster shaped over a rough stone core.

patina The term for the general surface appearance resulting from the aging of an artifact; it is usually used in a positive, favorable sense.

pectoral An ornament worn on the chest.

petroglyph An engraving on natural rock, displaying various signs, designs, and figures.

pictogram Figurative drawing with an explanatory purpose. Earliest form in the evolution of a system of writing.

pipe Often associated with ritual smoking; of two basic structures: the elbow pipe (where the bowl culminates in a right angle) and the platform pipe (where the bowl stands upright. in the center of the pipe stem).

pirca Andean wall construction of dry-laid unshaped stones.

pit house Structure consisting of a shallow pit, with a superstructure of wood covered with turf, thatch, or skins.

Pleistocene The geological period corresponding with the last, or Great, Ice Age. It began at least two million years ago and ended about 10,000 years ago, with the final retreat of the ice sheets that covered a wide region of North America.

polychrome Painted in many colors.

pony beads Also known as "trade beads," these imported beads of about 5mm. diameter were made of glass and were introduced by European traders in the early nineteenth century.

positive painting The direct application of a design by use of pigments, as in pottery painting.

potlatch An important Northwest Coast tribal ceremony or festival, during which the giving of gifts was an important activity.

potsherds (potshards) Fragments of broken pottery.

pre-ceramic Before the invention and manufacture of ceramics, referring to a period antedating the use of pottery.

provenance Source or site of an object, plus its subsequent history.

projectile point The technical name for stone weapon points often called arrowheads. The development of projectiles apparently did not

occur until after the migration of Paleo-Indians from northeastern Asia.

pyramid In the Americas, the word is loosely used to describe a tall, flat-topped mound or solid construction which usually supported a temple or civil building. Most American examples were not tombs.

punctate decoration Pottery decoration achieved by punching a sharp tool into the wet clay; called punctation.

quipu A device made with varicolored and knotted strings to assist in calculating and to transmit messages; used by the ancient Peruvians.

radiocarbon (carbon-14) dating Measurement in organic matter of the radioactive isotope carbon 14 to determine age.

rebus writing A mode of expressing words and phrases by pictures of objects whose names resemble those words or the syllables of which they are composed.

repoussé The process of "pushing out" a design from the back on thin sheets of metal.

resist painting See also "negative painting." Sometimes this process is also called "batik," after a similar Southeast Asia technique of dyeing textiles.

roach Made of porcupine hair, a vertically projecting part of a ceremonial headdress, especially among the North American Plains tribes.

rocker stamping Preclassic decorative technique in which a sharp curved edge, probably a shell, was "walked" back and forth on a clay vessel while it was wet and before firing, to create a curved zigzag incised line.

roof comb Ornamental vertical extension rising above the rear wall or over the center of Maya temple roofs, especially the structures of Palenque. The structures located over the front wall are called "flying facades."

sacbe Causeway or road of the lowland Maya.

scarification Cosmetic puncturing of the skin to produce small welts for decorative effect.

secondary burial Reburial of a corpse, now dismembered.

sello Spanish for a "rocker stamp"; an object for imprinting a design on another surface.

shaft tomb Boot-shaped in its simplest form; examples consist of a vertical shaft that leads to one or more horizontal burial chambers. It is prominent from Peru to Colombia, but its only appearance in Mesoamerica is in the Jalisco, Nayarit, and Colima region.

shaman The spiritual leader, male or female, of a tribe.

shard (or sherd) Fragment of broken pottery.

slip A thin coating of liquid clay applied to clay objects before firing; usually different in color from the vessel's paste.

spindle whorls The clay or stone disks affixed to a hand spindle which keep it in motion. The device is used for twisting fibers together into one continuous strand, or thread.

stela (plural, stelae) Columnar stone monument erected to record historic and religious events; sometimes plain but more usually decorated with carved figures and glyphs. Prominent particularly in the Olmec, Maya, and Zapotec cultures.

stepped fret Abstract decorative motif, possibly inspired by serpents or waves, consisting of diagonally rising steps and ending in an angular curved hook.

stirrup spout A semicircular tubular spout set vertically on top of a closed vessel. The two hollow tubes rise from the body of the vessel and join in a single spout, having the appearance from the side of a stirrup.

stucco Lime plaster, used for covering walls and floors and for modeling in relief; of particularly refined use by the Maya.

sweathouse A special building for taking sweat baths, usually of a ritualistic nature.

tablero-talud An architectural term referring to a sloped basal apron surmounted by a recessed vertical tablet.

tapestry A weave in which wefts are battened so closely together as to conceal warps.

temple A structure for ritual; usually placed on a raised platform or pyramid.

temple mound A flat-topped mound of earth which served as a platform for a temple; found in the Mississippian culture as well as Mesoamerica.

terracotta Glazed or unglazed fired clay.

terraced motif A stairstep design.

trophy heads Believed, without verification, to be of South American origin; the heads were part of a cult associated with ritual sacrifice and possibly with warfare.

tundra Treeless Arctic plain.

Valley of Mexico The heartland of Mesoamerica in central Mexico; an area of 5,000 square miles at an elevation of about 7,000 feet.

wall The material part of a vessel; the side of a container.

warp The yarn stretched on the loom preparatory to weaving.

weft The yarn woven over and under warps at right angles to them.

whistling jar A clay vessel composed of two connected pots—one open at the top, the other provided with a small hole. As water is poured in or out the air passing through the small aperture produces a whistling sound.

yoke A large U-shaped stone sculpture, often elaborately carved, associated with the ritual ball game but of unknown use.

zoomorphic In the shape of or having the attributes of an animal.

Selected Bibliography

Adams, Richard E. W., ed. *The Origins of Maya Civilization* (Albuquerque: University of New Mexico Press), 1977.

Alexander, H. B. *Mystery of Life* (Chicago: Open Court), 1913.

Amano, Yushitaro. *Diseños Pre-Colombinos del Peru* (Lima: Museo Amano).

Anderson, Marilyn. *Guatemalan Textiles Today* (New York: Watson-Guptill Publications), 1978.

Andrews, George F. *Maya Cities: Place-Making and Urbanization* (Norman: University of Oklahoma Press), 1975.

Anton, Ferdinand. *Art of the Maya* (London: Thames and Hudson), 1970.

———. *The Art of Ancient Peru* (New York: G. P. Putnam's Sons), 1972.

Appleton, Le Roy H. *American Indian Design and Decoration* (New York: Dover Publications), 1950.

Arnheim, Rudolf. *Art and Visual Perception: A Psychology of the Creative Eye* (Berkeley: University of California Press), 1969.

———. *Visual Thinking* (Berkeley: University of California Press), 1969.

Astrov, Margot, ed. *American Indian Prose and Poetry: An Anthology* (New York: Capricorn Books), 1962.

Bahti, Tom. *Southwestern Indian Ceremonials* (Tucson: KC Publications), 1947.

Baldwin, Gordon C. *America's Buried Past: The Story of North American Archaeology* (New York: G. P. Putnam's Sons), 1962.

Bankes, George. *Peru Before Pizarro* (New York: E. P. Dutton), 1977.

Barrett, S. A. *Ceremonies of the Pomo Indians* (Berkeley: University of California Press), 1914.

Basso, Keith H. *The Cibecue Apache* (New York: Holt, Rinehart & Winston), 1970.

Beltran, Miriam. *Cuzco: Window on Peru* (New York: Alfred A. Knopf), 1970.

Benson, Elizabeth P. *The Mochica: A Culture of Peru* (New York: Praeger Publications), 1972.

Bernal, Ignacio. *One Hundred Masterpieces of the Mexican National Museum of Anthropology* (New York: Harry N. Abrams), 1969.

———. *Mexico Before Cortes: Art, History and Legend*, rev. ed. Willis Barnstone, trans. (New York: Doubleday/Anchor), 1975.

Biebuyck, Daniel P., ed. *Tradition and Creativity in Tribal Art* (Berkeley: University of California Press), 1969.

Bierhorst, John. *Four Masterworks of American Indian Literature* (New York: Farrar, Straus and Giroux), 1974.

Boas, Franz, *Primitive Art* (New York: Dover Press), 1955. (Republication of original 1927 text.)

Bounoure, Vincent. *American Painting* (Geneva: Edito-Service), 1970.

Brandon, William, ed. *The American Heritage Book of Indians* (New York: Dell Publishing Co.), 1961.

Brascoupe, Simon, ed. *Directory of North American Indian Museums and Cultural Centers, 1981* (New York: North American Indian Museums Association), 1980.

Broder, Patricia Janis. *Bronzes of the American West* (New York: Harry N. Abrams), 1977.

———. *Hopi Painting: The World of the Hopis* (New York: Brandywine Press), 1978.

Brody, J. J. *Indian Painters and White Patrons* (Albuquerque: University of New Mexico Press), 1971.

———. *Mimbres Painted Pottery* (Albuquerque: University of New Mexico Press), 1977.

Brown, Joseph E. *The North American Indians: A Selection of Photographs by Edwards S. Curtis* (New York: Aperture Books), 1972.

Bruhns, Karen Olsen. *A Coloring Album of Ancient Mexico and Peru* (Berkeley: Saint Hieronymous Press), 1973.

Bunzel, Ruth L. *Zuñi Katchinas* (Bureau of American Ethnology, Annual Report 47), 1929–30.

Burland, C. A. *Montezuma: Lord of the Aztecs* (New York: G. P. Putnam's Sons), 1973.

———. *Peoples of the Sun: The Civilizations of Pre-Columbian America* (New York: Praeger Publications), 1976.

Burland, Cottie. *Eskimo Art* (New York: Hamlyn Publishing), 1973.

Burnham, Dorothy K. *Warp and Weft: A Textile Terminology* (Toronto: Royal Ontario Museum), 1980.

Bushnell, G. H. S. *Ancient Arts of the Americas* (New York: Praeger Publications), 1965.

———. *The First Americans* (New York: McGraw-Hill Book Co.), 1968.

Buttree, Julia M. *The Rhythm of the Redman* (New York: Barnes), 1930.

Cano, Jesus Arango. *Ceramica: Quimbaya y Calima* (Bogotá: Plaza y Janes Editores), 1976.

———. *Pre-Columbian Ceramics* (Bogotá: Plaza y Janes Editores), 1979.

Carmichael, Elizabeth. *Turquoise Mosaics from Mexico* (London: Trustees of the British Museum), 1970.

Caso, Alfonso. *The Aztecs: People of the Sun.* Lowell Dunham, trans. (Norman: University of Oklahoma Press), 1958.

Cavallo, Adolph S. *Tapestries of Europe and of Colonial Peru in the Museum of Fine Arts, Boston,* vols. I–II (Boston: Museum of Fine Arts), 1967.

Ceram, C. W. *The First American: A Story of North American Archaeology* (New York: Harcourt Brace Jovanovich), 1971.

Cervantes, Maria Antonieta. *Treasures of Ancient Mexico: From the National Anthropological Museum* (New York: Crescent Books), 1978.

Chafe, Wallace L. *Seneca Thanksgiving Rituals* (Bureau of American Ethnology, vol. 19), 1961.

Chapman, Abraham, ed. *Literature of the American Indians: Views and Interpretations* (New York: New American Library), 1975.

Cinader, Bernard. "Art of the Woodland Indians." Introduction, *Contemporary Native Art of Canada—The Woodland Indians* (Toronto: Royal Ontario Museum), 1976.

———. "Explorations of Past, Present and Future," *The Indian Trader,* vol. 10, no. 1 (January 1979).

———. "Tradition and Aspiration in Contemporary Canadian Indian Art," in *Contemporary Indian Art—The Trail from the Past to the Future* (Peterborough: Trent University Press), 1977.

Coe, Michael D. *The Maya* (London: Thames and Hudson), 1966.

Coe, Ralph T. *Sacred Circles: Two Thousand Years of North American Indian Art* (Kansas City: Nelson Art Gallery), 1977.

Coe, William R. *The Maya* (New York: Praeger Publishing), 1966.

———. "Resurrecting the Grandeur of Tikal,"

National Geographic, December 1975, pp. 792–795.

Collaer, Paul, ed. *Music of the Americas: An Illustrated Music Ethnology of the Eskimo and American Indian Peoples* (New York: Praeger Publishing), 1973.

Collier, John. *Indians of the Americas* (New York: W. W. Norton & Co.), 1947.

Conn, Richard. *Native American Art in the Denver Art Museum* (New York: A. Colish), 1979.

Covarrubias, Miguel. *Indian Art of Mexico and Central America* (New York: Alfred A. Knopf), 1966.

———. *The Eagle, the Jaguar, and the Serpent: Indian Art of the Americas* (New York: Alfred A. Knopf), 1967.

Crosby, Harry. "Baja's Murals of Mystery," *National Geographic,* November 1980, p. 692–702.

Culbert, T. Patrick, ed. *The Classic Maya Collapse* (Albuquerque: University of New Mexico Press), 1973.

Curtis, Edward S. *North American Indian, 1907* (New York: A & W Publishers), 1975.

D'Harcourt, Raoul, *Textiles of Ancient Peru and Their Techniques* (Seattle: University of Washington Press), 1962.

Davies, Nigel. *The Aztecs: A History* (London: MacMillan), 1973.

———. *The Toltecs: Until the Fall of Tula* (Norman: University of Oklahoma Press), 1977.

———. *The Toltec Heritage: From the Fall of Tula to the Rise of Tenochtitlan,* vol. 153 of *The Civilizations of the American Indian* series (Norman: University of Oklahoma Press), 1980.

Davis, E. Adams, ed. *Of the Night Wind's Telling: Legends from the Valley of Mexico* (Norman: University of Oklahoma Press), 1946.

Dawdy, Doris Ostrander. *Annotated Bibliography of American Indian Painting* (New York: Heye Foundation), 1968.

Densmore, Frances. *Teton Sioux Music* (Bureau of American Ethnology), 1918.

———. *Chippewa Music Parts I and II* (Bureau of American Ethnology, bulletin 58), 1929.

———. *Pawnee Music* (Bureau of American Ethnology), 1929.

———. *Menominee Music* (Bureau of American Ethnology), 1932.

————. *Yuman and Yaqui Music* (Bureau of American Ethnology), 1932.

————. *Nootka and Quileute Music* (Bureau of American Ethnology), 1939.

————. *Seminole Music* (Bureau of American Ethnology), 1956.

Deregowski, Jan B. "Pictorial Perception and Culture," *Scientific American*, November 1972, pp. 79–85.

Dickason, Olive Patricia. *Indian Art in Canada* (Ottawa: Department of Indian Affairs and Northern Development), 1972.

Disselhoff, Hans-Dietrich, and Linne, Siguald. *The Art of Ancient America: Civilizations of Central and South America* (New York: Crown Publications), 1961.

Dockstader, Frederick J. *Indian Art in North America: Arts and Crafts* (Greenwich: New York Graphic Society), 1961.

————. *Indian Art in Middle America* (Greenwich: New York Graphic Society), 1964.

————. *Indian Art in America: The Arts and Crafts of the North American Indian* (Greenwich: New York Graphic Society), 1967.

————. *Indian Art of the Americas* (New York: The Heye Foundation), 1973.

————. *Weaving Arts of the North American Indian* (New York: Thomas Y. Crowell Publishers), 1978.

Doig, Federico Kauffmann. *Sexual Behaviour in Ancient Peru* (Lima: Kompaktos, S.C.R.L.), 1979.

————. *Manual de Arqueologia Peruana* (Lima: Peisa), 1980.

Dorsey, George A. *The Cheyenne: The Sun Dance* (Chicago: Chicago Field Museum), 1905.

Douglas, Frederic H., and D'Harnoncourt, René. *Indian Art of the United States* (New York: Museum of Modern Art), 1941.

Driver, Harold E. *Indians of North America* (Chicago: University of Chicago Press), 1969.

Dufrenne, Mikel. *The Phenomenology of Aesthetic Experience* (Evanston: Northwestern University Press), 1973.

Dunn, Dorothy. "America's First Painters," *National Geographic*, March 1955, pp. 349–378.

————. *American Indian Painting* (Albuquerque: University of New Mexico Press), 1968.

————. Introduction, 1877: *Plains Indian Sketch Books of Zo-Tom and Howling Wolf* (Flagstaff: Northland Press), 1969.

Dutton, Bertha P. *Sun Father's Way: The Kiva Murals of Kuana* (Albuquerque: University of New Mexico Press), 1963.

Easby, Dudley T., Jr. "Early Metallurgy in New York," in *Scientific American*, April 1966.

Easby, Elizabeth Kennedy; Scott, John F.; Hoving, Thomas P. F.; Easby, Dudley T., Jr. *Before Cortes: Sculpture of Middle America* (New York: Metropolitan Museum of Art/New York Graphic Society), 1970.

Editorial Universo, S.A., ed. *Nazca: The Lines* (Lima: Librerias S.A., ABC), 1978.

Eisleb, Dieter. *Töpferkunst der Maya* (Berlin: Staatliche Museum Preusischer Kulturbesitz), 1969.

————. *Alt-Amerika: Führer durch die Ausstellung der Abteilung Amerikanische Archäologie* (Berlin: Museum für Völkerkunde), 1974.

Enciso, Jorge. *Design Motifs of Ancient Mexico* (New York: Dover Publications), 1953.

Evans, May G., and Evans, Bessie. *American Indian Dance Steps* (New York: Barnes), 1931.

Ewers, John Canfield. *Plains Indian Painting* (Palo Alto: Stanford University Press), 1939.

————. "The Emergence of the Named Indian Artist in the American West," *American Indian Art*, vol. 6, no. 2 February 1981, pp. 52–61, 77–79.

Ewing, Robert A. "The New Indian Art," *El Palacio* vol. 76, no. 1 (Spring 1969), pp. 33–39.

Farb, Peter. *Man's Rise to Civilization: The Cultural Ascent of the Indians of North America* (New York: E. P. Dutton Publishers), 1968.

Feder, Norman. *American Indian Art* (New York: Harry N. Abrams), 1965.

Feest, Christian F. *Native Arts of North America* (New York: Oxford University Press), 1980.

Fenton, William N. *An Outline of Seneca Ceremonies at Coldspring Longhouse* (New Haven: Yale University Publications in Anthropology, no. 9), 1936.

Fewkes, J. Walter. *Hopi Katchinas*. Bureau of American Ethnology, 1903 (Glorieta: Rio Grande Press), 1969.

Fisch, Olga. *Exposicion de Artesanias: Primera Bienal de Arquitectura de Quito* (Quito: El Galpon), 1978.

Fletcher, Alice C. *The Hako: A Pawnee Ceremony*, Part II. Bureau of American Ethnology, 1900–1901.

Folsom, Franklin. *America's Ancient Treasures: Guide to Archaeological Sites and Museums*

(New York: Rand McNally and Co.), 1971.

Frank, Larry, and Francis H. Harlow. *Historic Pottery of the Pueblo Indians: 1600–1880* (Boston: New York Graphic Society), 1974.

Friedman, Martin; Libertus, Ron; Clark, Anthony M., Forewords. *American Indian Art: Form and Tradition* (New York: E. P. Dutton and Co.), 1972.

Furst, Peter T. "Hallucinogens in Precolumbian Art," in Mary E. King and Idris R. Traylor, Jr., eds. *Art and Environment in North America*, Special Publication No. 7, Texas Tech University Museum, pp. 11–101, 1974.

Gallenkamp, Charles. *Maya: The Riddle and Re-discovery of a Lost Civilization* (New York: David.McKay), 1976.

Gallo, Miguel Mujica; Rey, Alvaro Roca; Quesada, Aurelio Miro. *Oro Del Peru* (Lima: Monterrico Museum), 1965.

Geiogamah, Hanay. *New Native American Drama: Three Plays* (Norman: University of Oklahoma Press), 1980.

Gheerbrant, Alain, ed. *The Incas: The Royal Commentaries of Garcilaso the Inca* (New York: Orion Press), 1961.

Goddard, Pliny E. *Dancing Societies of the Sarsi Indians* (New York: American Museum of Natural History), 1914.

Gomez, Luis Duque. *San Augustin Archaeological Park* (Bogotá: Corporacion Nacional de Turismo), 1981.

Goodman, Jeffrey. *American Genesis: The American Indian and the Origins of Modern Man* (New York: Summit Books), 1981.

Gorenstein, Shirley. *North America* (New York: St. Martin's Press), 1975.

Graburn, Nelson H. H., ed. *Ethnic and Tourist Arts: Cultural Expressions from the Fourth World* (Berkeley: University of California Press), 1976.

Grieder, Terence, and Mendoza, Alberto Bueno. "La Galgada: Peru Before Pottery," *Archaeology*, vol. 34, no. 2 (March/April, 1981), pp. 44–51.

Gross, Daniel R., ed. *Peoples and Cultures of Native South America* (Garden City: Doubleday/Natural History Press), 1973.

Haberland, Wolfgang. *The Art of North America* (New York: Crown Publishers), 1964.

Hall, Alice J., and Spier, Peter. "A Traveler's Tale of Ancient Tikal," *National Geographic*, December 1975, pp. 799–811.

Hammond, Norman. "The Earliest Maya," *Scientific American*, March 1979, pp. 116–133.

Hardoy, Jorge E. *Pre-Columbian Cities* (New York: Walker and Co.), 1964.

Hartmann, Horst. *Die Plains und Prärieindianer Nordamerikas* (Berlin: Museum für Völkerkunde, 1973.

Hefritz, Hans. *Mexican Cities of the Gods: An Archaeological Guide* (New York: Frederick A. Praeger Publishers), 1970.

Hemming, John. *The Conquest of the Incas* (London: MacMillan), 1970.

Hess, Hans. *How Pictures Mean* (New York: Pantheon Books), 1974.

Hester, Joseph A., Jr., and MacGawan, Kenneth. *Early Man in the New World* (New York: Peter Smith), 1962.

Hewett, Edgar L. *Ancient Life in the American Southwest* (Indianapolis: Bobbs-Merrill), 1930.

Hewitt, J. N. B. *Iroquoian Cosmology* Bureau of American Ethnology: Part I, 1899–1900; Part II, 1925–1926.

Hibben, Frank C. *Kiva Art of the Anasazi at Pottery Mound* (Las Vegas: KC Publications), 1975.

Highwater, Jamake. *Indian America* (New York: David McKay Co.), 1975.

––––––. *Song from the Earth: American Indian Painting* (Boston: New York Graphic Society), 1976.

––––––. *Anpao: An American Indian Odyssey* (New York: J. B. Lippincott Co.), 1977.

––––––. *Ritual of the Wind: North American Indian Ceremonies, Music, and Dances* (New York: Viking Press), 1977.

––––––. *Dance: Rituals of Experience* (New York: A&W Publications), 1978.

––––––.*The Sweet Grass Lives On: Fifty Contemporary North American Indian Artists* (New York: Harper & Row), 1980.

––––––. *The Primal Mind: Vision and Reality in Indian America* (New York: Harper & Row), 1981.

Hobson, Geary, ed. *The Remembered Earth: An Anthology of Contemporary Native American Literature* (Albuquerque: University of New Mexico Press), 1980.

Hodnett, M. K. *Molds Used in Ceramics of Chancay: Art Techniques of Ancient Peru* (Lima: M. K. Hodnett), 1978.

Holder, Preston. *The Hoe and the Horse on the Plains: A Study of Cultural Development Among North American Indians* (Lincoln:

University of Nebraska Press), 1970.

Holland, James R. *The Amazon* (Cranbury: A. S. Barnes and Co.), 1971.

Hunter, Bruce C. *A Guide to Ancient Maya Ruins* (Norman: University of Oklahoma Press), 1974.

————. *A Guide to Ancient Mexican Ruins* (Norman: University of Oklahoma Press), 1974.

Introduction to American Art, to Accompany the First Exhibition of American Indian Art Selected Entirely with Consideration of Esthetic Value (Glorieta: Rio Grande Press), 1970.

Inverarity, Robert Bruce. *Art of the Northwest Coast Indians* (Berkeley: University of California Press), 1971.

Irvine, Keith, ed. *Encyclopedia of Indians of the Americas* (St. Clair Shores: Scholarly Press), 1974.

Jacobson, Oscar Brousse. *Kiowa Indian Art* (Nice, France: C. Szwedzicki), 1929.

James, George Wharton. *Indian Basketry* (New York: Dover Publications), 1972.

Javitch, Gregory. *Selective Bibliography of Ceremonies, Dance, Music and Song of the American Indians* (Montreal: Osiris), 1974.

Jennings, Jesse D., and Norbeck, Edward, eds. *Prehistoric Man in the New World* (Chicago: William Marsh Rice University), 1964.

————. *Prehistory of North America*, second ed. (New York: McGraw-Hill Book Co.), 1974.

————. ed. *Ancient Native Americans* (San Francisco: W. H. Freeman & Co.), 1978.

Joe, Eugene Baatsoslanii, and Bahti, Mark. *Navajo Sandpainting Art* (Tucson: Treasure Chest Publications), 1978.

Josephy, Alvin M., Jr. *The Indian Heritage of America* (New York: Alfred A. Knopf), 1968.

Kan, Michael; Meighan, Clement; and Nicholson, H. B. *Sculpture of Ancient West Mexico* (Los Angeles County Museum of Art), 1970.

Keen, Benjamin. *The Aztec Image in Western Thought* (New Brunswick, N.J.: Rutgers University Press), 1971.

Kelemen, Pal. *Art of the Americas: Ancient and Hispanic* (New York: Bonanza Books), 1969.

Kelley, Patricia, and Orr, Carolyn. *Sarayacu Quichua Pottery* (Dallas: Summer Institute of Linguistics), 1976.

King, Mary E., and Idris R. Traylor, Jr., eds., *Art and Environment in North America*, Special Publication No. 7, Texas Tech University Musuem, 1974.

Kubler, George. *The Art and Architecture of Ancient America* (Baltimore: Penguin Books), 1975.

Kurath, Gertrude P. *Iroquois Music and Dance.* Bureau of American Ethnology, No. 187, 1964.

La Barre, Weston. *The Peyote Cult* (New York: Schocken Books), 1969.

La Farge, Oliver. *Introduction to American Indian Art* (Glorieta: Rio Grande Press), 1973.

————. *A Pictorial History of the American Indian*, rev. ed. (New York: Crown Publishers), 1974.

La Flesche, Francis. *War Ceremony and Peace Ceremony of the Osage Indians.* Bureau of American Ethnology, 1939.

La Fay, Howard. "Children of Time," *National Geographic*, December 1975; pp. 728–767.

Langer, Suzanne K. *Problems of Art* (New York: Charles Scribner's Sons), 1957.

————. *Mind: An Essay on Human Feeling*, volume I (Baltimore: Johns Hopkins Press), 1967.

Lanning, Edward P. *Peru Before the Incas* (Englewood Cliffs: Prentice-Hall), 1967.

Lapiner, Alan. *Pre-Columbian Art of South America* (New York: Harry N. Abrams), 1976.

Laski, Vera. *Seeking Life: The Raingod Ceremony of San Juan.* (Washington, D.C.: American Folklore Society), 1958.

Lathrap, Donald W. *The Upper Amazon* (London: Camelot Press), 1970.

————. *Ancient Ecuador: Culture, Clay and Creativity, 3000–300* B.C. (Chicago: Field Museum of Natural History), 1975.

Leach, E. R. "Aesthetics," from *The Institutions of Primitive Society, a Series of Broadcast Talks* (London: Basin Blackwell), 1956.

Leftwich, Rodney L. *Arts and Crafts of the Cherokee* (Cullowhee: Land-of-the-Sky Press), 1970.

Le Goff, Jacques. "The Historian and the Ordinary Man," in *Time, Work, and Culture in the Middle Ages* (Chicago: University of Chicago Press), 1980.

Leon, Luisa Castañeda. *Arte Popular del Peru* (Lima: Museo Nacional de la Cultura Peruana), 1977.

Leon-Portilla, Miguel. *The Broken Spears, Az-*

tec Account of the Conquest of Mexico, Lysander Kemp, trans. (Boston: Beacon Press), 1962.

———. *Aztec Thought and Culture*, Jack Emory Davis, trans. (Norman: University of Oklahoma Press), 1963.

———. *Pre-Columbian Literatures of Mexico*. Grace Lobanov and Jamake Highwater, trans. (Norman: University of Oklahoma Press), 1969.

———. *Time and Reality in the Thought of the Maya* (Boston: Beacon Press), 1973.

Leonard, Jonathan Norton. *Ancient America* (New York: Time-Life Publications), 1967.

Linton, Ralph. *Annual Ceremony of the Pawnee Medicine Men* (Chicago: Field Museum of Natural History), 1922.

———. *The Sacrifice to the Morning Star by the Skidi Pawnee* (Chicago: Field Museum of Natural History), 1922.

Lipton, Barbara; Rainey, Dr. Froelich; and Chapman, Allan. *Survival: Life and Art of the Alaskan Eskimo* (New York: Morgan Press), 1977.

Lister, Robert H., and Florence C. Lister. *Anasazi Pottery* (Albuquerque: University of New Mexico Press), 1978.

Lommel, Andreas. *Prehistoric and Primitive Man* (London: Paul Hamlyn), 1966.

Lothrop, Samuel Kirkland. *Pre-Columbian Designs from Panama: 591 Illustrations of Cocle Pottery* (New York: Dover Publications), 1976.

Lowie, Robert H. *Sun Dance of the Shoshone, Ute and Hidatsa.* (New York: American Museum of Natural History), 1919.

Lumbreras, Luis Guillermo. *Pre-Hispanic Textiles* (Lima: Librerias ABC S.A.), 1974.

———. *Guia Para Museos de Arqueologia Peruana* (Lima: Editorial Carlos Milla Batres S.A.), 1975.

———. Meggers, Betty J., trans. *The Peoples and Cultures of Ancient Peru* (Washington, D.C.: Smithsonian Institution Press), 1976.

———. *Pre-Hispanic Ceramics* (Lima: Libererias ABC S.A.), 1980.

Mallery, Garrick. *Picture Writing of the American Indians* (New York: Dover Publications), 1972.

Marriott, Alice, and Rachlin, Carol K. *Peyote* (New York: Thomas Y. Crowell), 1971.

Martin, Paul S. et al. *Indians Before Columbus: Twenty Thousand Years of North American History Revealed by Archaeology* (Chicago: University of Chicago Press), 1947.

Mason, J. Alden. *The Ancient Civilizations of Peru* (London: Penguin Books), 1957.

Mason, Otis Tufton. *Aboriginal Indian Basketry: Studies in a Textile Art Without Machinery* (Gloriata: Rio Grande Press), 1902.

Matthews, Washington. *The Mountain Chant*. Bureau of American Ethnology, 1887.

———. *Navajo Legends* (Washington, D.C.: American Folklore Society), 1897.

———. *The Night Chant, Memoirs*, volume VI, May 1902 (American Museum of Natural History), 1902.

Maurer, Evan M. *The Native American Heritage: A Survey of North American Indian Art* (Chicago: The Art Institute of Chicago), 1977.

Meisch, Lynn. *A Traveler's Guide to El Dorado and the Inca Empire* (New York: Penguin Books), 1977.

Meggers, Betty J., Clifford Evans, and Emilio Estrada. *Early Formative Period of Coastal Ecuador: The Valdivia and Machalilla Phases* (Washington, D.C.: Smithsonian Institution), 1965.

Merriam, C. H. *Studies of California Indians* (Berkeley: University of California Press), 1962.

Miles, Charles, *Indian and Eskimo Artifacts of North America* (New York: Bonanza Books),1963.

Monti, Franco, *Pre-Columbian Terracottas* (London: Hamlyn Publishing Group), 1969.

Mooney, James, *The Ghost Dance Religion*. Bureau of American Ethnology, 1892–93.

Morgan, Lewis H. *Houses and House Life of the American Aborigines* (Chicago: University of Chicago Press), 1966.

Morley, Sylvanus Griswold. *The Ancient Maya* (Stanford: Stanford University Press), 1968.

Muser, Curt, compiler. *Facts and Artifacts of Ancient Middle America* (New York: E. P. Dutton), 1978.

Nabokov, Peter. "Native American Architecture: Preserving Social and Religious Life," *Four Winds*, Winter/Spring 1981, pp. 42–47.

National Geographic Society. *The World of the American Indian* (Washington, D.C.: National Geographic Society), 1974.

Naylor, Maria, ed. *Authentic Indian Designs* (New York: Dover Press), 1975.

Neale, Gay. "Textiles of North American Indians," *The Indian Trader*, vol. 9, no. 11 (November 1978), pp. 1–2, 9–12, 16–18.

Nelson, Ralph, trans. *Popol Vuh: The Great Mythological Book of the Ancient Maya* (Boston: Houghton Mifflin Co.), 1951.

Oritz, Alfonso, *The Tewa World* (Chicago: University of Chicago Press), 1969.

———. *Mexico Arte Moderno II* (Mexico City: Camara Nacional de Comercio de la Ciudad de Mexico), 1977.

Osborne, Lilly de Jongh. *Indian Crafts of Guatemala and El Salvador* (Norman: University of Oklahoma Press), 1965.

Oswalt, Wendell H. *This Land Was Theirs: A Study of the North American Indian*, second ed. (New York: John Wiley & Sons), 1973.

Owen, Roger C. et al. *The North American Indians: A Sourcebook* (New York: Macmillan Co.), 1967.

Pagden, A. R., ed. *The Maya: Diego de Landa's Account of the Affairs of Yucatán* (Chicago: J. Philip O'Hara), 1975.

Painter, Muriel Thayer. *A Yaqui Easter* (Tucson: University of Arizona Press), 1971.

Panesso, Antonio, ed. *El Dorado* (Bogotá: Banco de la Republica), 1979.

Parsons, Elsie Clews, *The Pueblo of Jemez* (Washington, D.C.: Phillips Academy), 1925.

———. *The Scalp Ceremonial of Zuñi* (Washington, D.C.: American Anthropological Association), 1928.

———. *Pueblo Indian Religion*, 2 volumes (Chicago: University of Chicago Press), 1939.

Parsons, Lee A. *Pre-Columbian Art* (New York: Harper & Row), 1980.

Patterson, Nancy-Lou. *Canadian Native Art, Arts and Crafts of Canadian Indians and Eskimos* (Toronto: Collier-Macmillan), 1973.

Paz, Octavio. *The Labyrinth of Solitude* (London: Allen Lane), 1957.

Petersen, Karen Daniels, *Plains Indian Art from Fort Marion* (Norman: University of Oklahoma Press), 1971.

———. *Howling Wolf* (Palo Alto: American West Publishing Co.), 1968.

Prescott, William H. *The Conquest of Mexico* (New York: Modern Library), 1943.

Proskouriakoff, Tatiana. *An Album of Maya Architecture* (Norman: University of Oklahoma Press), 1963.

Radin, Paul, *Indians of South America* (New York: Doubleday, Doran and Co.), 1942.

———. *The Road of Life and Death* (Princeton: Bollingen Series V), 1945.

Ragghianti, Carlo Ludovico, and Collobi, Licia Ragghianti. *National Museum of Anthropology: Mexico City* (New York: Newsweek), 1970.

Ranney, Edward. *Stonework of the Maya* (Albuquerque: University of New Mexico Press), 1974.

Ray, Dorothy Jean. *Graphic Arts of the Alaskan Eskimo* (Washington, D.C.: Indian Arts and Crafts Board), 1969.

Read, Herbert. *Icon and Idea: The Function of Art in the Development of Human Consciousness* (Cambridge, Mass.: Harvard University Press), 1965.

Reed, Verner Z. "The Ute Bear Dance," *American Anthropology*, vol. IX (July 1896).

Reid, James W. "Wondrous Clothes," *Art News*, February 1980, pp. 102–107.

Rios, Marcela, and Ponce, Pedro Rojas. *Gold of Peru* (Lima: Librerias ABC S.A.), 1979.

Rodee, Marian E. *Southwestern Weaving* (Albuquerque: University of New Mexico Press), 1977.

Rowe, Ann Pollard. *Warp-Patterned Weaves of the Andes* (Washington, D.C.: Textile Museum), 1977.

Russell, Frank. *The Pima Indians*. Bureau of American Ethnology, 1908.

Salas, Lola. *Peruvian Arts and Crafts* (Lima: Librerias ABC S.A.), 1979.

Sanders, William T., and Marino, Joseph P. *New World Prehistory: Archaeology of the American Indian* (Englewood Cliffs: Prentice-Hall), 1971.

Savoy, Gene. *Antisuyo: The Search for the Lost Cities of the Amazon* (New York: Simon and Schuster), 1970.

Sawyer, Alan R. *Ancient Peruvian Ceramics* (New York: Metropolitan Museum of Art, and Greenwich: New York Graphic Society), 1966.

Sejourne, Laurette. *Burning Water: Thought and Religion in Ancient Mexico* (San Francisco: Repub. Shambala Press), 1976.

Sellards, Elias H. *Early Man in America: A Study in Prehistory* (Austin: University of Texas Press), 1952.

Senungetuk, Joseph E. *Give or Take a Century: An Eskimo Chronicle* (San Francisco: The Indian Historian Press), 1971.

Sides, Dorothy Smith. *Decorative Art of the Southwestern Indians* (New York: Dover Publications), 1961.

Silberman, Arthur. "Early Kiowa Art," *Oklahoma Today*, vol. 23, no. 1 (Winter 1972–73).

———. "Tiger," *Oklahoma Today*, vol. 21, no. 3 (Summer 1971).

Silverberg, Robert. *Mound Builders of Ancient America: The Archaeology of a Myth* (Greenwich: New York Graphic Society), 1968.

Smith, Watson. "Kiva Mural Decorations at Awatovi and Kawaika-a," *Peabody Museum Papers*, vol. 37 (New Haven), 1952.

Snodgrass, Jeanne O. *American Indian Painters: A Biographical Directory* (New York: Museum of the American Indian, Heye Foundation), 1968.

———. "American Indian Painting," *Southwestern Art*, vol. 11, no. 1 (1969).

Snow, Dean. *The Archaeology of North America* (New York: Viking Press), 1976.

Soustelle, Jacques. *Daily Life of the Aztecs* (London: Weidenfeld and Nicolson), 1961.

———. *The Four Suns: Recollections and Reflections of an Ethnologist in Mexico* (New York: Grossman Publishers/Orion Press),1971.

Southwest Indian Art (Tucson: University of Arizona Press), 1960.

Speck, Frank G., and Broom, Leonard. *Cherokee Dance and Drama* (Berkeley: University of California Press), 1951.

Spencer, Robert F. et al. *The Native Americans* (New York: Harper & Row), 1965.

Spicer, Edward H., and Balastrero, Phyllis. "Yaqui Easter Ceremonial," *Arizona Highways*, vol. 67, no. 3 (March 1971).

Spinden, Herbert J. *A Study of Maya Art: Its Subject Matter and Historical Development* (New York: Dover Publications), 1975.

Sten, Maria. *Codices of Mexico and Their Extraordinary History* (Mexico D.F.: Editorial Joaquin Mortiz), 1972.

Stephen, Alexander M. *Hopi Journal*, 2 vols. Columbia University Contributions to Anthropology, vol. 23. 1936.

Stevenson, Matilda C. *The Sia*, Bureau of American Ethnology, 1894.

———. *The Zuñi Indians*, Bureau of American Ethnology, 1904.

Stewart, Hilary. *Looking at Indian Art of the Northwest Coast* (Seattle: University of Washington Press), 1979.

Stuart, George E., and Imboden, Otis. "Riddle of the Glyphs," *National Geographic*, December 1975, pp. 768–791.

Tanner, Clara Lee. *Southwest Indian Painting* (Tucson: University of Arizona Press), 1957.

———. *Southwest Indian Craft Arts* (Tucson: University of Arizona Press), 1968.

———. *Prehistoric Southwestern Craft Arts* (Tucson: University of Arizona Press), 1976.

Taylor, Michael. "Faces and Voices," *Moccasins on Pavement: The Urban Indian Experience, a Denver Portrait* (Denver Museum of Natural History), 1979.

Tedlock, Dennis, and Tedlock, Barbara, eds. *Teaching from the American Earth: Indian Religion and Philosophy* (New York: Liveright), 1975.

Thompson, J. Erick S. *The Rise and Fall of Maya Civilization* (Norman: University of Oklahoma Press), 1966.

———. *Maya History and Religion* (Norman: University of Oklahoma Press), 1976.

Tillett, Leslie, ed. *Wind on the Buffalo Grass: The Indians' Own Account of the Battle at the Little Big Horn River, and the Death of Their Life on the Plains* (New York: Thomas Y. Crowell), 1976.

Tooker, Elizabeth. *Iroquois Ceremonial of Midwinter* (Syracuse: Syracuse University Press), 1970.

Toral, Hernan Crespo. *Ecuador: Hands, Light and Color: Ecuadorian Popular Art* (Washington: Interamerican Development Bank), 1980.

Turolla, Pino. *Beyond the Andes* (New York: Harper & Row), 1980.

Underhill, Ruth M. *Singing for Power* (Berkeley: University of California Press), 1938.

———. *Red Man's Religion* (Chicago: University of Chicago Press), 1965.

———. *Red Man's America: A History of the Indians in the United States* (Chicago: University of Chicago Press), 1971.

Urbanski, Edmund Stephen. *Hispanic America and Its Civilizations: Spanish Americans and Anglo Americans* (Norman: University of Oklahoma Press), 1978.

Vaillant, George C. *The Aztecs of Mexico* (Baltimore: Penguin Books), 1972.

Von Hagen, Victor Wolfgang, ed. *The Incas of Pedro de Cieza de Leon*, from volume 53 of The Civilizations of the American Indian se-

ries (Norman: University of Oklahoma Press),1959.

——. *World of the Maya* (New York: New American Library), 1960.

——. *The Aztec: Man and Tribe* (New York: New American Library), 1961.

——. *Realm of the Incas* (New York: New American Library), 1961.

——. *Maya Explorer: John Lloyd Stephens and the Lost Cities of Central America and Yucatan* (Norman: University of Oklahoma Press), 1967.

Warner, John Anson. *The Life and Art of the North American Indian* (London: Hamlyn Publishing Group), 1975.

——. *A Cree Life: The Art of Allen Sapp* (Vancouver: J. J. Douglas Publishers), 1977.

——. "Contemporary Algonkian Legend Painting," *American Indian Art*, vol. 3, no. 3 (May 1, 1978).

Waters, Frank. *The Book of the Hopi* (New York: Viking Press), 1963.

Wauchope, Robert, ed. *Handbook of Middle American Indians*, vols. 1–16 (Austin: University of Texas Press), 1966.

Weaver, Muriel Porter. *The Aztecs, Maya, and Their Predecessors: Archaeology of Mesoamerica* (New York: Seminar Press), 1972.

Webb, William, and Weinstein, Robert A. *Dwellers at the Source, Southwestern Indian Photographs by A.C. Vroman, 1895–1904* (New York: Grossman Publishers), 1973.

Wesche, Alice. *Wild Brothers of the Indians: As Pictured by the Ancient Americans* (Tucson: Treasure Chest Publications), 1977.

Westheim, Paul; Ruz, Alberto; Armillas, Pedro; de Robina, Ricardo; and Laso, Alfonso. *Prehistoric Mexican Art* (Mexico City: Editorial Herrero S.A.), 1972.

White, Fifi. "Ribbon Appliqué: A Unique American Art Form," *Native Arts/West*, April 1981, pp. 15–17.

White, Leslie A. *The Acoma Indians*, Bureau of American Ethnology, no. 27, 1929–30.

Whiteford, Andrew Hunter. *North American Indian Arts* (New York: Golden Press), 1970.

Whitman, William III. "The Pueblo Indians of San Ildefonso," *Contributions to Anthropology* (New York: Columbia University Press), no. 34, 1947.

Wilder, Carleton S. *The Yaqui Deer Dance*, Bureau of American Ethnology, no. 66, 1963.

Wilkerson, S. Jeffrey K. "Man's Eighty Centuries in Veracruz," *National Geographic*, August 1980, pp. 203–231.

Willey, Gordon R. *An Introduction to American Archaeology: Volume I, North and Middle America* (Englewood Cliffs: Prentice-Hall), 1966.

——. *An Introduction to American Archaeology: Volume II, South America* (Englewood Cliffs: Prentice-Hall), 1971.

——. *A History of American Archaeology* (San Francisco: W.H. Freeman & Co.), 1974.

Wingert, Paul S. *Primitive Art: Its Traditions and Styles* (New York: Oxford University Press), 1962.

Witthoft, John. *Green Corn Ceremonialism in the Eastern Woodlands* (Ann Arbor: Museum of Anthropology of The University of Michigan), no. 13, 1949.

Wormington, H.M. *Ancient Man in North America.* (Denver Museum of Natural History), 1957.

Wright, Barton. *Kachinas, a Hopi Indian's Documentary* (Flagstaff: Northland Press), 1973.

Wuthenan, Alexander von. *Pre-Columbian Terracottas* (London: Methuen & Co.), 1970.

Wyman, Leland C. *Navajo Sandpainting: The Huckel Collection* (Colorado Springs: Taylor Museum), 1960.

Yazzie, Ethelous, ed. *Navajo History*, vol. I (Chinle: Navajo Community College Press), 1971.

Zalamea, Gustano. *Colombia: Archaeological Areas* (Bogotá Corporacion Nacional de Turismo), 1982.

Zo-Tom. *1877: Plains Indian Sketch Books of Zo-Tom and Howling Wolf.* Introduction by Dorothy Dunn (Flagstaff: Northland Press), 1969.

Zubrow, Ezra B.W.; Fritz, Margaret C.; and Fritz, John M. *New World Archaeology: Theoretical and Cultural Transformations* (San Francisco: W.H. Freeman & Co.), 1974.

Index

Numbers in *italics* refer to black-and-white illustrations.